A Photographer's Life
1990–2005

Susan Sontag, Petra, Jordan, 1994

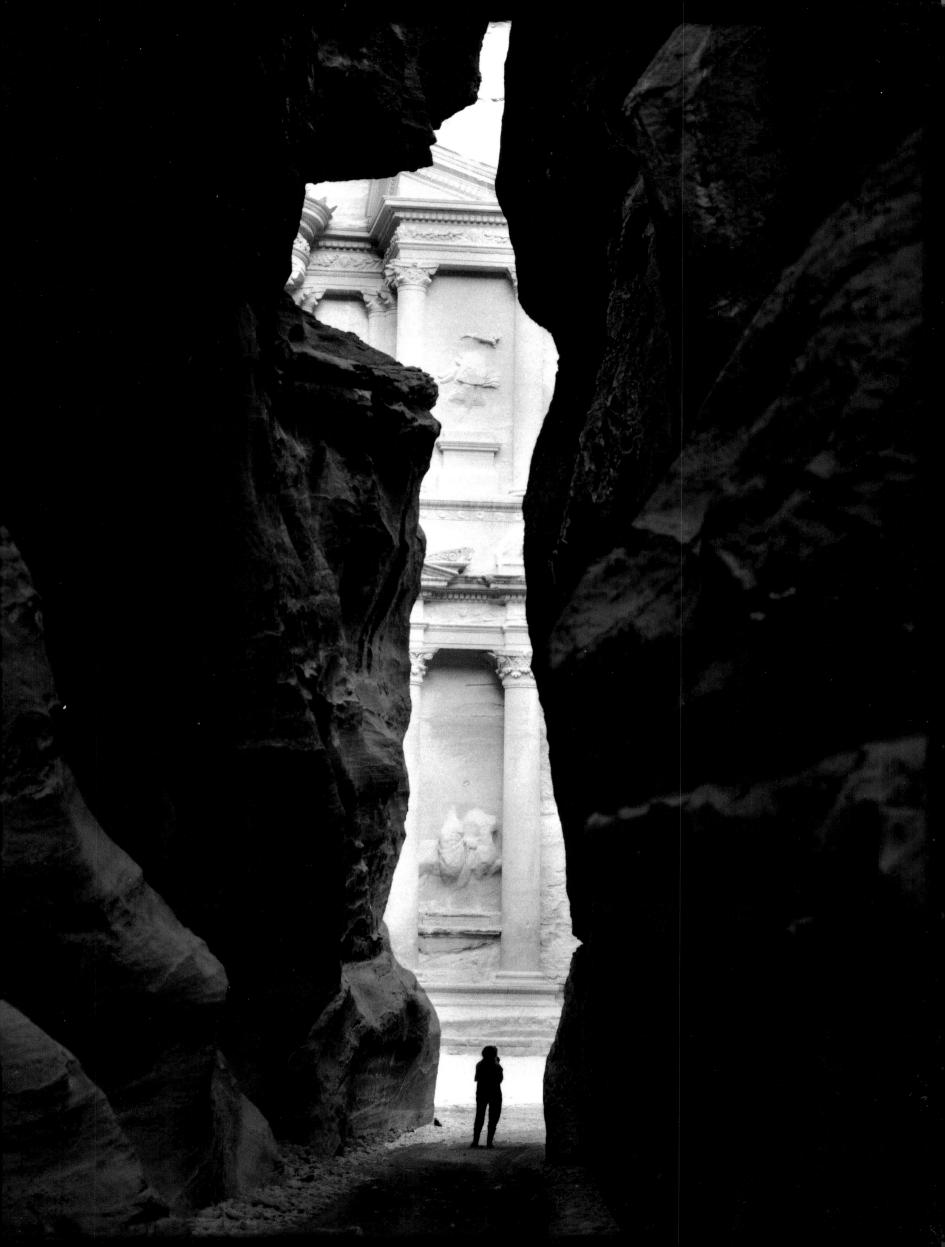

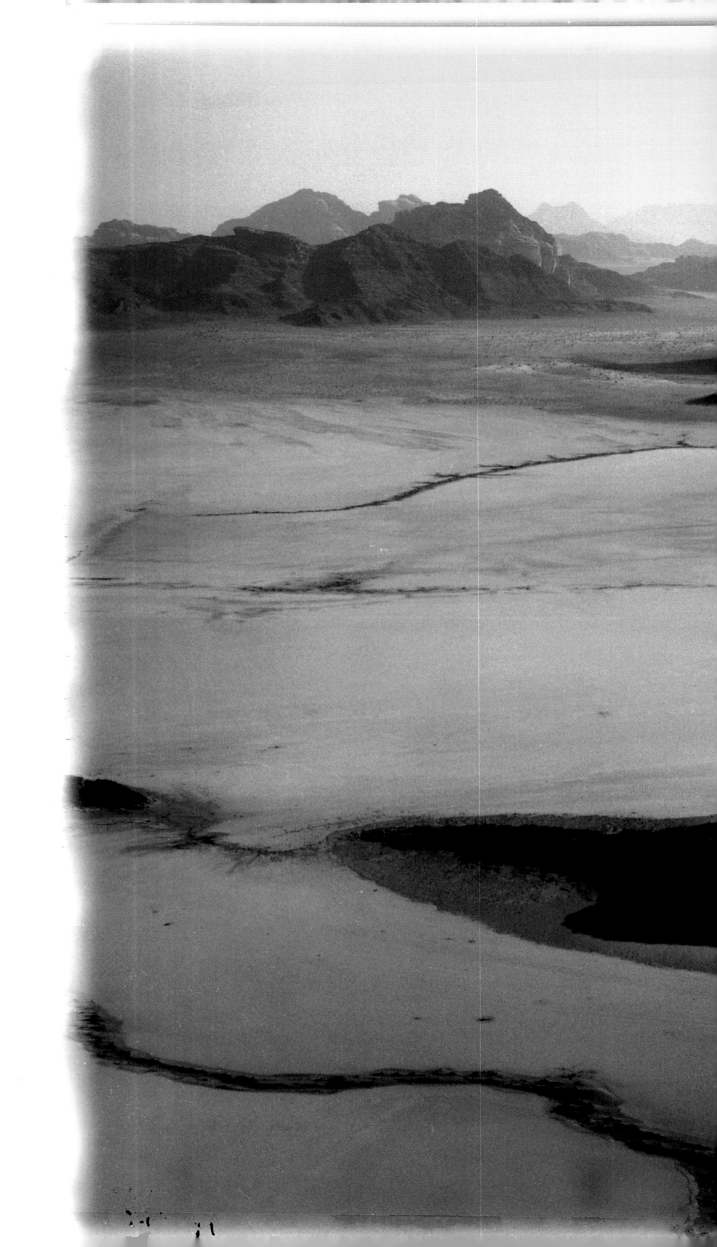

Wadi Rum, Jordan, 1994

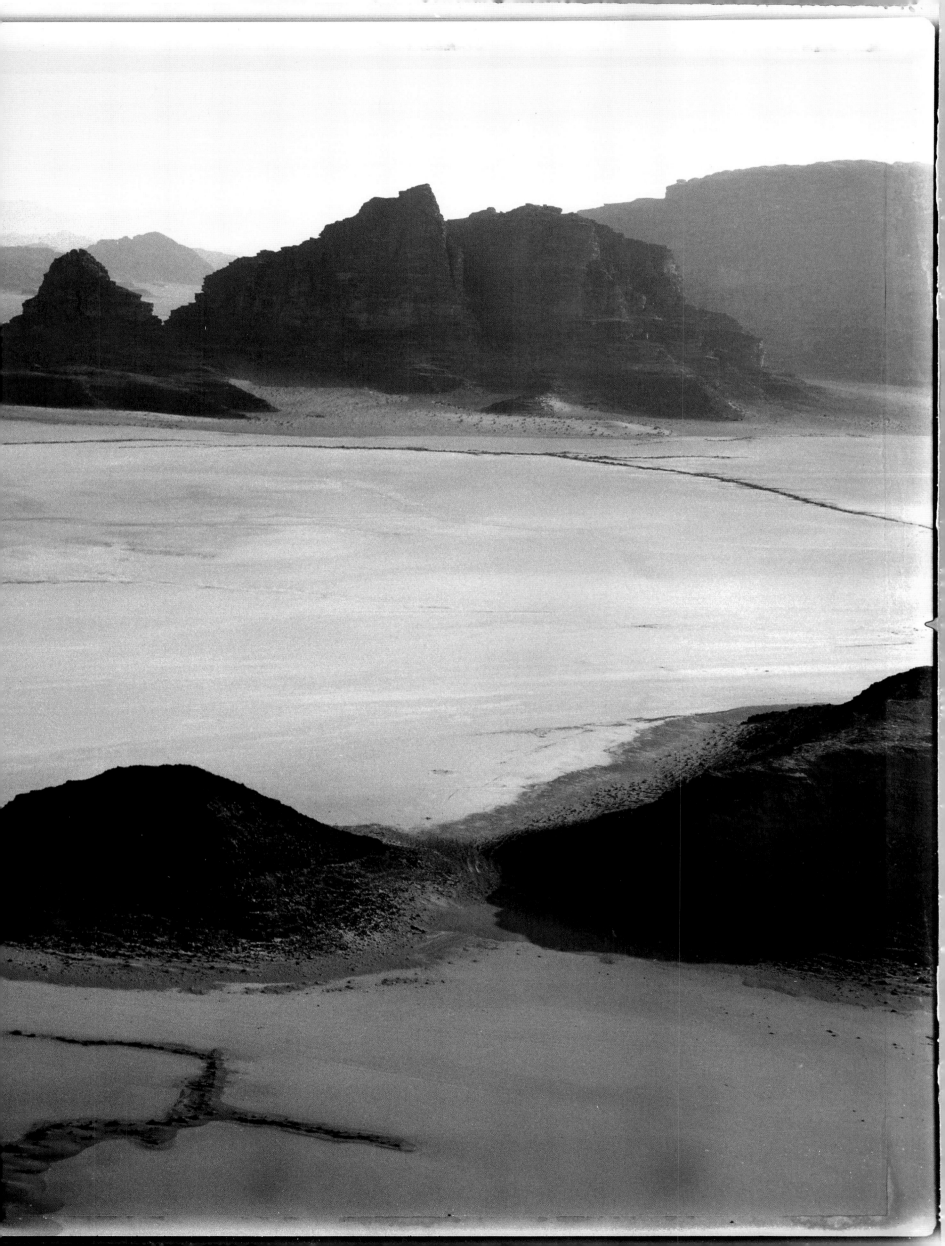

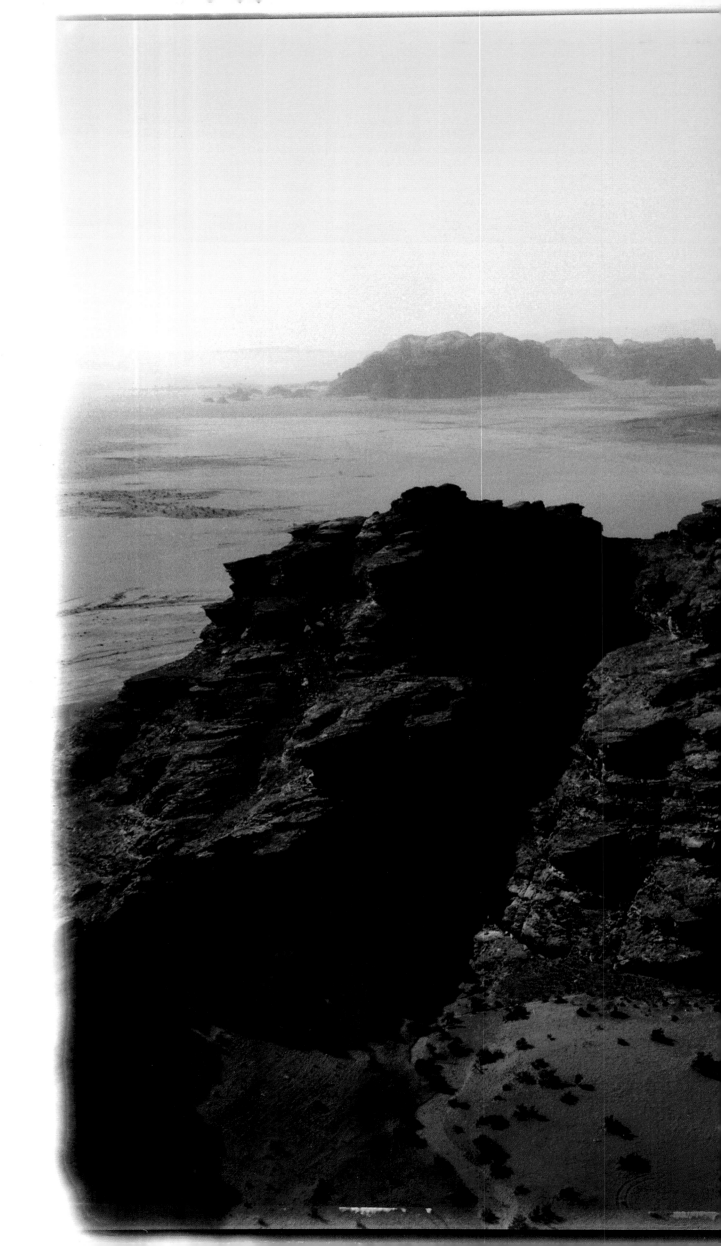

Wadi Rum, Jordan, 1994

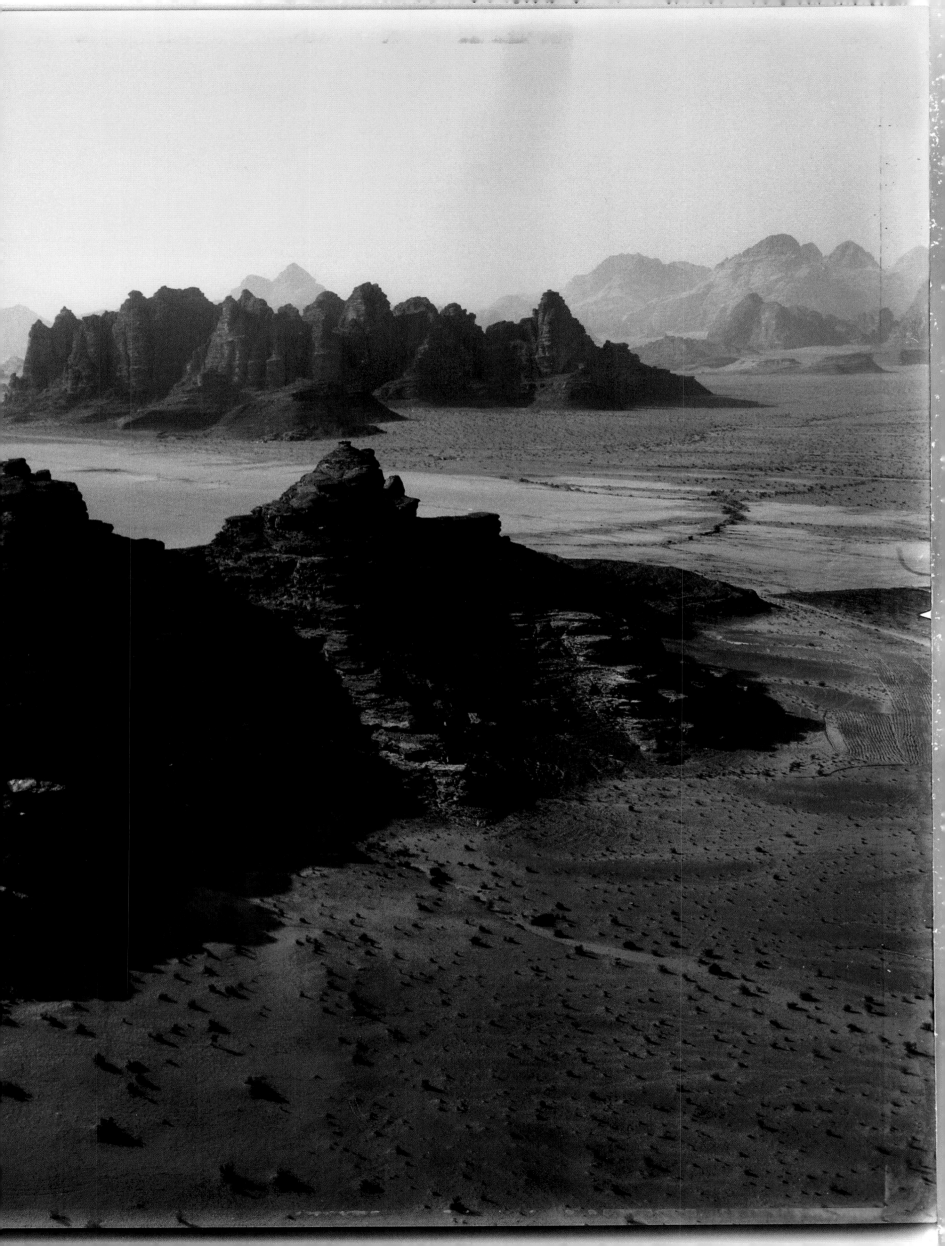

ANNIE LEIBOVITZ

A Photographer's Life

1990–2005

Random House New York

For my daughters, Sarah, Susan, and Samuelle

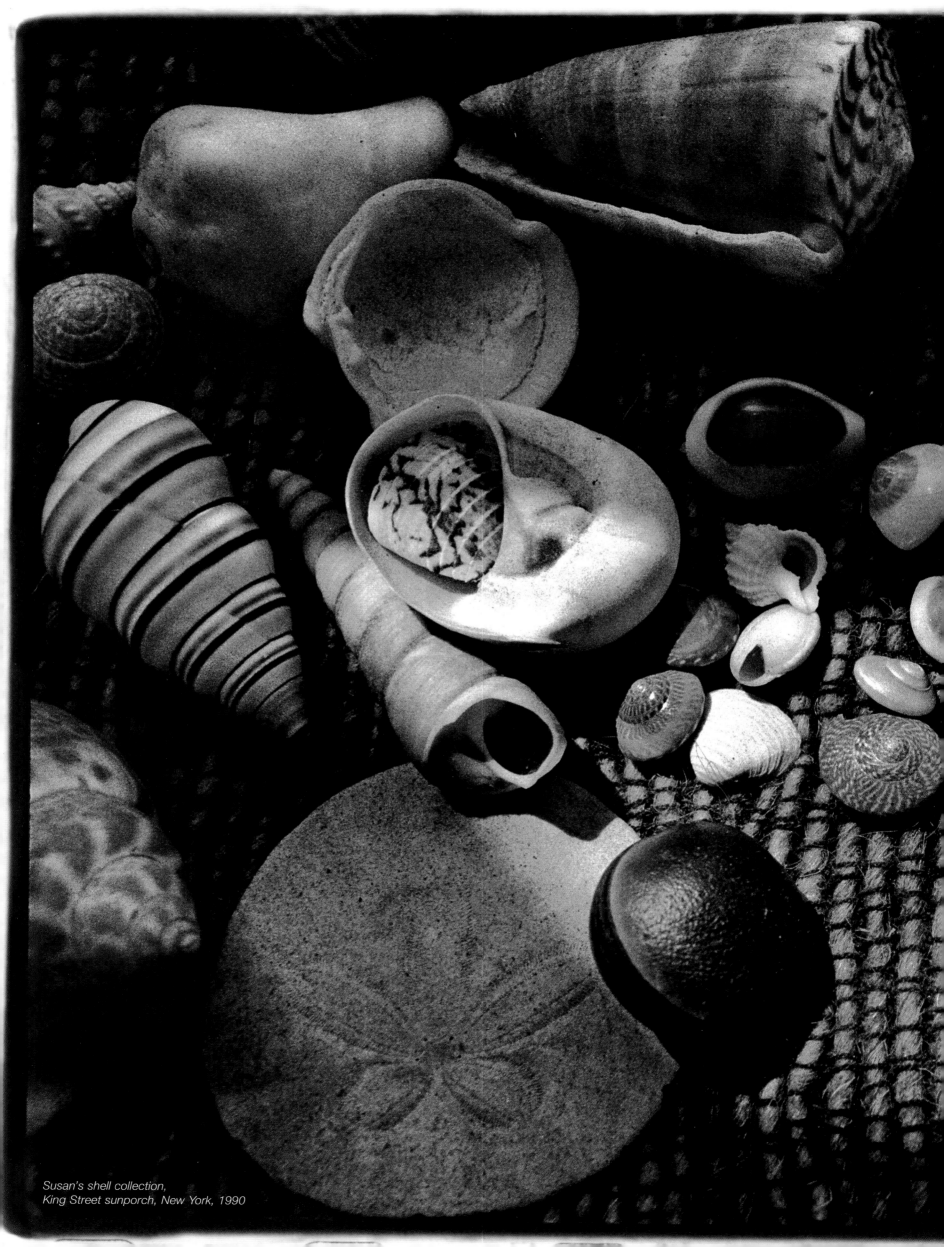

Susan's shell collection,
King Street sunporch, New York, 1990

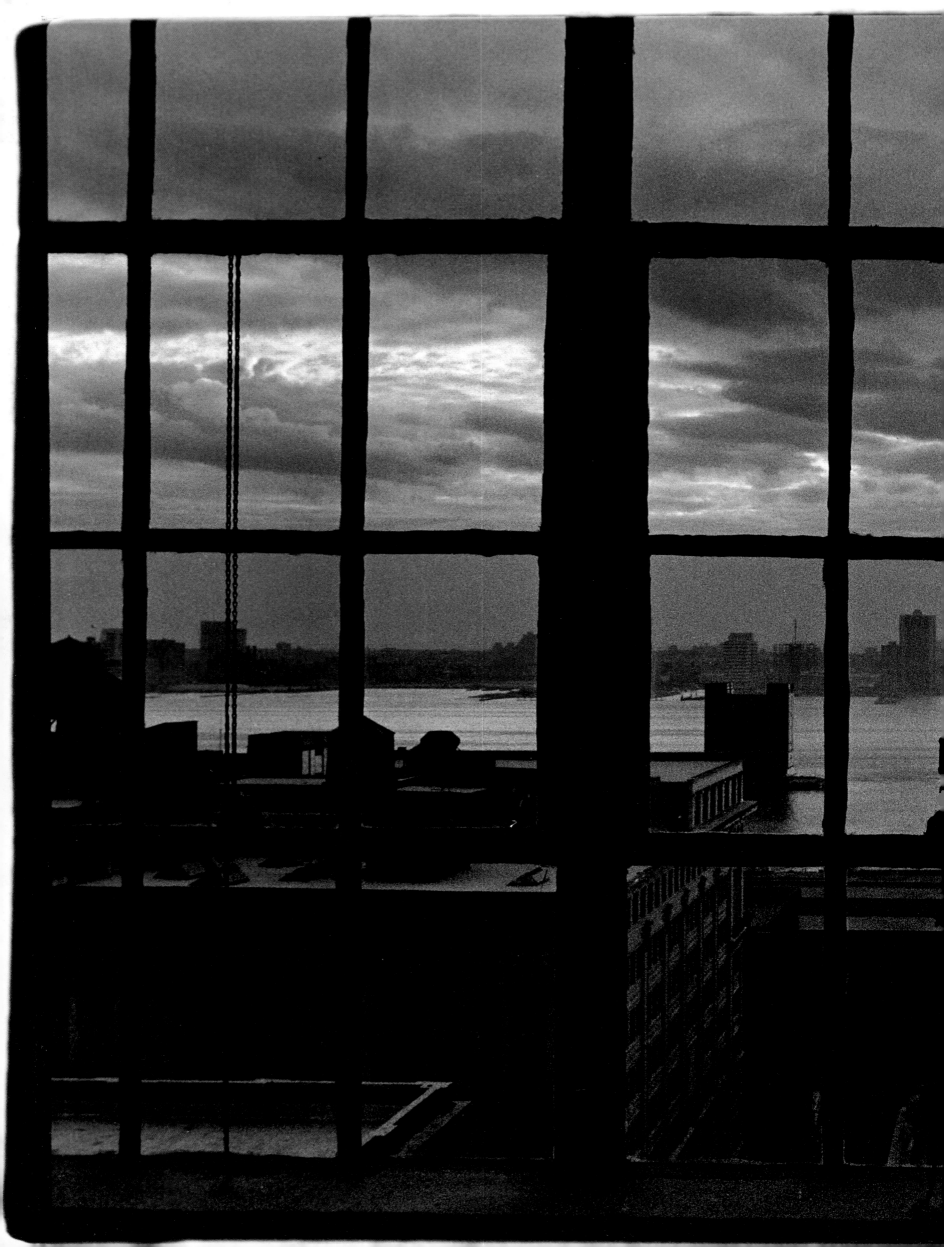

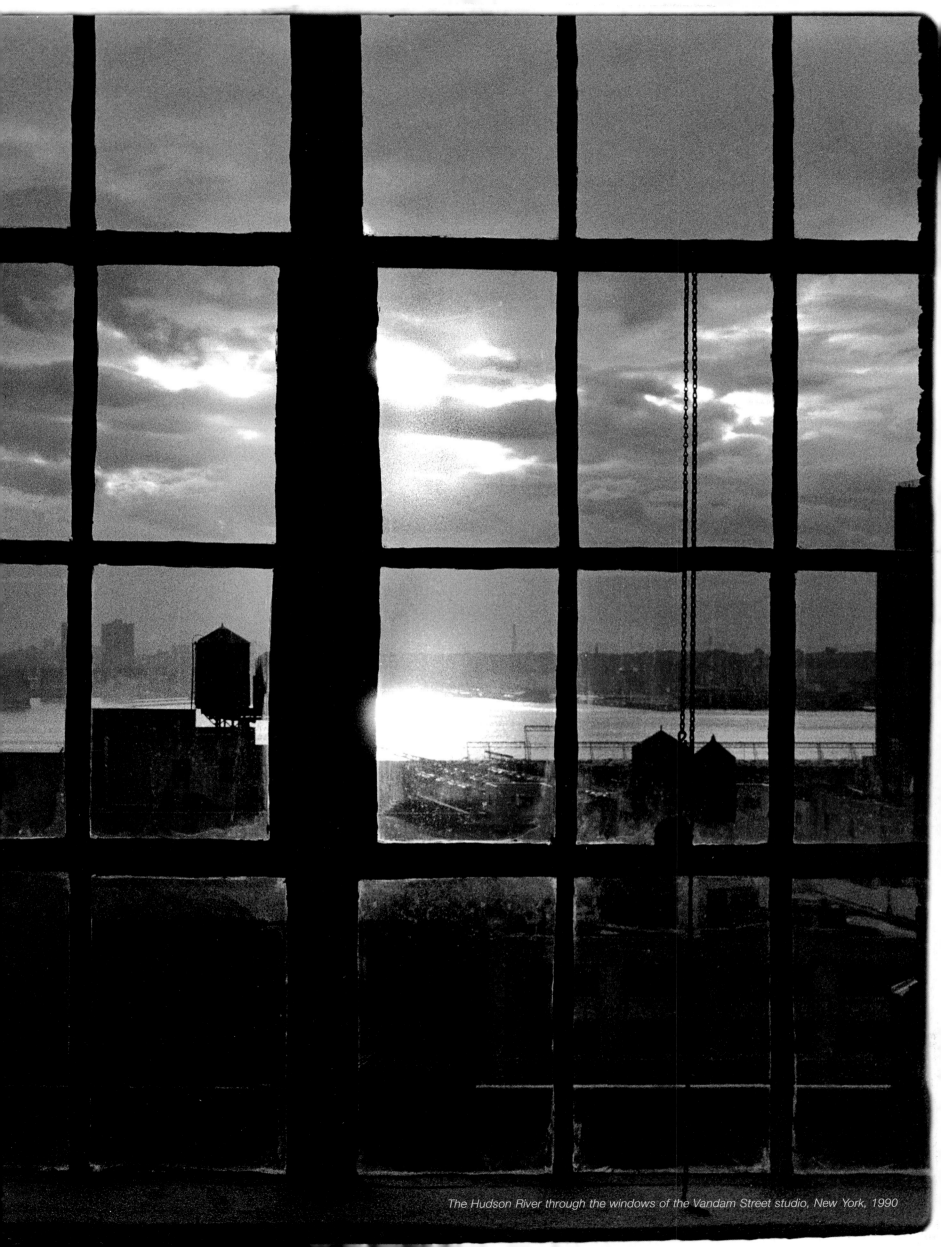

The Hudson River through the windows of the Vandam Street studio, New York, 1990

Residencia Santo Spirito, Milan, 1991

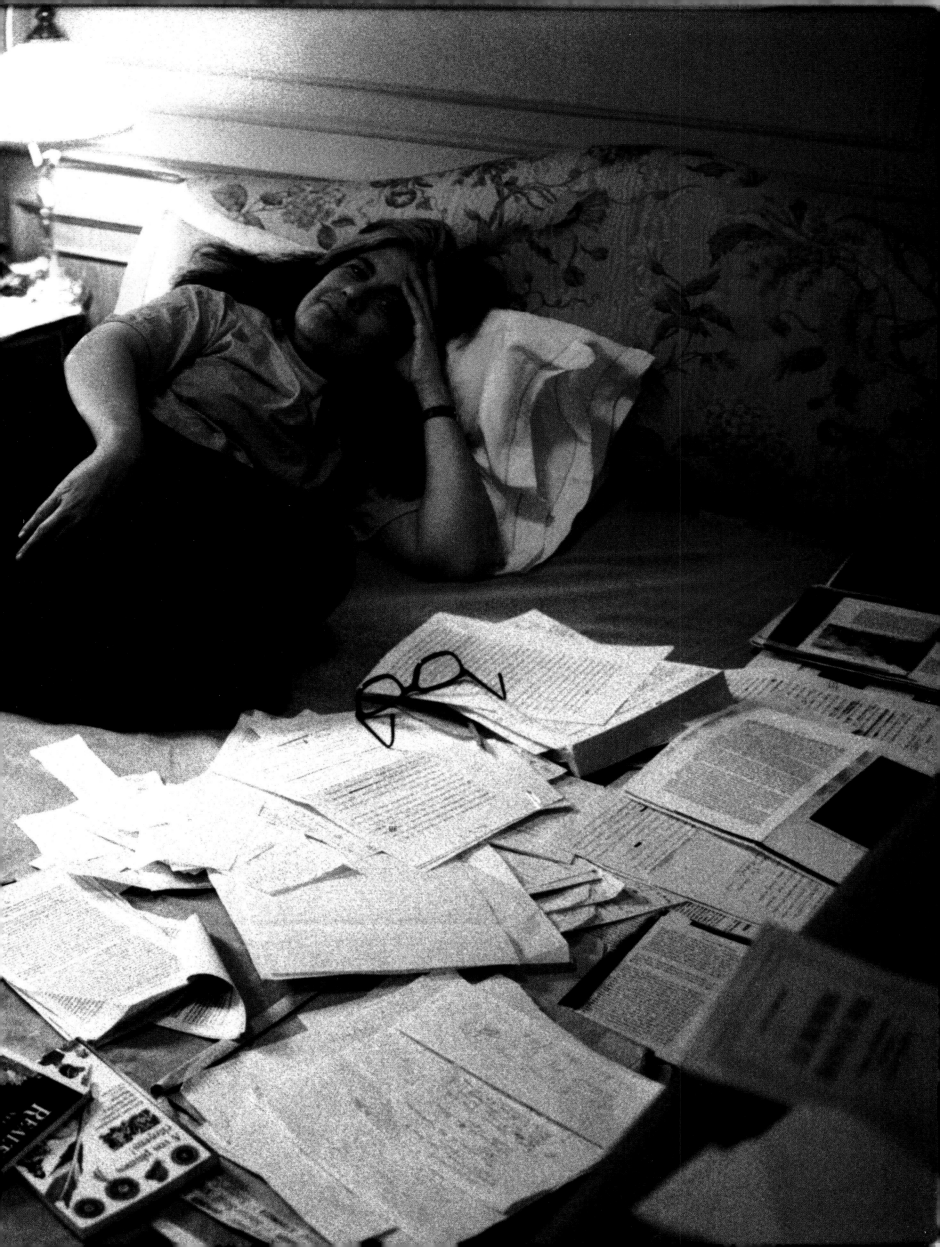

GOING through my pictures to put this book together was like being on an archaeological dig. The work I did on assignments for magazines and for advertisements was edited and organized, but I didn't even know how much other material I had. I don't take a lot of purely personal pictures. Susan Sontag, who was with me during the years the book encompasses, used to complain that I didn't take enough pictures. She would say that every other photographer she knew took pictures all the time. I would take a few rolls of film and throw them in a box and they wouldn't be developed for months. Sometimes I wouldn't even look at the contact sheets. But after Susan died, on December 28, 2004, I began searching for photographs of her to put in a little book that was intended to be given to the people who came to her memorial service. The project was important to me, because it made me feel close to her and helped me to begin to say good-bye. I found so many things I didn't remember or perhaps had not even seen before. I also began looking at all the photographs I had taken of the rest of my family. My father had been ill for some time, and I had flown down to Florida to be with him after spending Christmas in the hospital in New York with Susan. She died before I could get back. He died six weeks later.

My mother and father took photographs and made eight-millimeter home movies when I was growing up, but I didn't start taking pictures myself until the late Sixties, when I was studying at the San Francisco Art Institute. Personal reportage was a prominent element of the curriculum then. You were supposed to photograph things that meant something to you. One of the most meaningful pictures to me is Robert Frank's portrait of his wife and kids in the car when the sun is coming up. They've pulled over to the side of the road and may even have slept there. That reminds me so much of my family. My father was in the Air Force, and every time he was transferred to a new base we jumped into the car and drove there. We lived together in cars. When young photographers ask me what they should do, I always tell them to stay close to home.

I had put a few personal pictures in the first retrospective collection of my work, which covered the years 1970–1990, and I thought that I would do that again for this book. Then, when I realized that I had so much more personal material than I had imagined, and that the period this book covers is almost exactly the years I was with Susan, I considered doing a book made up completely of personal work. I thought about

that for a while and concluded that the personal work on its own wasn't a true view of the last fifteen years. I don't have two lives. This is one life, and the personal pictures and the assignment work are all part of it.

The photographs here are arranged pretty much chronologically, with some artistic license. I found that first photograph, of Susan at Petra, when I was working on the memorial book. Photographs take on new meanings after someone dies. When I made the picture, I wanted her figure to give a sense of scale to the scene. But now I think of it as reflecting how much the world beckoned Susan. She was so curious, with a tremendous appetite for experience and a need for adventure. Petra is an ancient city in southern Jordan that was more or less deserted for over a thousand years. It's in a remote valley surrounded by nearly impenetrable mountains. A Swiss explorer stumbled on it in the early nineteenth century. You get there by going through a long, narrow sandstone gorge that opens up suddenly to a view of a huge classical façade carved into a cliff. It's spectacular, with enormous columns and friezes. That's where Susan is standing. She loved art, architecture, history, travel, surprises. The photograph epitomizes all of that for me. Discovery. She knew so much, but she always wanted to find out about something that she didn't know before. And if you were lucky, you were with her when that happened. In retrospect, the photograph is also about the smallness of individual life. And since the façade is covered in funerary symbols, and since it was probably used as a tomb or a mausoleum, the picture sounds the themes of death and grief that wind through the book.

Susan's favorite book as a child was *Richard Halliburton's Complete Book of Marvels*, in two volumes. Whenever we saw a vintage set we would buy it, and she would often take my copies to better her collection. Halliburton was an American adventurer who wrote about traveling to exotic places in the Twenties and Thirties. He climbed the Matterhorn and Mount Fuji and swam the Hellespont and stayed on Devil's Island. His books sparked Susan's lifelong ardor for travel. Whenever she finished writing one of her own books, she liked to be rewarded with a trip. We would always talk about the next place we would go. The last one was the Amazon. But she didn't make it to the Amazon.

The book I had intended to do next, before another collection of my work, was Susan's idea. We called it the Beauty book, and it was to a certain extent an excuse for Susan and me to take trips. Anything that we were attracted to, or interested in, could be included in the Beauty book. I thought of it as a collection of photographs that I would take in an old-fashioned way, when I was moved to. We had started making lists for the Beauty book, and some of what was meant for it is in this book. We had climbed the pyramids. We saw a lot of the world. She took me to places I would never have gone by myself. You would go into a museum with her and she would see something she liked and she'd make you stand exactly where she stood when she looked at it,

so that you could see what she was seeing. You couldn't stand a little to the left or a little to the right. You had to stand exactly where she had stood. I edited this book with her in mind, as if she were standing behind me, saying what she would like to see in it.

I LIKE scouting for locations for shoots. It's like being back in the car with my family. You drive around without the pressure of actually having to take a picture. I finally realized that I liked the locations best without a subject in them, which brought me to landscape photography. The photographs of Vanessa Bell's house, Charleston, and Vita Sackville-West's garden at Sissinghurst were taken on scouting trips. They were places I wanted to see. Virginia Woolf was very important to Susan. *Mrs. Dalloway* was one of her favorite books. I did a shoot with Vanessa Redgrave at Charleston, and then one with Nicole Kidman. The picture of Charleston here was taken from the downstairs bedroom, where Vanessa Bell died.

In 1993 I accepted a contract with *Condé Nast Traveler* explicitly because I wanted to do landscape work. They asked me where I wanted to go first, and I said Monument Valley, and they said fine. I don't know what I was thinking. It was summer, and the best time to take pictures was in the early morning, around four or five, and at the end of the day, in the last light, which wasn't until eleven o'clock. In between, there were long stretches of scorching hot, bright sun. It was miserable. Besides that, every other American photographer had come to Monument Valley and taken pictures, and I had set myself up to compete with them. For three or four days I exhausted myself by driving around in the heat looking for "the spot" where the picture should be taken. I had booked a helicopter, but I felt guilty because it seemed like cheating. At the end of the very last day, I told myself that Ansel Adams would have rented a helicopter. When I met him in the Seventies he had high-tech equipment in his darkroom. He loved new technology. So I took the helicopter up to the top of one of the huge sandstone buttes and got out and walked around, but there wasn't a picture there. I got back into the helicopter and we made some flybys, and I realized that as long as you didn't go any higher than the top of the butte, the picture wouldn't look like an aerial photograph. You might think it was taken from another high vantage point. Like the way Bernd and Hilla Becher shoot buildings. They find a way to photograph them straight on. Since the sun was setting and we were moving, my pictures were a bit blurry, but they were satisfying to me. I came away from Monument Valley thinking that the spot to take the picture was where Adams had stood. Where the garbage cans and the picnic tables are now. That's the spot. It's famous. There's even a poster with a photograph taken from there that includes the garbage cans and the tables.

I don't think that the *Traveler* was very happy with what I had done, but they published it, and they gave me more assignments, one of them being Jordan. Susan was really excited about this, because she wanted to go to Petra, but the magazine

wanted me to photograph Queen Noor. They had already done Petra. I said I wouldn't go to Jordan unless I could go to Petra, and they said okay, but I had to photograph Queen Noor first. When we got there, the queen asked me if I also wanted to photograph King Hussein, and afterward we went to Petra with their blessing. We were very well taken care of. The mayor of Wadi Musa, the little town where visitors stay, met us and took us into the old city. He fixed up a place for us to sleep overnight, in a cave in front of the Monastery, which was actually a temple of some sort. Our backs were turned to it. There was a campfire in the cave, and the mayor was telling us stories as the sun was going down, and when we went outside the cave we saw that he had lit the Monastery with candles. It was magical. Susan was so happy. A couple of days later we took a hot-air balloon over the strange, rocky desert landscape of Wadi Rum. When I got out, the balloon took off with Susan still in it and went another couple of miles. She said later that she had never had such a good time.

The magazine wanted color photographs, and I had given Susan a camera and asked her to shoot some color pictures. Most of the photographs that ran with the story were hers. Susan took some very good pictures. But it was the beginning of the end of my relationship with *Condé Nast Traveler*. They sent me to do a story in Costa Rica about the world's greatest beach and I did these stormy beach scenes, with clouds. When I came back they said, "It's our *beach* issue! It's supposed to be sunny!" I realized this wasn't going to work.

A couple of years earlier, Susan and I had gone to a show of paintings by Wright of Derby at the Metropolitan Museum of Art. Wright was a successful eighteenth-century British portrait painter who as he got older painted more and more landscapes. I feel a great affinity with him. I can see how you might want to turn your back on society and paint lakes and mountains.

WHEN I worked for *Rolling Stone* in the Seventies I was called a rock 'n' roll photographer. I began calling myself a portrait photographer because it lent a kind of dignity to shooting well-known people. But I'm not a great studio portraitist. At best, my studio photographs are graphic. I can always fall back on composition. When you have a subject who projects himself well, an actor or some other kind of entertainer, you can get an interesting picture, but I don't like trying to make something happen in the studio. It feels cheap to me. On the other hand, when you strip everything away, it's terrifying. It's just you and another person. I started doing studio portraits in the Eighties when I had a large working space on Vandam Street. I did a lot of the work for the first Gap portrait campaign there. The pictures of Brice Marden and Tony Kushner are from that. And then I moved to an even larger studio on 26th Street. But the productions got so big that I felt that the situation was out of control. It's one of the reasons I sold the 26th Street building.

There are truly intelligent photographers who work in the studio, but it's not for me. Richard Avedon's genius was that he was a great communicator. He pulled things out of his subjects. But I observe. Avedon knew how to talk to people. What to talk to them about. As soon as you engage someone, their face changes. They become animated. They forget about being photographed. Their minds become occupied and they look more interesting. But I'm so busy looking, I can't talk. I never developed that gift. I have the same problem with my children. I know I have to be more involved, to interact more, but I love just looking at them.

I hadn't realized how much Avedon meant to me until he died. He set a great example with his magazine work. He rode both horses. It didn't seem like he was a commercial photographer. He was an artist. I took his portrait for *Vanity Fair* when he had that last big show at the Metropolitan Museum of Art. He was nervous, perhaps about appearing old and frail—he was seventy-nine and had been ill—and I turned to him and said, "Don't worry." You go into a situation like that thinking that you want to be Avedon, to expose him the way he would very likely expose you. And then you don't. Afterward he sent me a note saying, "Thank you for taking care of me."

My pictures are helped by an environment. I love the street. I love going to someone's house, seeing what's on their walls, what chair they sit in. I like to see how they live. When I shot Bill Gates at his home in Bellevue, Washington, every time we set up lights between shots he would disappear and I'd find him sitting at his computer. It was all he did. This was before computers were omnipresent. I was bewildered, and I thought that I would never want to have one. Then I realized that that was the picture.

When you work closely with people, you build relationships that last over time. I worked with Demi Moore quite a lot, and I did her wedding pictures when she married Bruce Willis. I said to her then that I was interested in photographing a pregnant woman, which I had never done before, and she called me when she was going to have her first child. That black-and-white photograph of her belly was done for them. Bruce was working on a film in Kentucky, and I stopped there on the way back to New York from L.A. and took a few rolls of film. Then three years later, when Demi had a movie coming out, *Vanity Fair* asked me to take a picture of her for the cover, and she was pregnant again and everyone was concerned about not showing that. We shot some close-ups for the magazine, and I said that I thought we should do some nudes, just for her. As I was shooting them, I said, "You know, this would be a great cover." That was a very radical idea at the time, although I hadn't quite taken it in.

Taking intimate pictures of family members and people to whom you are close is a privilege, and it brings a certain responsibility. And it doesn't usually lend itself to a single image. When I was editing this book I would mark up contact sheets, and the work prints would be scanned, and we started putting four pictures on a sheet

of paper so we could look at more pictures at once. This was done quite randomly, but the result was unexpectedly powerful. The pictures created portraits that were like little films. It wasn't a single moment. It was a flow of images, which is more like life, so we designed the book using four images across two pages quite frequently, to keep this effect.

MOST of the photographs of my family were taken at gatherings around a dining table or a pool or beside the ocean. After my father retired from the Air Force, my parents lived in Silver Spring, Maryland, a suburb of Washington, D.C., but they always had a house at the beach. My father built a shack in Ocean City, Maryland, with his own hands. And they had a place in St. Thomas for a few years. When they got older they decided to spend the winters in Sarasota, Florida, and they rented a house there while they looked for something to buy. My mother would wake up and put her bathing suit on. She grew up in Brooklyn, but she had spent every summer at the Jersey shore, swimming in the ocean. She met my father during World War II. He was a handsome guy in uniform. He came from Waterbury, Connecticut, and he had worked in a rubber mill to support his family. He was the oldest son. He put his younger brother through medical school and paid for his parents' house. My mother came from a more cultured world. She graduated from Brooklyn College when she was nineteen and married my father a few months later. He was twenty-eight. When he got out of the service at the end of the war he started manufacturing pajamas and robes in Waterbury, but his business went bankrupt in a few years, around the time I was born. I was the third child of six. He went back into the military, which surprised people. They would say, "He's a Jew in the Air Force?" He hadn't graduated from college, so he and my mother took night classes. He accumulated credits for years, and in 1964 he finally decided to graduate, a year before my older sister, Susan, graduated. He stood in line at the ceremony at the University of Maryland and got his diploma.

My father lived for our family. So did my mother, but I think she may have had other ambitions. She had studied dancing and she played the piano. She expressed herself through dance and swimming, and she counted a lot on her physicality. My father couldn't dance or sing, but the whole family was physically exuberant.

I always imagined the property at Rhinebeck, which I bought in 1996, as a gathering place for my family. I wanted to have land, and privacy, and I had started looking in the Hamptons for acreage, but it wasn't really the country. Then one Sunday I saw an ad in the back of *The New York Times Magazine* for a set of stone buildings near New Paltz. With a clock tower. It was something from another era. I looked at it and it wasn't right for me, but I became intrigued with upstate New York. For a year I rented a small hunting lodge on top of a hill outside New Paltz. Susan loved that.

Then I rented a place in Rhinebeck, on the east side of the Hudson River. And I started looking for land there. When I was visiting a real estate agent's office, I saw pictures of some extraordinary stone barns that turned out to be the dairy barns of the old Astor estate. They were built in a late Arts and Crafts style, with very obvious references to barns in Normandy. The main barn has a steeple in the middle, and from a distance the place looks like a small village. The buildings were designed by a society architect, H. T. Lindeberg, and were constructed by Charles Platt, the Astors' architect, in 1914. The milking barn has a Guastavino vaulted tile ceiling. It was not uncommon for great estates of that period to produce their own milk and cheese. They had greenhouses, stables, recreational buildings, places to dock their train cars, moorages for their yachts. These barns were what were called "show barns." They weren't too serious. There were about twenty cows.

Two hundred acres were for sale. This was just a small piece of the original estate, which was almost three thousand acres. The buildings were set in from the river, but the parcel included river frontage. I first saw the place in the winter, when the stone structures were beautifully graphic against the white of the snow. When I went back in the spring and was trying to figure out how much the restoration would cost, everything was completely overgrown. It was scary. In a book of Charles Platt's architecture, the complex is referred to as a ruin. The slate roof on the hay barn had started to deteriorate because someone had ripped tiles out of it in order to make a pathway to the weather vane, which had been taken away. I hired a roofer with experience in working on church steeples and he was with me for two years.

We made the first repairs to get ready for the wedding of my aunt Sally Jane's daughter Dianne. That was the first time my family came to stay on the property. My father had been worried that it was too much for me to take on, but I remember walking down to the pond house with him, and he said, "You know, I've changed my mind. It's great that you have this place. There's just one thing you need to do." And I said, "What, Dad?" And he said, "Get rid of that steeple. It will be too hard to keep up. I'd chop it off." That was so like my dad.

The pond house is one of the earliest buildings in the county. It was part of an eighteenth-century working farm, and the Astors left it as a kind of folly on a little knoll down the hill from the main barn complex. Raccoons were living in it when I first saw it. It was the first house that was made livable. Originally, the roof probably had been cedar shingles, but I wanted to put on a tin roof. Since tin and lead are environmentally harmful, I decided on copper, although I didn't want it to turn ye olde green, and we found a way to retard the discoloration. I tortured myself for months over that roof. Susan and I moved into the pond house while the cottage in the main complex was being restored, and then when we could live in that, she used the pond house to work in. It became hers.

I took that formal portrait of my mother one summer in Rhinebeck, for my book called *Women*, which was published in 1999. We set up a chair for her in the shade outside the creamery, the stone building across from the cottage that I had renovated as living quarters and where my parents stayed when they visited. It was a tough shoot because she was nervous. She said she was worried about looking old. I was crying behind the camera. When I was growing up we all had to smile and look happy in family pictures, even in the worst times. This had always bothered me, because it wasn't real. I resented it. My mother was now in her seventies, and I wanted her age to show in this picture. Of course she didn't like it. My father didn't like it. He said that she wasn't smiling. But I felt that it was a good picture. I used it as a sort of dedication picture in the book. As Susan said, my mother was the first woman I knew. At the opening of the show of the work at the Corcoran Gallery in Washington she had a real fan club around her. She signed books. And I think she ended up liking the picture.

The next year, I bought an apartment in Paris. I had been doing work there for *Vogue,* and I was thinking about having a child. I had Rhinebeck. I thought I had everything I had ever wanted, and I wanted Susan to have something that she had always wanted. She had lived in Paris off and on since the Sixties and had spoken often about living there again. She liked to leave New York to write. We told the agents not to show us places without an elevator, since by that time Susan was having trouble walking. The chemotherapy from her second bout with cancer, in 1998, had left her with neuropathy in her feet. But one day an agent took us to a house with an apartment available two flights up. We got in through a courtyard entrance on a side street and climbed up some twisty stairs, Susan with some difficulty and both of us thinking that this was a waste of time. Then they opened the door and we just looked at each other. It was right on the Quai des Grands Augustins, and you could see the Seine and the Place Dauphine and the spire of Sainte-Chapelle through tall windows in the living room. It had been built in 1640 and had been used as a printing shop. And it was a wreck, which is what I love. We went back the next day and told the owner we wanted it. Then we found a photograph Atget had taken of it, and we walked around the block and saw a plaque on a building saying that Picasso had painted *Guernica* there. Later we discovered a photograph Brassaï had taken of our street at night. The picture of Susan looking at the apartment from across the river was taken the morning we were flying back to New York. We had been told that it would never get any direct light, but then we stopped on the way to the airport and saw the sun hitting it. We were so excited.

WHEN I was editing the 1970–1990 collection of my work, I found that my favorite pictures were early ones taken when I was doing reportage. The pictures from the 1975 Rolling Stones tour were particularly strong, probably because I spent so much time traveling with the band. The very last photographs we put in that book

were taken over a period of weeks in Florida in the summer of 1990, when I worked with Mikhail Baryshnikov and Mark Morris and a group of dancers, documenting their preparation for the first season of the White Oak Dance Project. It seemed like a return to the kind of work I had been doing in the beginning, but I wasn't able to go back to reportage in a completely pure way. I knew too much by then. Too much about how a picture can be set up, how you can manipulate a picture, when it should be taken.

I'm not a journalist. A journalist doesn't take sides, and I don't want to go through life like that. I have a more powerful voice as a photographer if I express a point of view. What I tried to do throughout the Nineties was strip things down and go off by myself once or twice a year, with no assistants and only the equipment I could carry, and cover a story. I did this in Sarajevo in 1993, for *Vanity Fair*. Susan had gone to Sarajevo that spring and had come back transformed and excited and terribly angry about what was going on there. The Serbs had begun the siege of Sarajevo the year before and were waging a war of ethnic cleansing. By July of 1993, when I first went in, the city was surrounded. There was great photography coming out of Sarajevo. And great journalism. But no one seemed to care. I thought that at the very least I could help keep the story alive.

I was nervous about how I would be accepted by the other photographers in Sarajevo, and I got a certain amount of crap. A few of the guys said, "What are *you* doing here?" That kind of thing. But on the first day, on the road from the airport to the hotel, which was the most dangerous trip you could take, Luc Delahaye, a very brave and distinguished young French photographer, said to me, "I'm so glad you're here. Whatever anyone can do is great." He was so elegant and sweet and helpful. That really meant a lot to me.

The city lies in a natural bowl, and Serb snipers were dug in on the mountains around it, deciding who would live and who would die. They would pick their victims at random. Several people told me that the first thing I should do when I got there was go to the morgue, so that I could really take in what was happening. When you walked into the morgue and saw who had been killed that day it was shocking. Children, mothers. People from all walks of life. It was horrible. I went out after dark on my second trip and saw tracer bullets, which made me realize how close the shooting was and that it was all over the place. The picture of people swimming in the river on a hot summer day was taken during a brief respite in the shelling. It could have started up again at any time, but people decided to go swimming anyway.

One set of pictures in the Sarajevo section was taken at the offices of *Oslobodjenje,* a newspaper that was published every day of the siege. A good friend of Susan's, Gordana Knežević, was the editor. They were so proud of being able to keep the paper going. It was a miracle. They printed at night, and once you got into their underground bunker you didn't go out until morning. The photograph of the naked wounded soldier

was taken in a makeshift operating room. I think the man died as I took the picture, but I didn't find that out until later. The picture of the bicycle and the smeared blood was taken just after the boy on the bike had been hit by a mortar that came down in front of our car. I was on my way to a housing project to photograph Miss Sarajevo. We put him in the car and sent him to the hospital, but he died on the way.

There's something intoxicating about being in a place where everything is stripped down to simple life and death. That's why war journalists and photographers go from war to war. Everything else seems trivial. But it's pretty unlikely that I would go into a situation like that again, now that I have children. I first realized that on September 11, when the World Trade Center was attacked. I was nearly eight months pregnant and was at my doctor's office that morning, having my baby's heartbeat monitored. When I got back to my apartment and looked out the window, the towers were gone. There was just smoke. I could not believe that I was not grabbing my camera and running down to the site, but I had to think about the baby. I worried about going into premature labor. A couple of weeks later, a friend who had volunteered to be a relief worker on the site managed to get Susan and me on a tour. I put on a big coat to disguise the fact that I was pregnant. The West Side Highway was closed several blocks north of the site and we had to walk in. The security people looked at me a little strangely, but maybe they just thought I was carrying a lot of camera equipment.

I was fifty-one when I had Sarah. I had wanted children for a long time, but I had a big, consuming career and I was hardly ever at home. Having children changes your life dramatically. When they wheeled Sarah into my hospital room and left me alone with her, I was scared out of my mind. But I knew right away that I wanted to have more children. I tried to convince everyone I knew to have children. Three and a half years later, my twins, Susan and Samuelle, were born.

WHEN Susan was treated for cancer in 1998, I took a month or two off from work and spent every day with her. The pictures I took then tell a complete story: She is diagnosed, goes into surgery, has chemo, loses her hair. The photograph of her in Rhinebeck on July 4th was taken just before she went into the city for the first tests. She had a feeling that something was wrong.

Susan's last illness, in 2004, was much more harrowing, and I didn't take any pictures of her at all until the end. She was told in March that she had myelodysplastic syndrome, a precursor of leukemia, and that she had little chance of surviving for very long. She almost died from an infection in May but rallied enough to make it to the Fred Hutchinson Cancer Research Center in Seattle, where they had agreed to give her a bone-marrow transplant, although the chances of it working were slim. I borrowed a friend's plane and took her there and made sure that she always had someone she knew with her and that the support system we had set up was functioning. I was working a lot

then, but I would fly in for weekends and straighten the bulletin board in her room and talk to her. By the middle of November it was clear that the treatment had failed, and I brought her back to New York in a small air ambulance.

I forced myself to take pictures of Susan's last days. Perhaps the pictures completed the work she and I had begun together when she was sick in 1998. I didn't analyze it then. I just knew I had to do it. After she died, I chose the clothes she would be buried in and took them to Frank Campbell's funeral home myself. The dress is one we found in Milan. It's an homage to Fortuny, made the way he made them, with pleated material. Susan had a gold one and a green-blue one. She had been sick on and off for several years, in the hospital for months. It's humiliating. You lose yourself. And she loved to dress up. I brought scarves we had bought in Venice, and a black velvet Yeohlee coat that she wore to the theater. I was in a trance when I took the pictures of her lying there.

We buried Susan in Paris, and when I got back to New York from her funeral I took photographs from the windows of my apartment in London Terrace, across the snow toward her apartment, which was only a few yards away. I was so used to looking over there and seeing a light on. A few weeks later, I photographed my father's death. He had chosen to die in a different way than Susan did. He didn't go to the hospital. He died at home, in his sleep early in the morning. My mother was holding him.

That summer, I moved the material for this book to Rhinebeck and set up a workshop in the barn. Rosanne Cash had given me an advance copy of her new CD, *Black Cadillac*, which she wrote after both her parents and her stepmother died. I would go into the barn every morning and put it on very loud and cry for ten minutes or so and then start working, editing the pictures. I cried for a month. I didn't realize until later how far the work on the book had taken me through the grieving process. It's the closest thing to who I am that I've ever done.

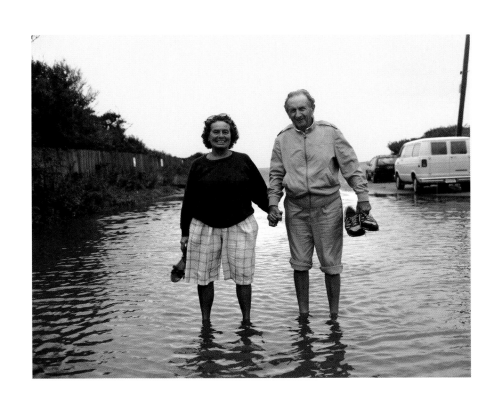

My parents, Marilyn and Samuel Leibovitz,
Beach Lane, Wainscott, Long Island, New York, 1988

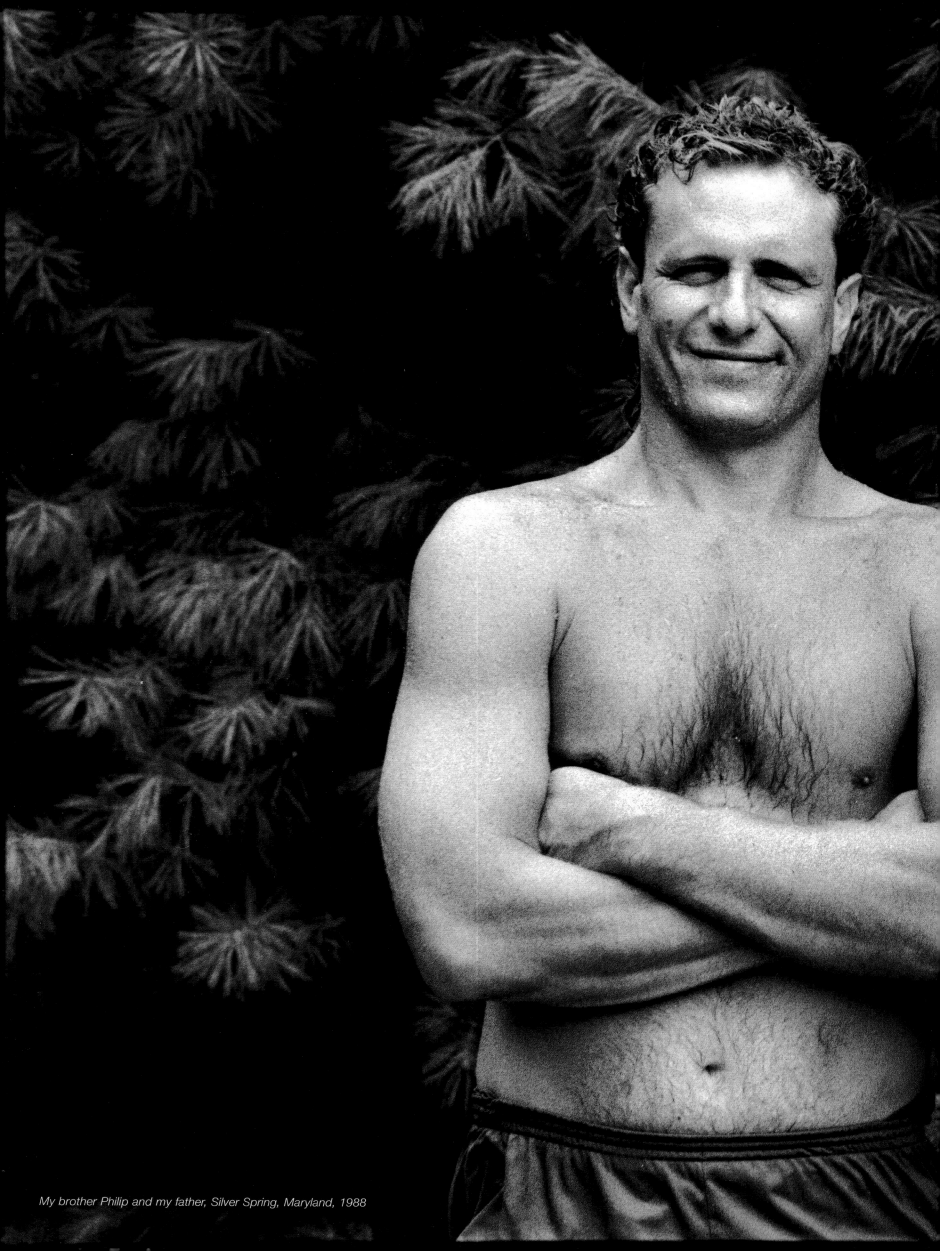

My brother Philip and my father, Silver Spring, Maryland, 1988

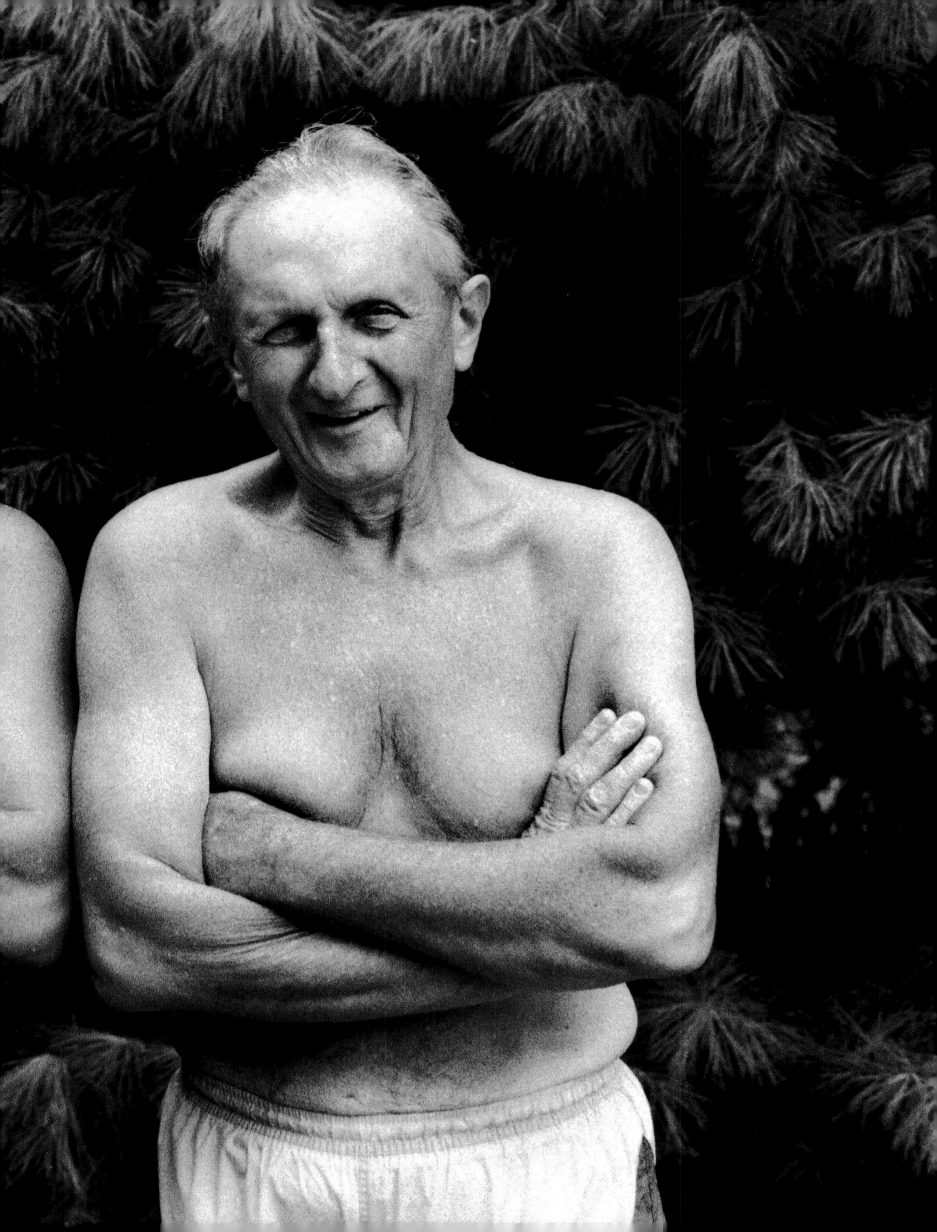

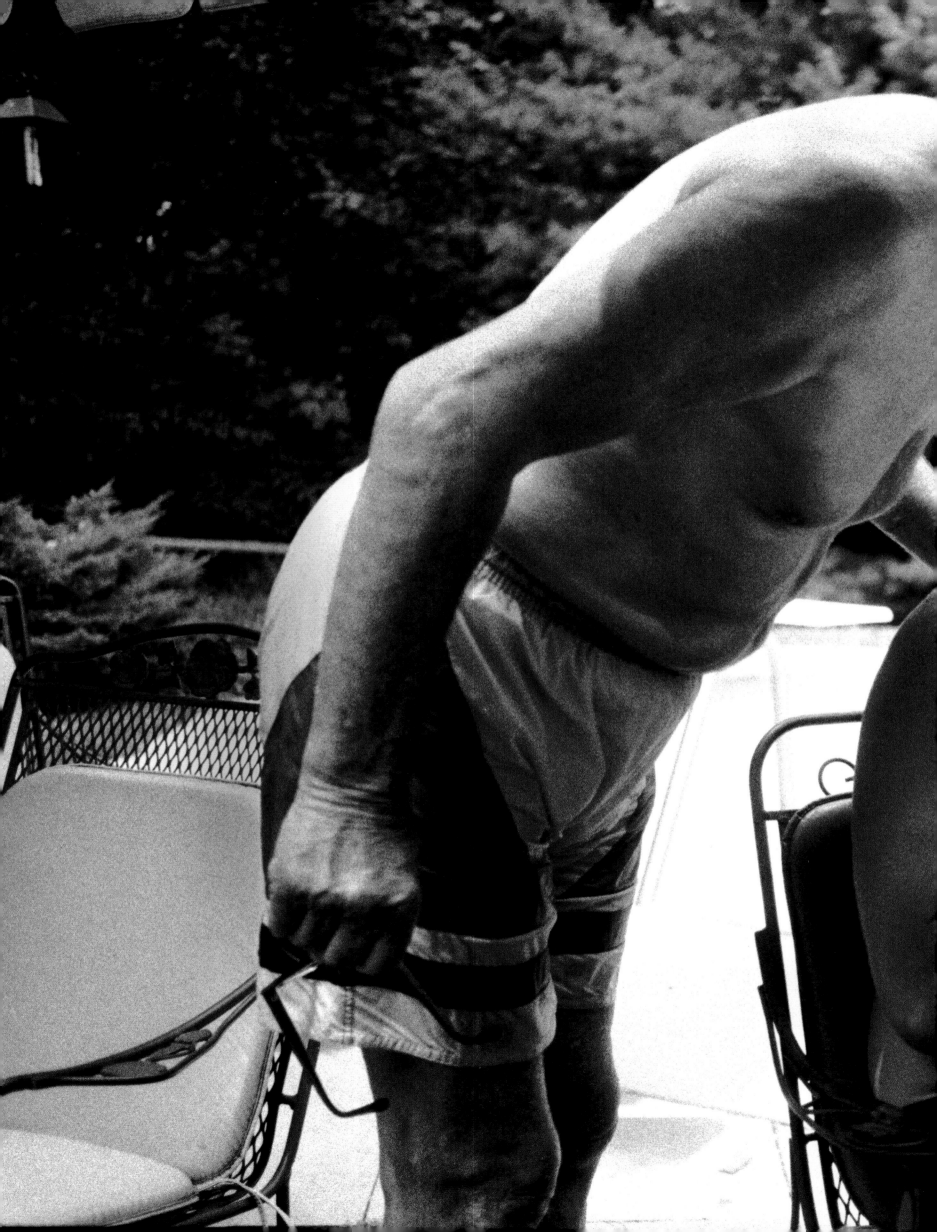

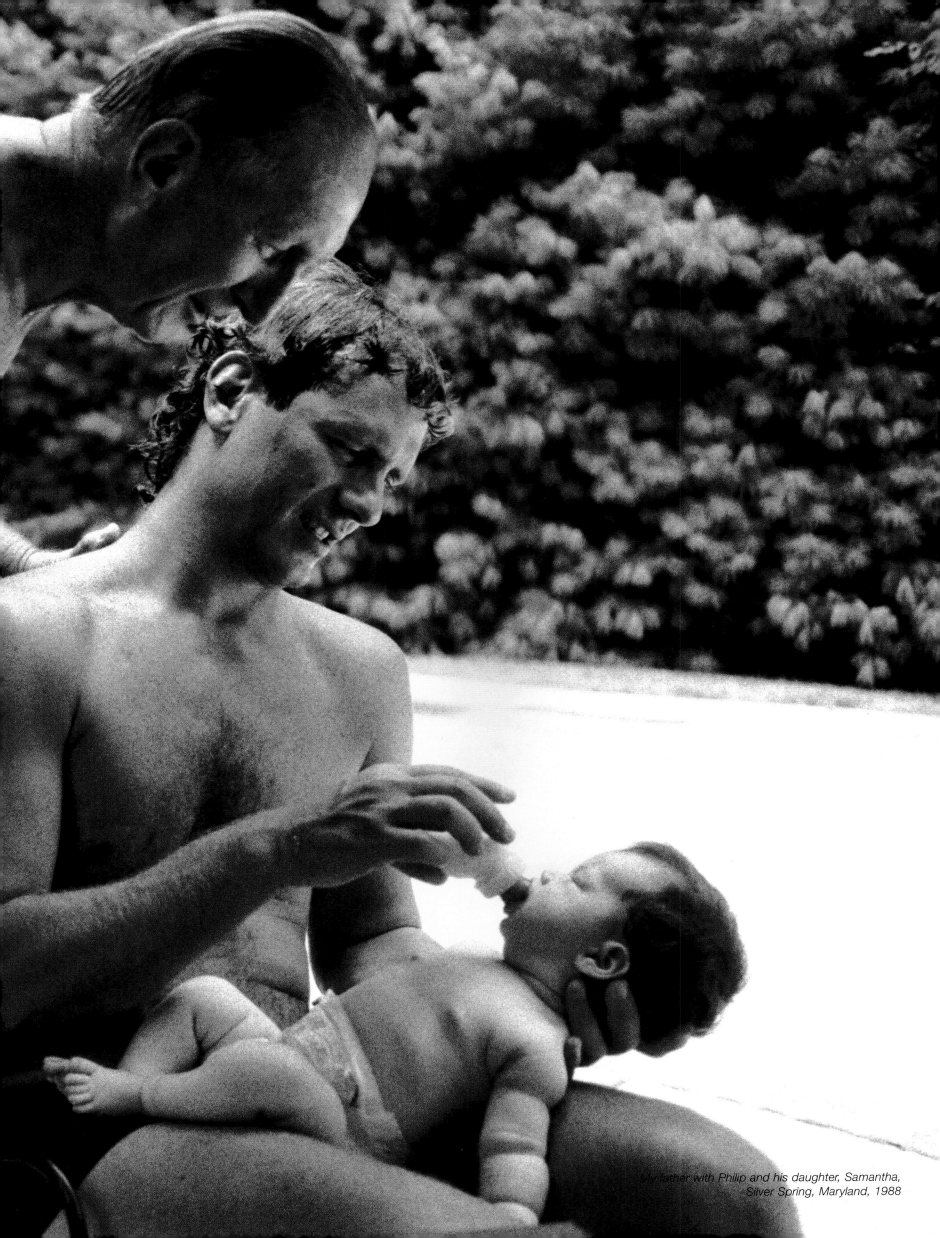

My father with Philip and his daughter, Samantha,
Silver Spring, Maryland, 1988

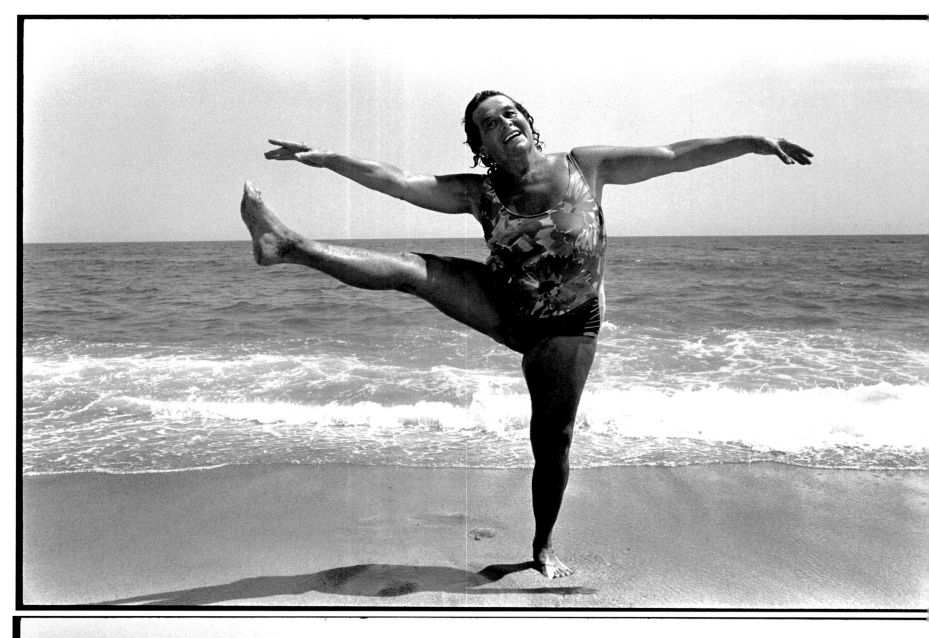

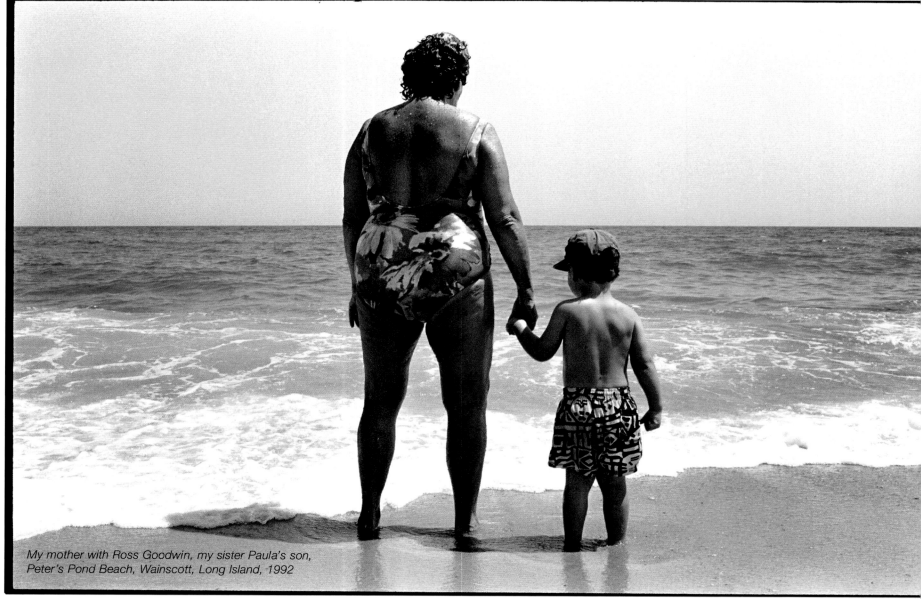

My mother with Ross Goodwin, my sister Paula's son,
Peter's Pond Beach, Wainscott, Long Island, 1992

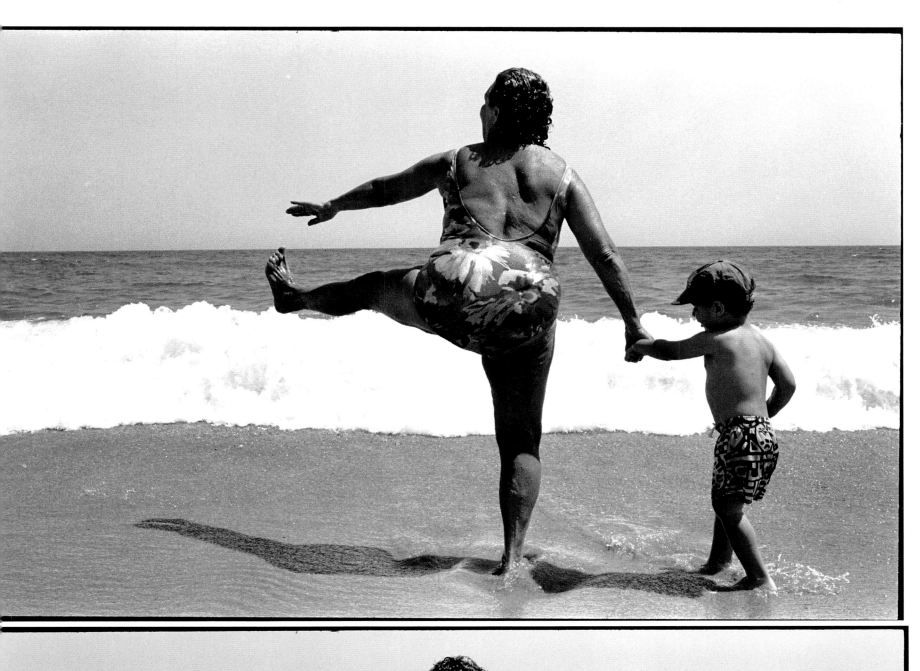
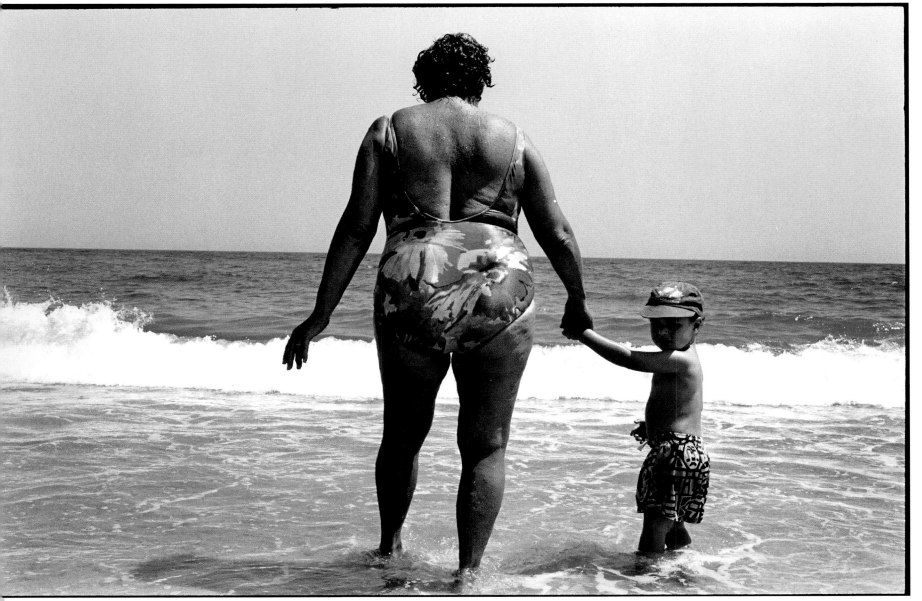

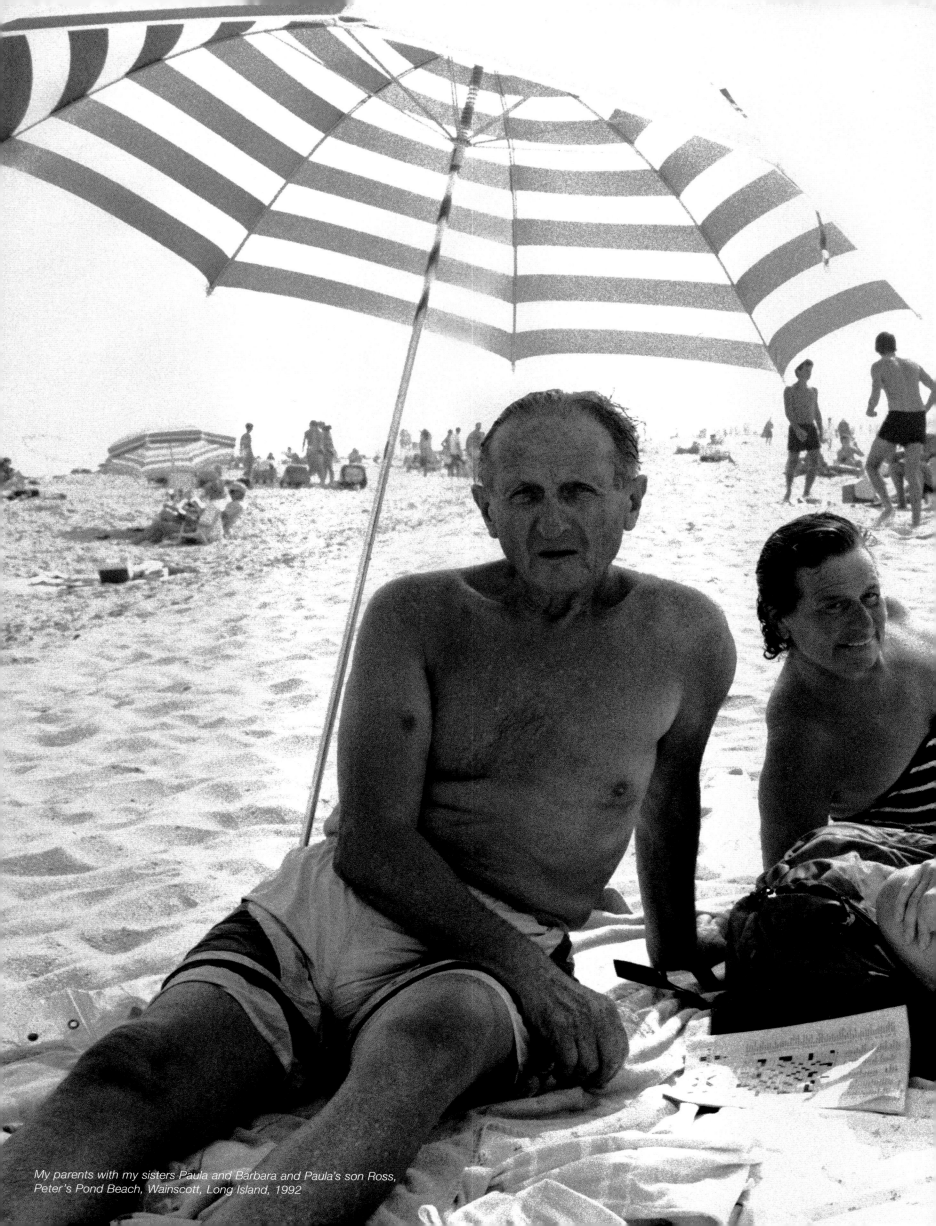

My parents with my sisters Paula and Barbara and Paula's son Ross,
Peter's Pond Beach, Wainscott, Long Island, 1992

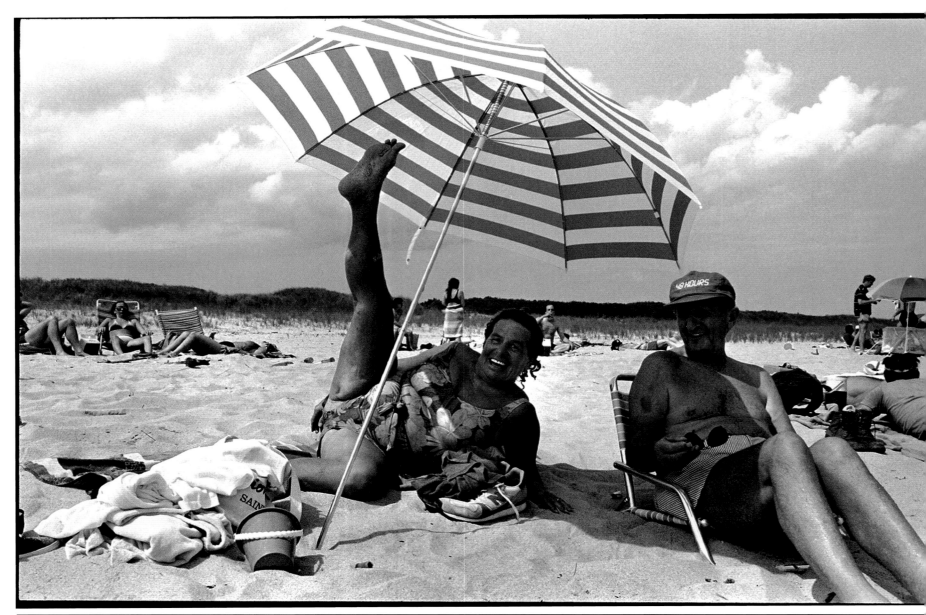

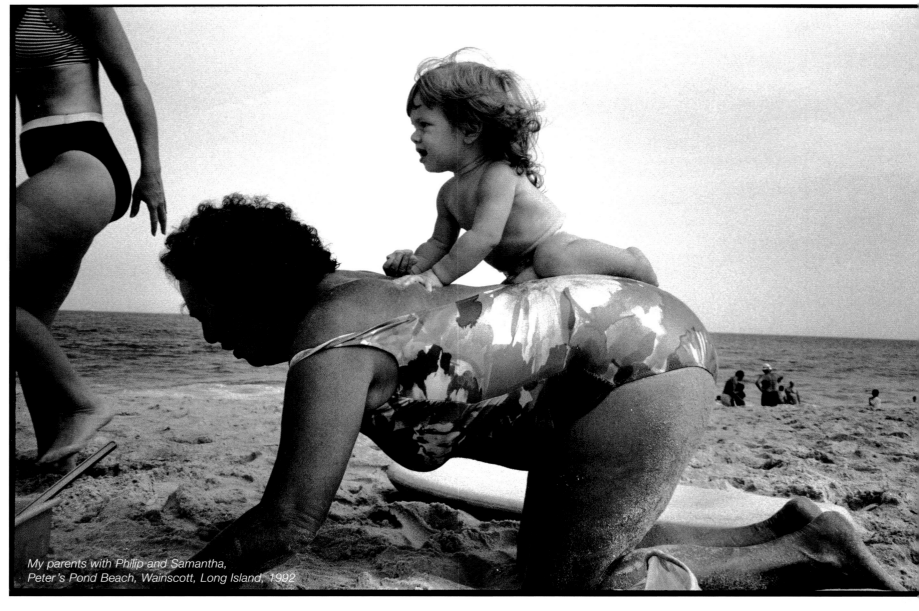

My parents with Philip and Samantha,
Peter's Pond Beach, Wainscott, Long Island, 1992

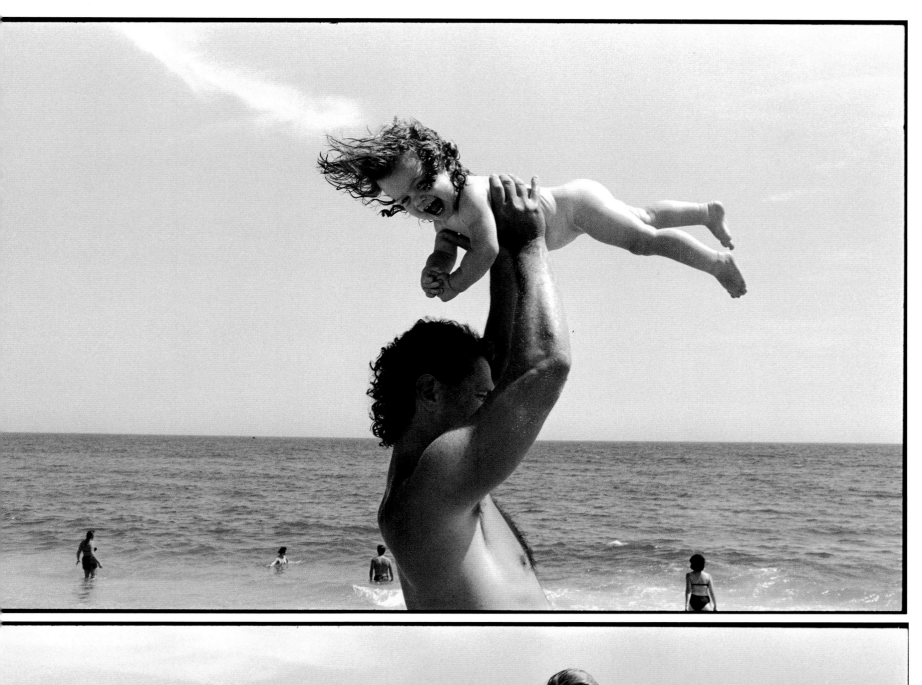
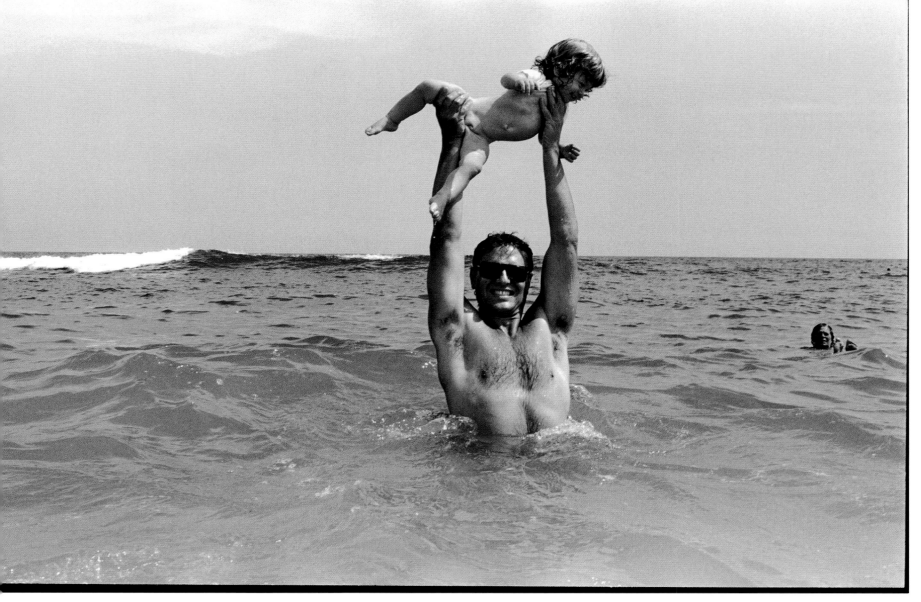

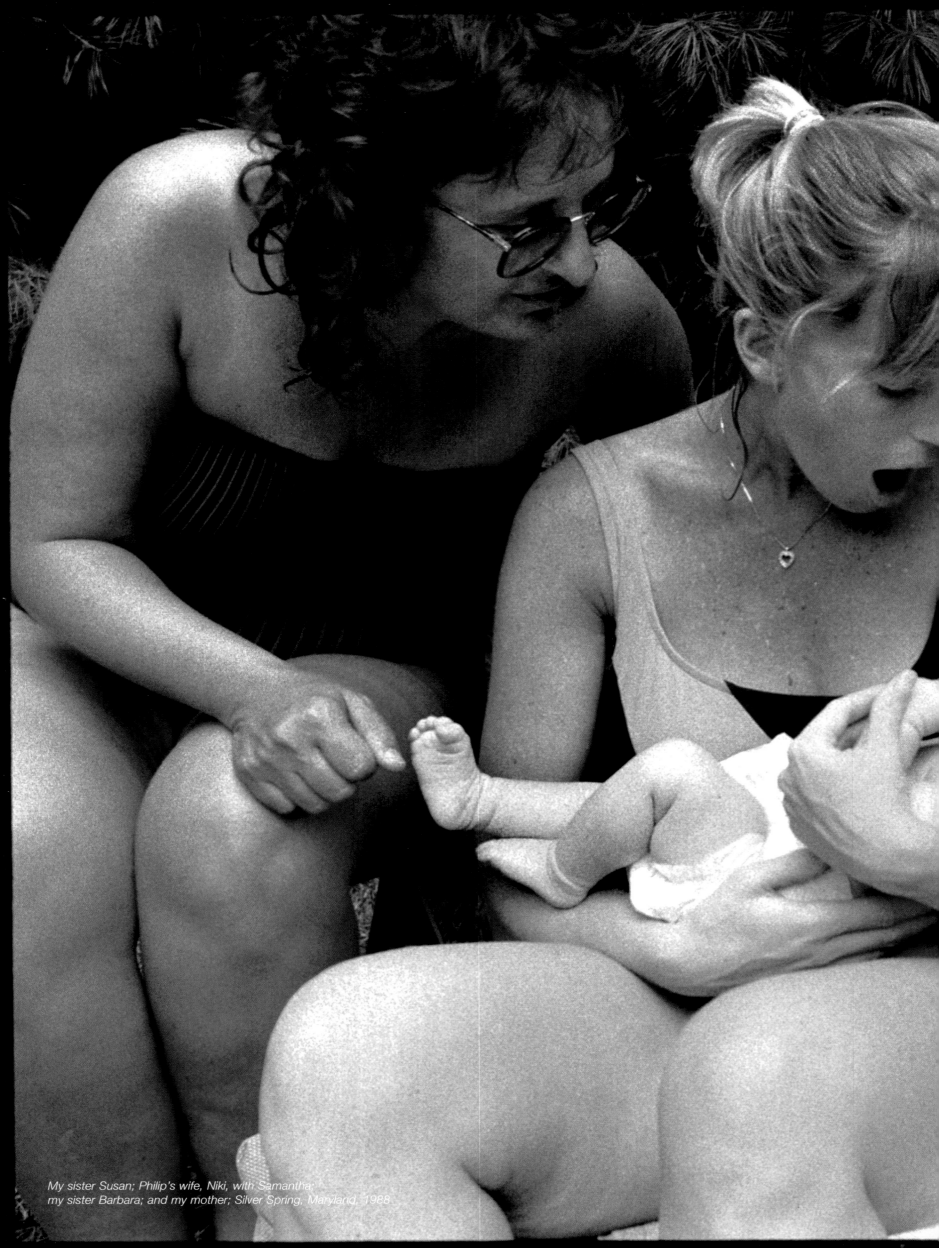

My sister Susan; Philip's wife, Niki, with Samantha; my sister Barbara; and my mother; Silver Spring, Maryland, 1988

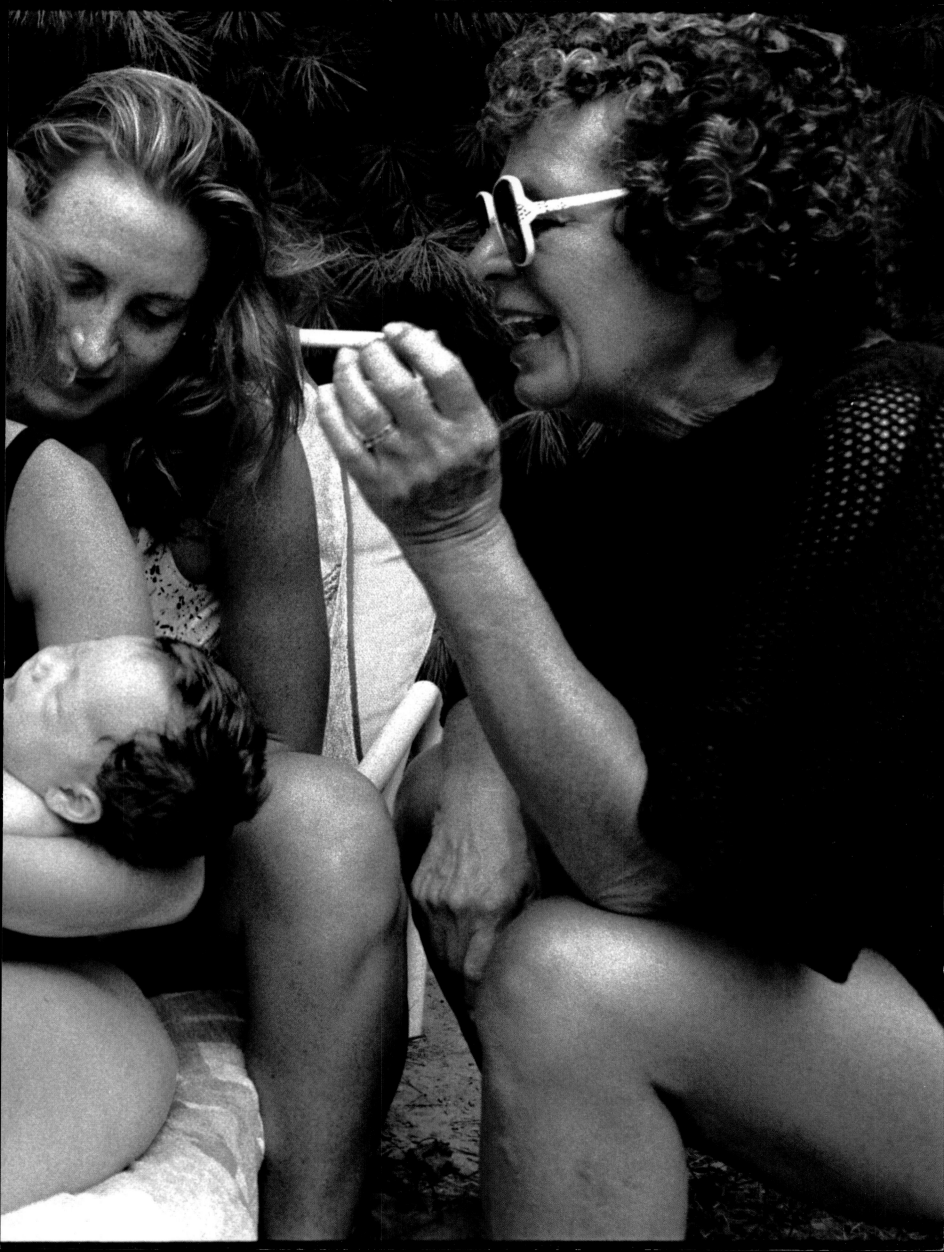

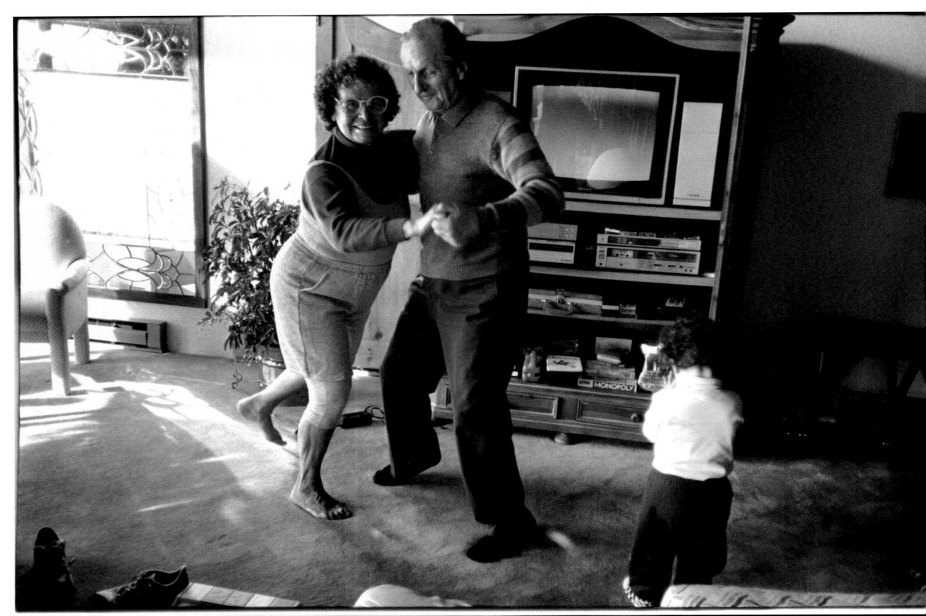

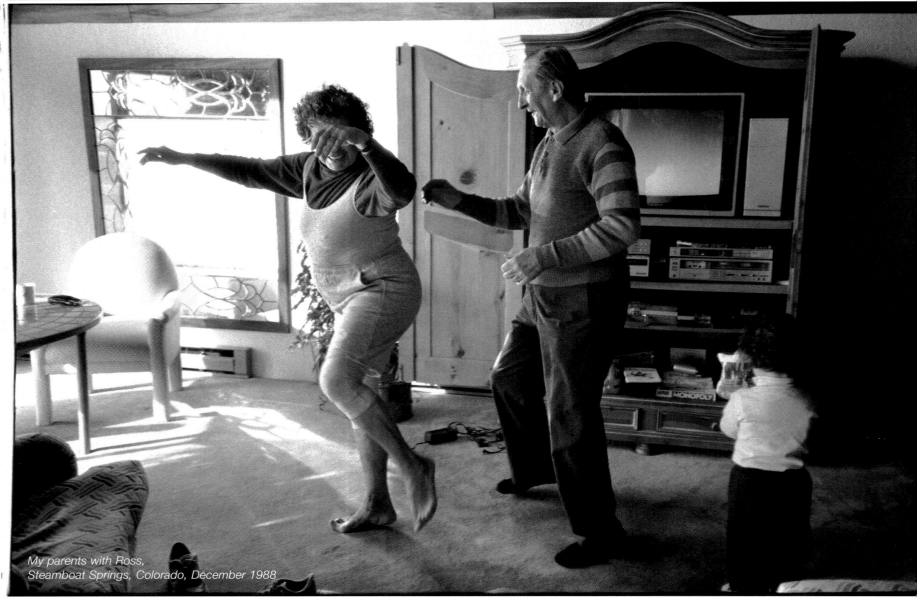

My parents with Ross,
Steamboat Springs, Colorado, December 1988

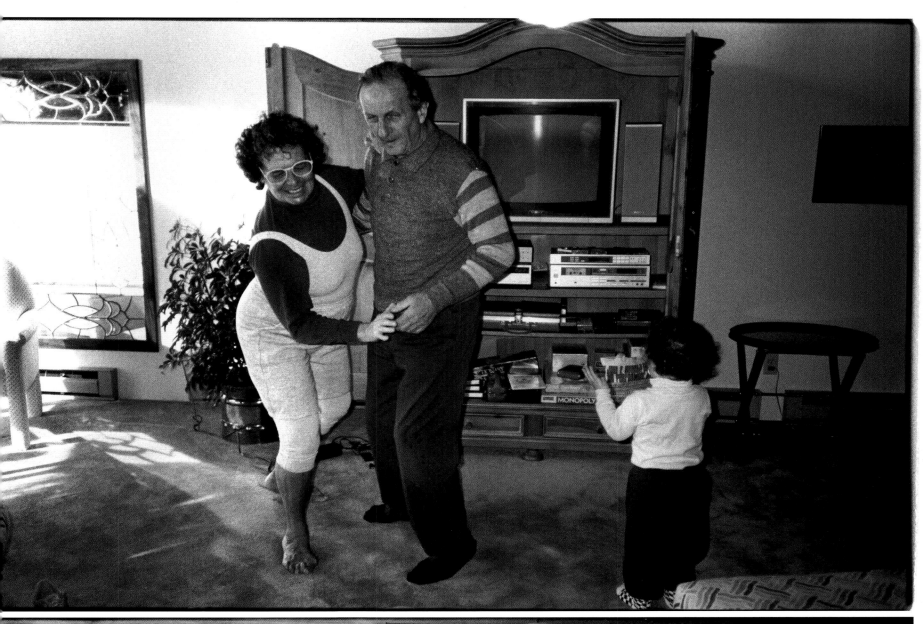
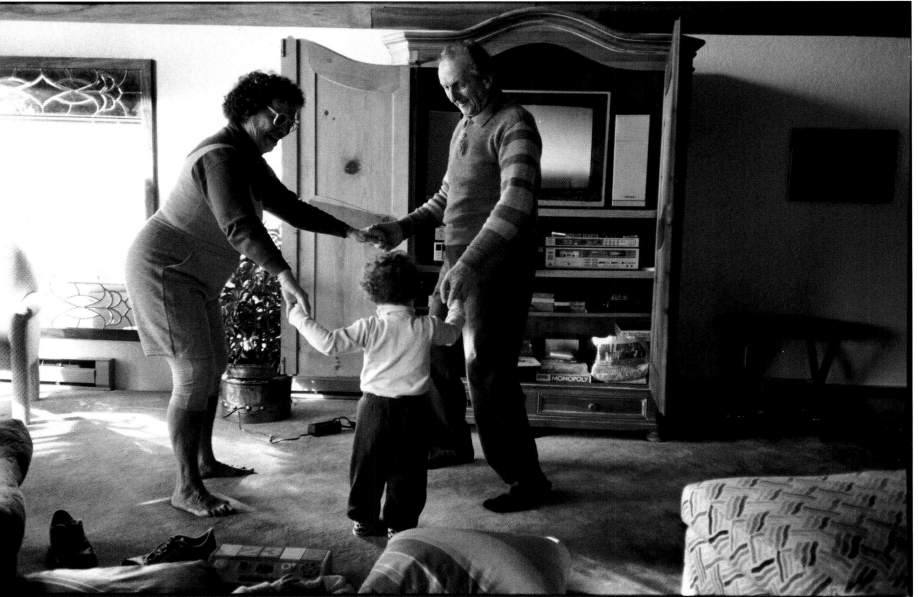

Susan at the house on Hedges Lane,
Wainscott, Long Island, 1988

Susan with Richmond Burton,
Hedges Lane, Wainscott, Long Island, 1988

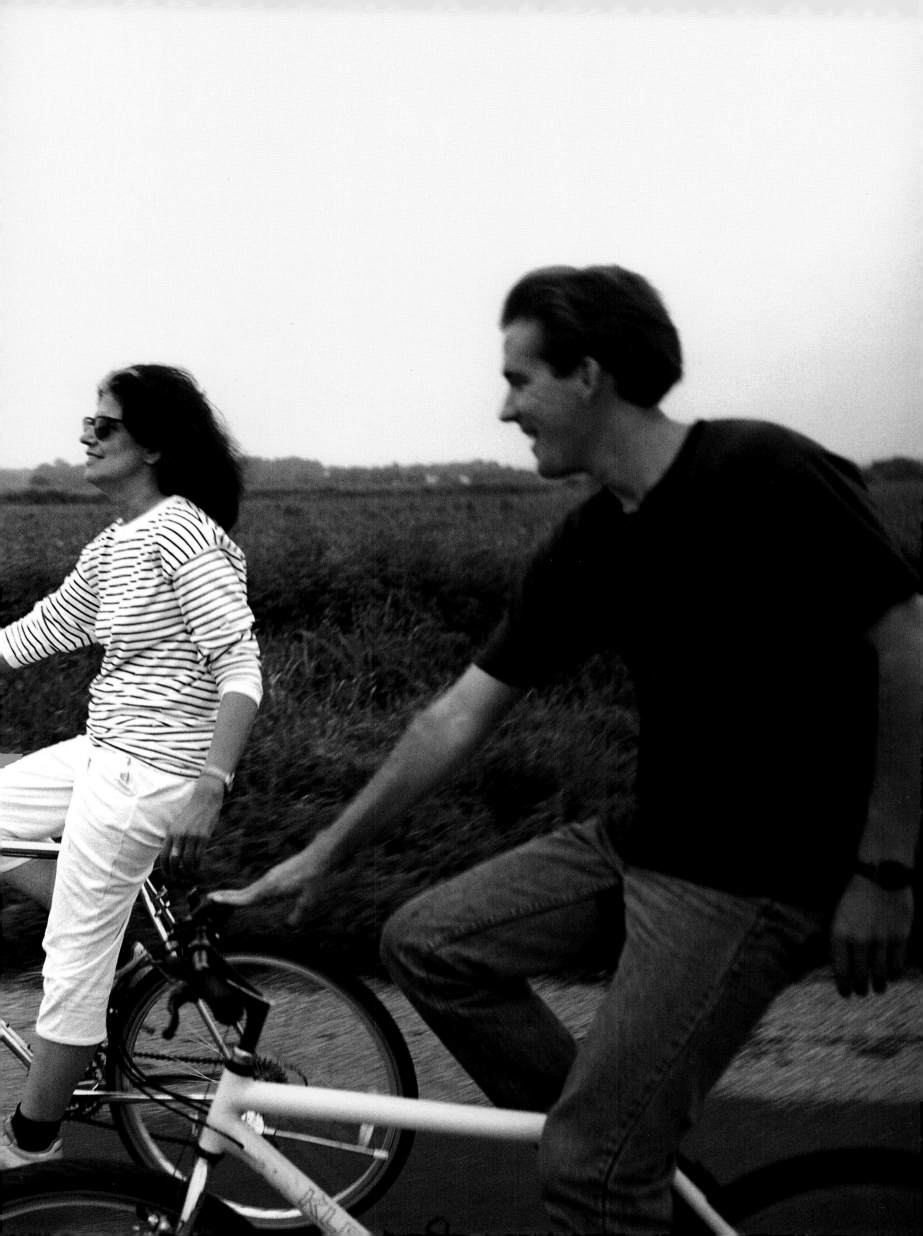

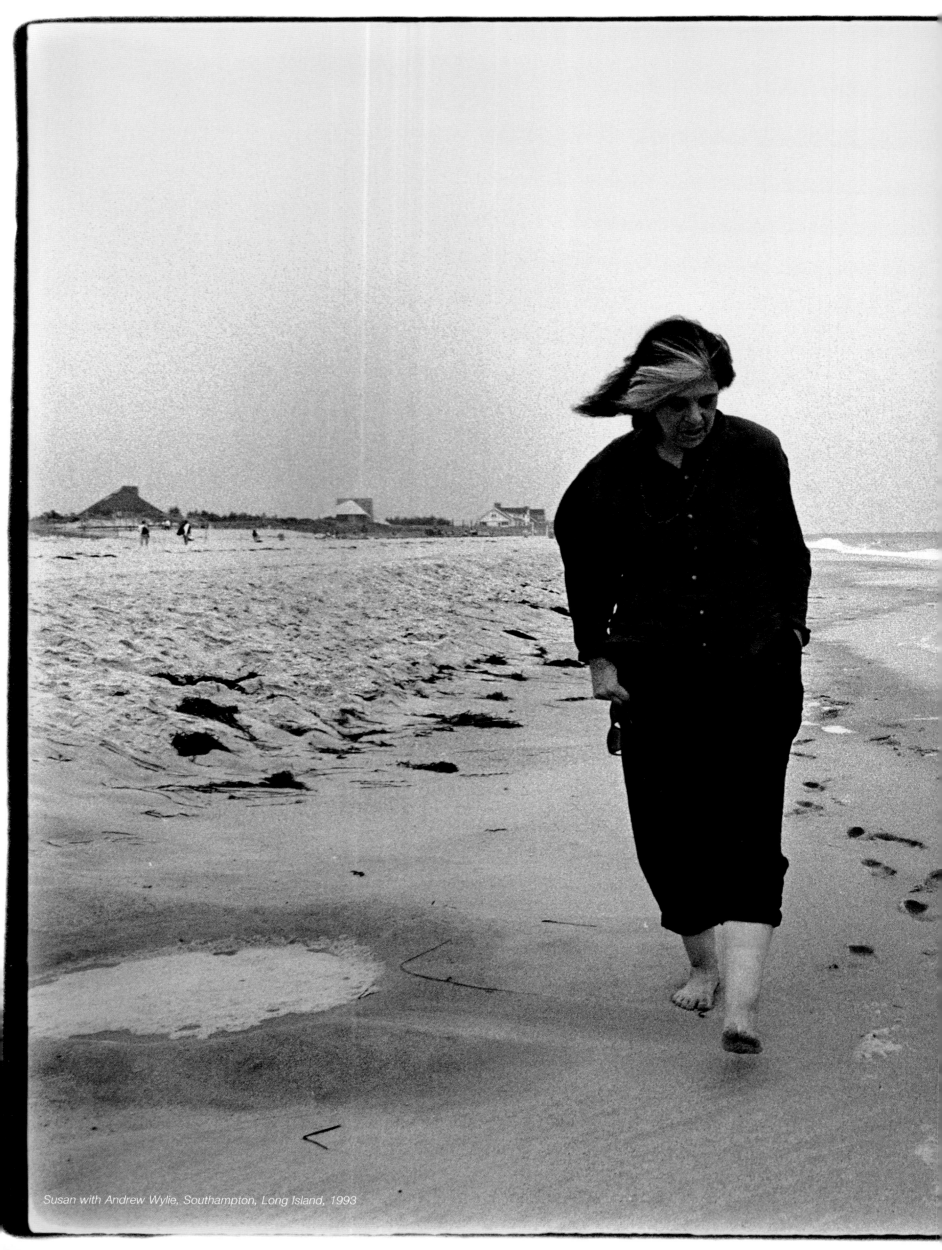

Susan with Andrew Wylie, Southampton, Long Island, 1993

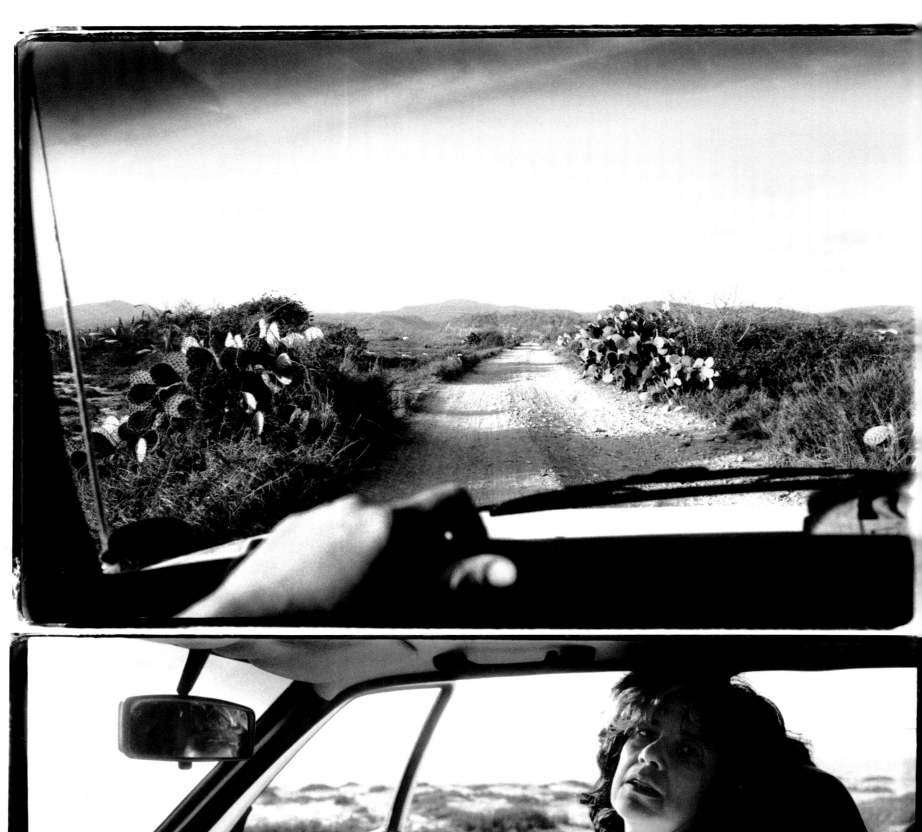

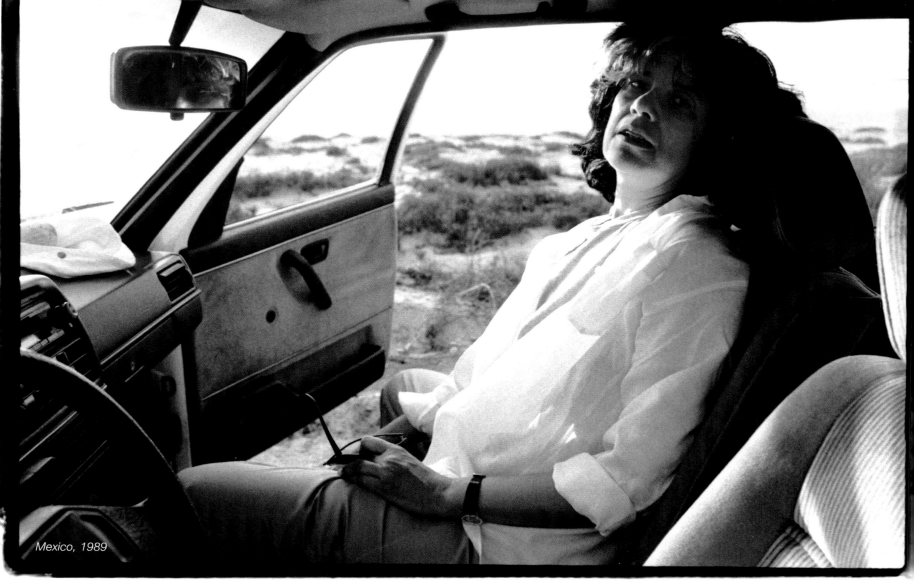

Mexico, 1989

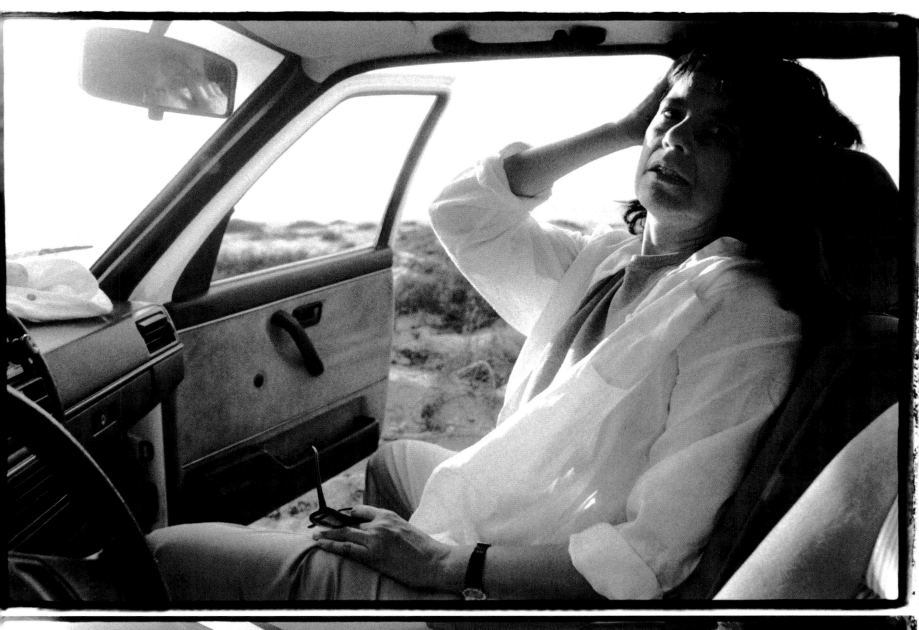
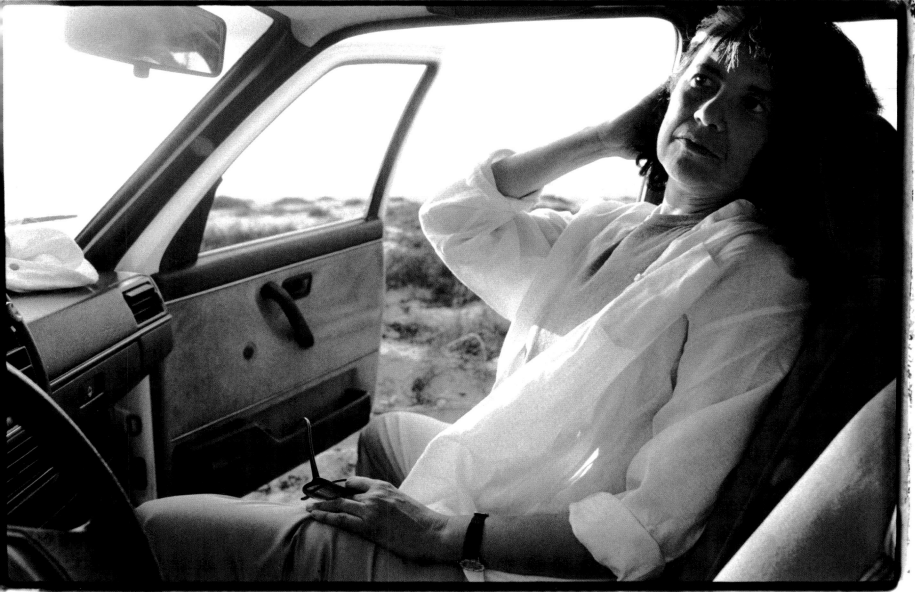

Hotel Gritti Palace, Venice, 1989

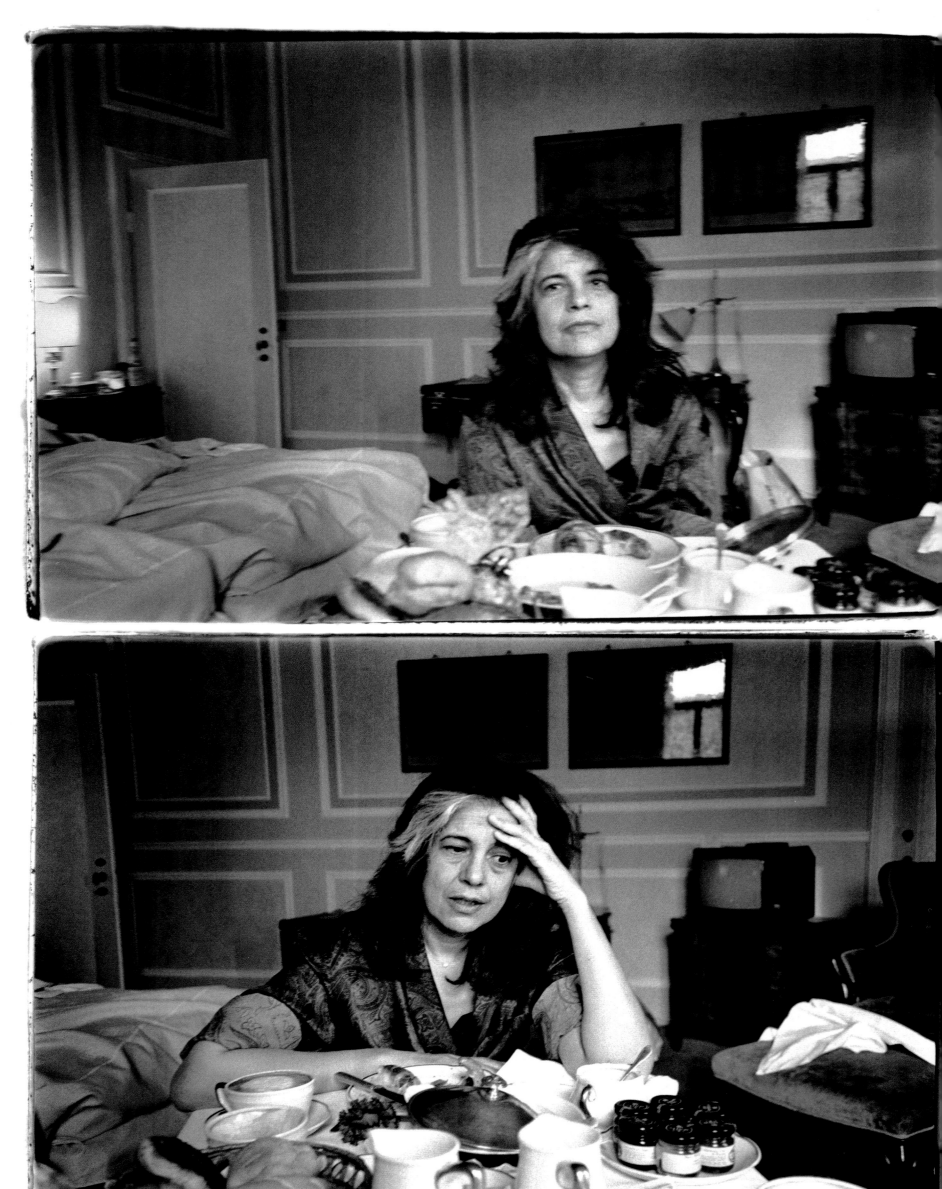

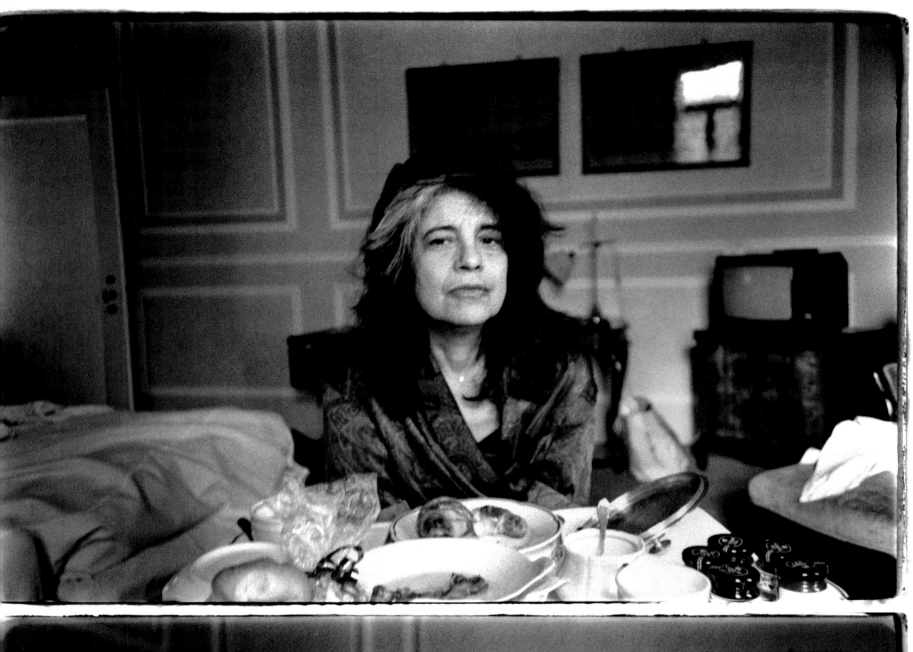
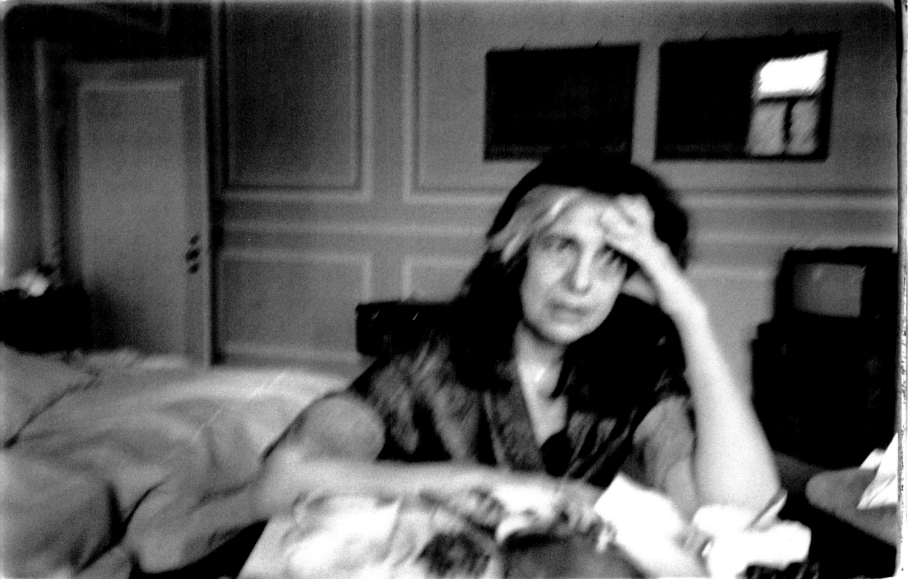

Susan, Hotel Gritti Palace, Venice, 1989

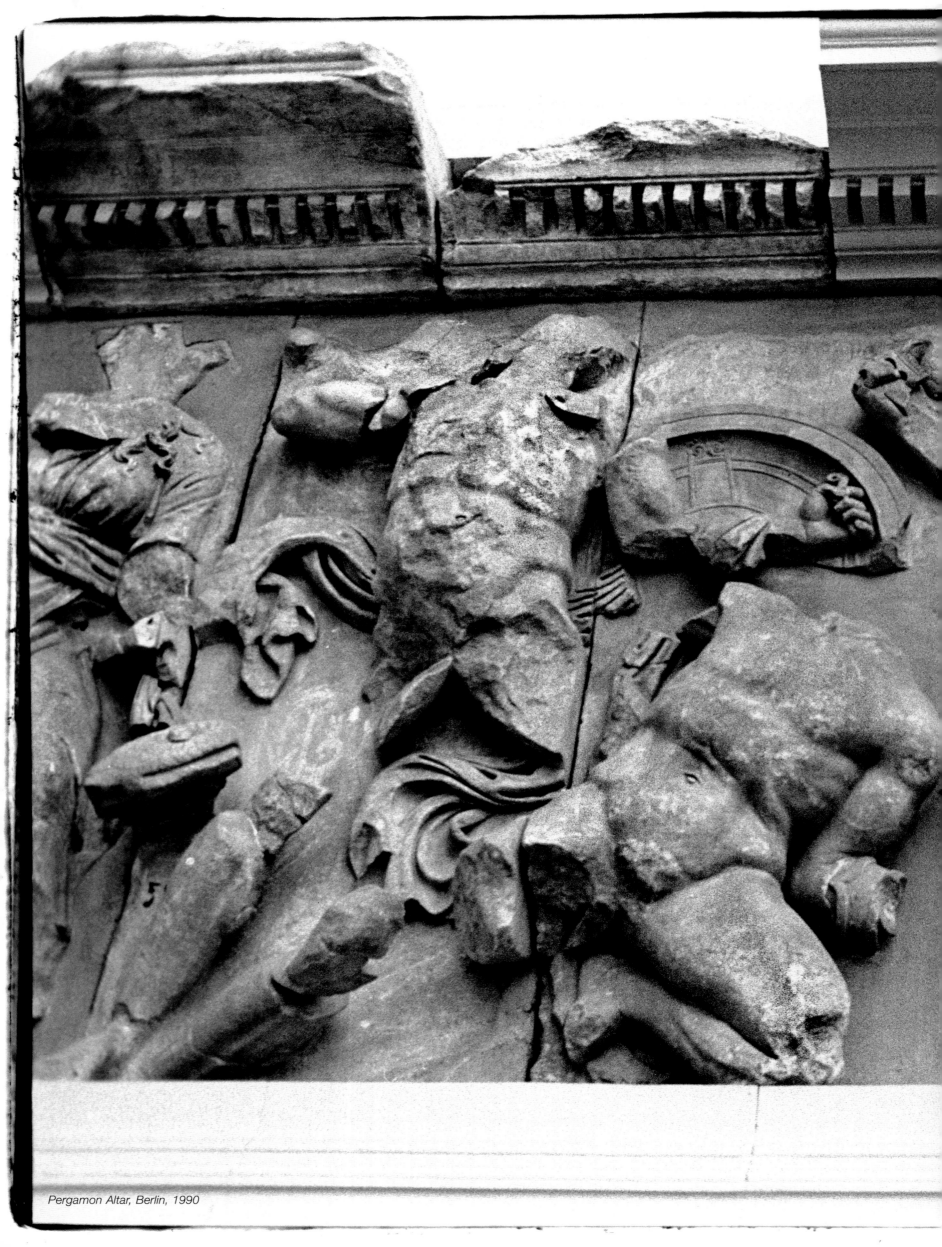

Pergamon Altar, Berlin, 1990

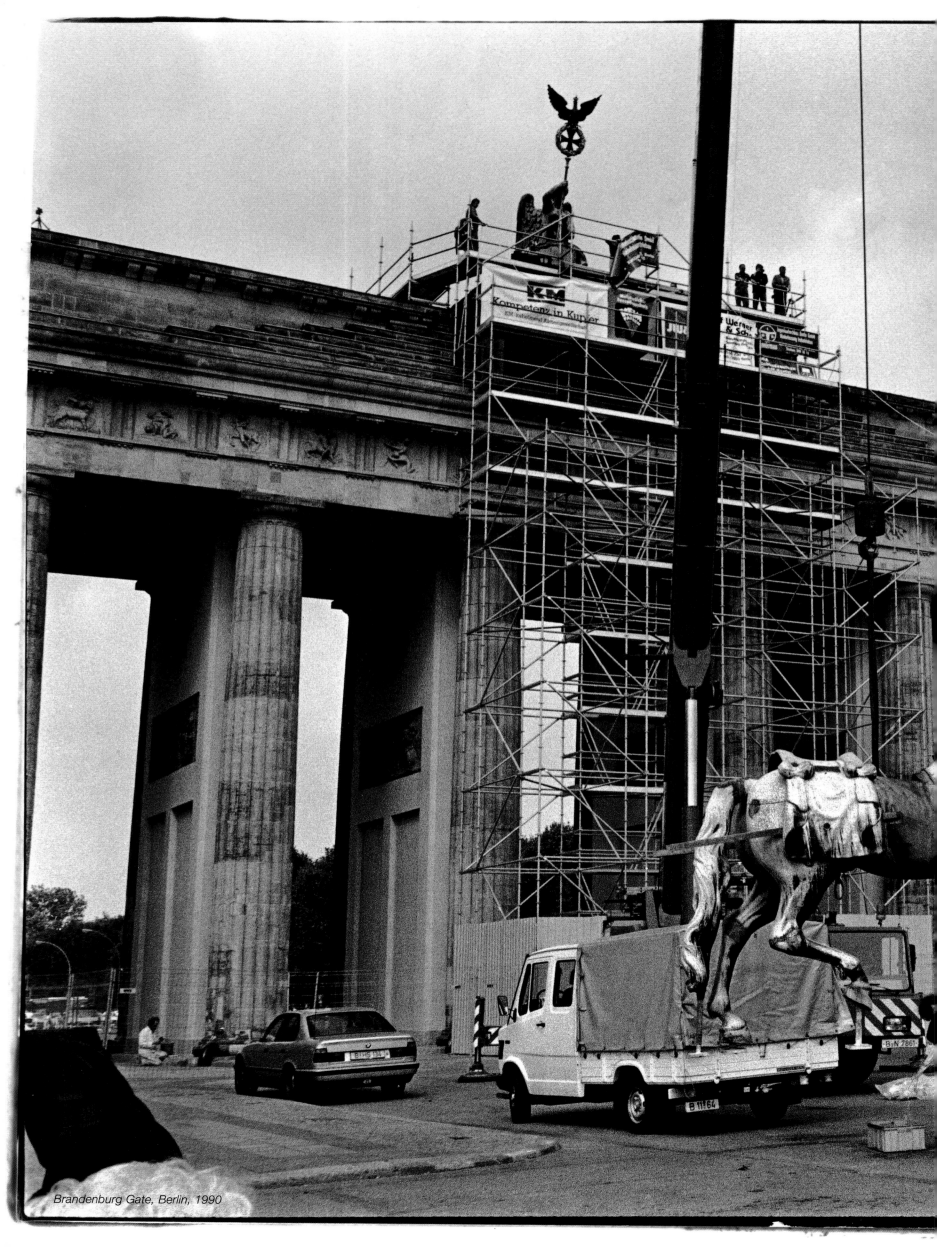

Brandenburg Gate, Berlin, 1990

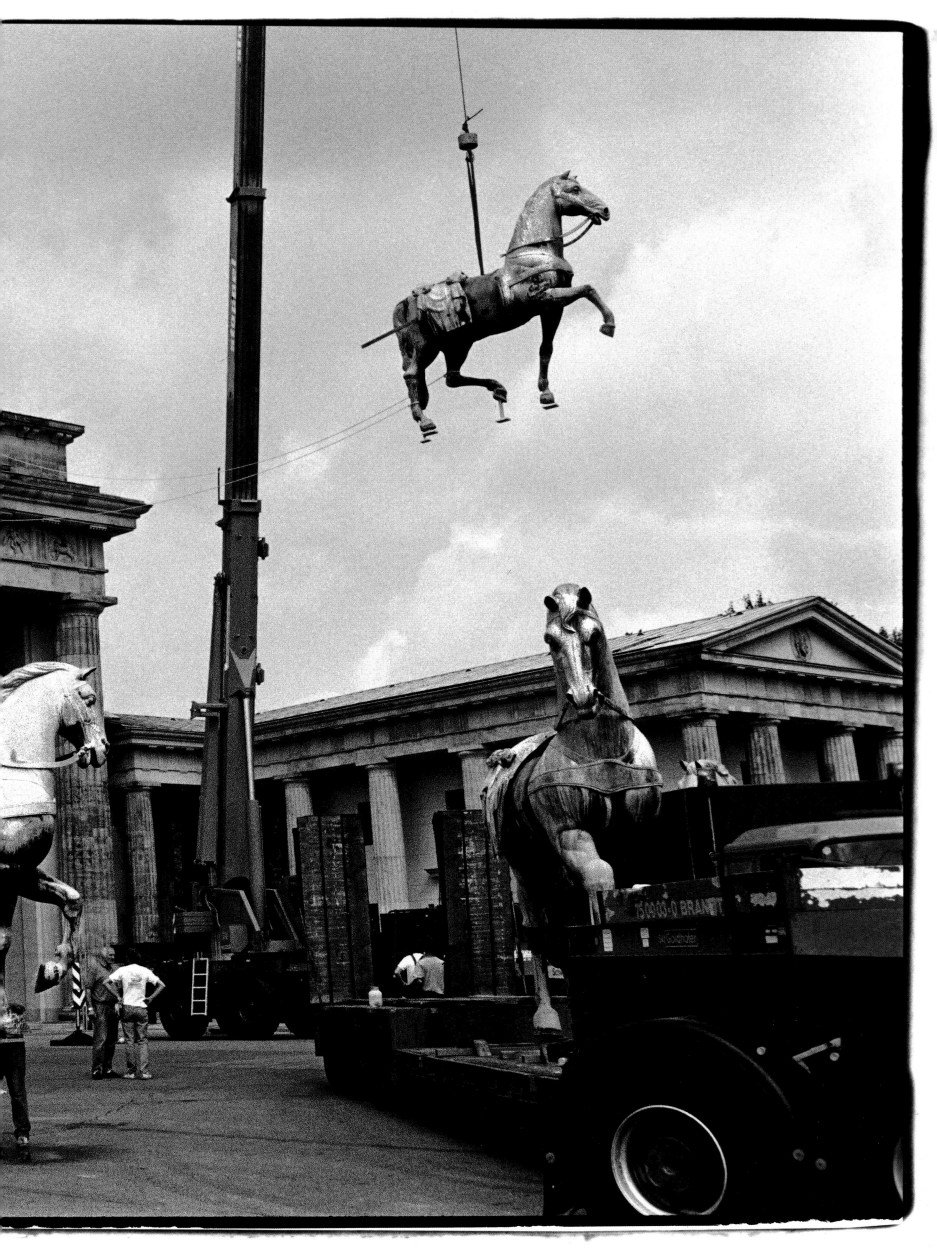

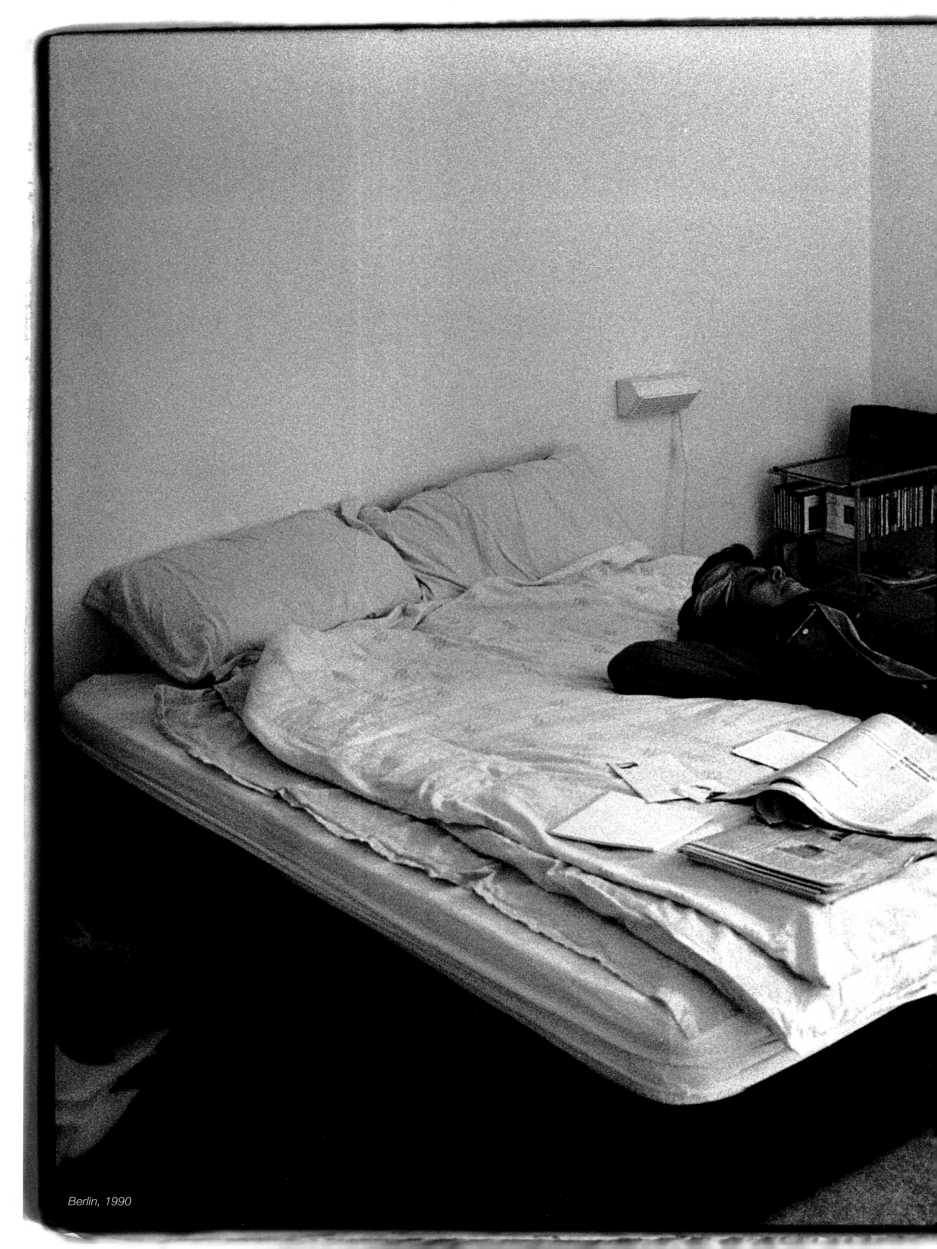

Berlin, 1990

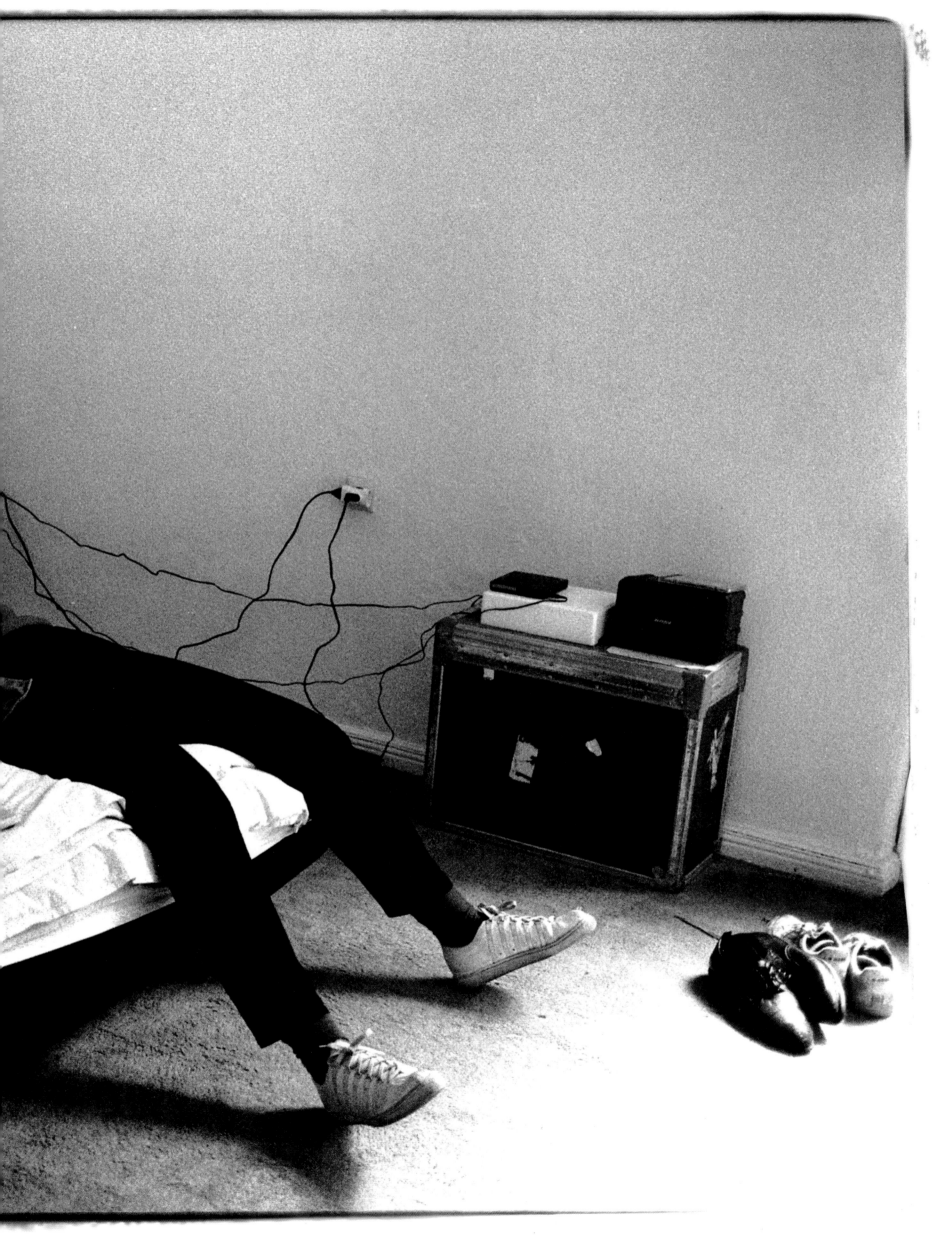

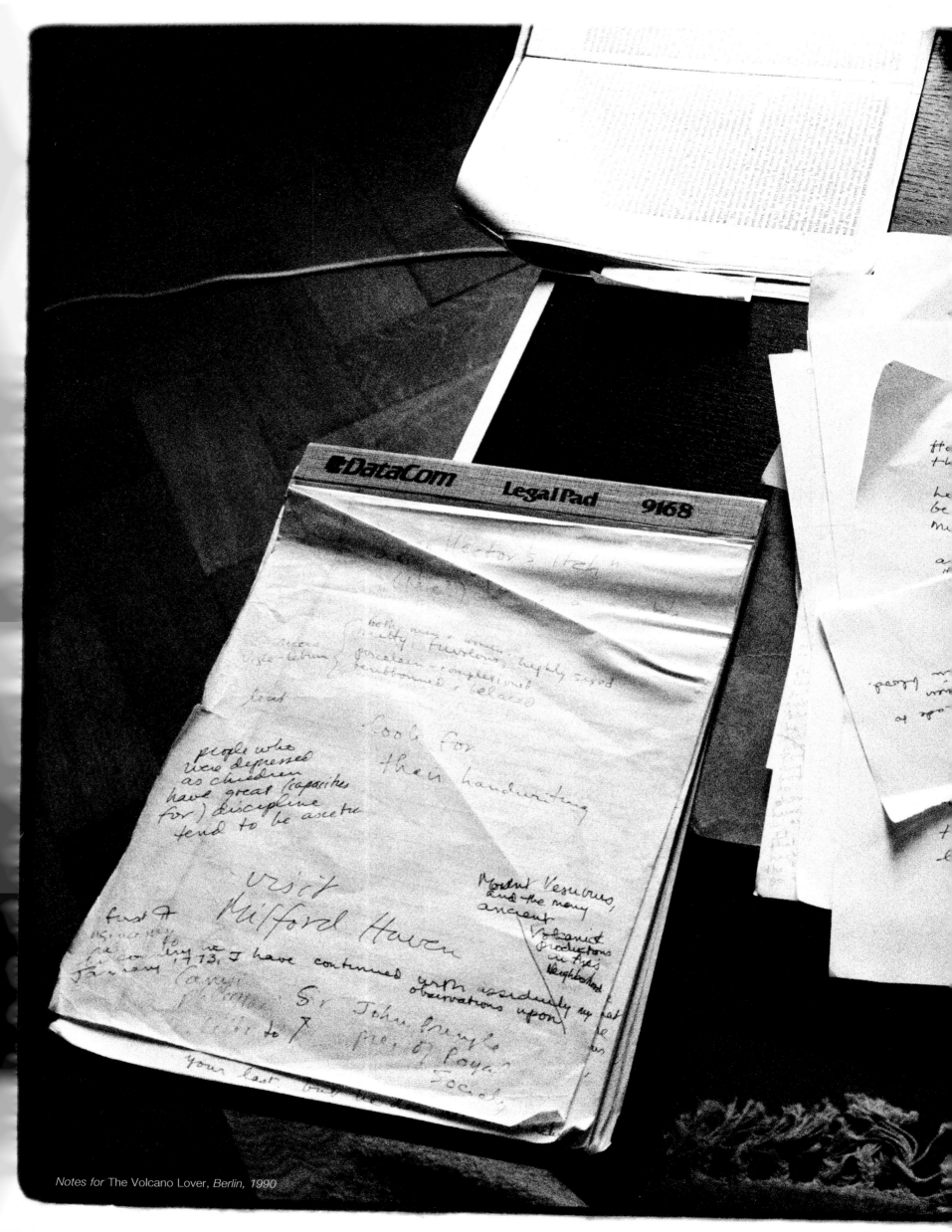

Notes for The Volcano Lover, *Berlin, 1990*

He stood near the ~~out of the~~ volcano's
~~big~~ huge red mouth. The air grew more
+ more stifling and acrid — the hot
the sulpher smell]. The earth trembling
under ~~his~~ feet. He ~~...~~
[eyelashes burnt], ~~...~~ he could
feel the hairs of his eyelashes, his
eyebrows move with the hot blast. It
was impossible to stand the heat
which tears his lungs any longer, yet
he felt strangely unwilling to go.

He watched the column of smoke swell and
balance against the sky. Night fell
The rumbling under his feet. The
column of flames shooting up
He stood motionless, his light
grey eyes wide open

violent heat
the thin stream
of red lava
widened

in villa —
heads of fig
English pendulum
clock stop at
the fatal hour

to be frightened of
the effect of bad
smells [sulphur smell of
camp Aleppey]

DataCom LegalPad 9168

[other papers, partially visible:]

I have J— 43 43

...ness because of his feminine appearance. And
...rstand, says the Cavali—

Cavaliere is thinking about the thing.
be a crisp, steady uncle to
...kleos, bloated, [ugly] thing
...therine is thinking about God
...thma, and there
...hildren and
being left

...of his pomp
...the Austrian
...his wife's white
the Cavaliere is
volcano, + when

the Cavaliere

[note card upper right:]
...watch the rock
...the novel
that sink into grains
of sand

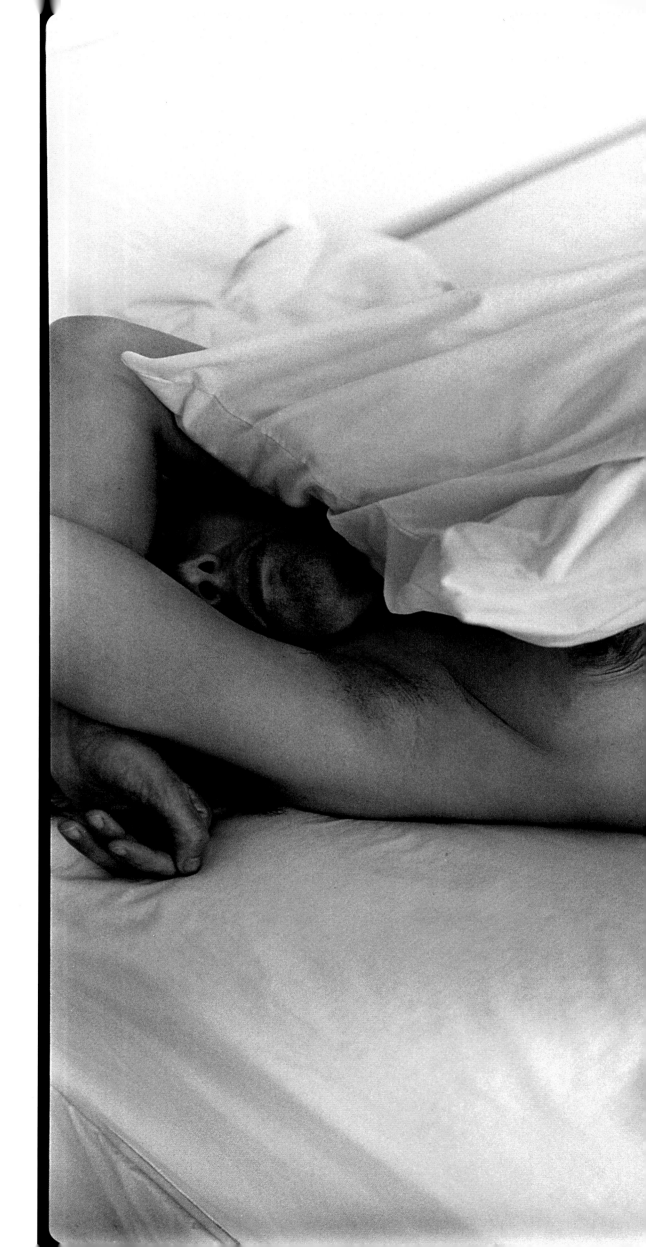

Hedges Lane, Wainscott, Long Island, 1994

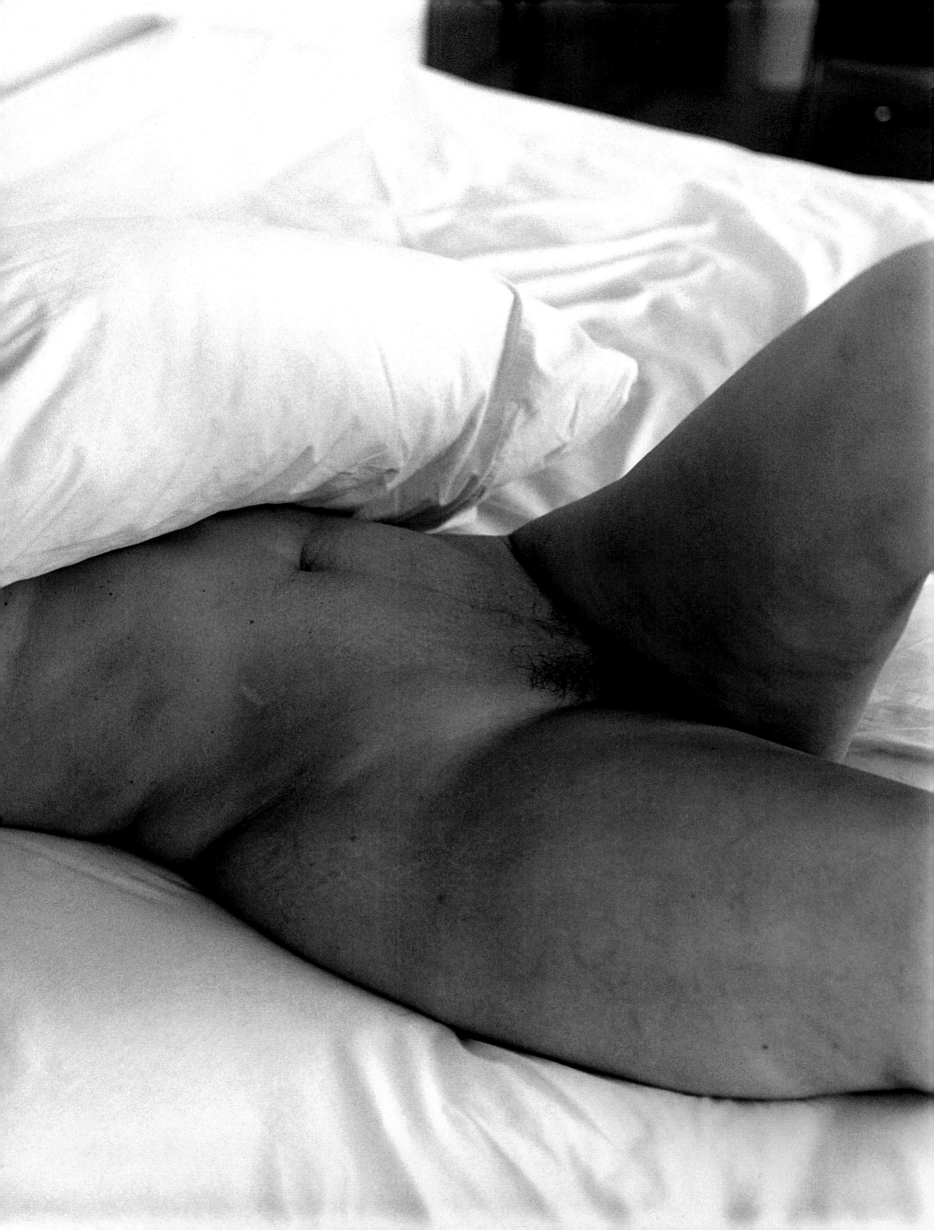

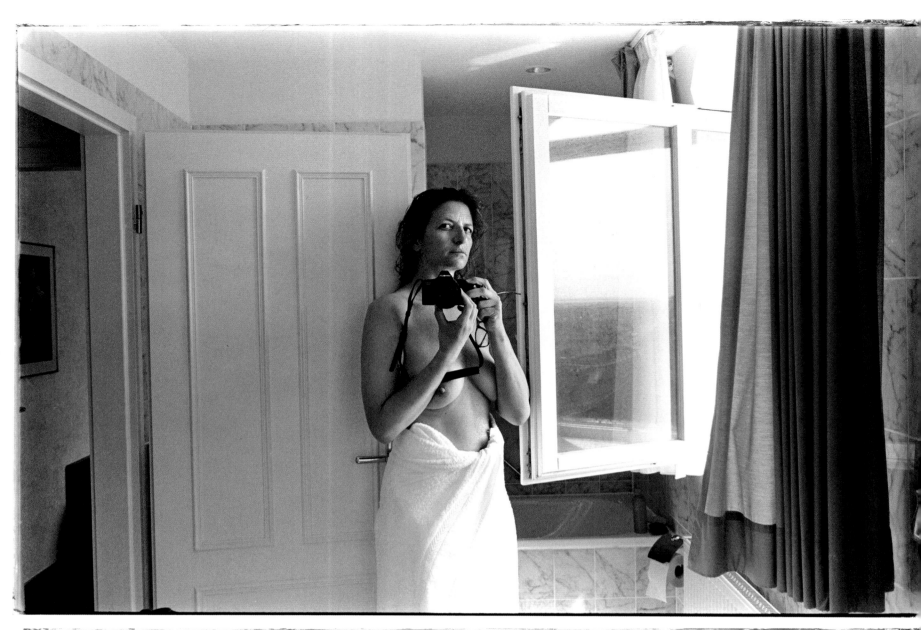

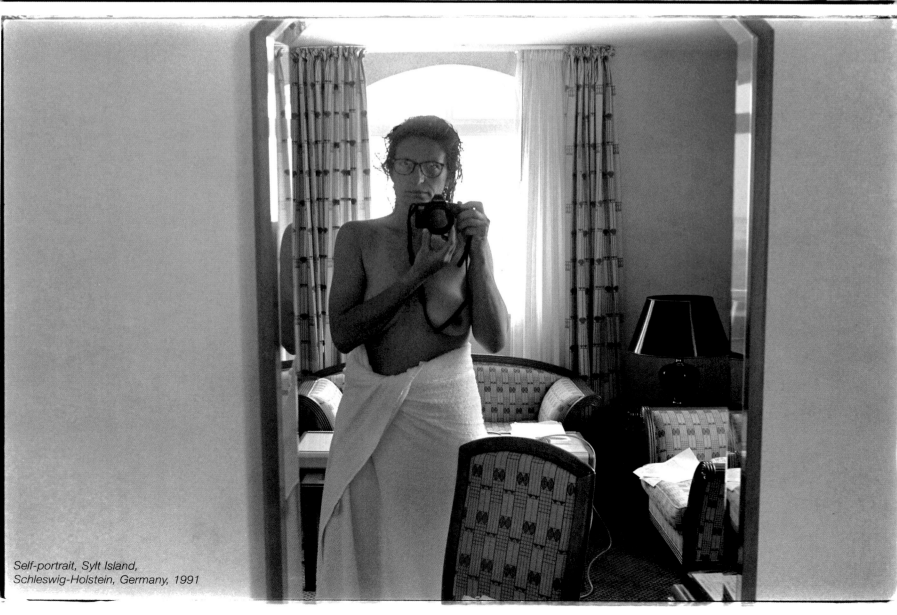

Self-portrait, Sylt Island,
Schleswig-Holstein, Germany, 1991

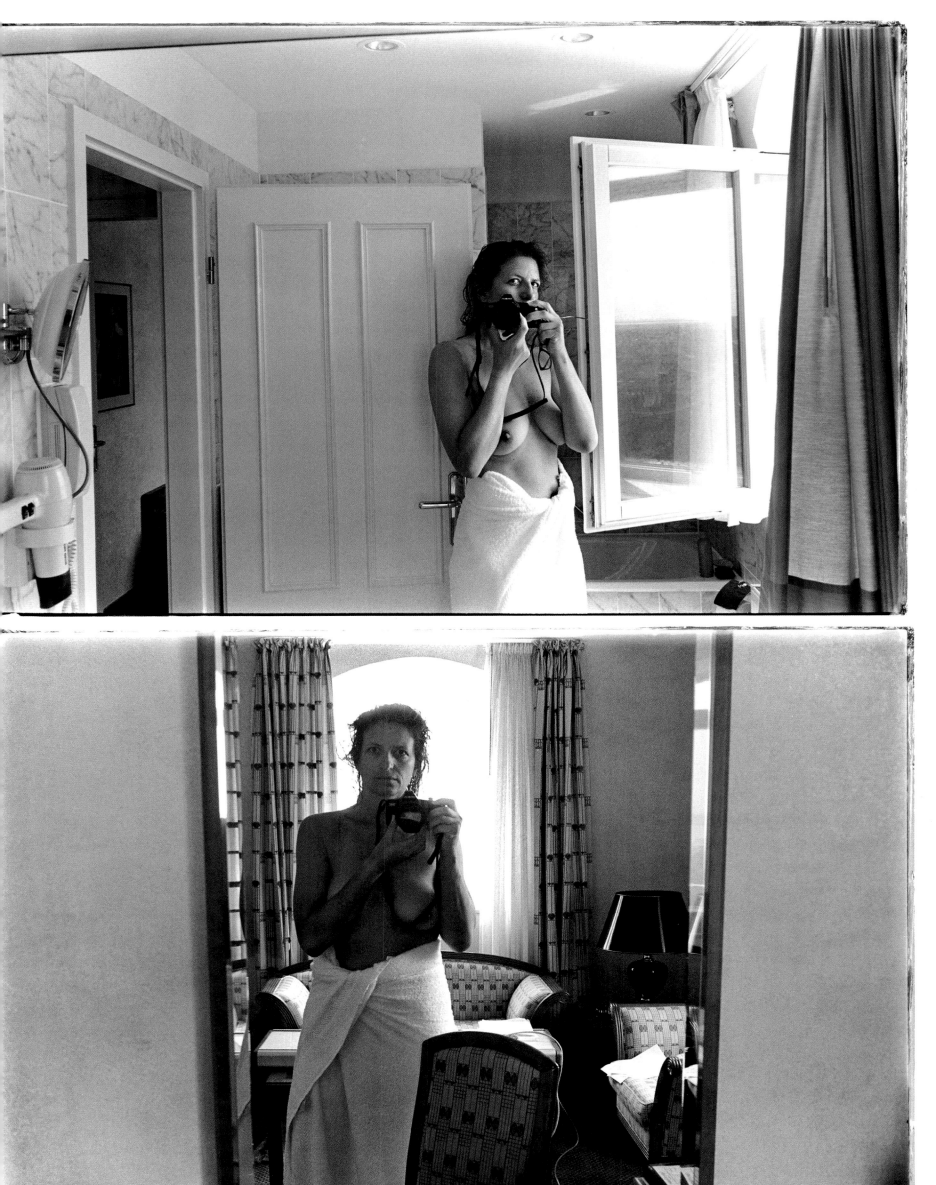

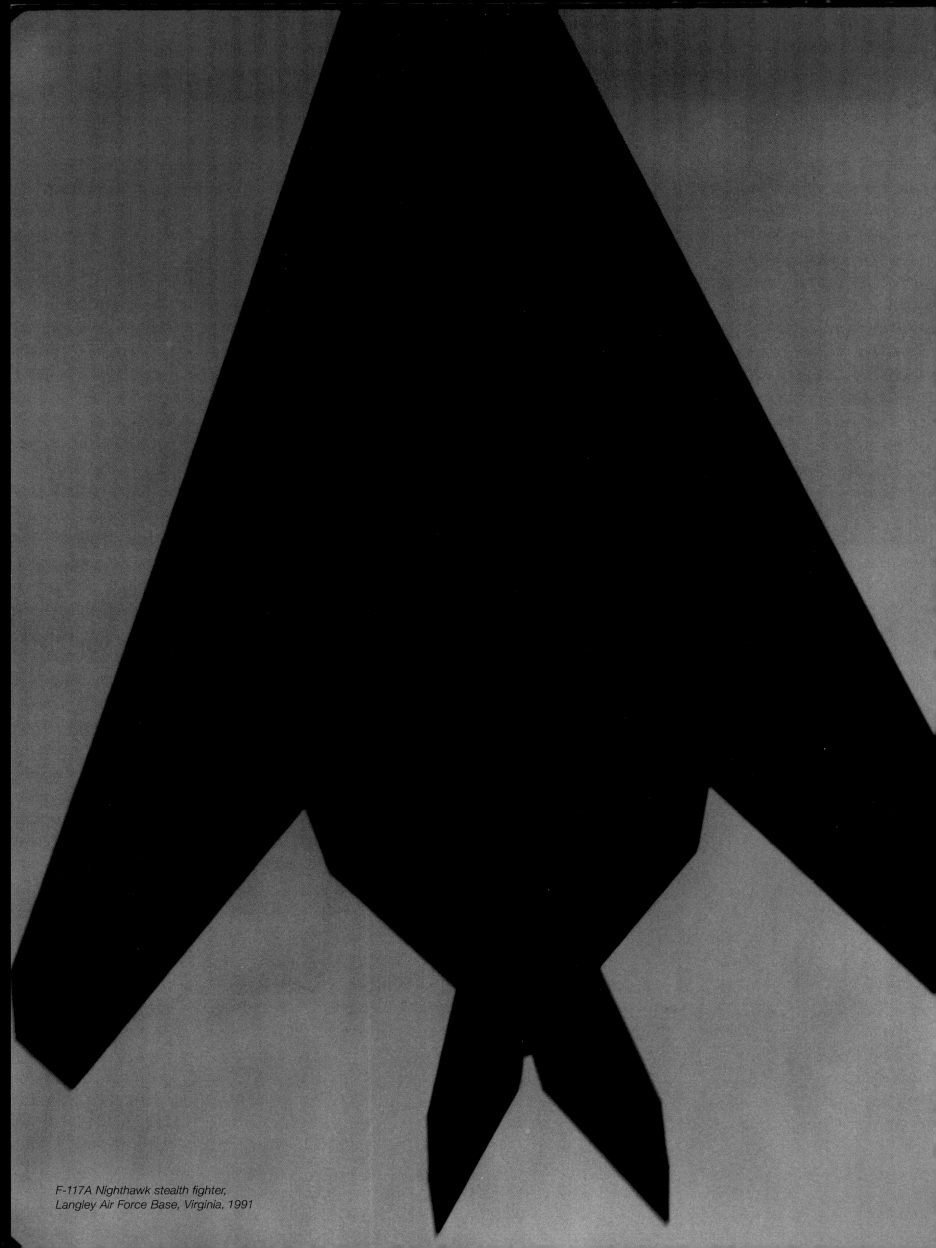

F-117A Nighthawk stealth fighter,
Langley Air Force Base, Virginia, 1991

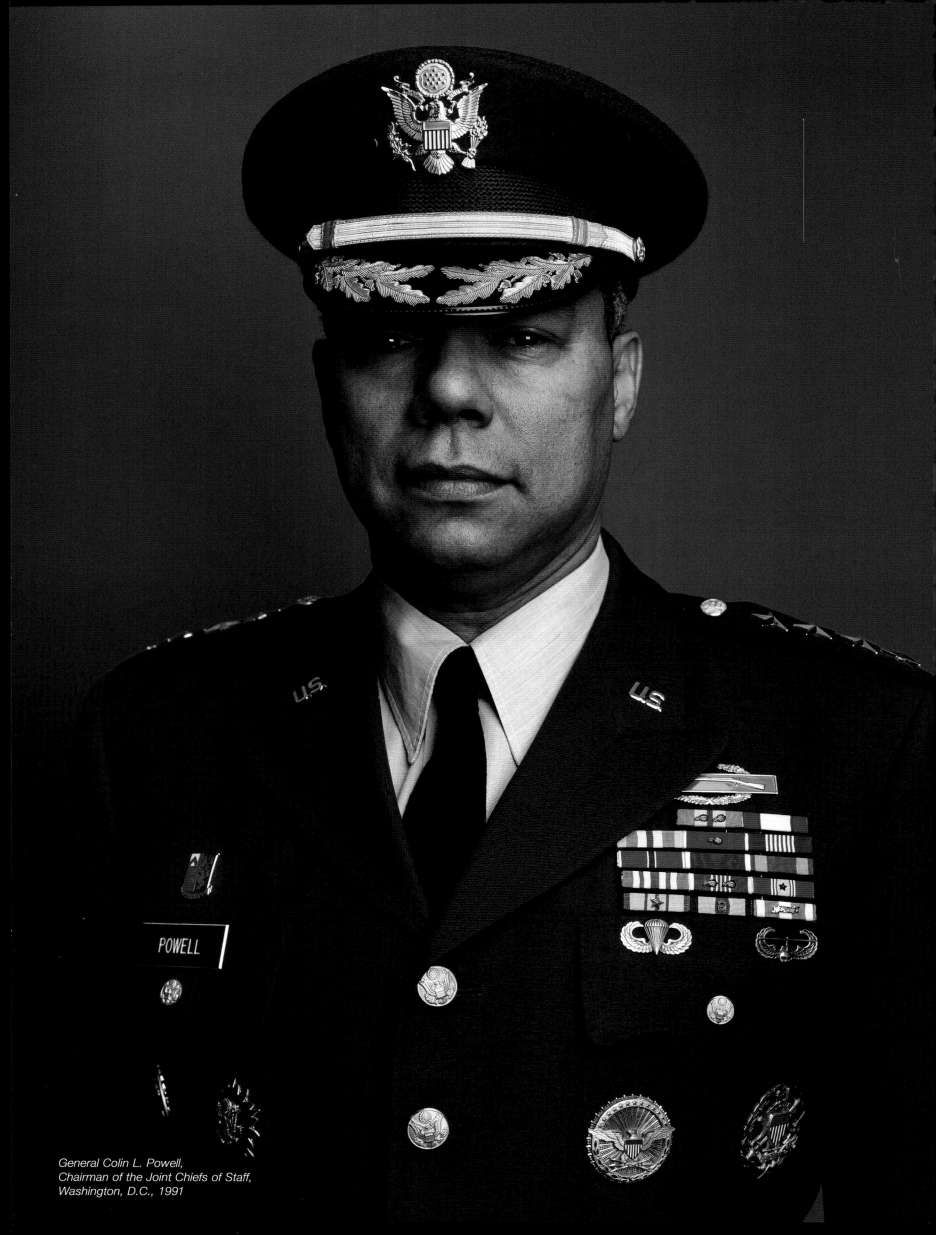

General Colin L. Powell,
Chairman of the Joint Chiefs of Staff,
Washington, D.C., 1991

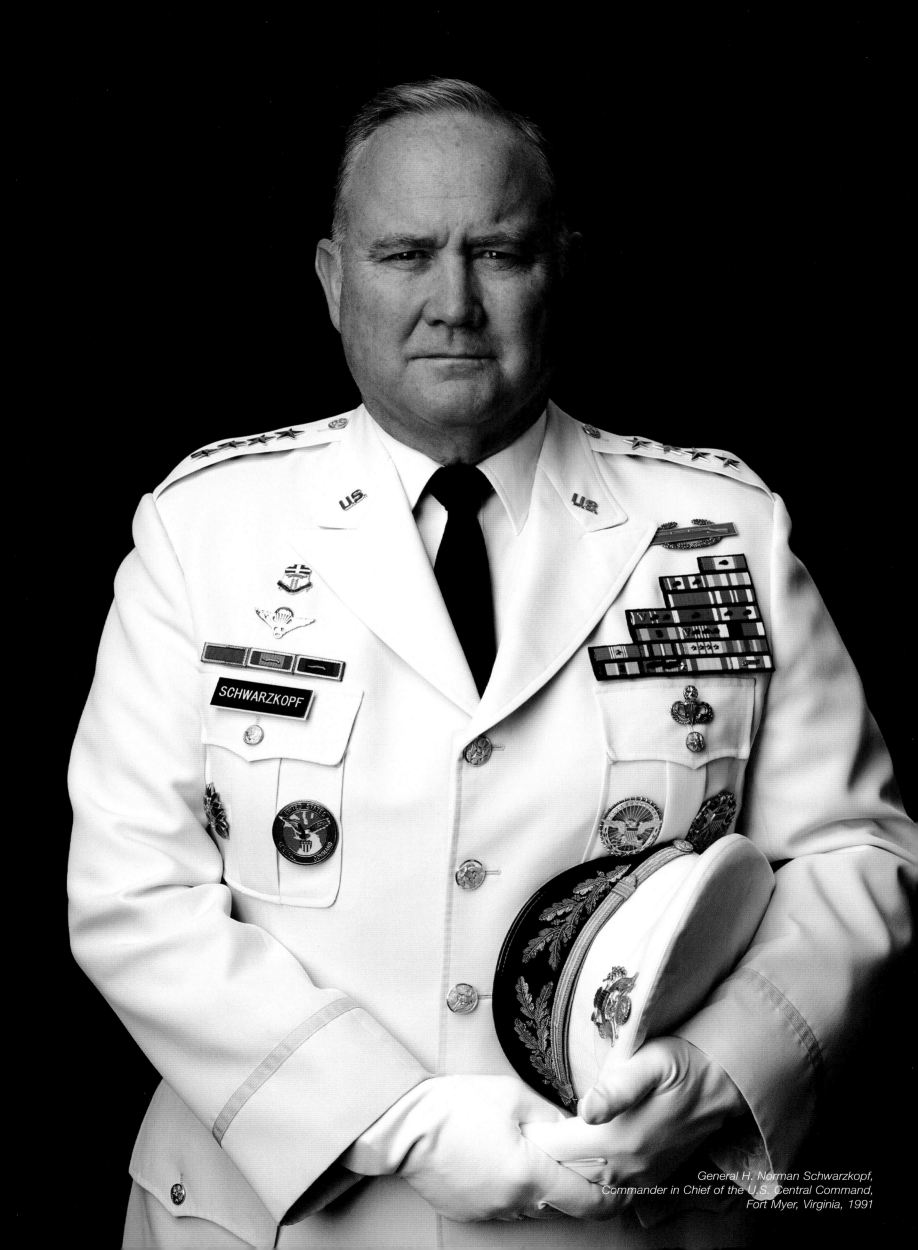

General H. Norman Schwarzkopf,
Commander in Chief of the U.S. Central Command,
Fort Myer, Virginia, 1991

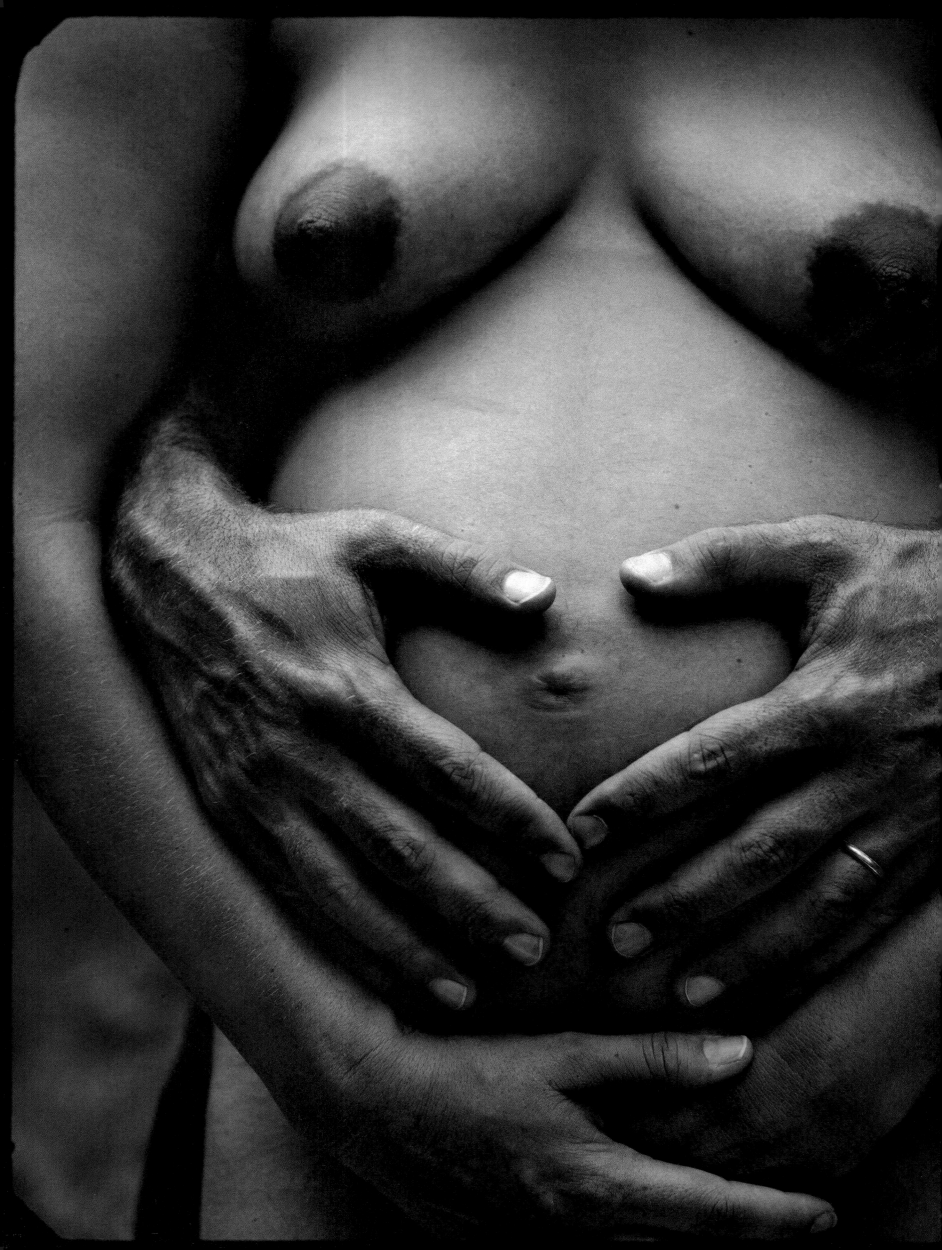

Bruce Willis and Demi Moore, pregnant with Rumer Glenn Willis,
Paducah, Kentucky, 1988

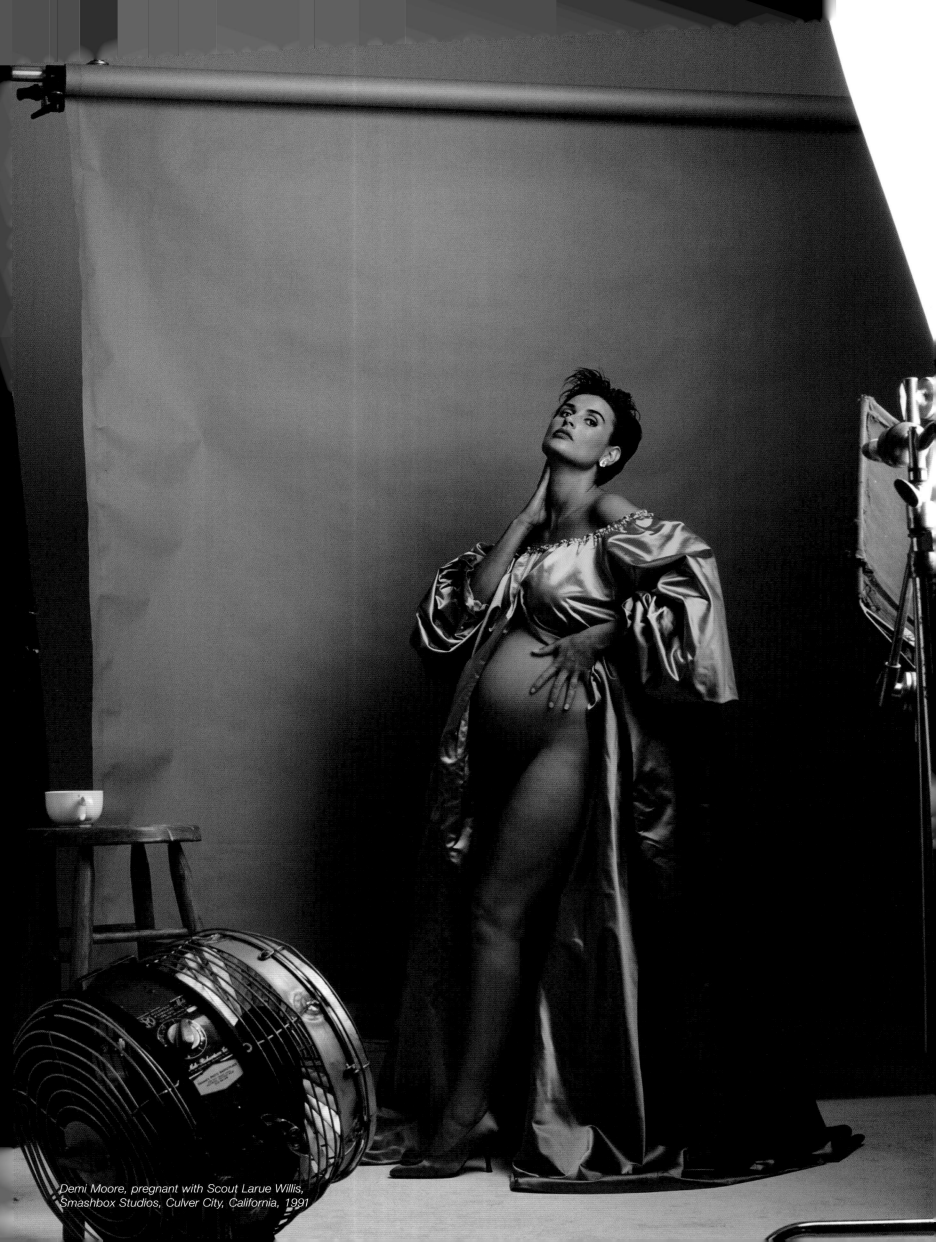

*Demi Moore, pregnant with Scout Larue Willis,
Smashbox Studios, Culver City, California, 1991*

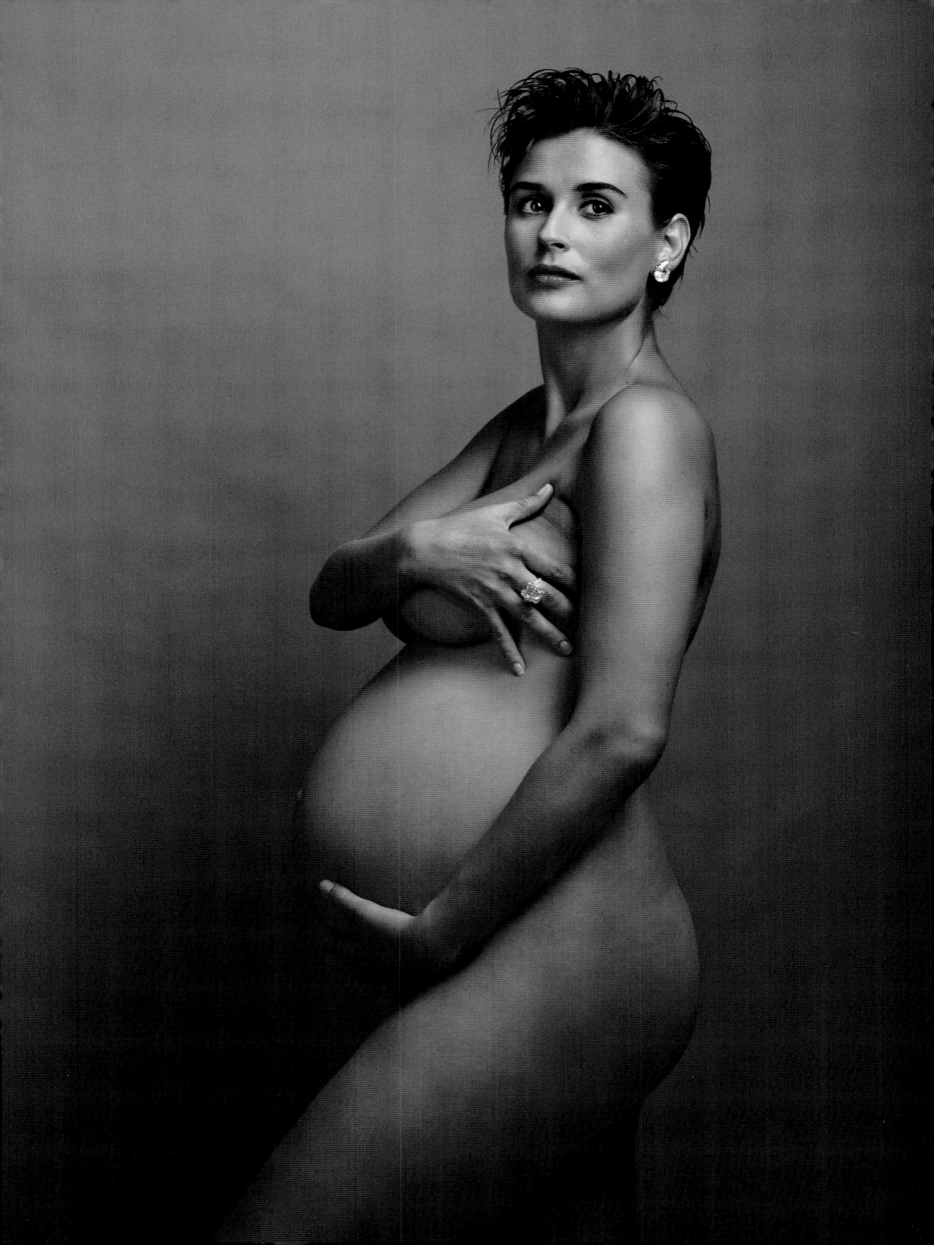

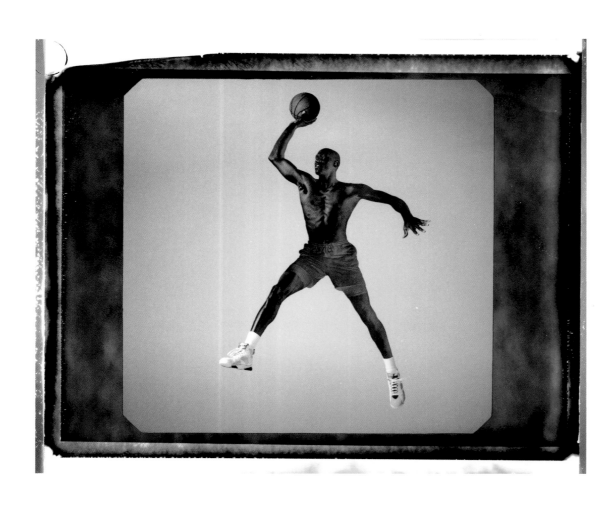

Michael Jordan, Vandam Street studio, New York, 1991

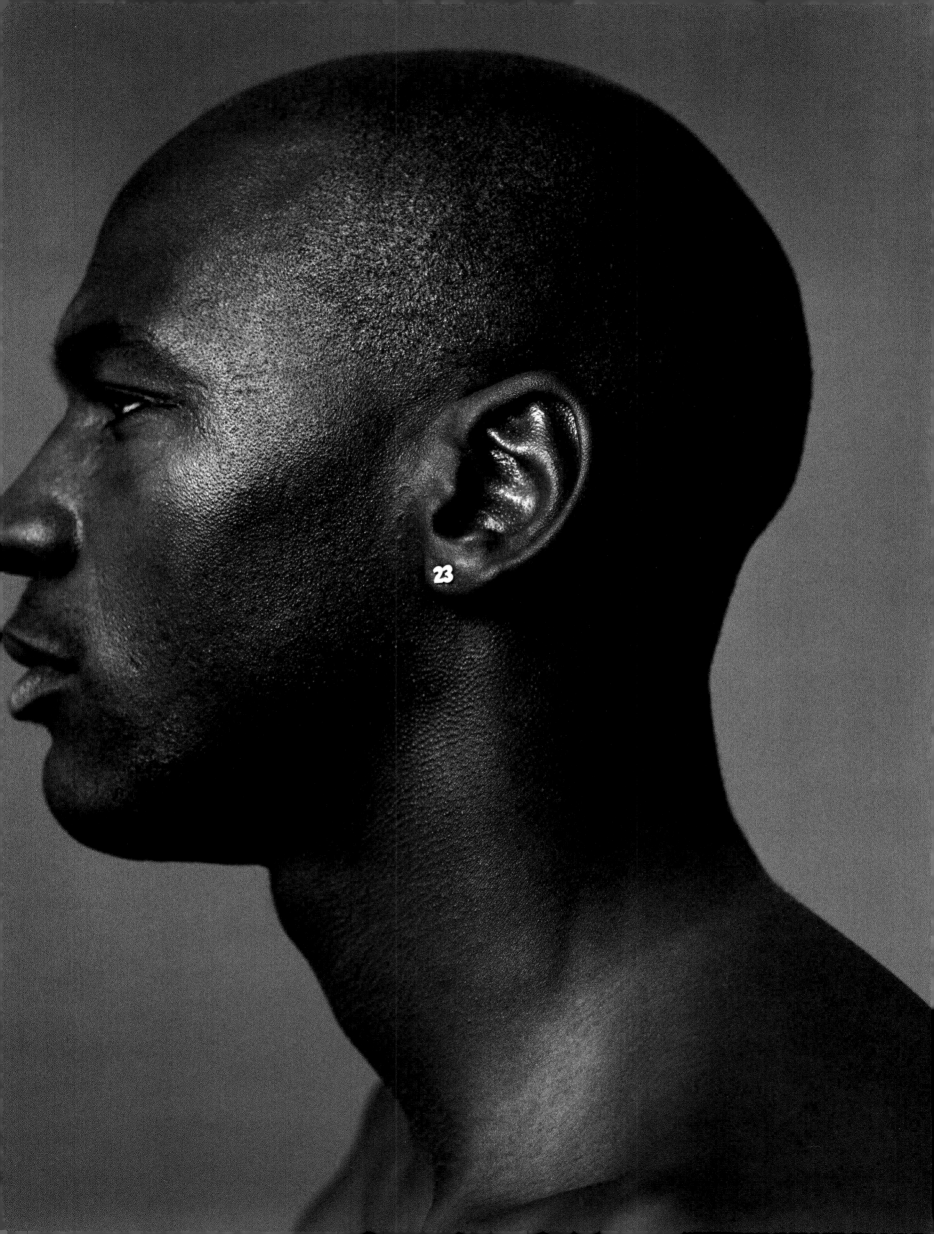

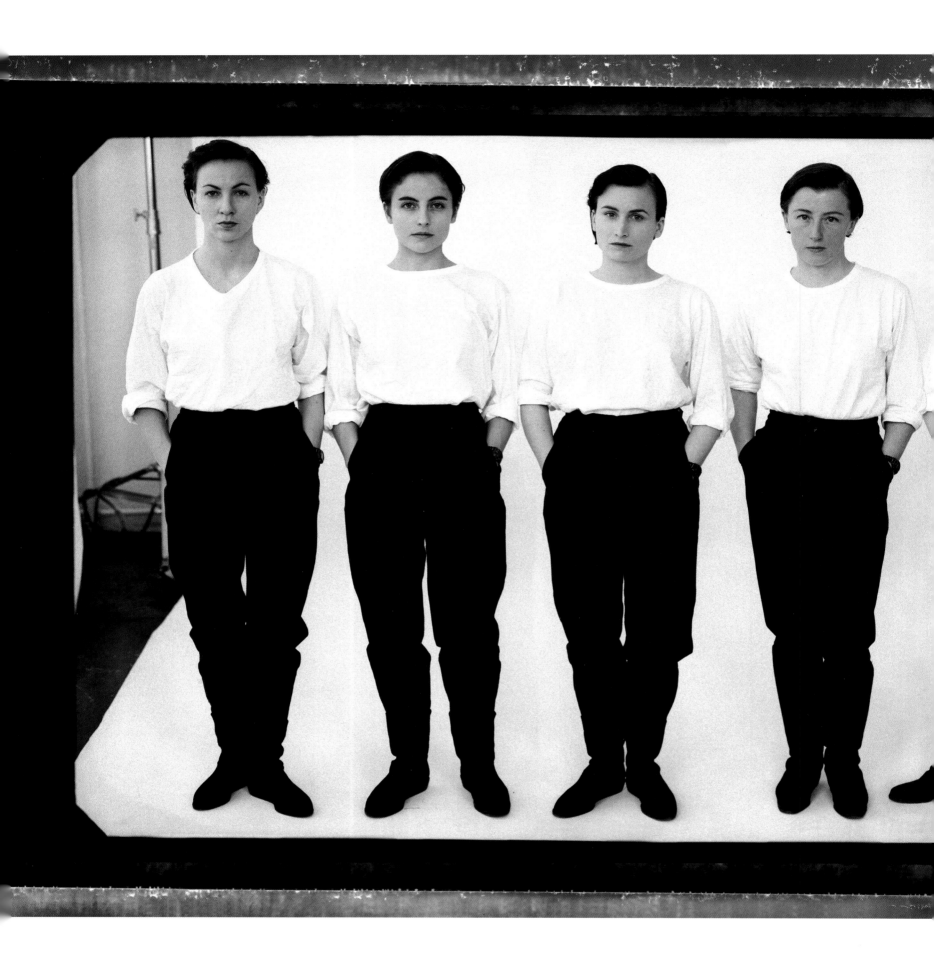

Cindy Sherman, Vandam Street studio, New York, 1992

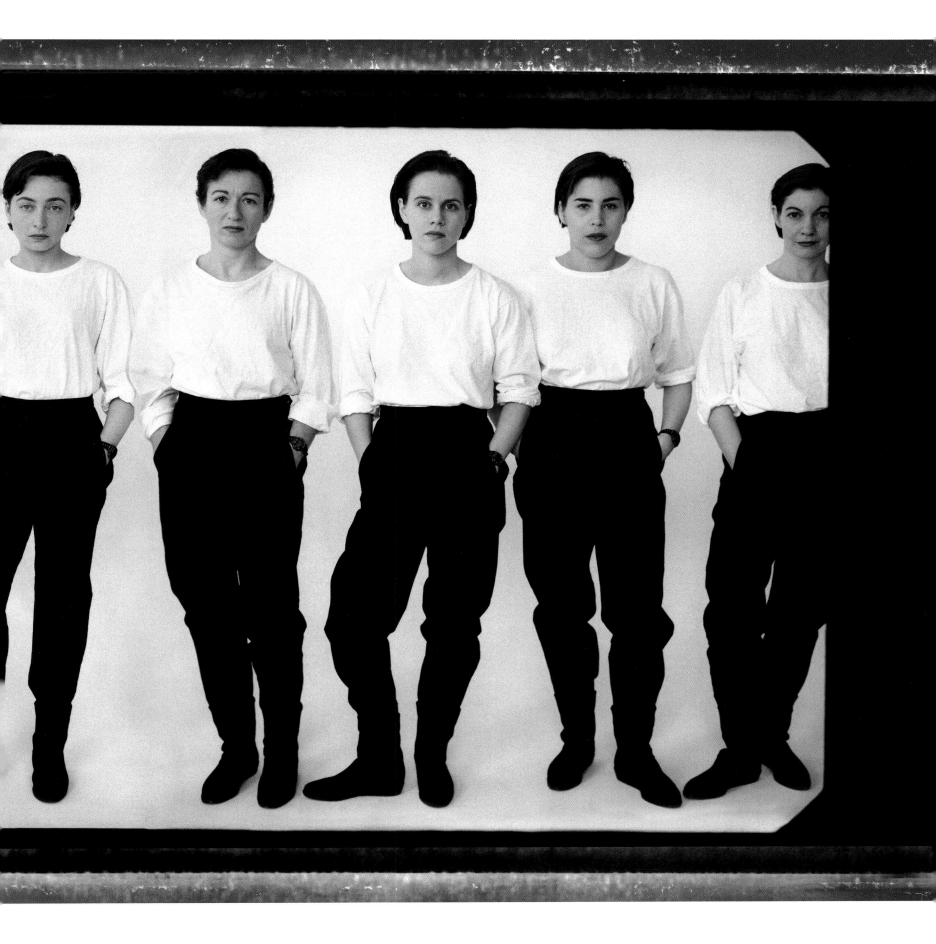

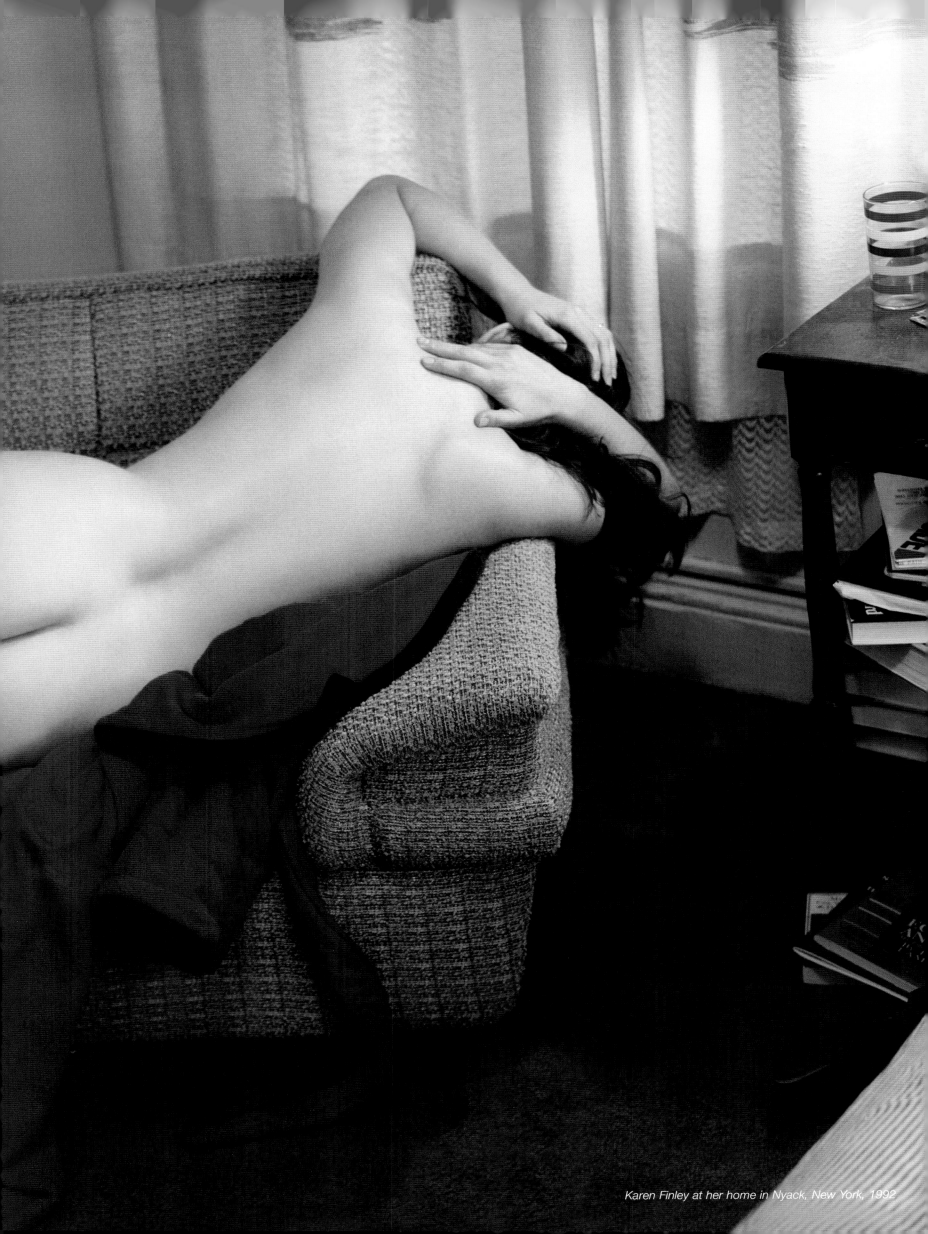

Karen Finley at her home in Nyack, New York, 1992

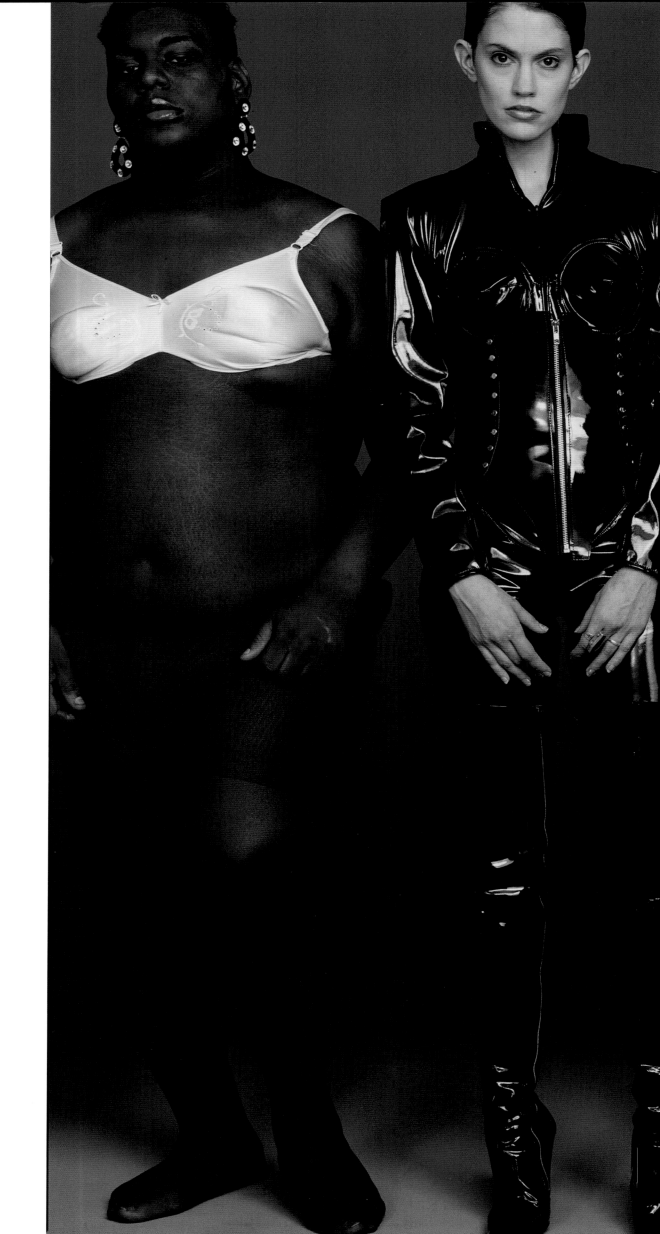

Reza Abdoh (second from right) with members of his Dar-A-Luz theater company: Dana Moppins, Juliana Francis, Tom Fitzpatrick, and Raphael Pimental, Vandam Street studio, New York, 1993

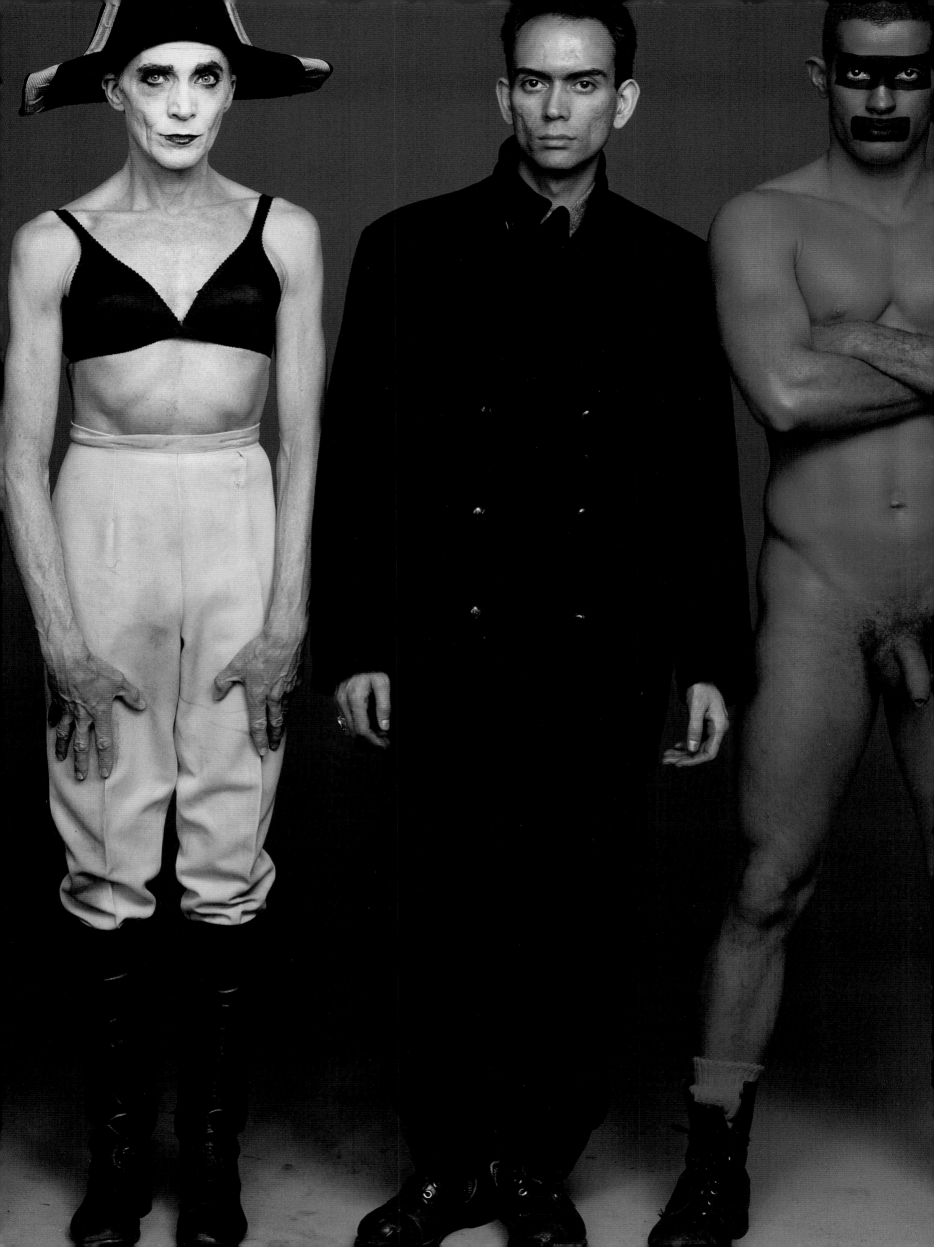

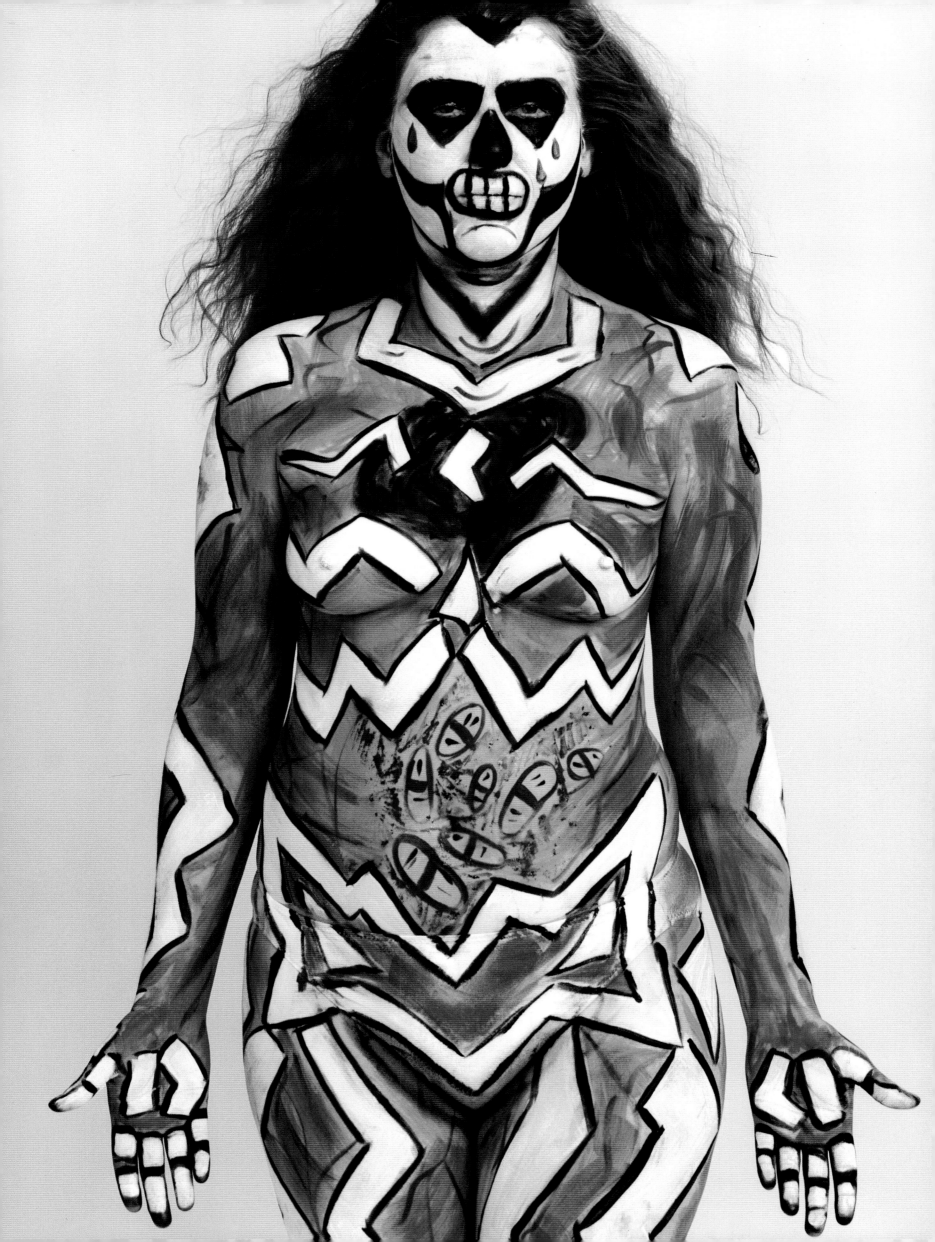

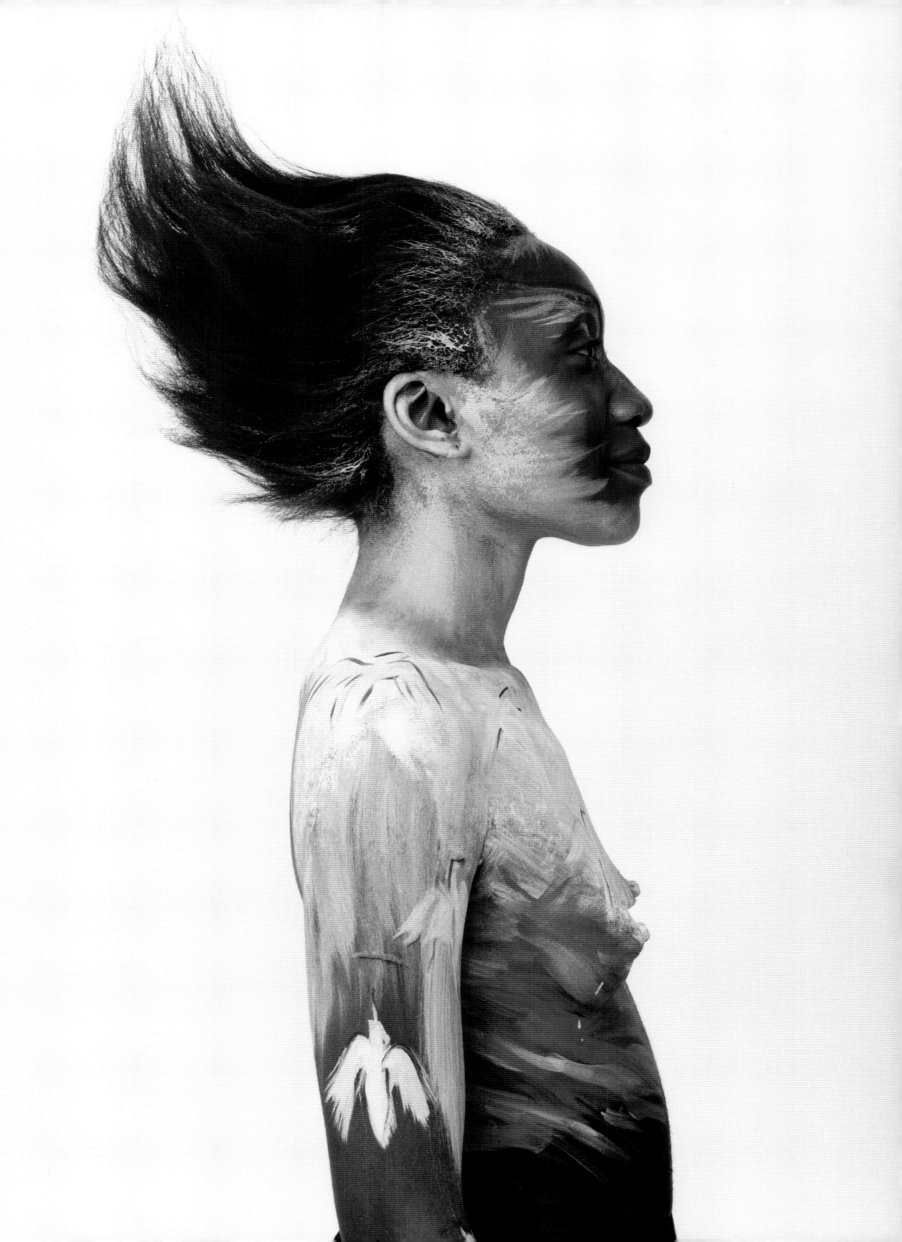

Nelson Mandela, Soweto, South Africa, 1990

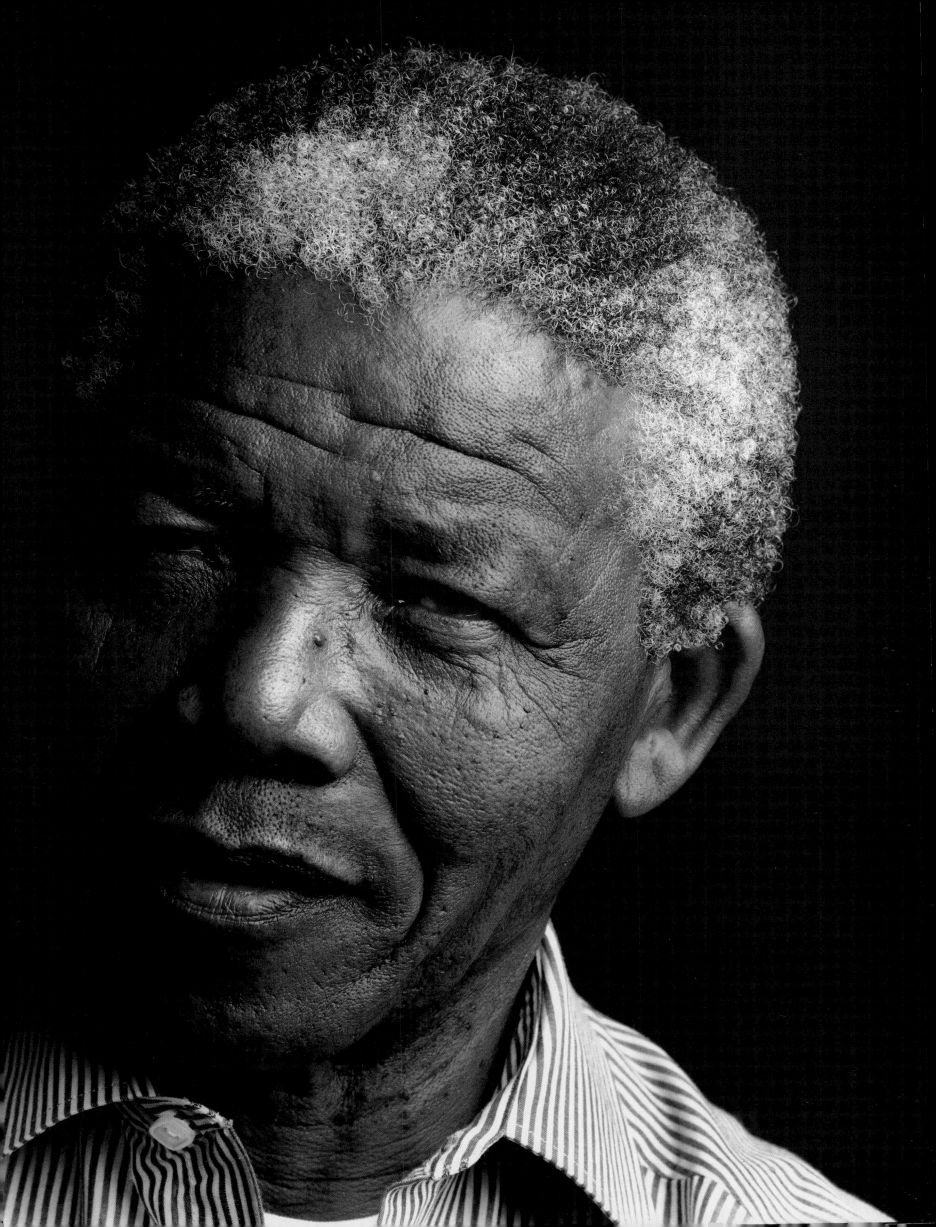

Mick Jagger, Los Angeles, 1992

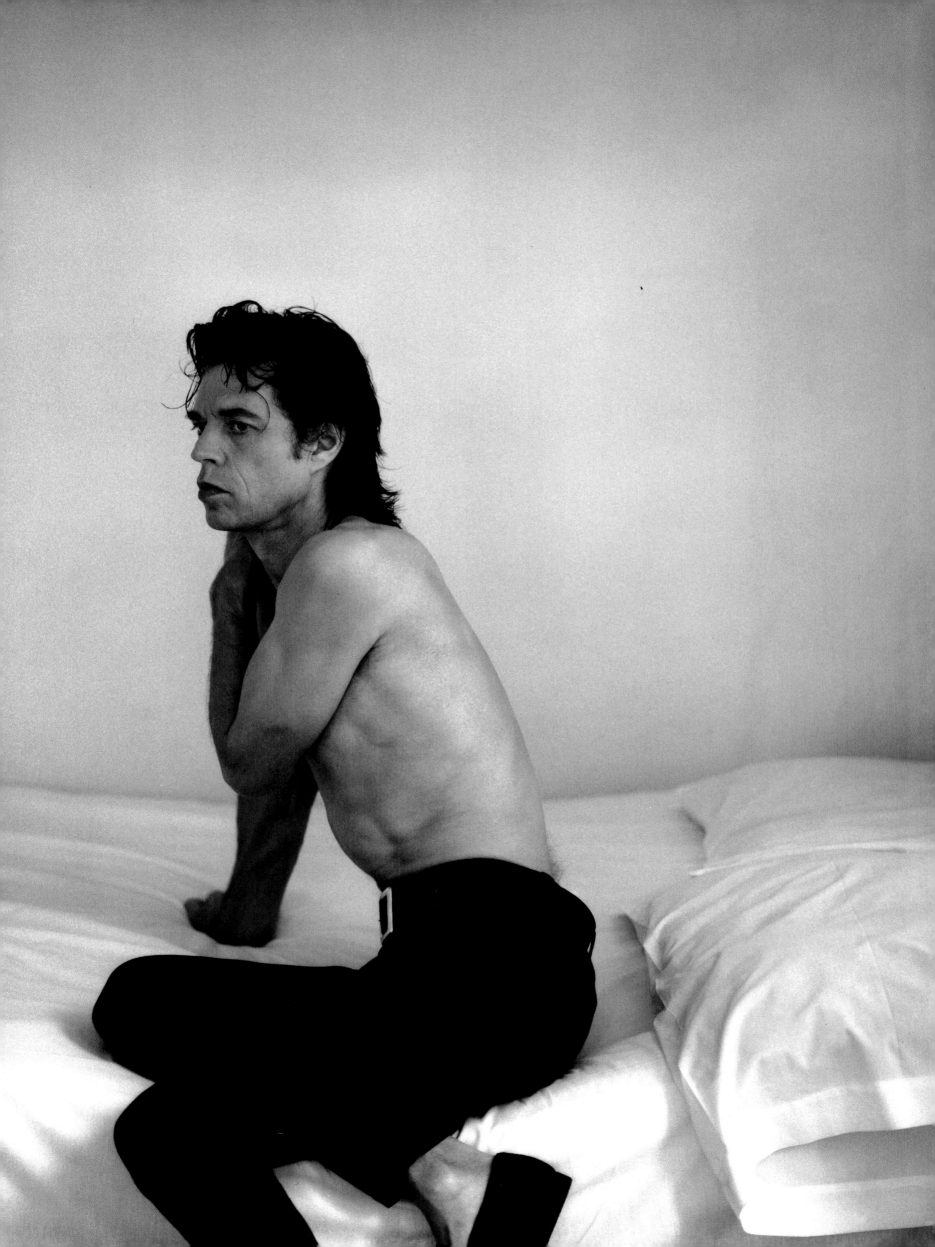

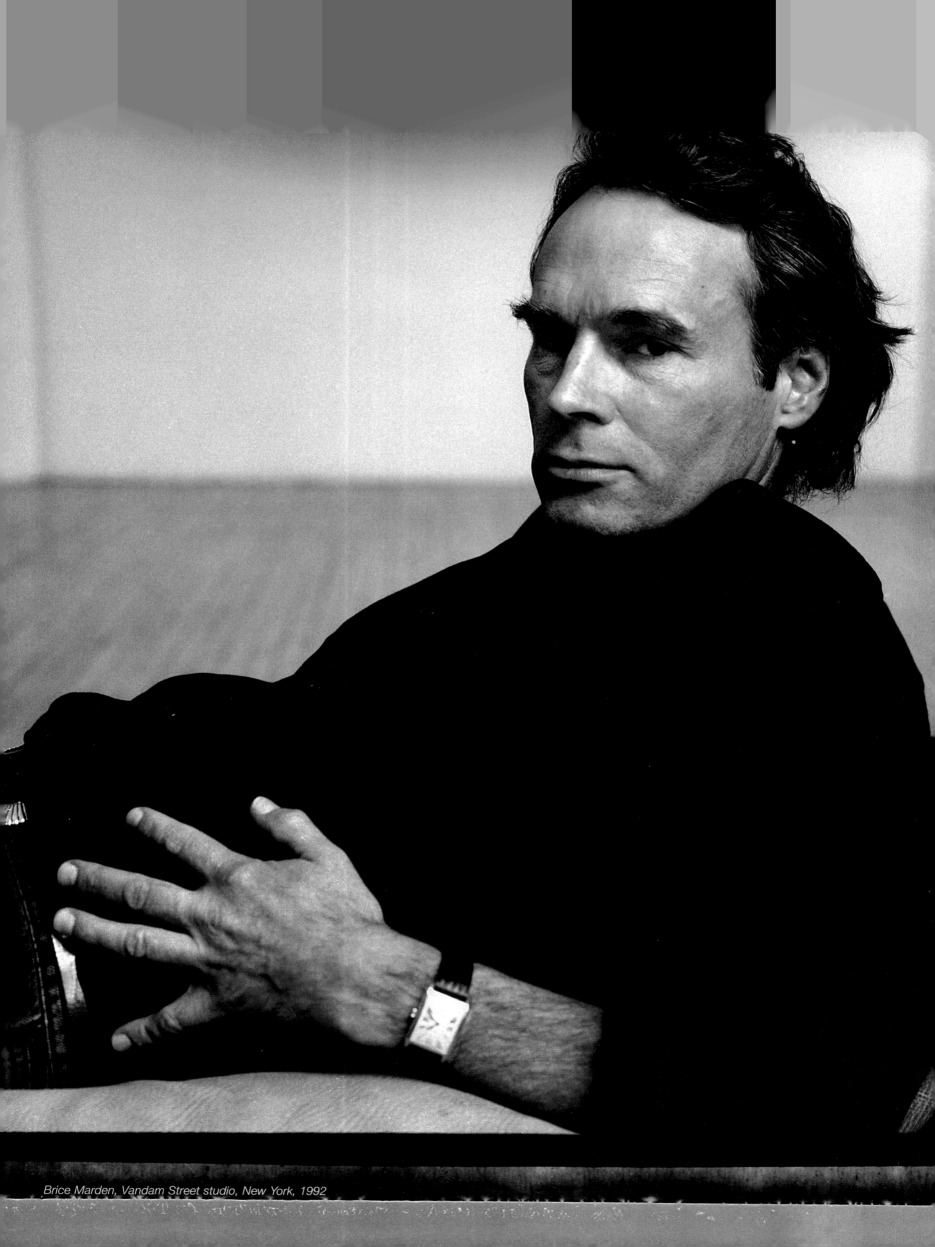

Brice Marden, Vandam Street studio, New York, 1992

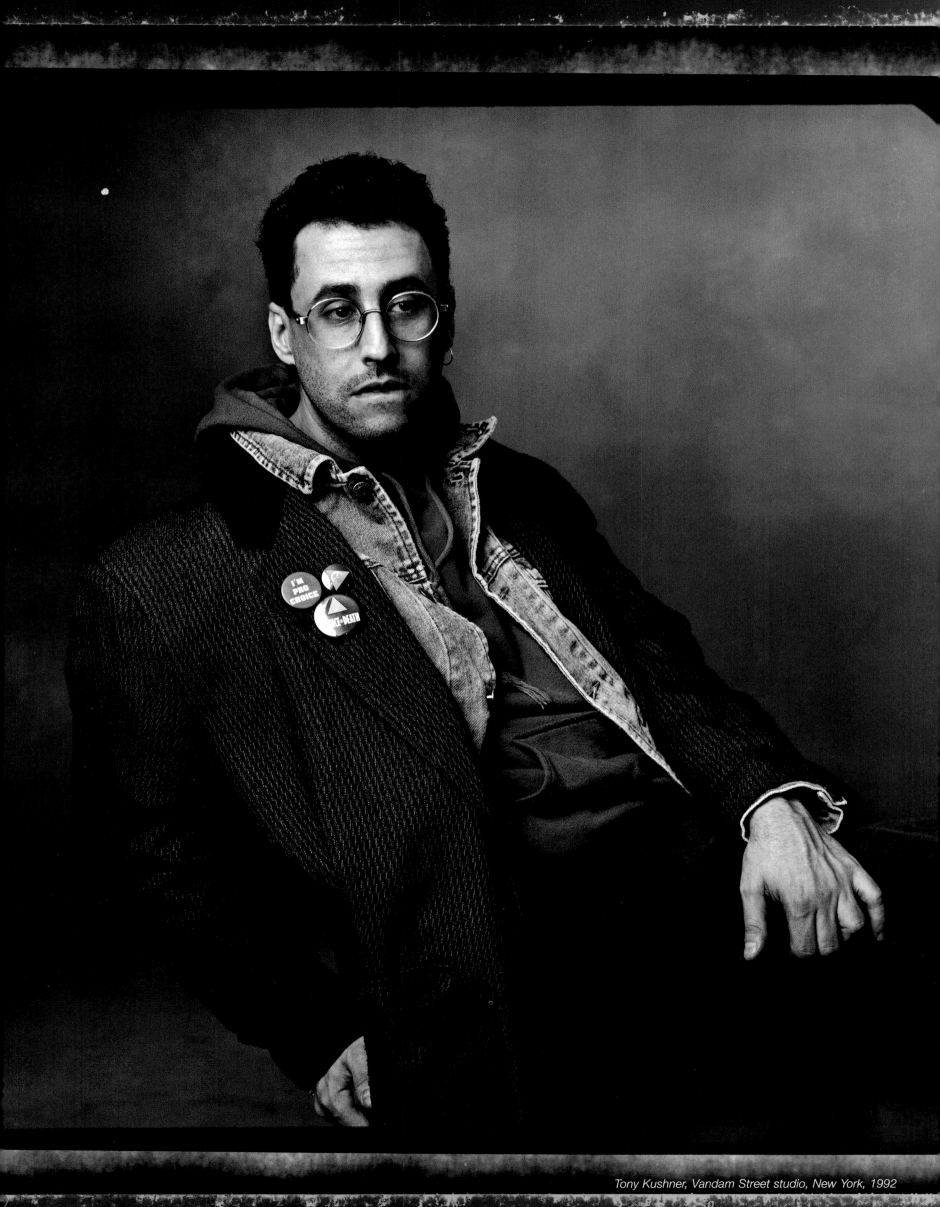

Tony Kushner, Vandam Street studio, New York, 1992

Patti Smith, Vandam Street studio, New York, 1996

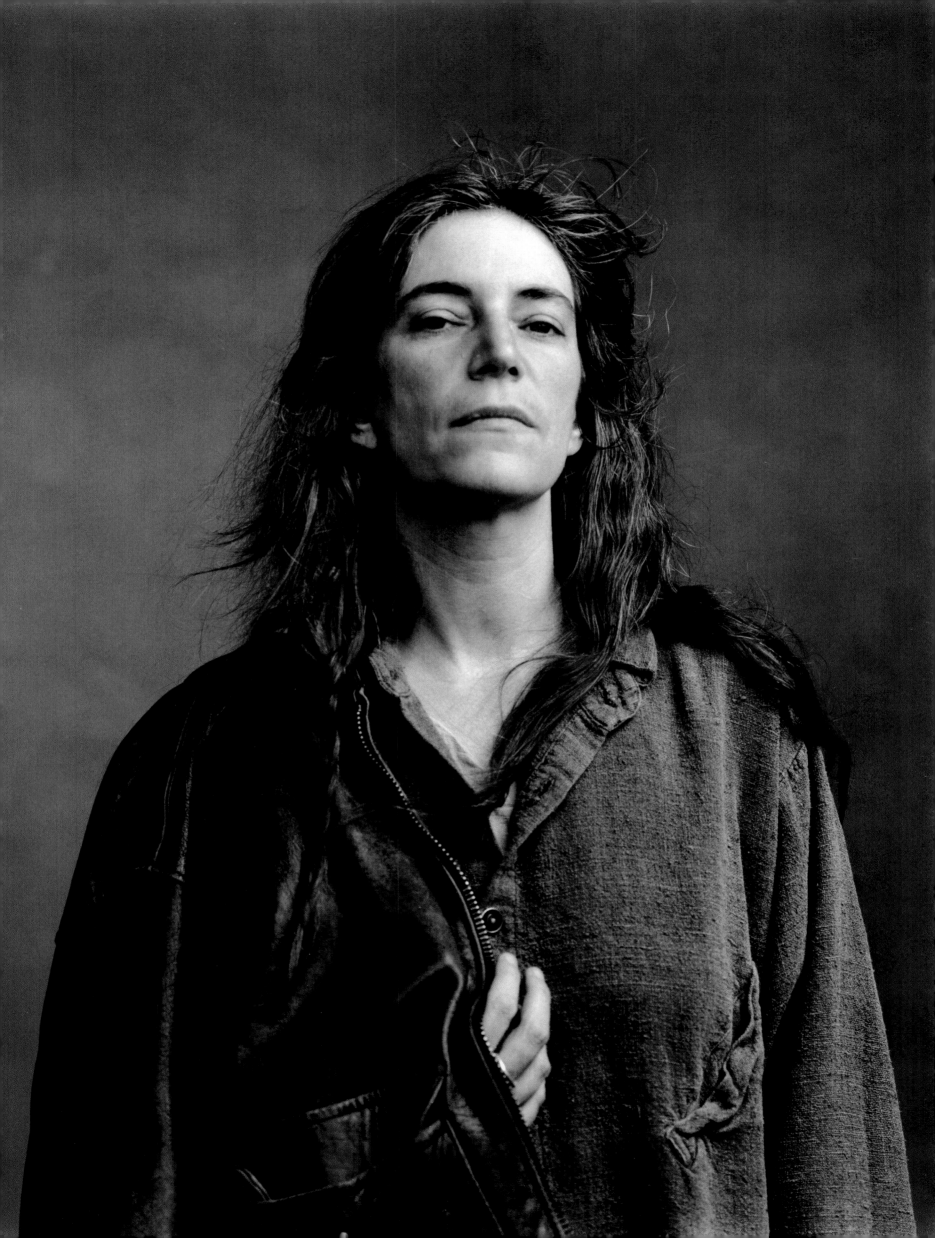

*Keith Richards in his library in
Weston, Connecticut, 1992*

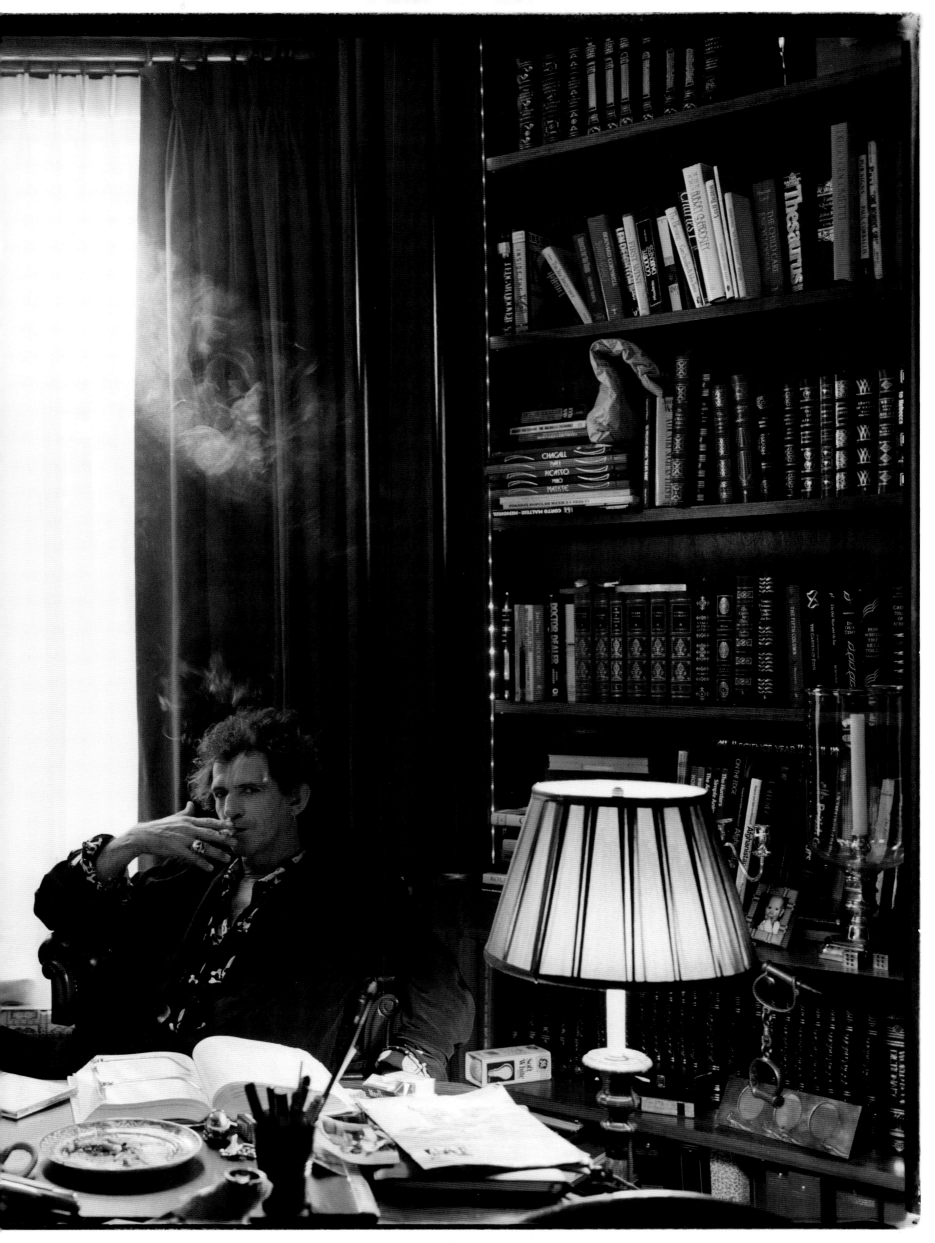

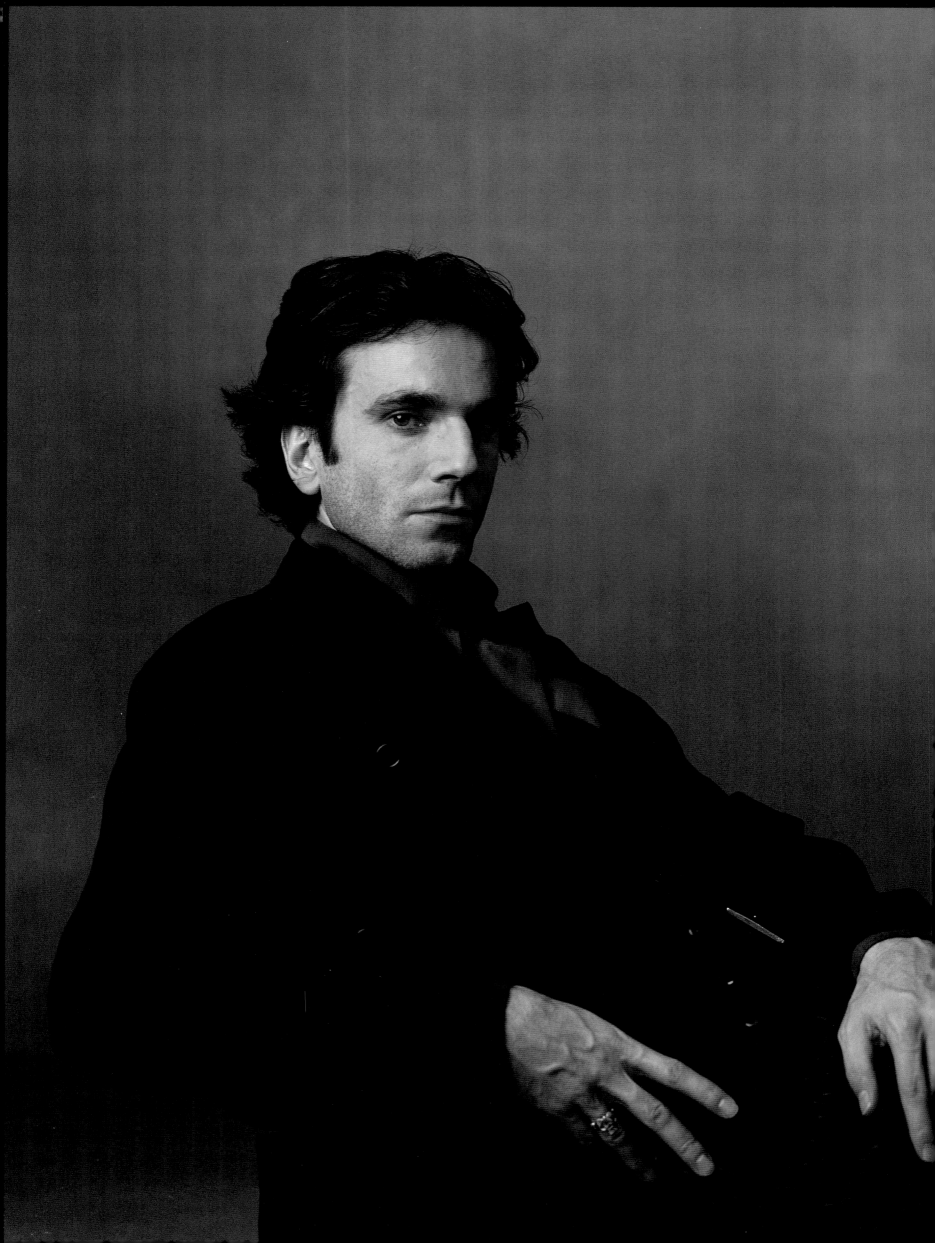

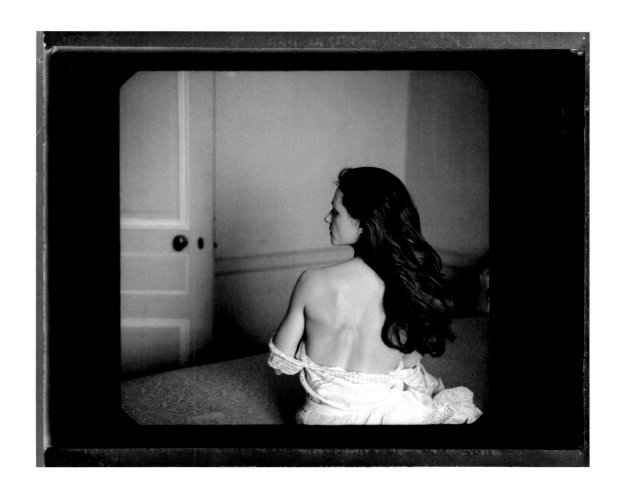

Holly Hunter, New York, 1993

Daniel Day-Lewis, Vandam Street studio, New York, 1992

Frances McDormand, Chelsea Hotel, New York, 1996

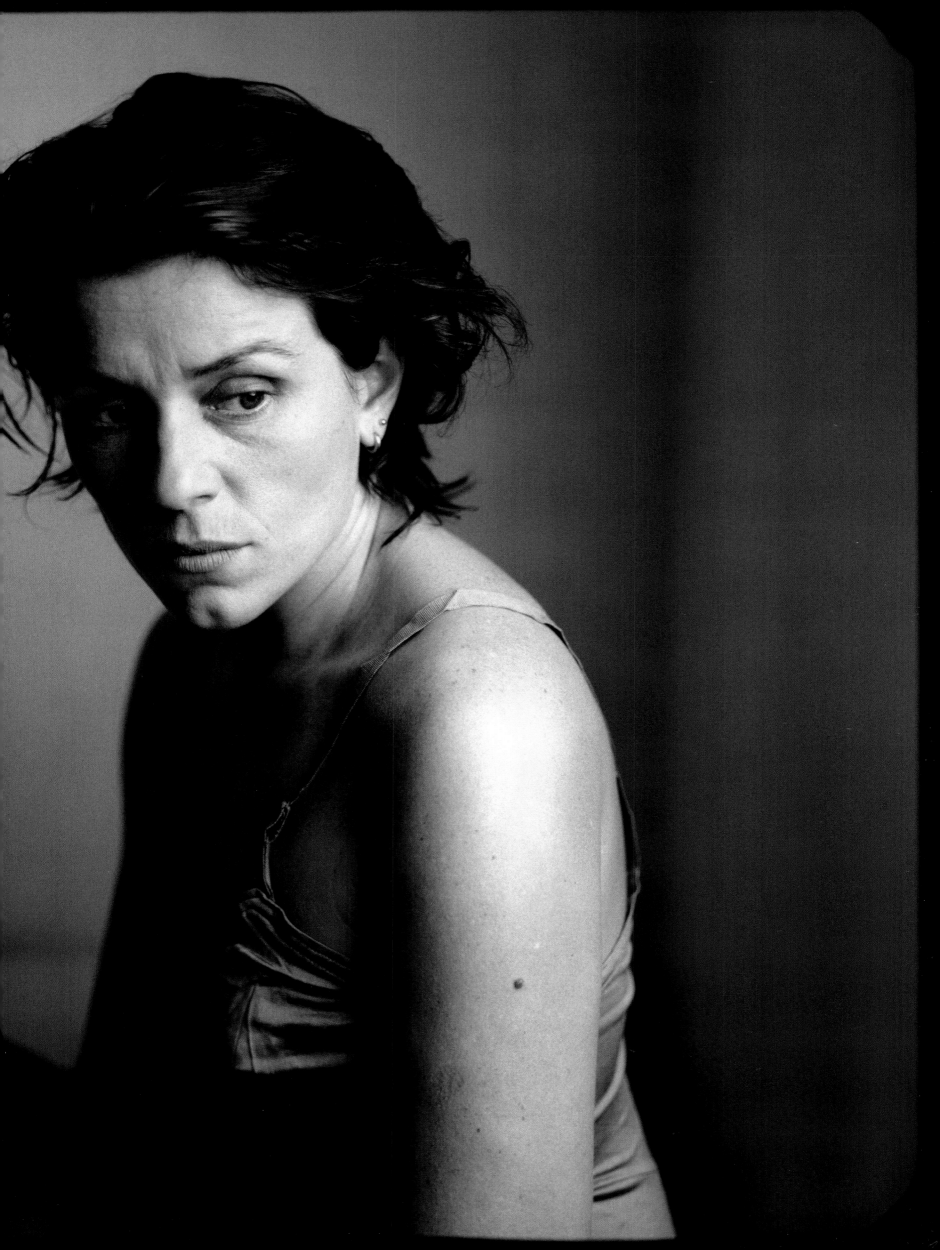

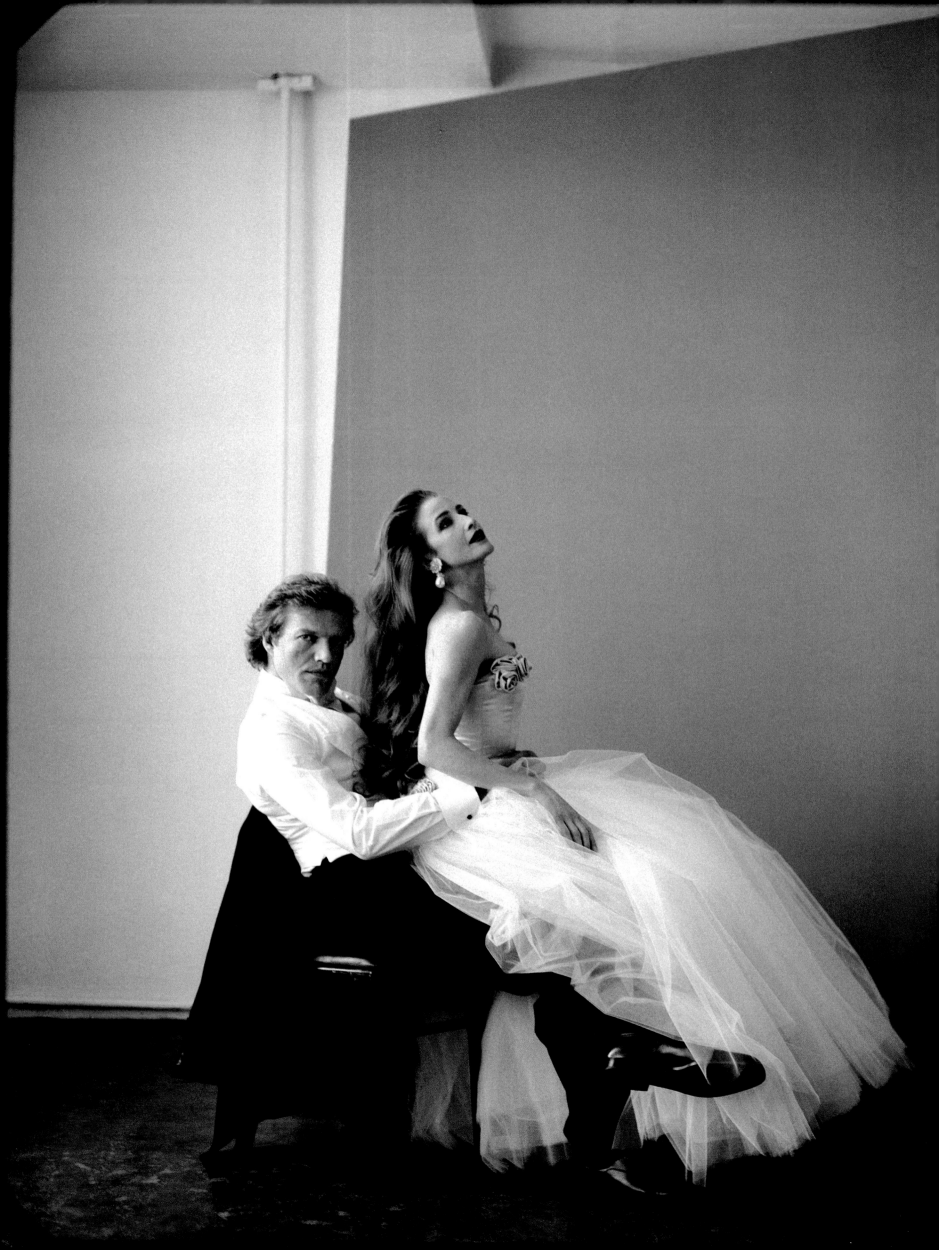

Peter Martins and Darci Kistler, Vandam Street studio, New York, 1992

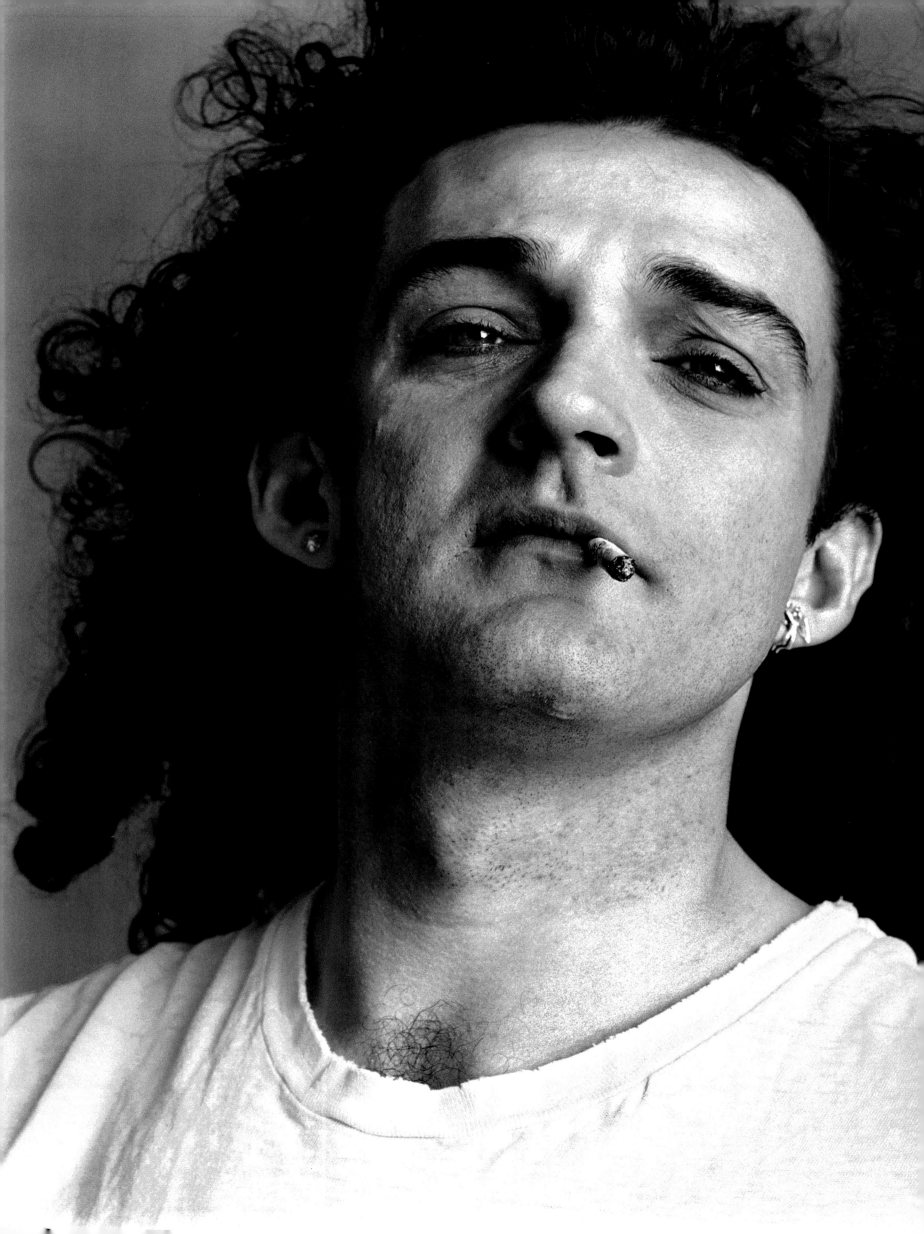

Mark Morris, New York, 1988

Mikhail Baryshnikov and Rob Besserer, Cumberland Island, Georgia, 1990

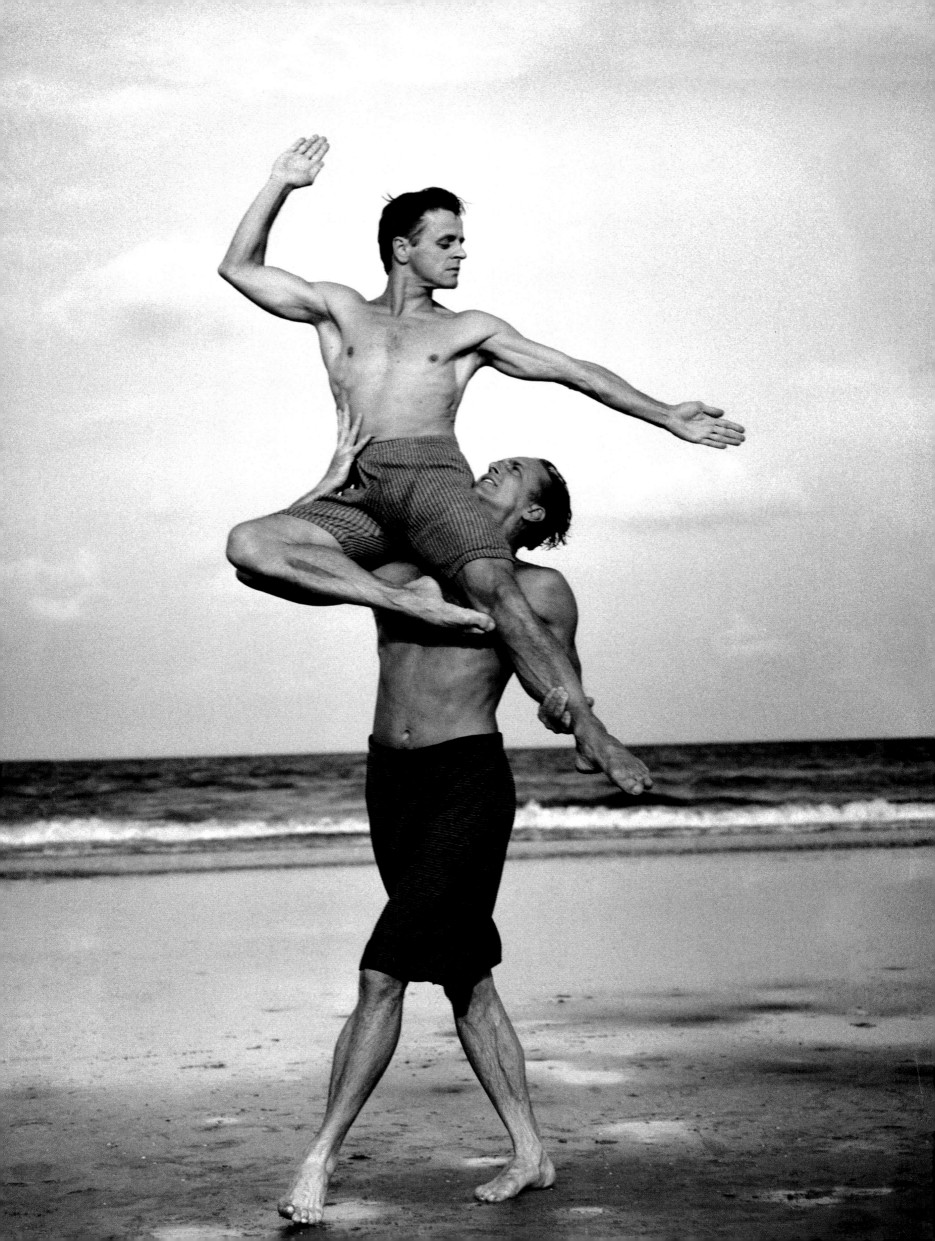

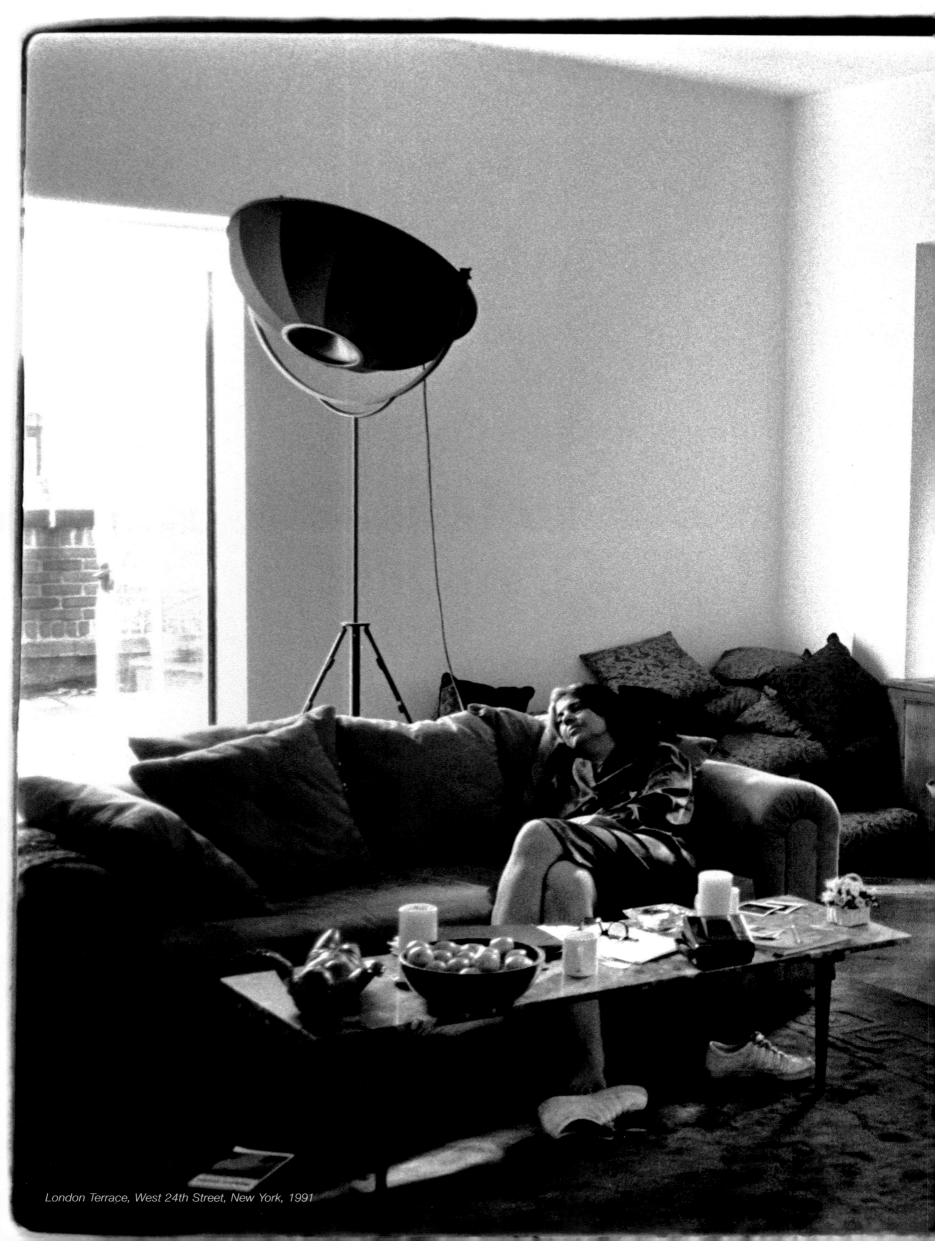

London Terrace, West 24th Street, New York, 1991

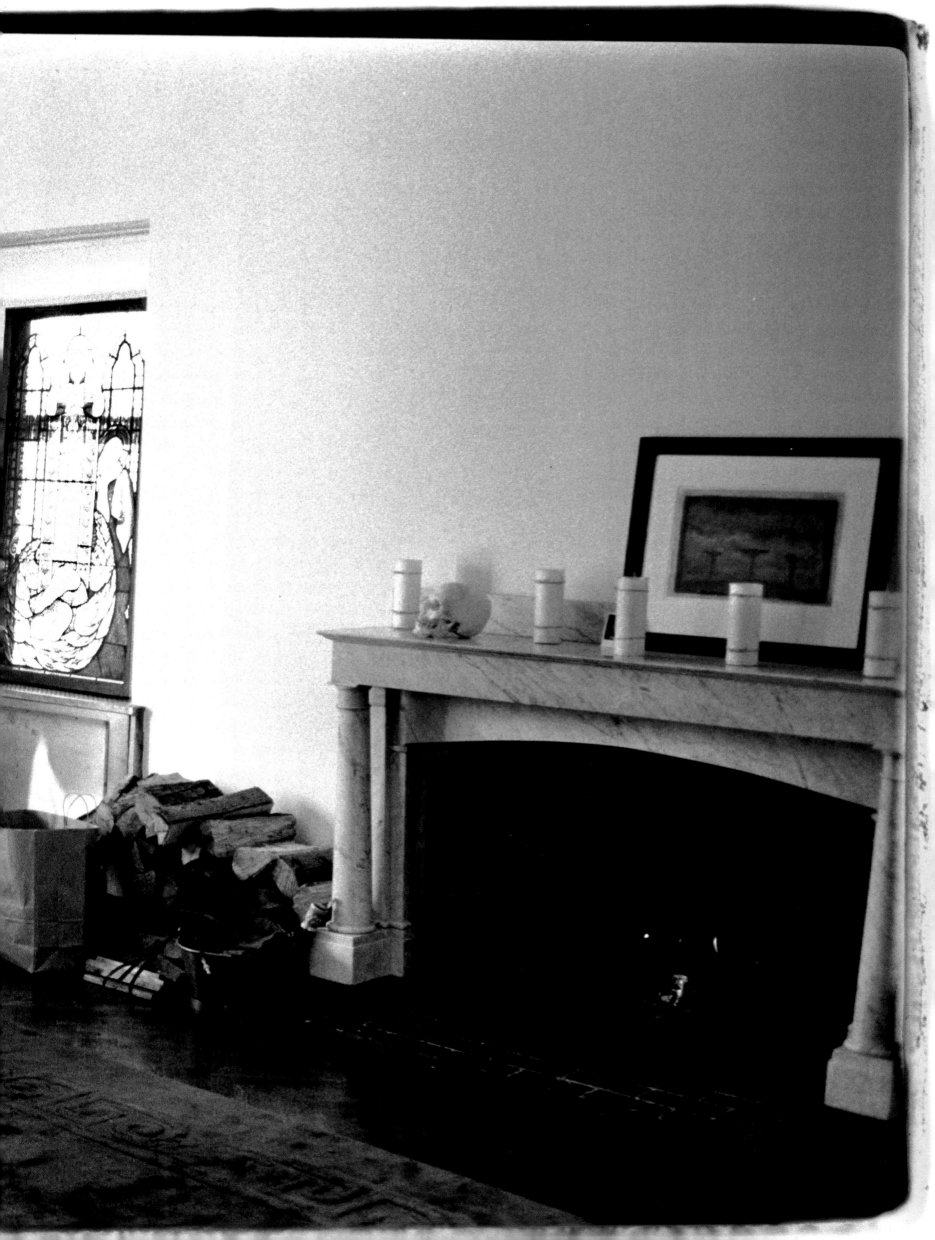

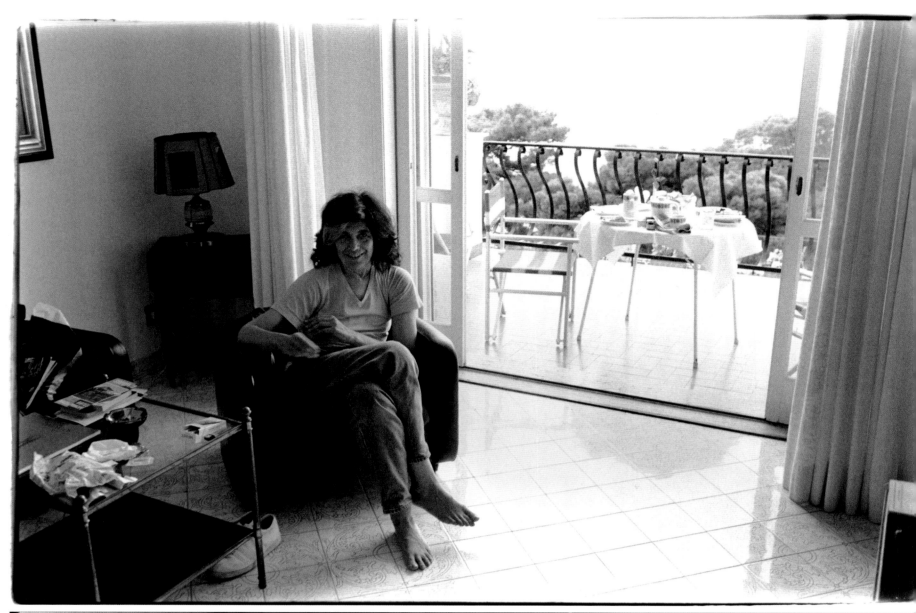

Grand Hotel Quisisana, Capri, 1992

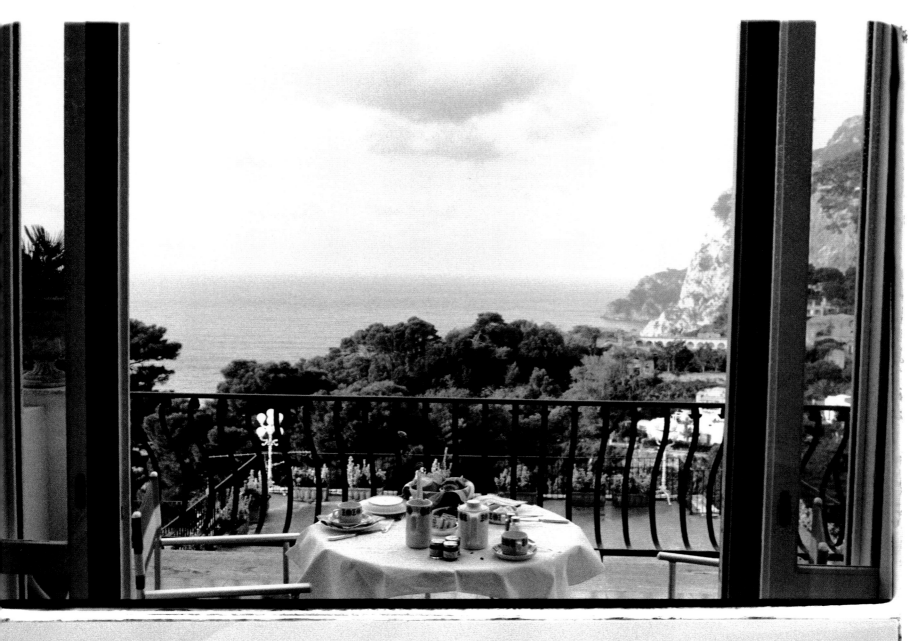
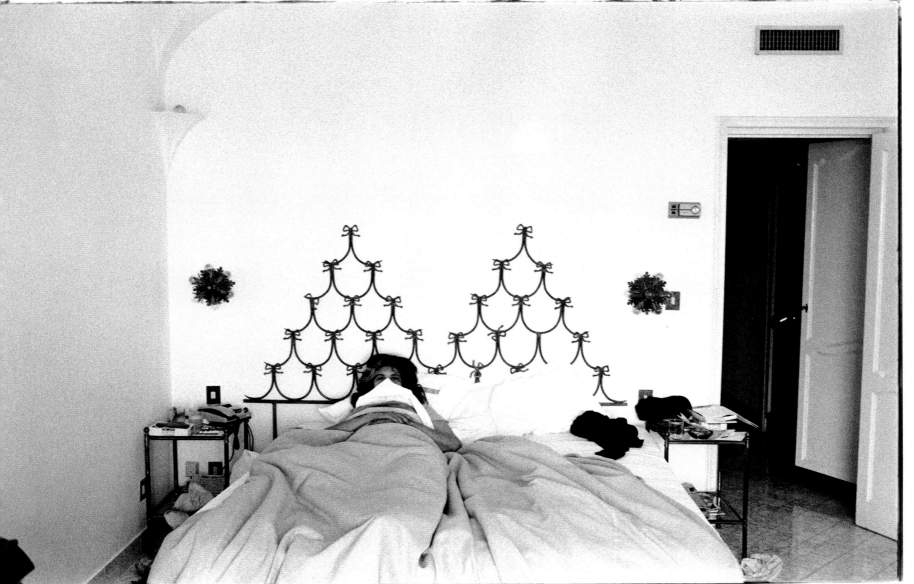

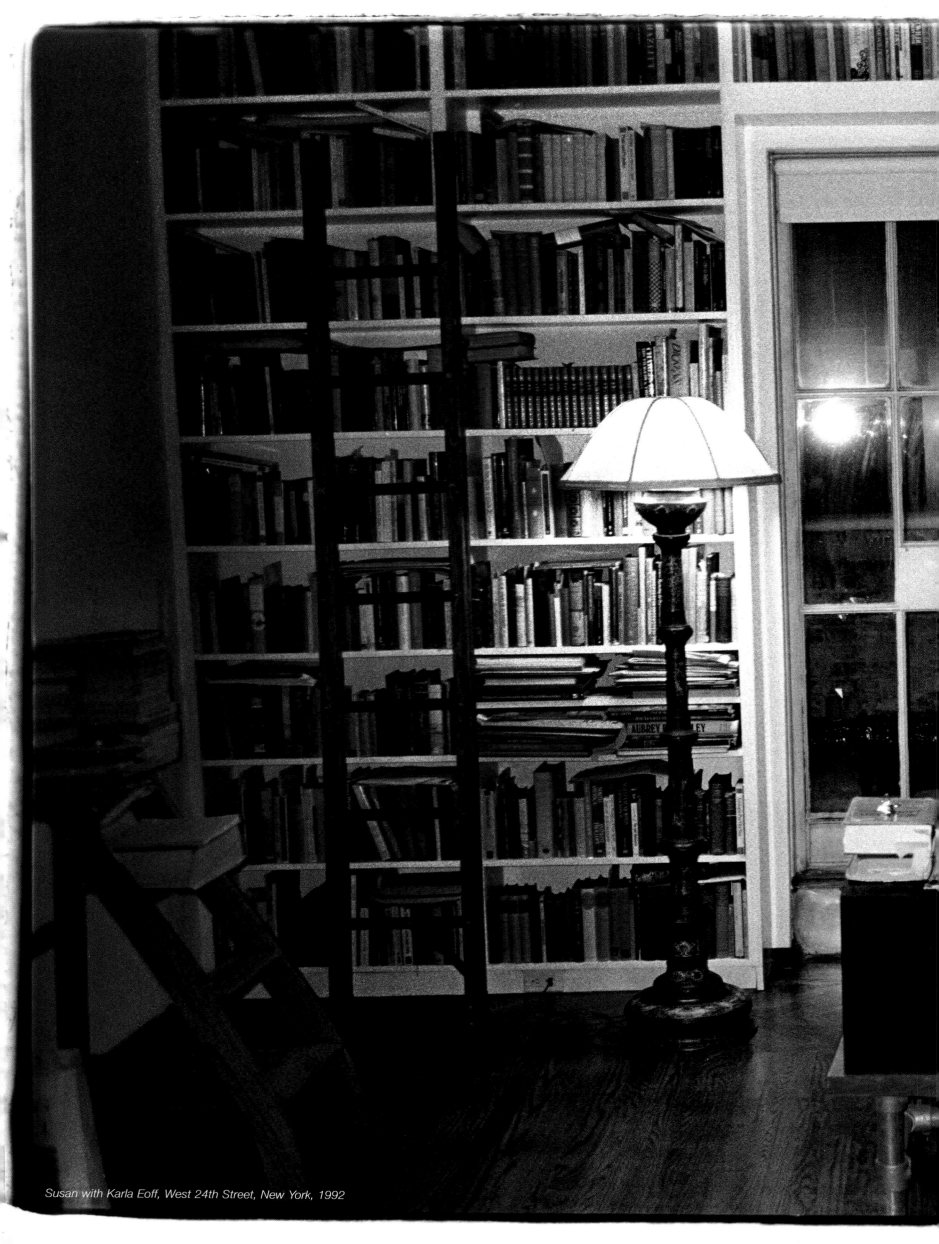

Susan with Karla Eoff, West 24th Street, New York, 1992

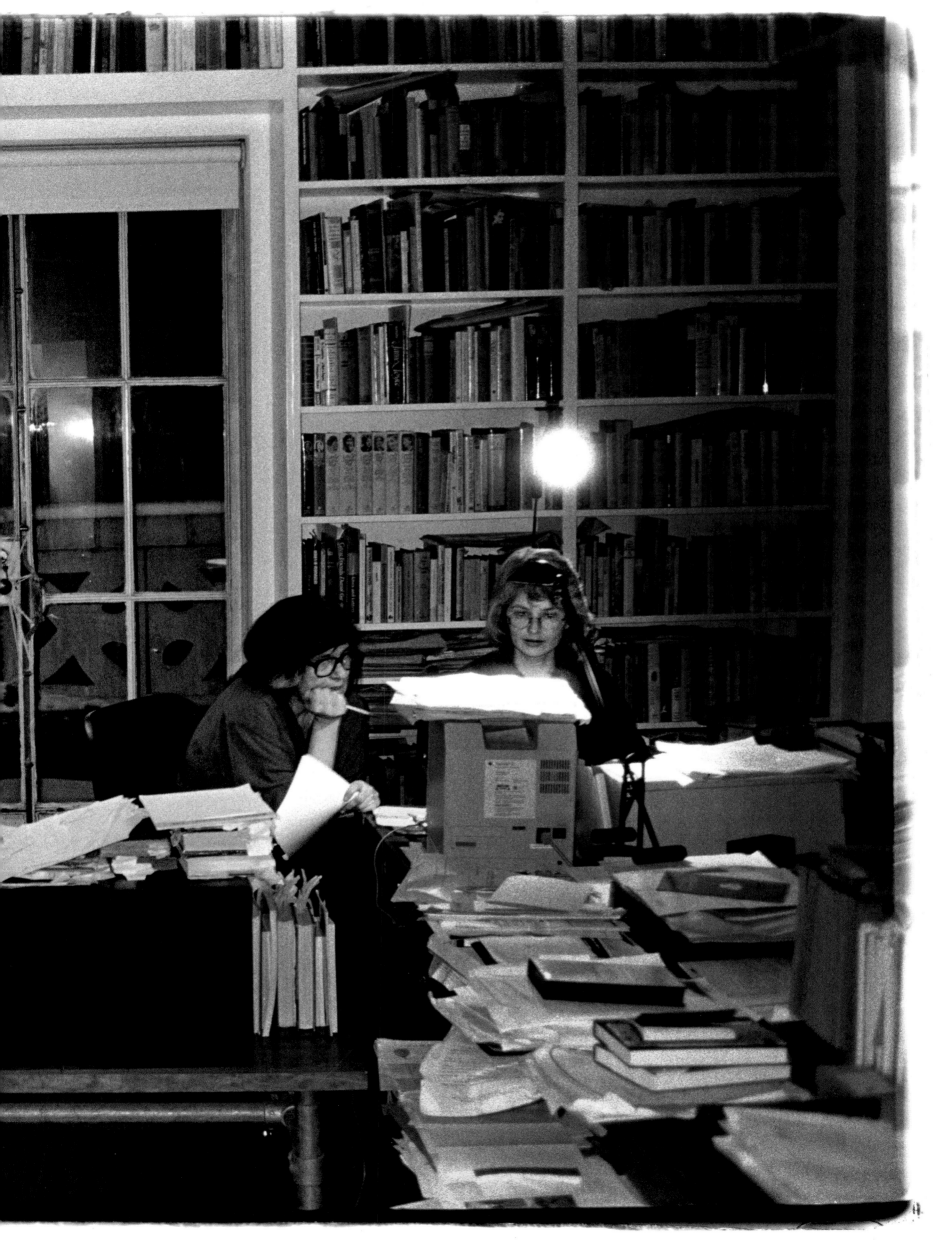

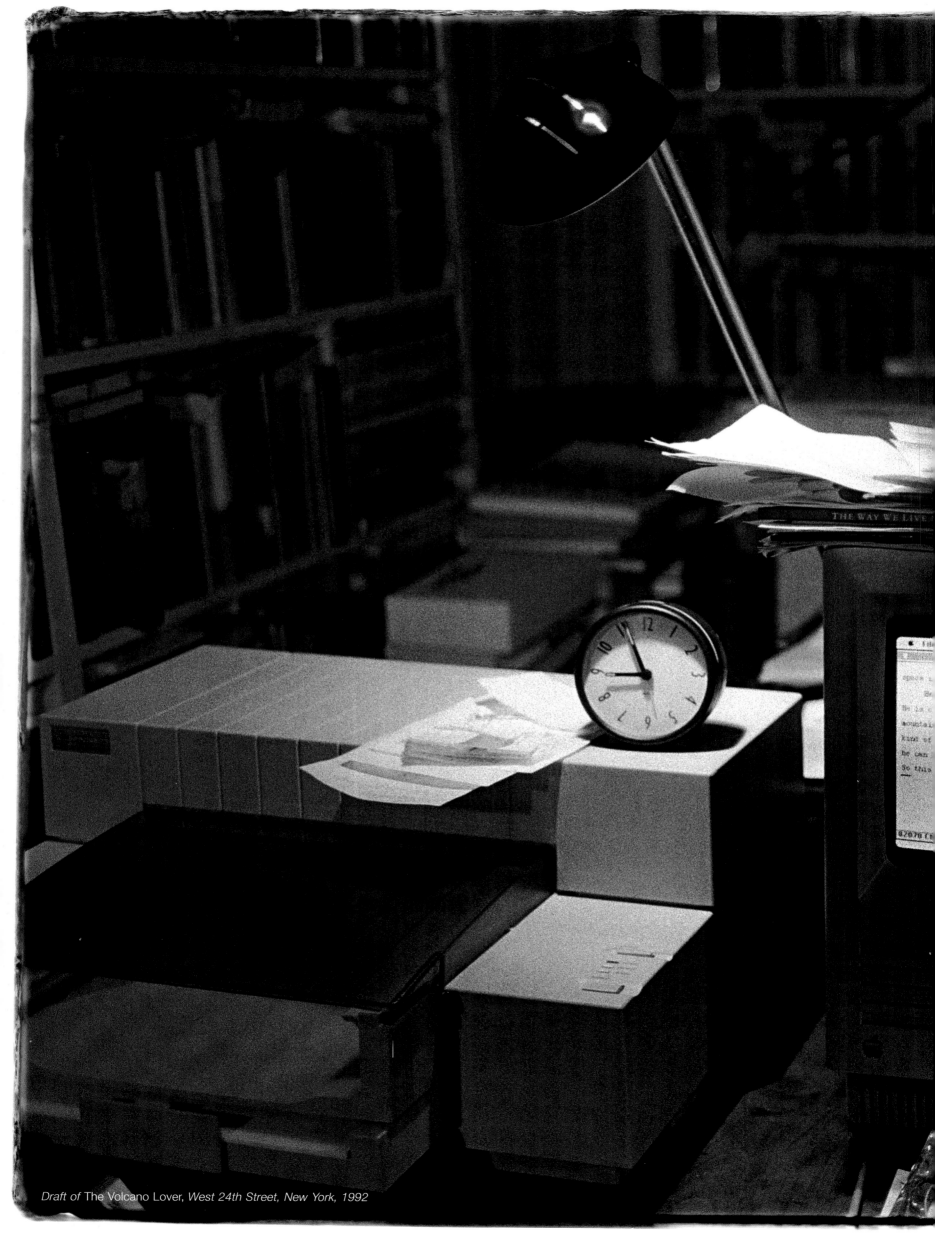

Draft of The Volcano Lover, *West 24th Street, New York, 1992*

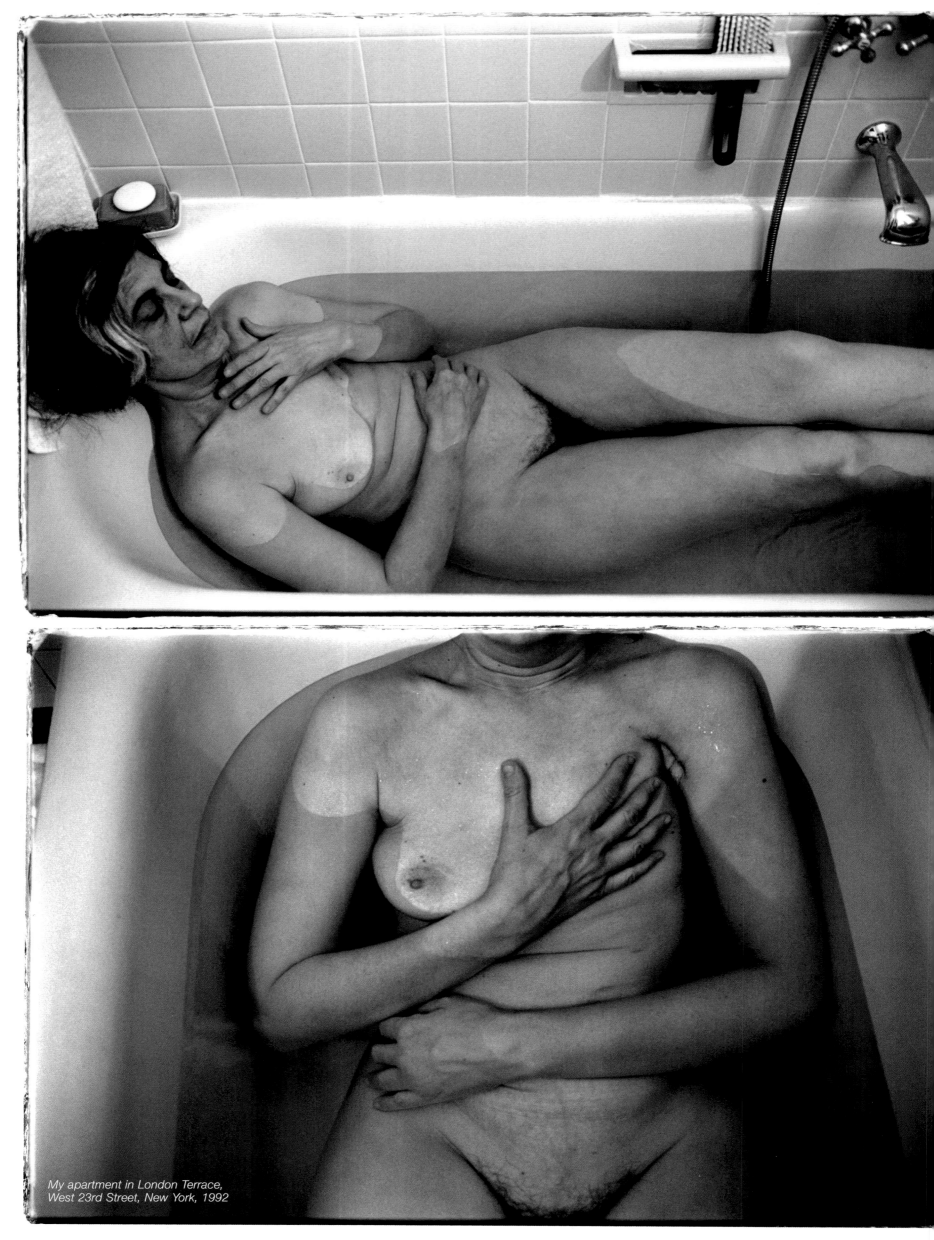

My apartment in London Terrace,
West 23rd Street, New York, 1992

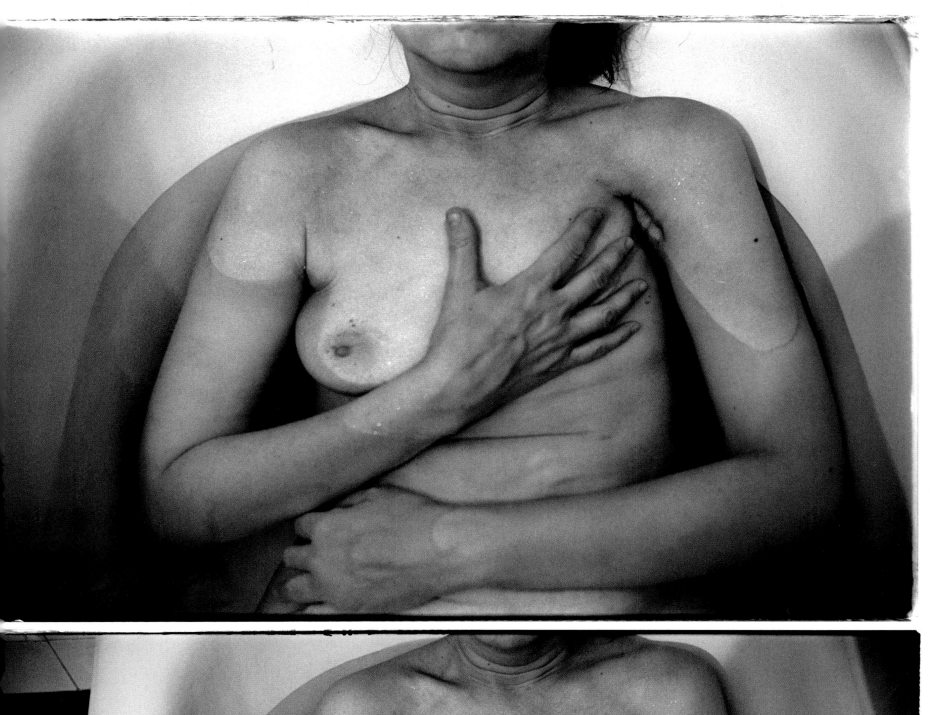
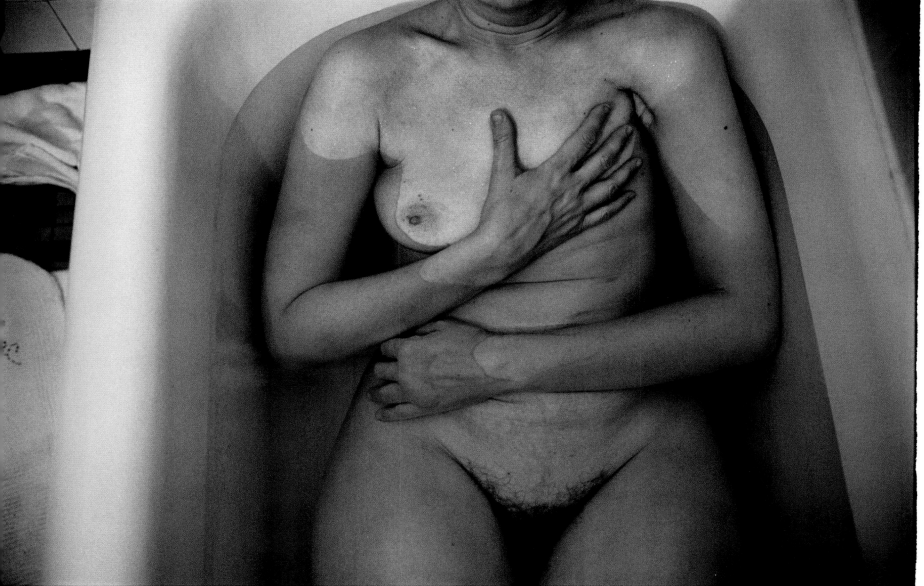

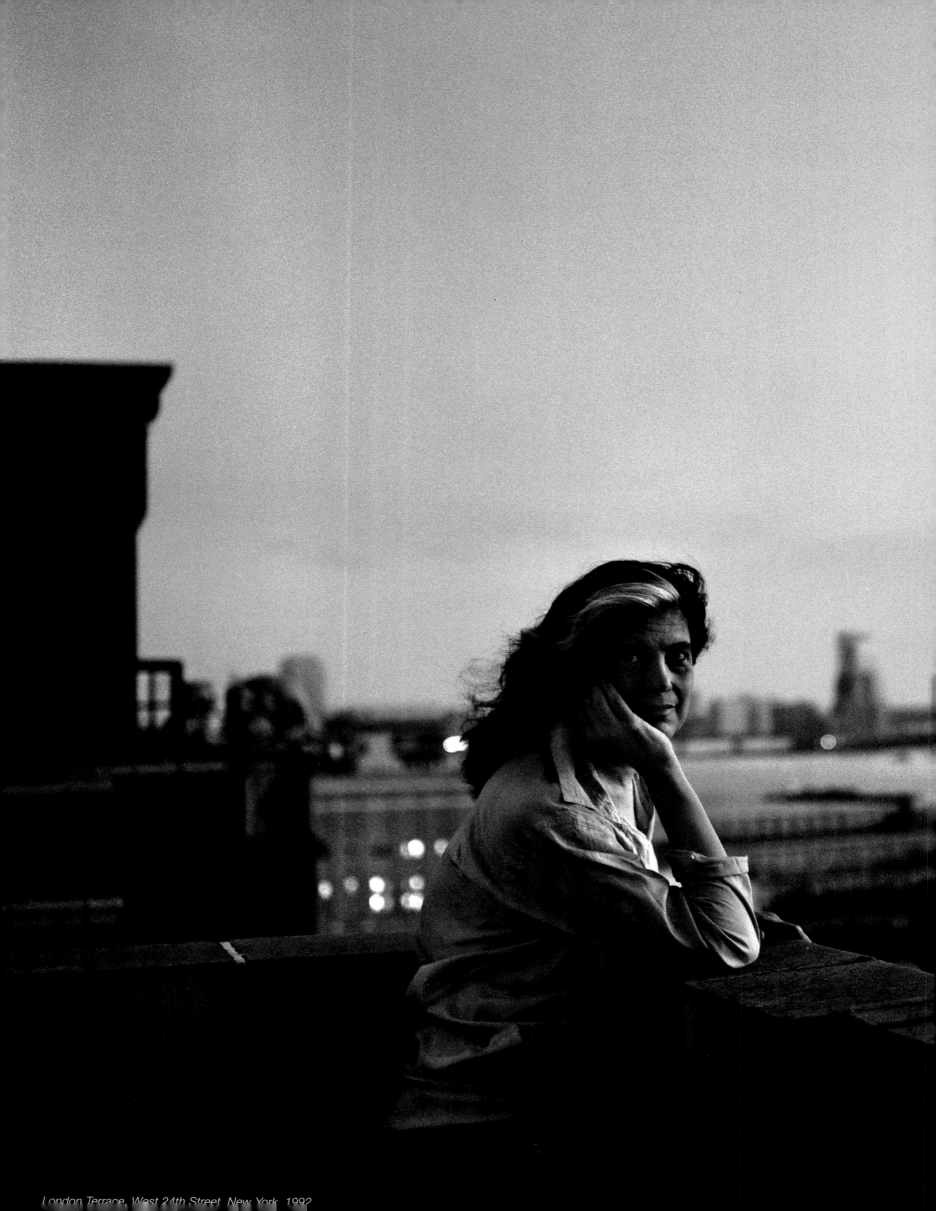

London Terrace, West 24th Street, New York, 1992

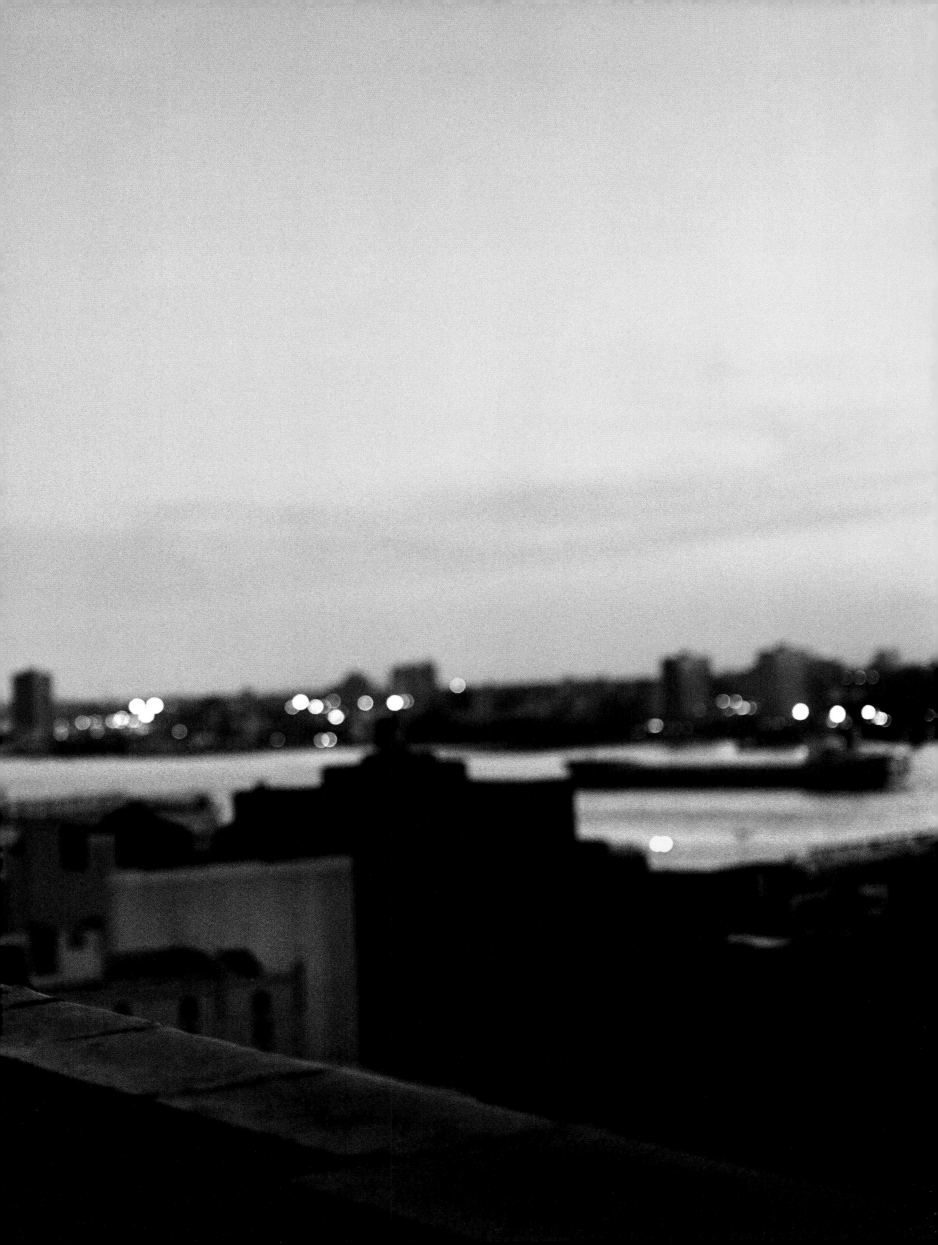

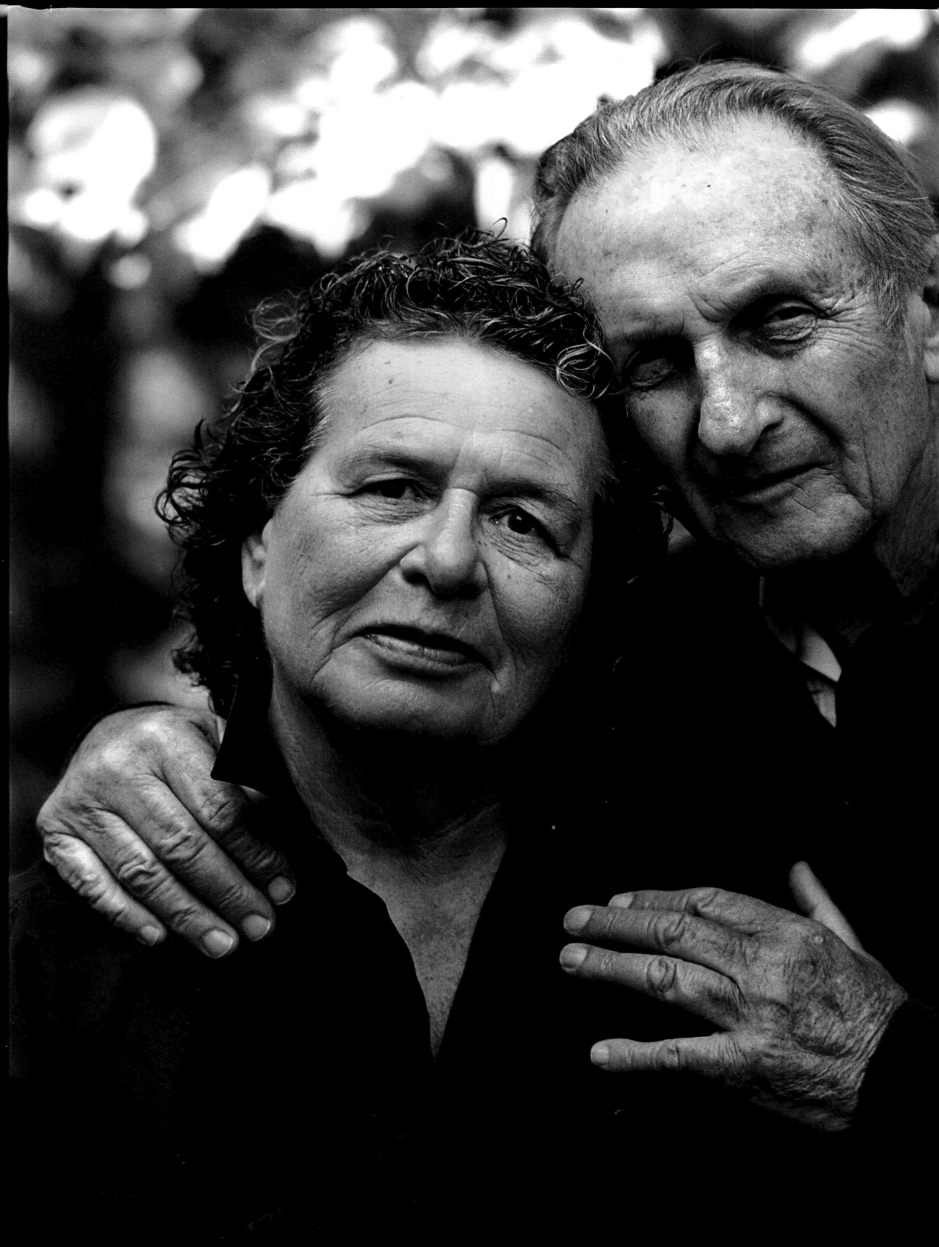

My parents on their
fiftieth wedding anniversary,
Silver Spring, Maryland, October 19, 1992

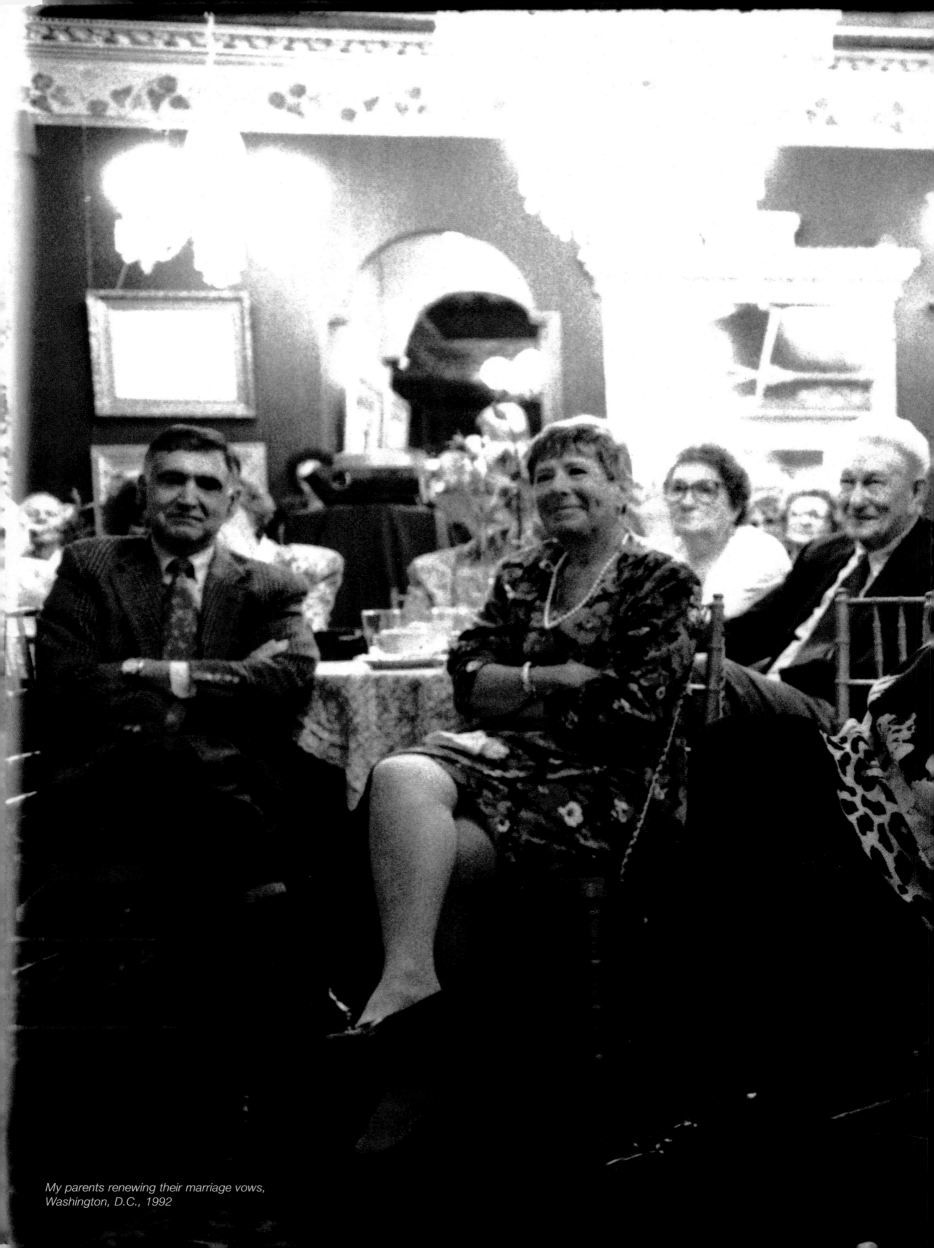

My parents renewing their marriage vows,
Washington, D.C., 1992

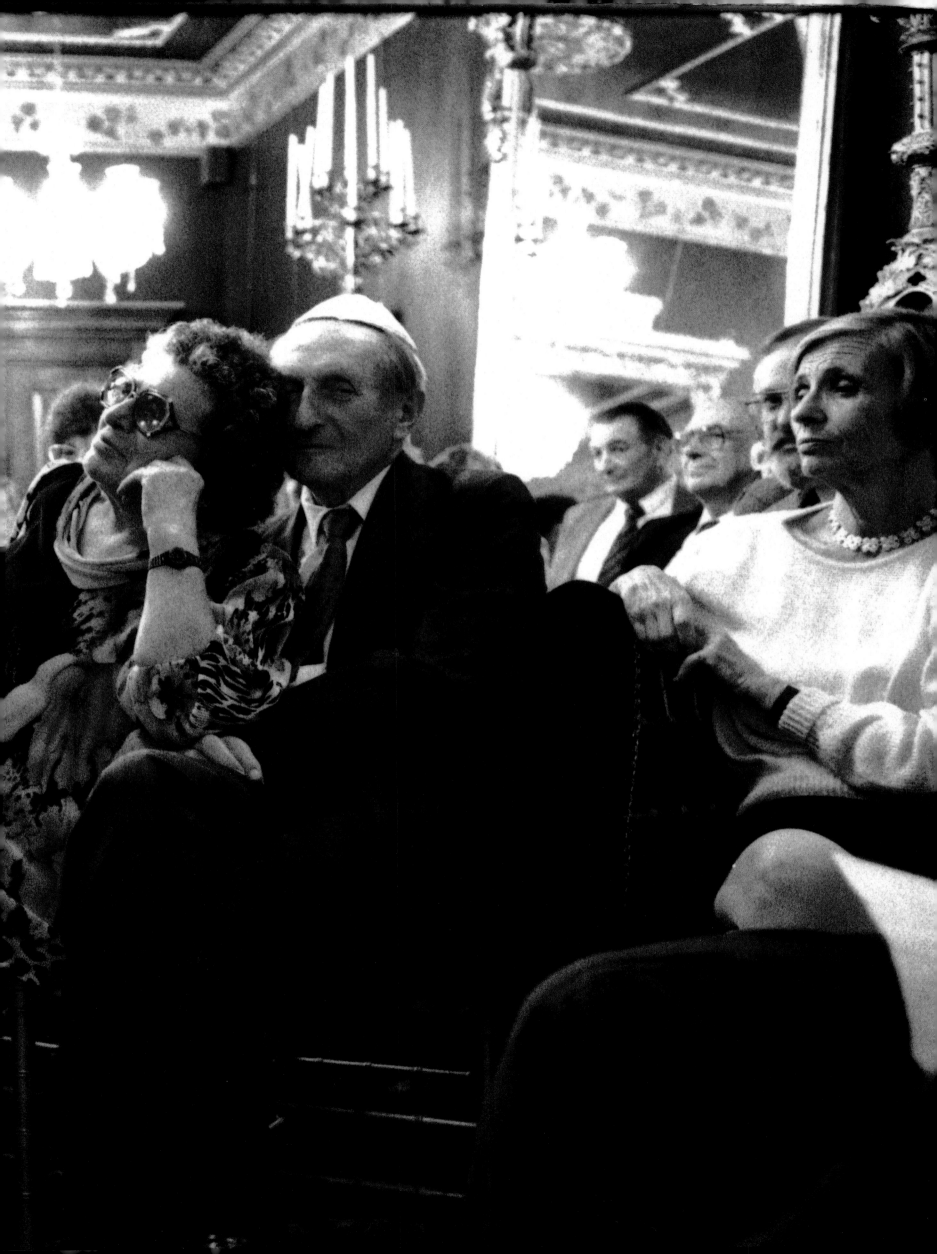

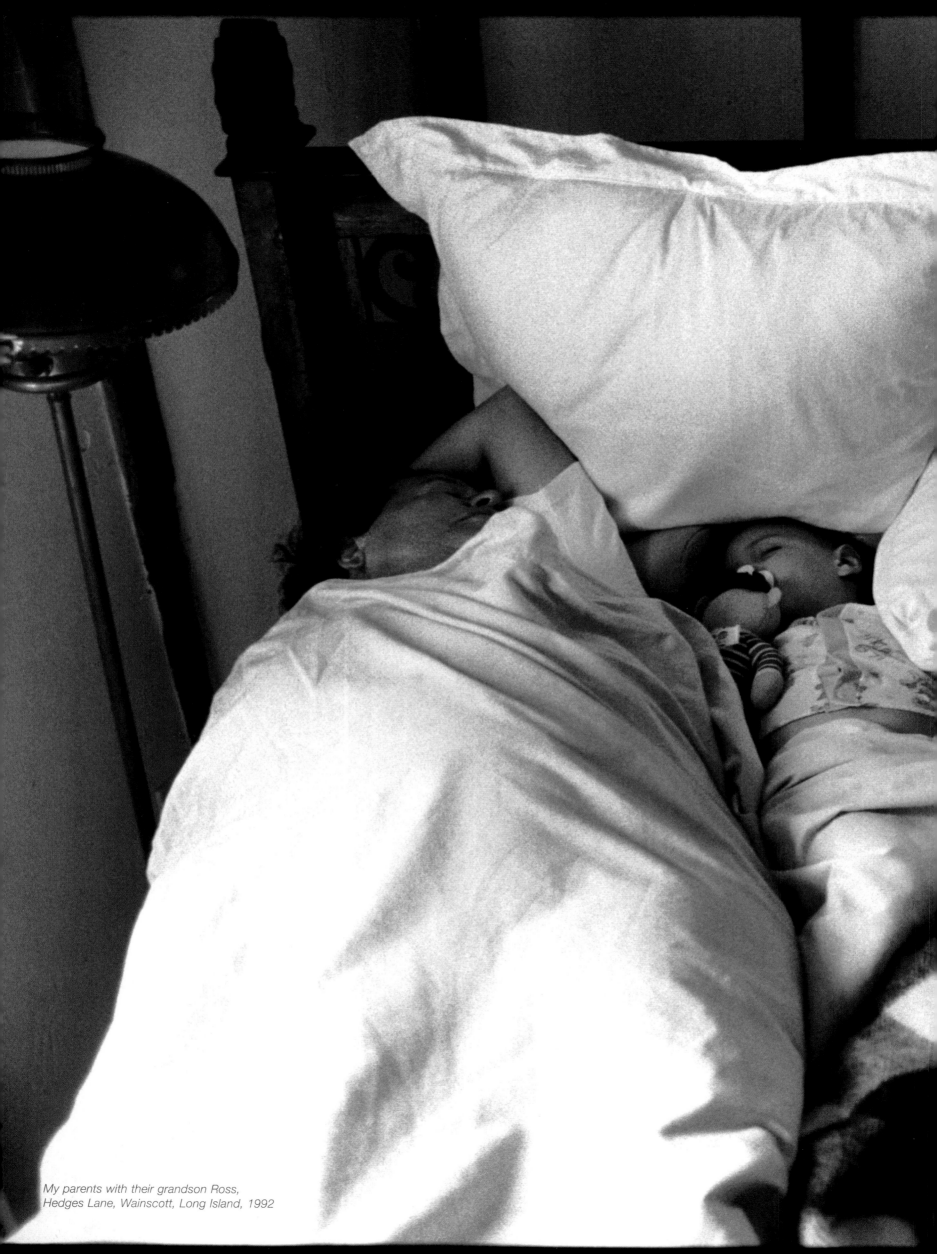

My parents with their grandson Ross,
Hedges Lane, Wainscott, Long Island, 1992

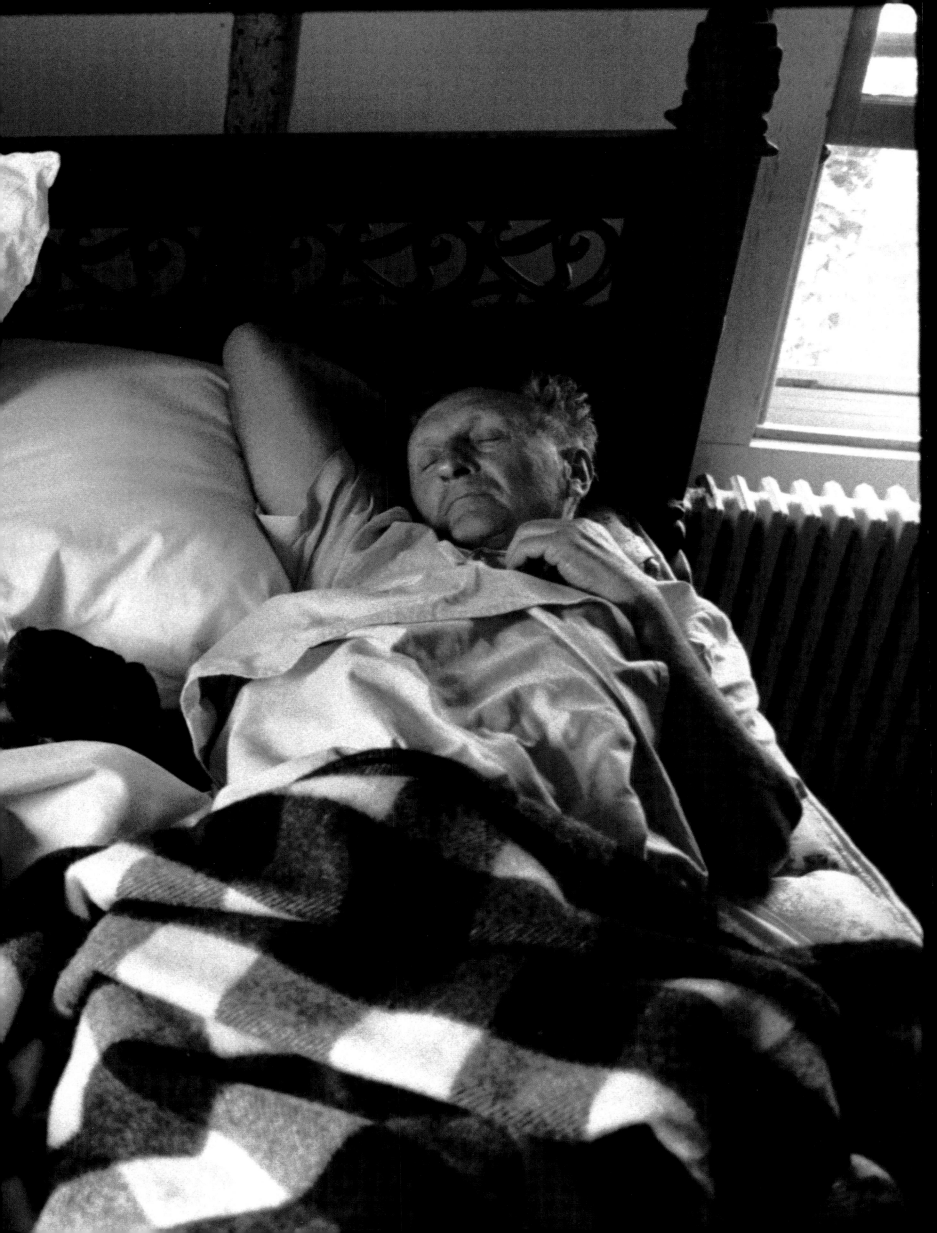

My sister Susan's daughters, Megan and Jennifer Steinman,
Silver Spring, Maryland, 1992

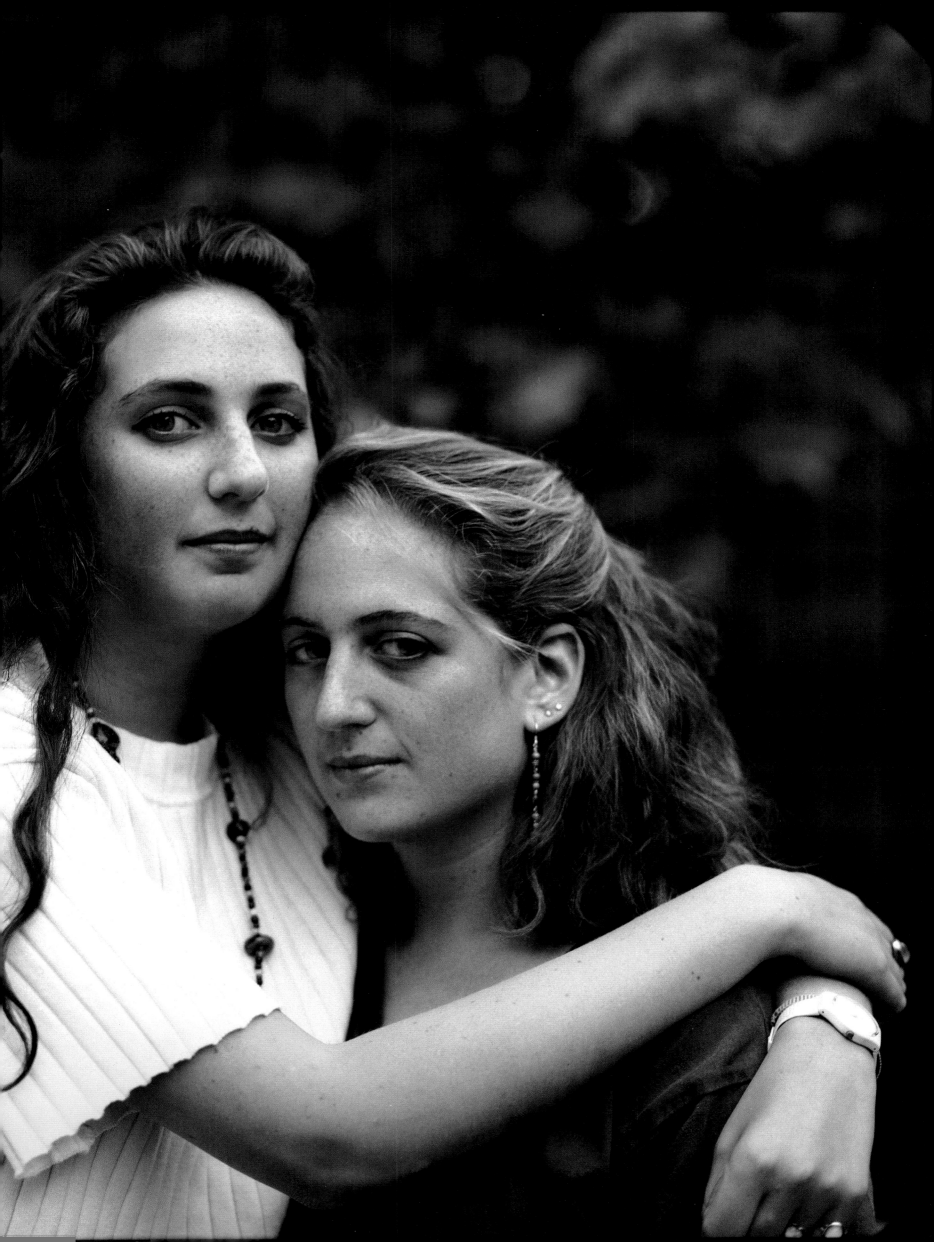

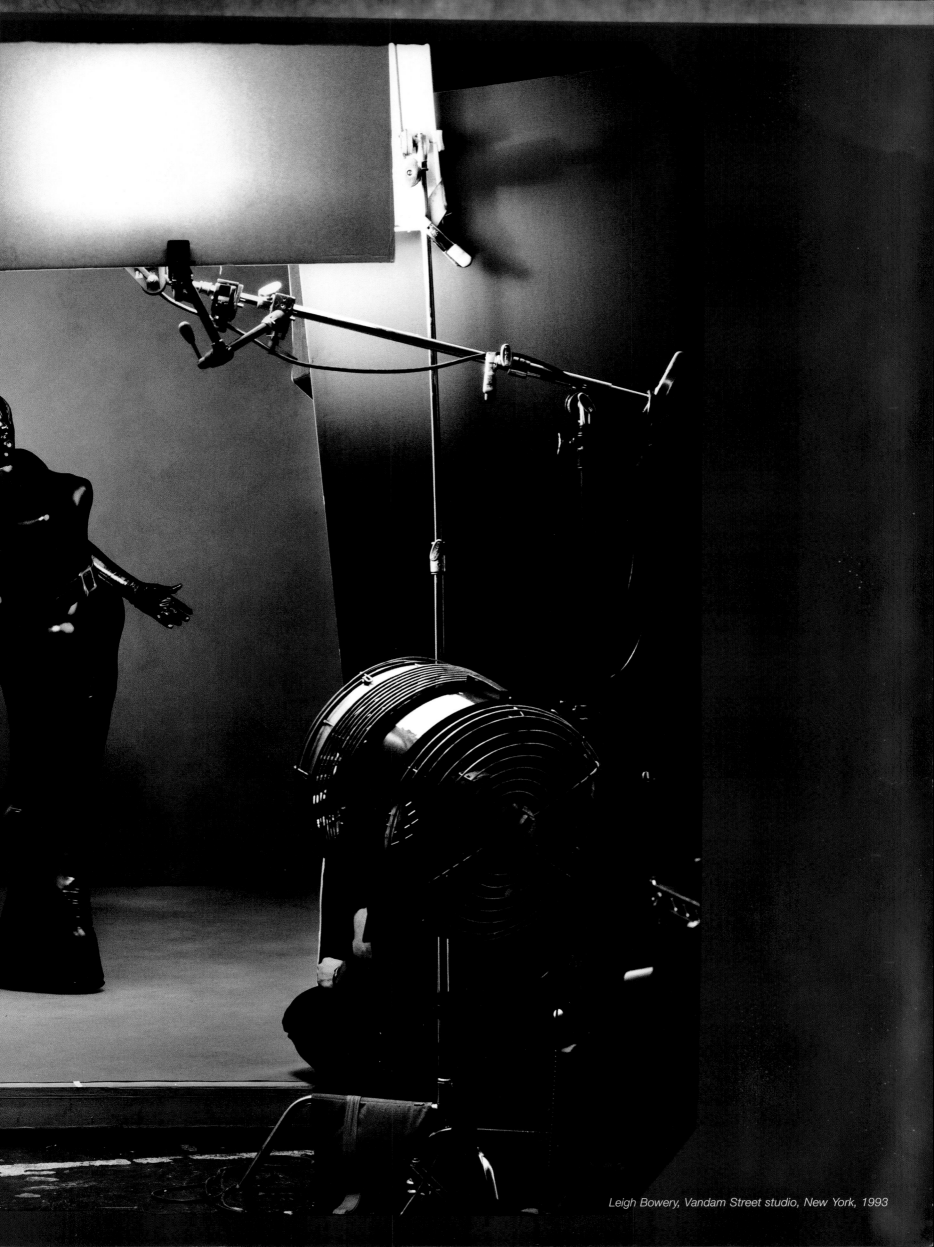

Leigh Bowery, Vandam Street studio, New York, 1993

Sylvester Stallone, Smashbox Studios, Culver City, California, 1993

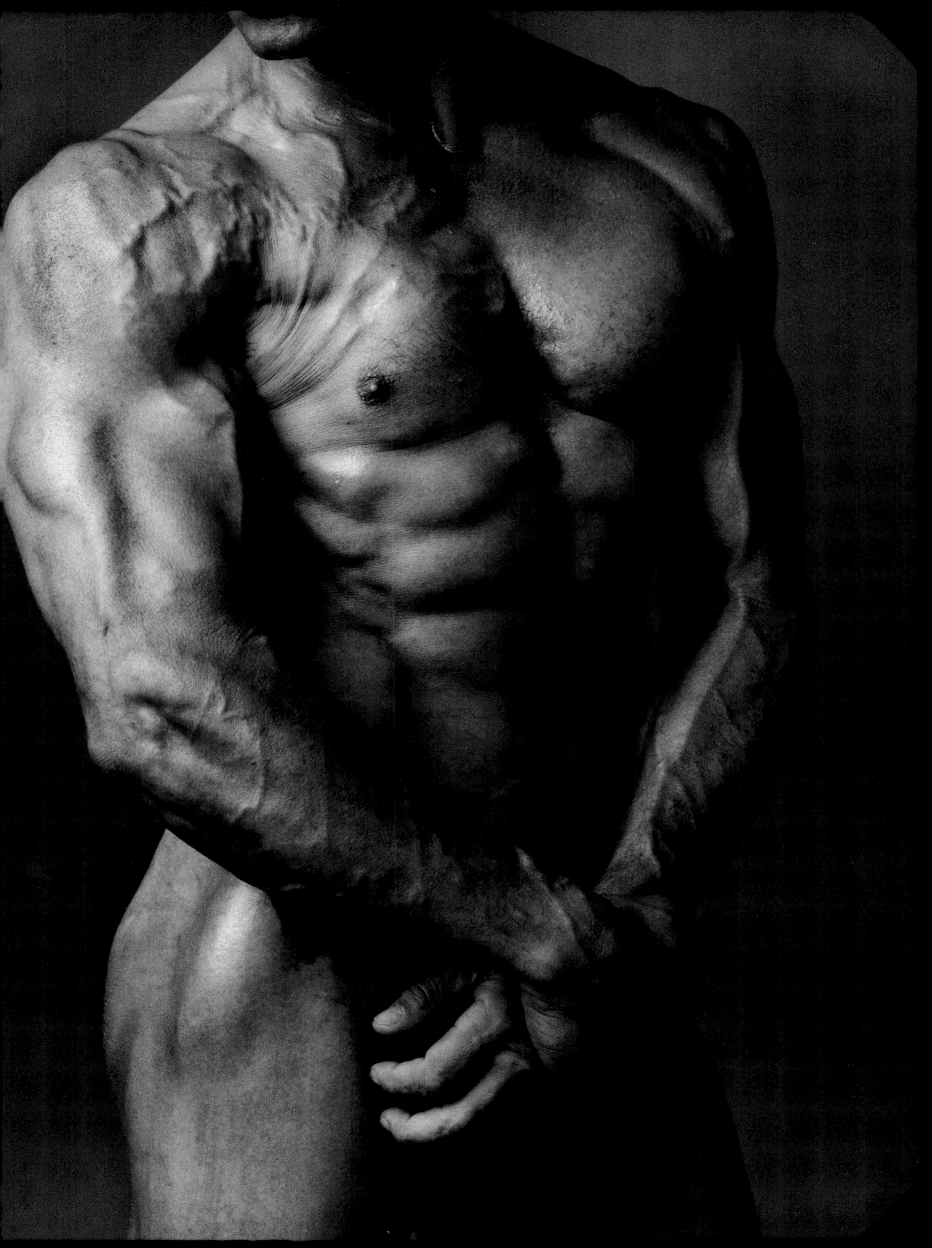

Cindy Crawford, New York, 1993

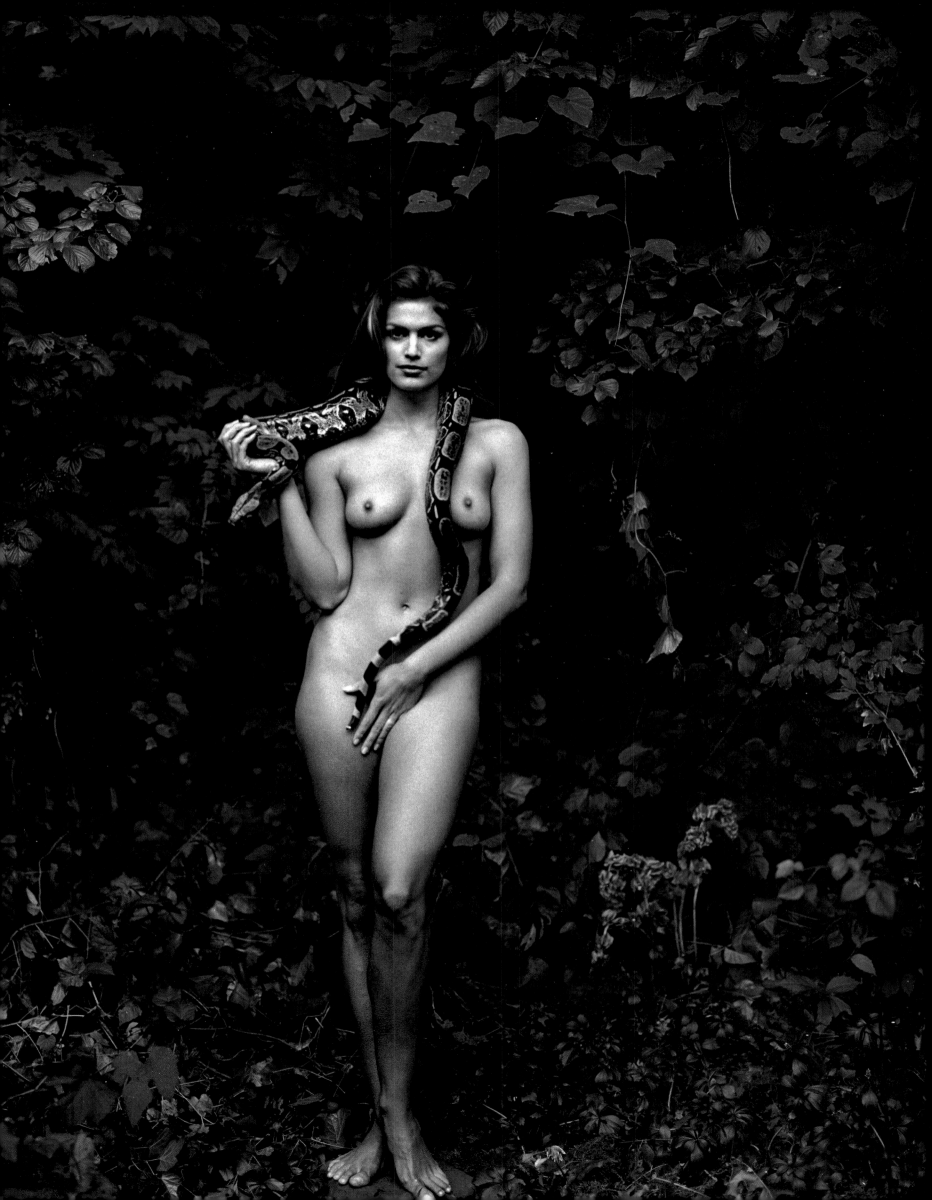

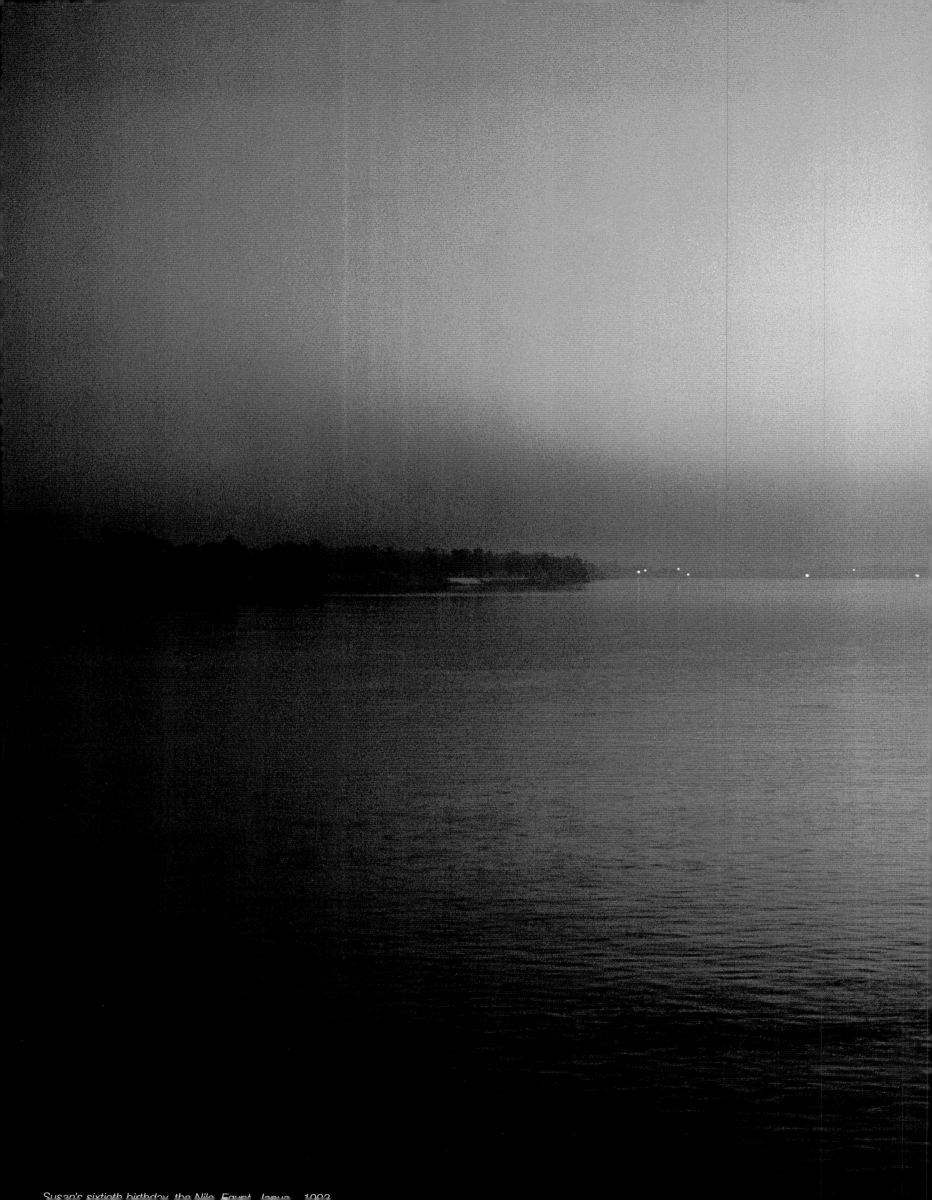

Susan's sixtieth birthday, the Nile, Egypt, Janua~ 1993

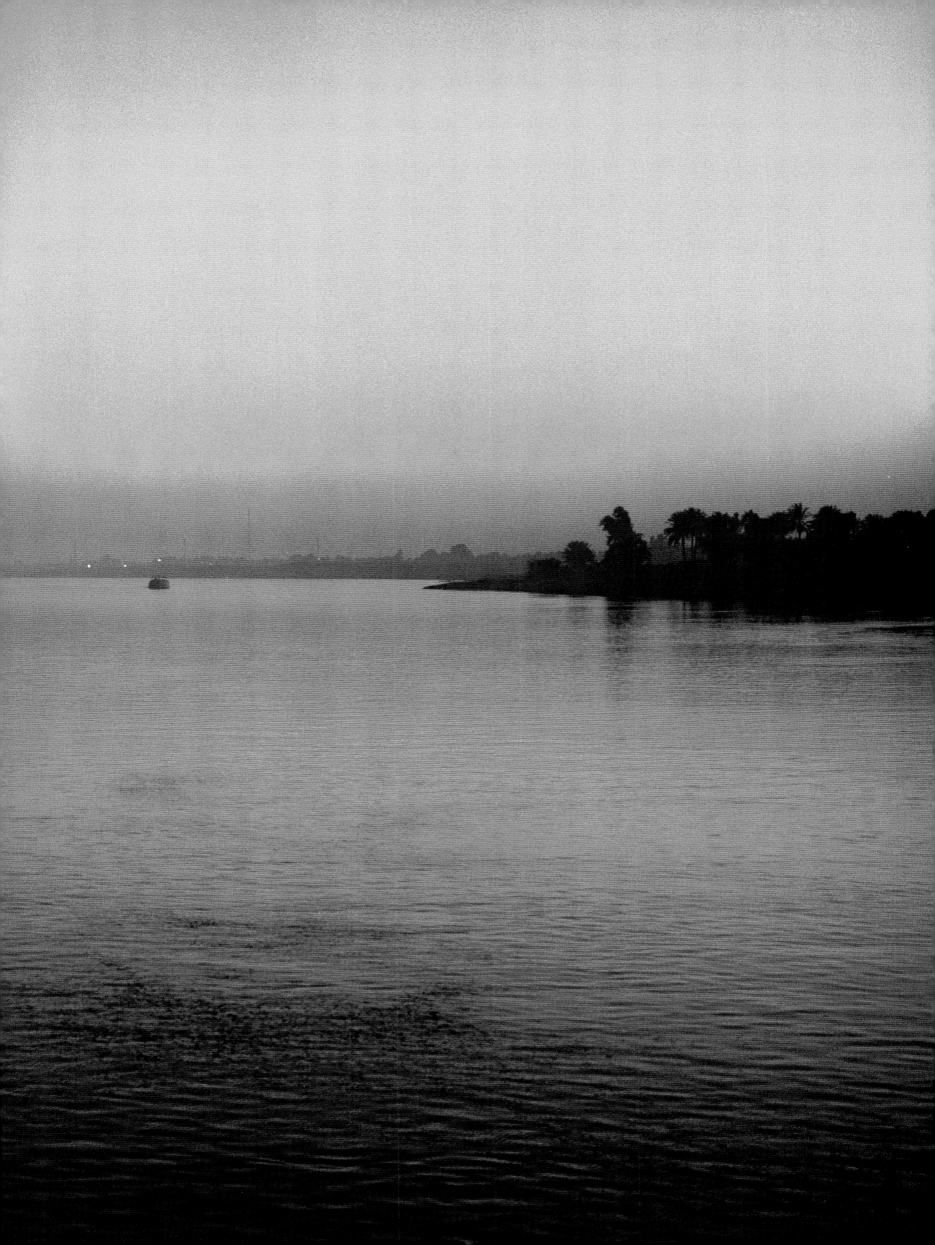

The Nile, Egypt, 1993

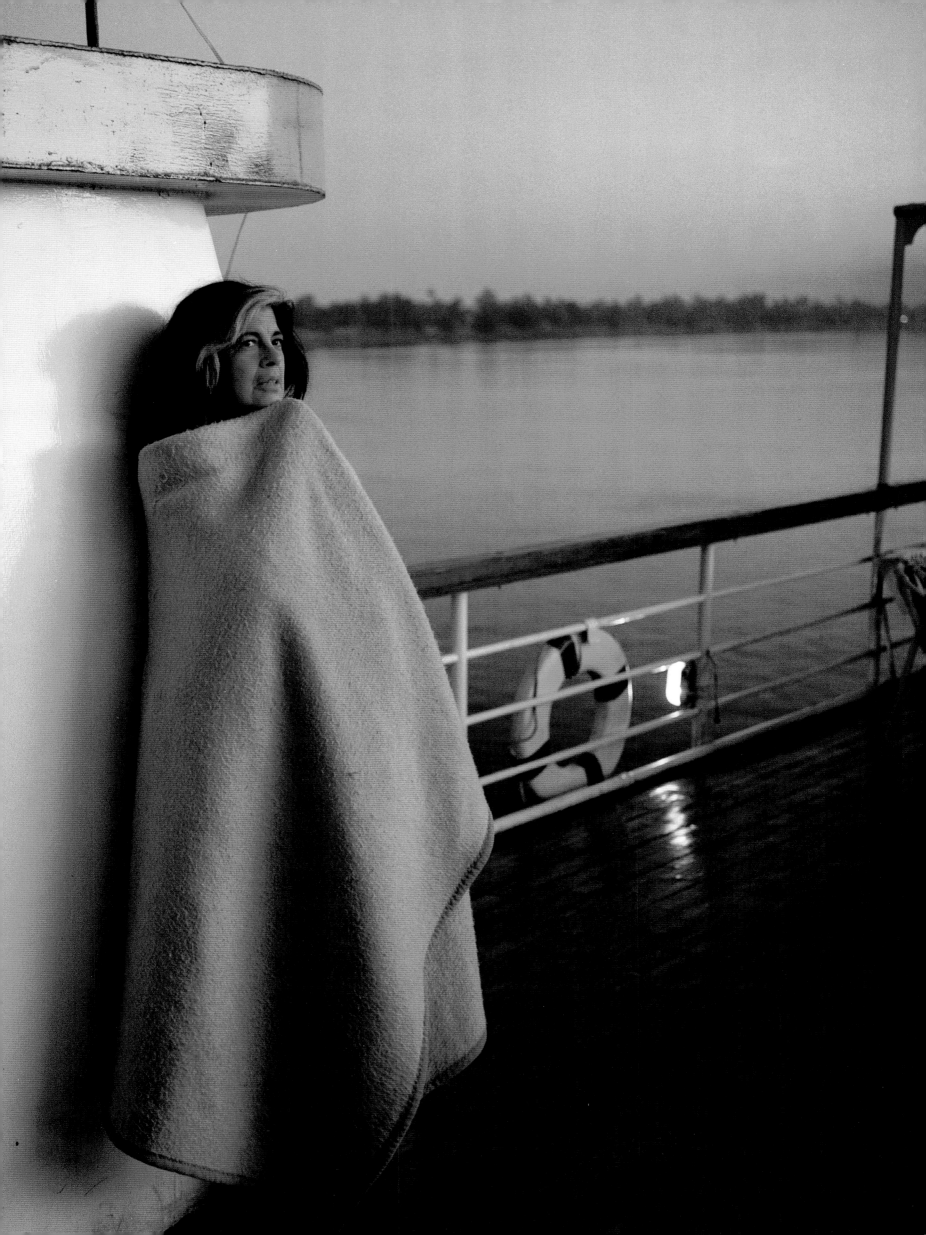

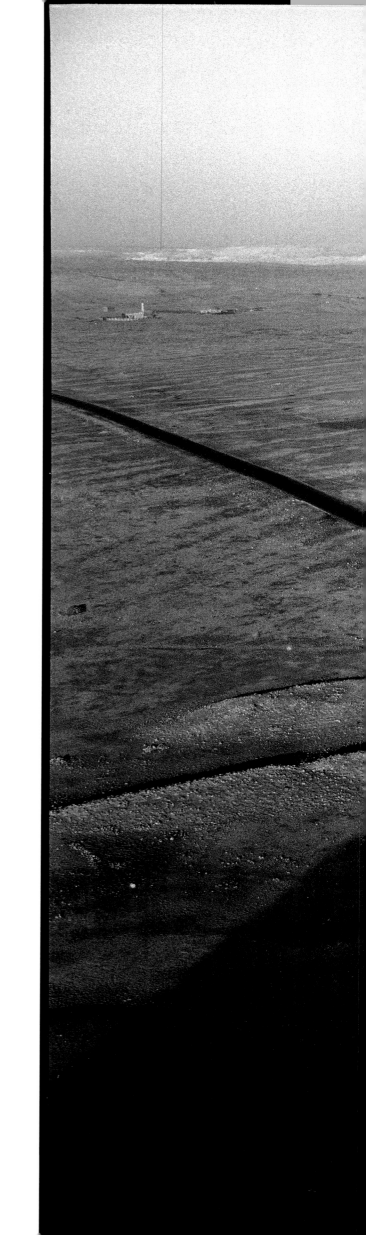

The Great Pyramid of Khufu, Giza, Egypt, 1993

Following pages:
Susan with Peter Perrone, Giza, 1993

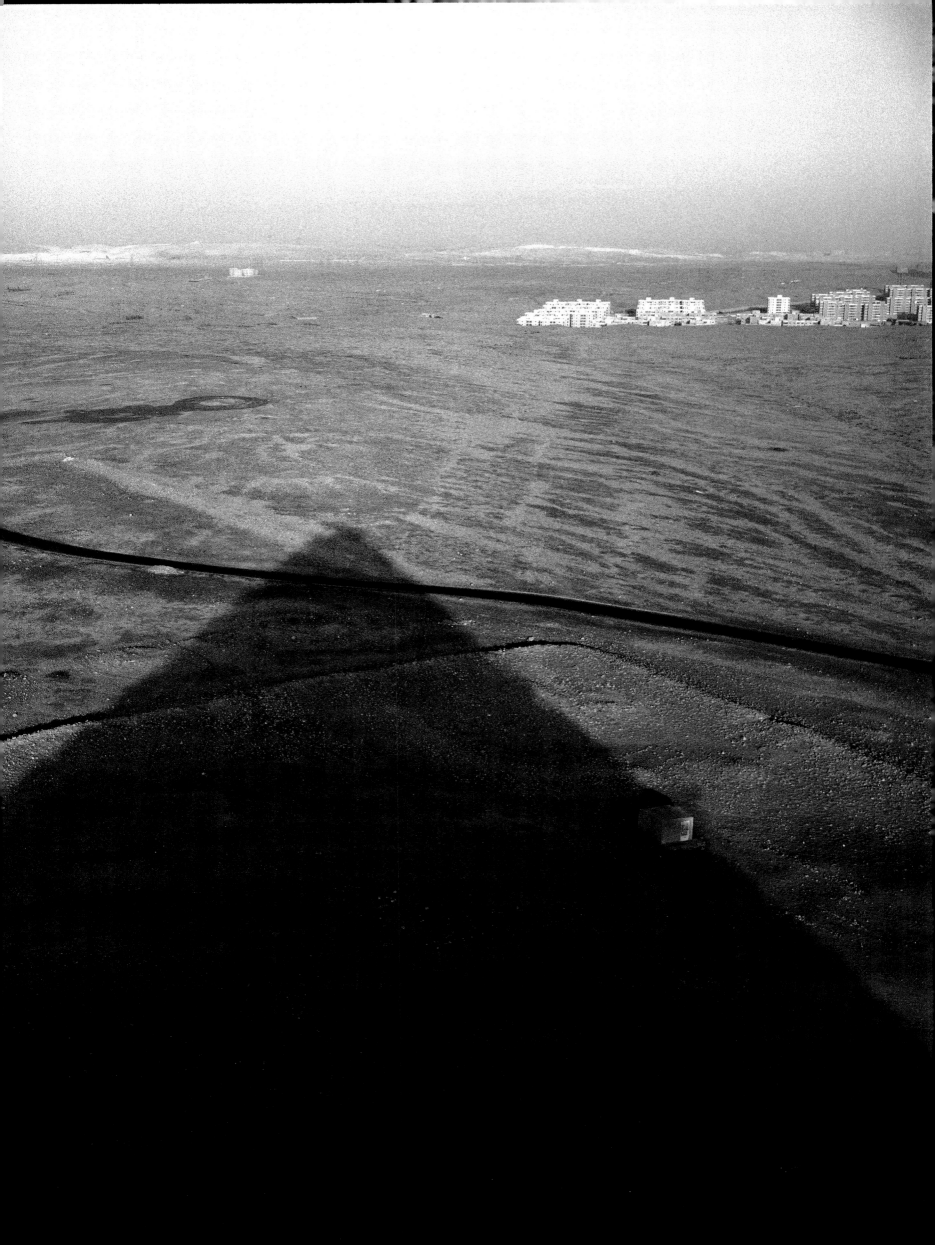

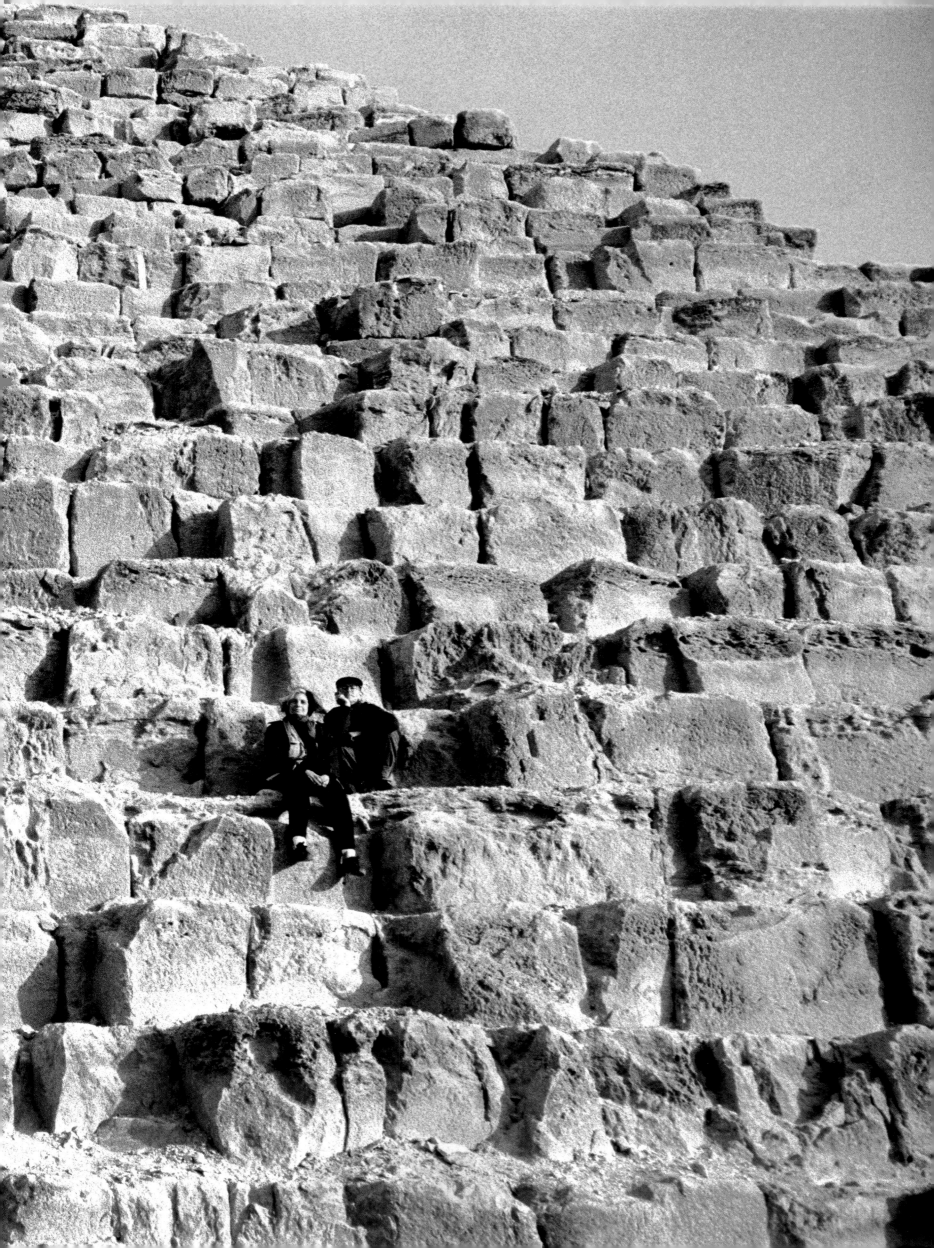

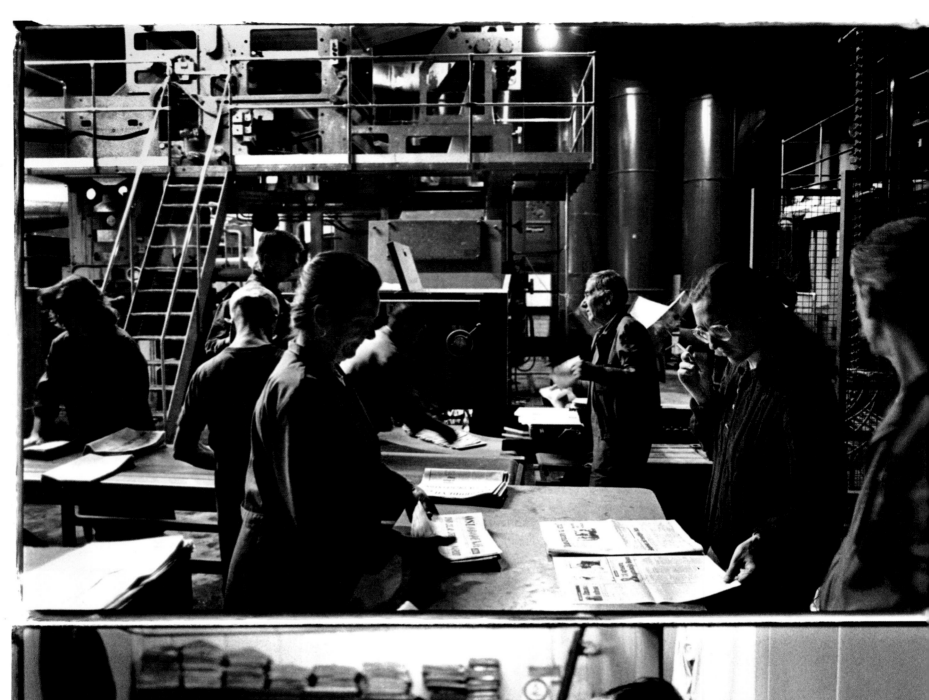

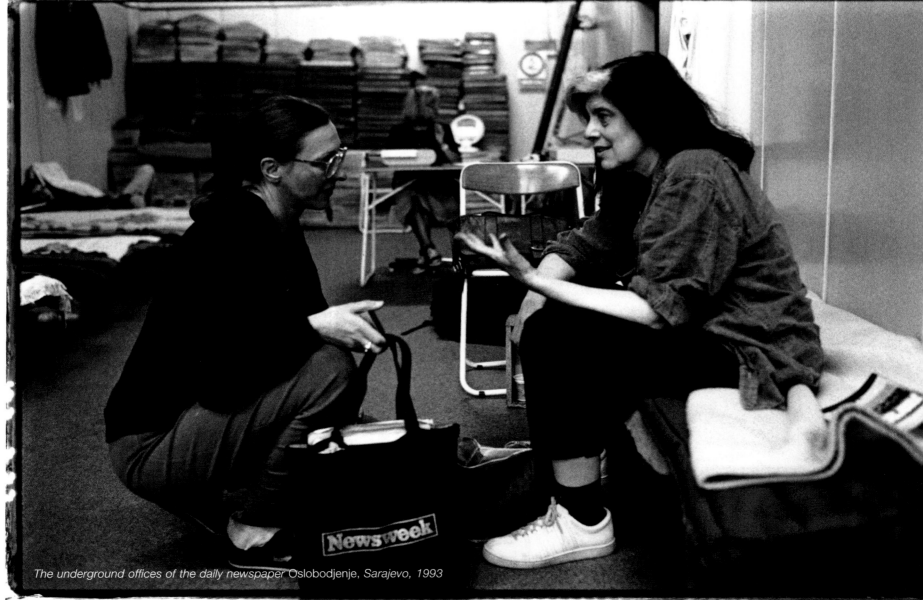

The underground offices of the daily newspaper Oslobodjenje, *Sarajevo, 1993*

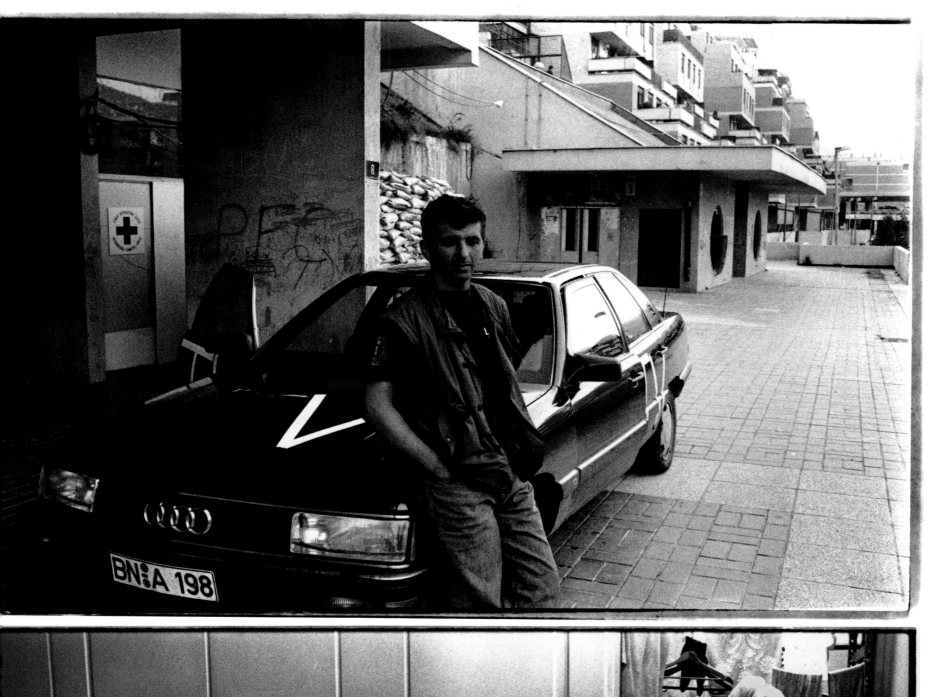

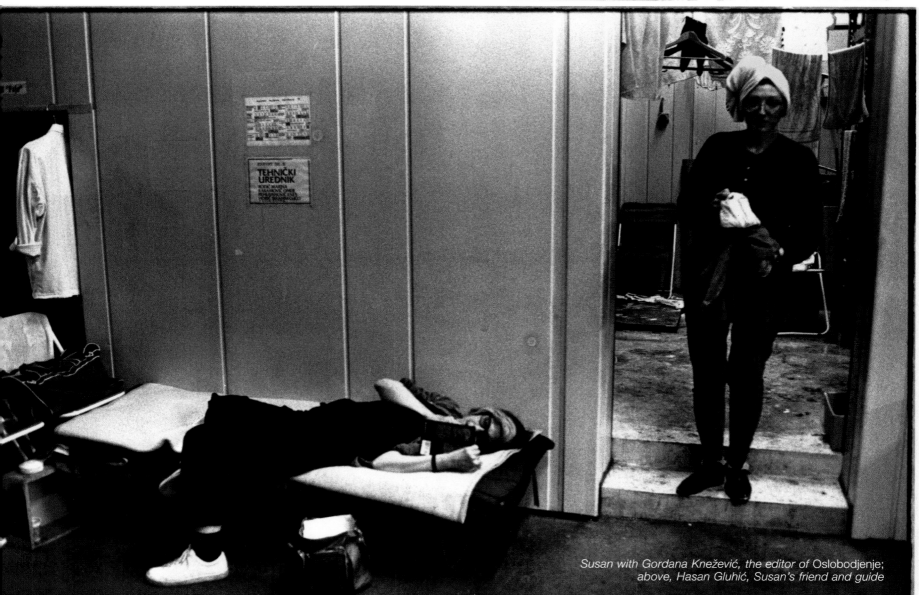

*Susan with Gordana Knežević, the editor of Oslobodjenje;
above, Hasan Gluhić, Susan's friend and guide*

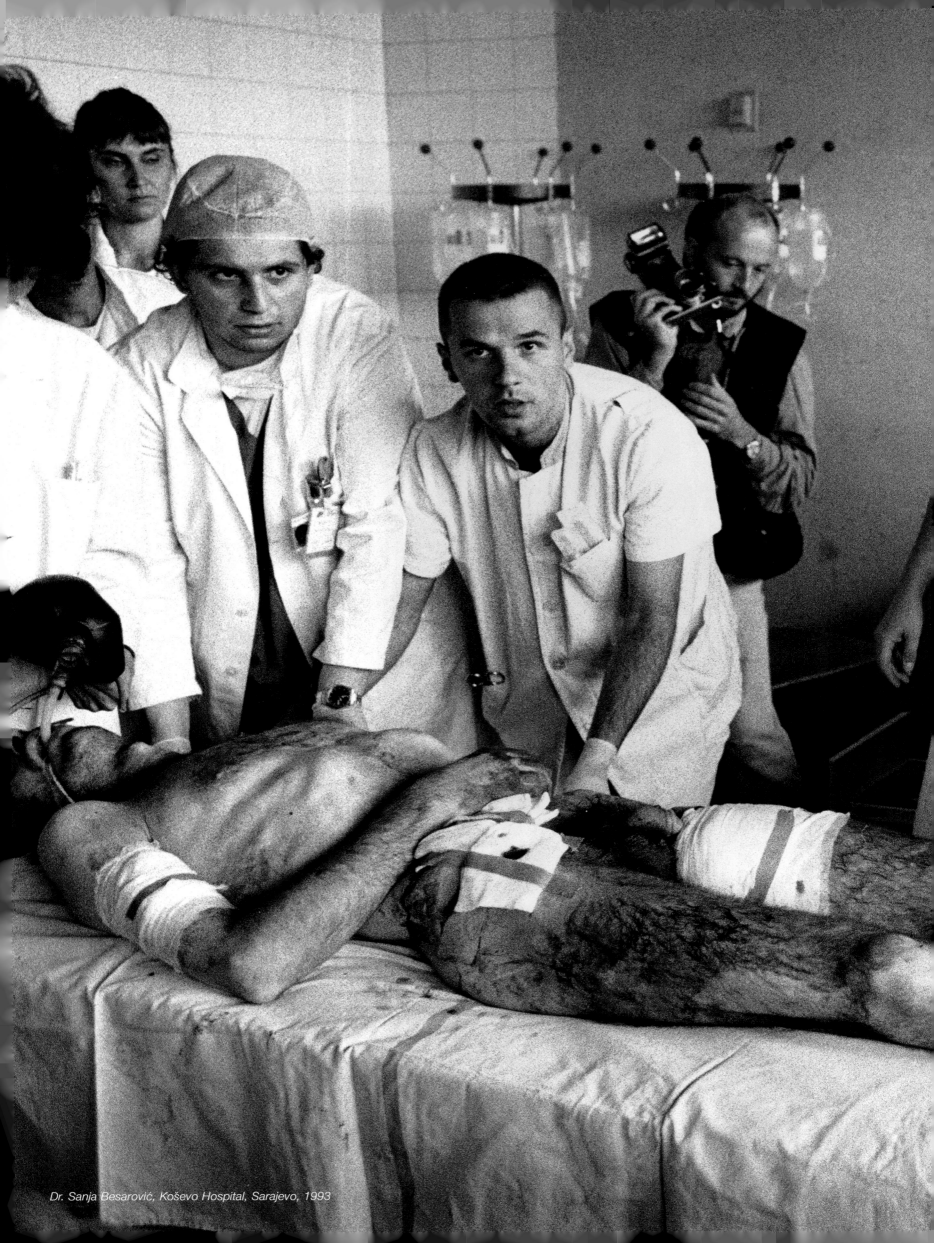

Dr. Sanja Besarović, Koševo Hospital, Sarajevo, 1993

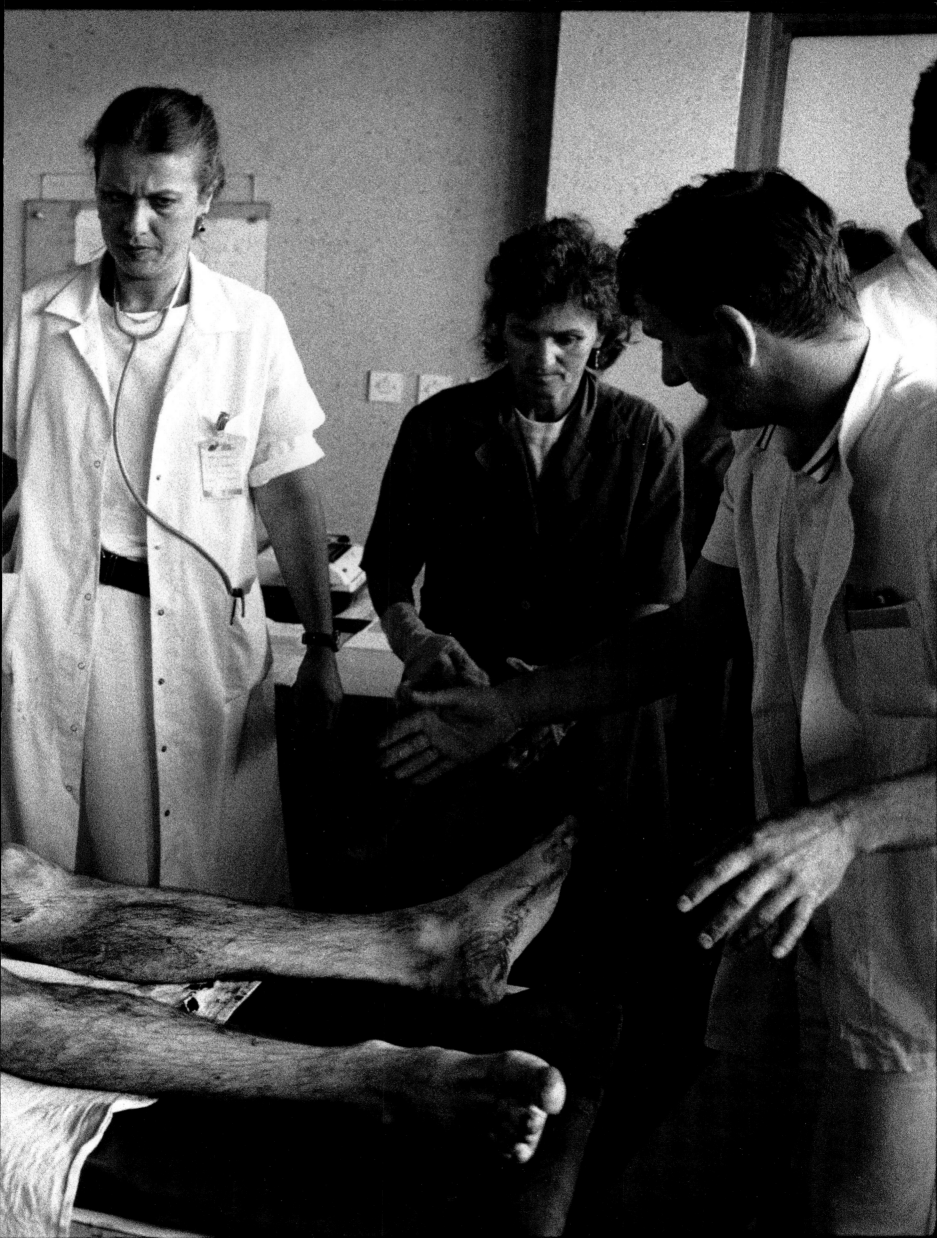

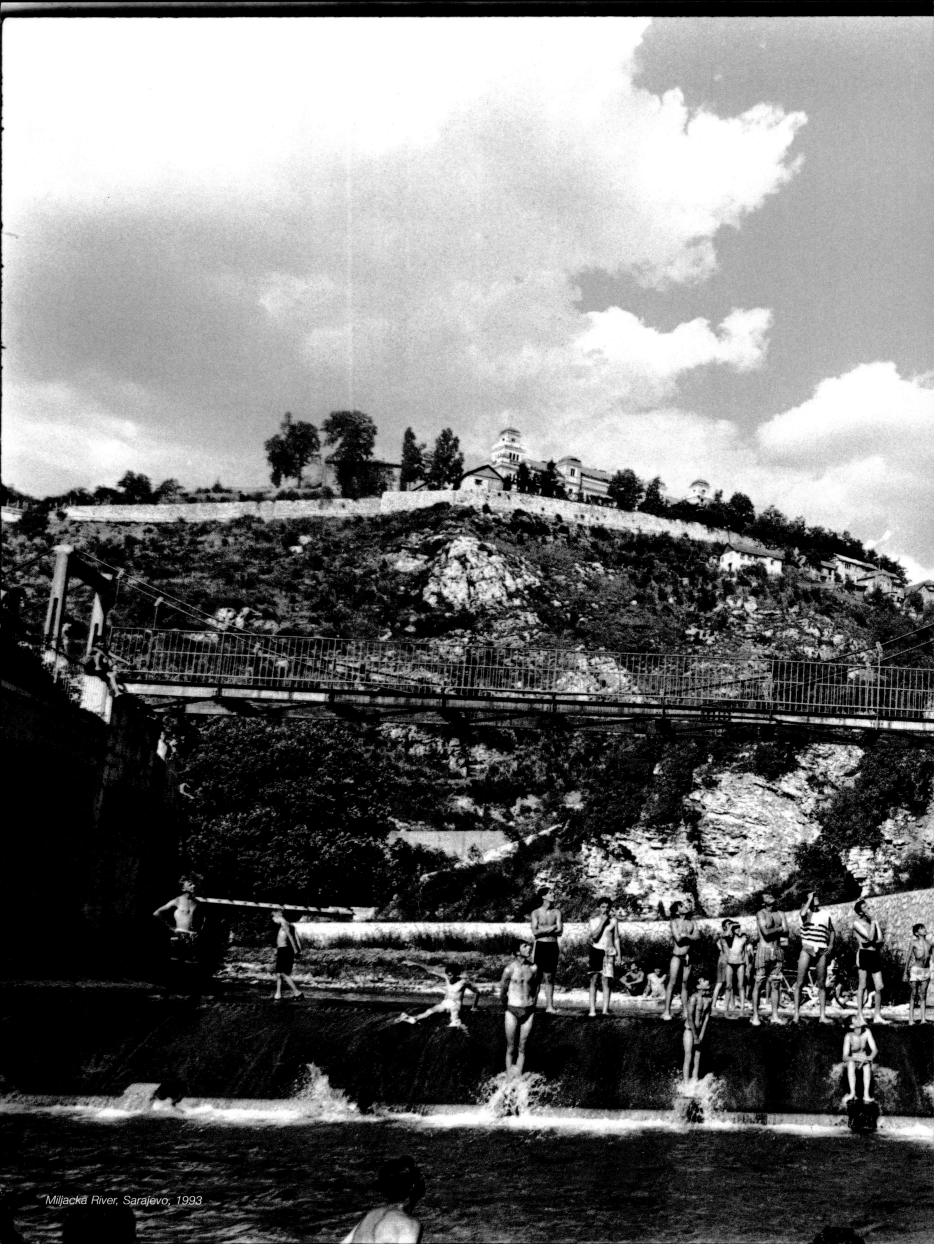

Miljacka River, Sarajevo, 1993

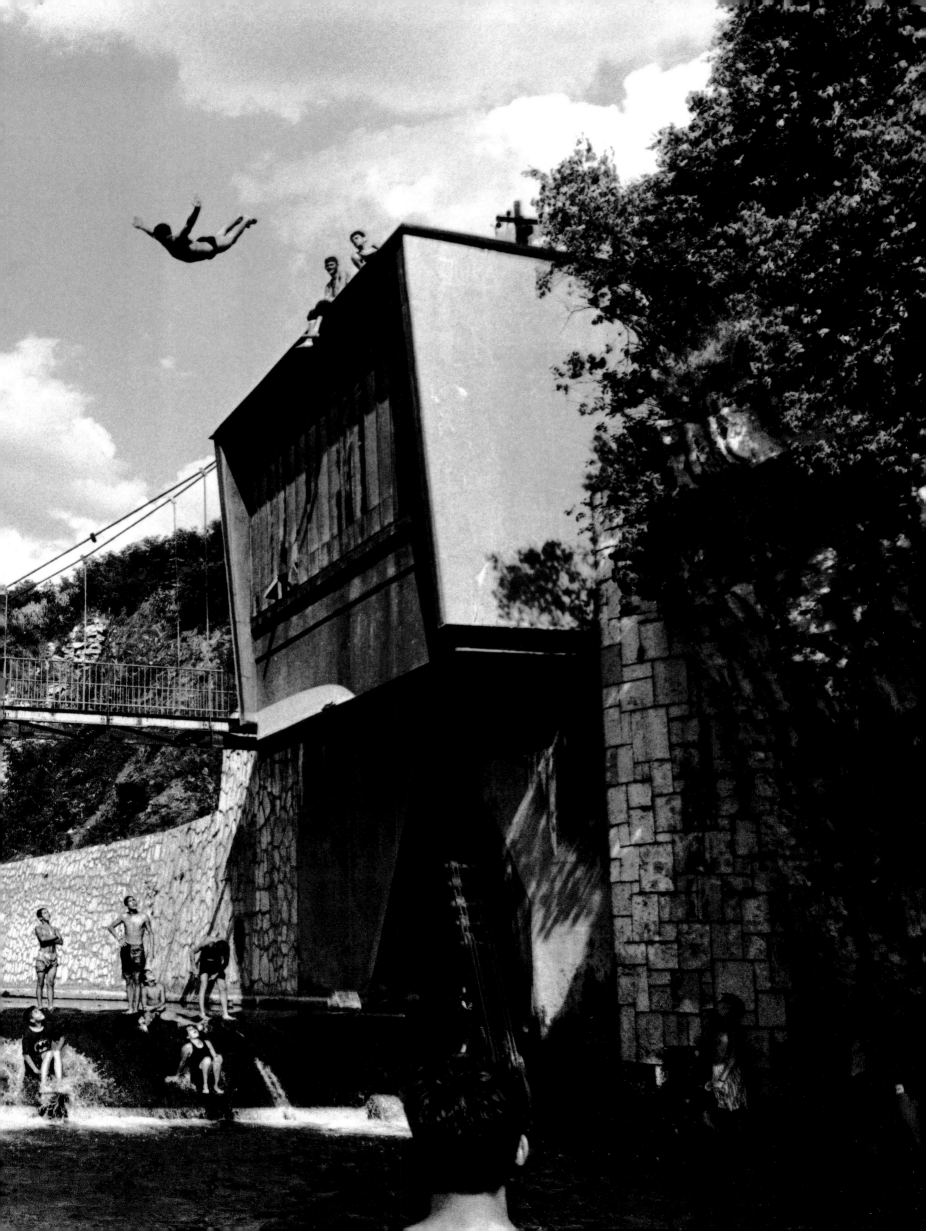

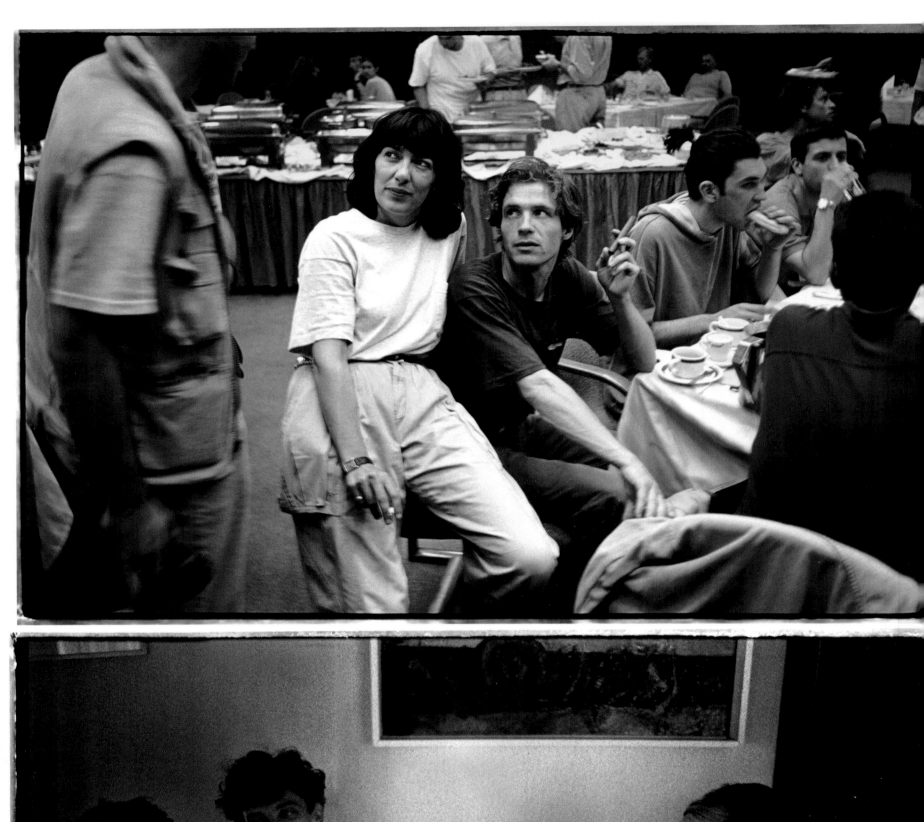

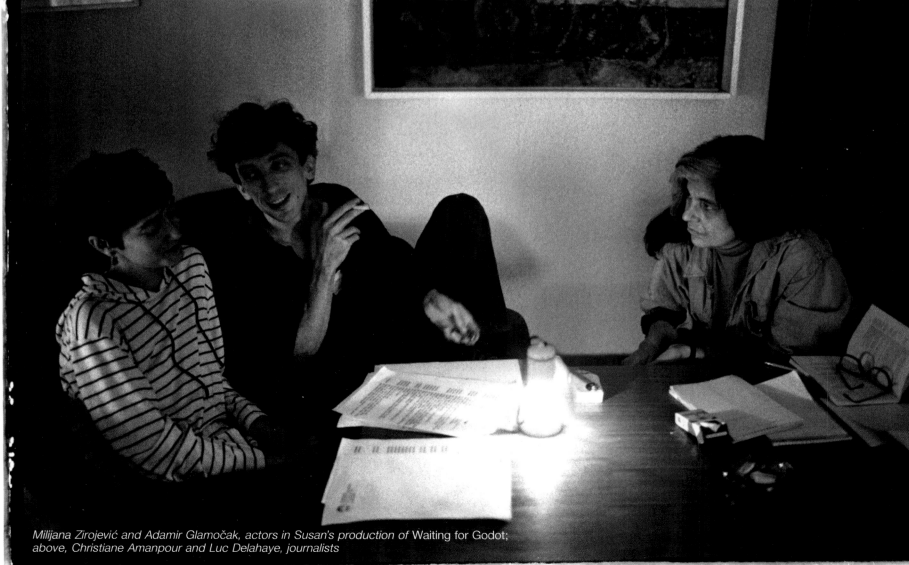

Milijana Zirojević and Adamir Glamočak, actors in Susan's production of Waiting for Godot; *above, Christiane Amanpour and Luc Delahaye, journalists*

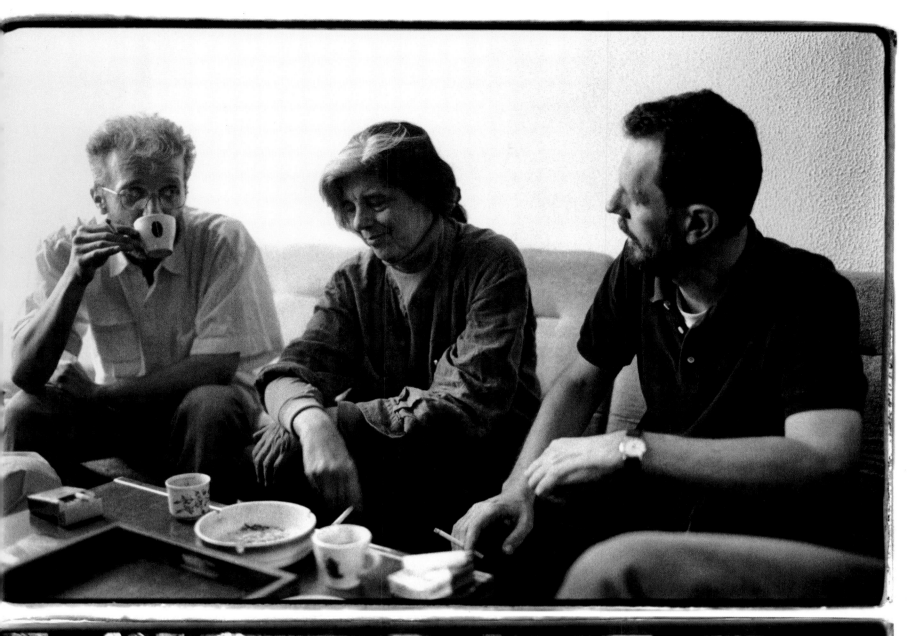

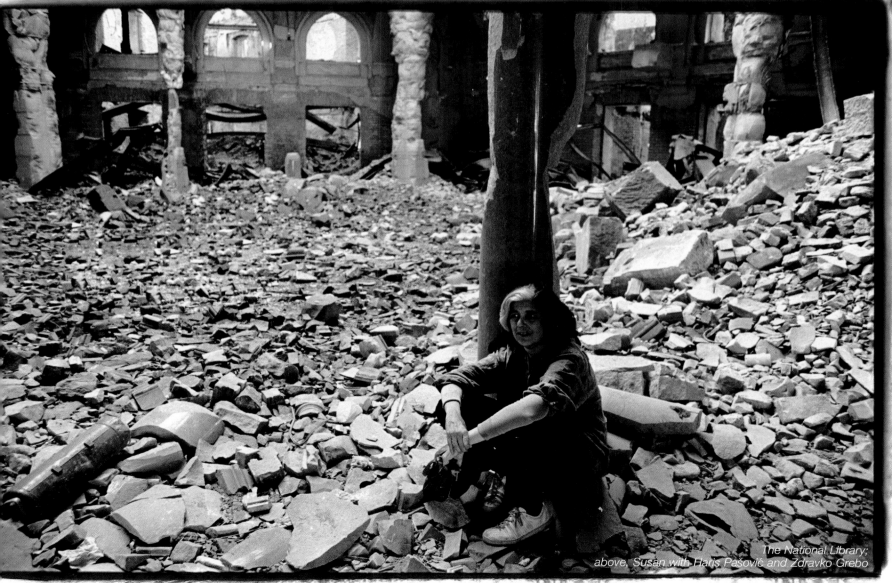

The National Library;
above, Susan with Haris Pašović and Zdravko Grebo

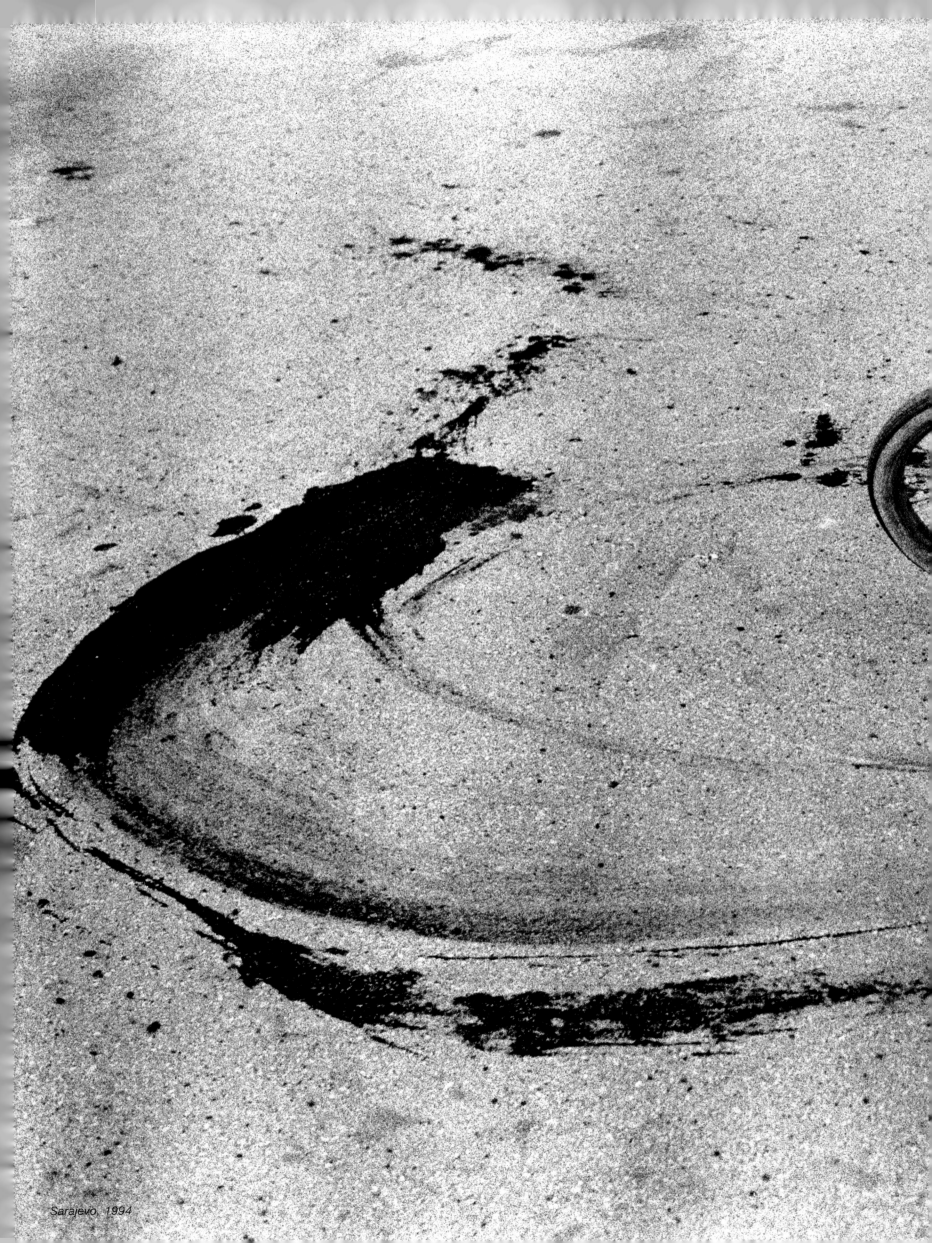

Sarajevo, 1994

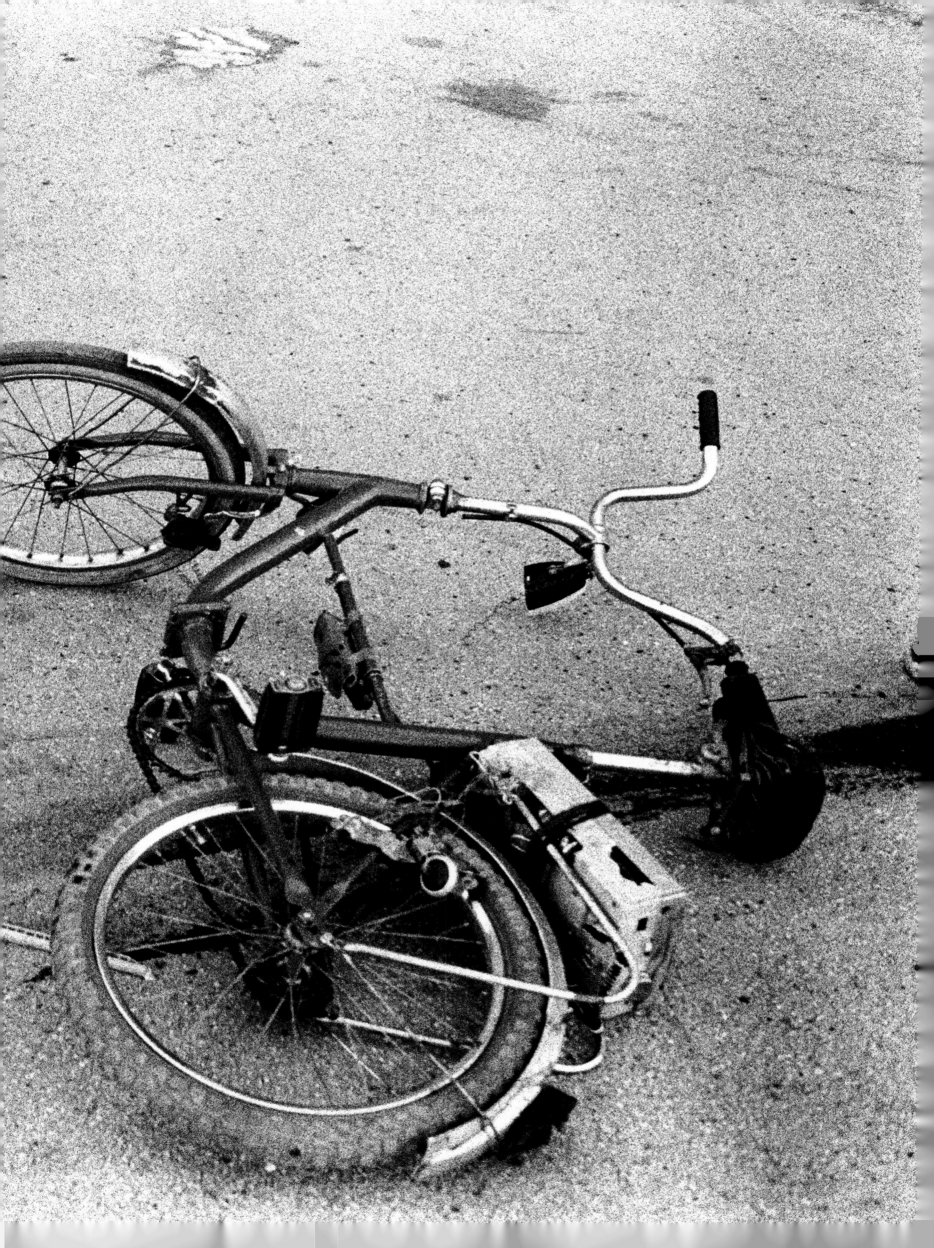

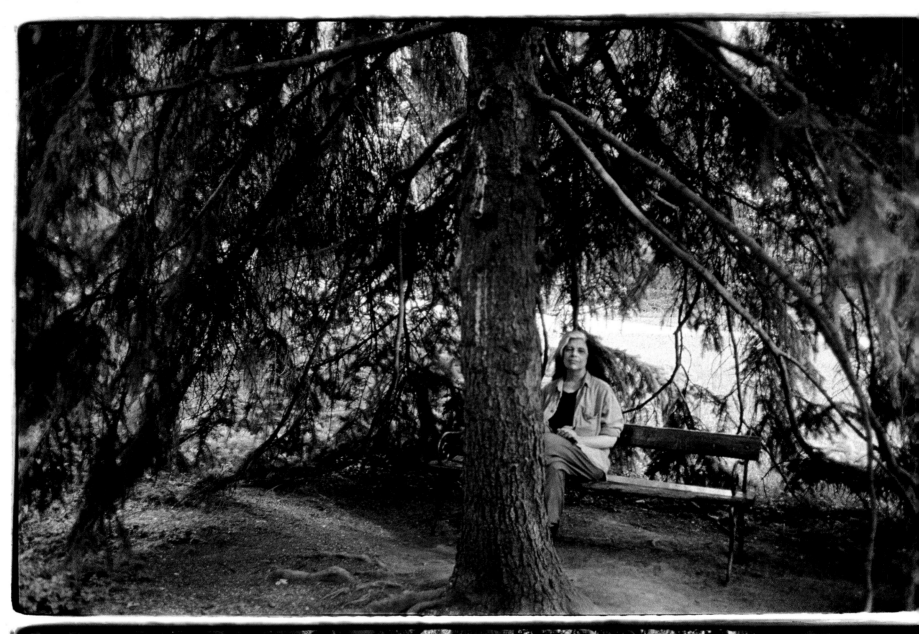

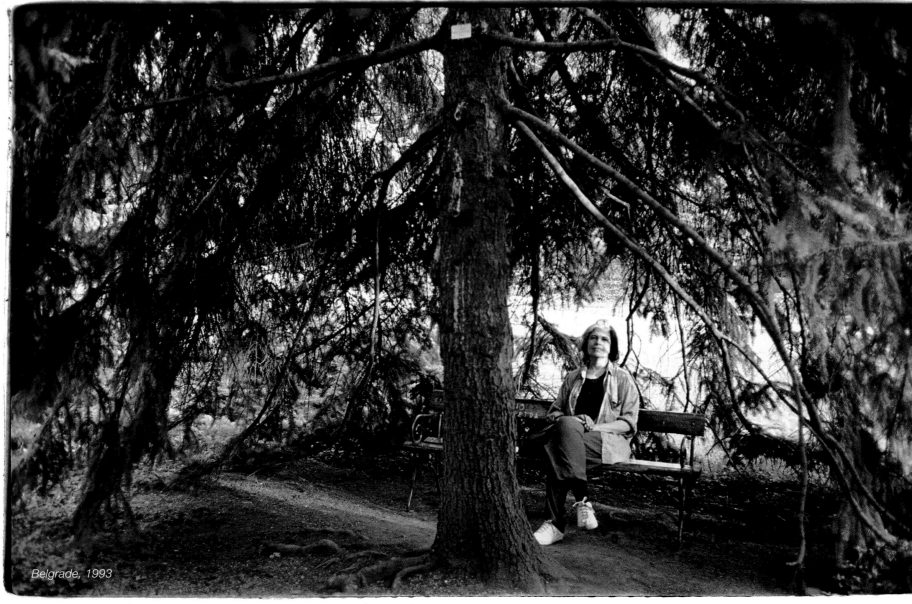

Belgrade, 1993

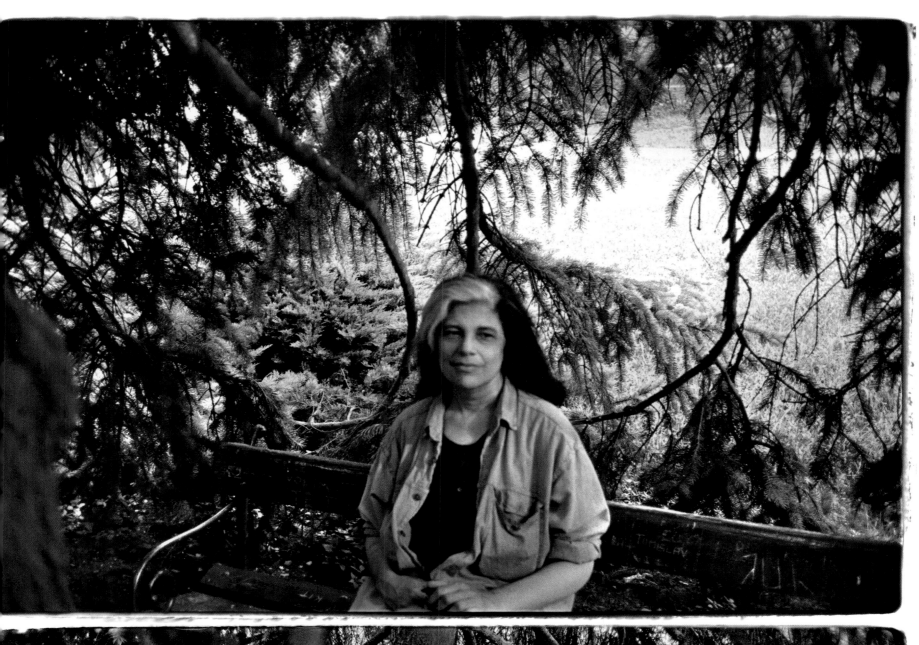
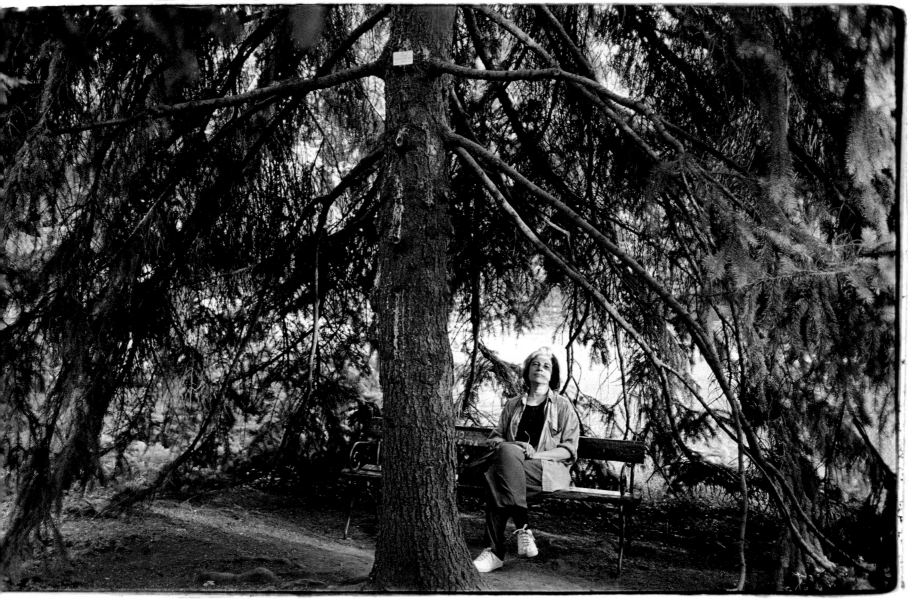

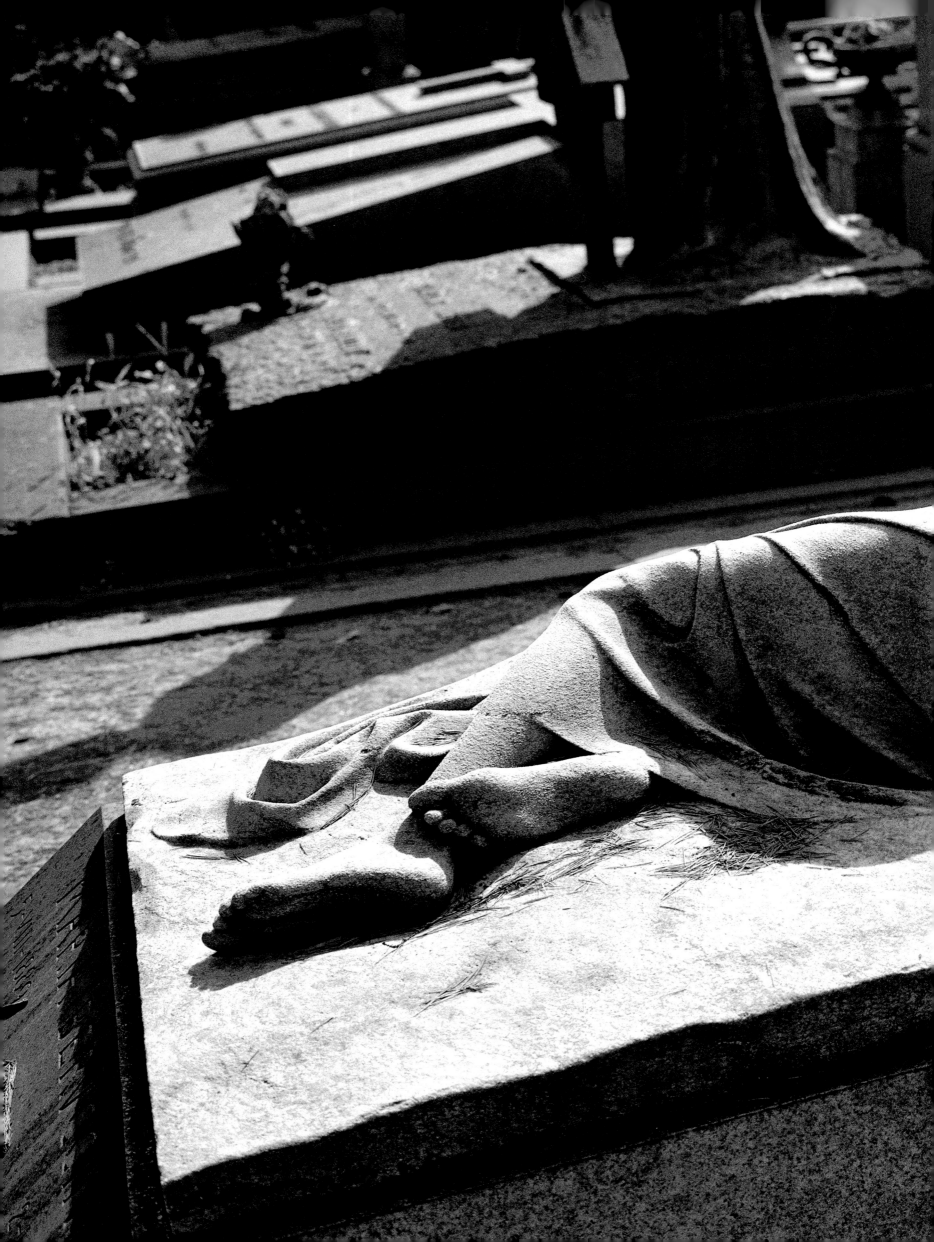

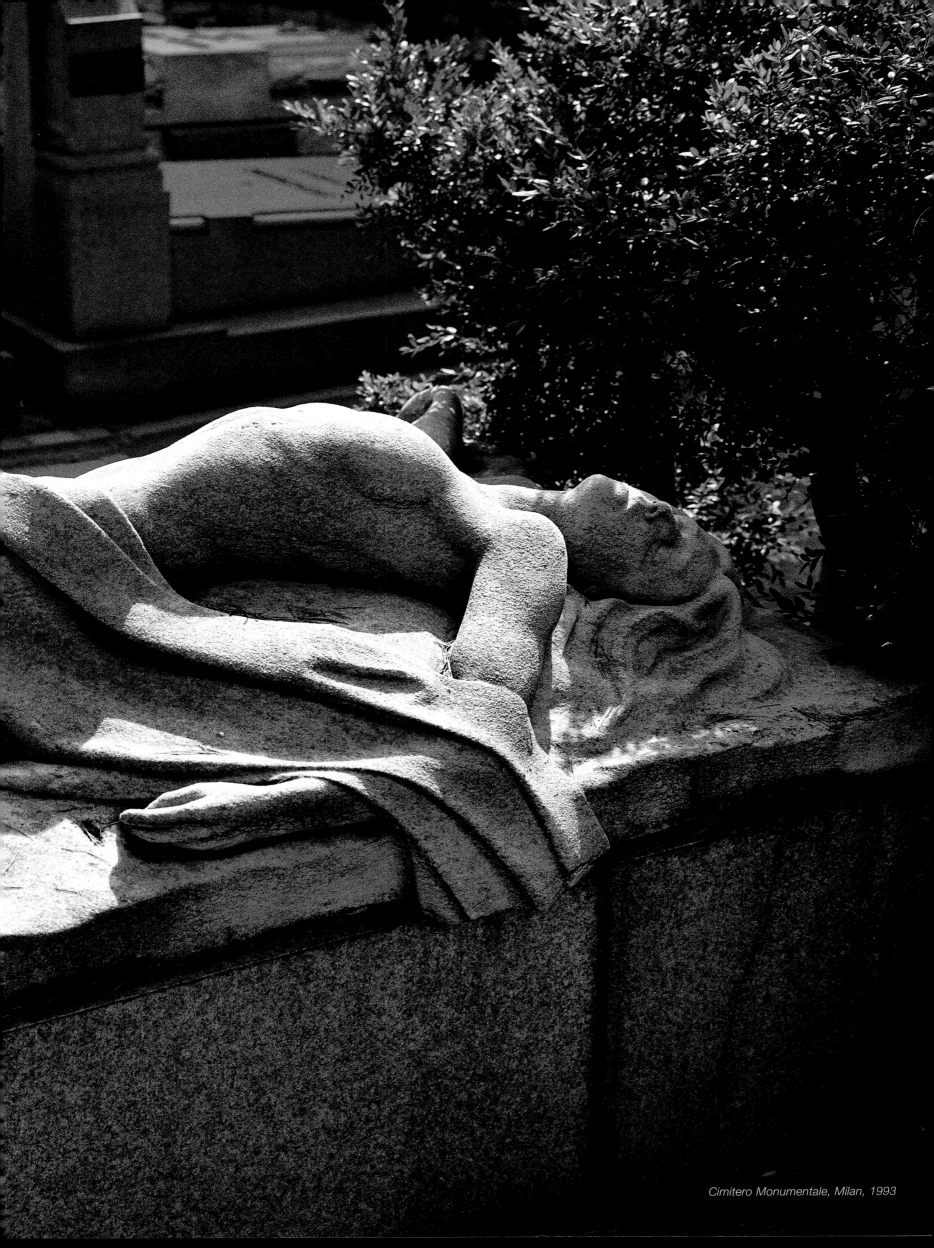

Cimitero Monumentale, Milan, 1993

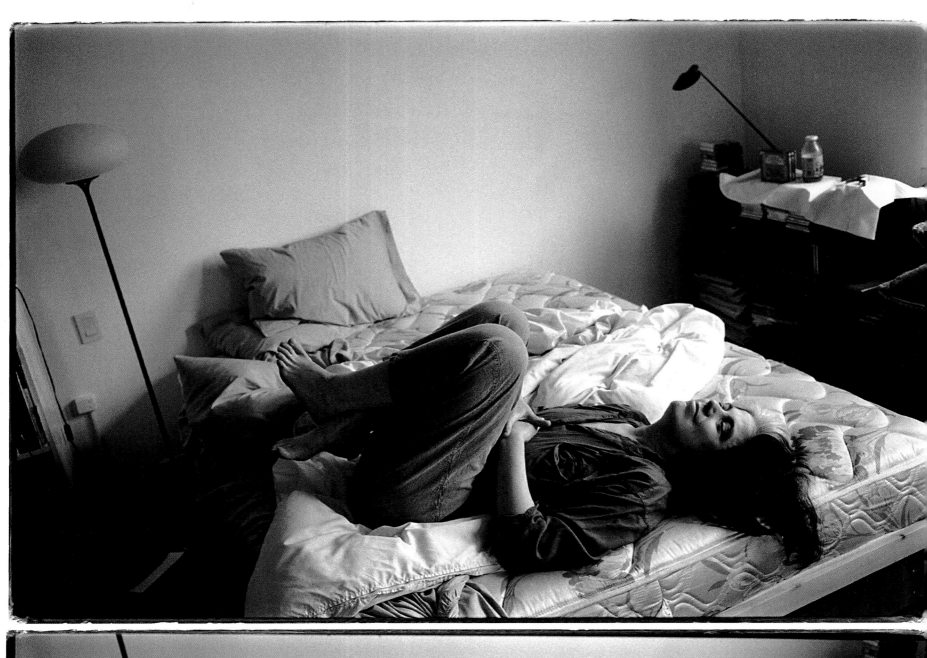
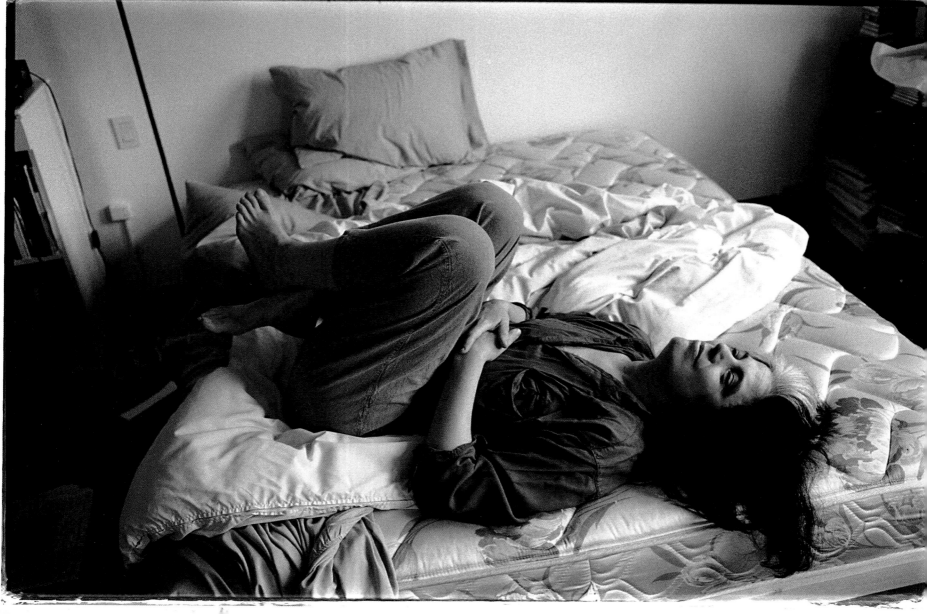

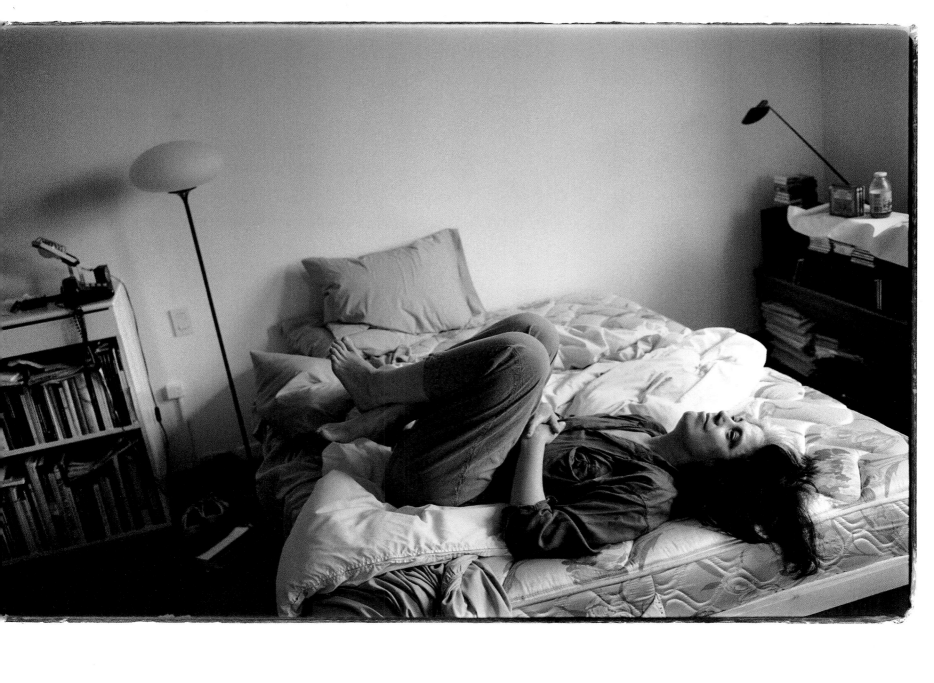

West 24th Street, New York, 1993

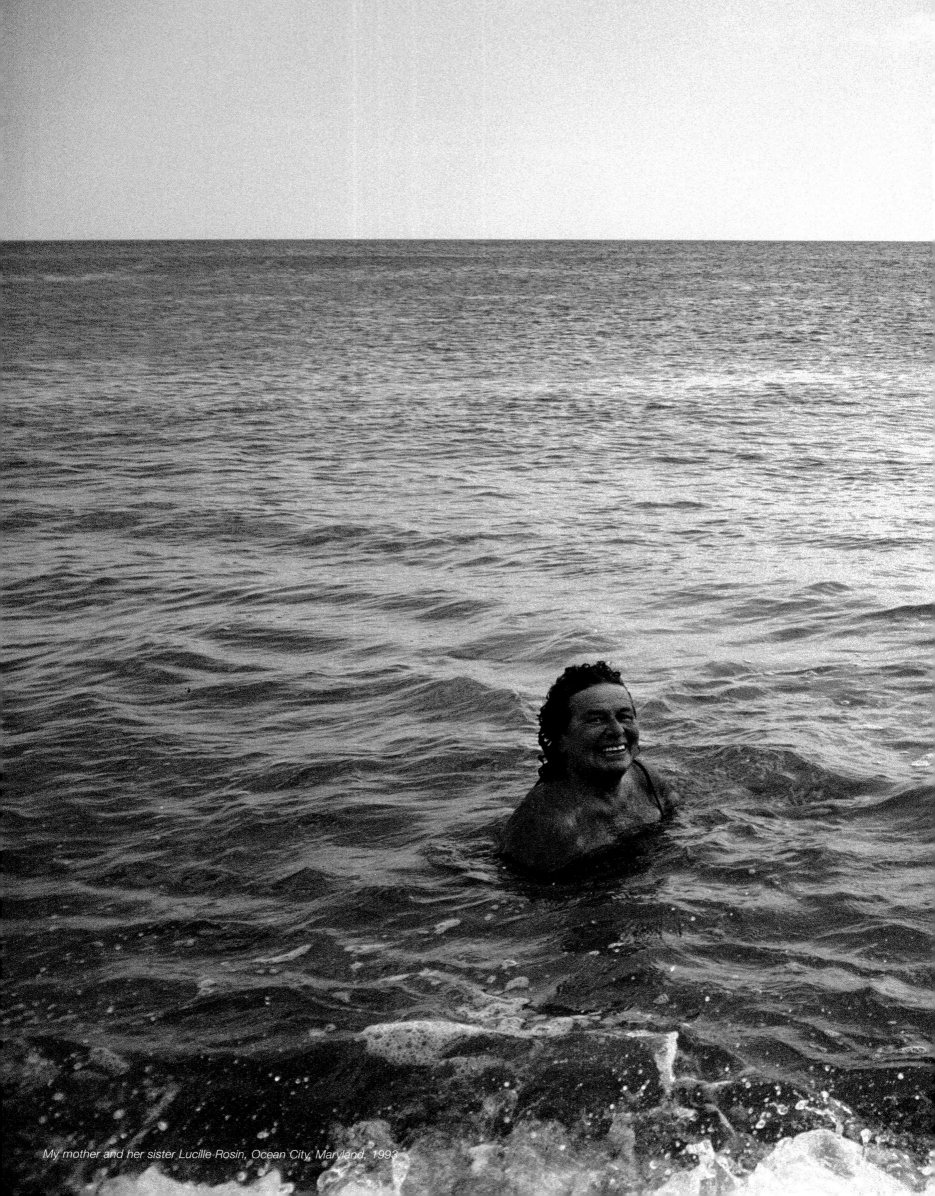

My mother and her sister Lucille Rosin, Ocean City, Maryland, 1993

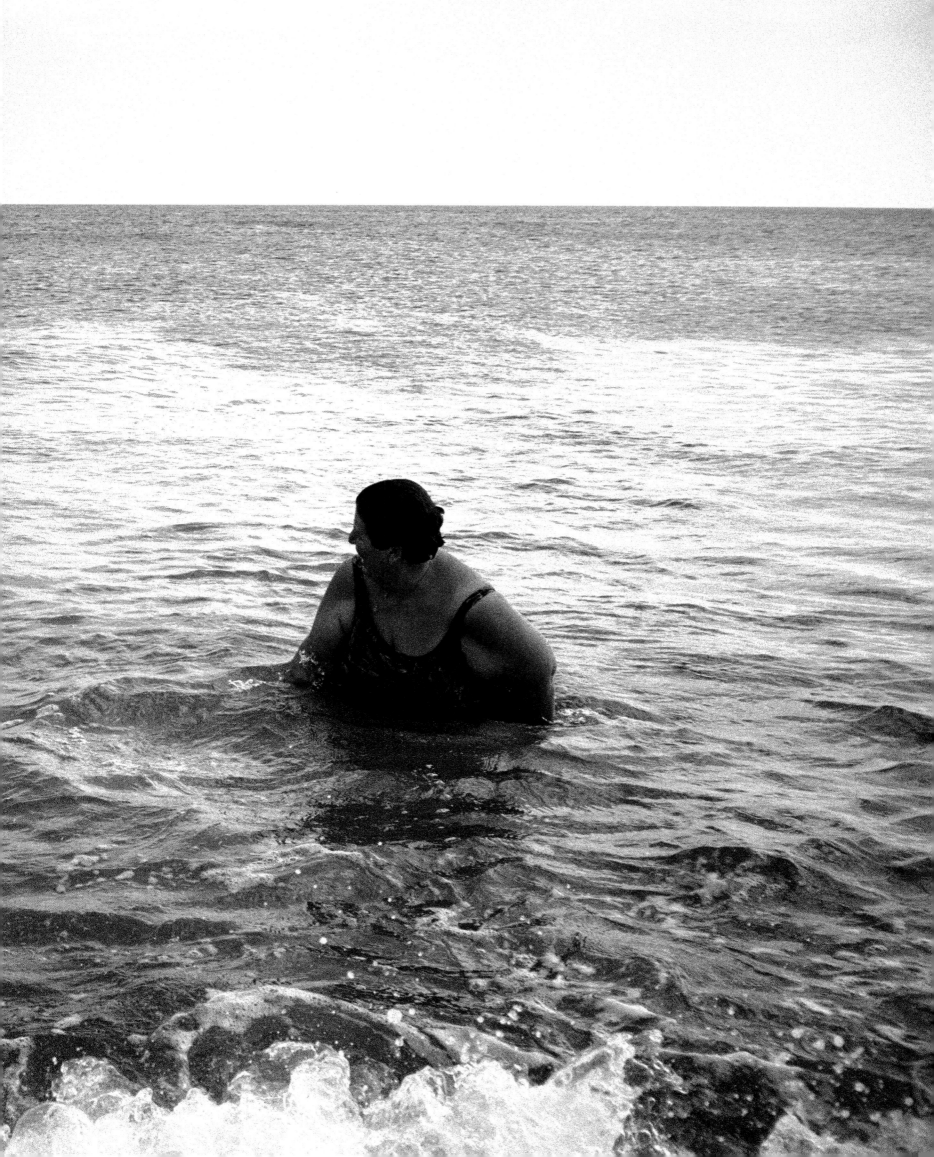

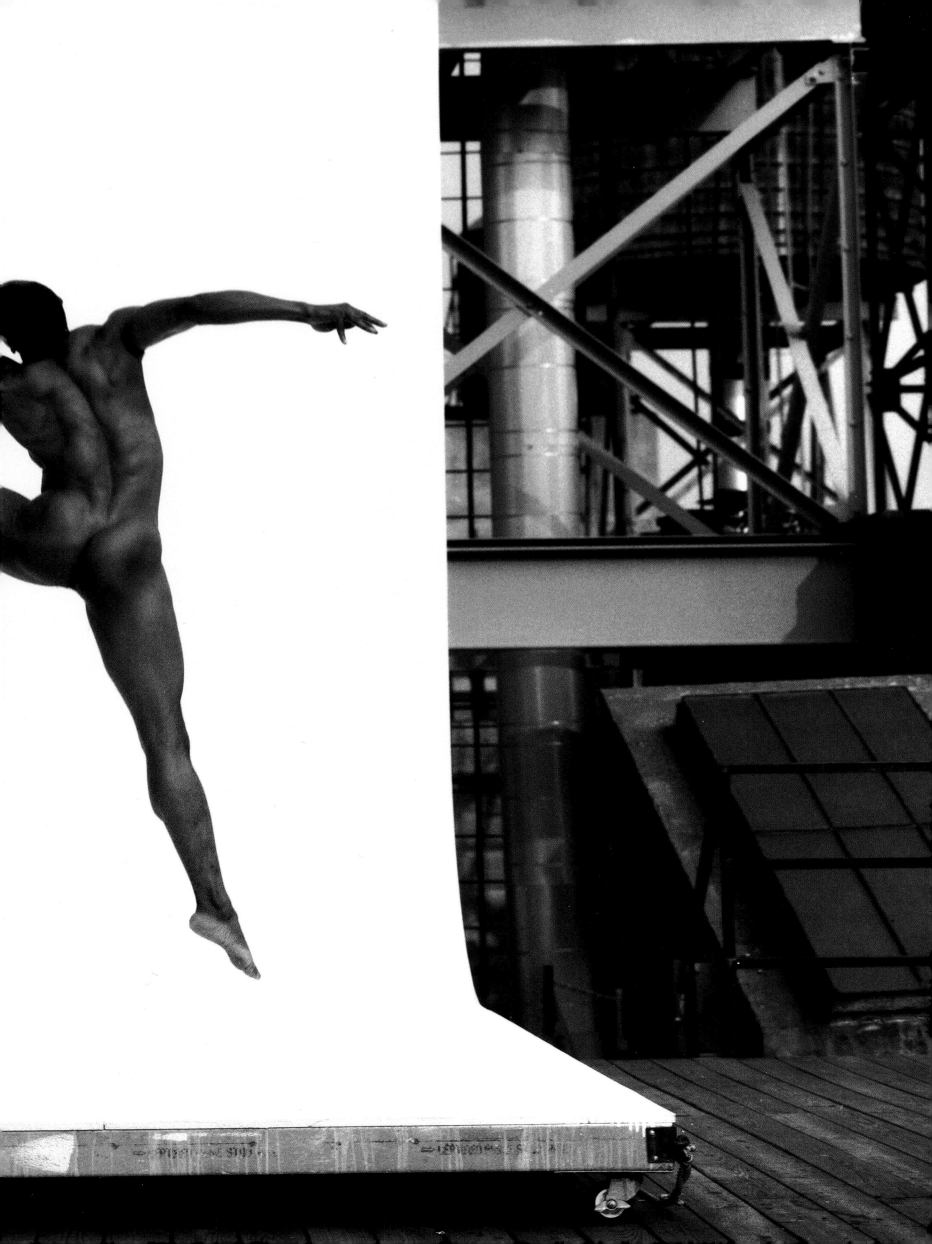

Arnold Schwarzenegger, Sun Valley, Idaho, 1997

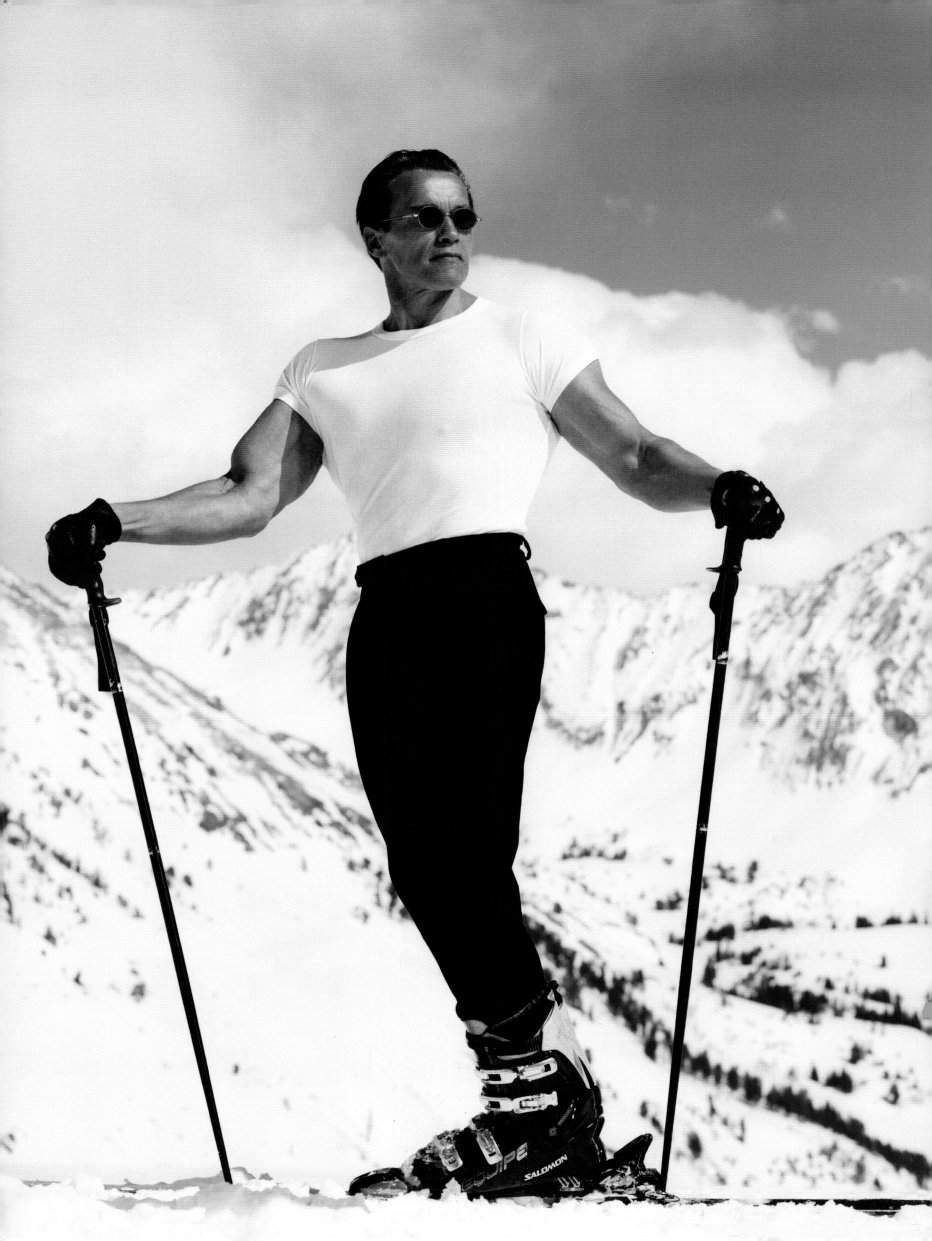

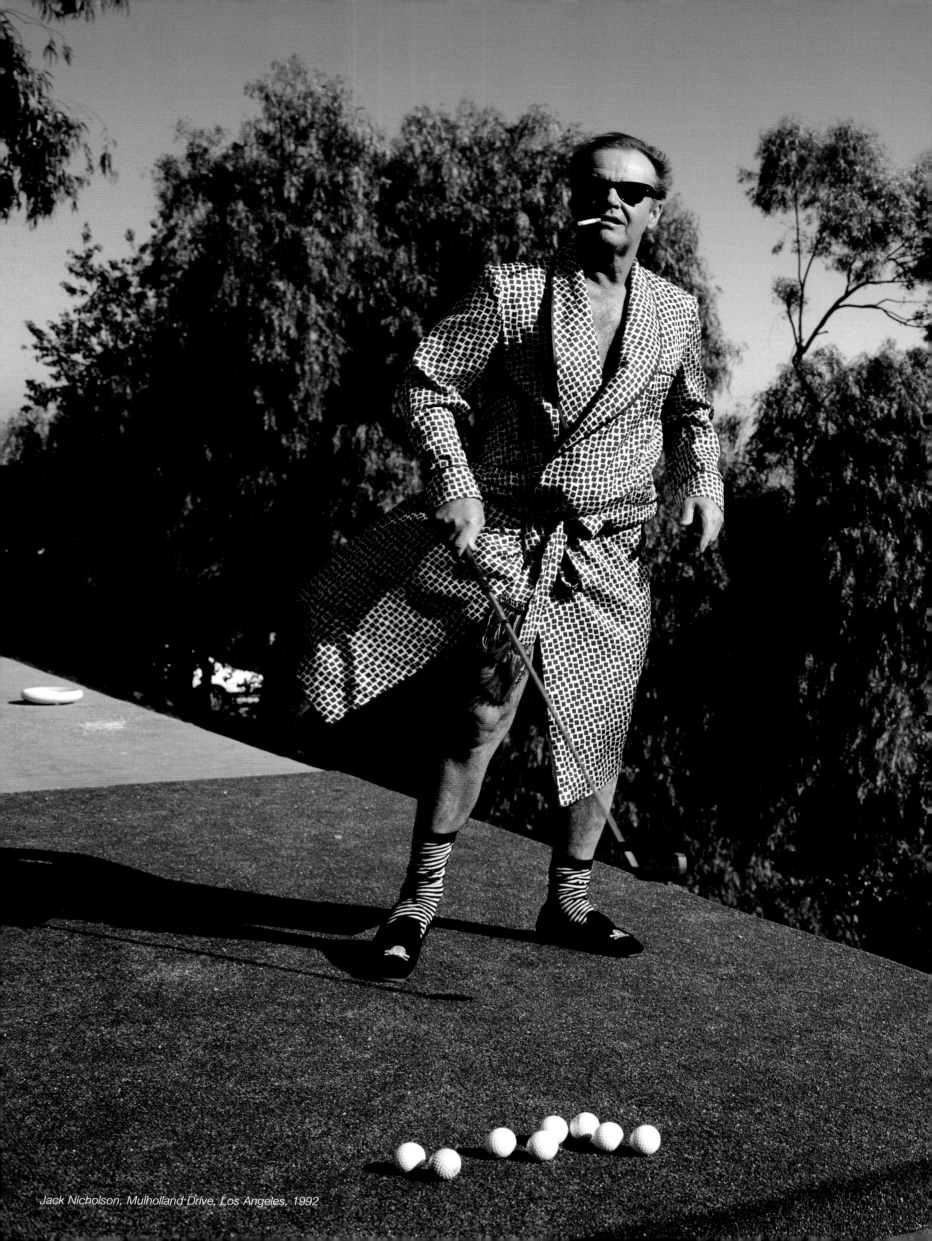

Jack Nicholson, Mulholland Drive, Los Angeles, 1992

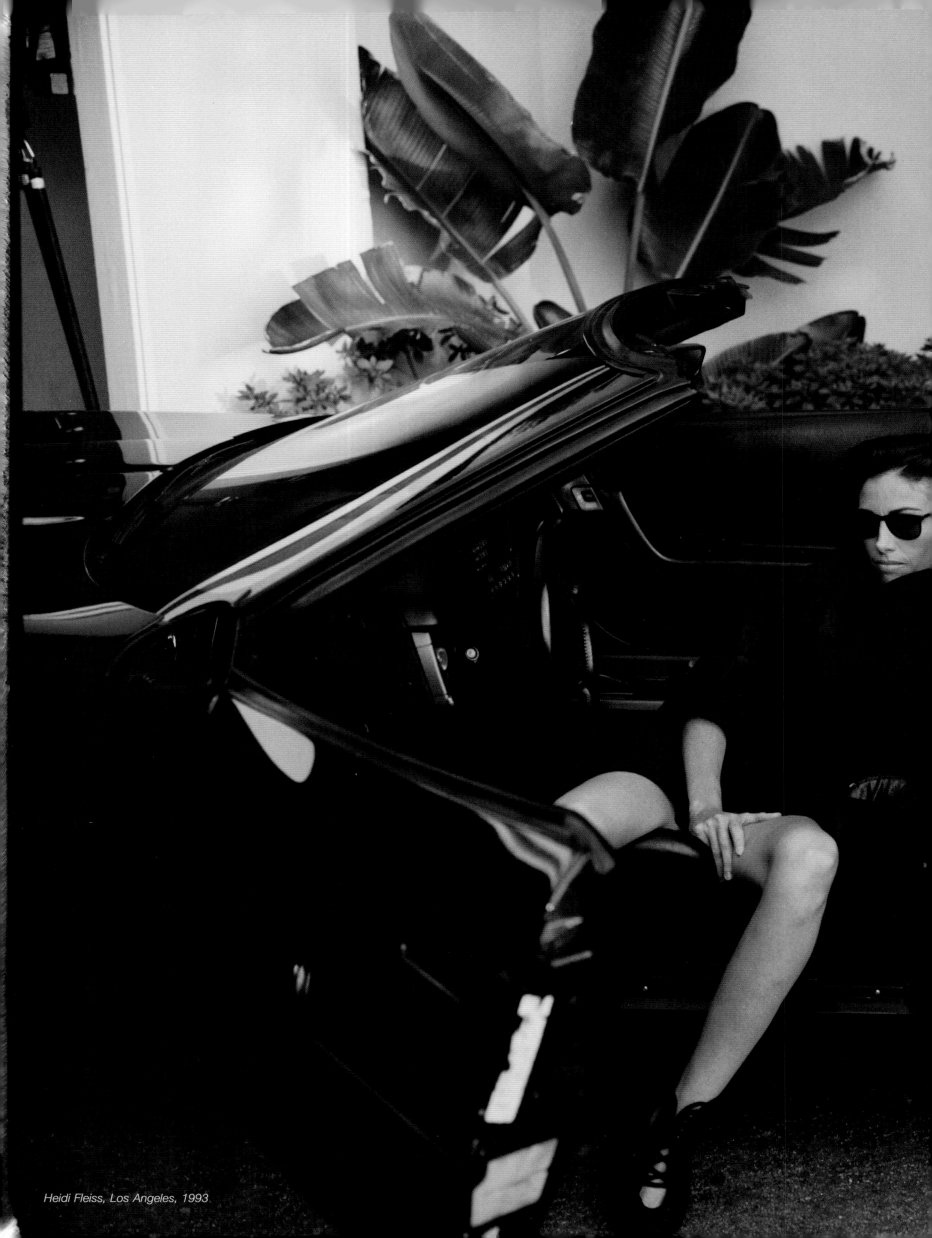

Heidi Fleiss, Los Angeles, 1993

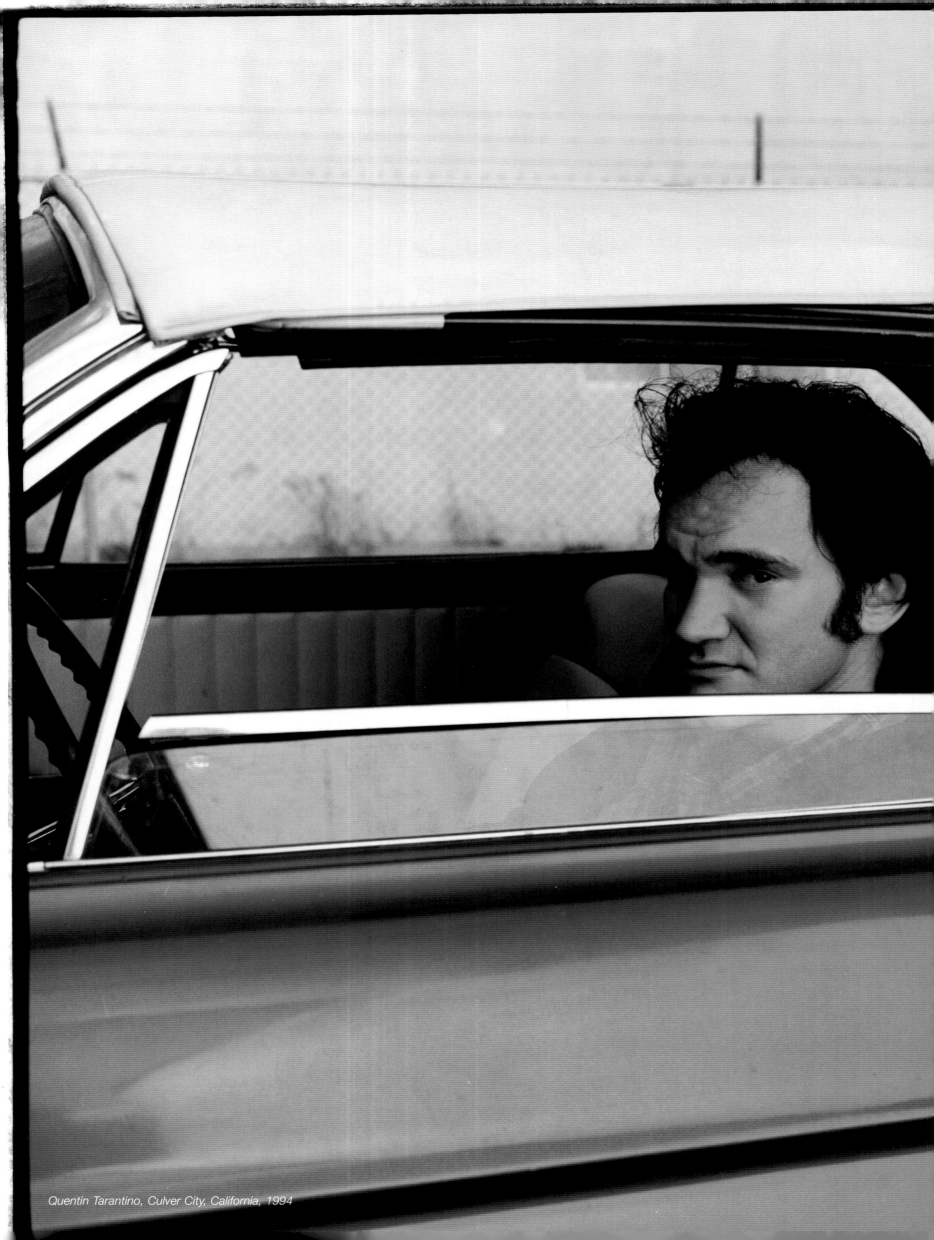

Quentin Tarantino, Culver City, California, 1994

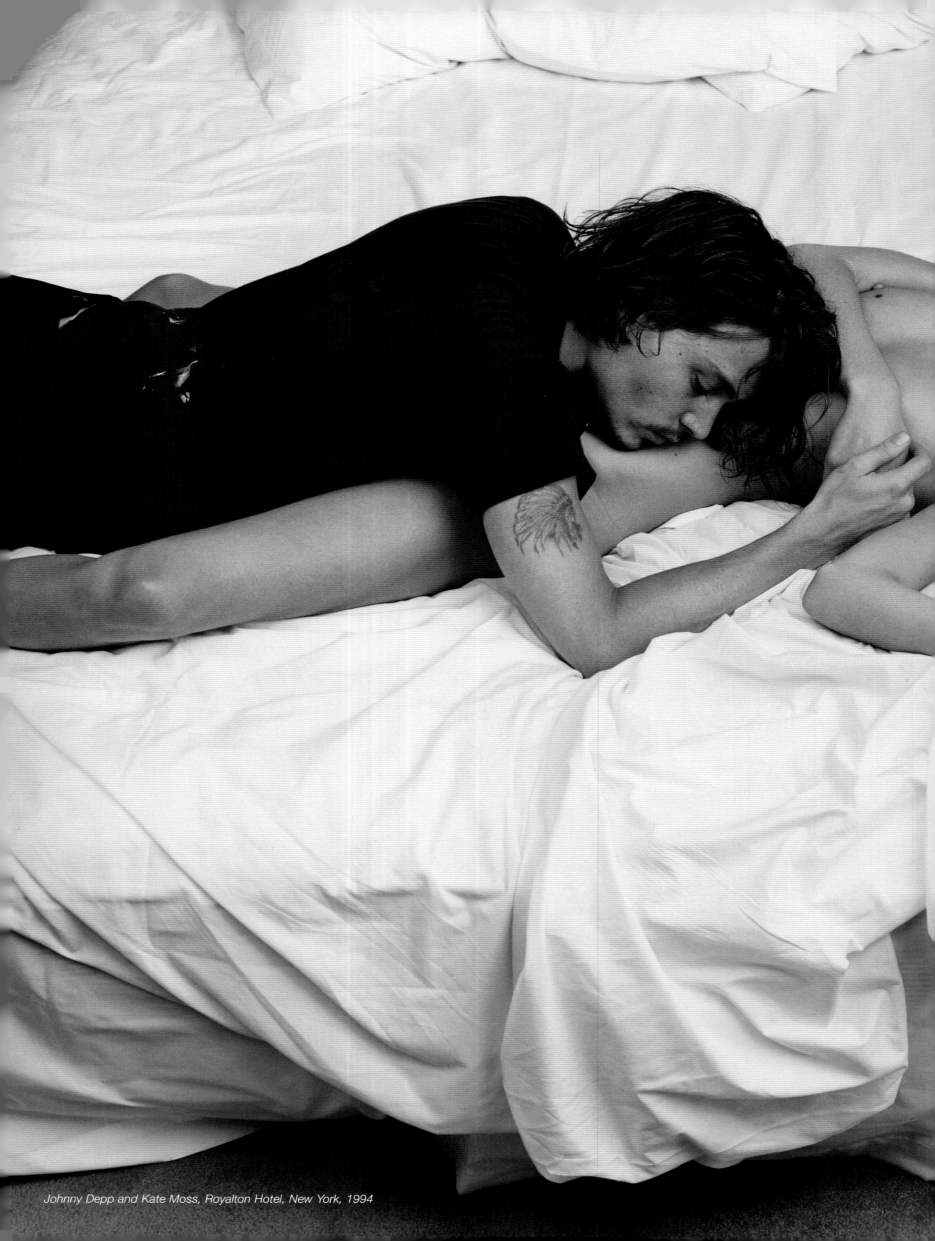

Johnny Depp and Kate Moss, Royalton Hotel, New York, 1994

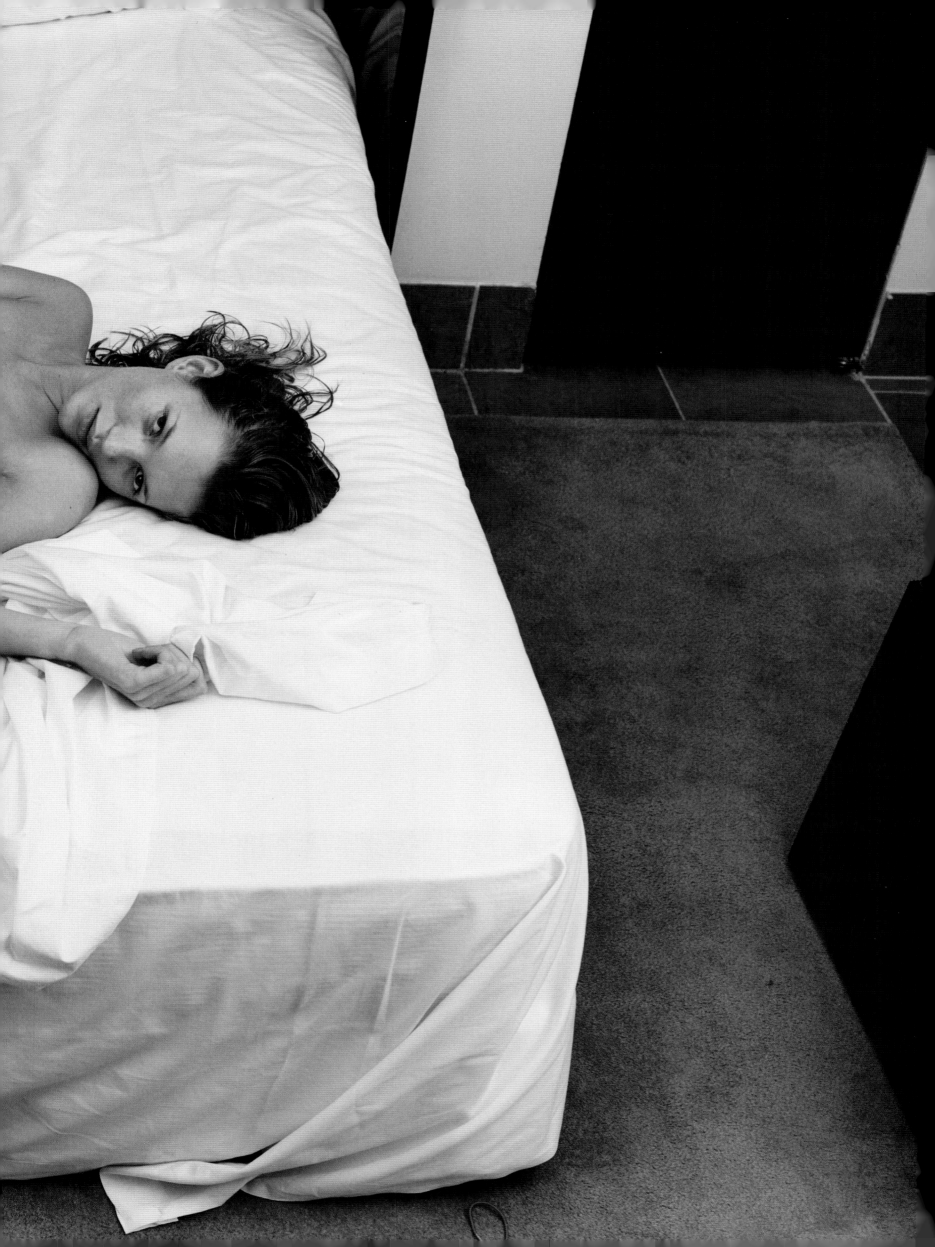

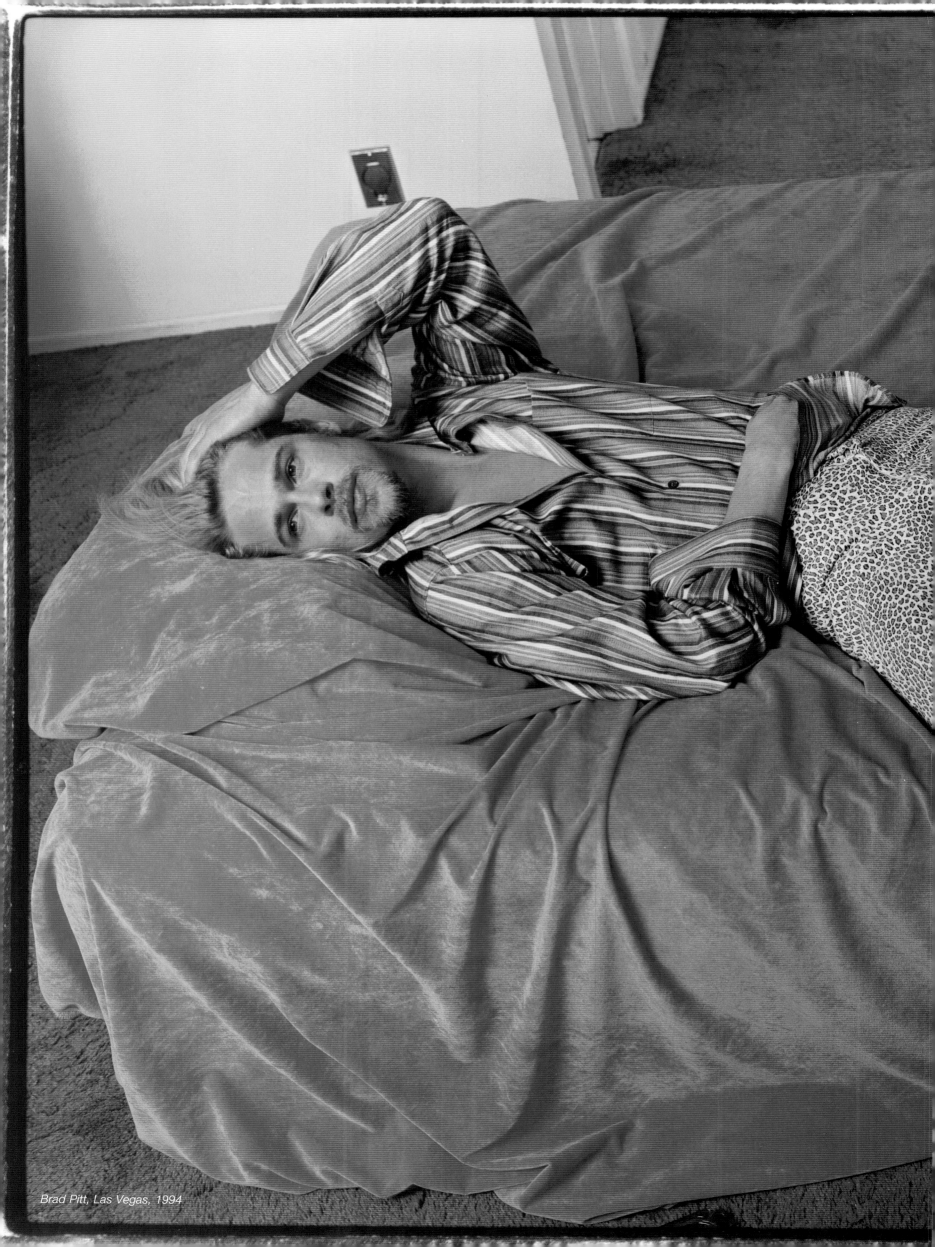

Brad Pitt, Las Vegas, 1994

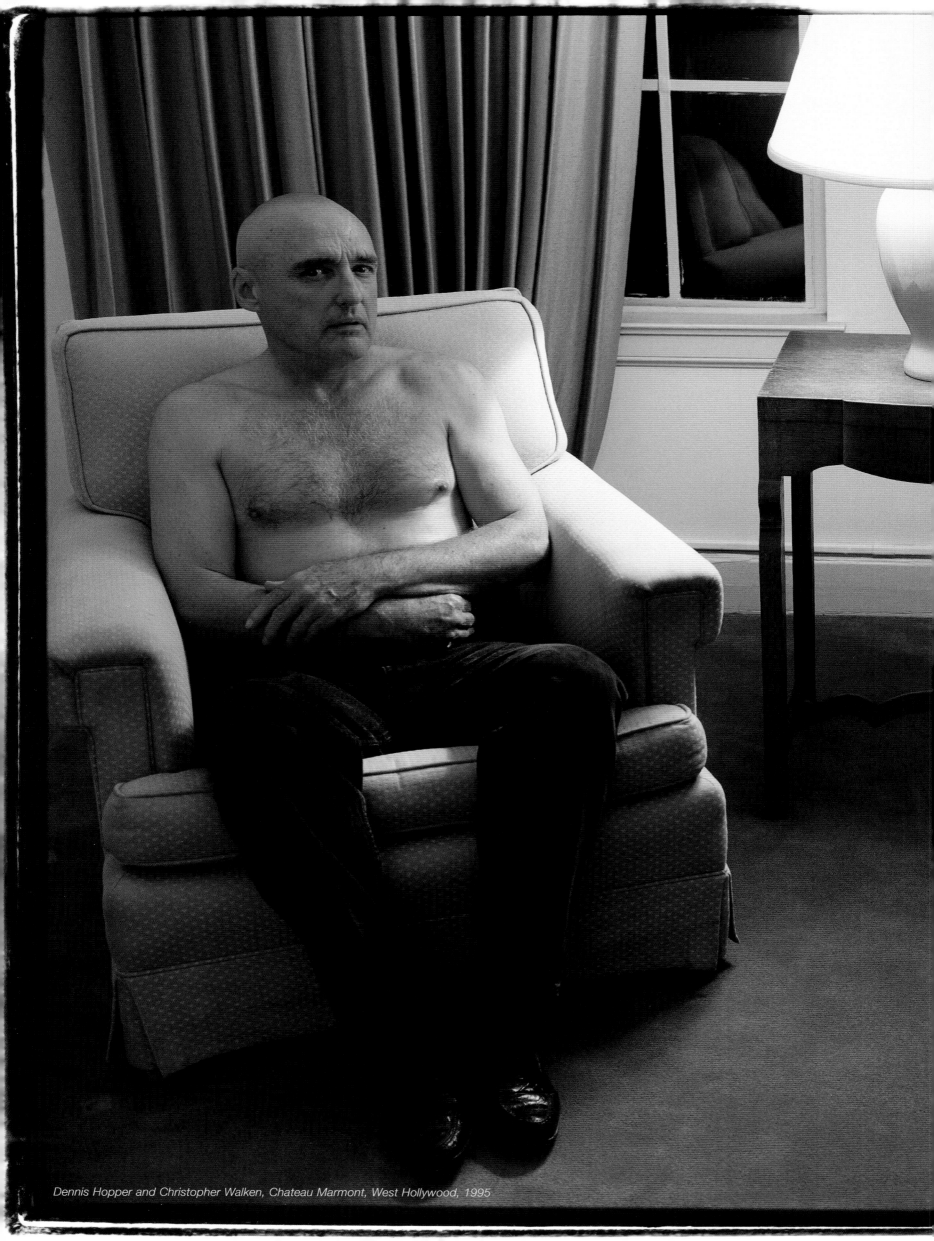

Dennis Hopper and Christopher Walken, Chateau Marmont, West Hollywood, 1995

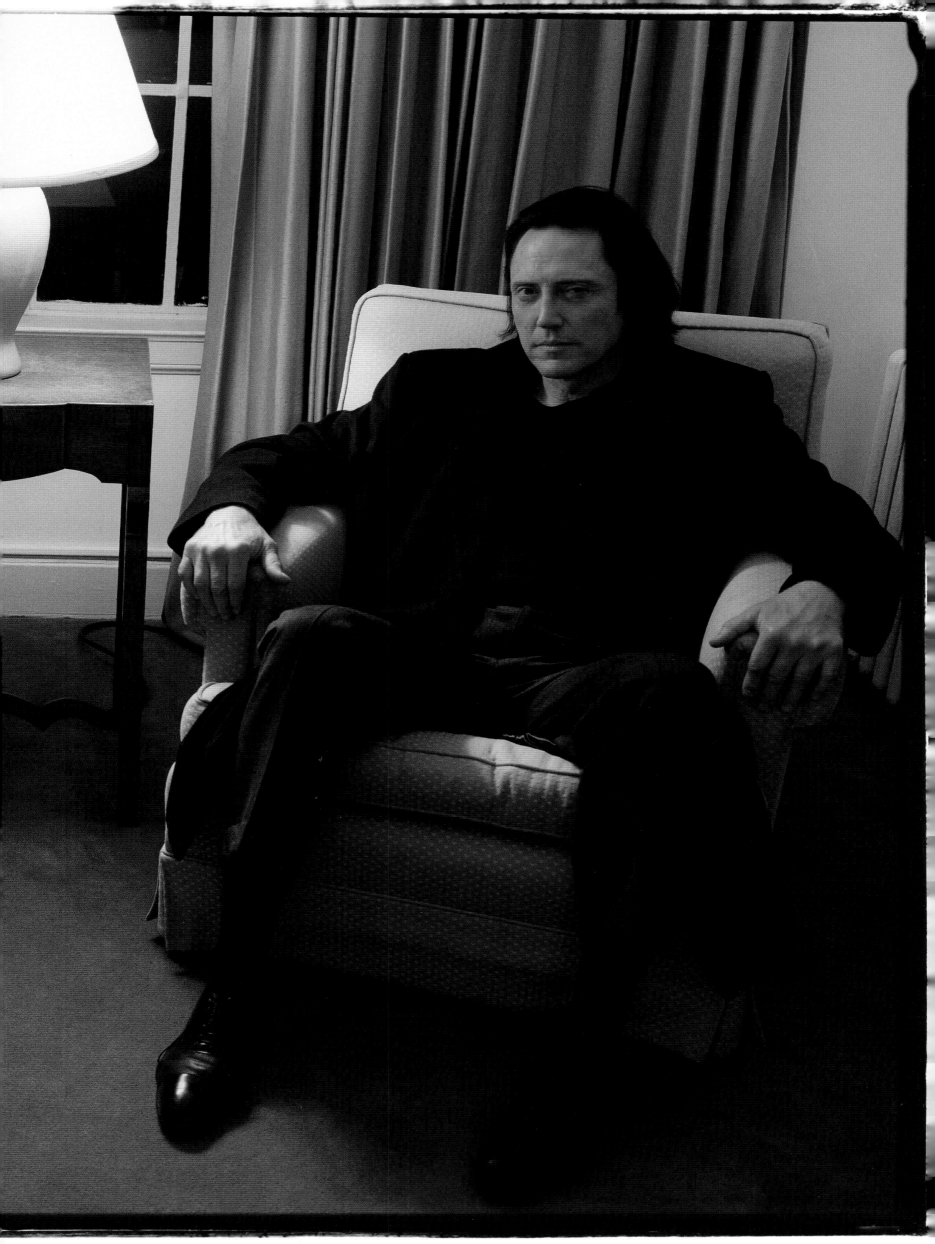

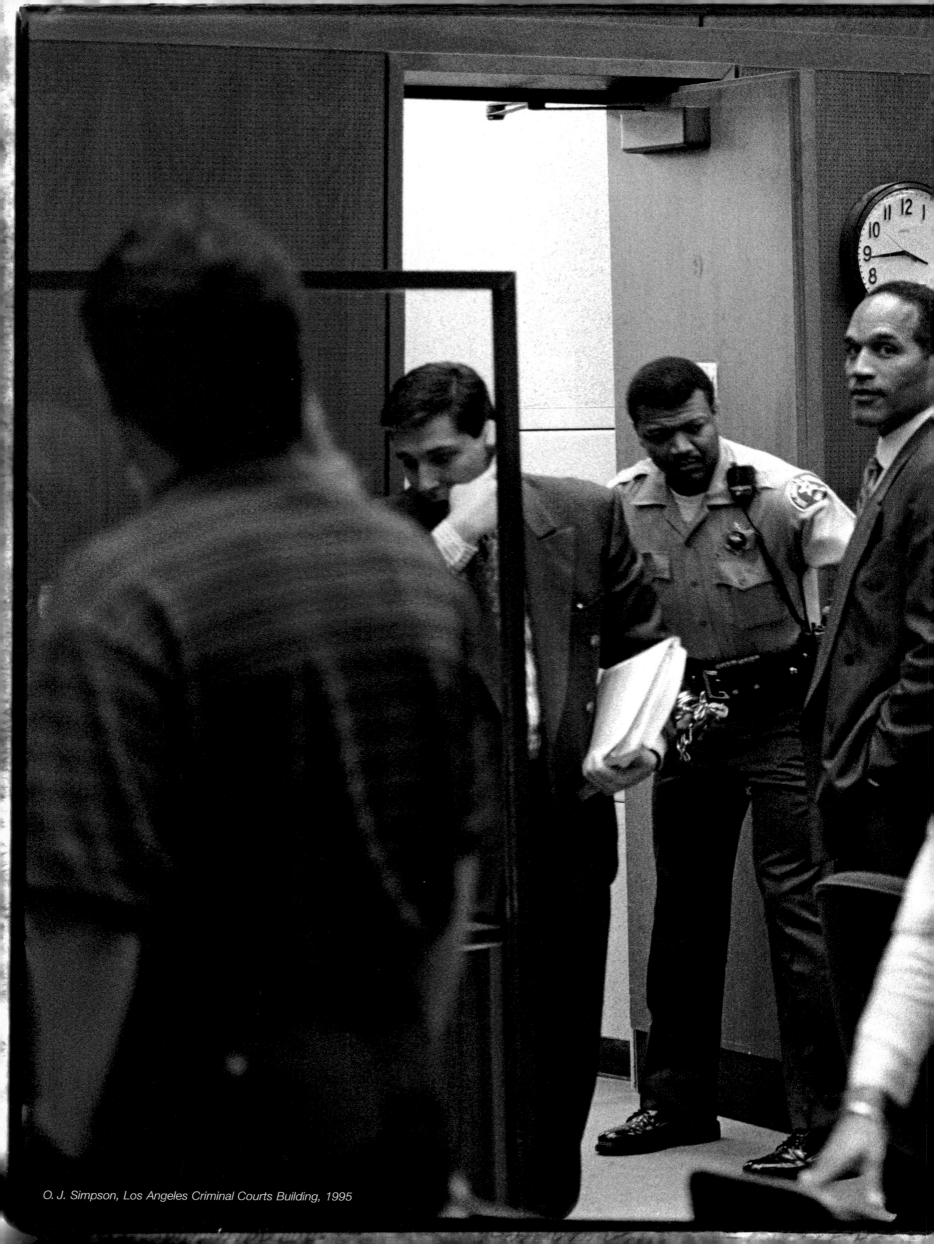

O. J. Simpson, Los Angeles Criminal Courts Building, 1995

Cable hookups for media coverage of O. J. Simpson trial,
Los Angeles Criminal Courts Building, 1995

Robert Wilson, Watermill Center,
Southampton, Long Island, New York, 1994

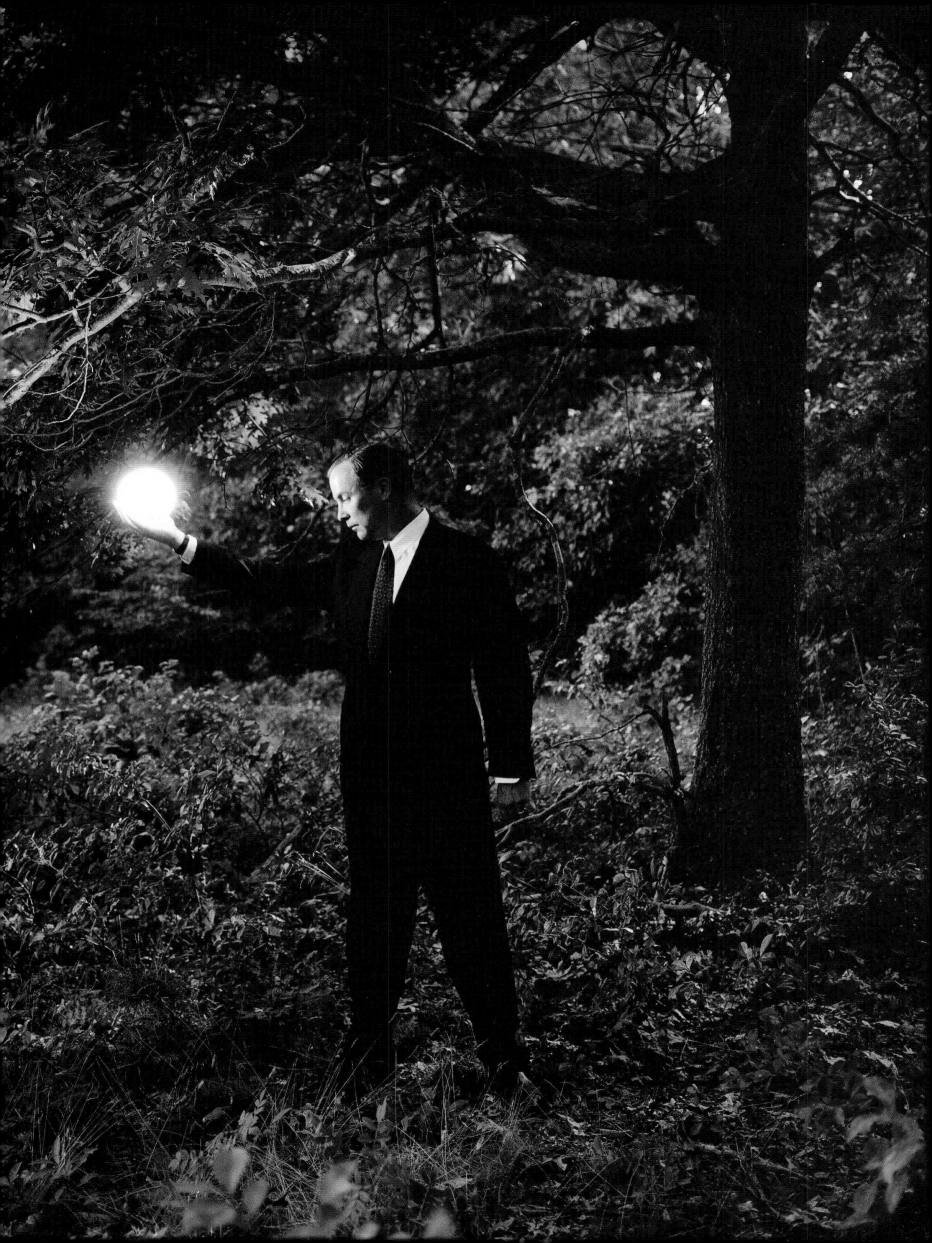

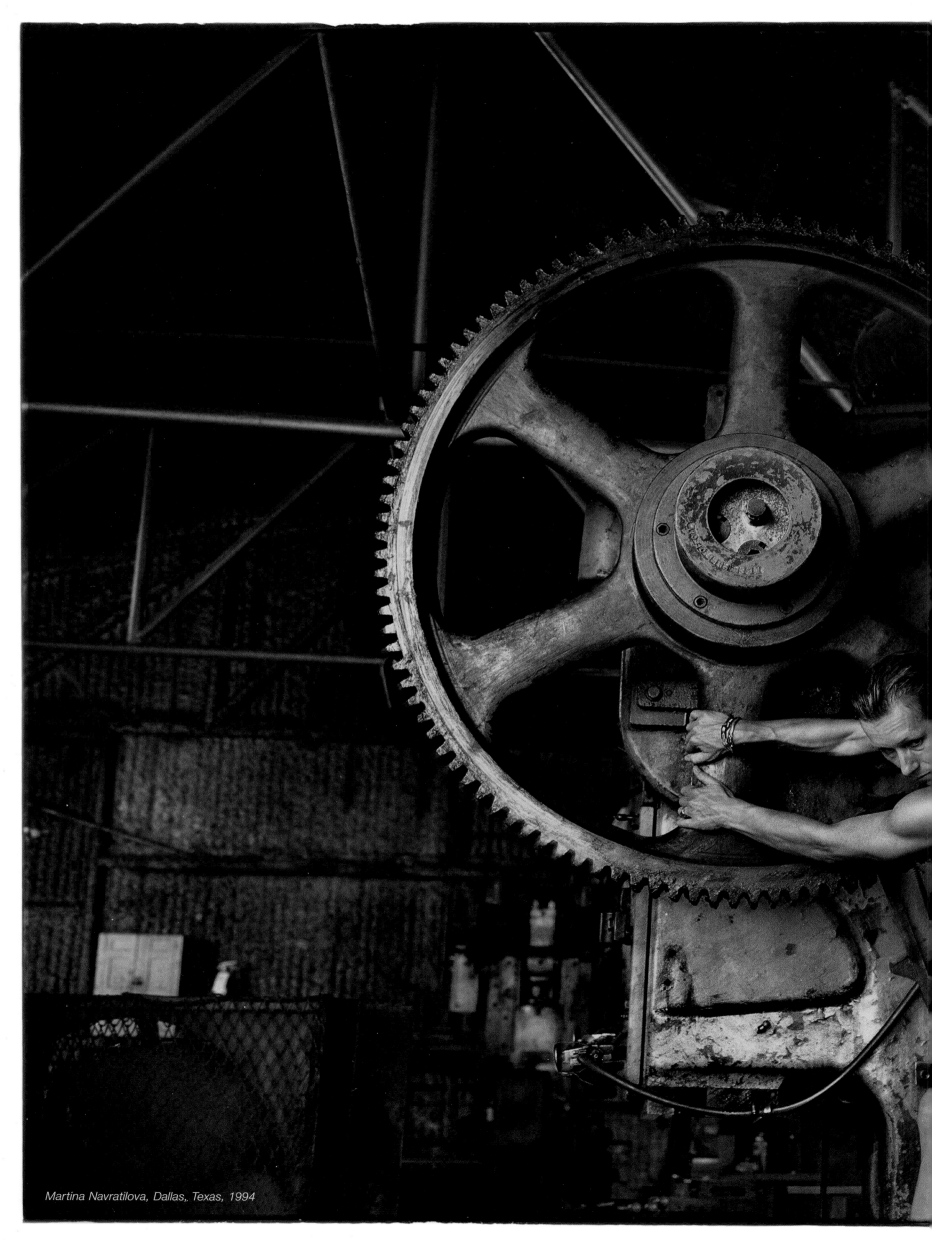

Martina Navratilova, Dallas, Texas, 1994

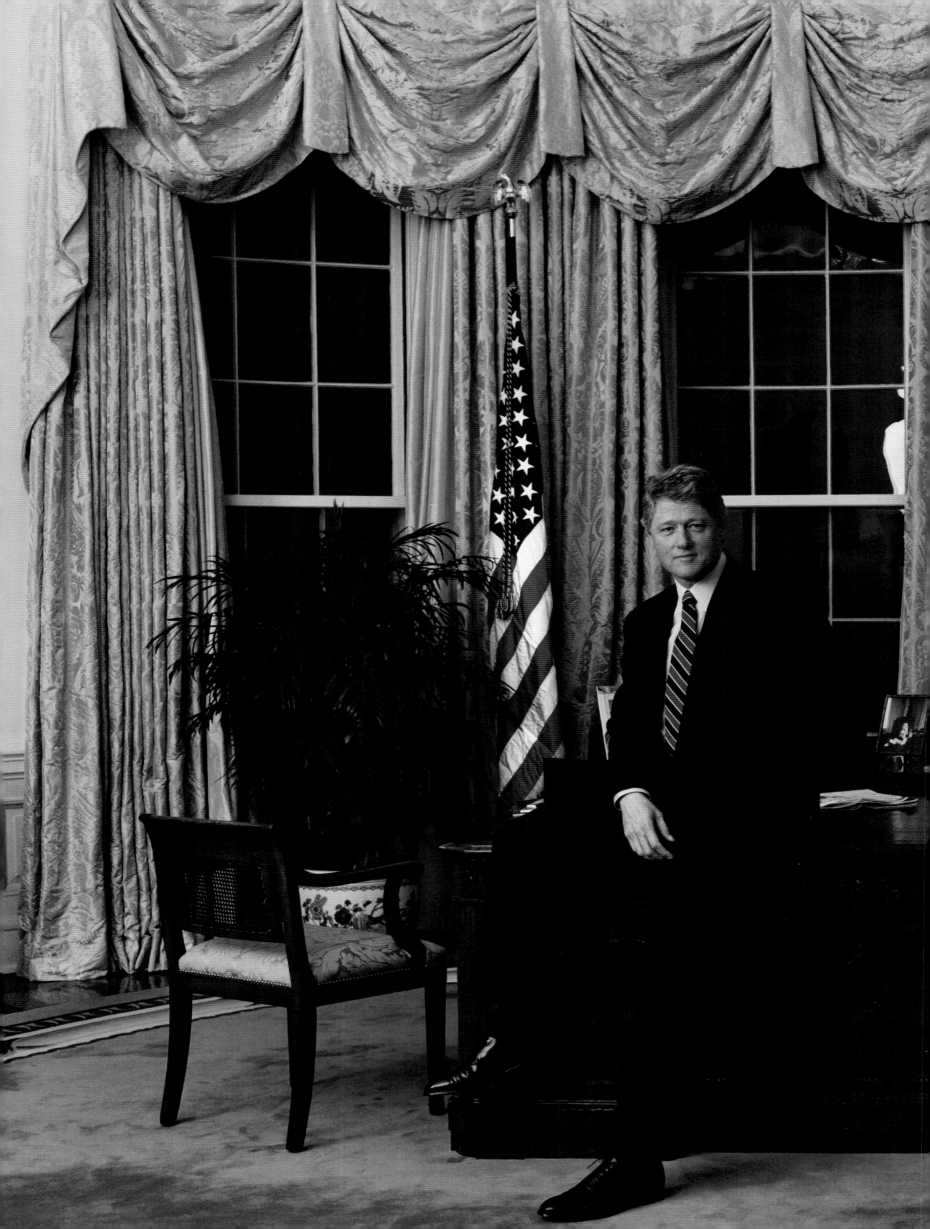

President William Jefferson Clinton,
Oval Office, the White House,
Washington, D.C., January 1993

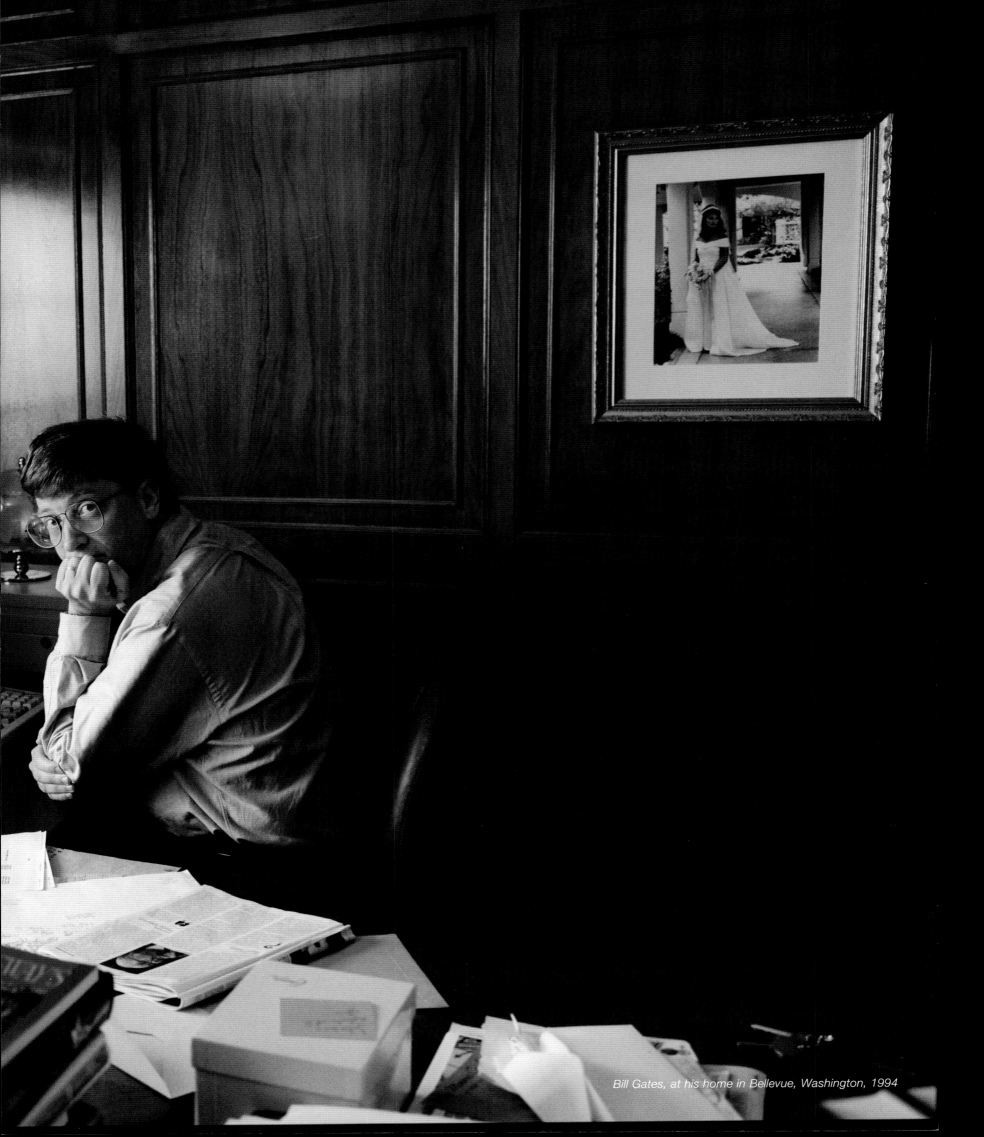

Bill Gates, at his home in Bellevue, Washington, 1994

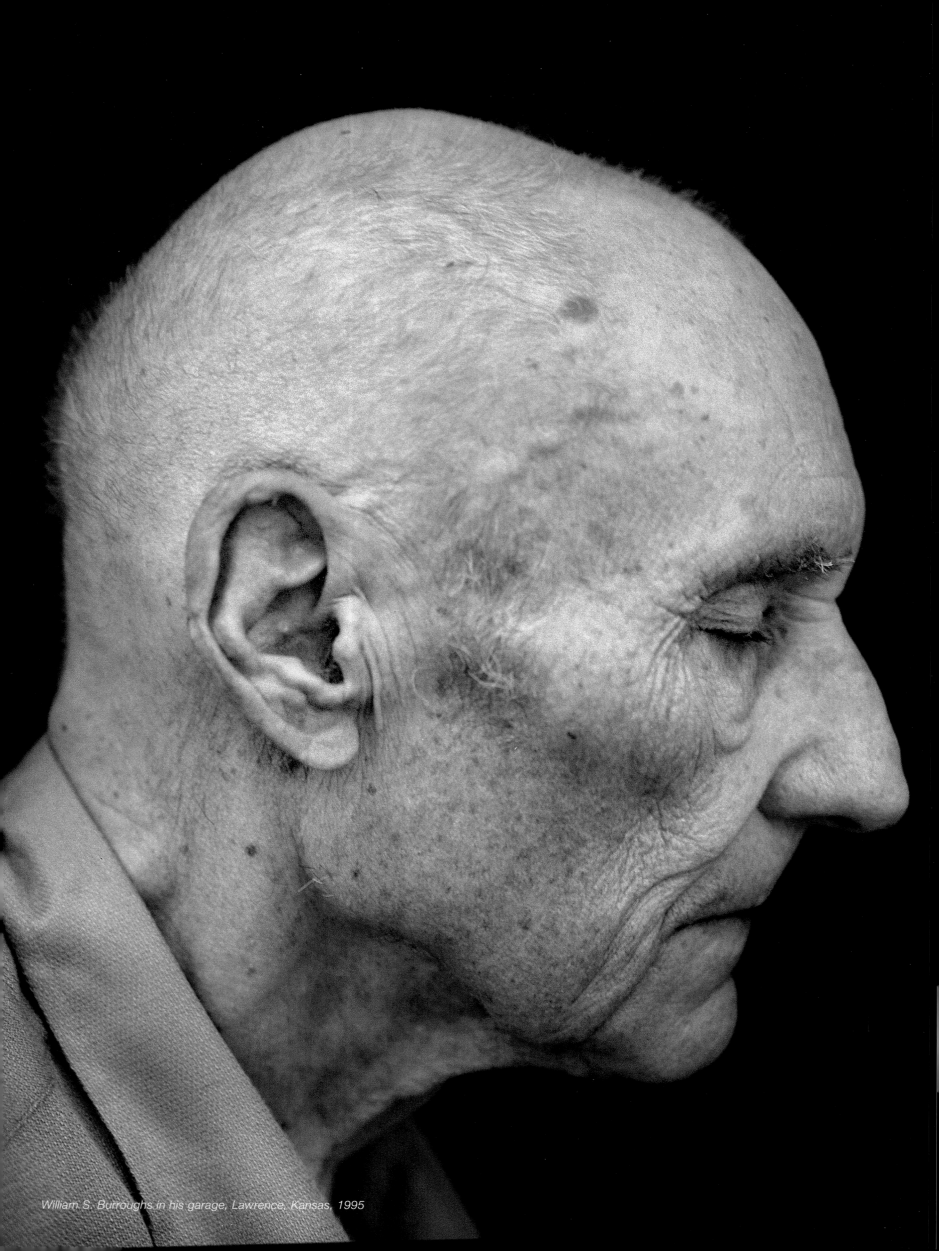

William S. Burroughs in his garage, Lawrence, Kansas, 1995

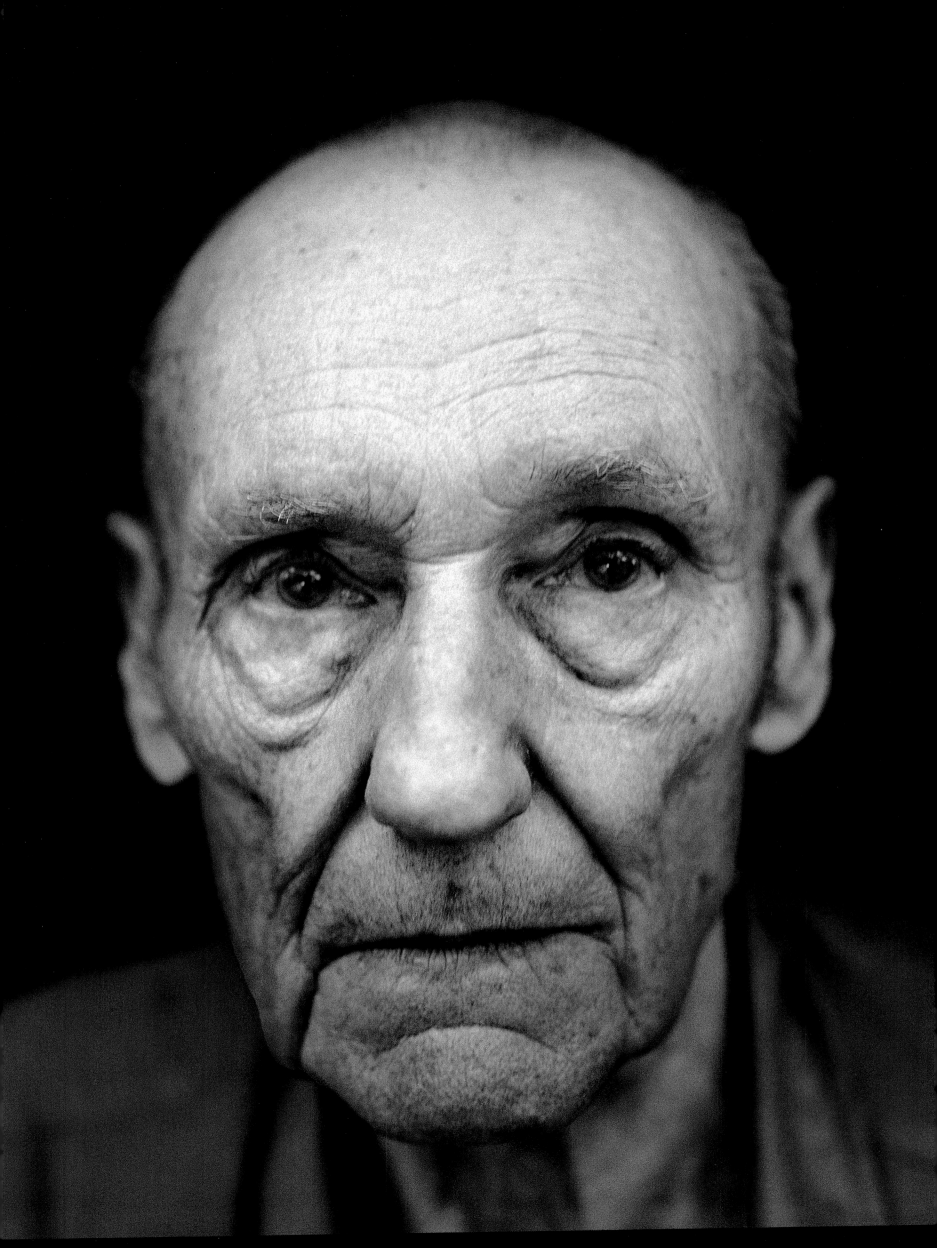

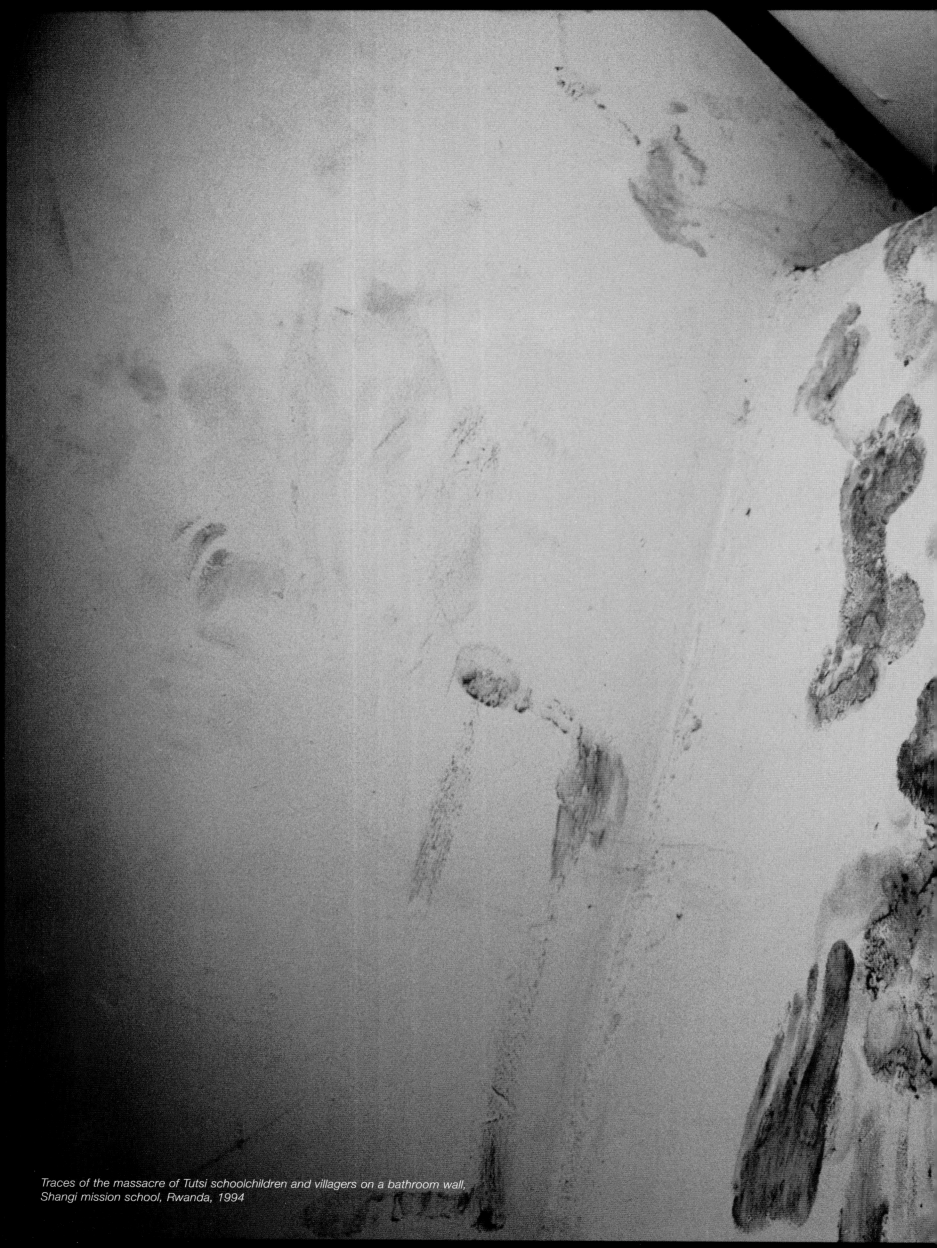

Traces of the massacre of Tutsi schoolchildren and villagers on a bathroom wall,
Shangi mission school, Rwanda, 1994

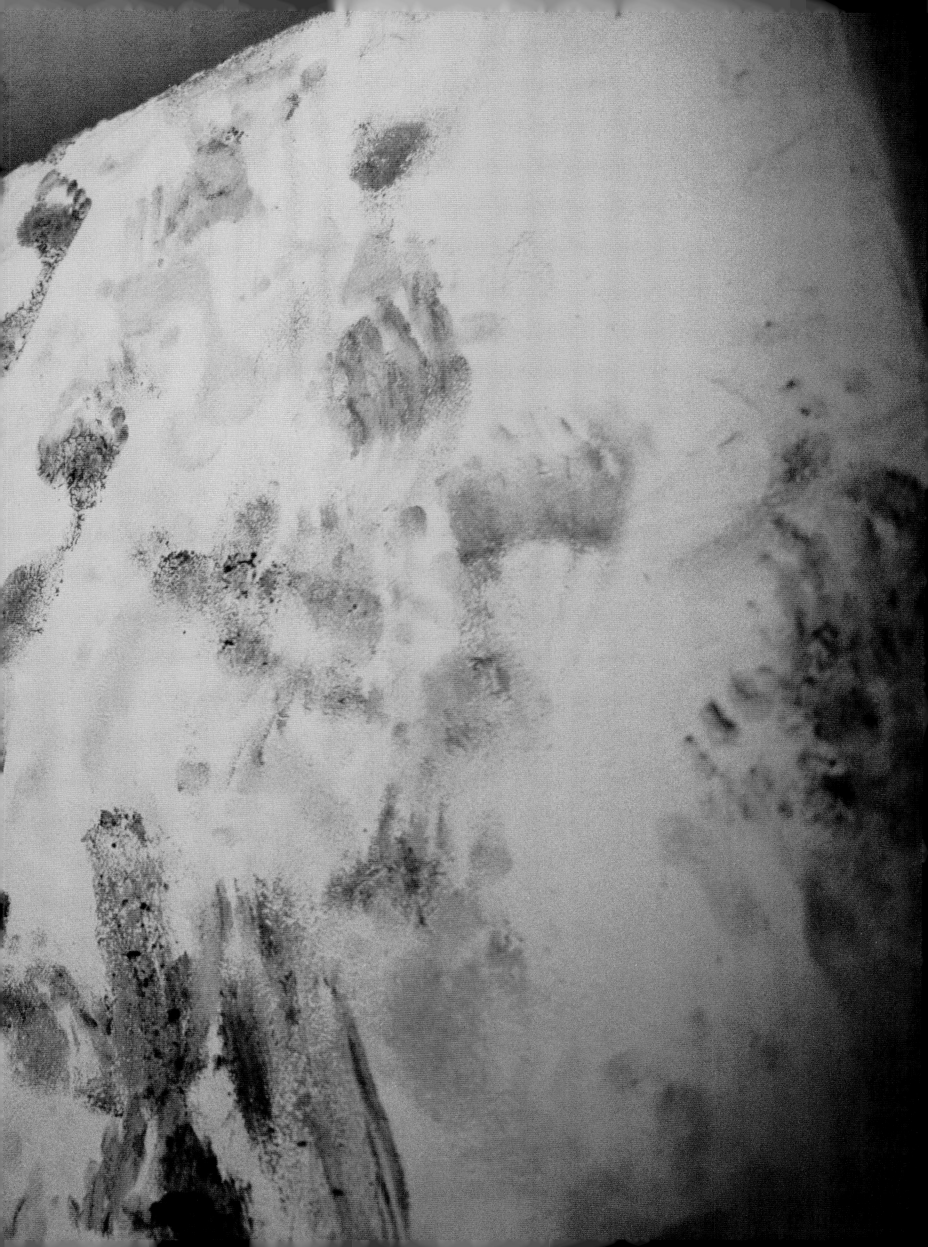

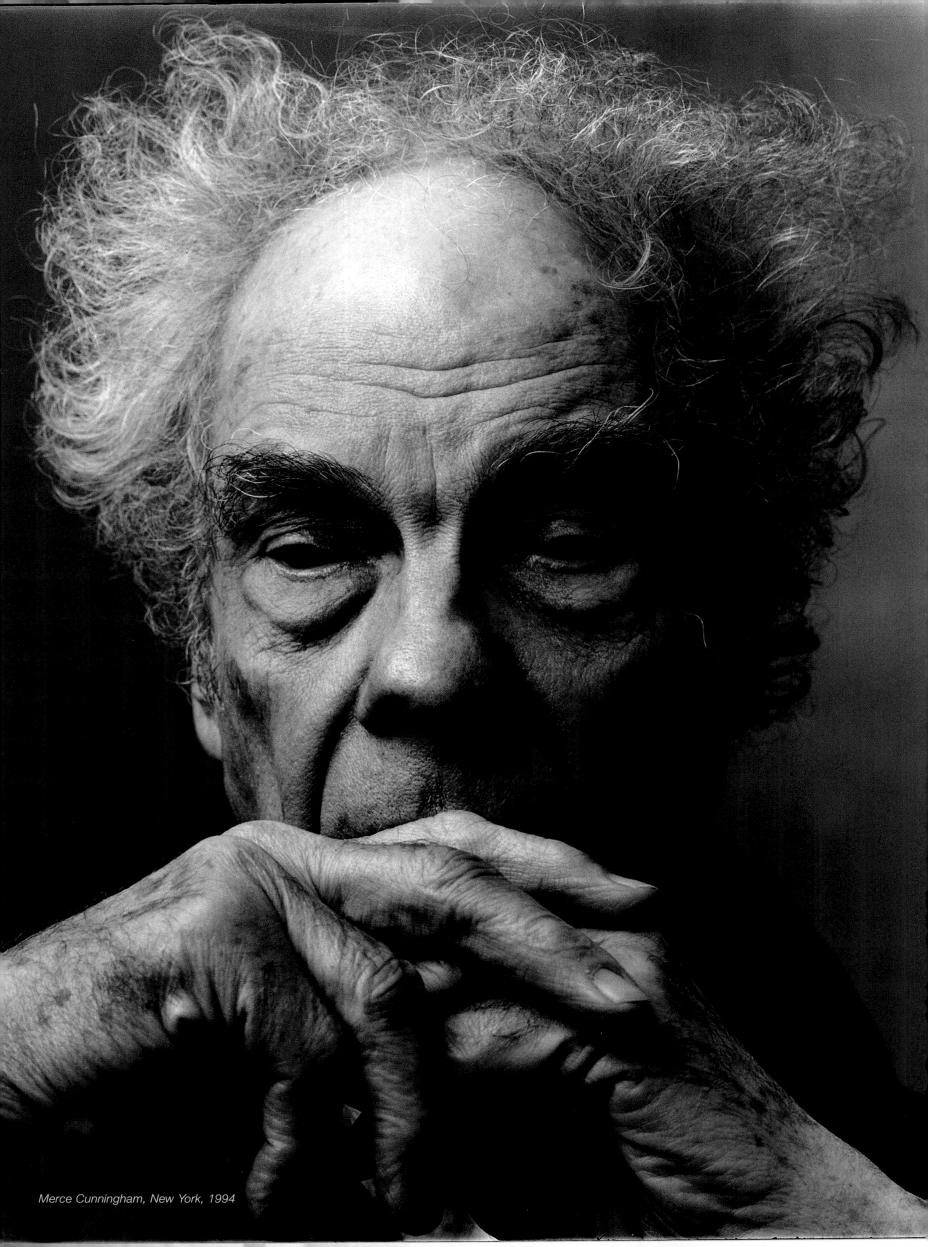

Merce Cunningham, New York, 1994

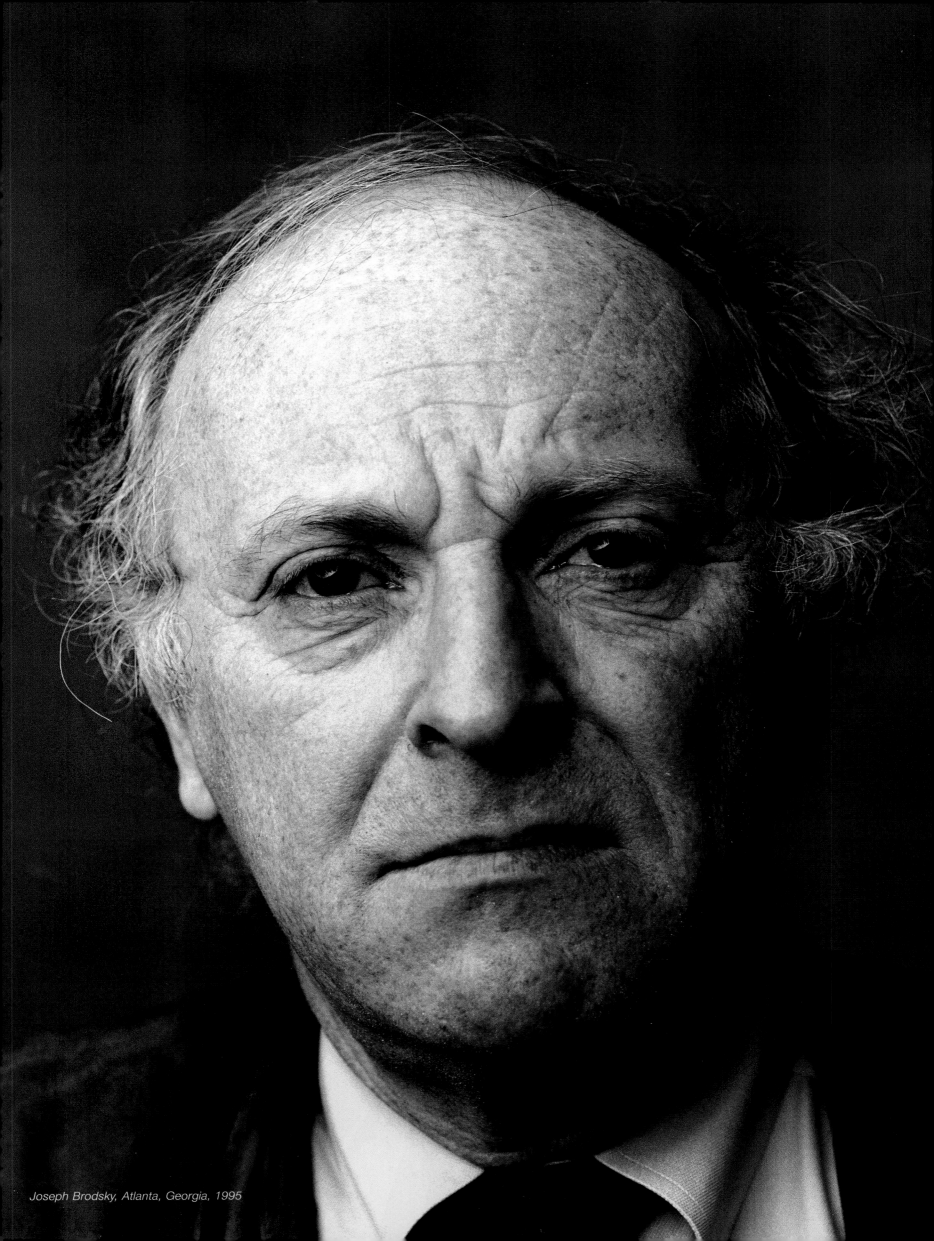

Joseph Brodsky, Atlanta, Georgia, 1995

Susan with Howard Hodgkin and Antony Peattie, Venice, December 1994

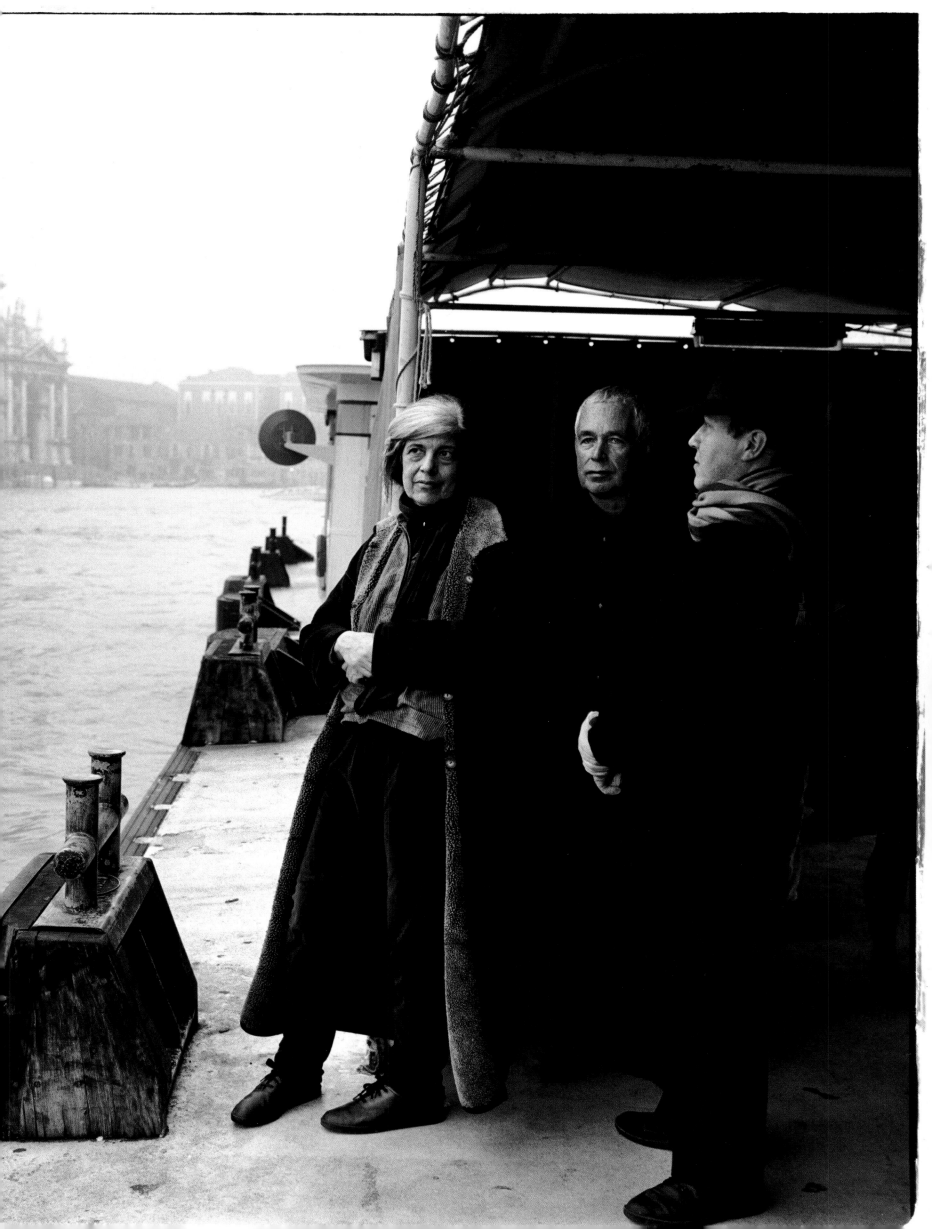

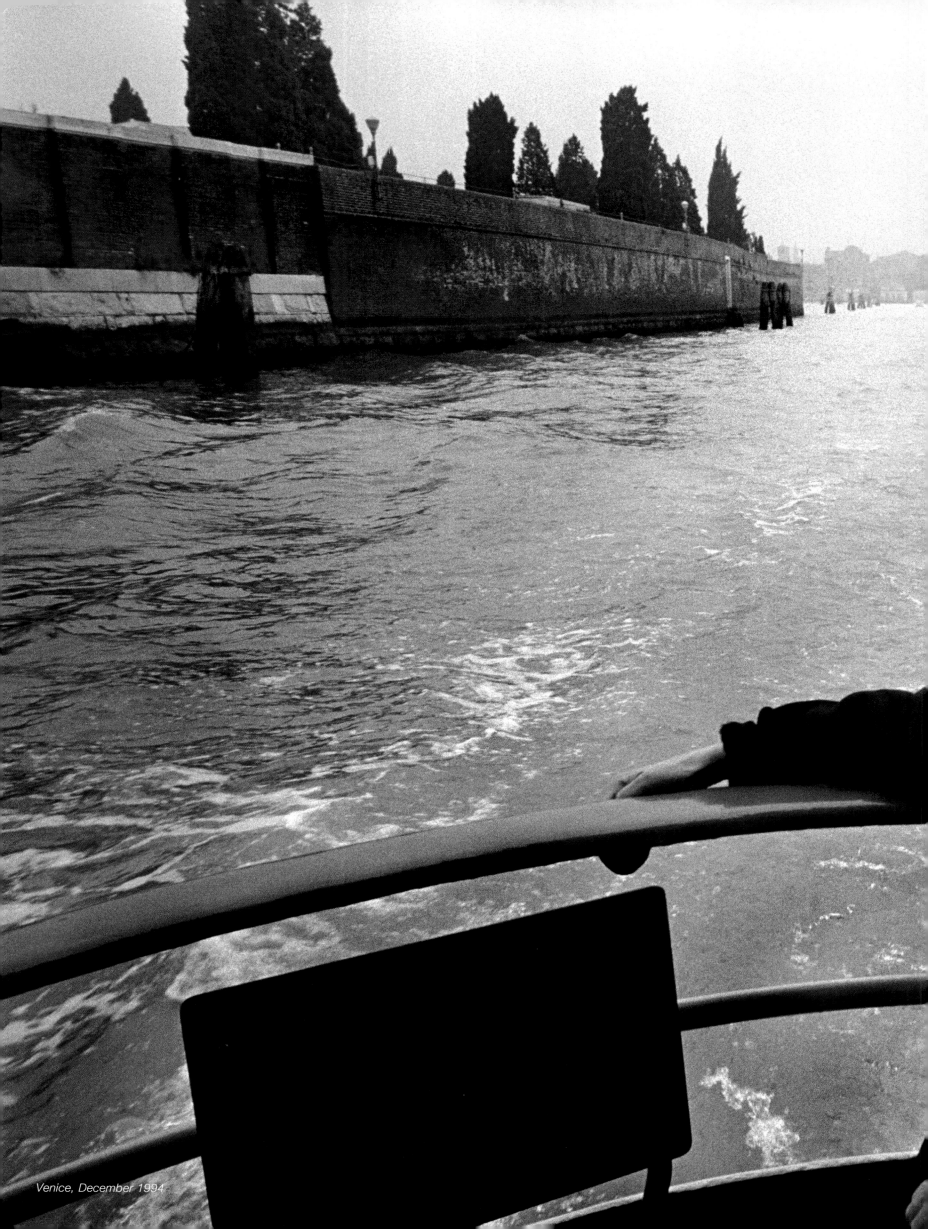

Venice, December 1994

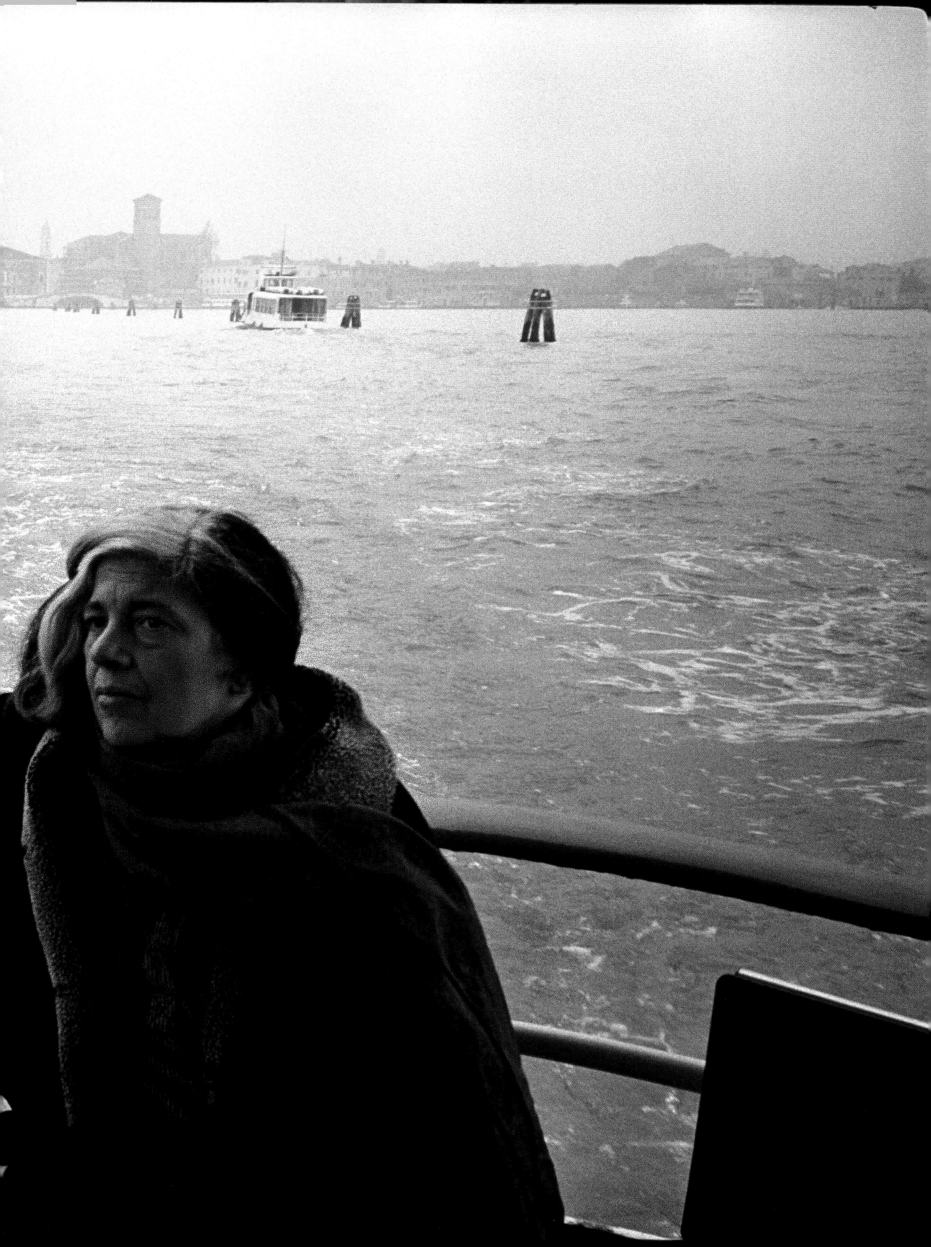

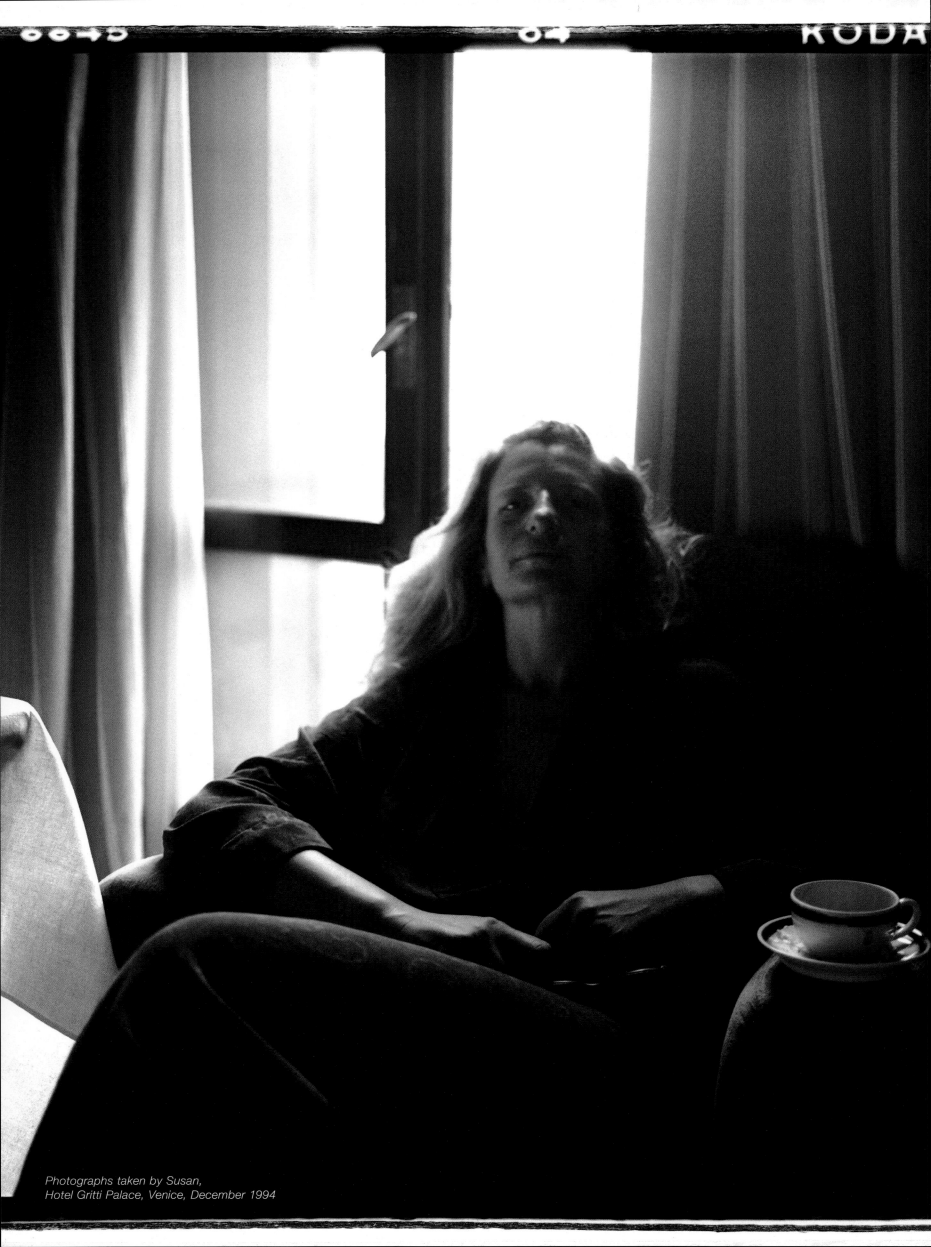

*Photographs taken by Susan,
Hotel Gritti Palace, Venice, December 1994*

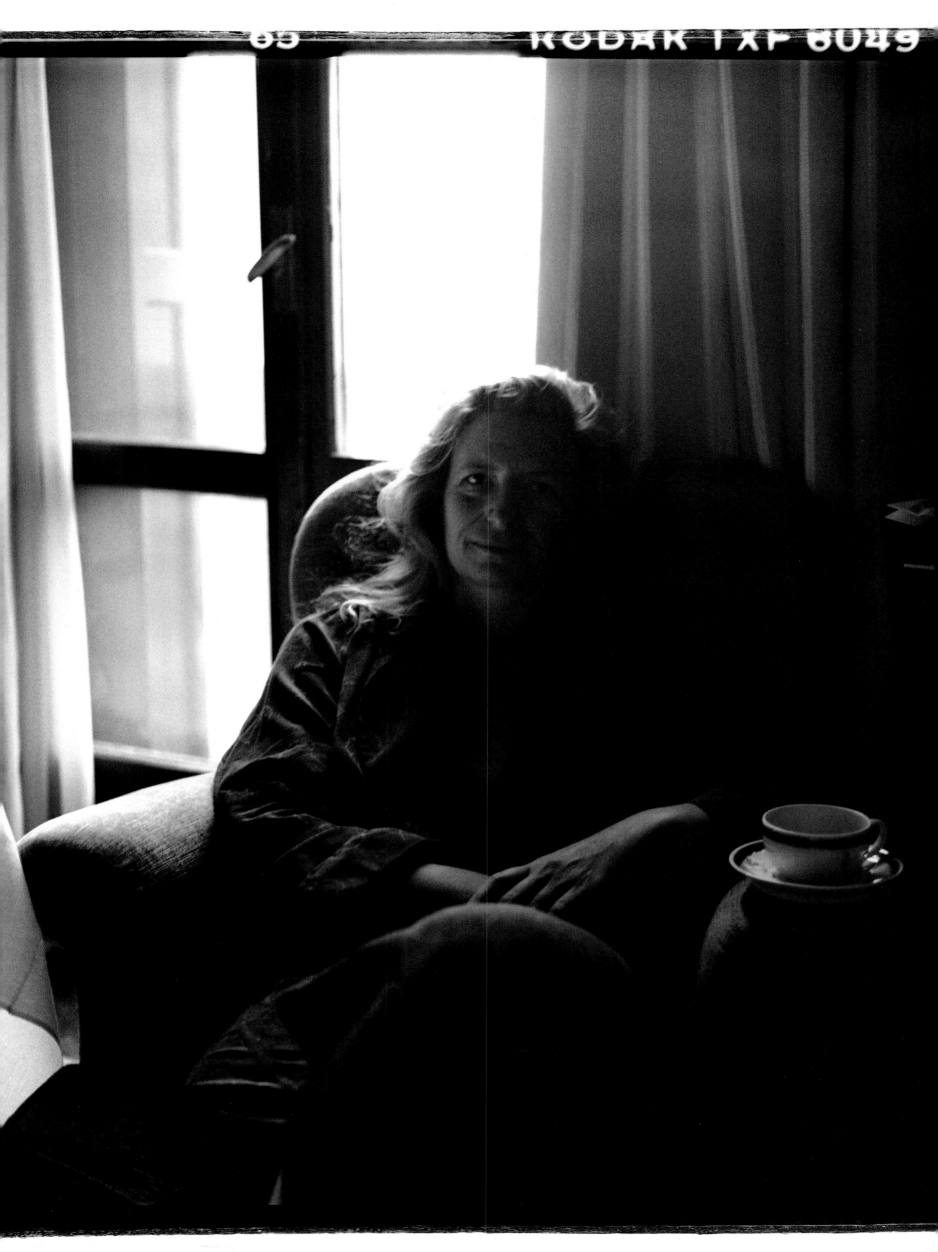

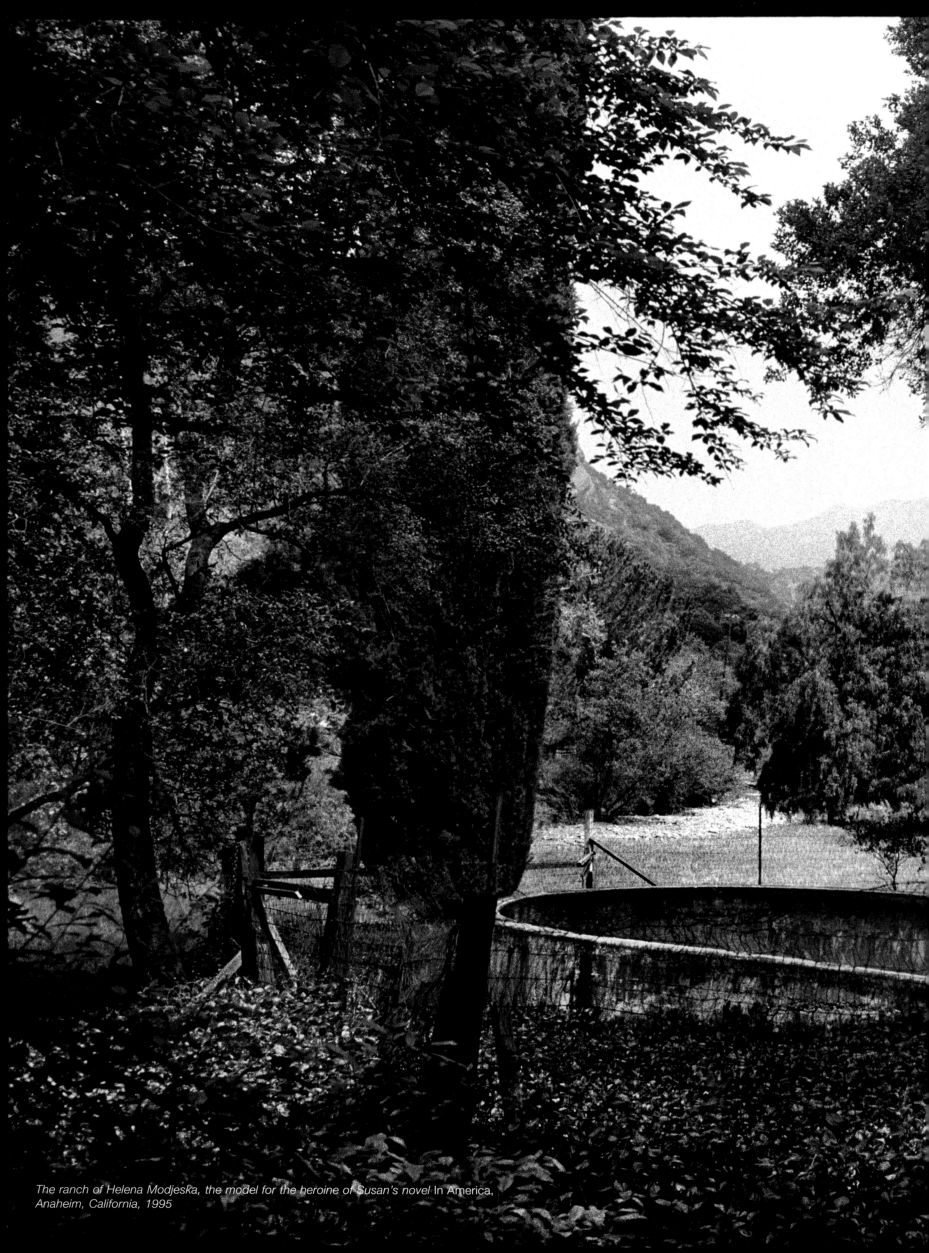

The ranch of Helena Modjeska, the model for the heroine of Susan's novel In America, *Anaheim, California, 1995*

Susan at Helena Modjeska's ranch, Anaheim, 1995

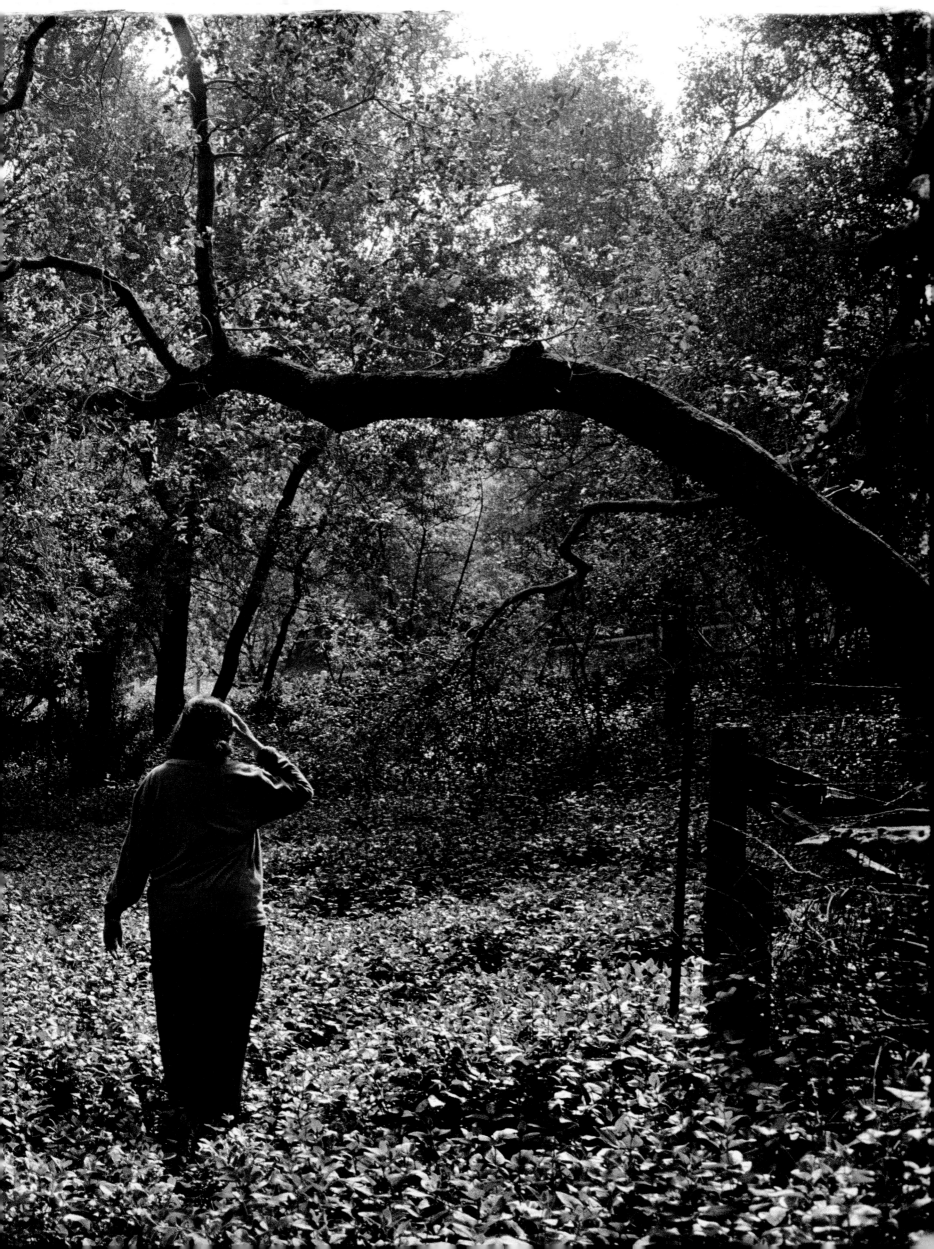

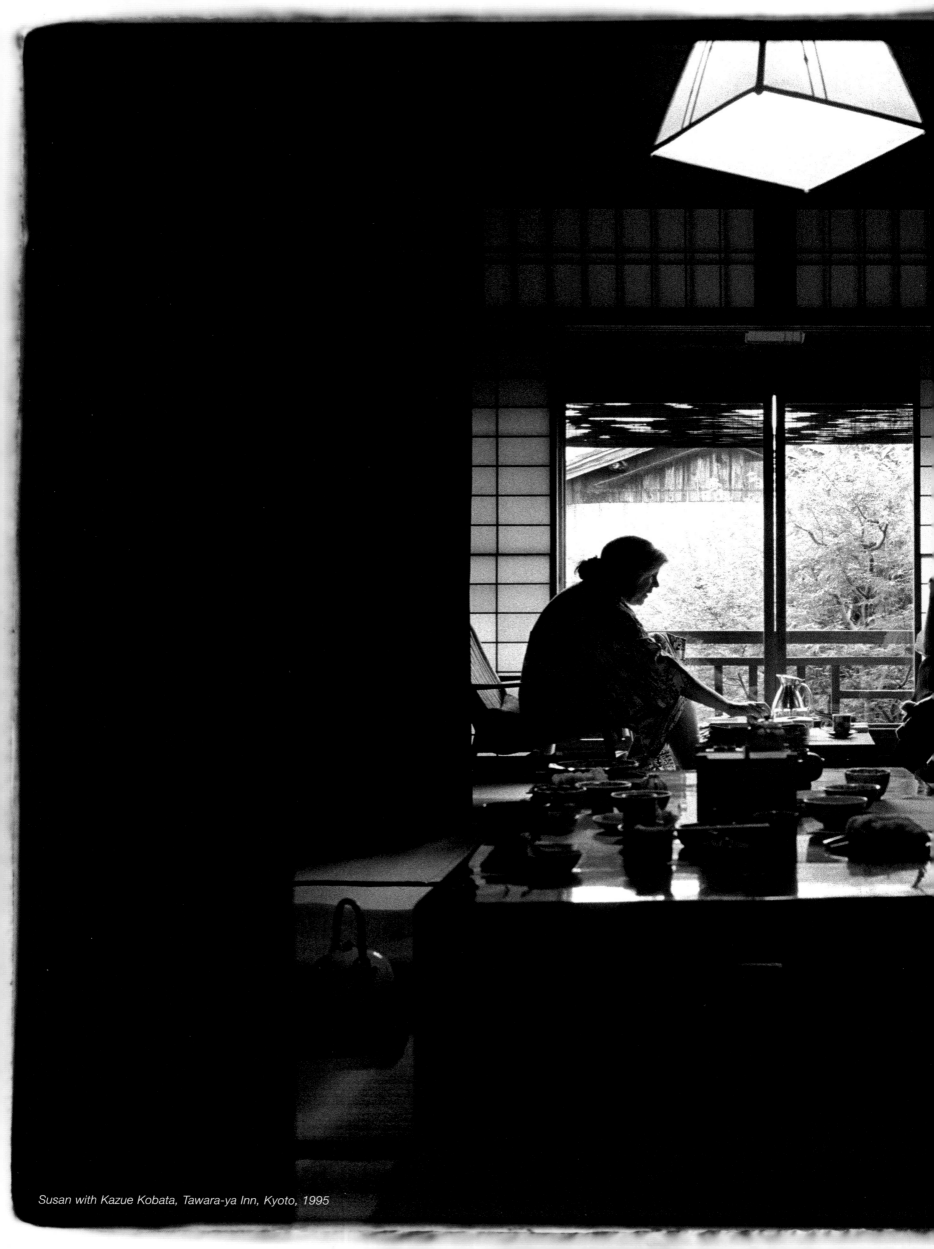

Susan with Kazue Kobata, Tawara-ya Inn, Kyoto, 1995

Min Tanaka, PS1, Long Island City, New York, 1988

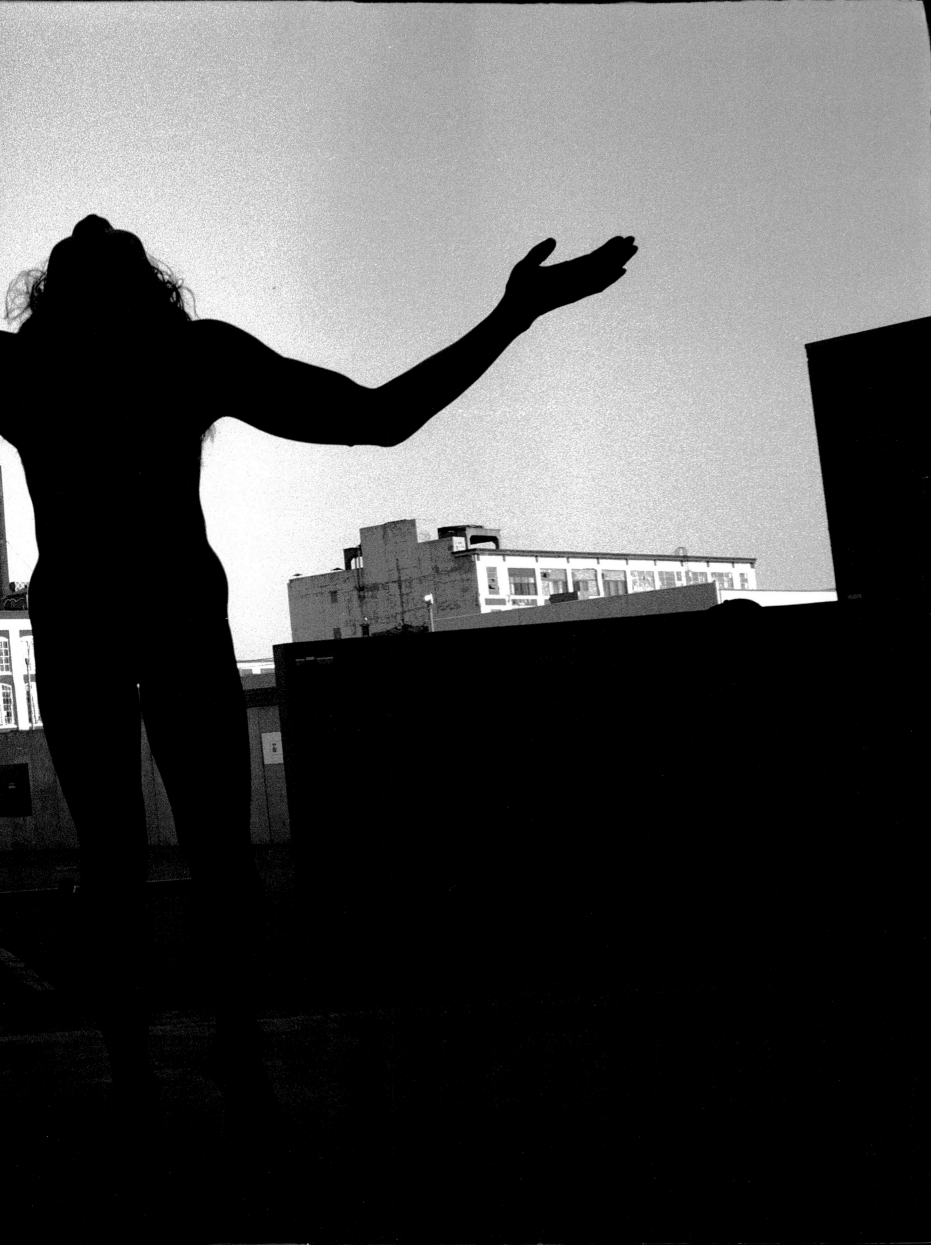

Matthew Barney, Hotel New York, Rotterdam, 1995

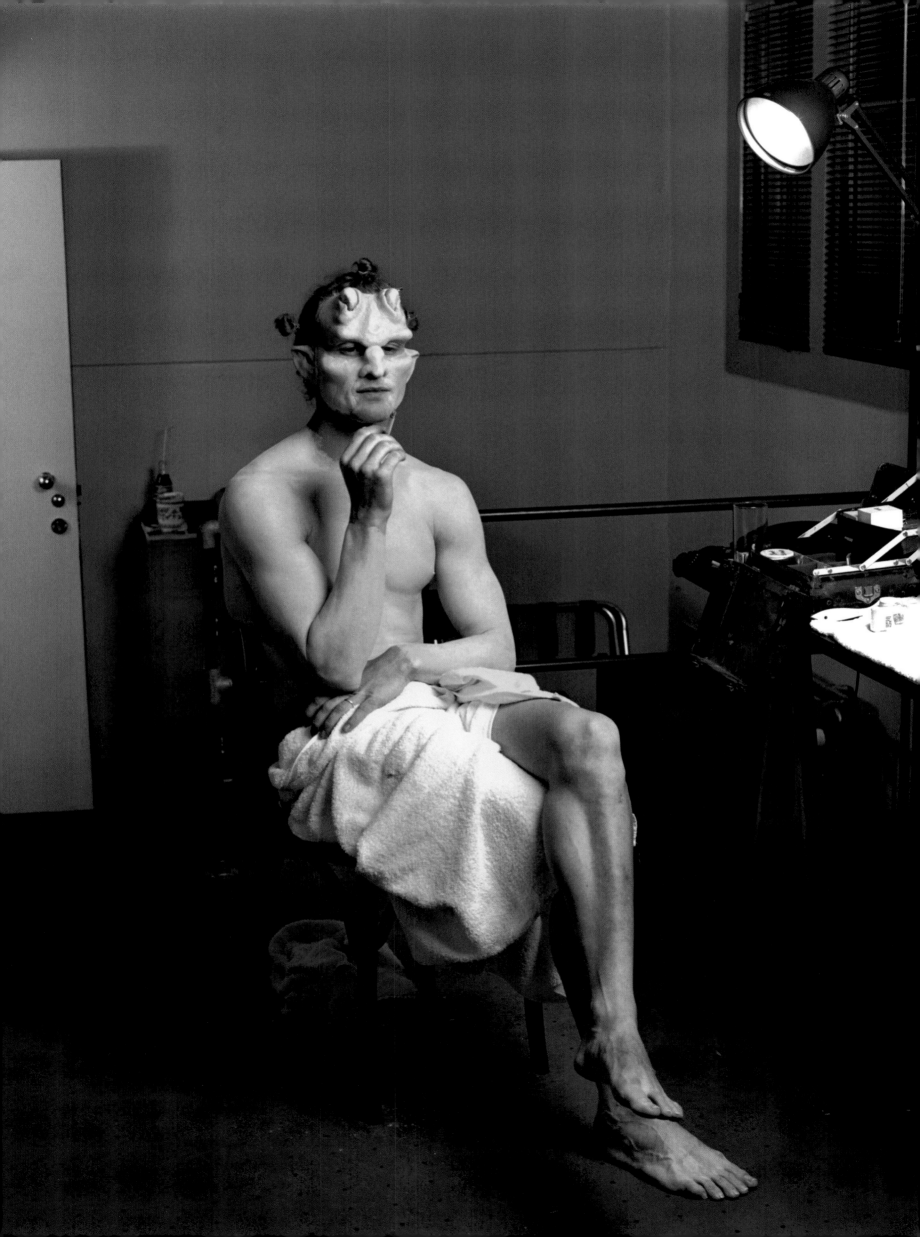

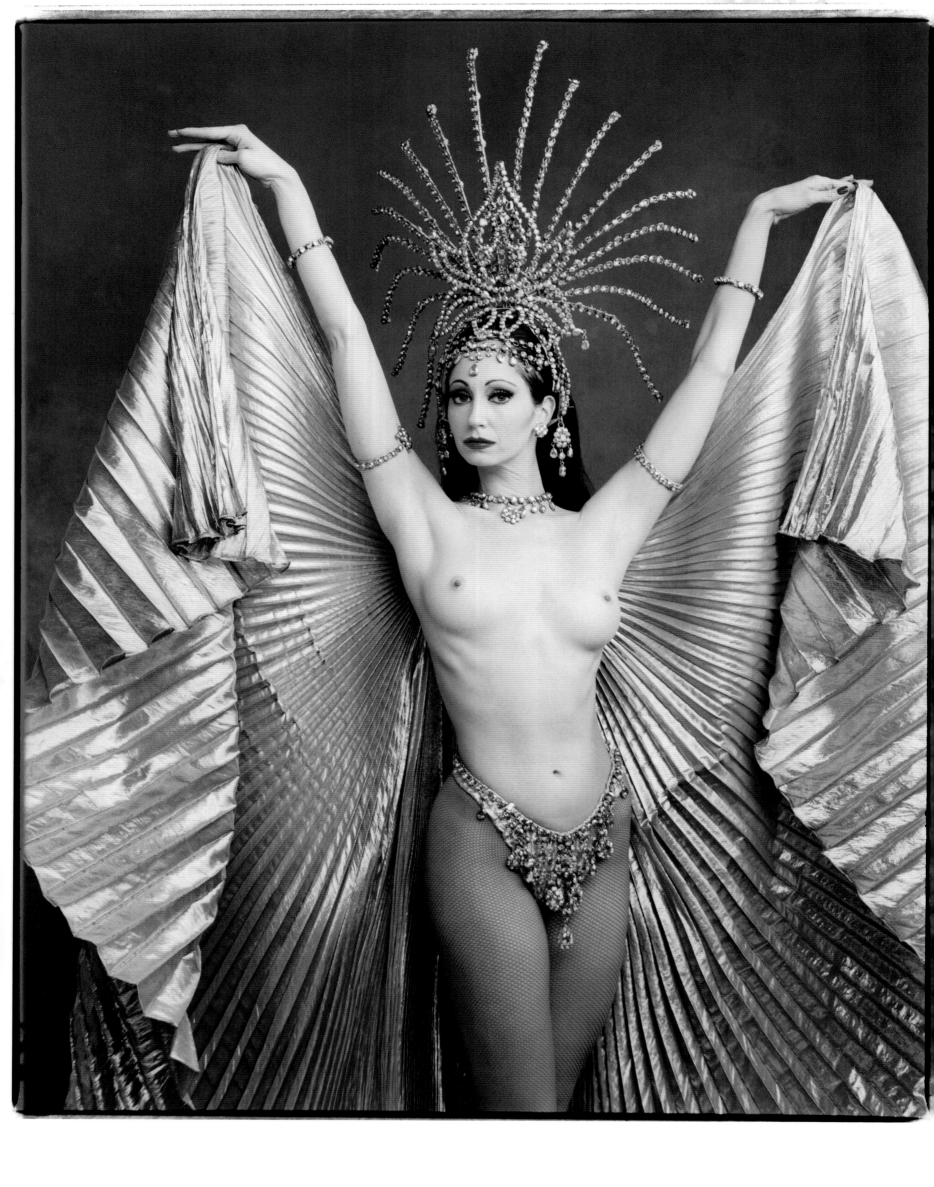

Susan McNamara, Bally's casino, Las Vegas, 1995

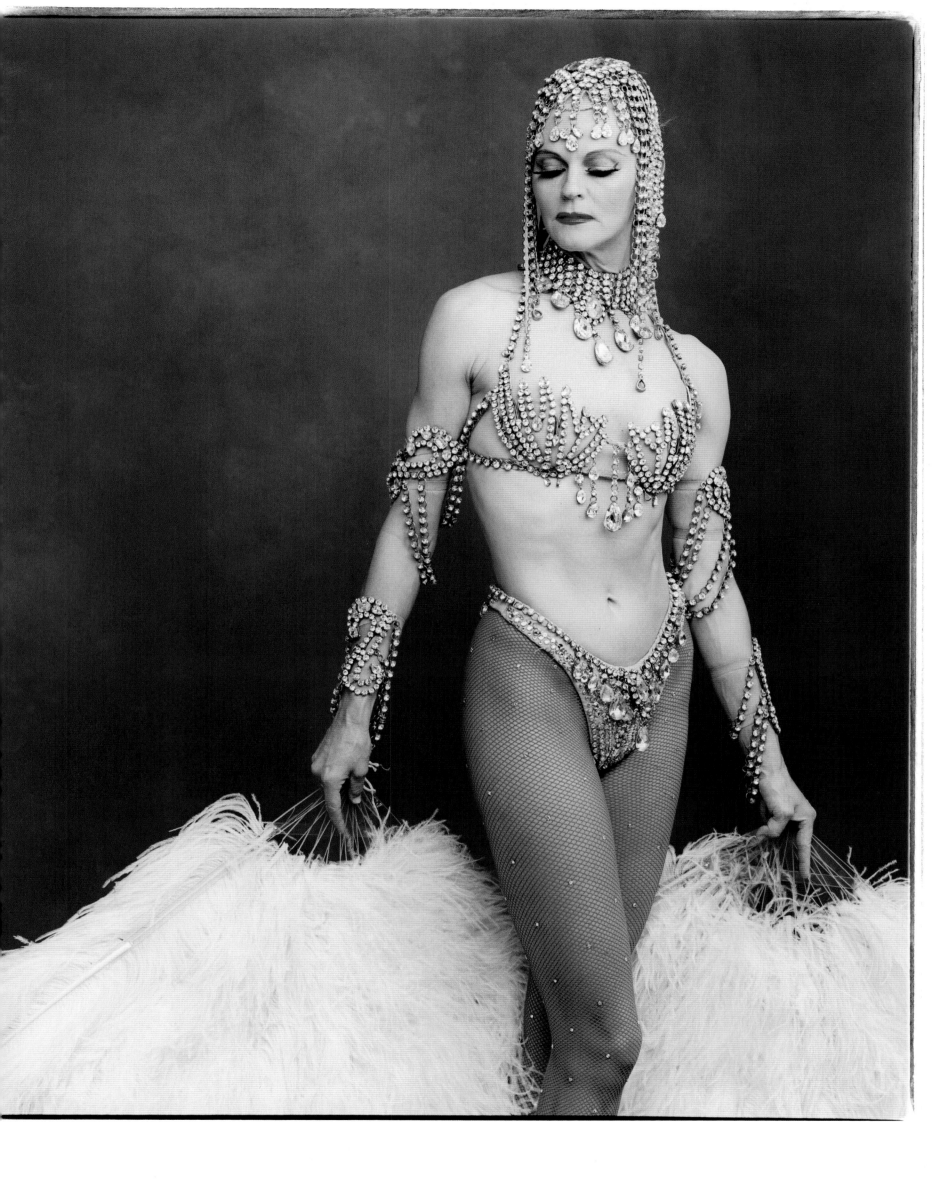

Linda Green, Bally's casino, Las Vegas, 1995

Susan McNamara, Las Vegas, 1995

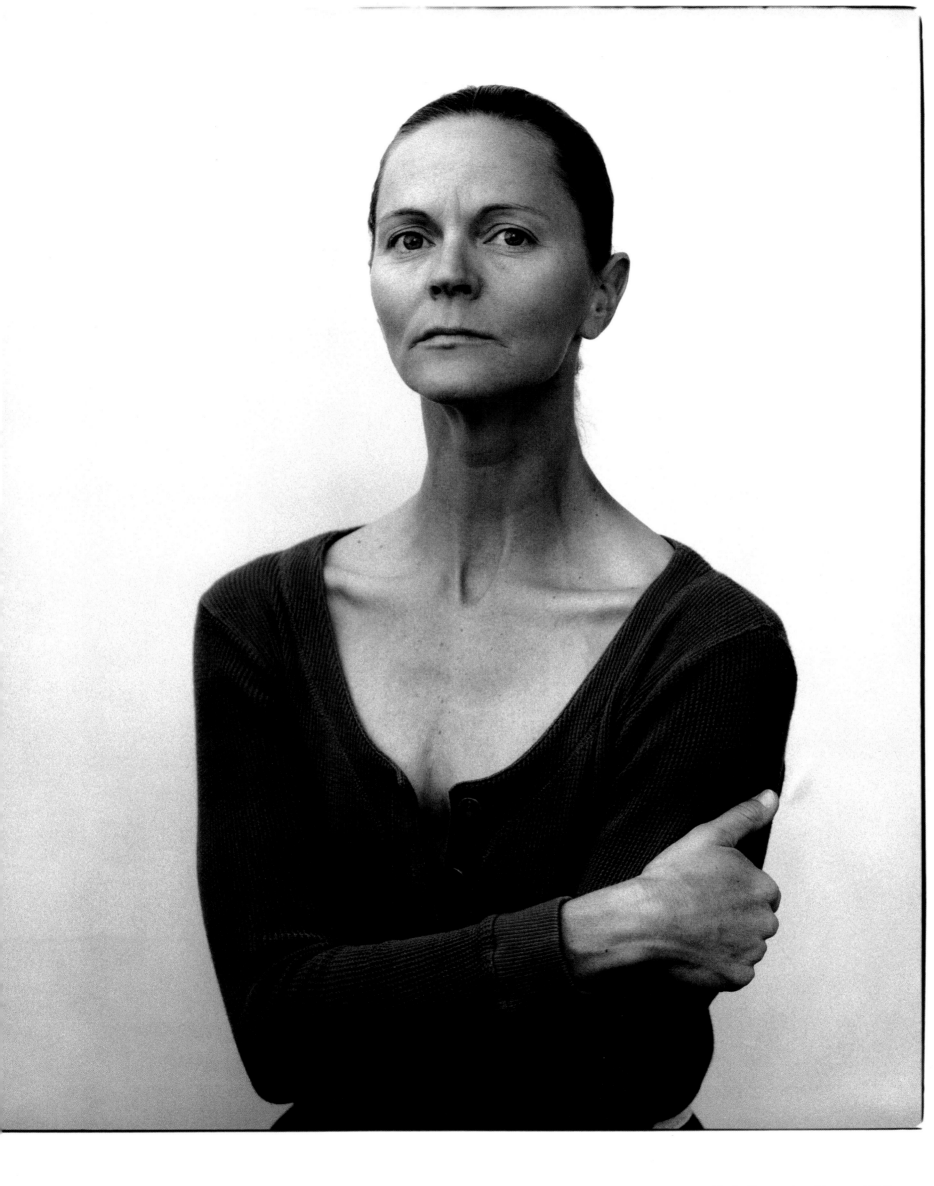

Linda Green, Las Vegas, 1995

Laurie Anderson, Coney Island, Brooklyn, 1995

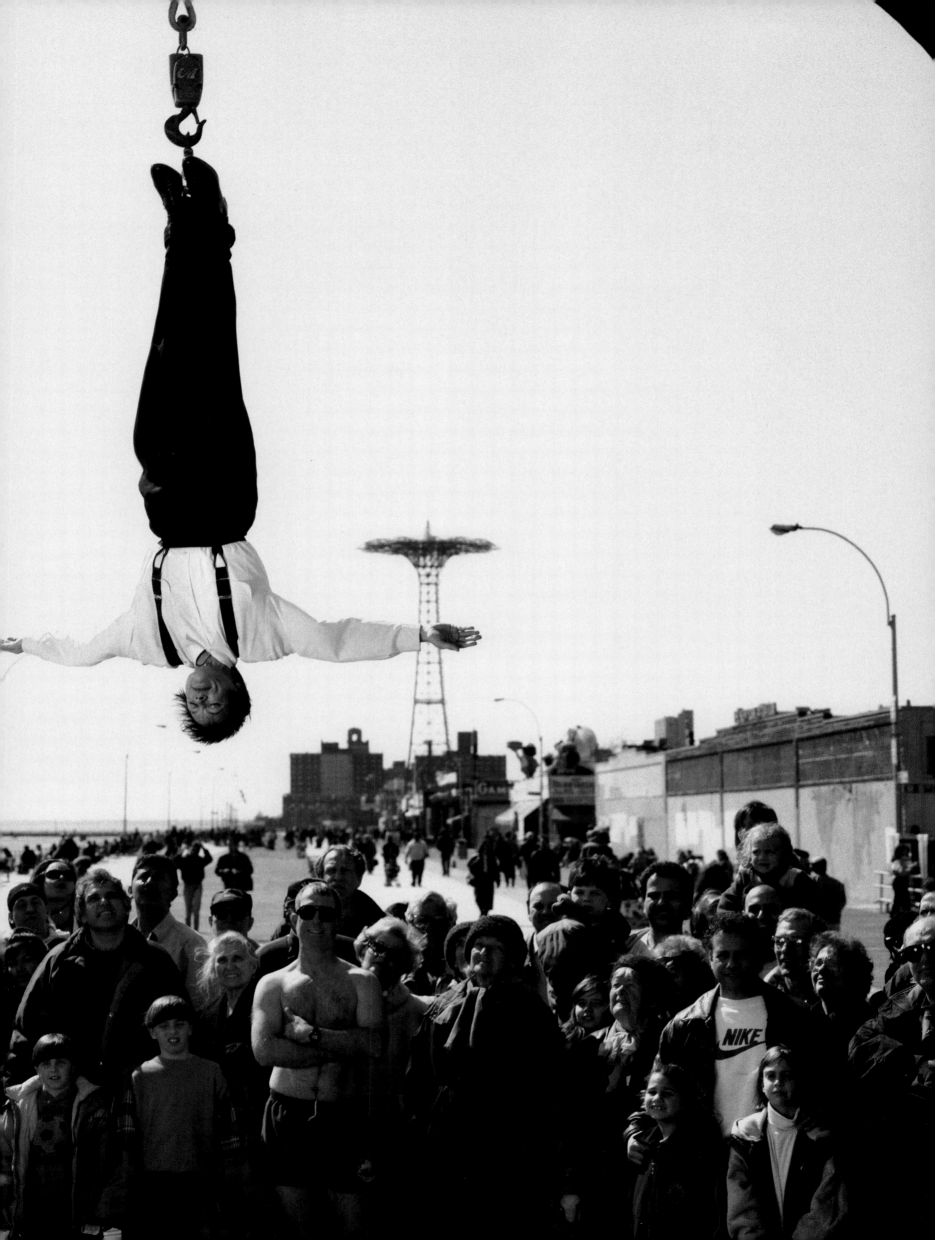

Becky Dyroen-Lancer, U.S. Olympic synchronized swimming team,
Culver City, California, 1996

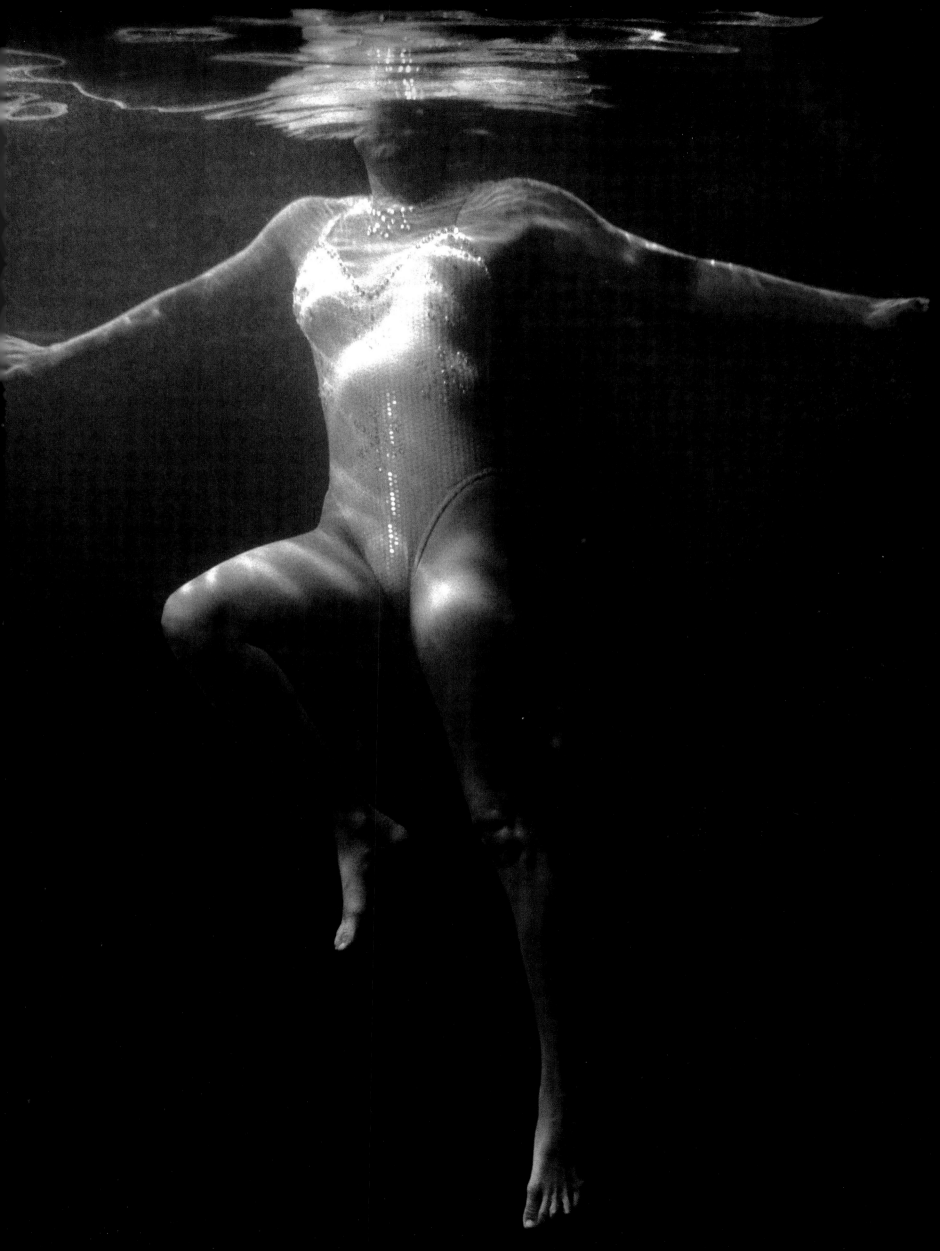

Becky Dyroen-Lancer, Jill Savery, Heather Simmons-Carrasco,
Jill Sudduth, U.S. Olympic synchronized swimming team,
Culver City, California, 1996

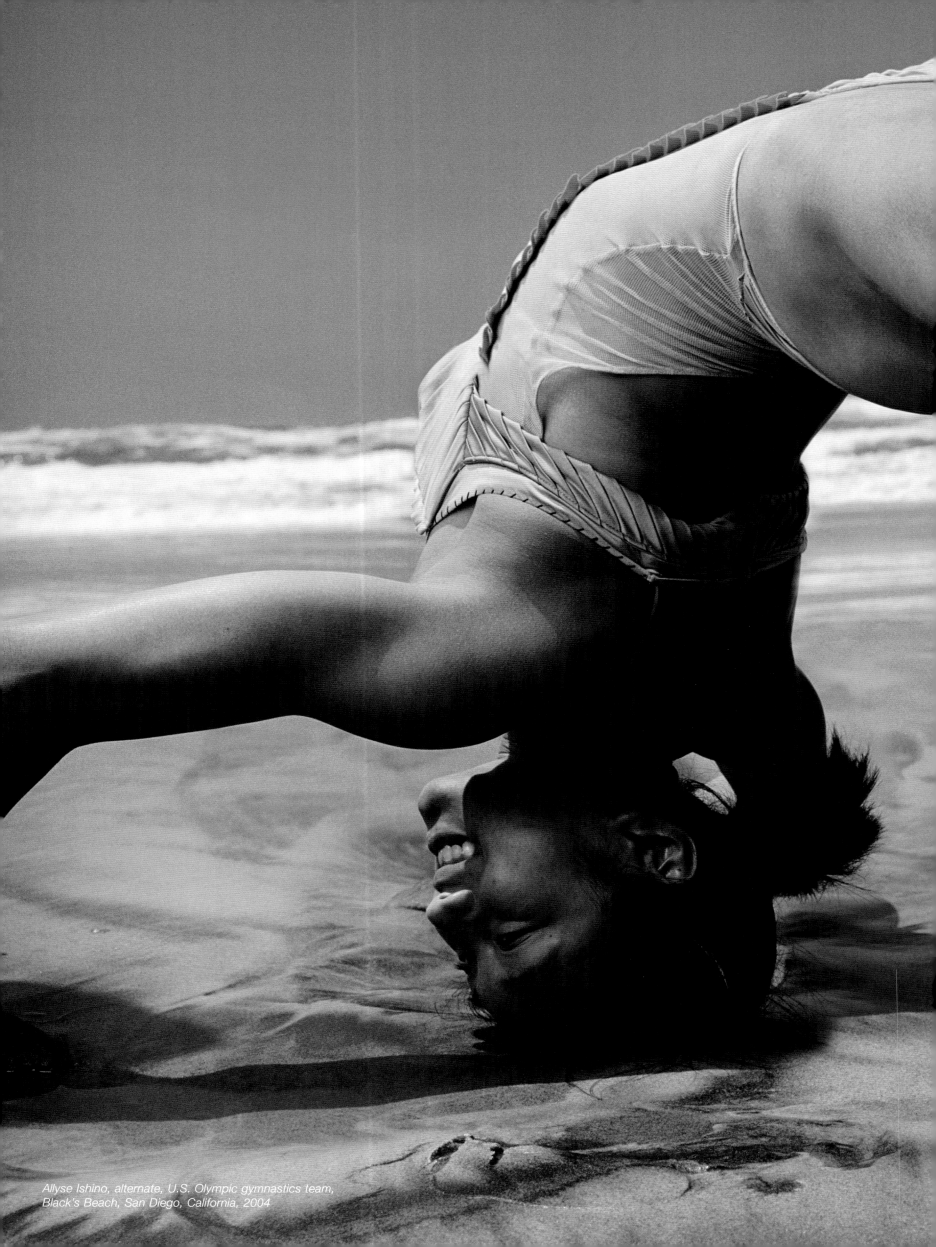

Allyse Ishino, alternate, U.S. Olympic gymnastics team,
Black's Beach, San Diego, California, 2004

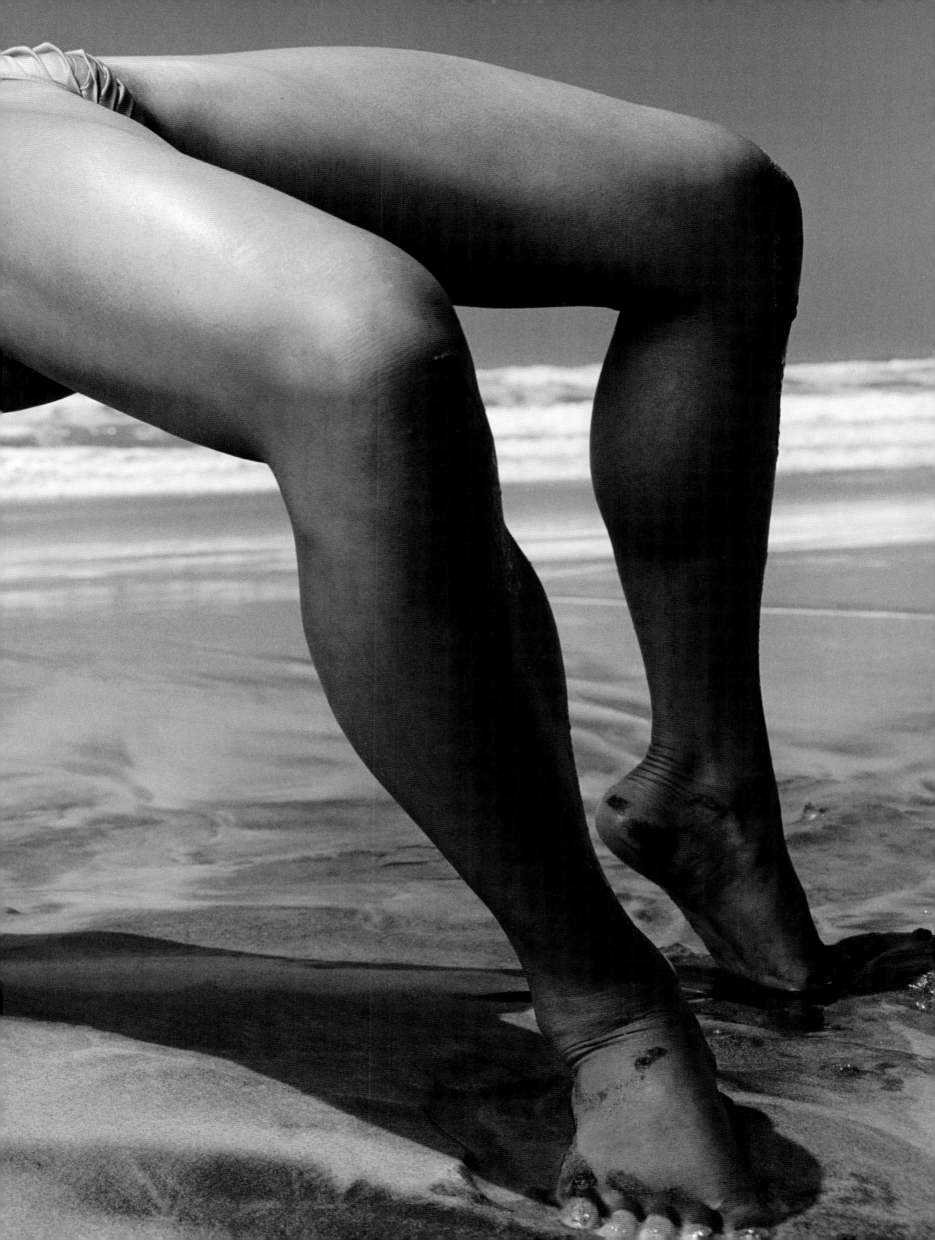

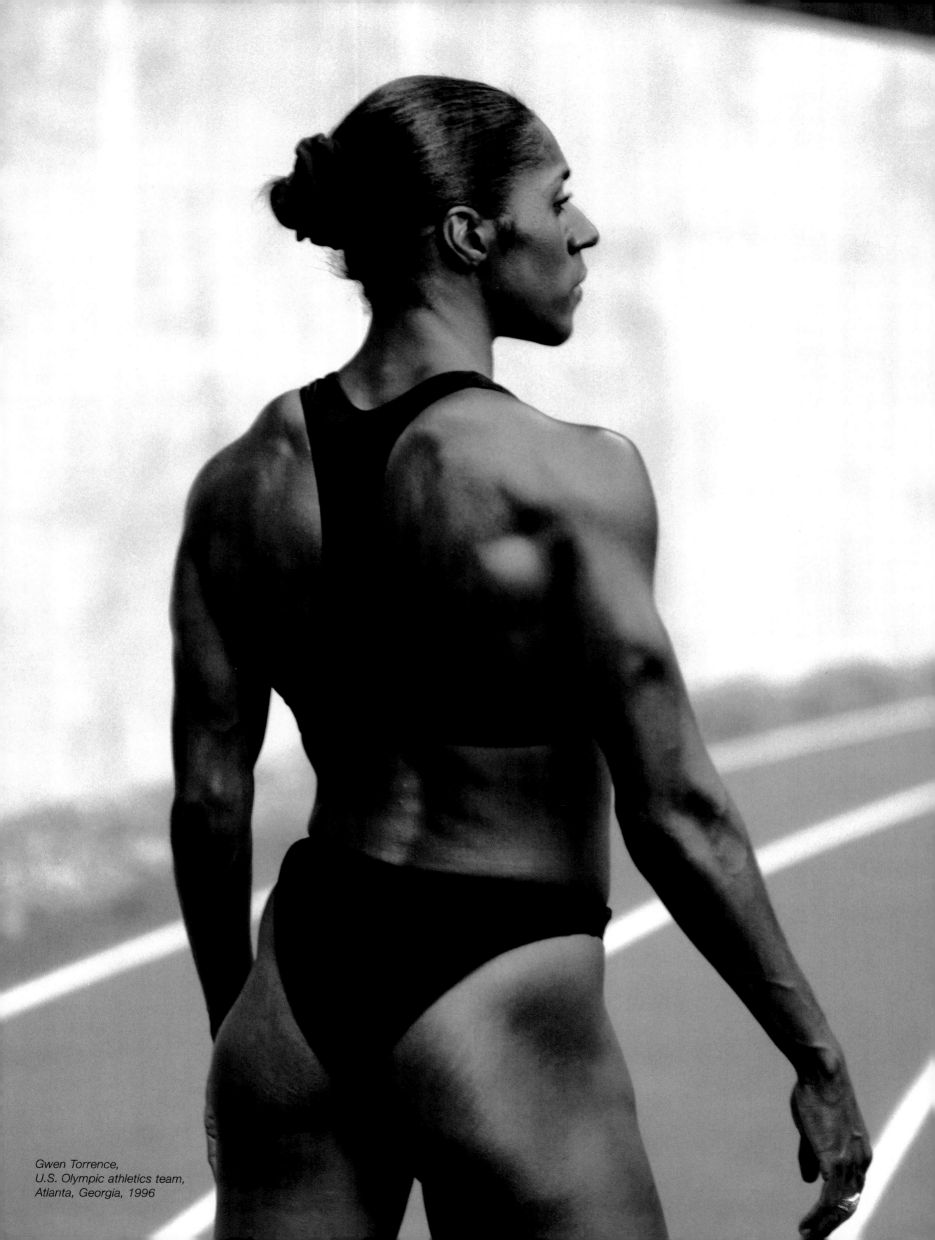

Gwen Torrence,
U.S. Olympic athletics team,
Atlanta, Georgia, 1996

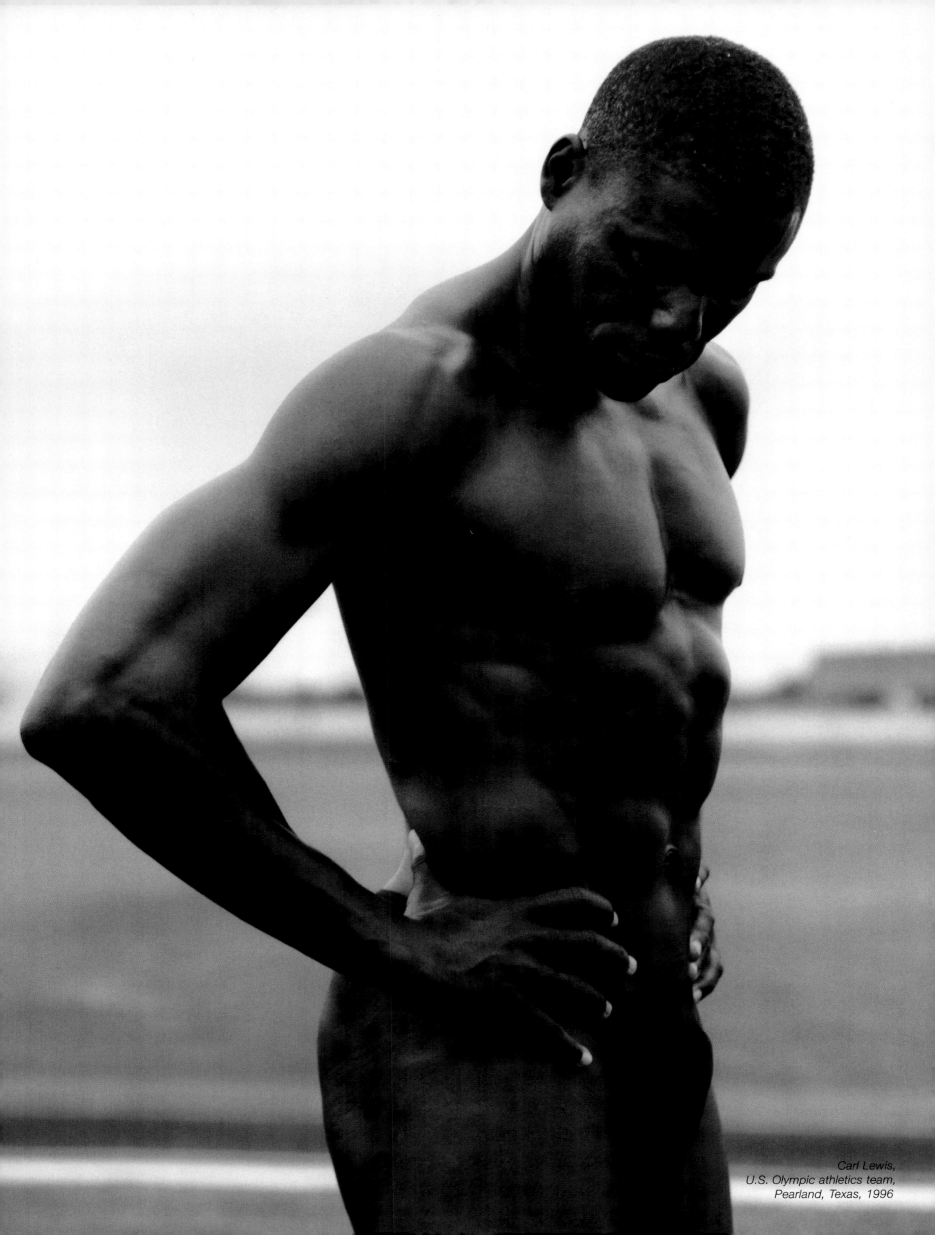

Carl Lewis,
U.S. Olympic athletics team,
Pearland, Texas, 1996

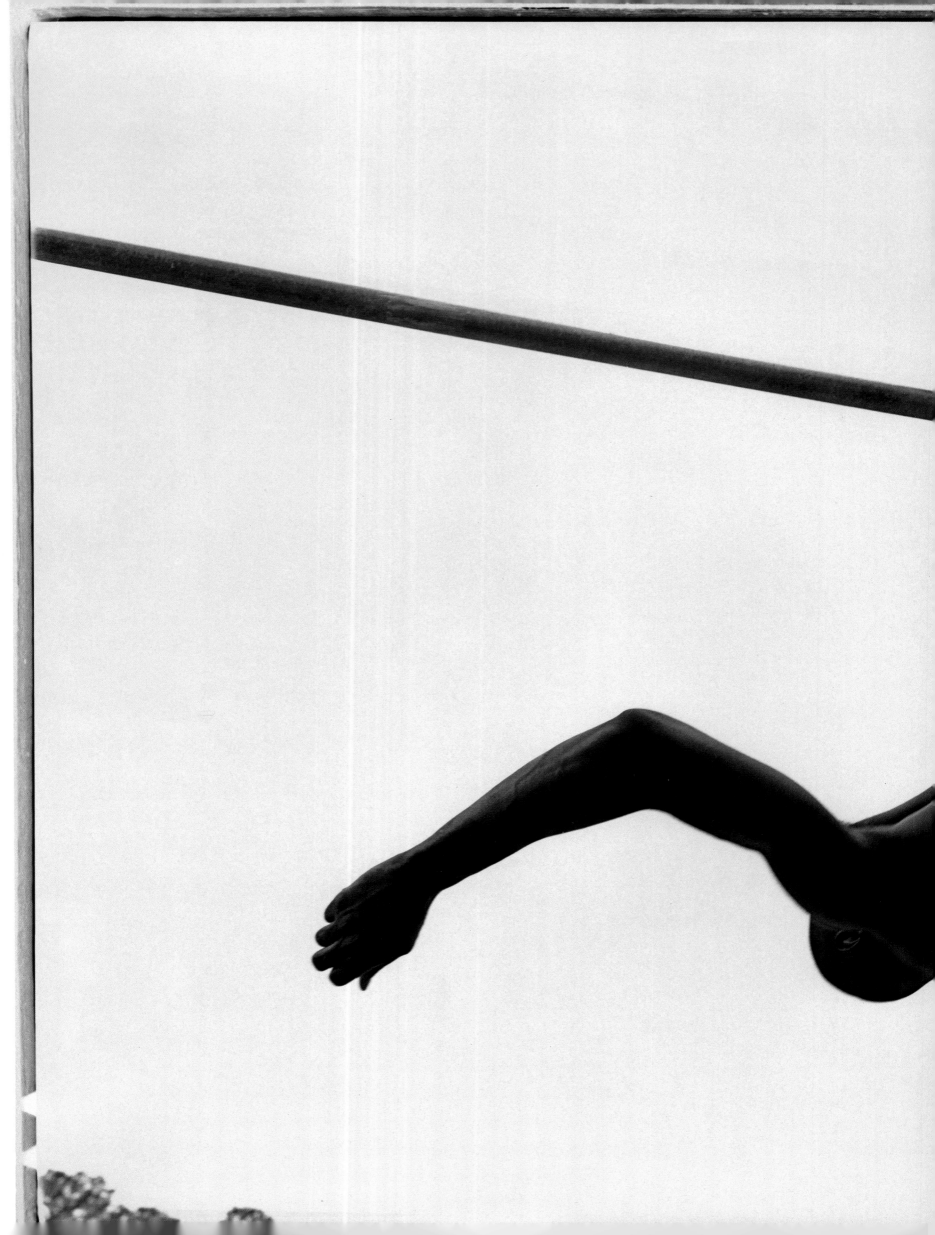

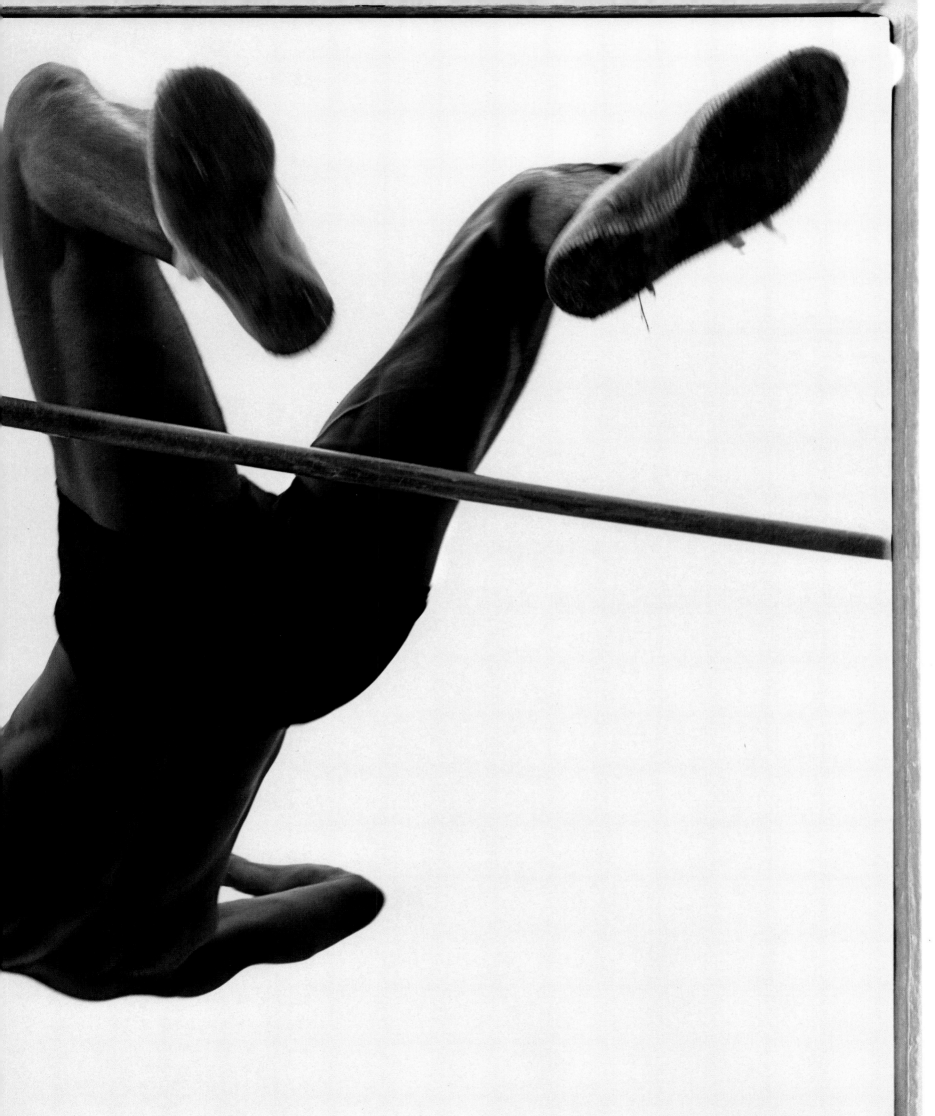

Charles Austin, U.S. Olympic athletics team,
Atlanta, Georgia, 1996

Brian Earley, U.S. Olympic Festival diving team,
Mission Viejo Aquatics Center, Los Angeles, 1993

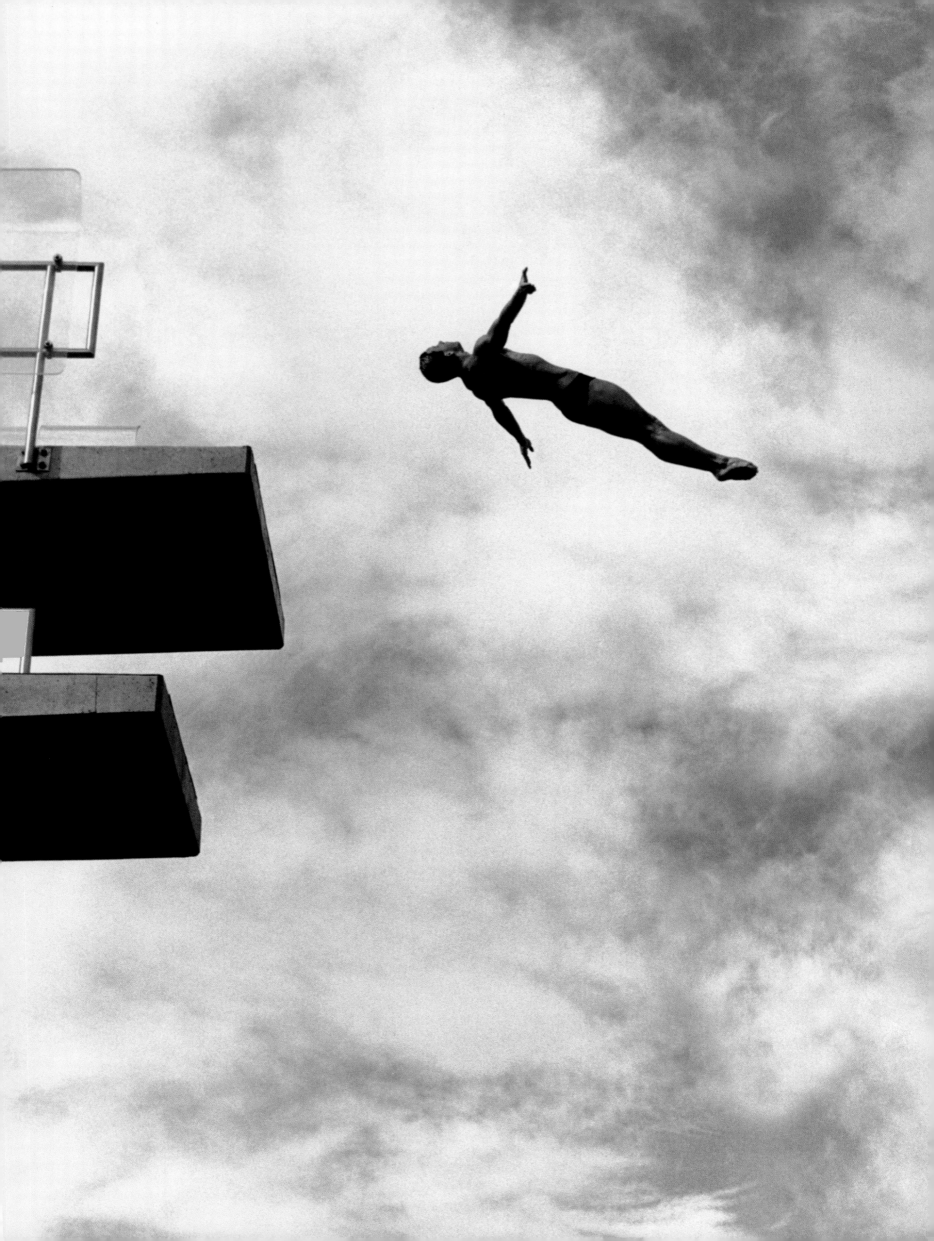

Archery target, Olympic training center, Chula Vista, California, 1995

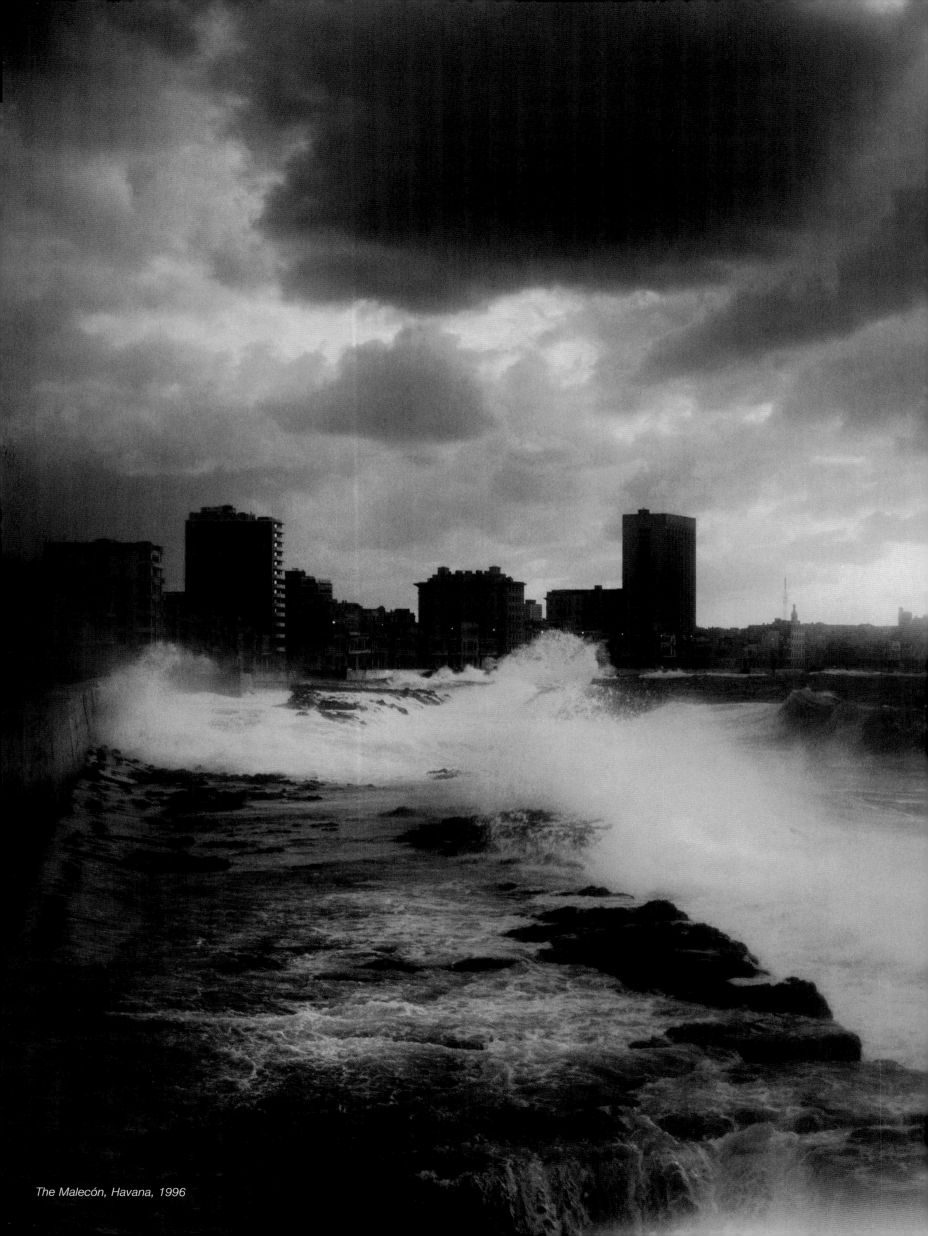

The Malecón, Havana, 1996

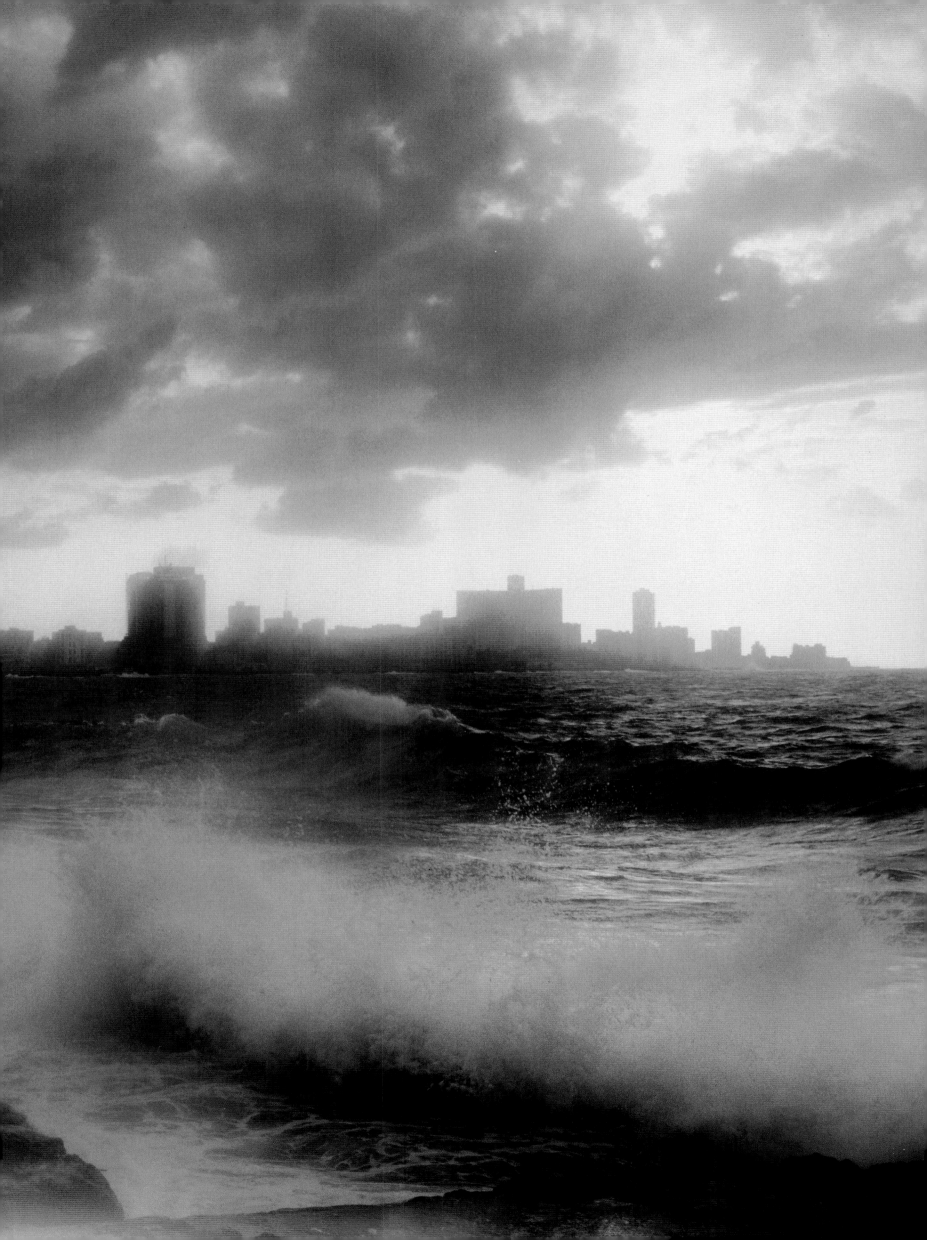

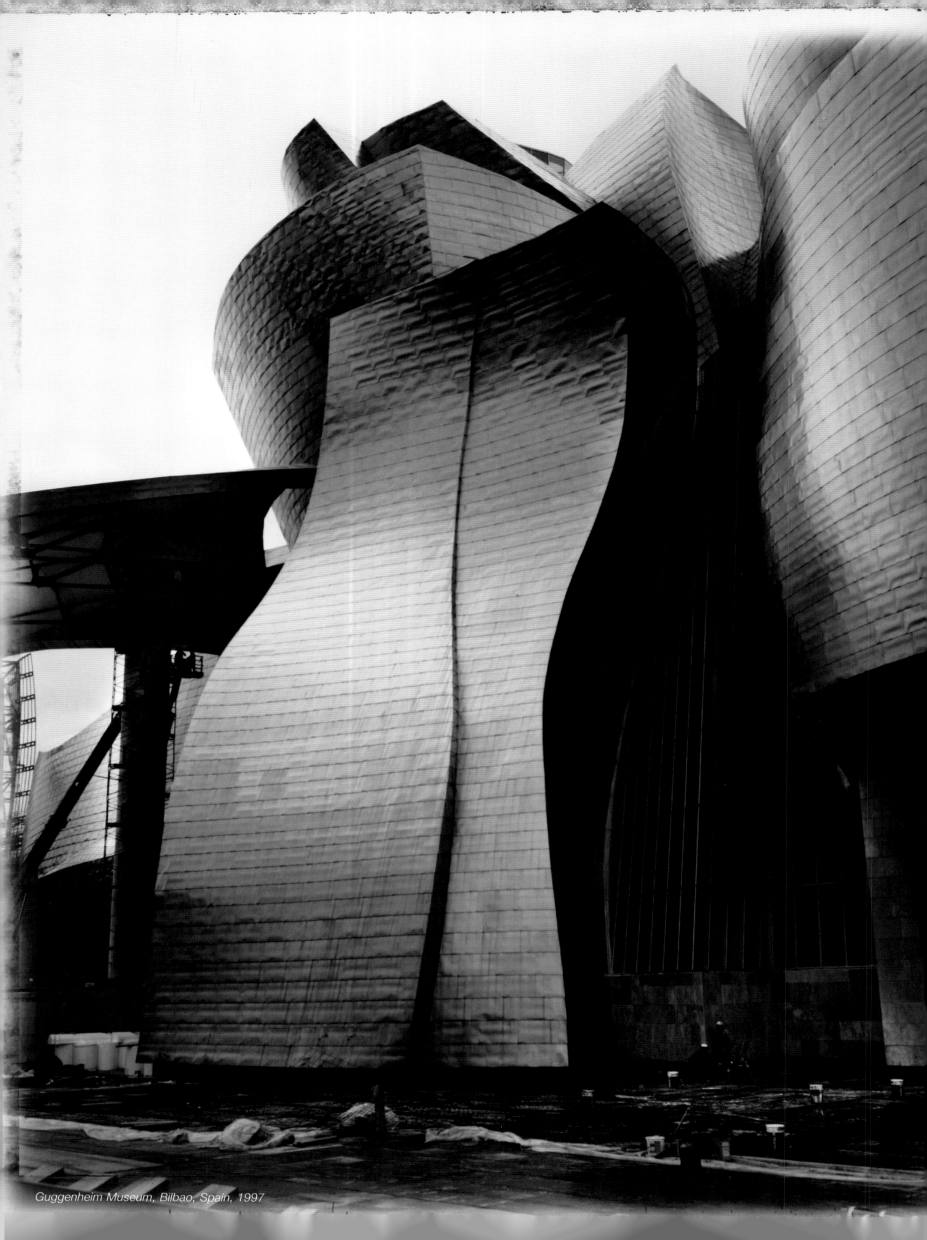

Guggenheim Museum, Bilbao, Spain, 1997

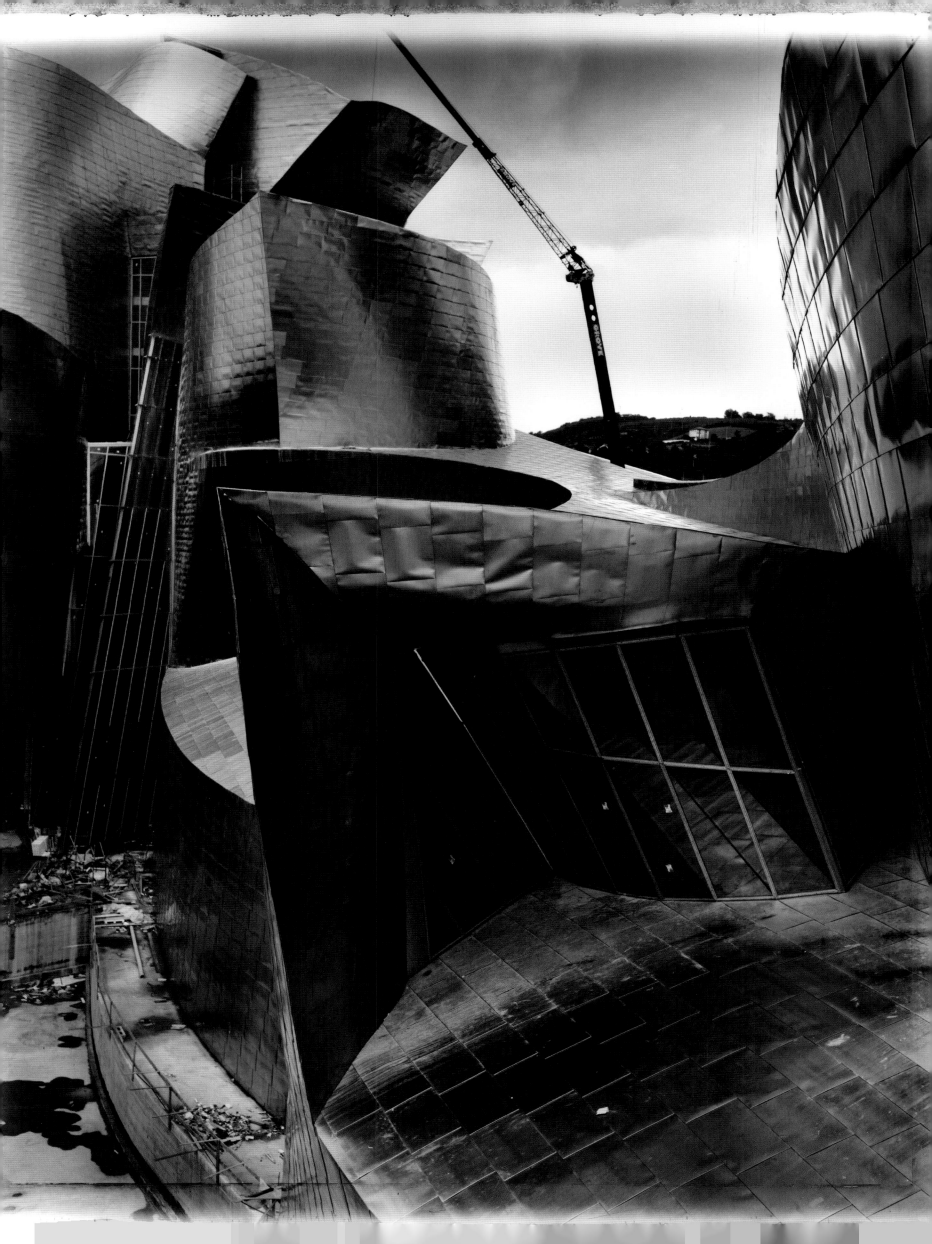

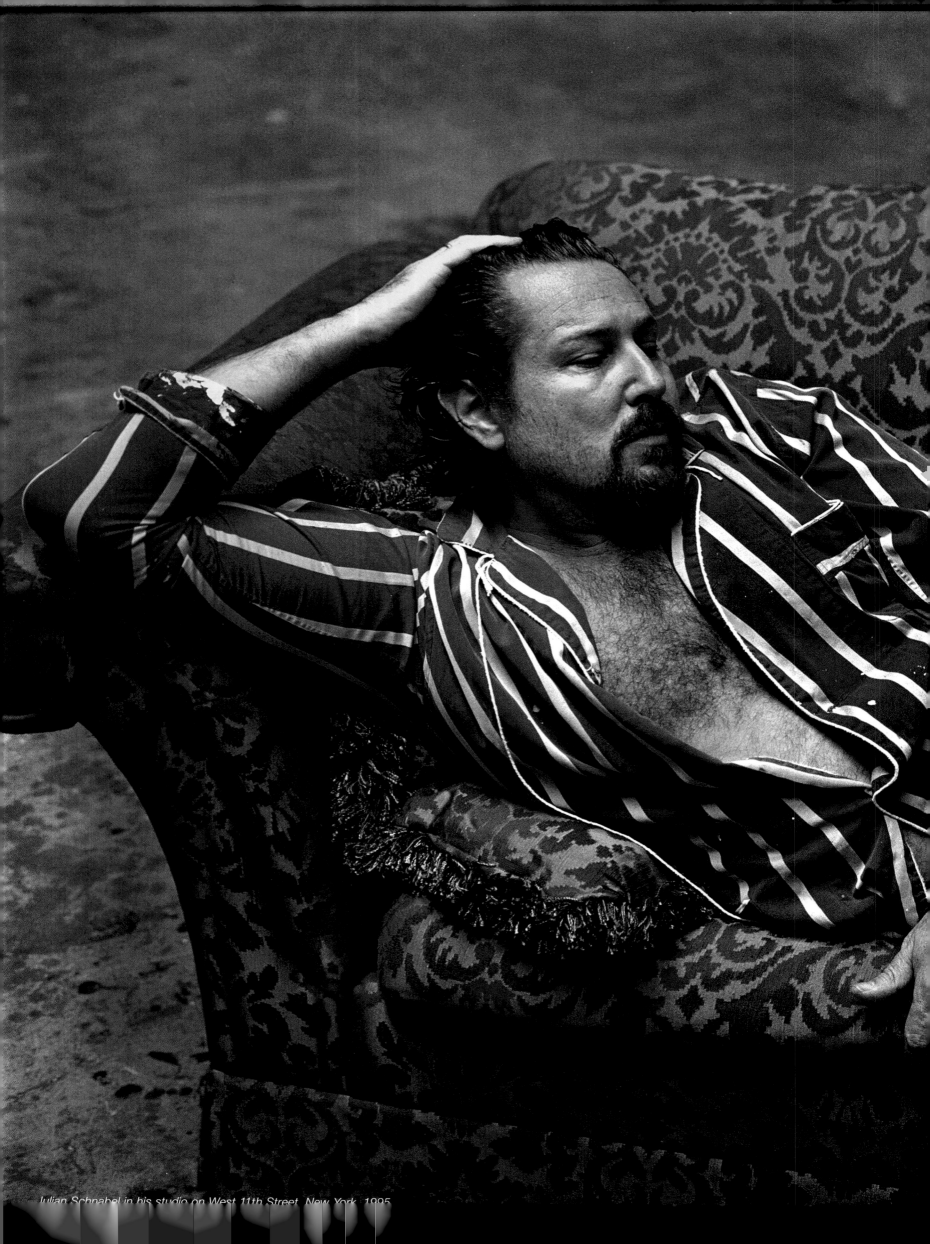

Julian Schnabel in his studio on West 11th Street, New York, 1995

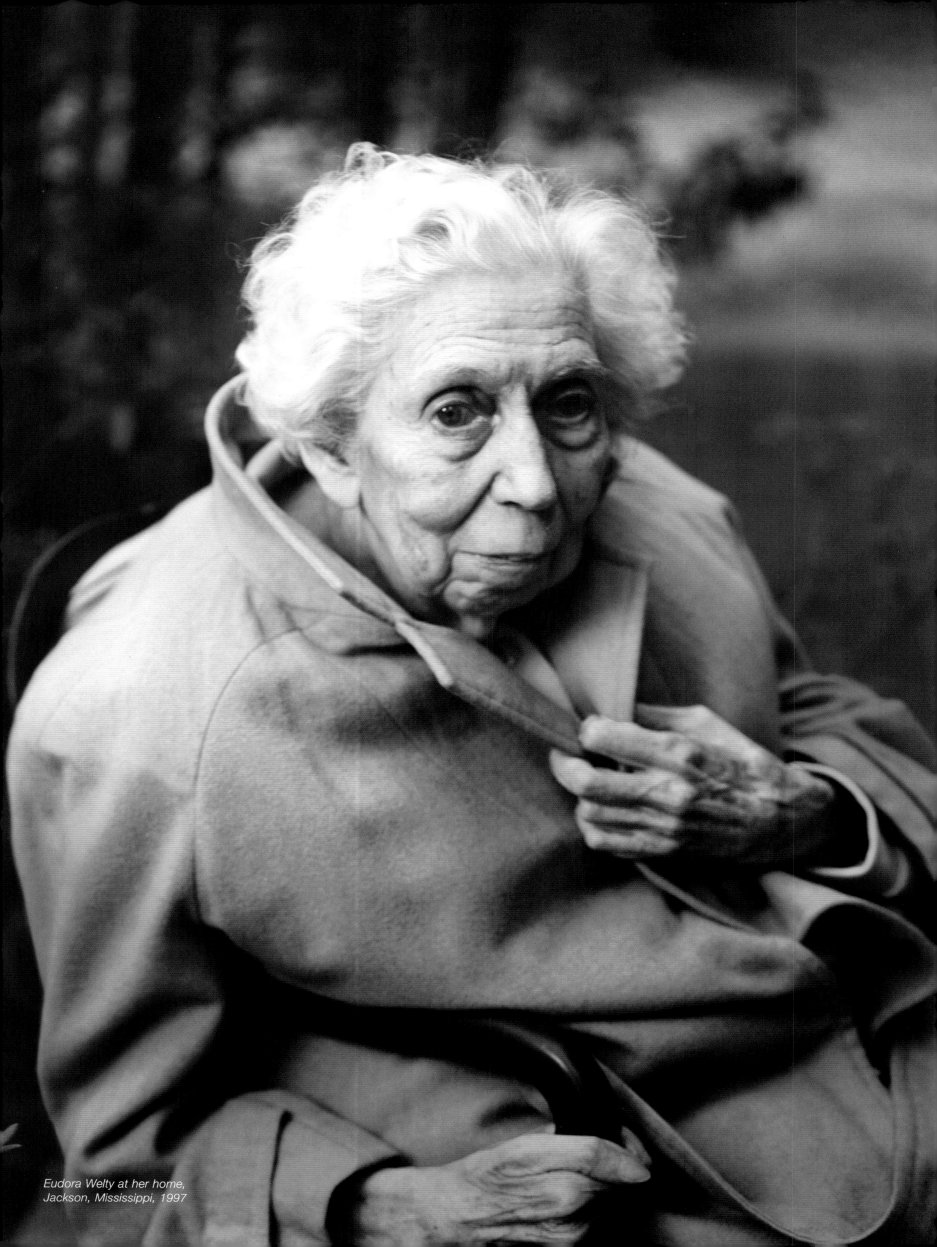

*Eudora Welty at her home,
Jackson, Mississippi, 1997*

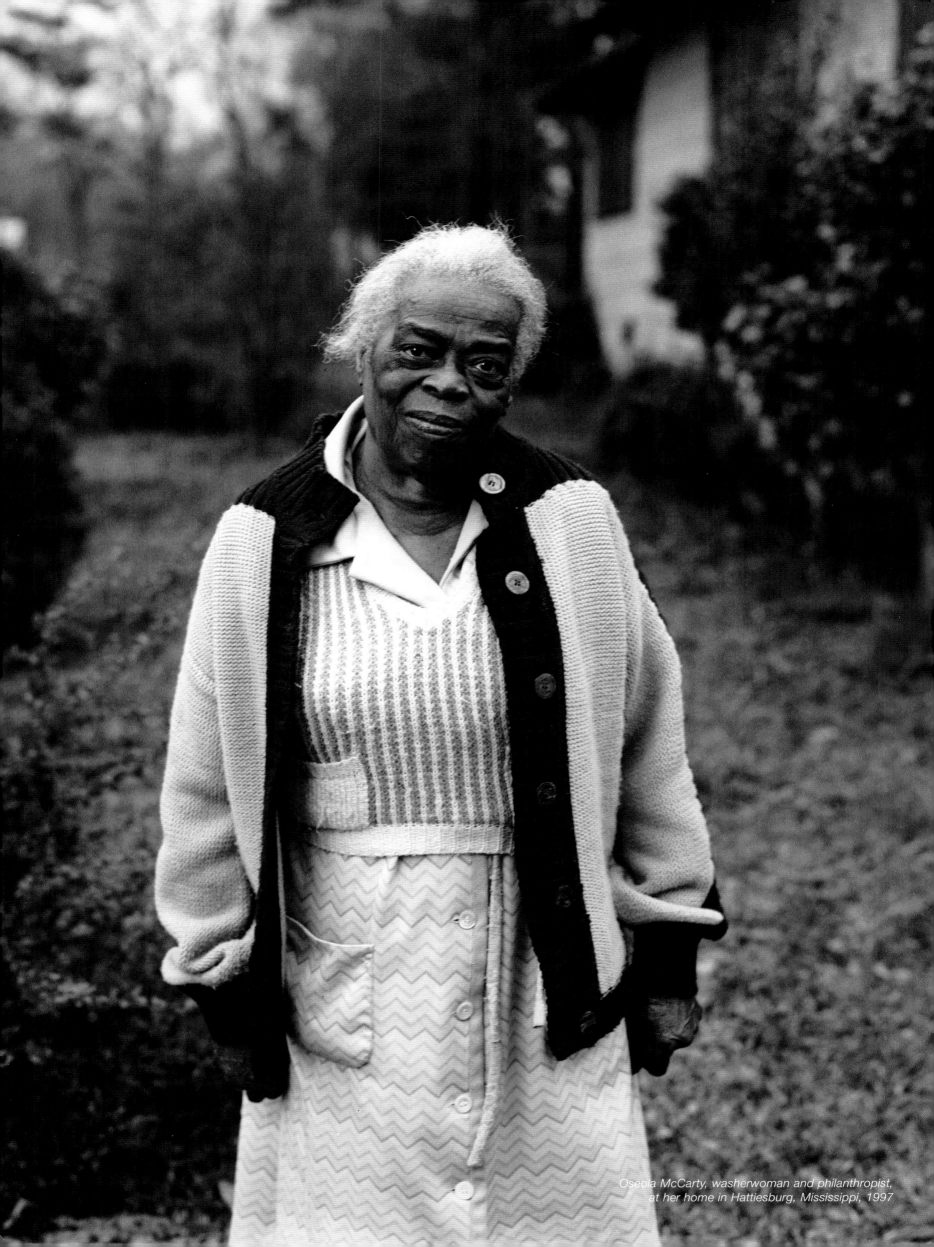

Oseola McCarty, washerwoman and philanthropist, at her home in Hattiesburg, Mississippi, 1997

Leonardo DiCaprio, Tejon Ranch, Lebec, California, 1997

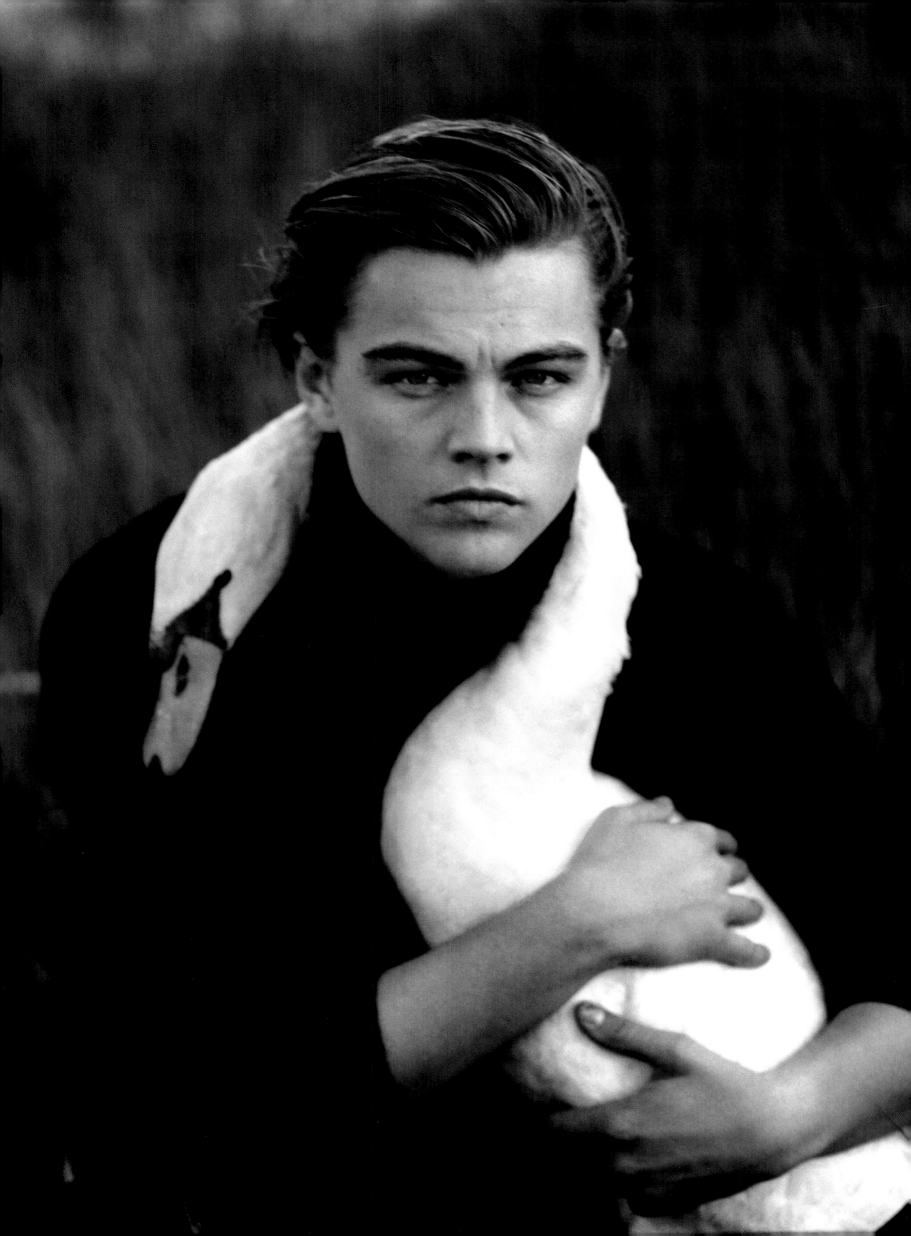

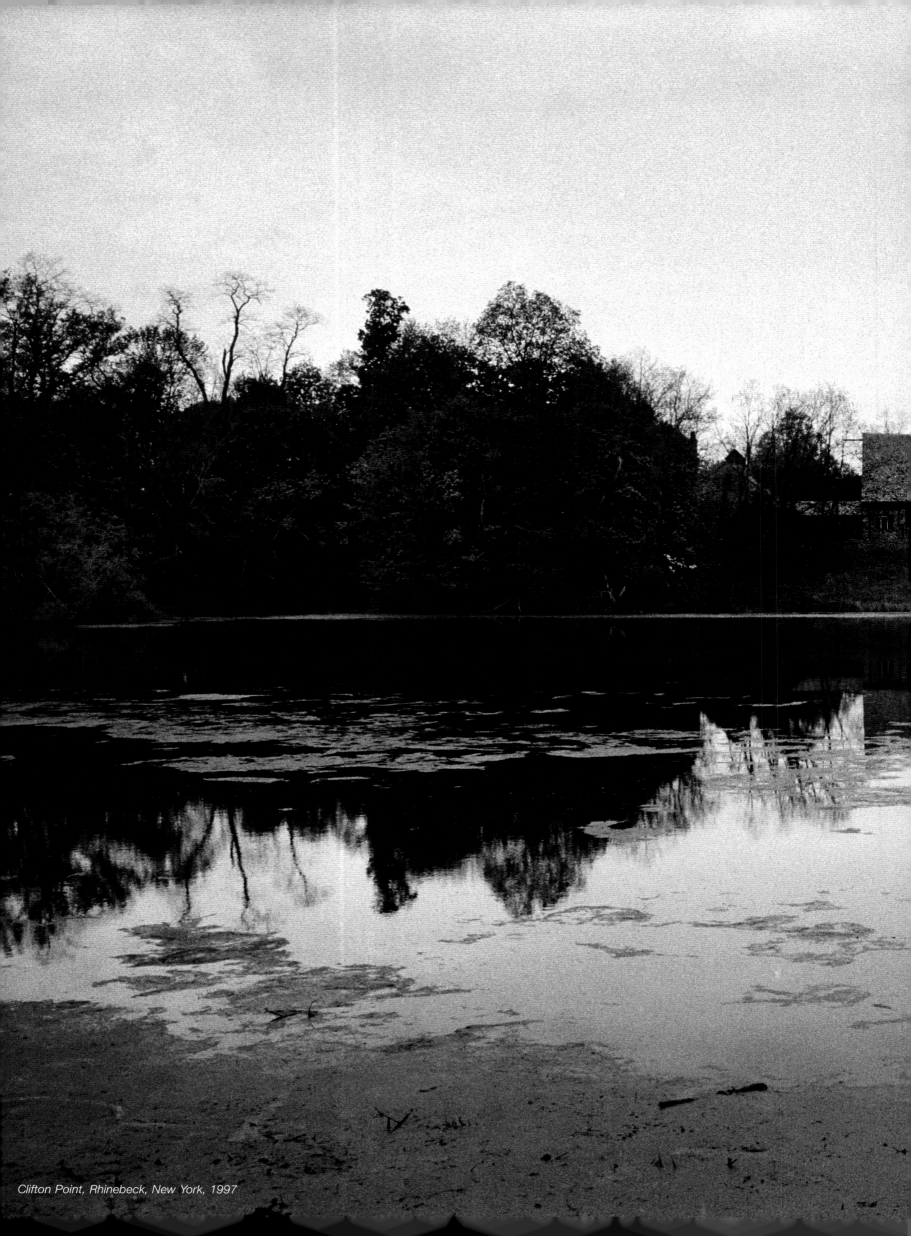

Clifton Point, Rhinebeck, New York, 1997

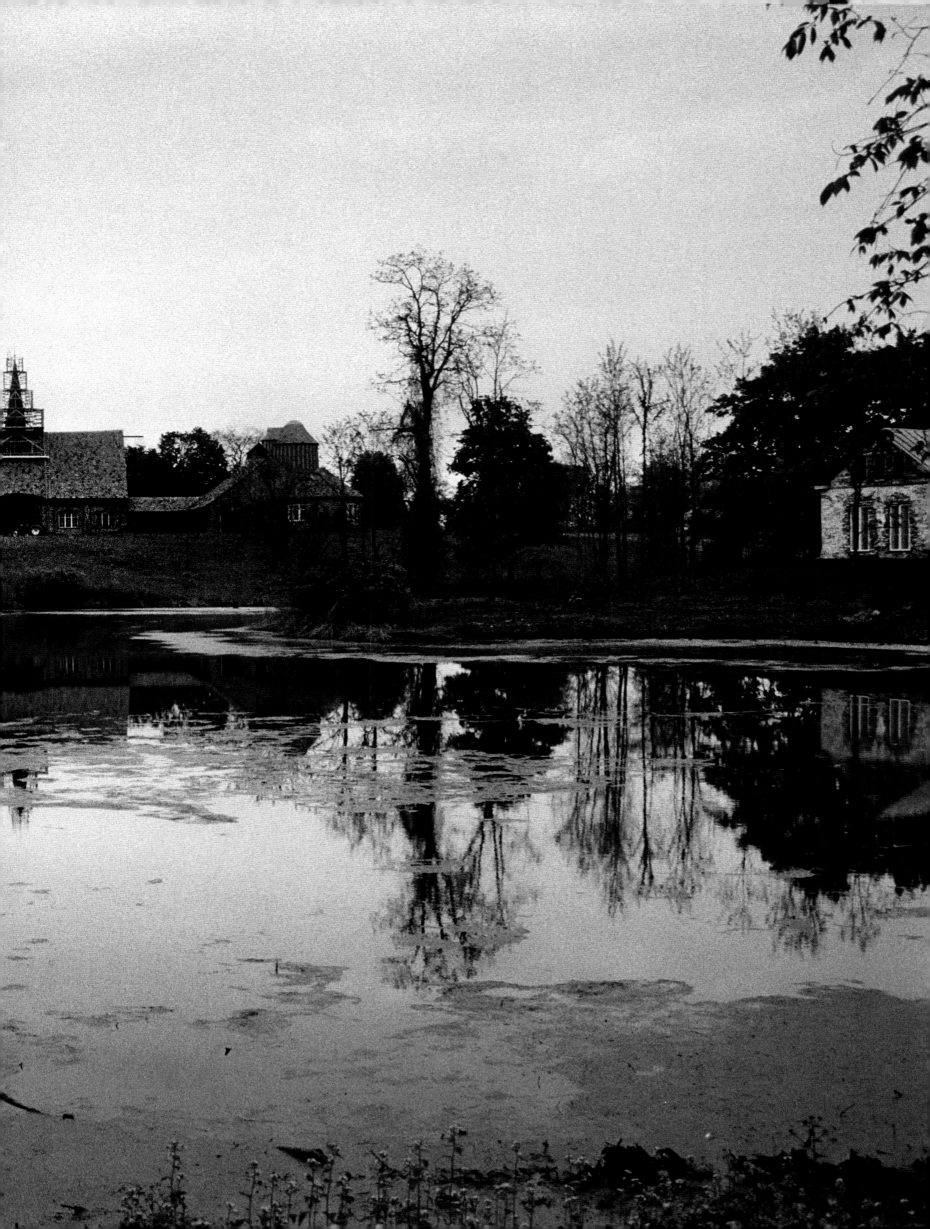

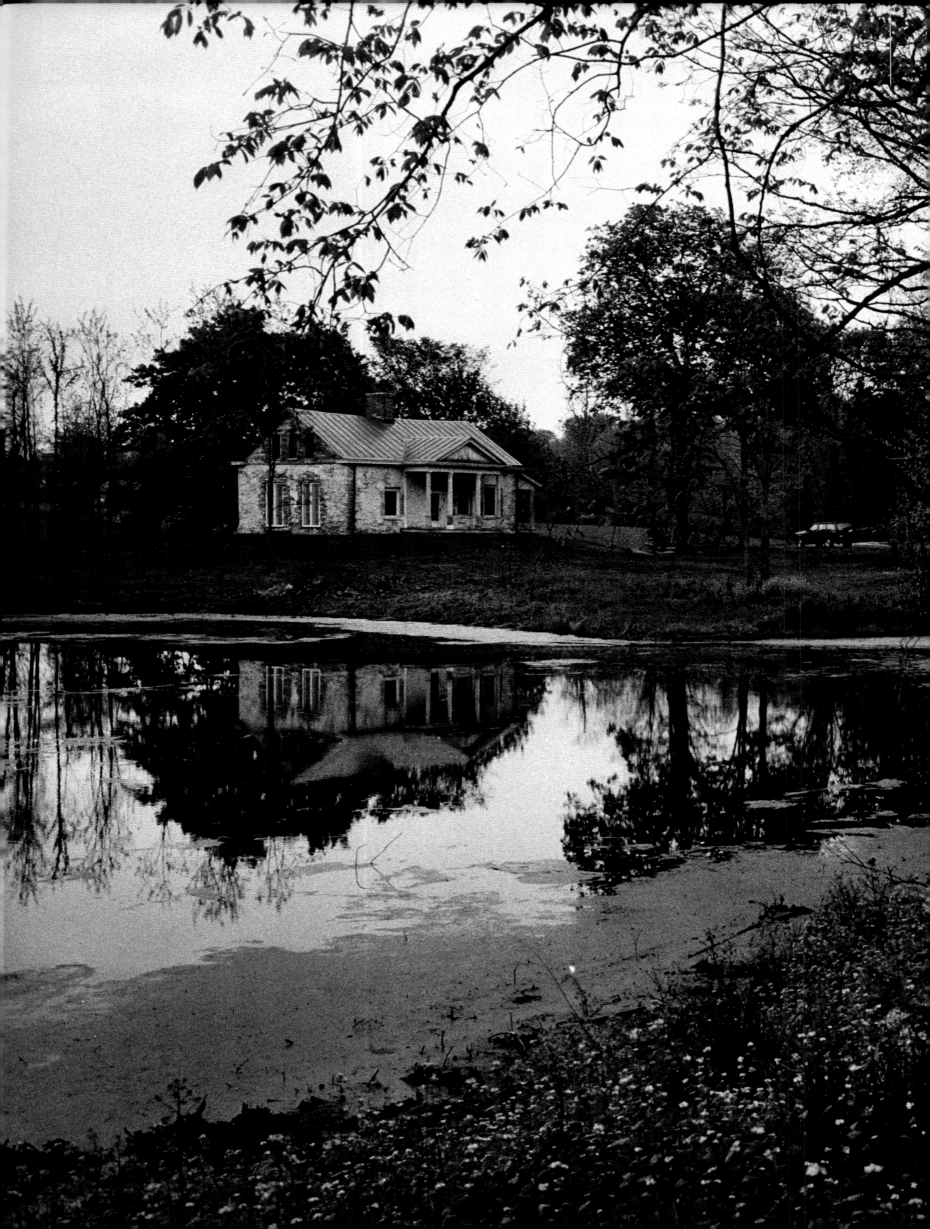

The pond house, Clifton Point, 1997

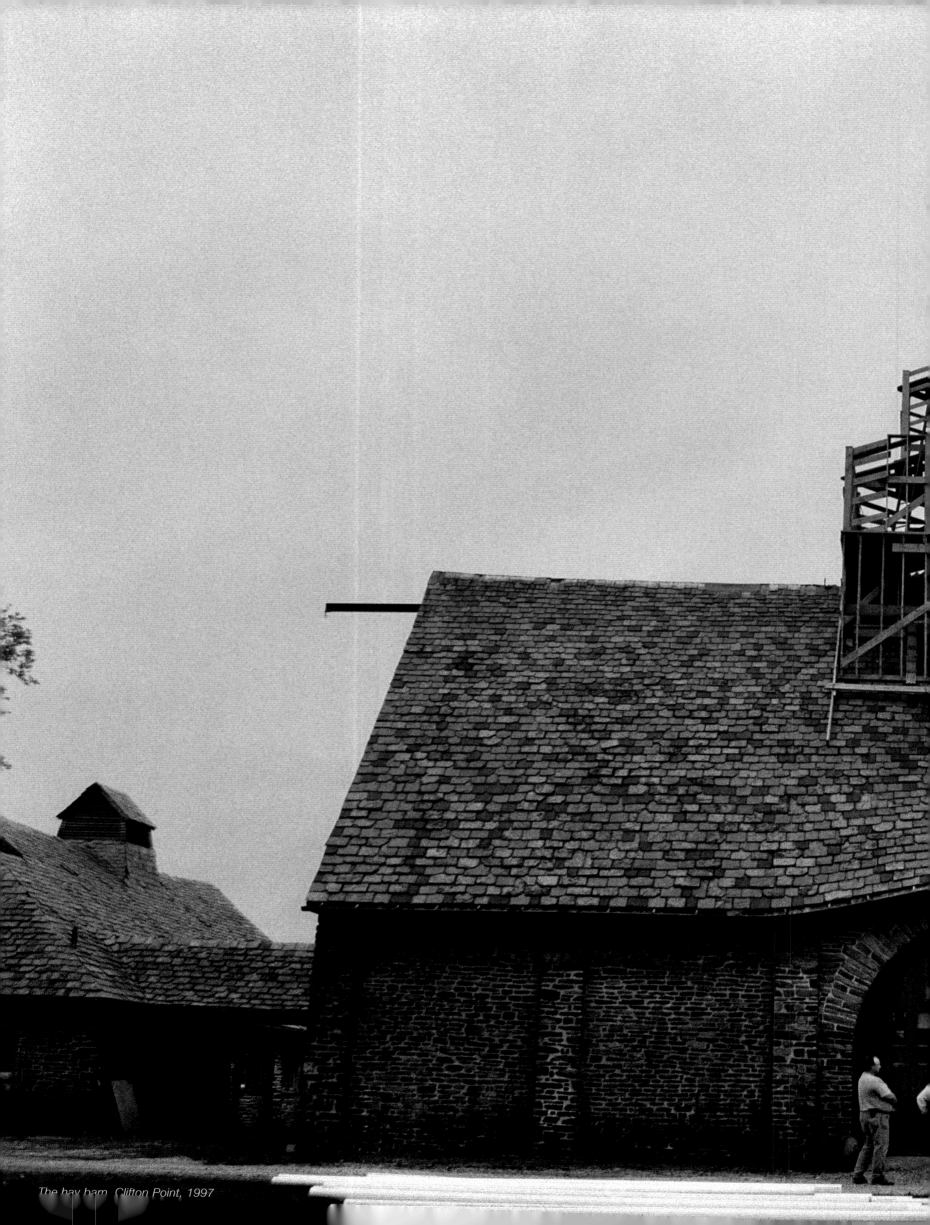

The hay barn, Clifton Point, 1997

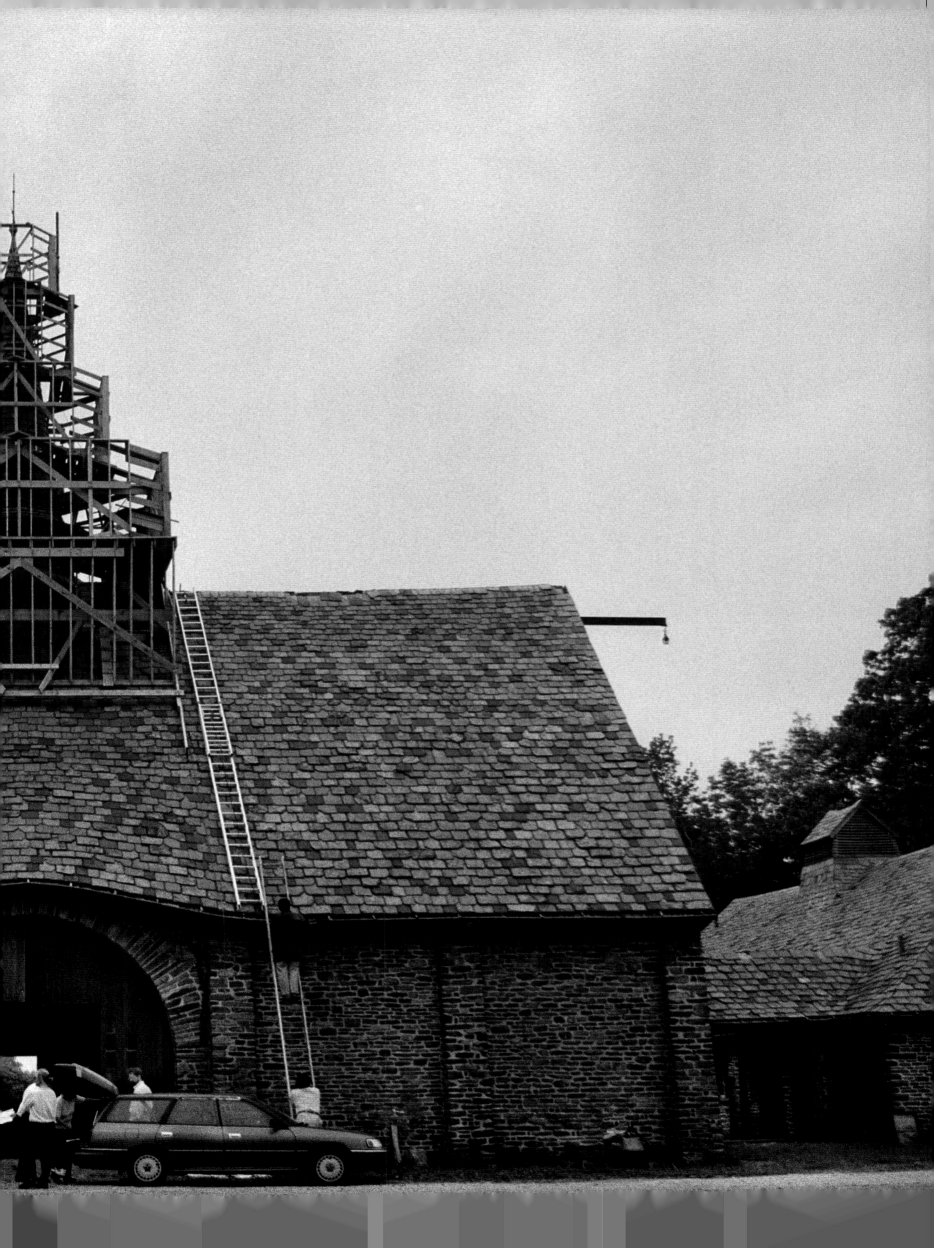

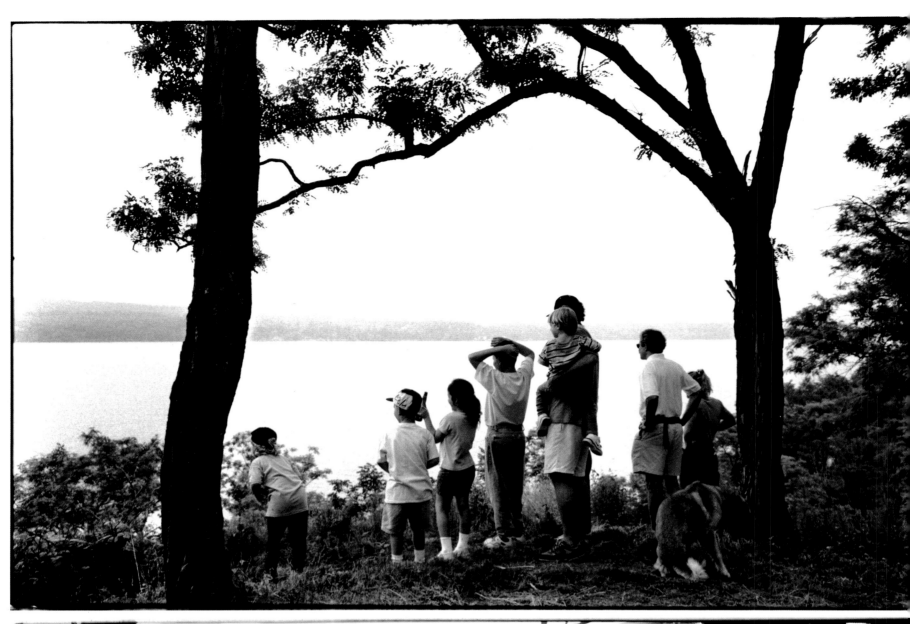

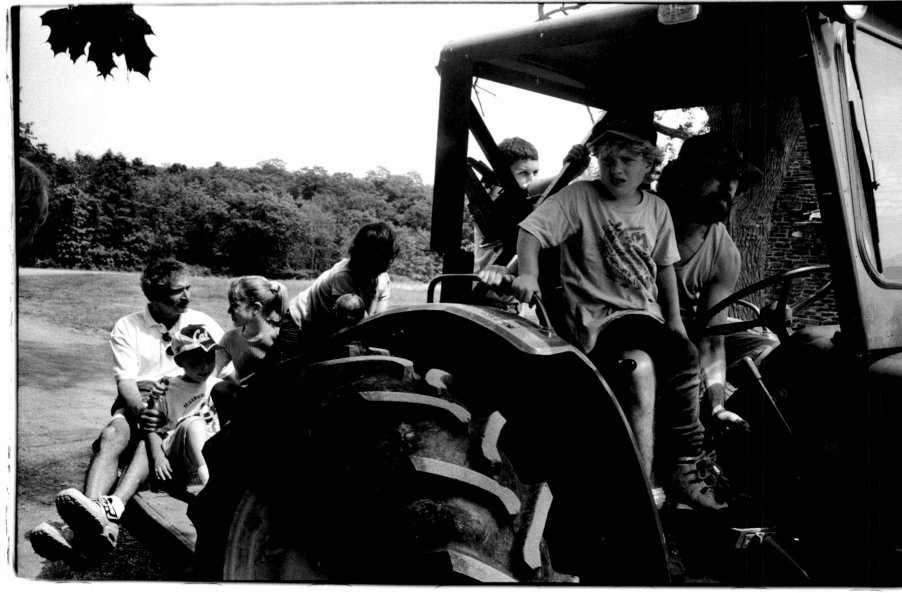

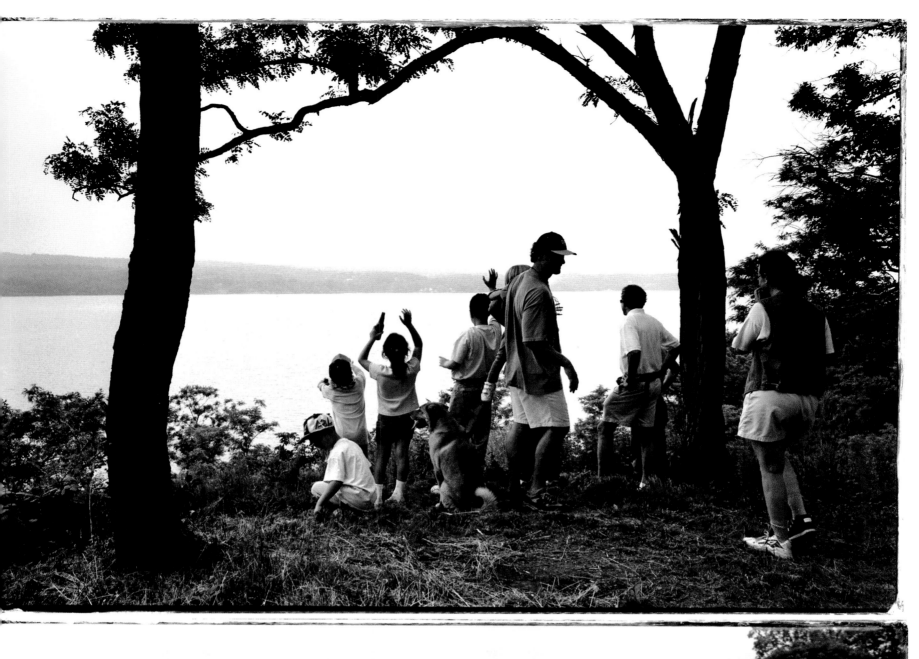

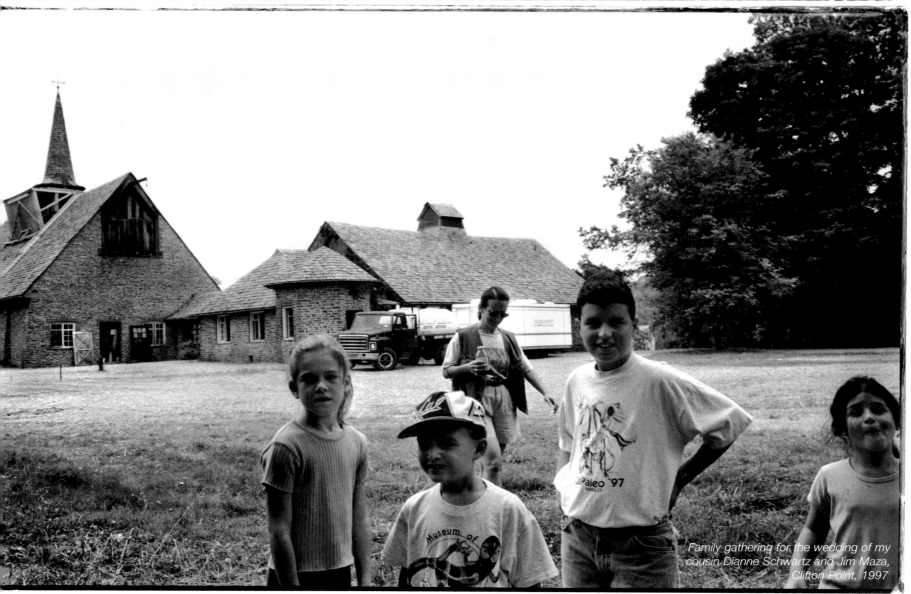

Family gathering for the wedding of my cousin Dianne Schwartz and Jim Maza, Clifton Point, 1997

My mother, Clifton Point, 1997

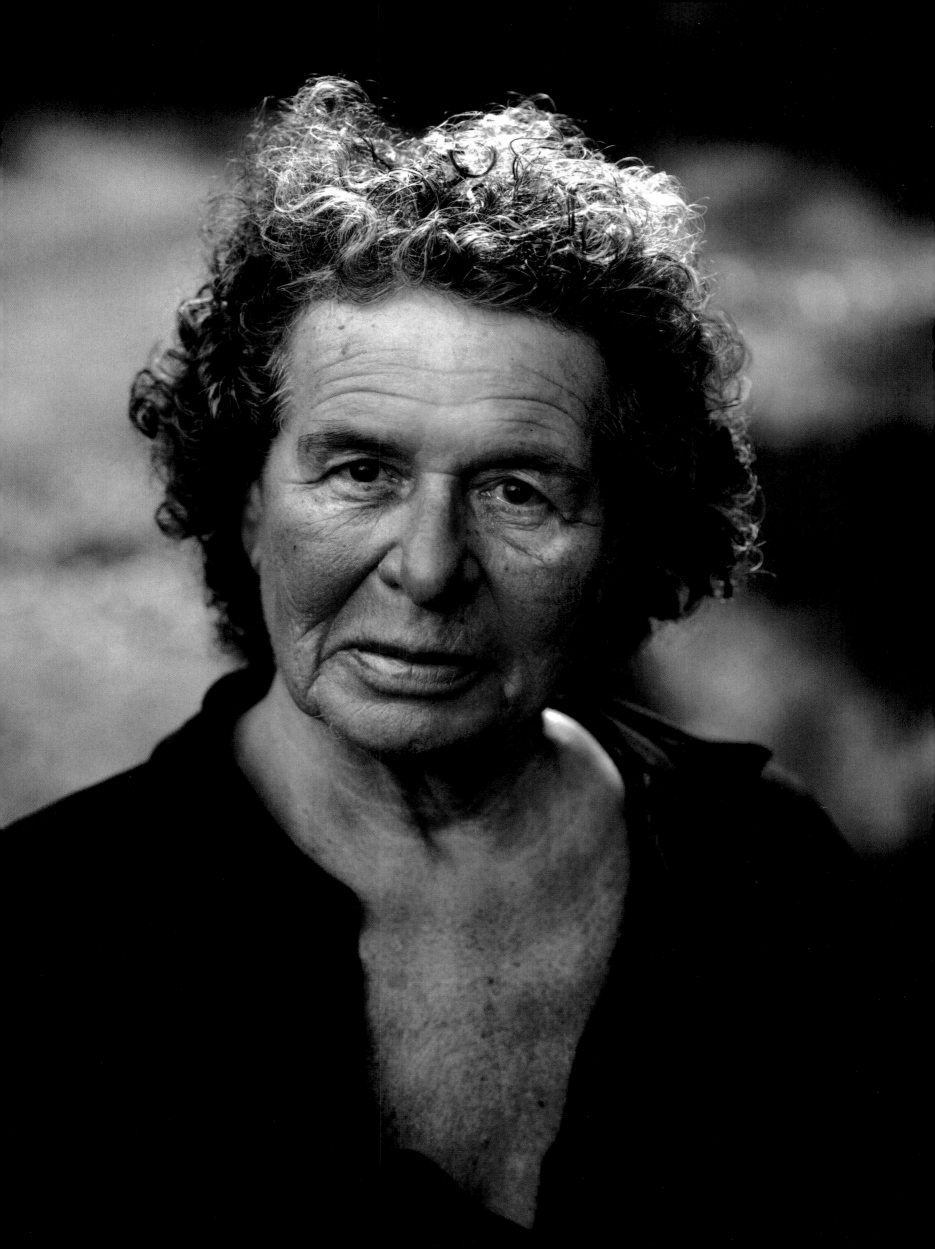

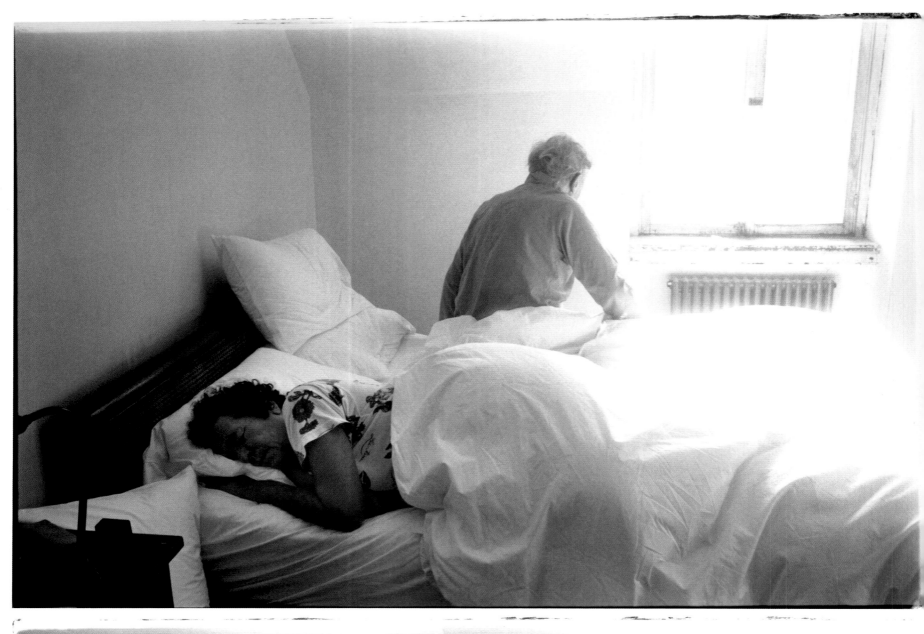

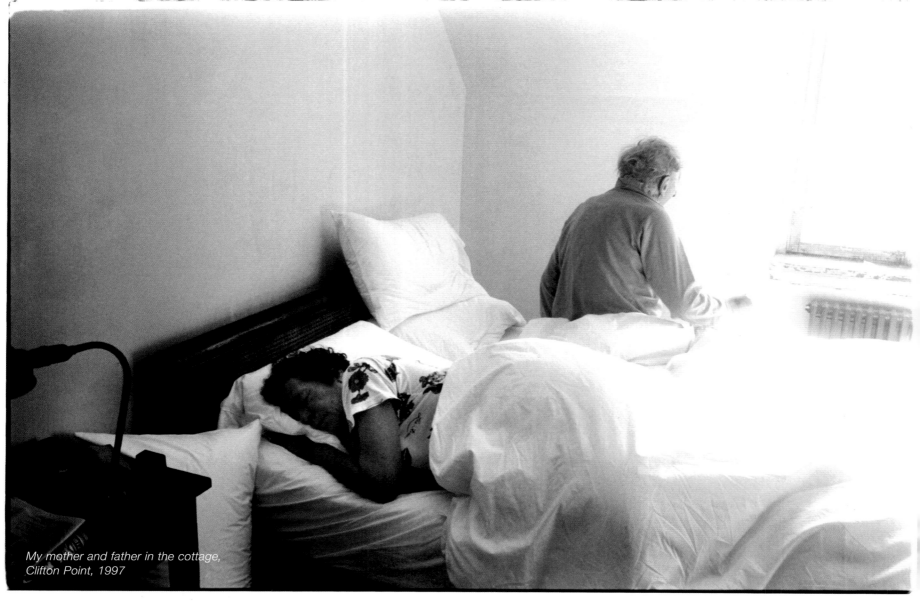

My mother and father in the cottage,
Clifton Point, 1997

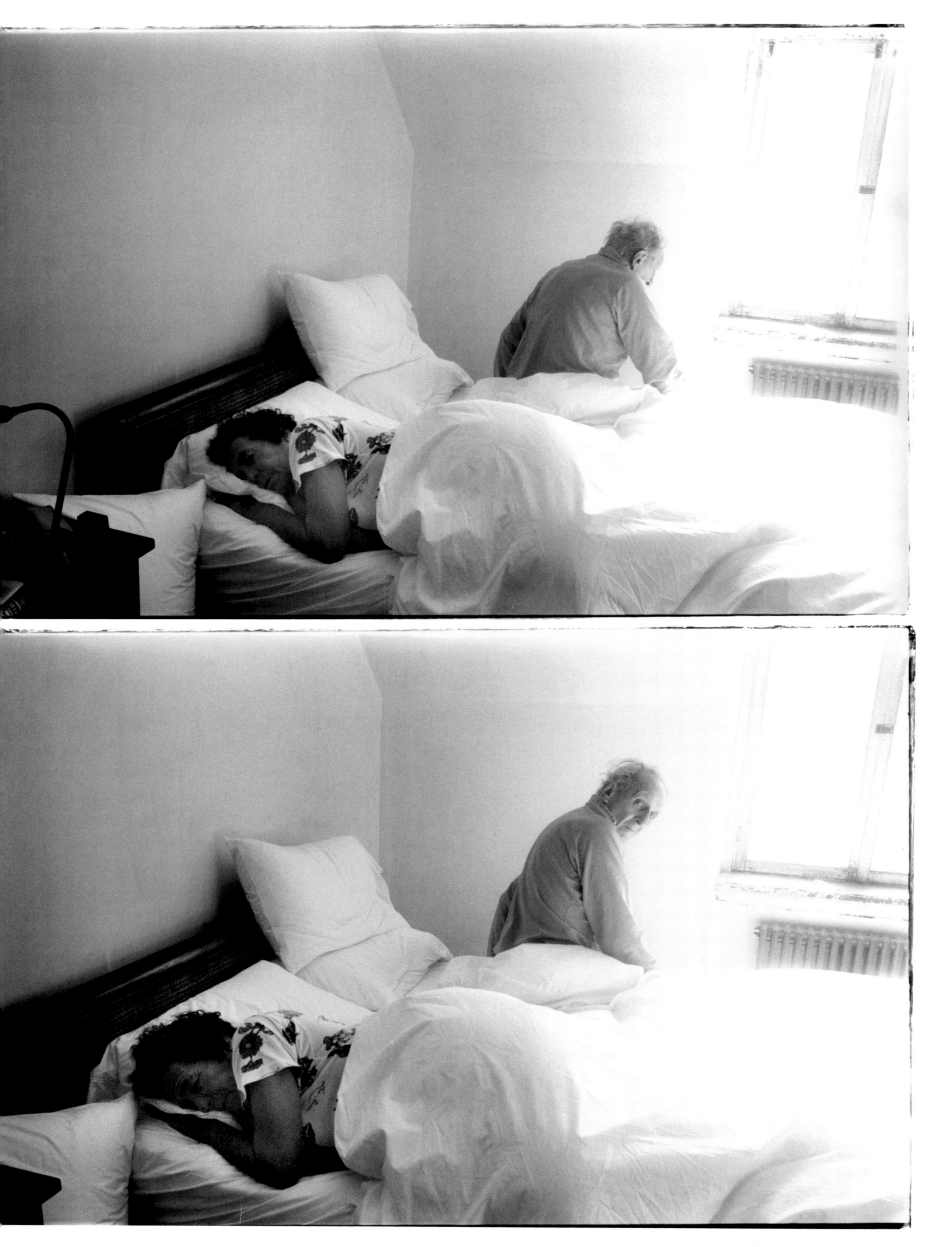

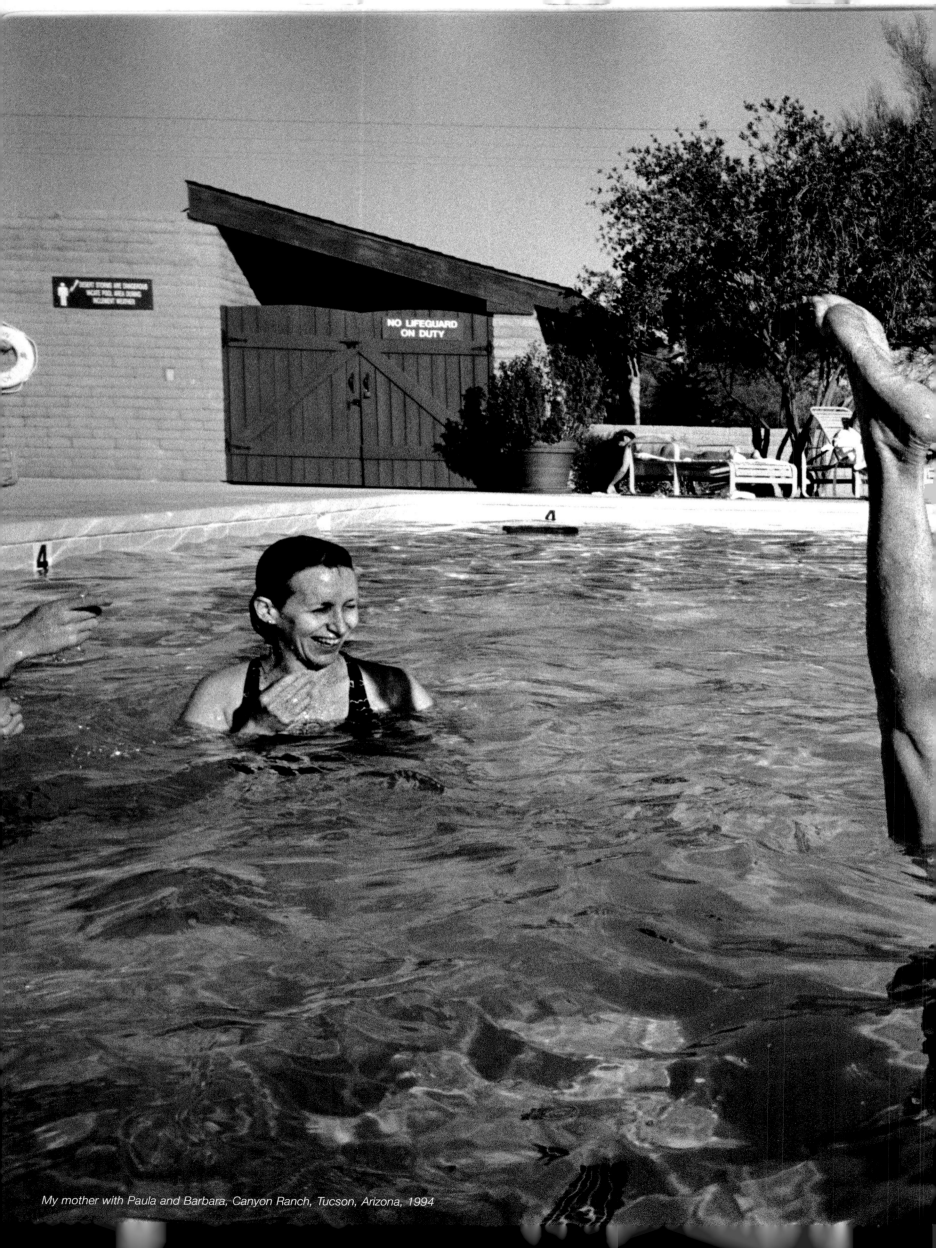

My mother with Paula and Barbara, Canyon Ranch, Tucson, Arizona, 1994

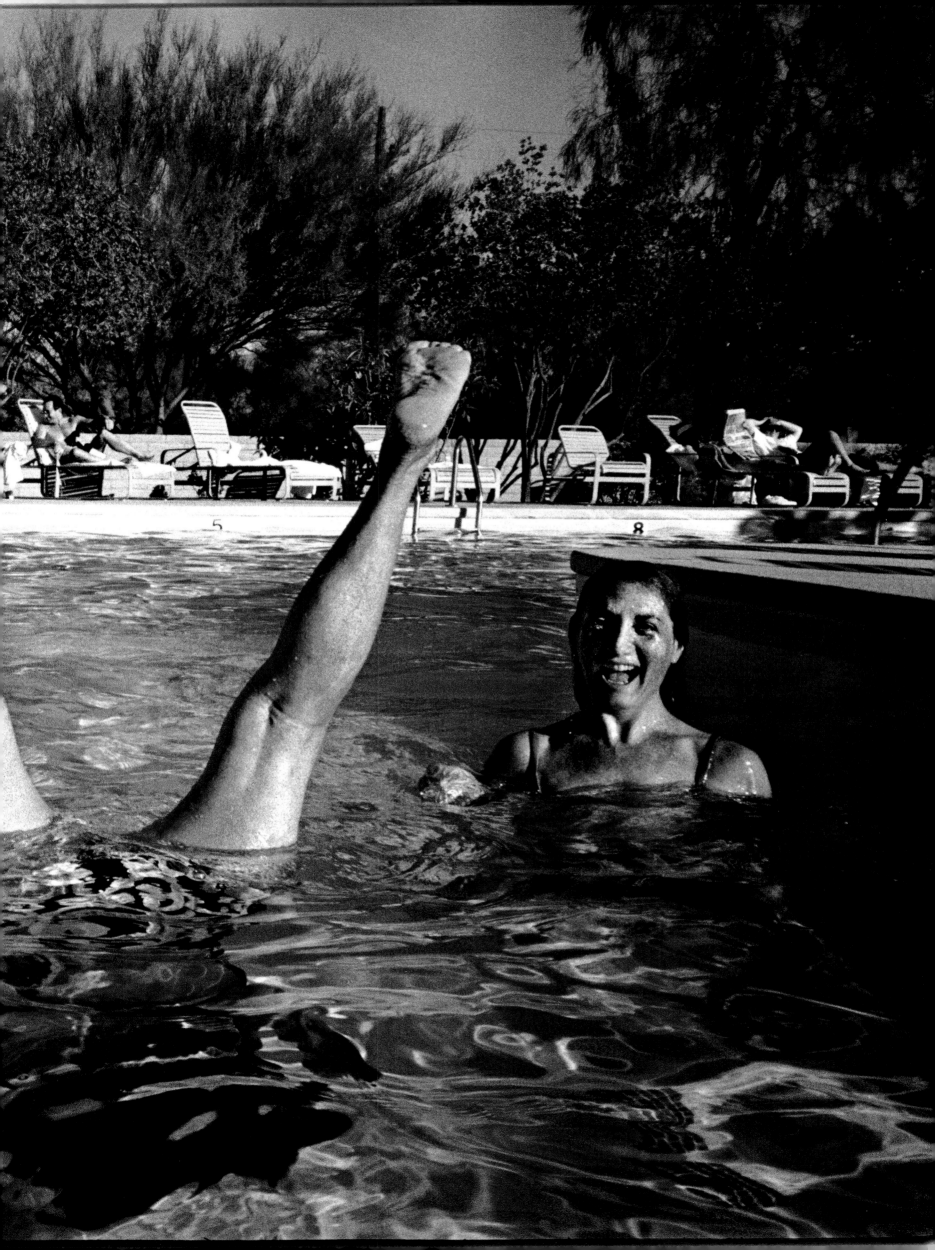

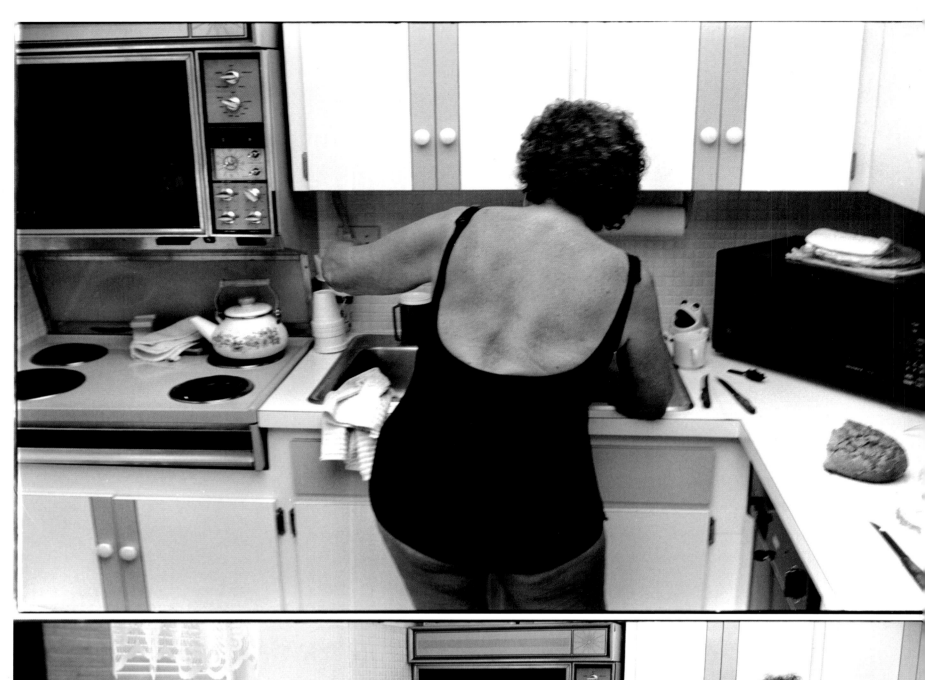

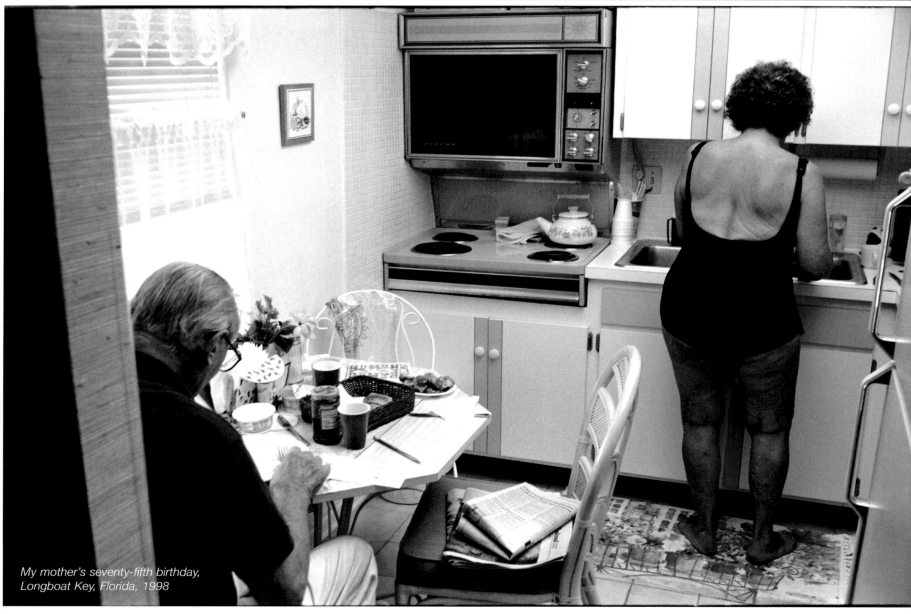

My mother's seventy-fifth birthday,
Longboat Key, Florida, 1998

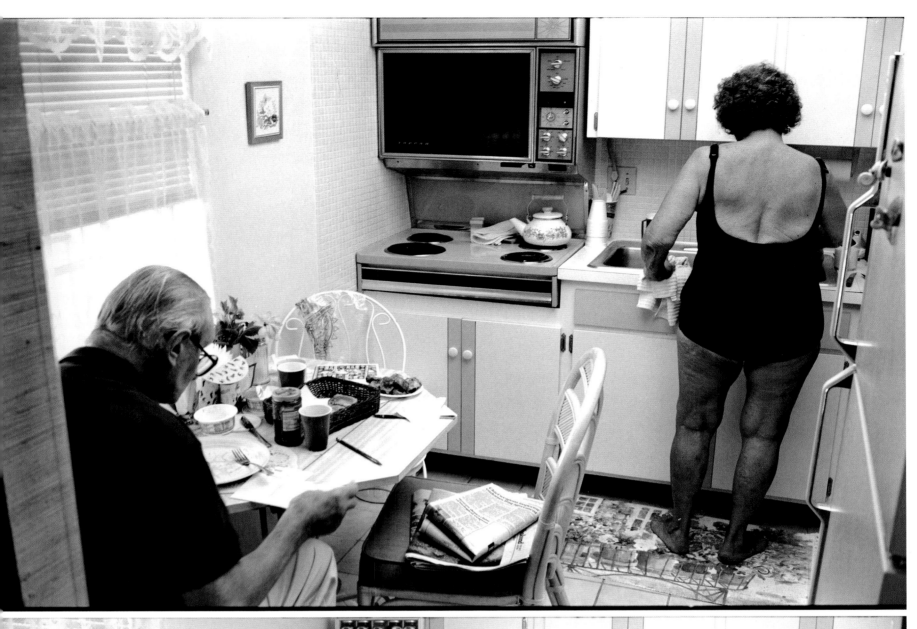

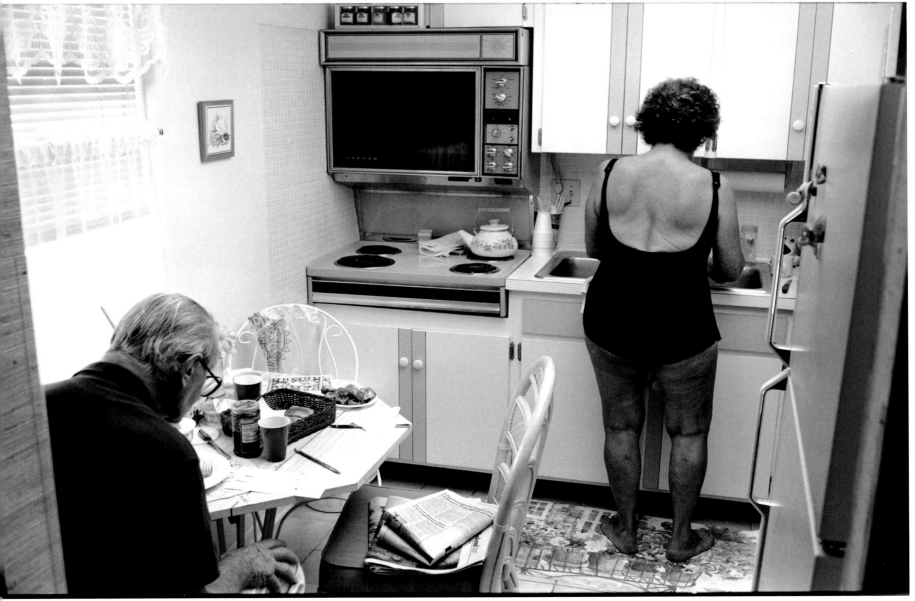

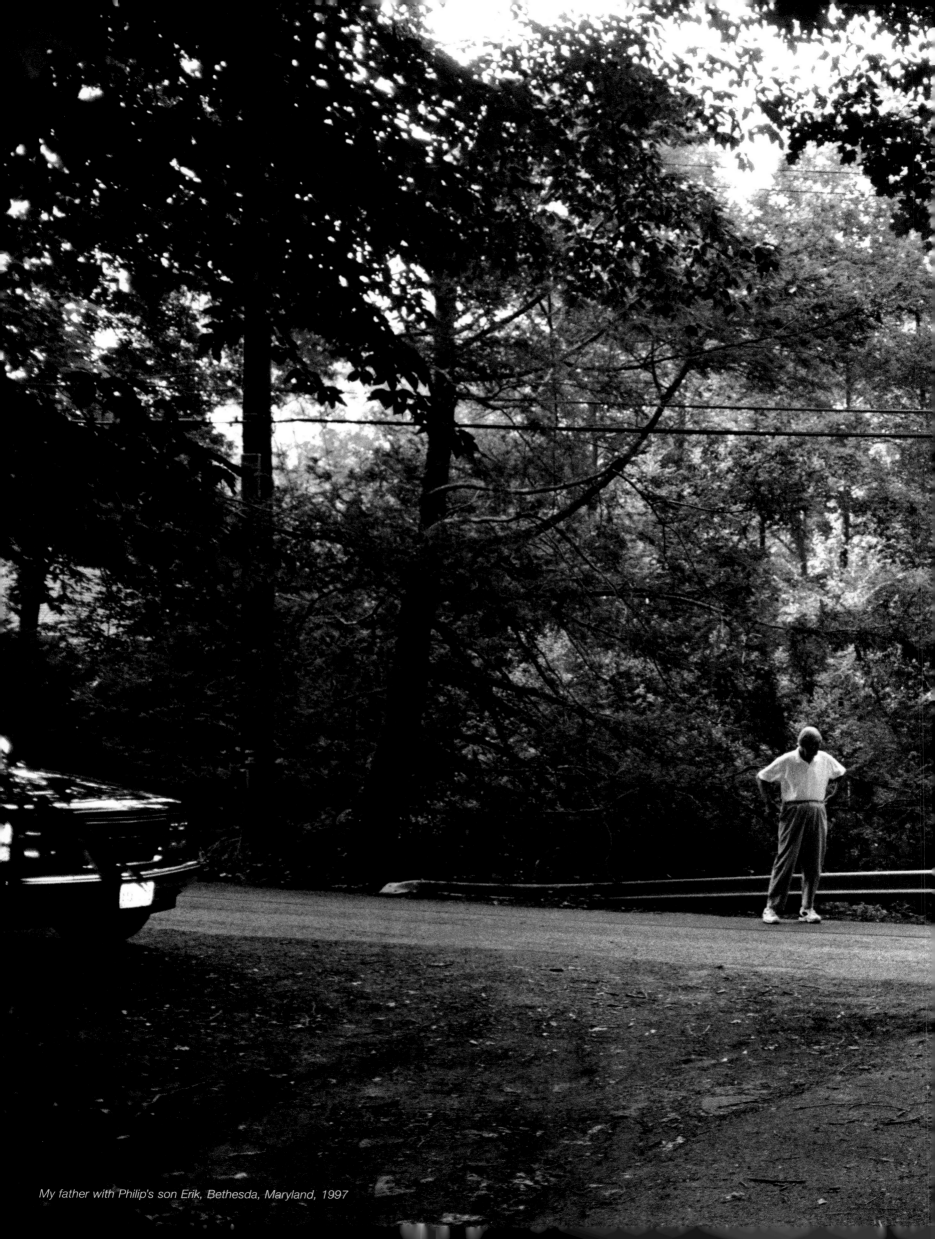

My father with Philip's son Erik, Bethesda, Maryland, 1997

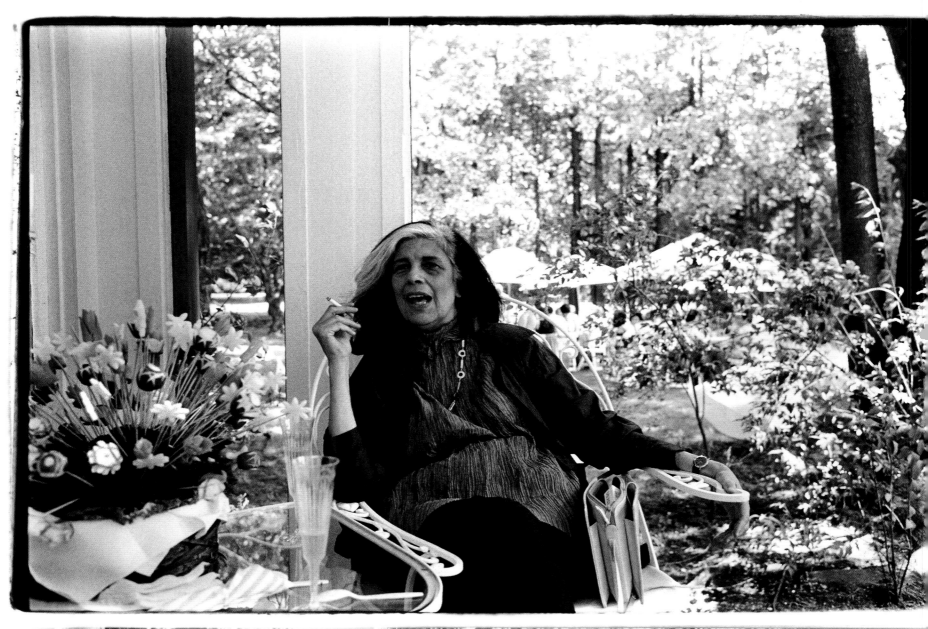

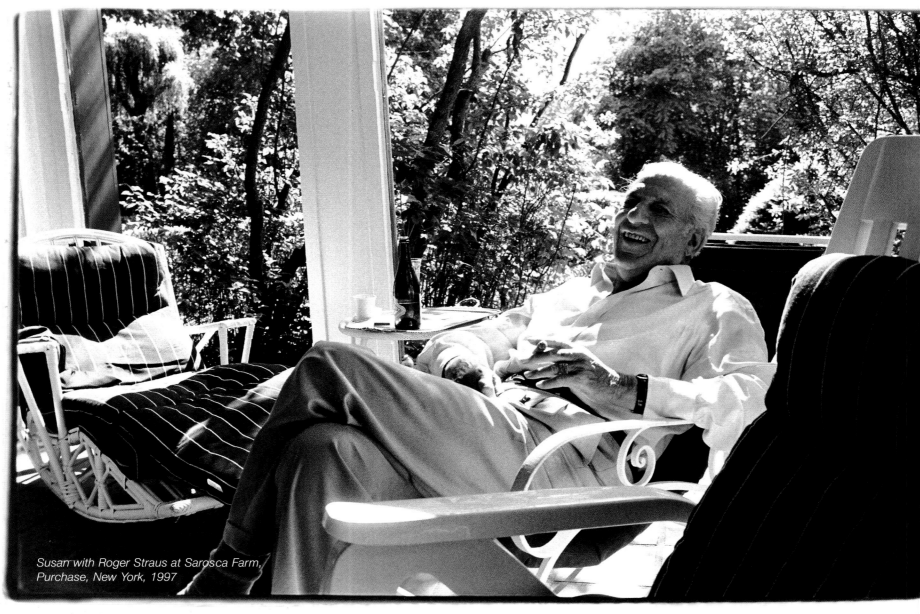

Susan with Roger Straus at Sarosca Farm,
Purchase, New York, 1997

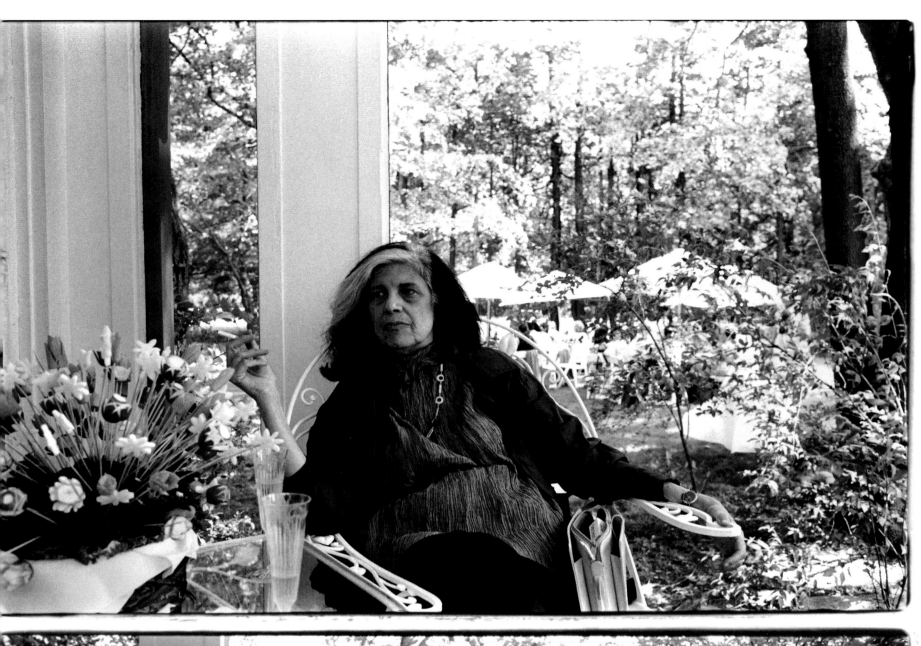

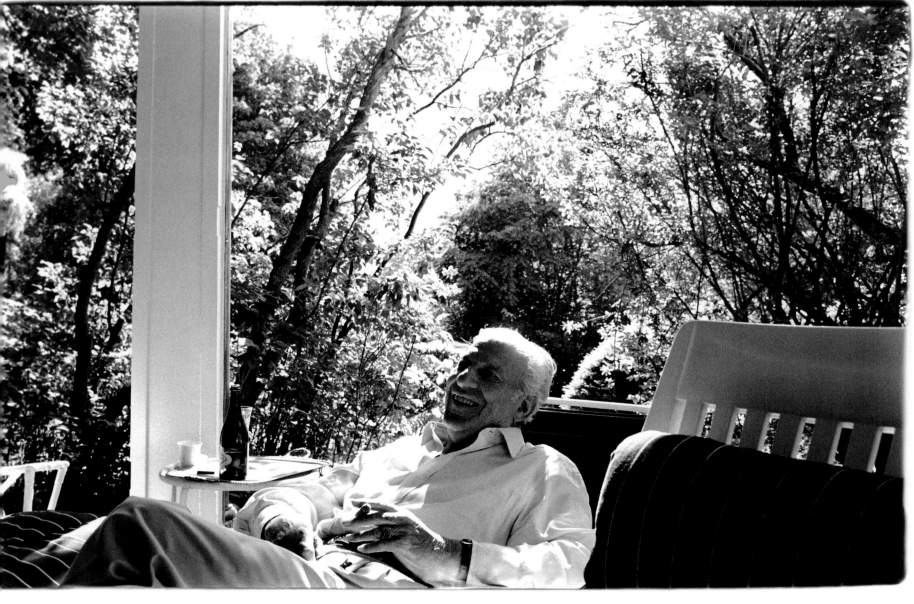

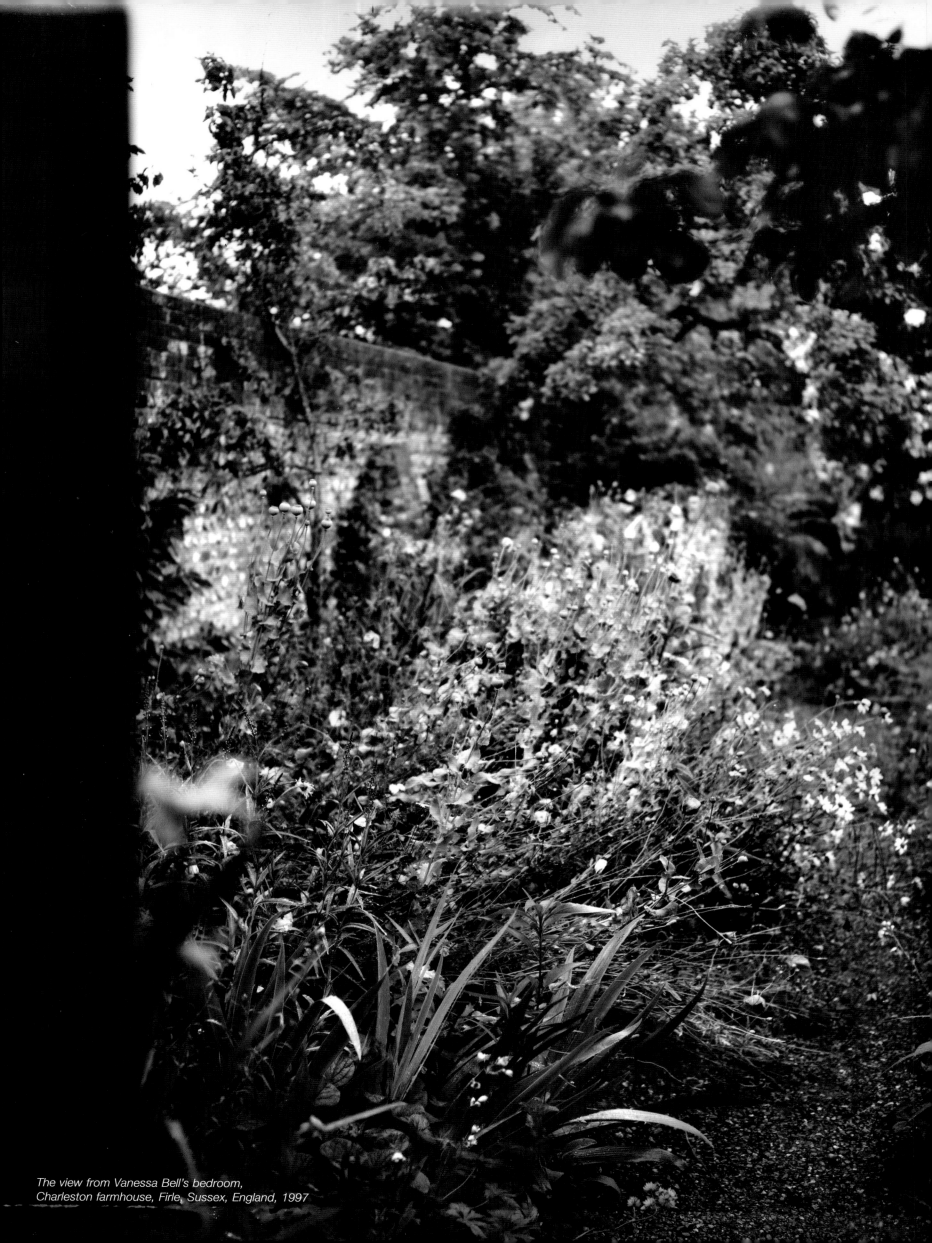

*The view from Vanessa Bell's bedroom,
Charleston farmhouse, Firle, Sussex, England, 1997*

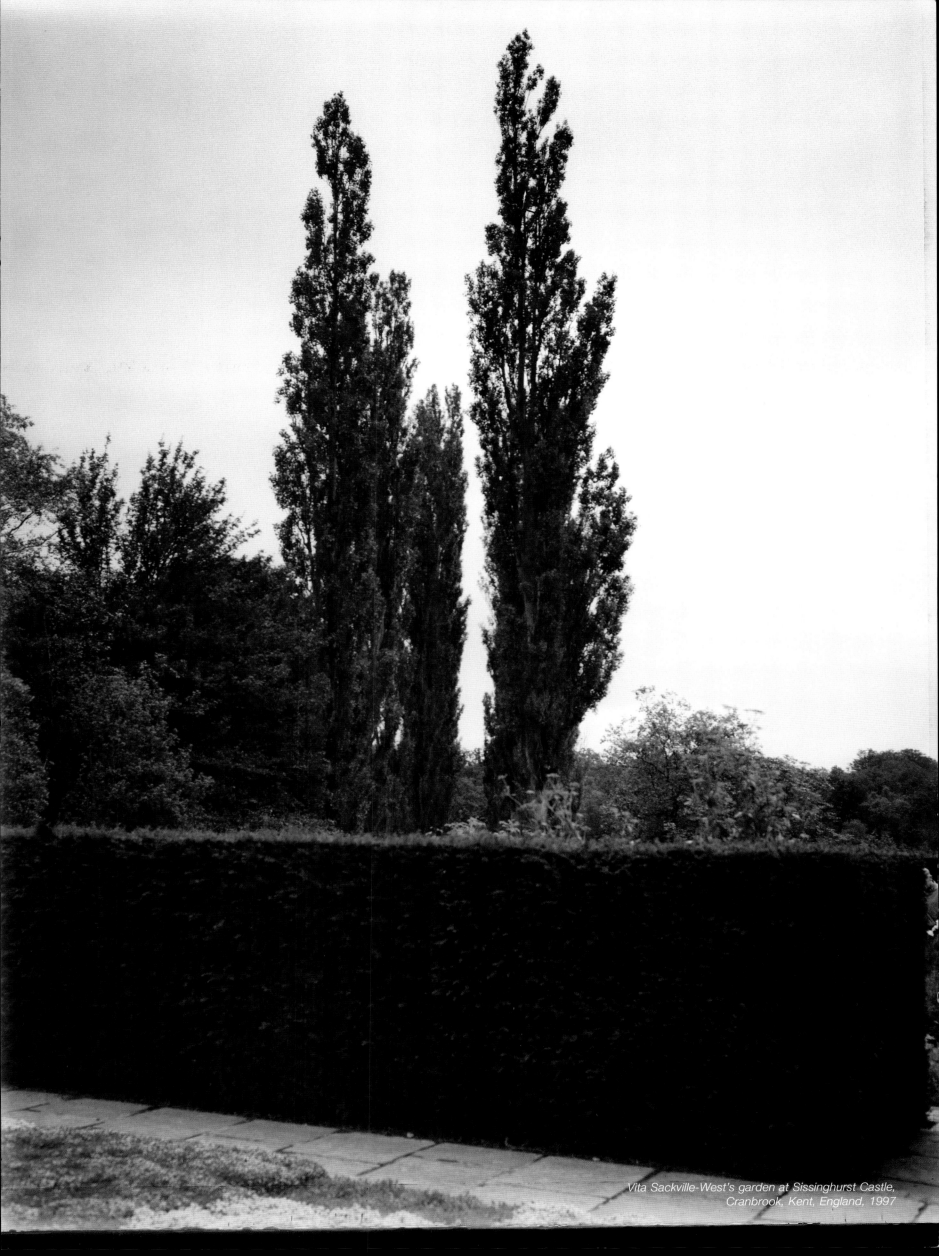

*Vita Sackville-West's garden at Sissinghurst Castle,
Cranbrook, Kent, England, 1997*

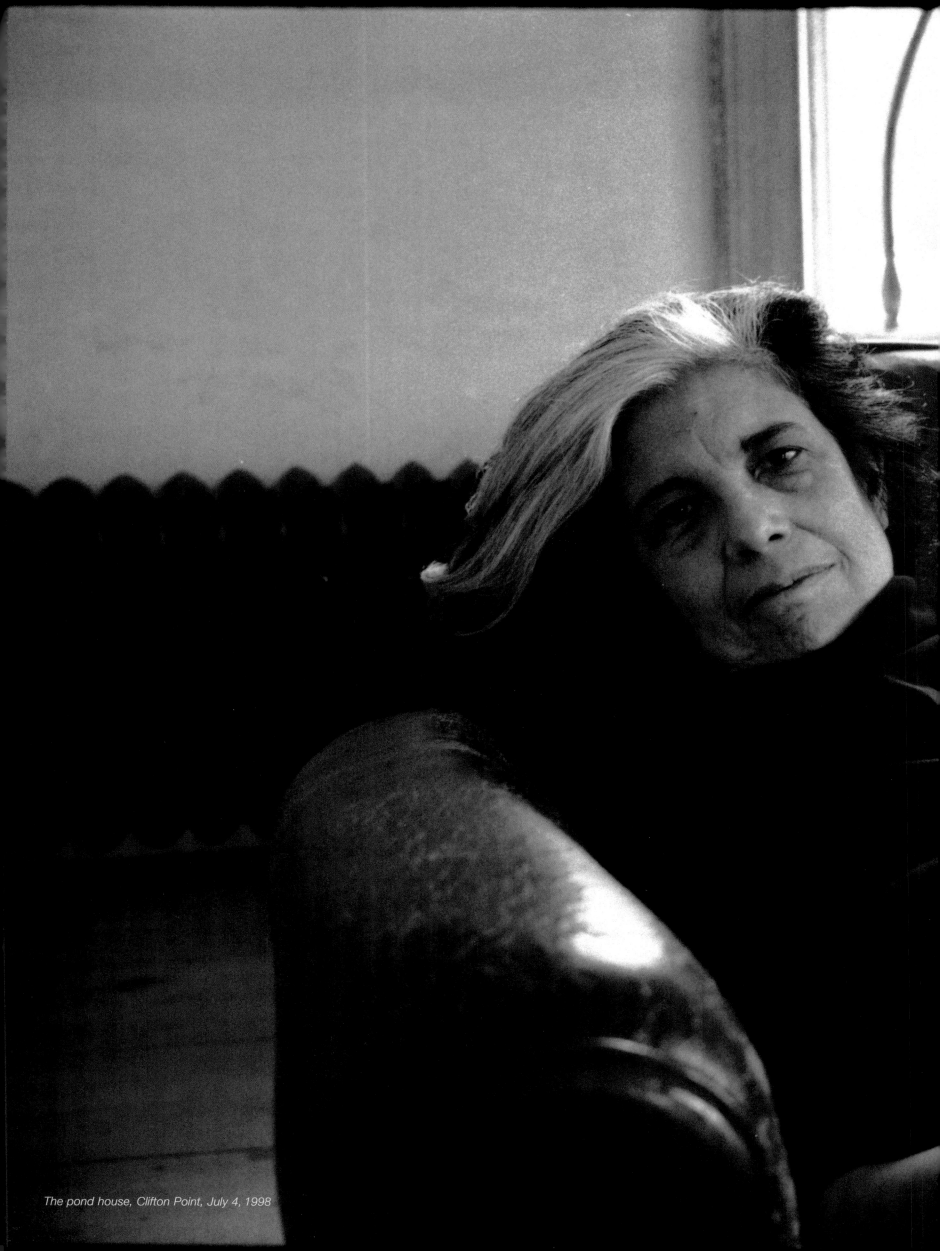

The pond house, Clifton Point, July 4, 1998

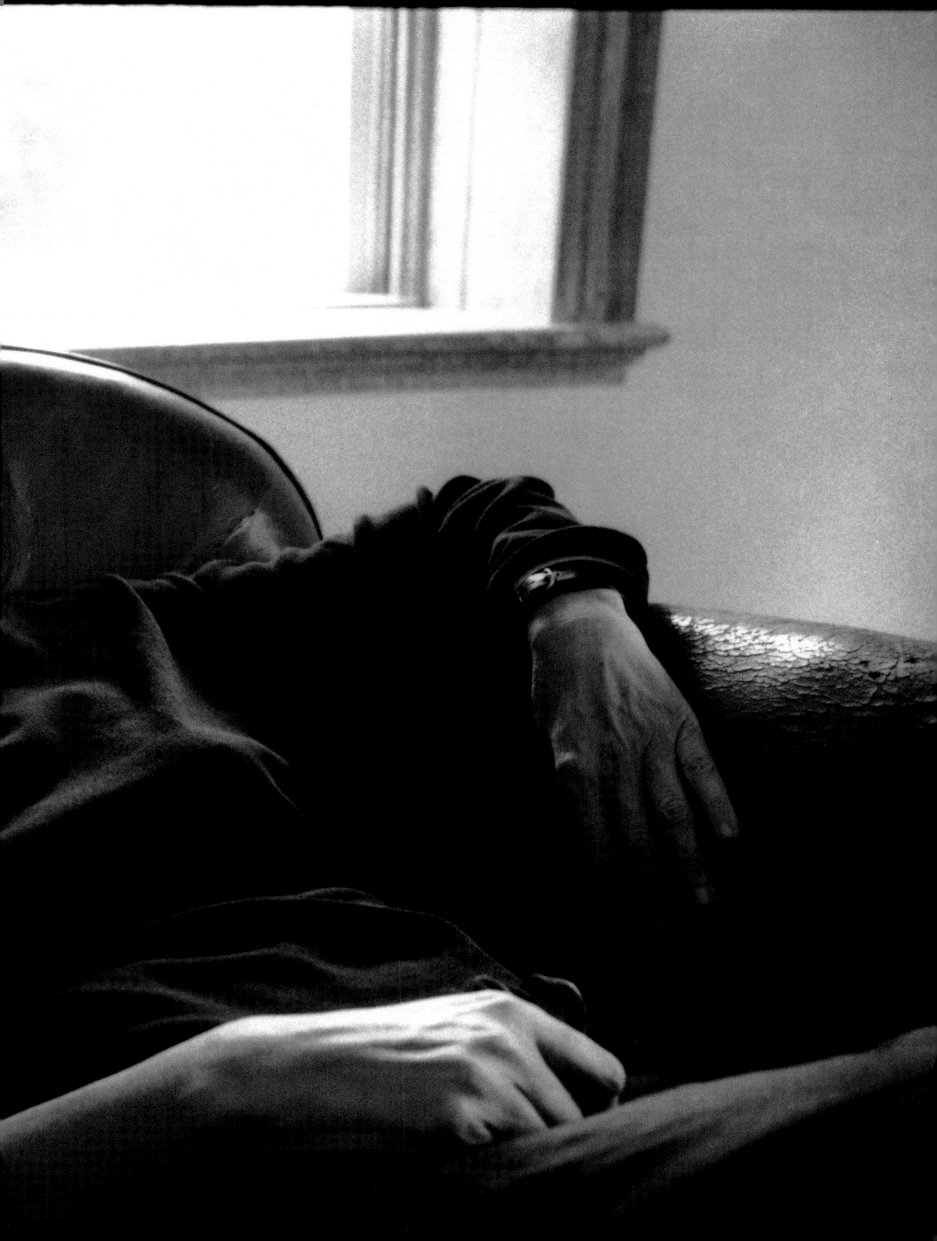

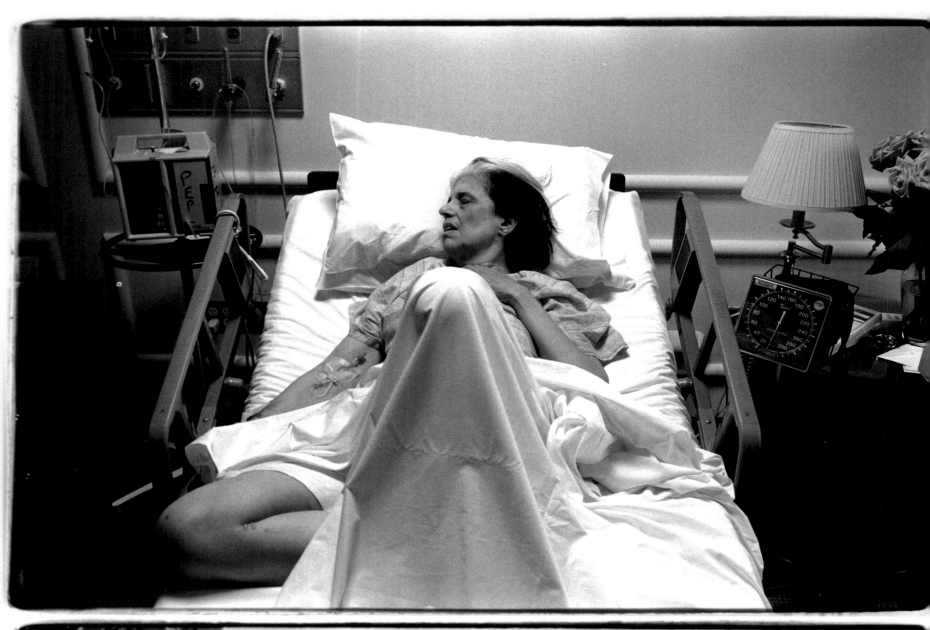
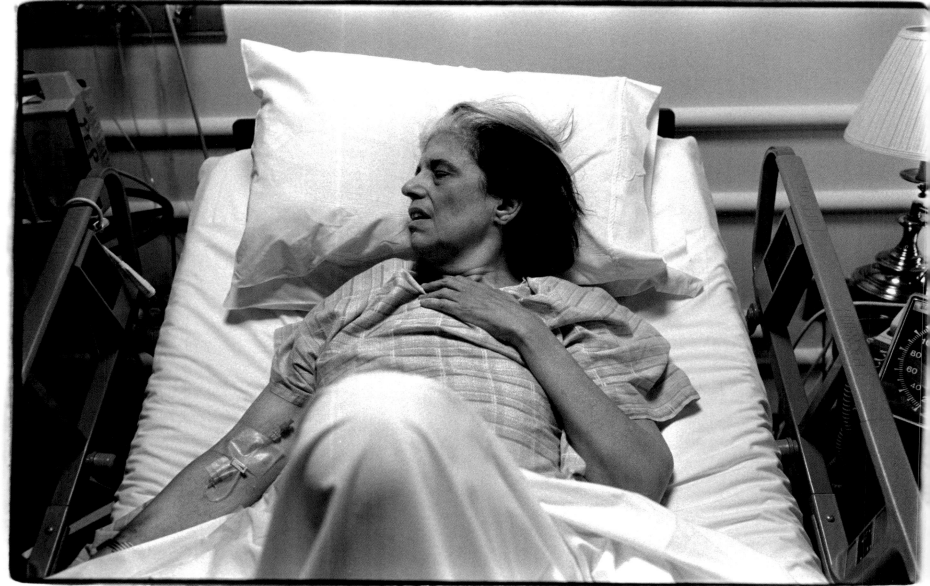

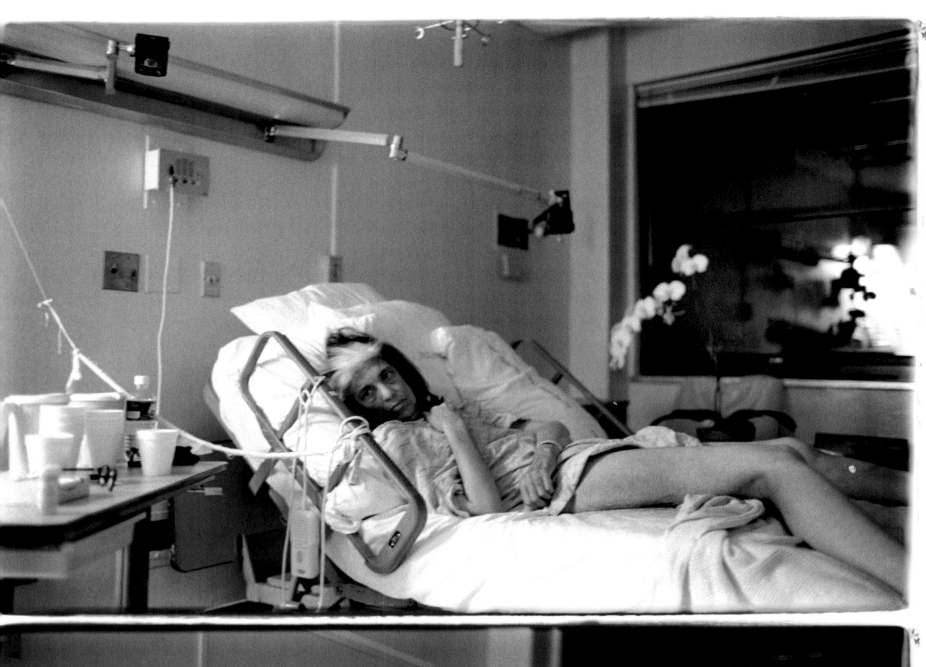

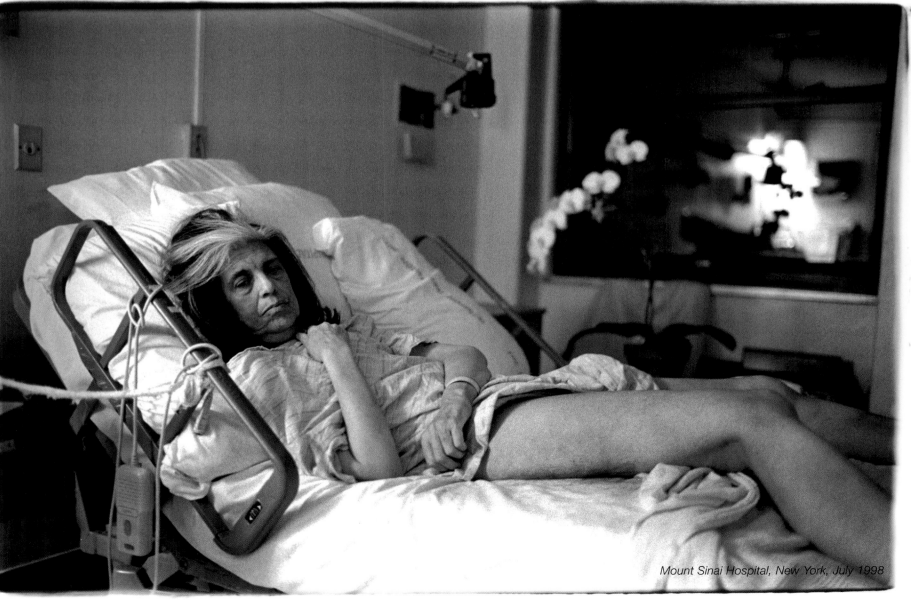

Mount Sinai Hospital, New York, July 1998

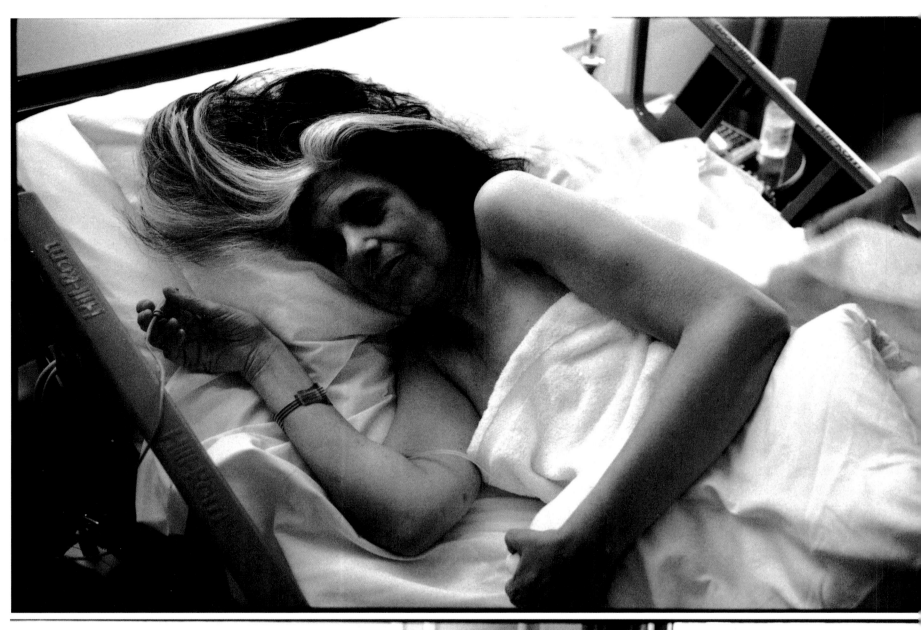

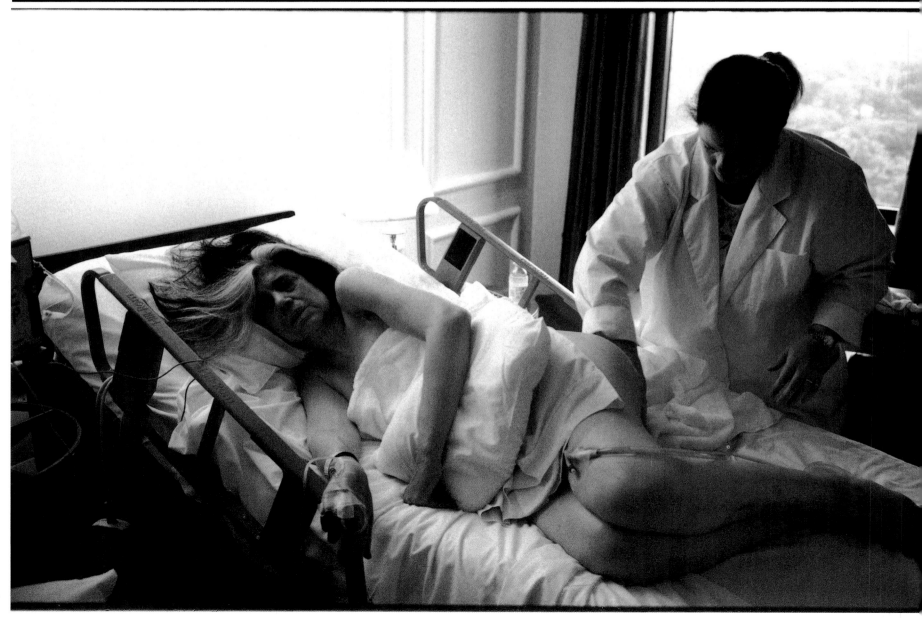

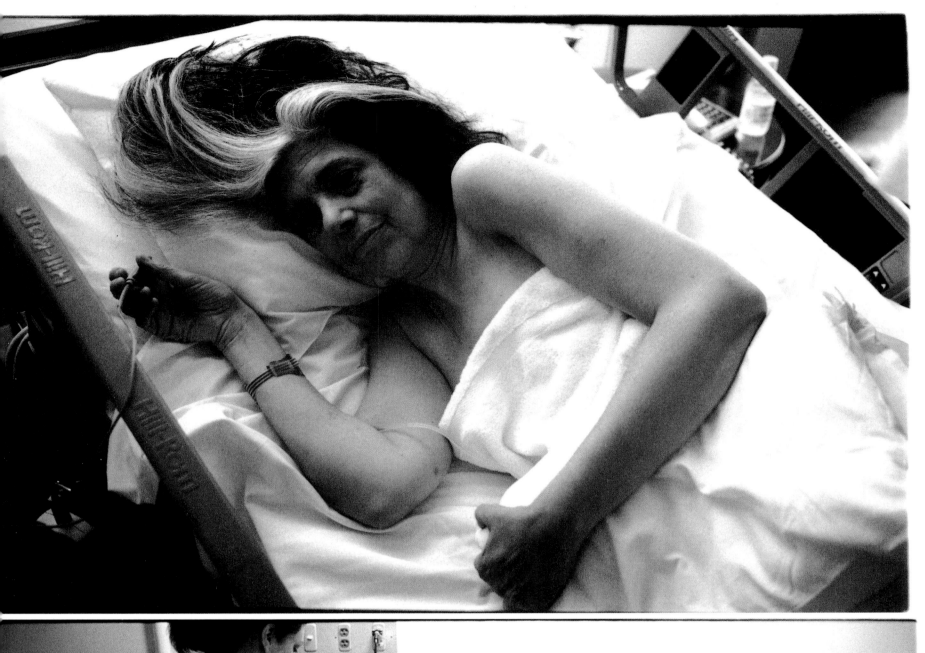
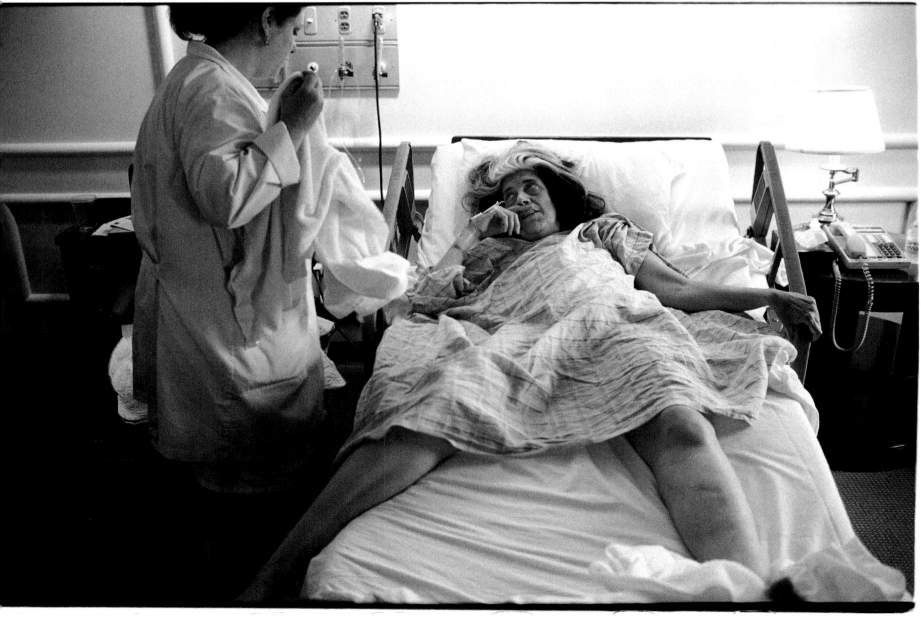

David Rieff, Susan's son, Mount Sinai Hospital, July 1998

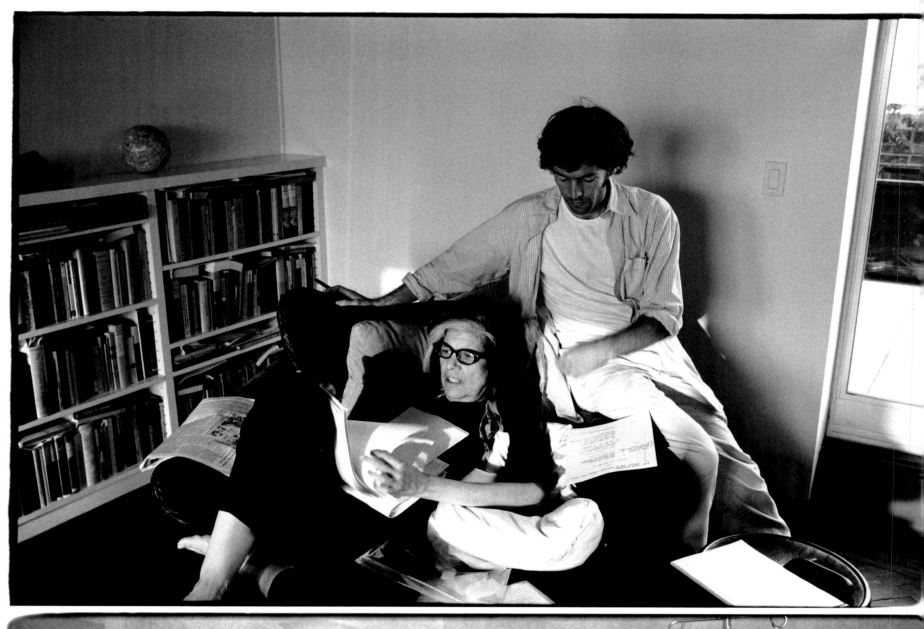

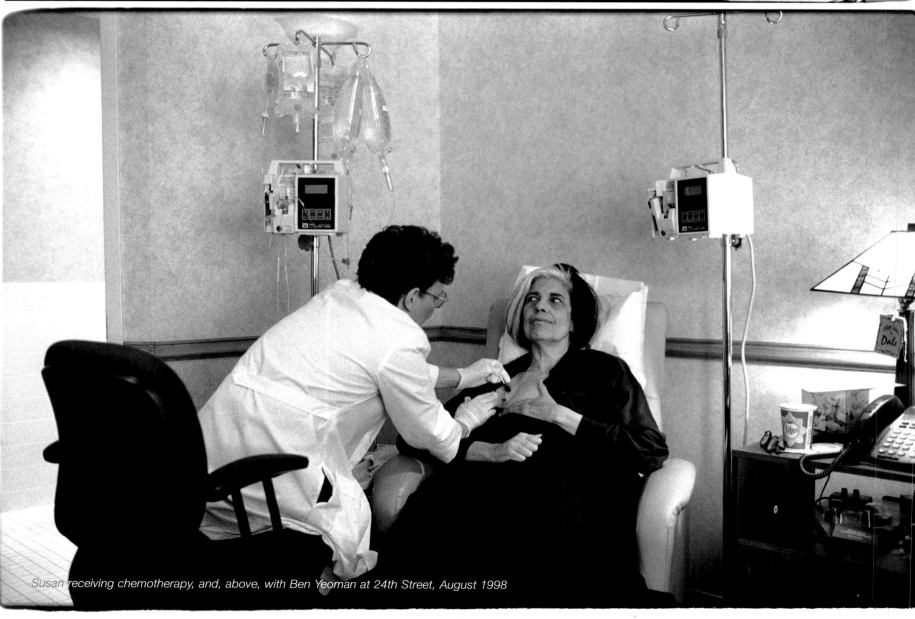

Susan receiving chemotherapy, and, above, with Ben Yeoman at 24th Street, August 1998

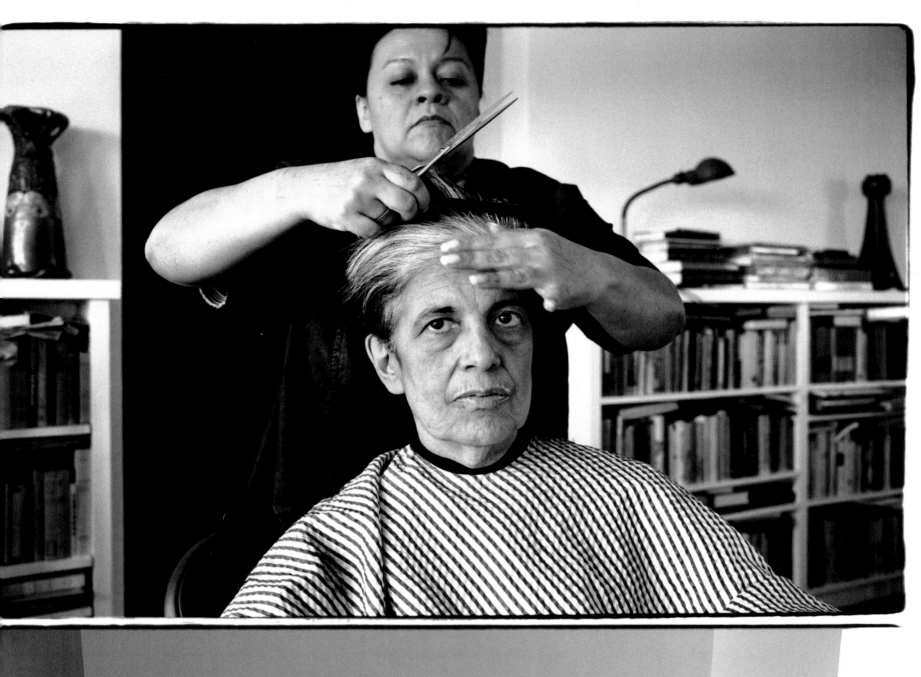

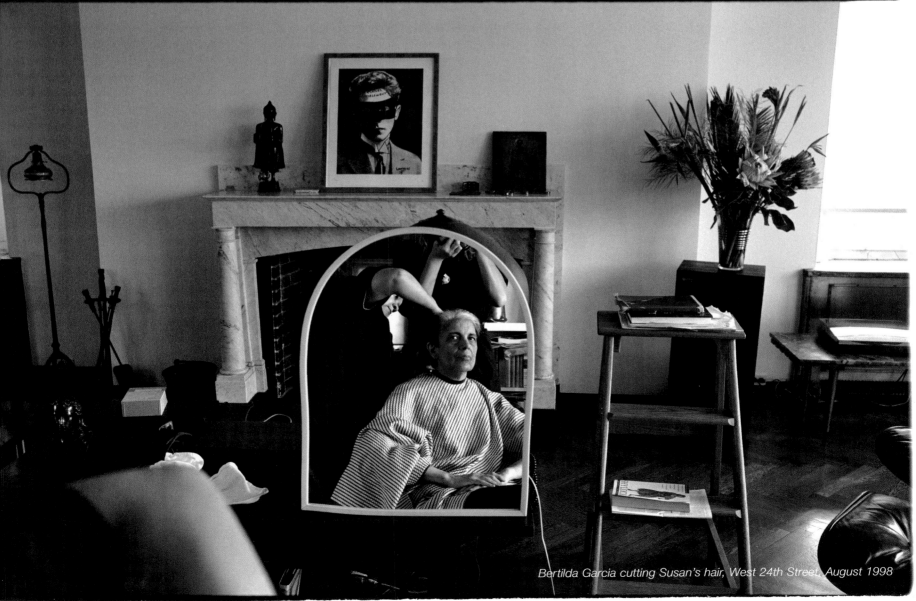

Bertilda Garcia cutting Susan's hair, West 24th Street, August 1998

Vandam Street studio, New York, 1999

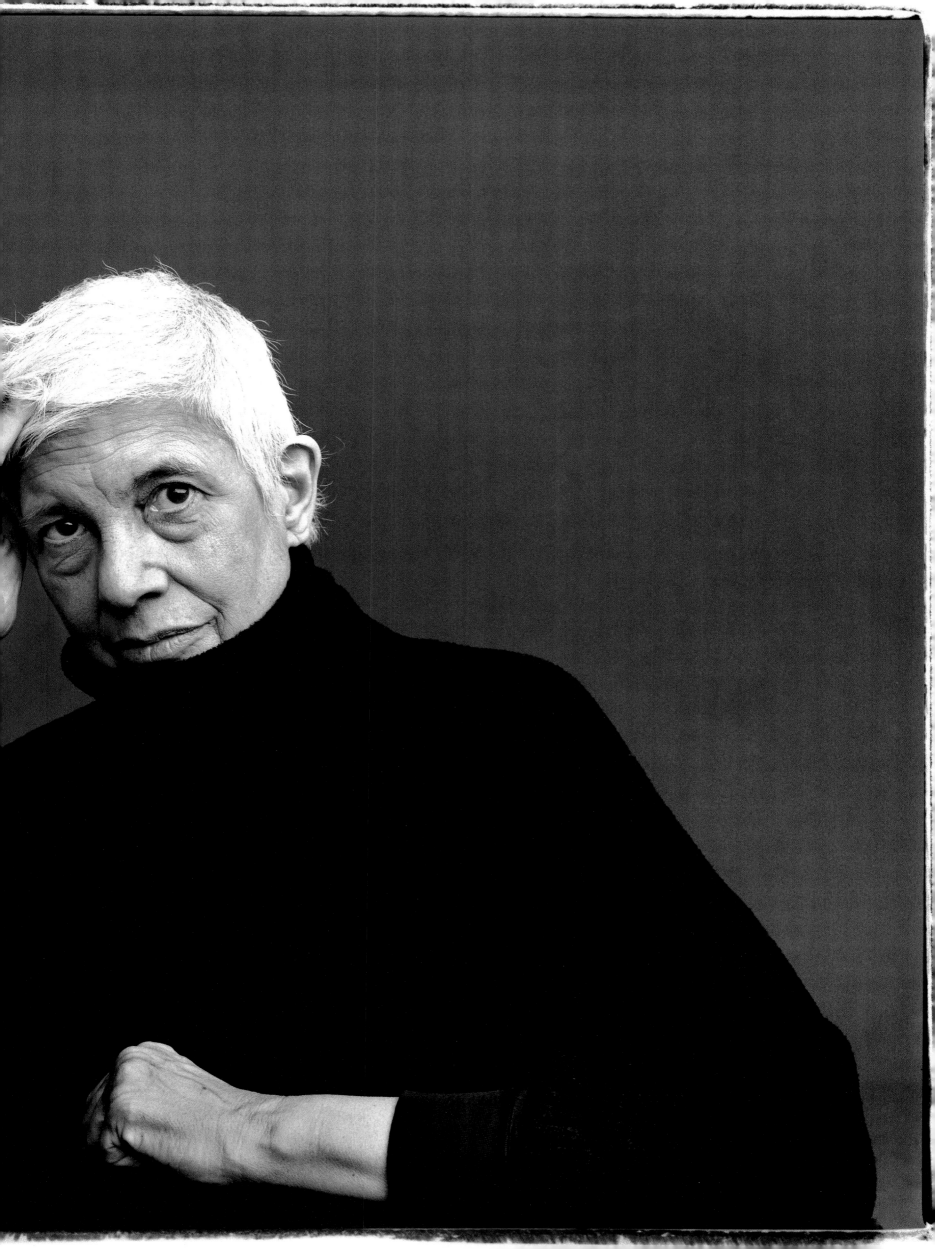

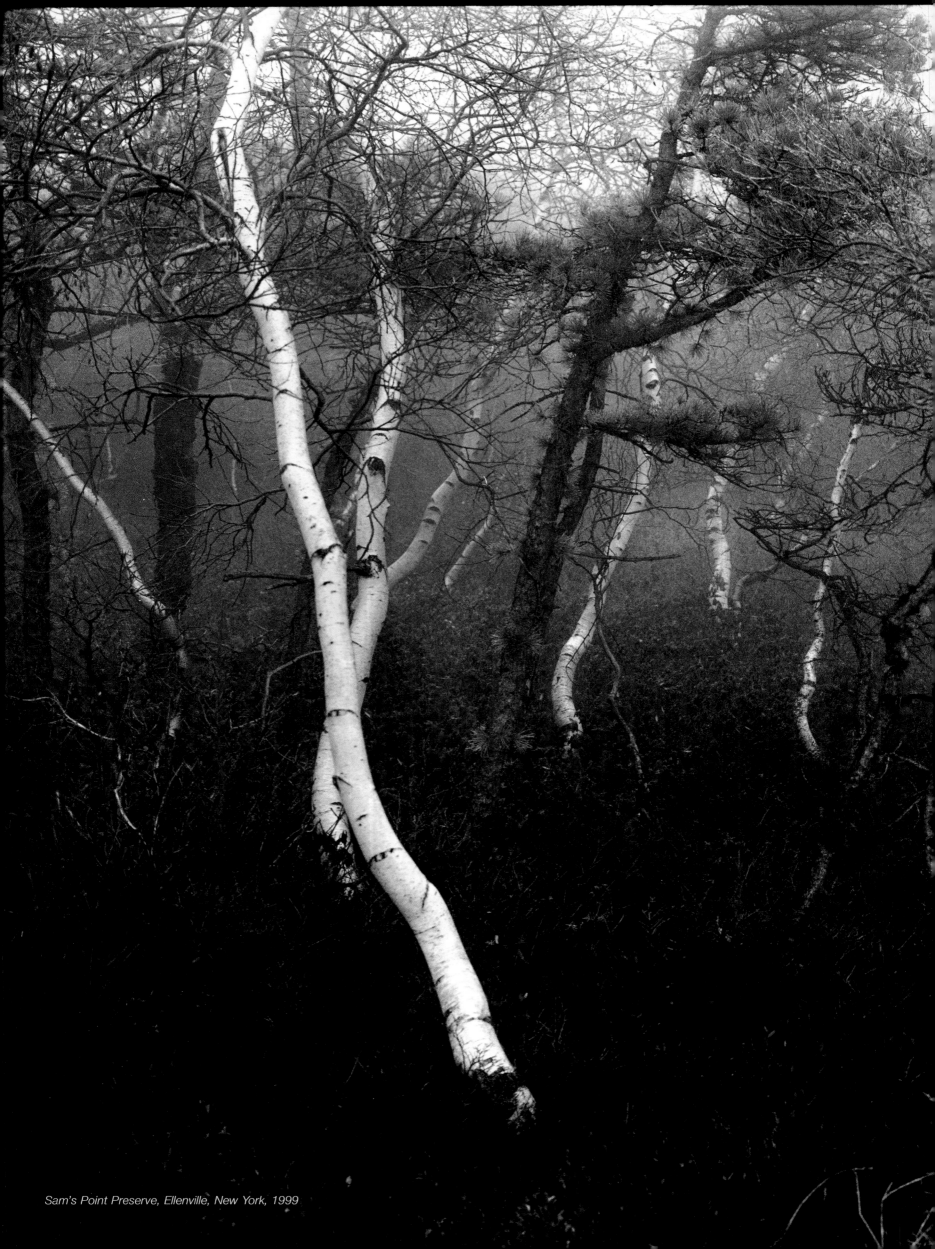

Sam's Point Preserve, Ellenville, New York, 1999

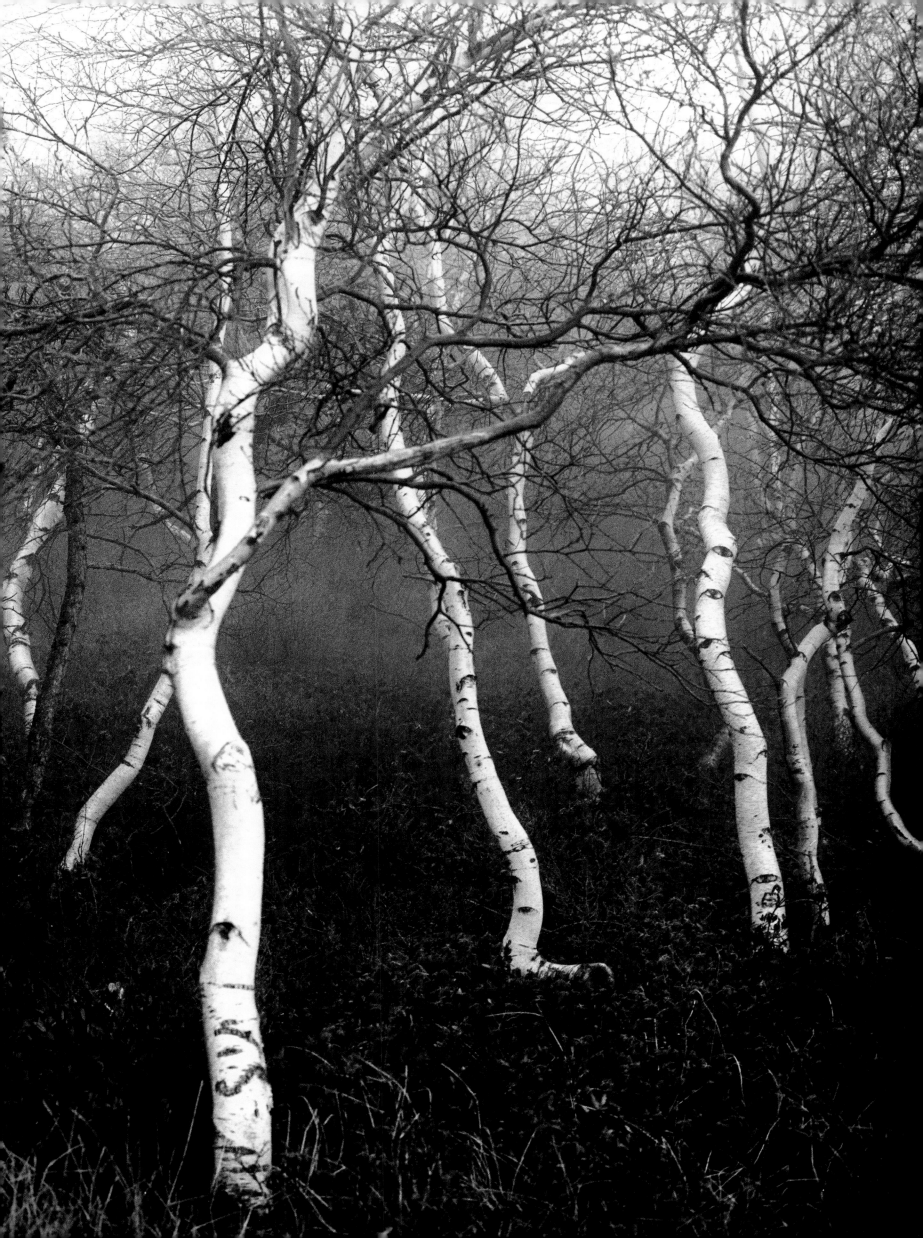

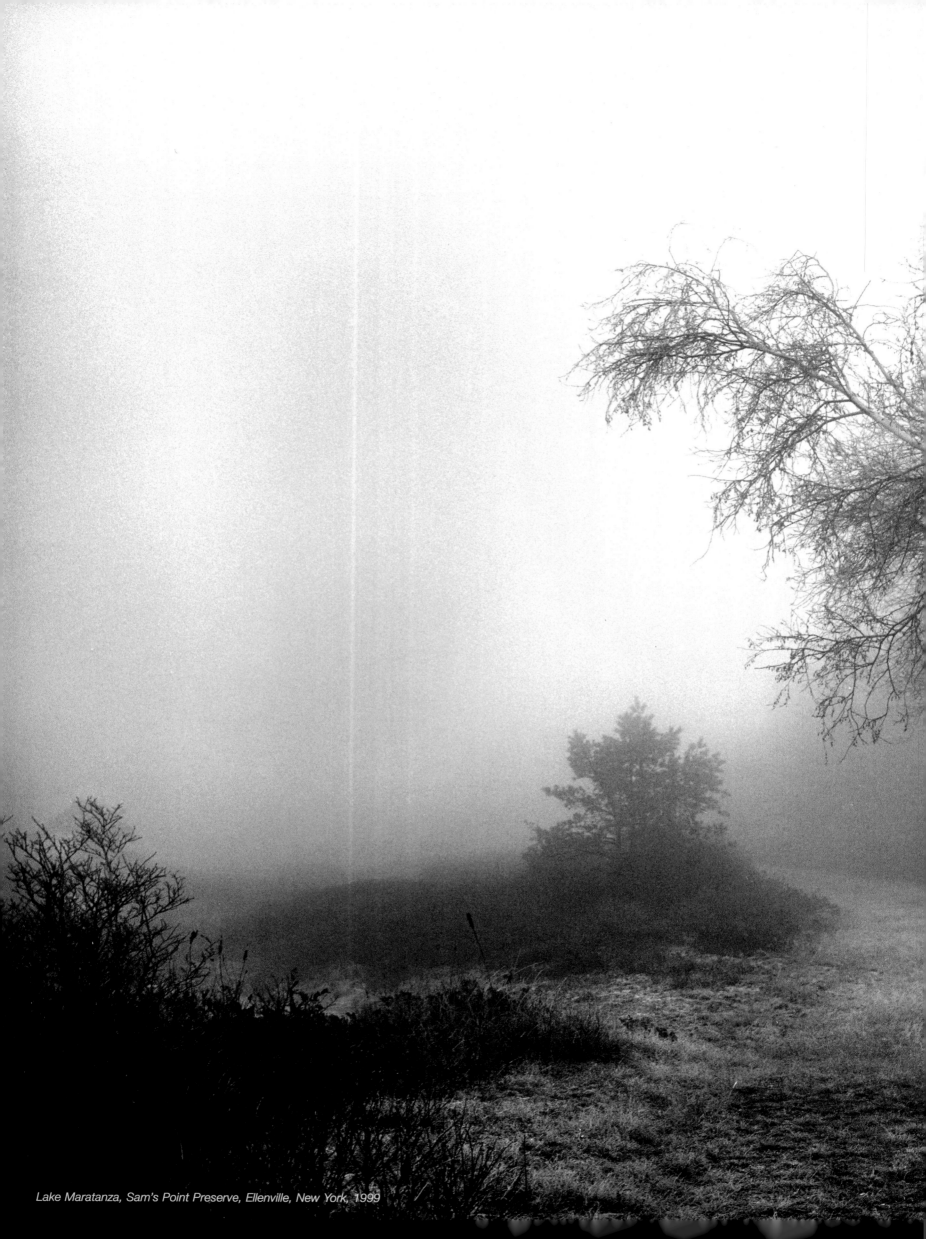

Lake Maratanza, Sam's Point Preserve, Ellenville, New York, 1999

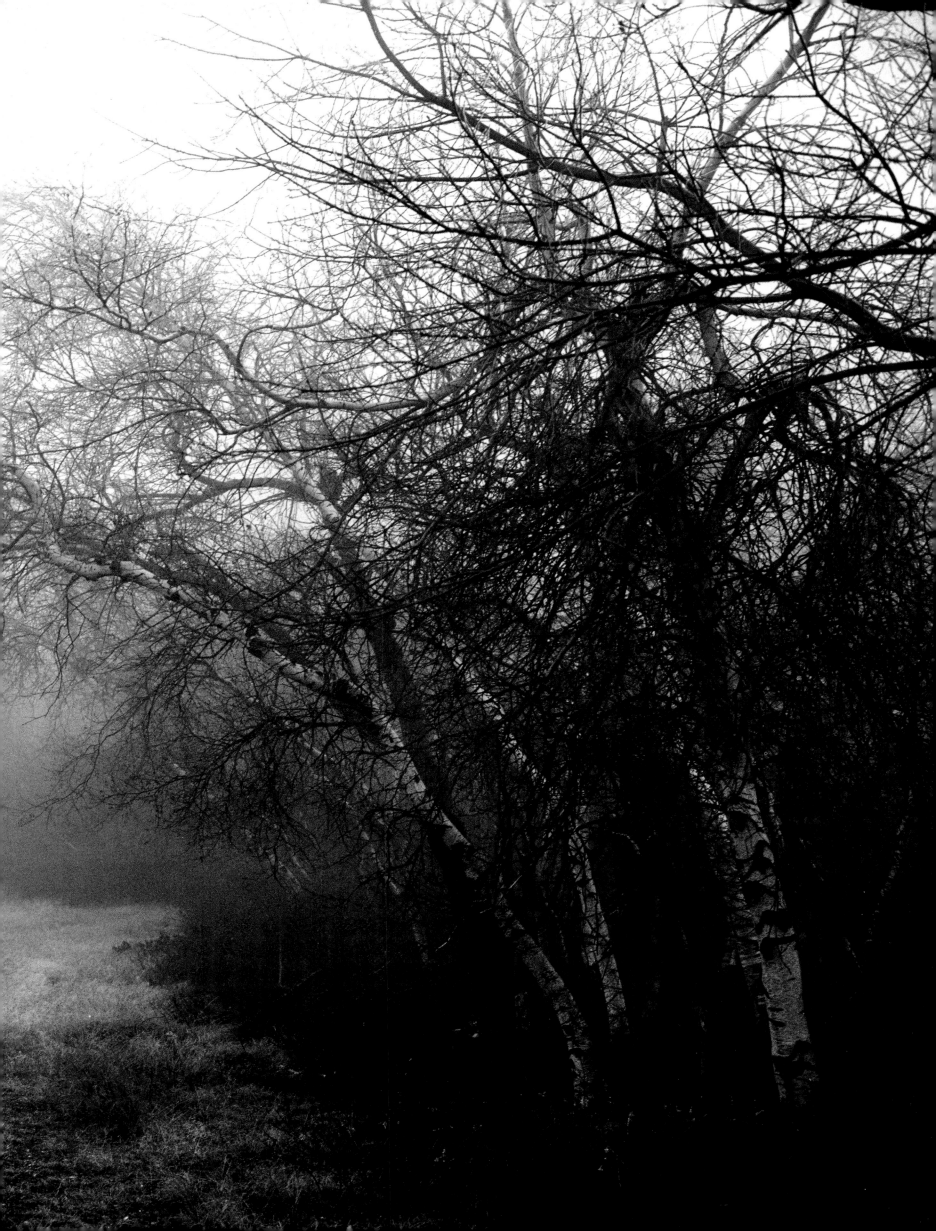

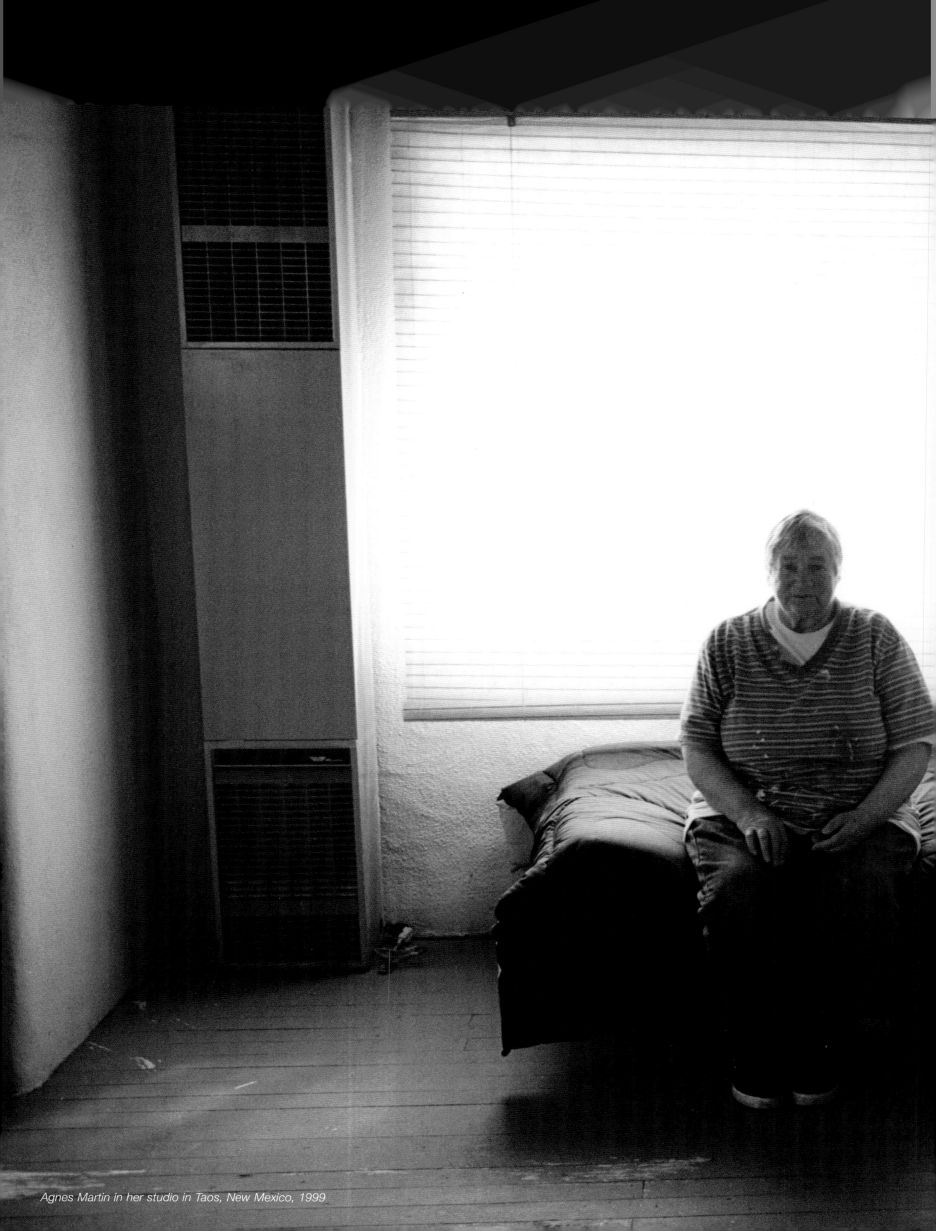

Agnes Martin in her studio in Taos, New Mexico, 1999

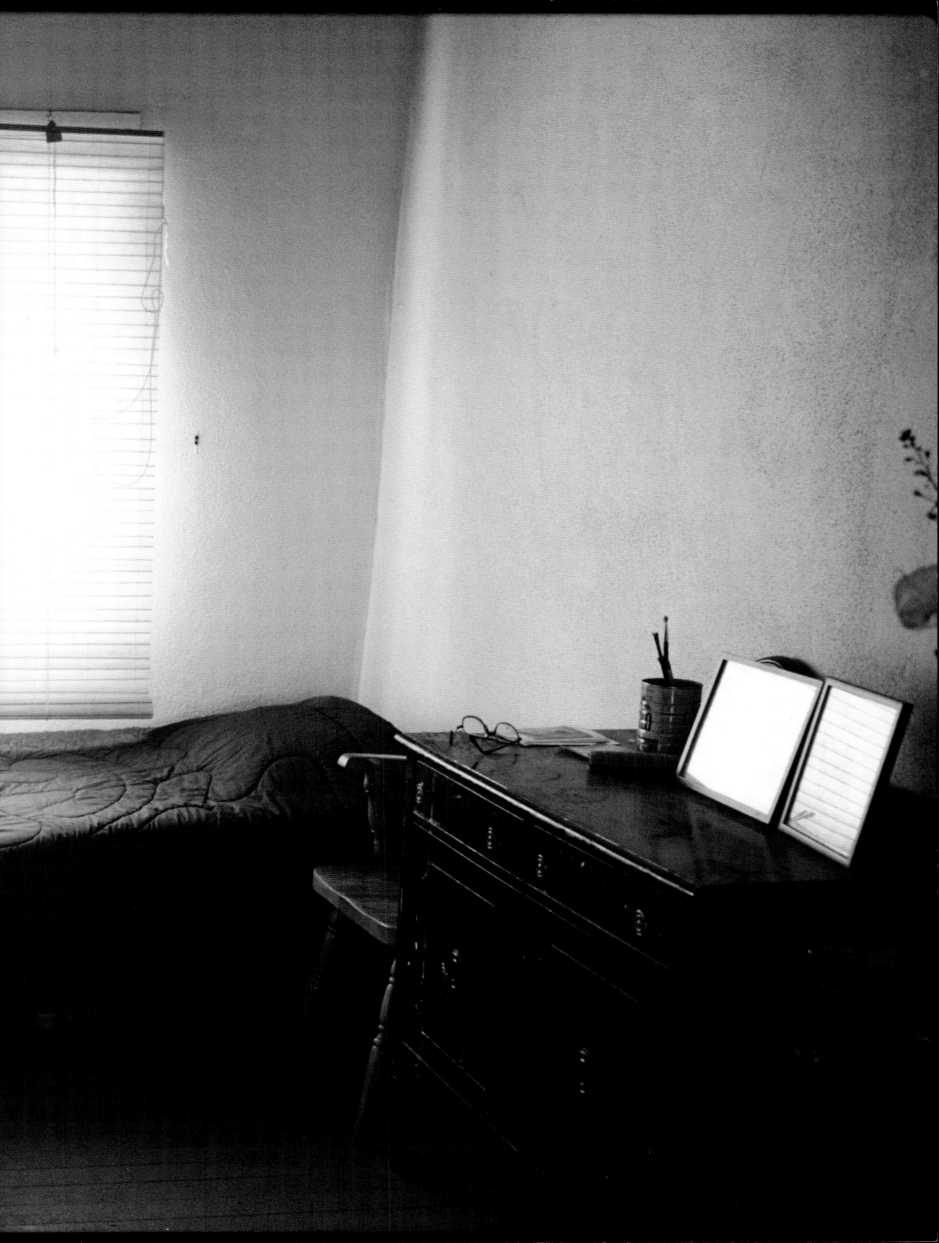

June Omura,
Mark Morris Dance Group,
Clifton Point, 1999

June Omura,
Mark Morris Dance Group,
Clifton Point, 1999

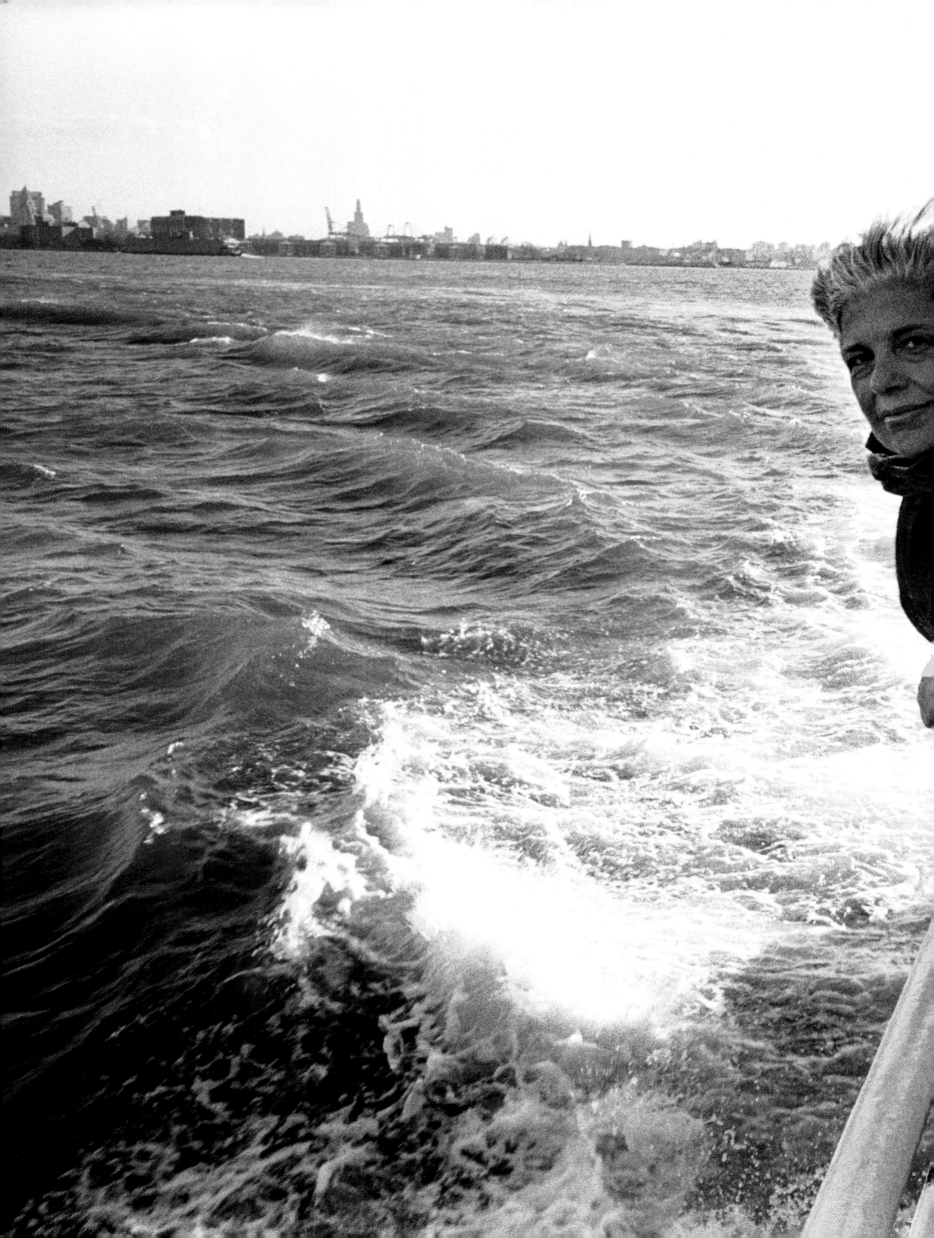

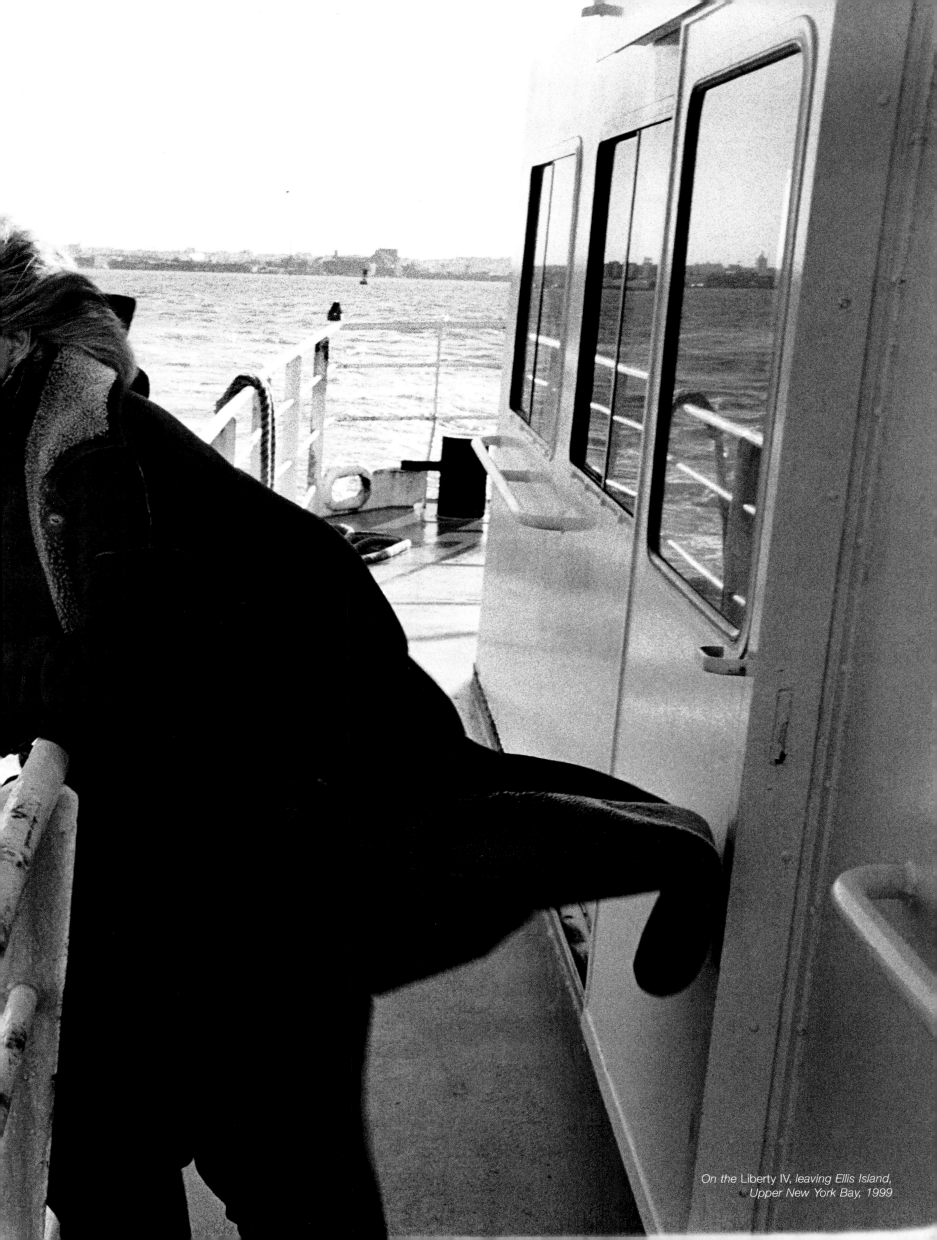

On the Liberty IV, leaving Ellis Island,
Upper New York Bay, 1999

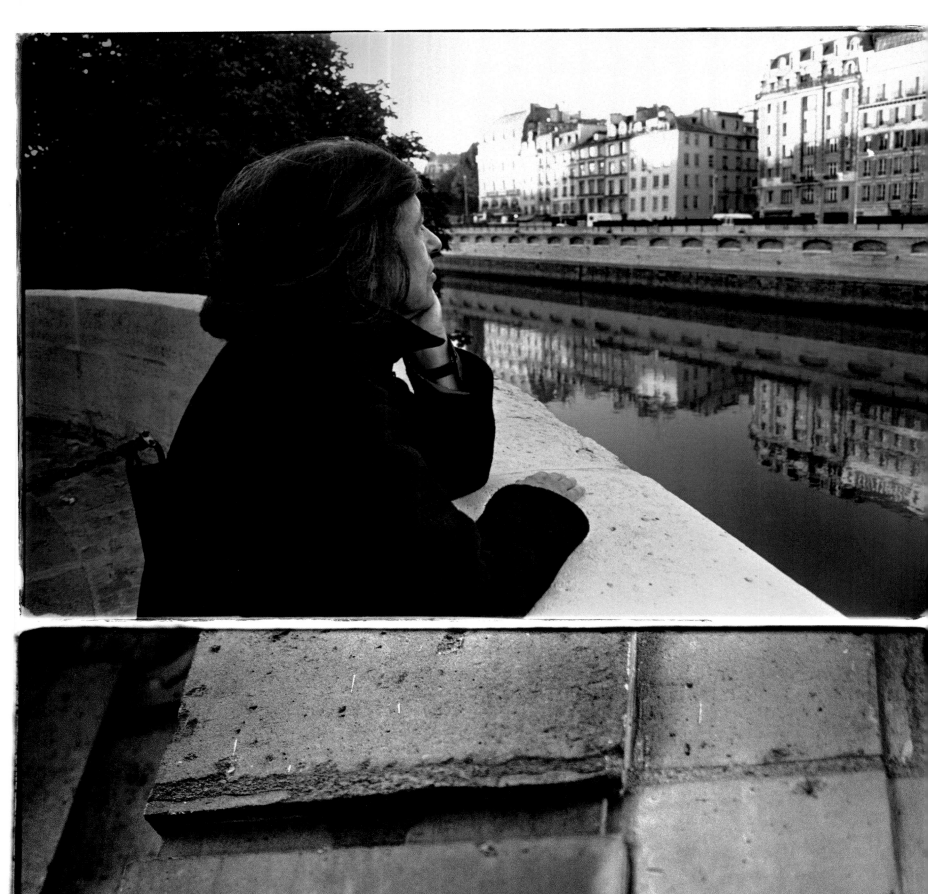

2 rue Séguier, Quai des Grands Augustins, Paris, 2000

Paris Opéra, 1994

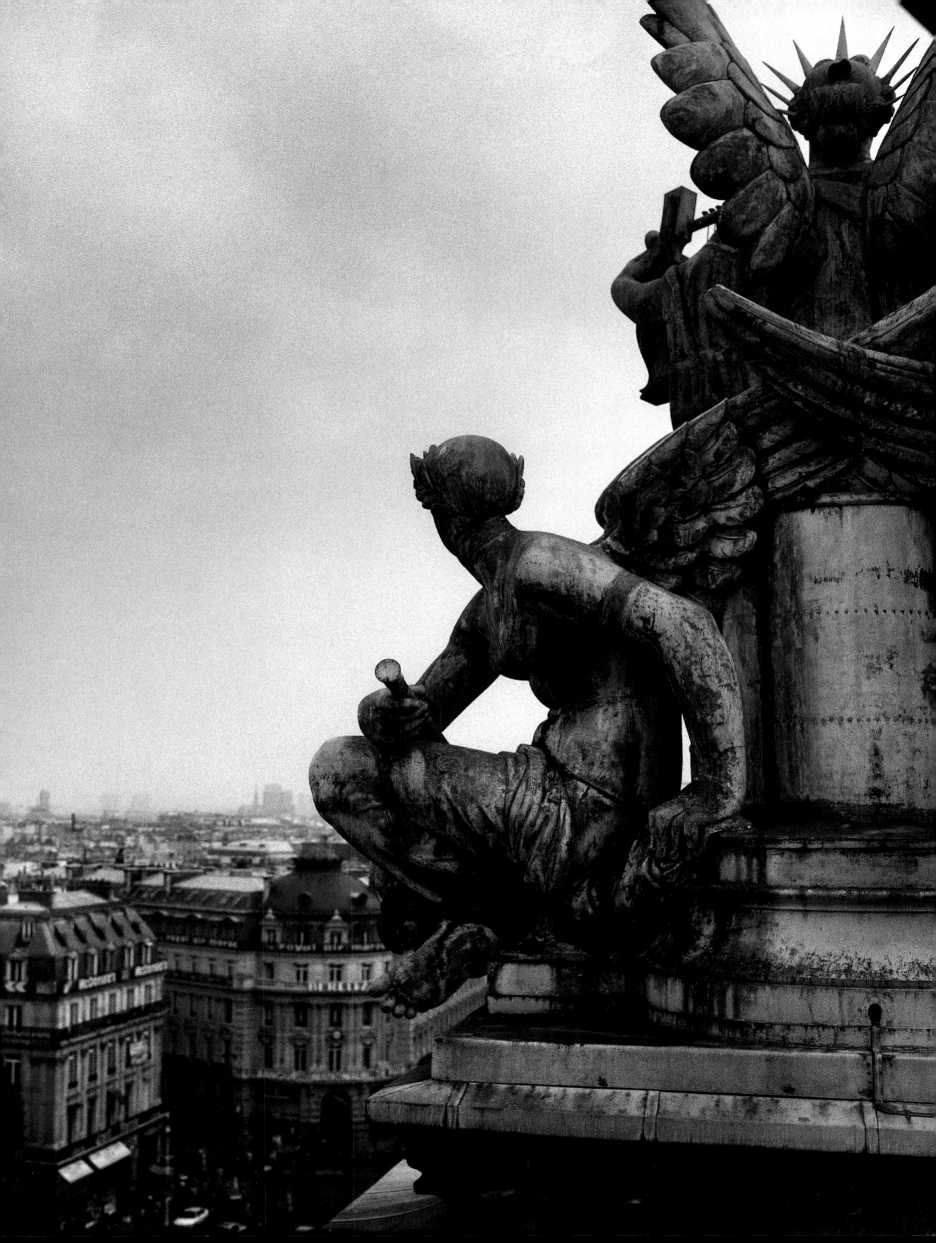

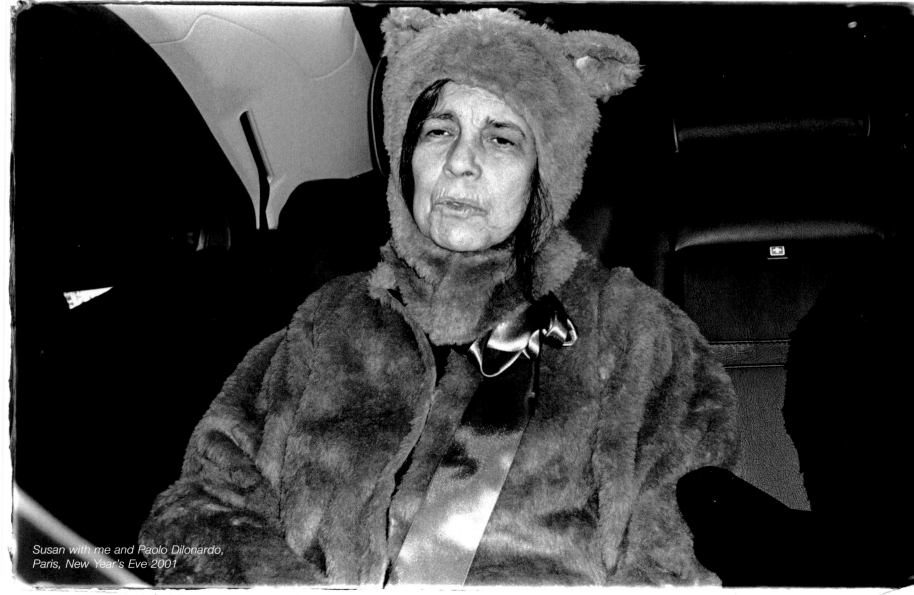

*Susan with me and Paolo Dilonardo,
Paris, New Year's Eve 2001*

Susan with Giovanella Zannoni, Carlotta del Pezzo, Mariella Zanardo,
and Marie-Christine Dunham-Pratt, Paris, New Year's Eve 2001

Chris Rock, Floyd Bennett Field, Brooklyn, 1998

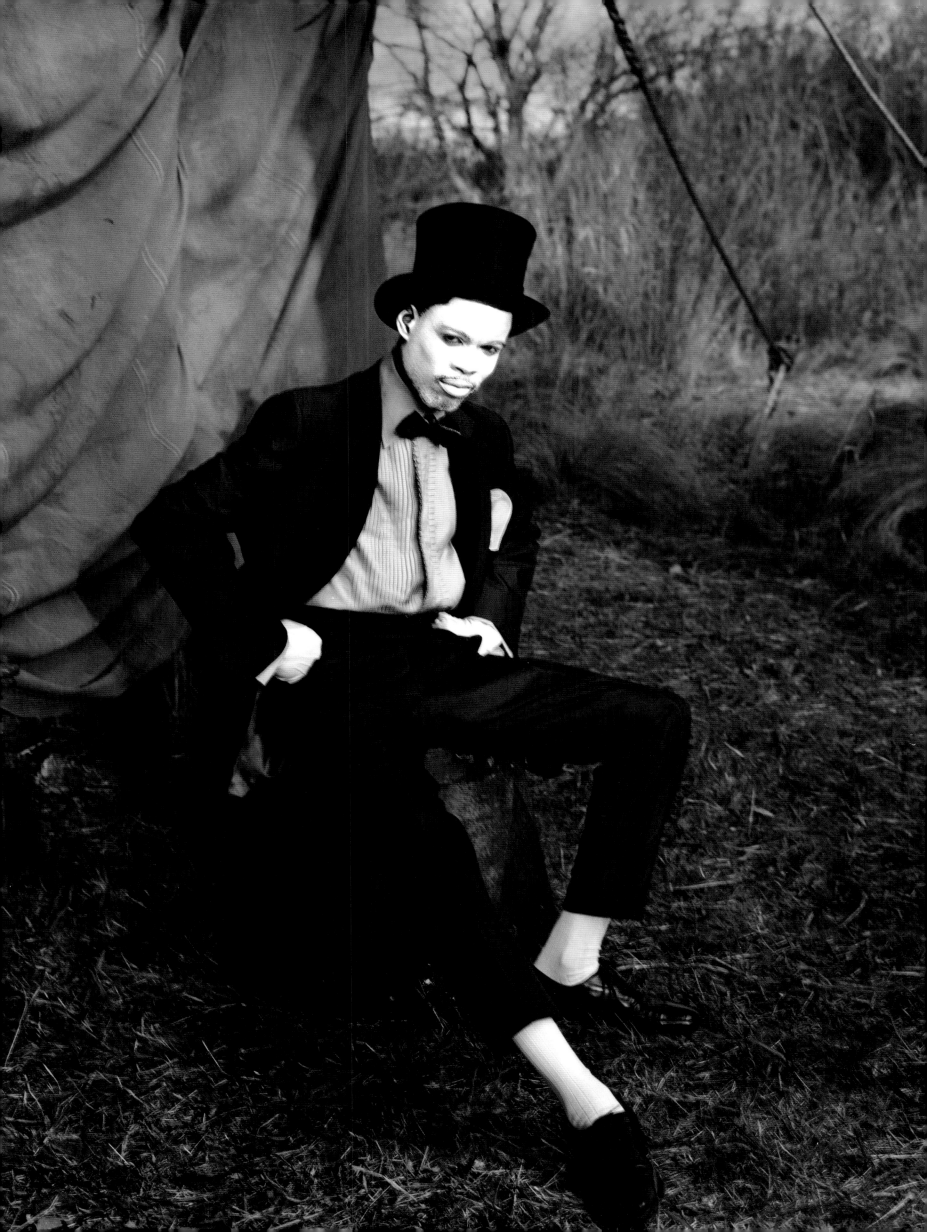

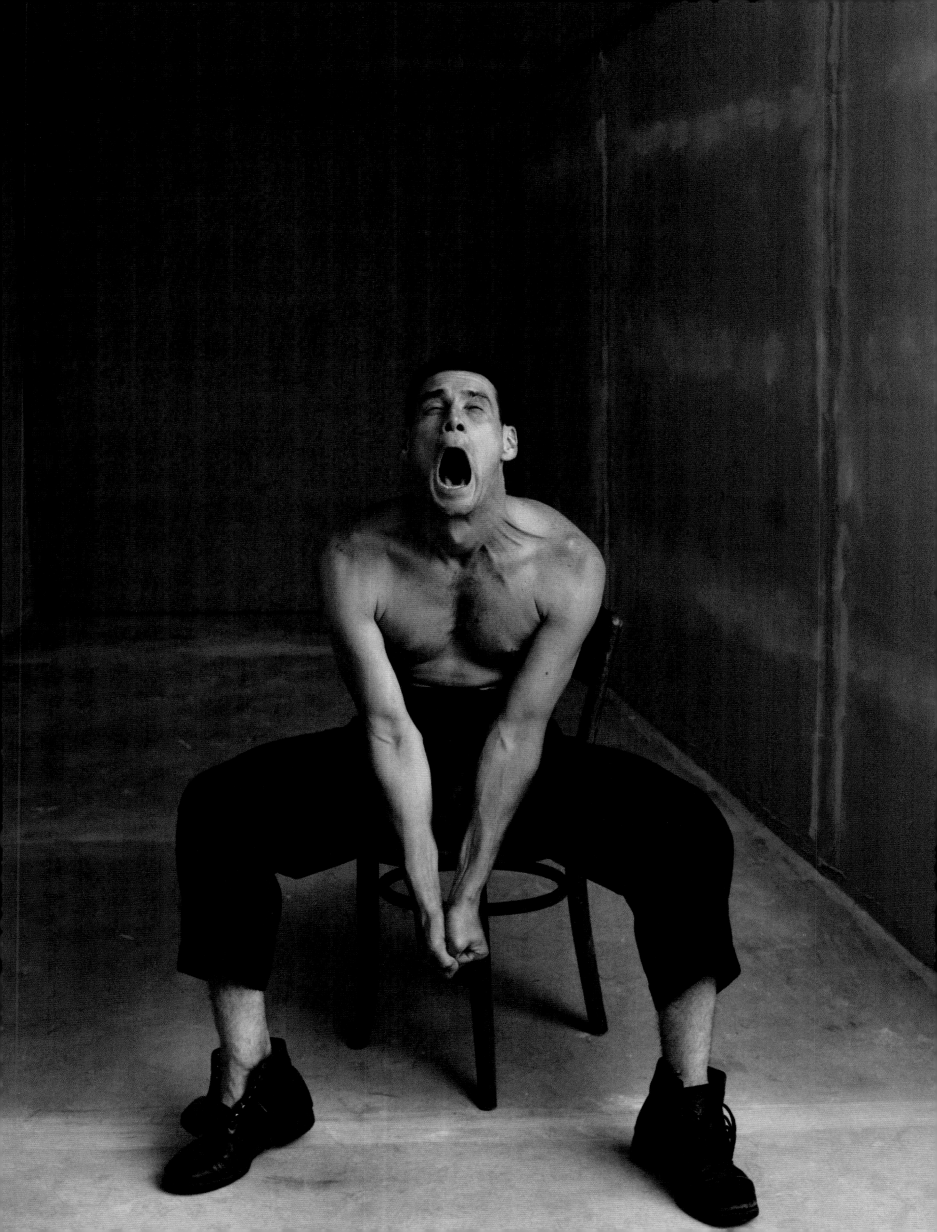

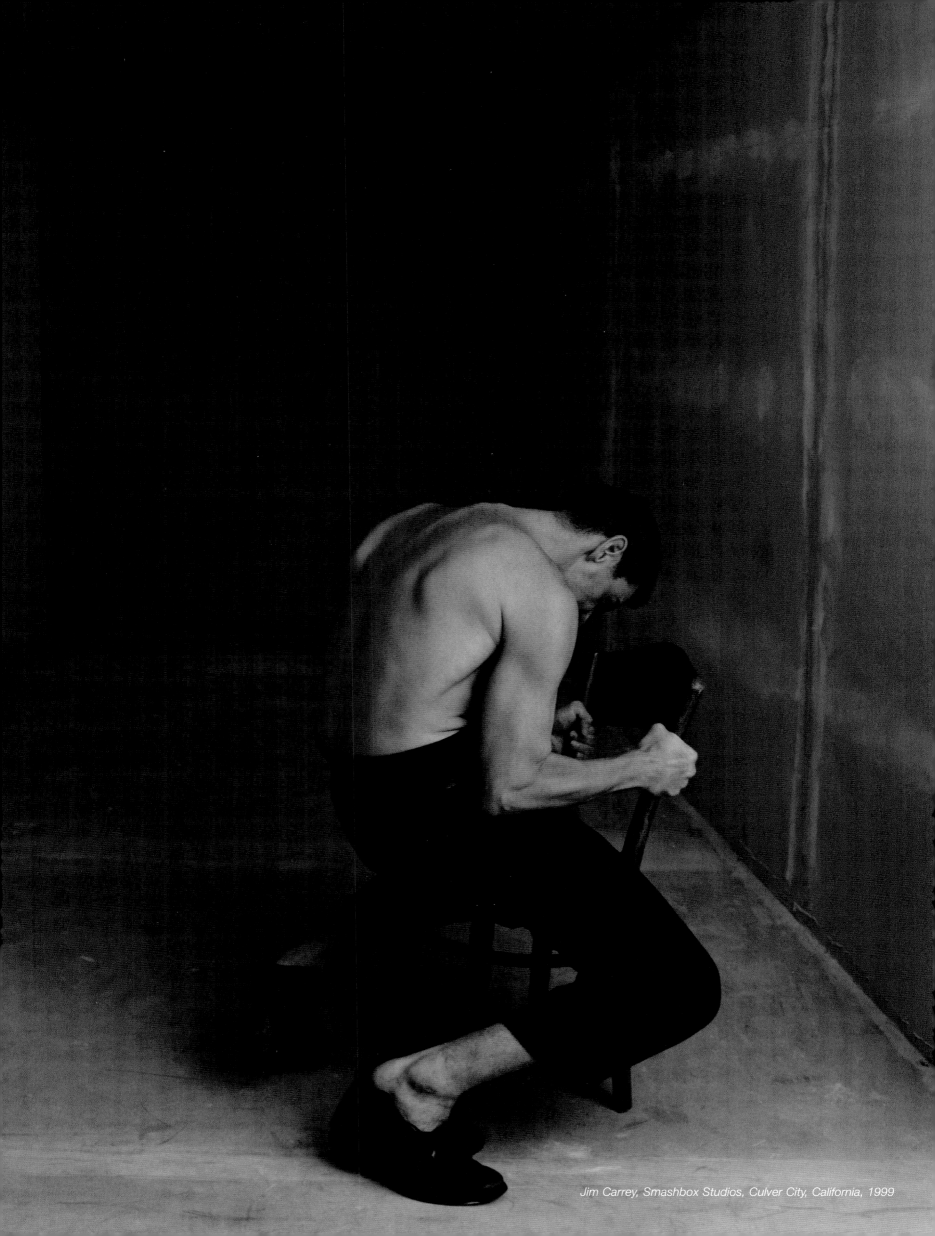

Jim Carrey, Smashbox Studios, Culver City, California, 1999

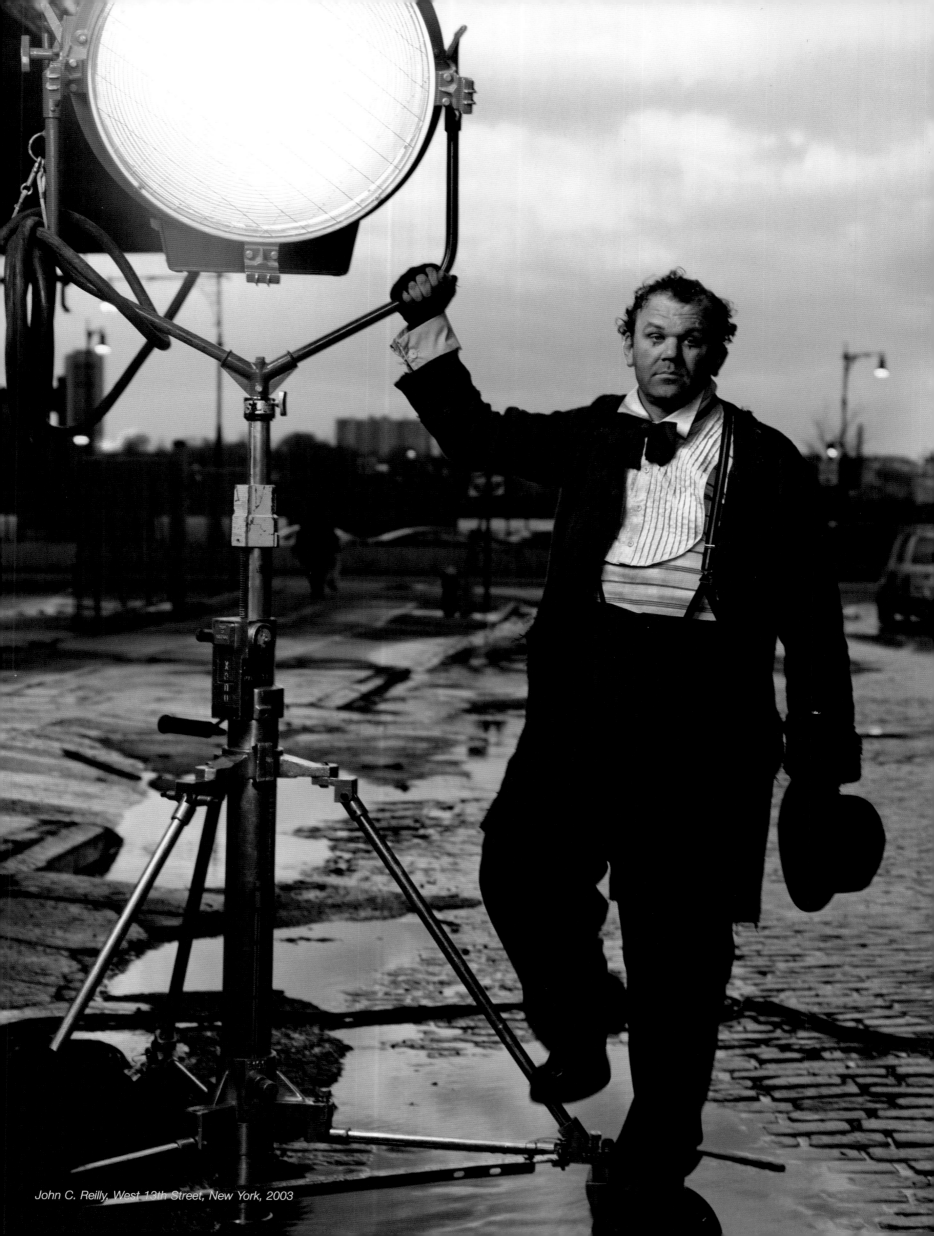

John C. Reilly, West 13th Street, New York, 2003

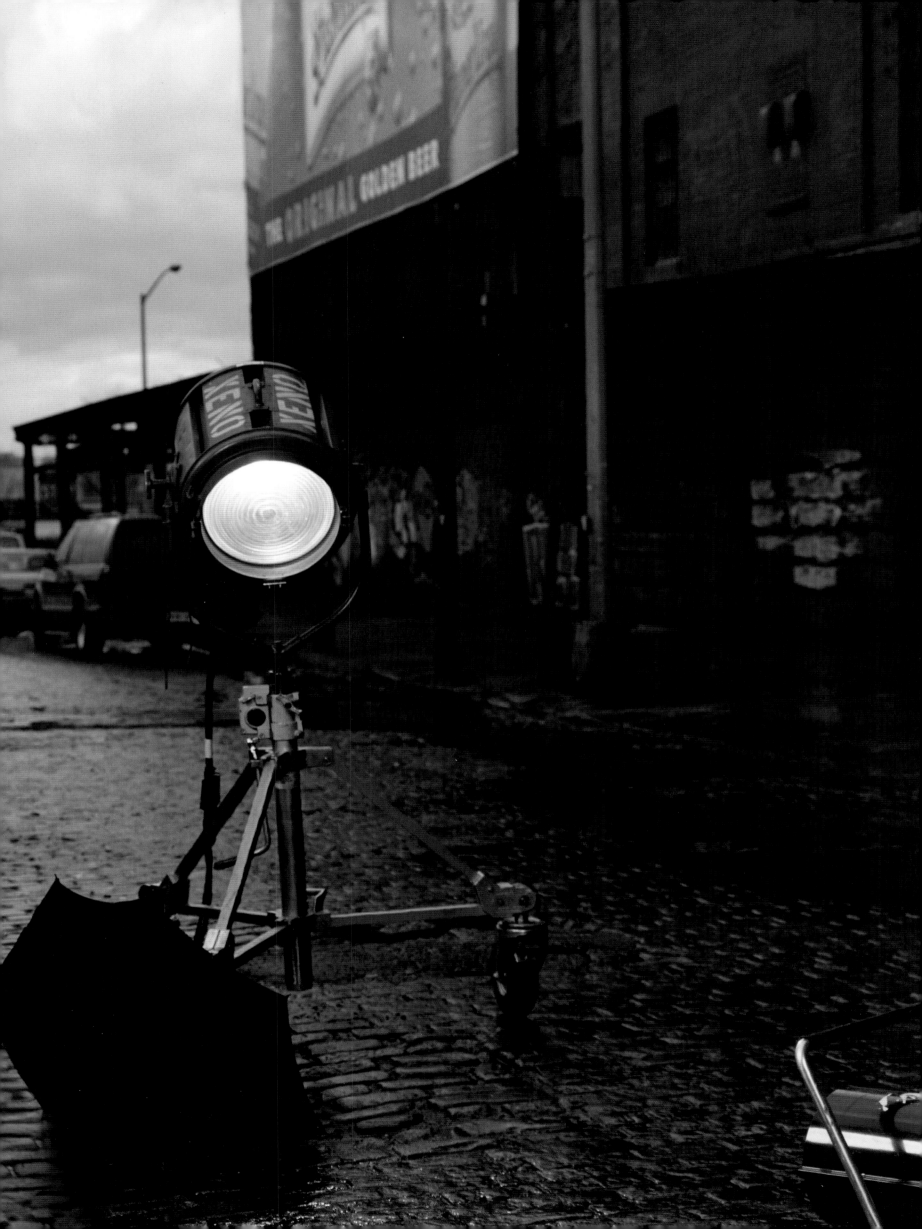

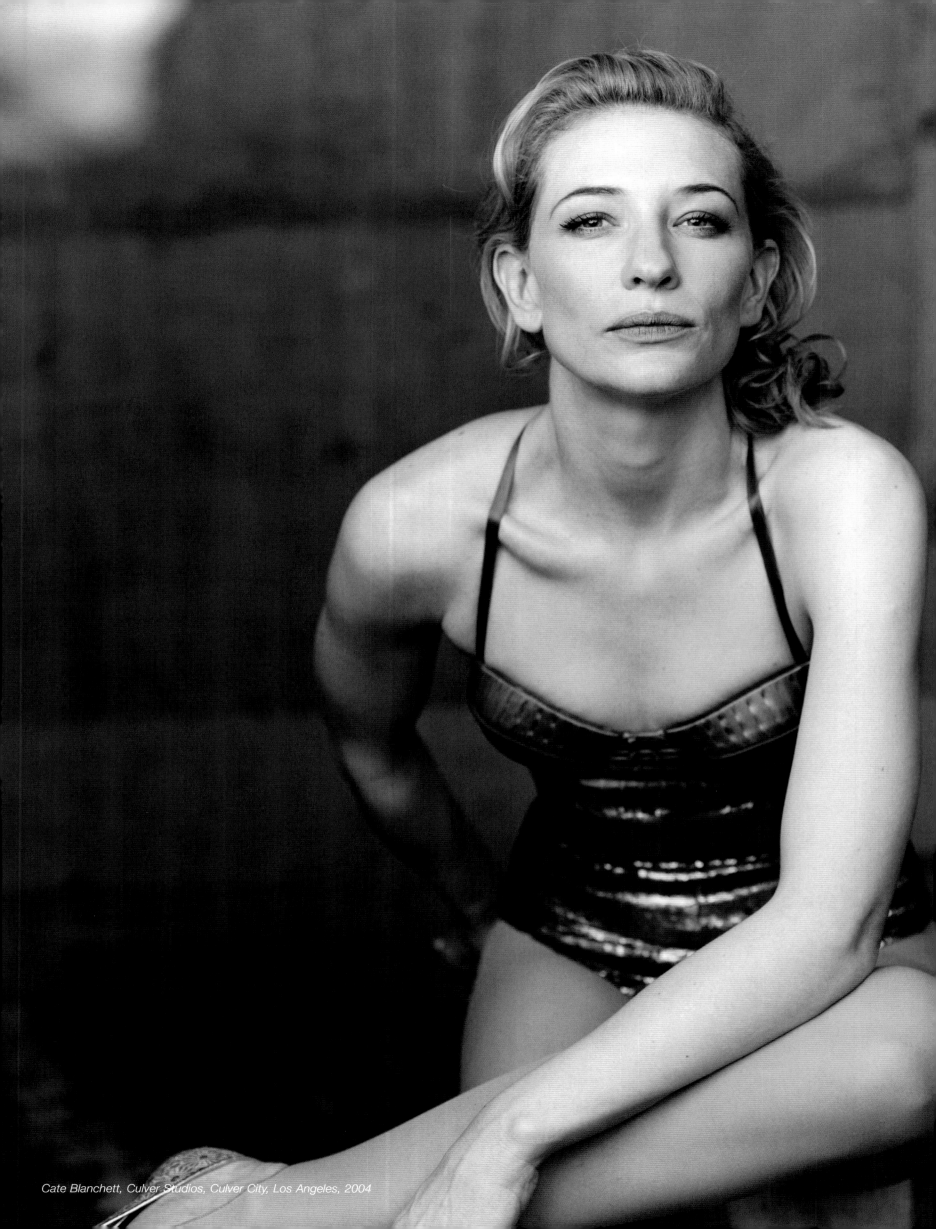

Cate Blanchett, Culver Studios, Culver City, Los Angeles, 2004

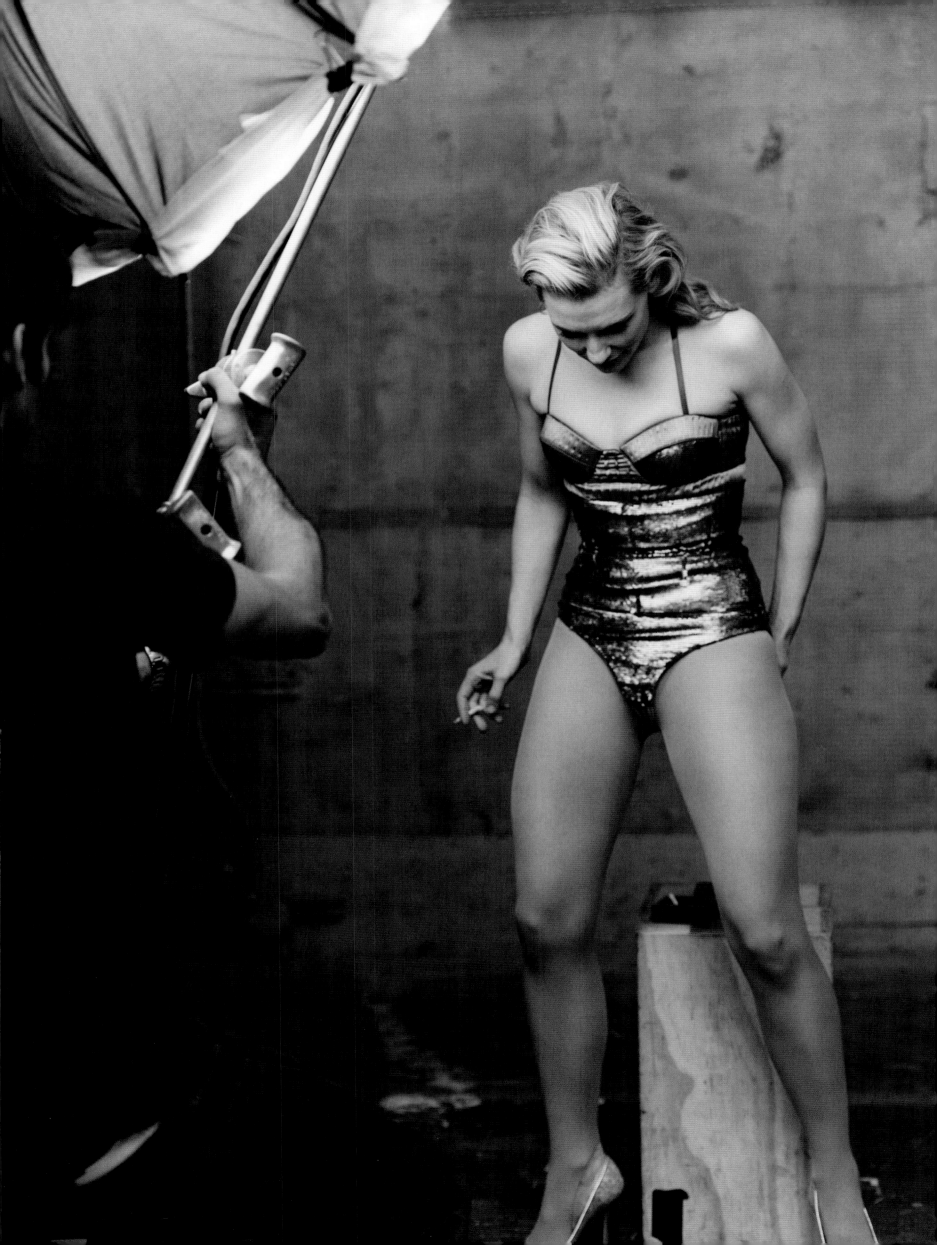

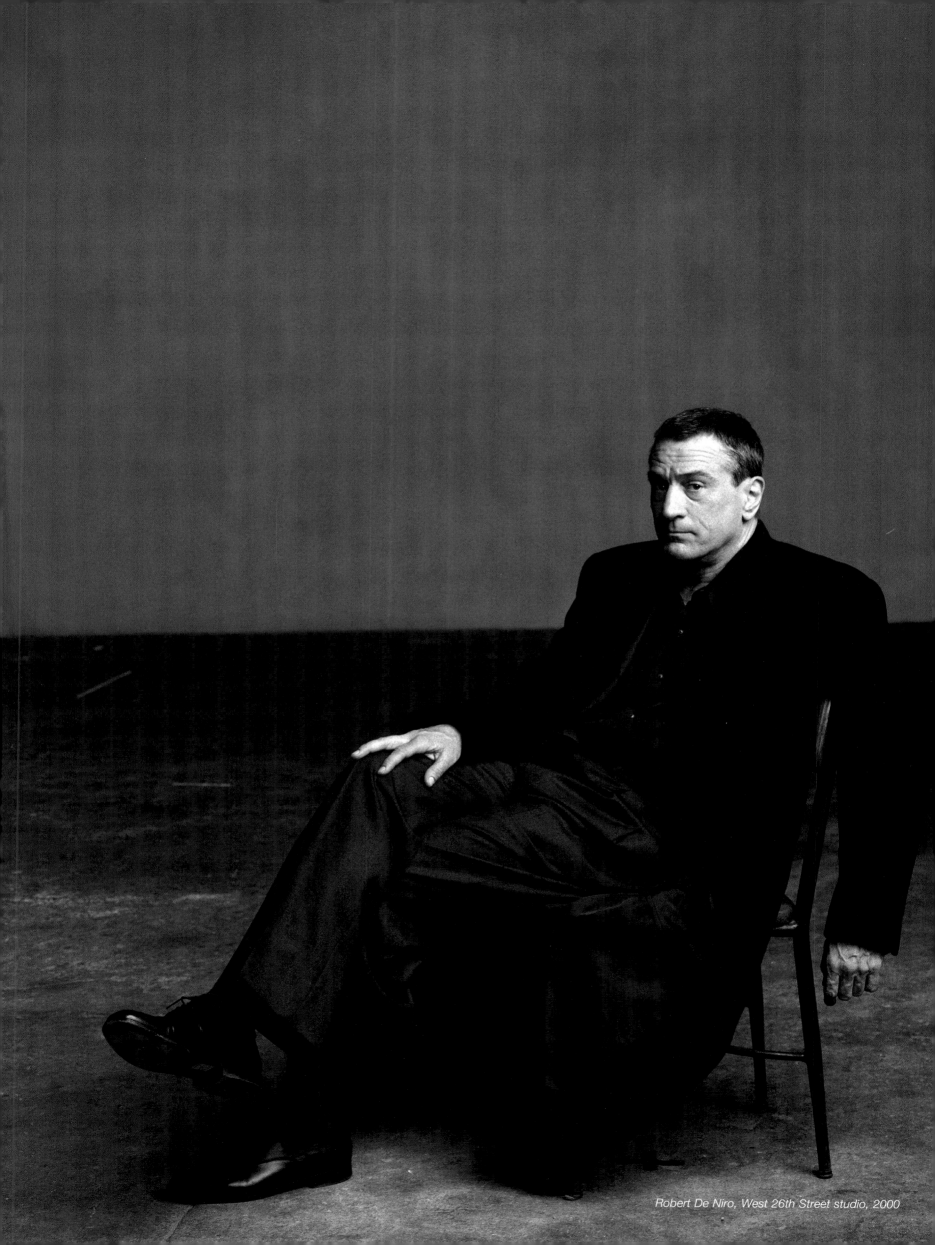

Robert De Niro, West 26th Street studio, 2000

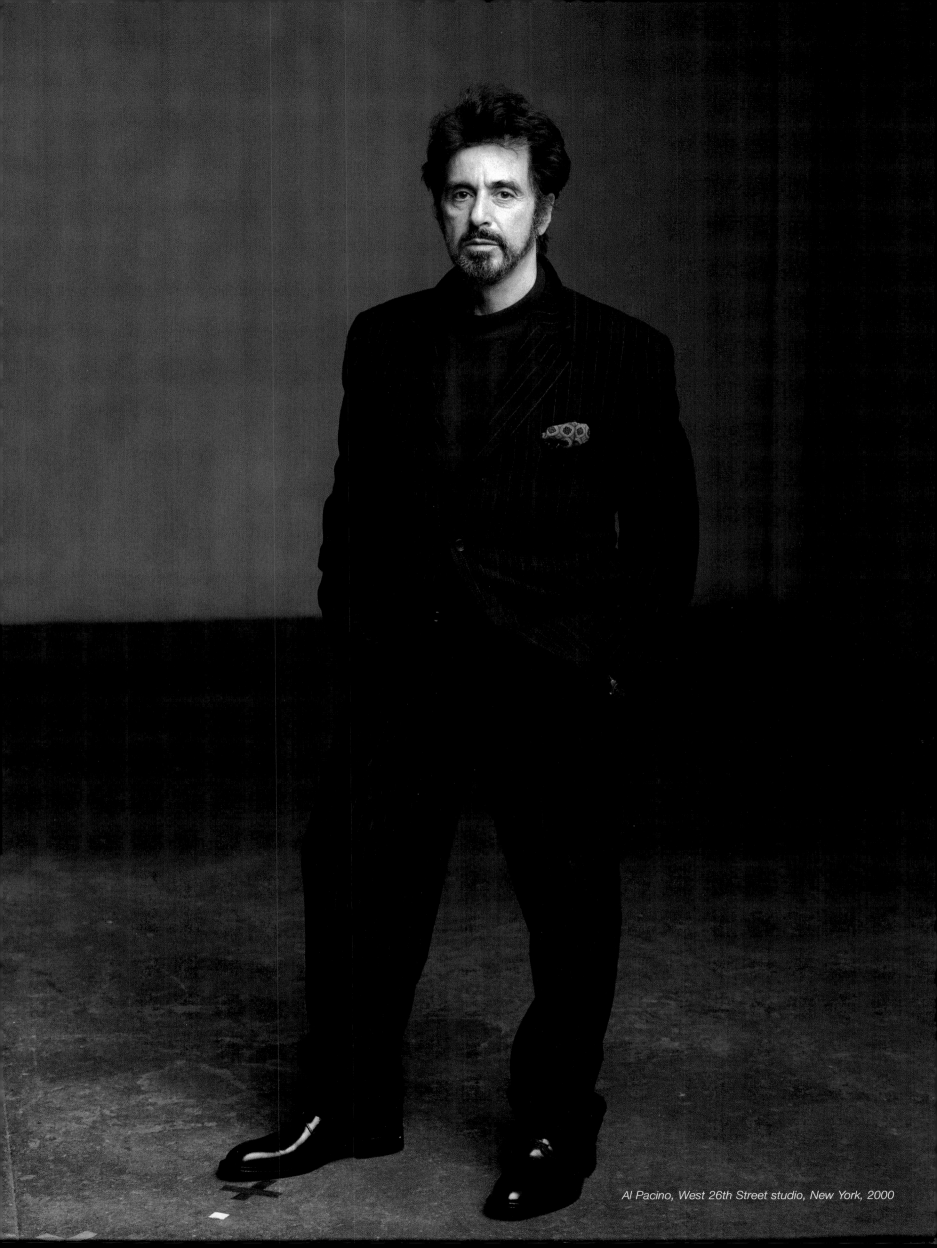

Al Pacino, West 26th Street studio, New York, 2000

Chuck Close, West 26th Street studio, New York, 2000

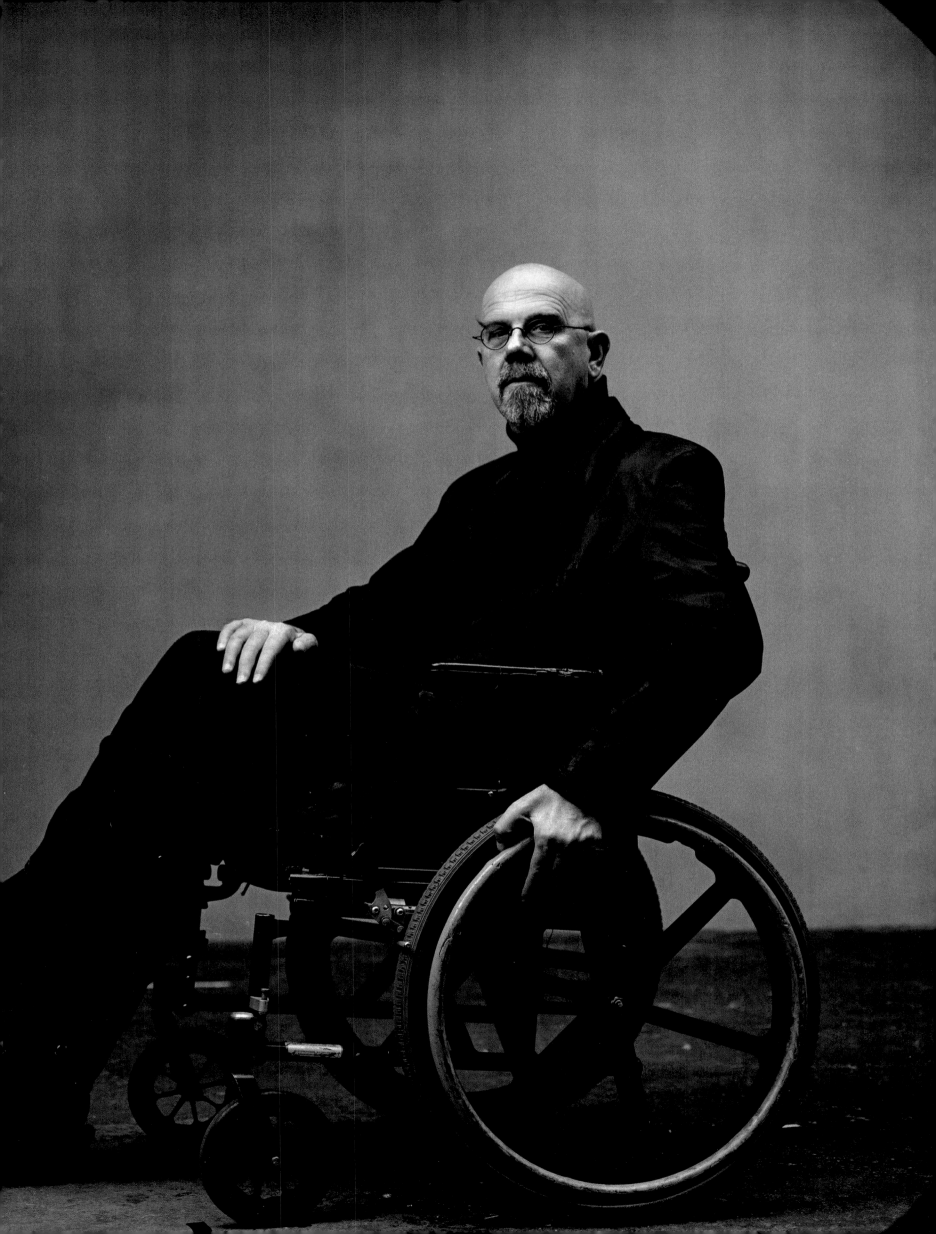

Lucinda Childs, West 26th Street studio, New York, 1999

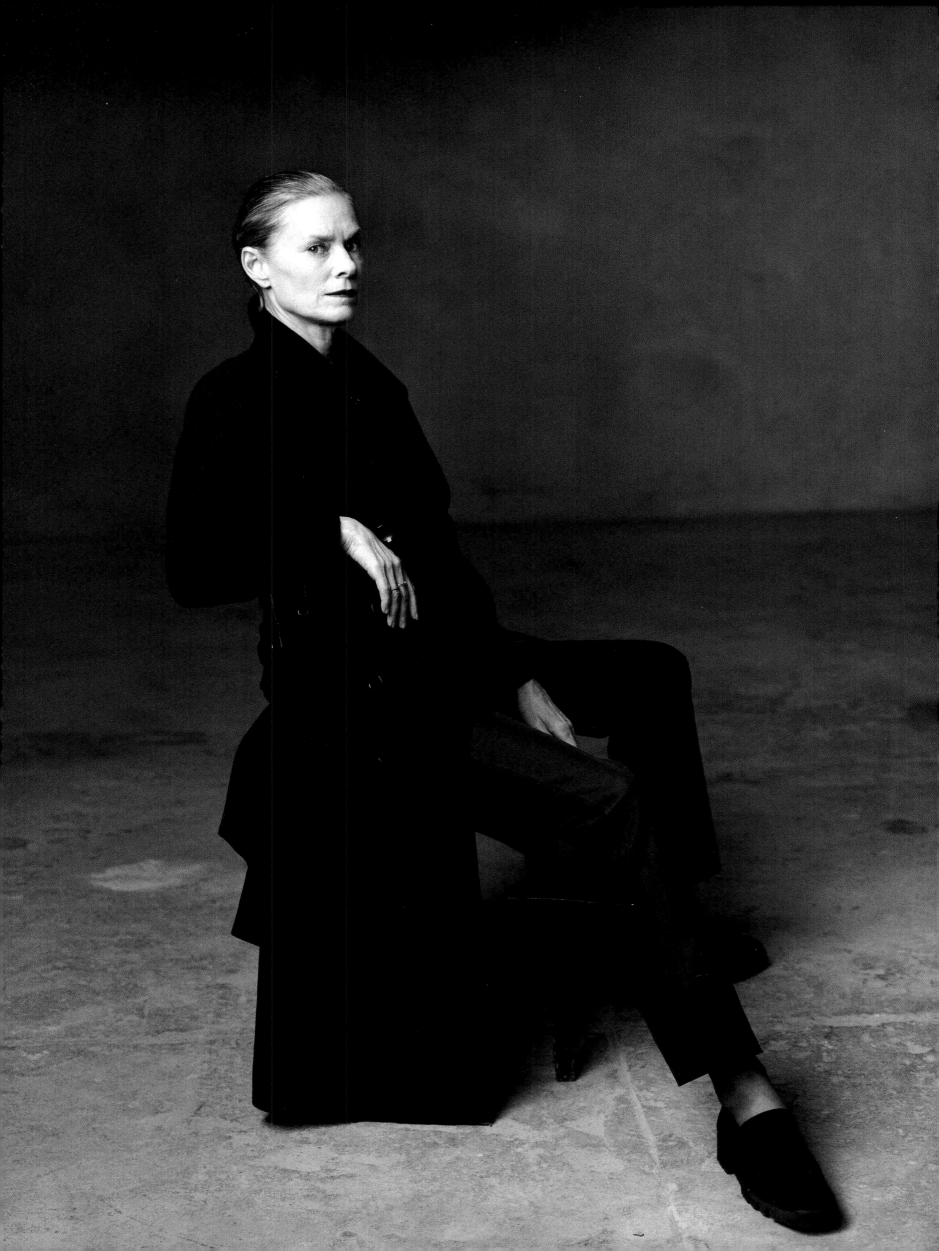

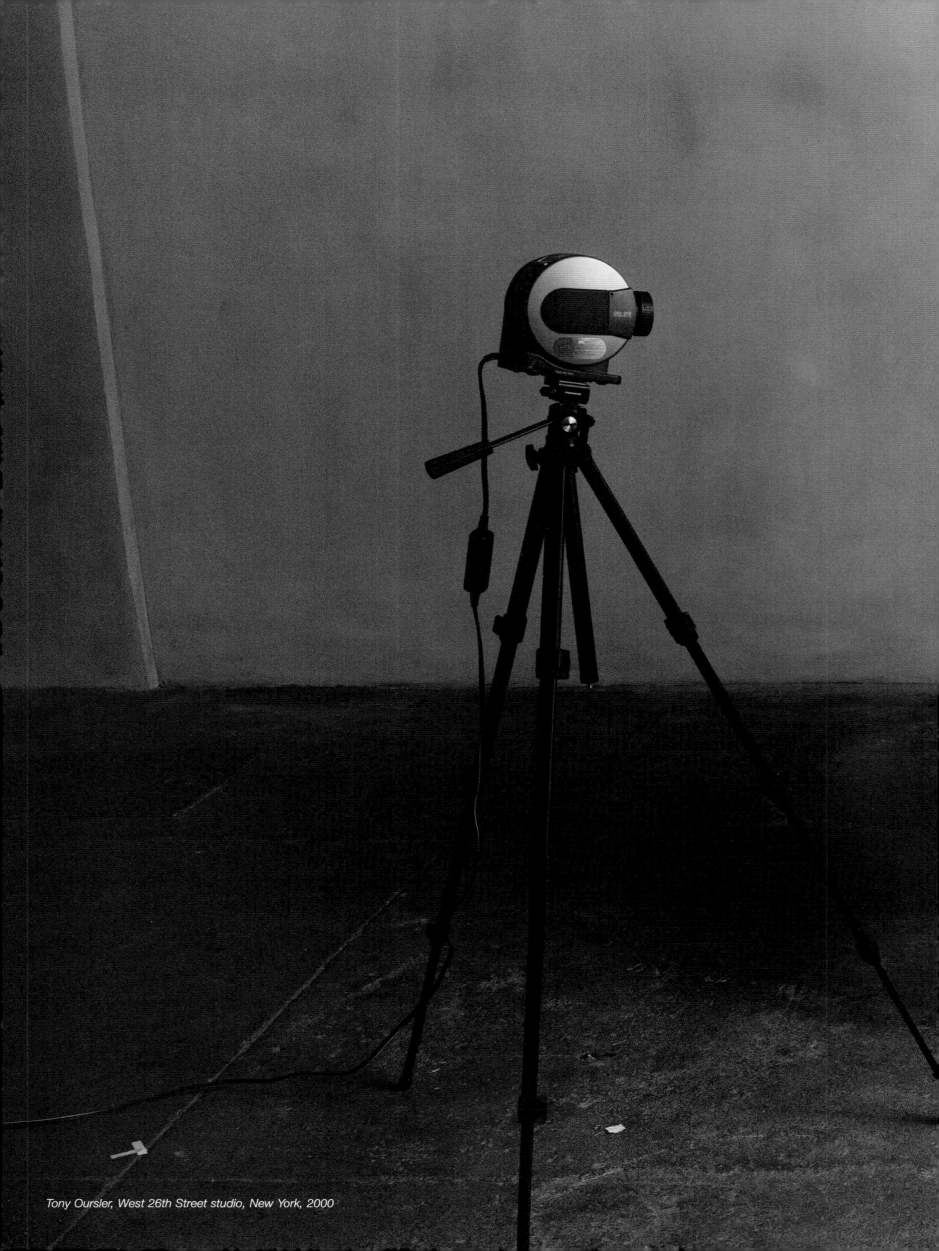

Tony Oursler, West 26th Street studio, New York, 2000

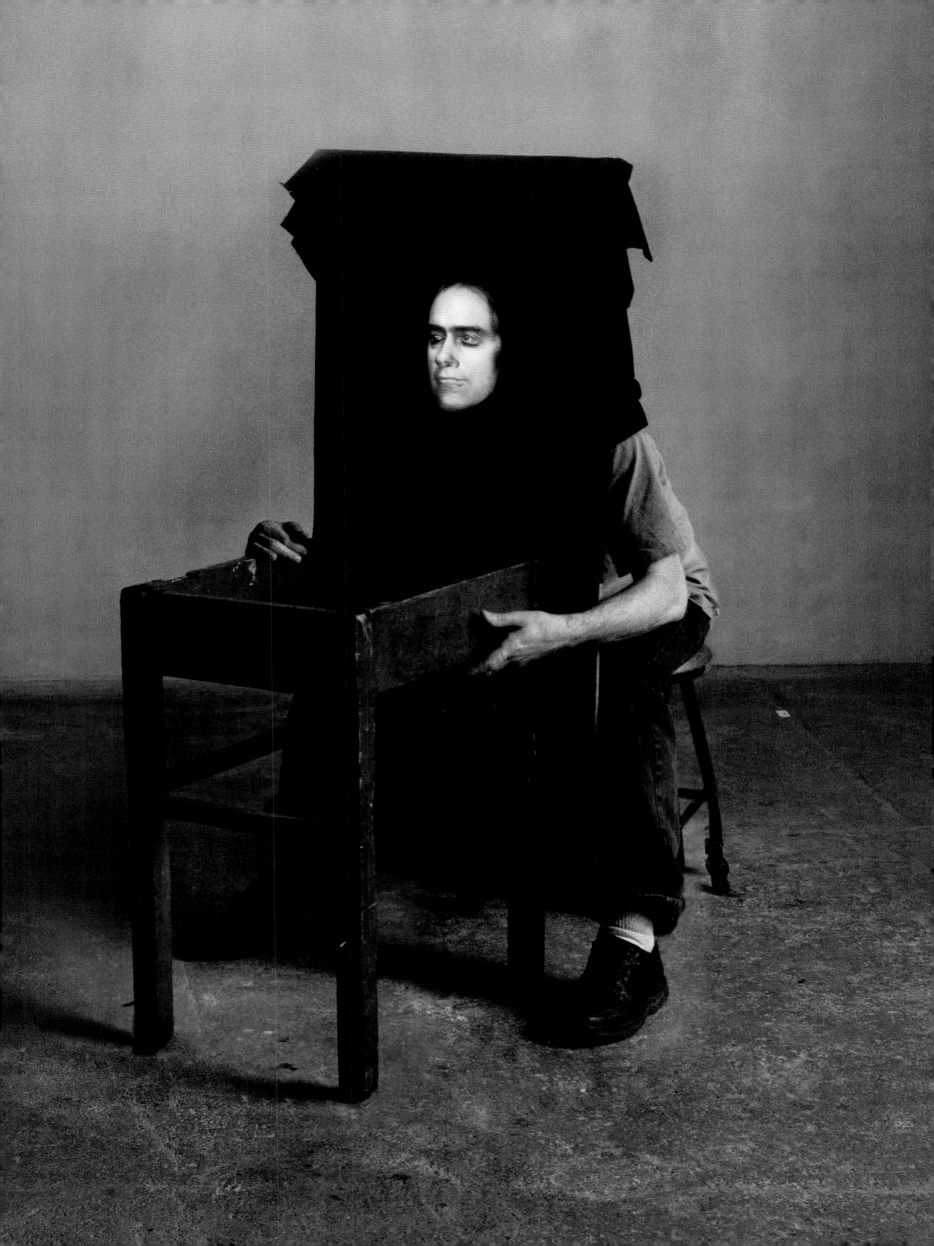

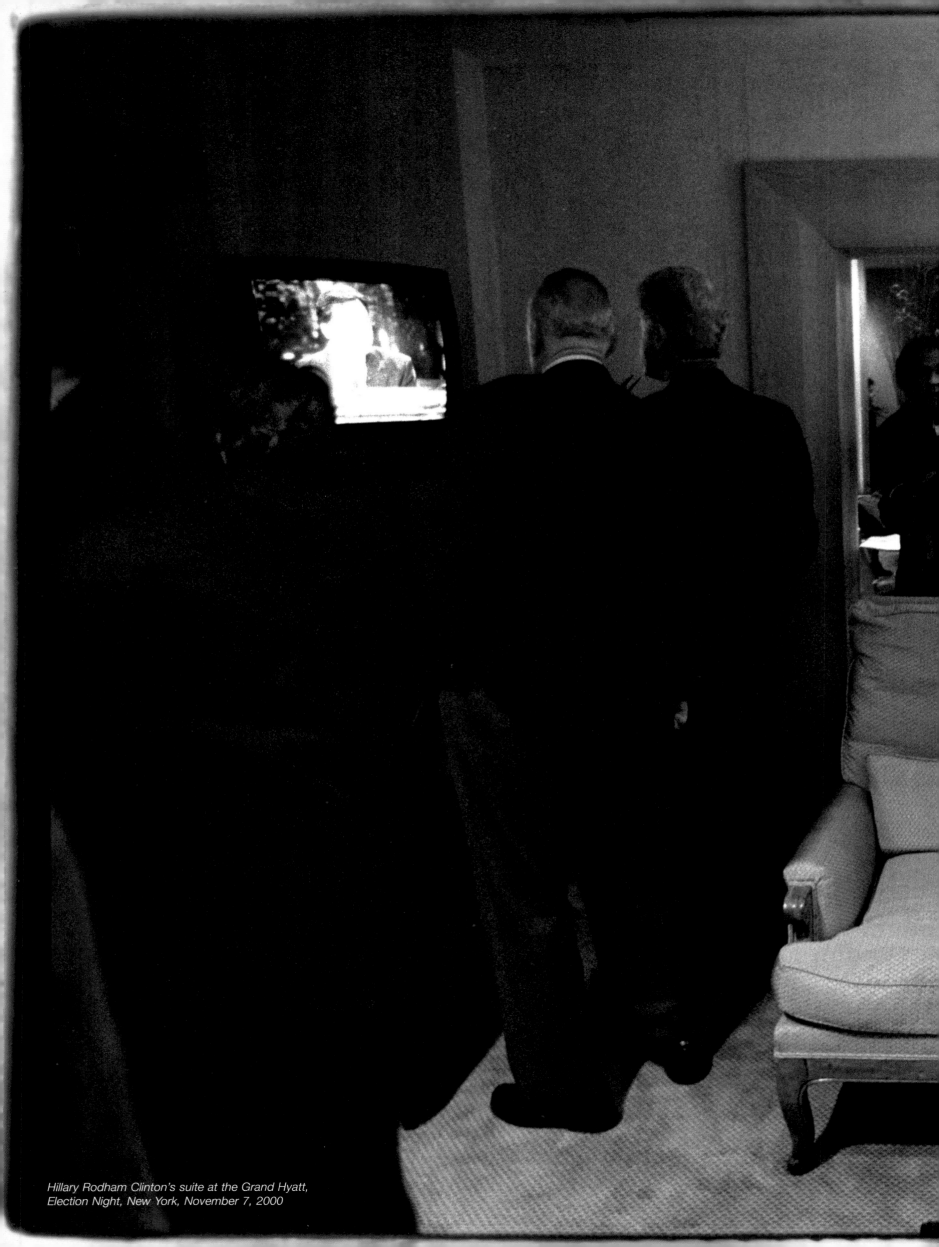

Hillary Rodham Clinton's suite at the Grand Hyatt,
Election Night, New York, November 7, 2000

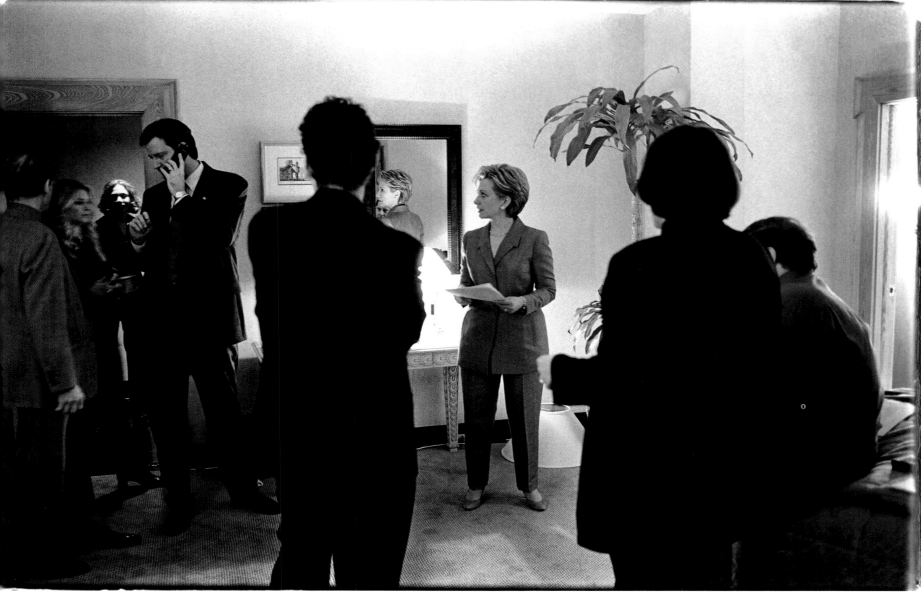

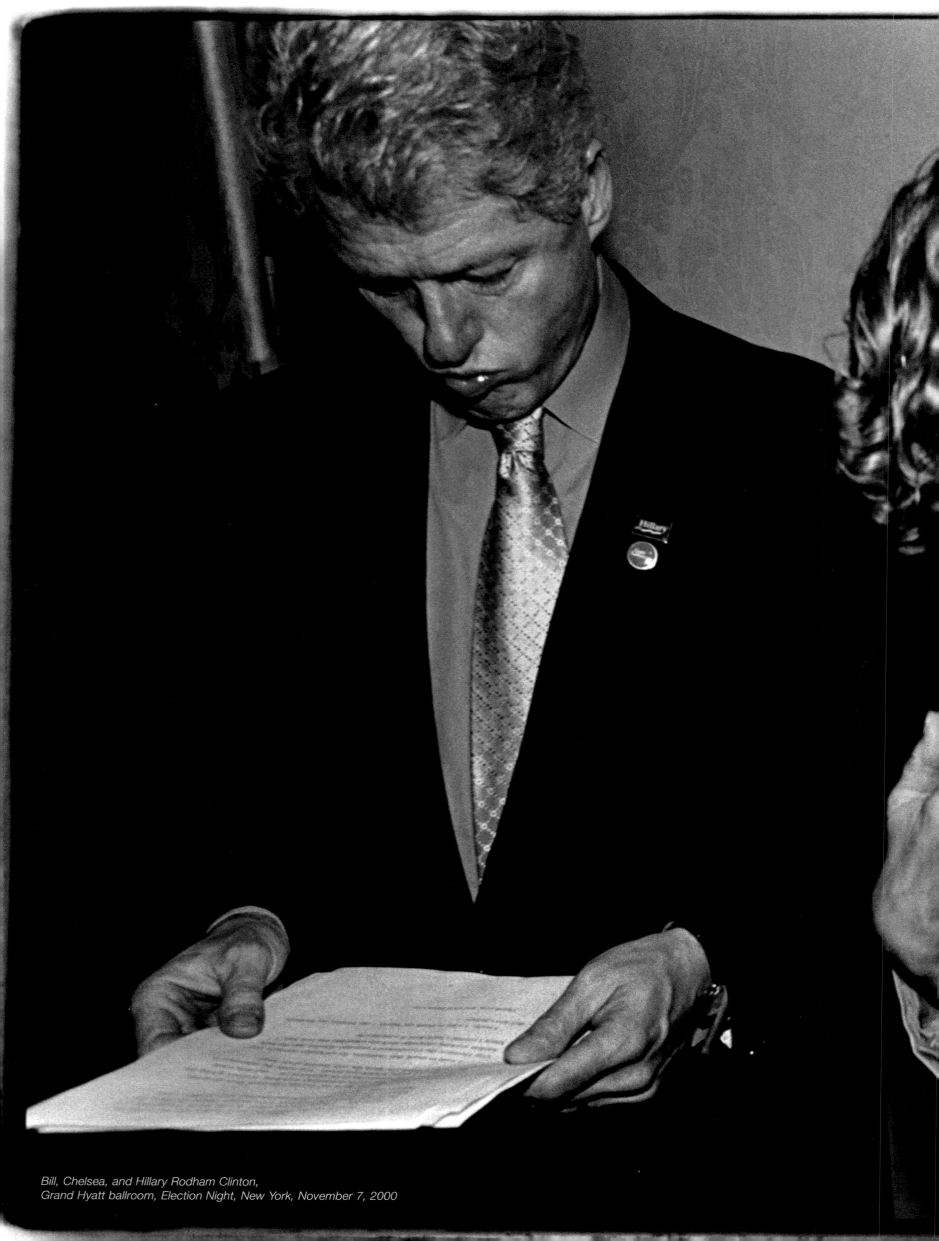

Bill, Chelsea, and Hillary Rodham Clinton,
Grand Hyatt ballroom, Election Night, New York, November 7, 2000

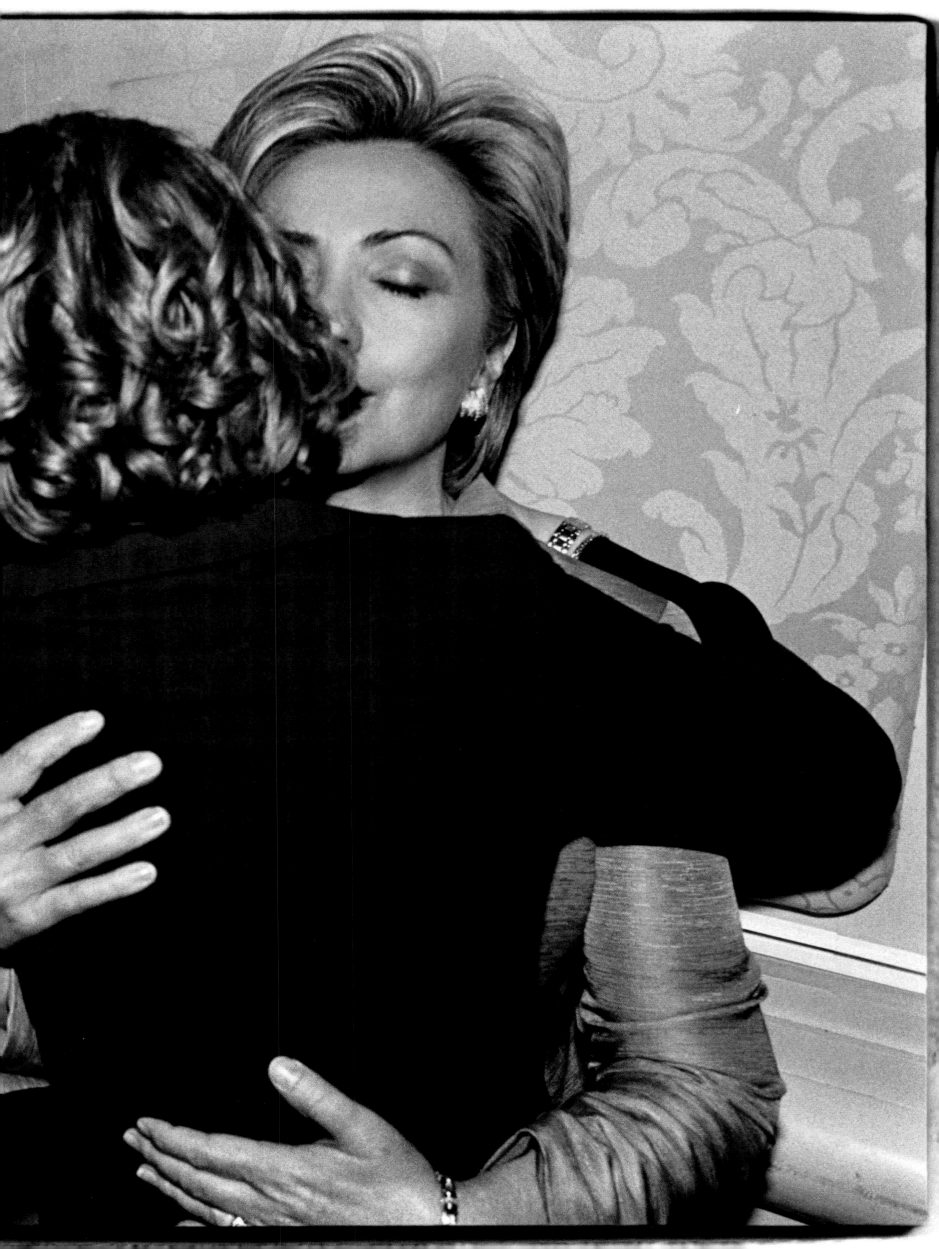

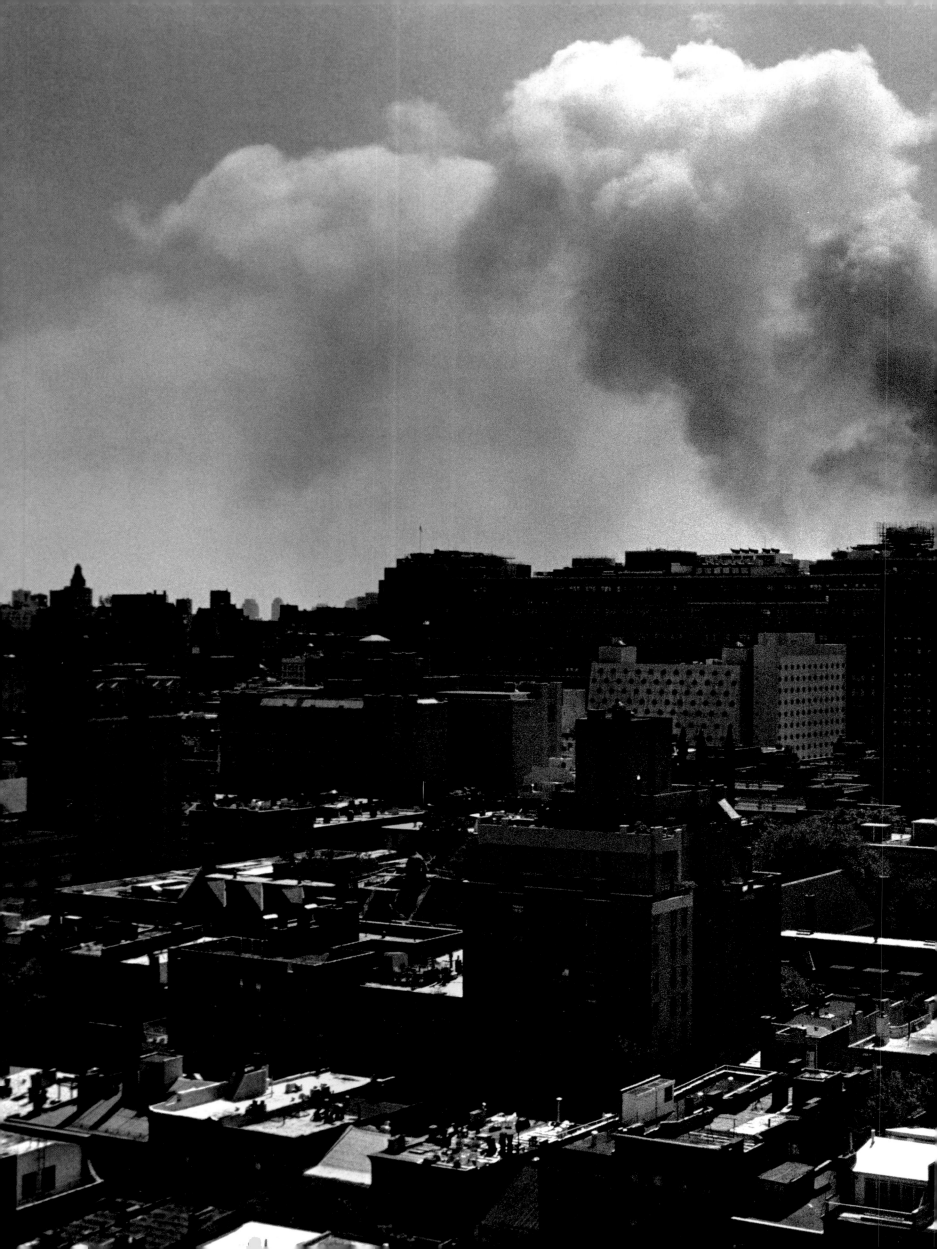

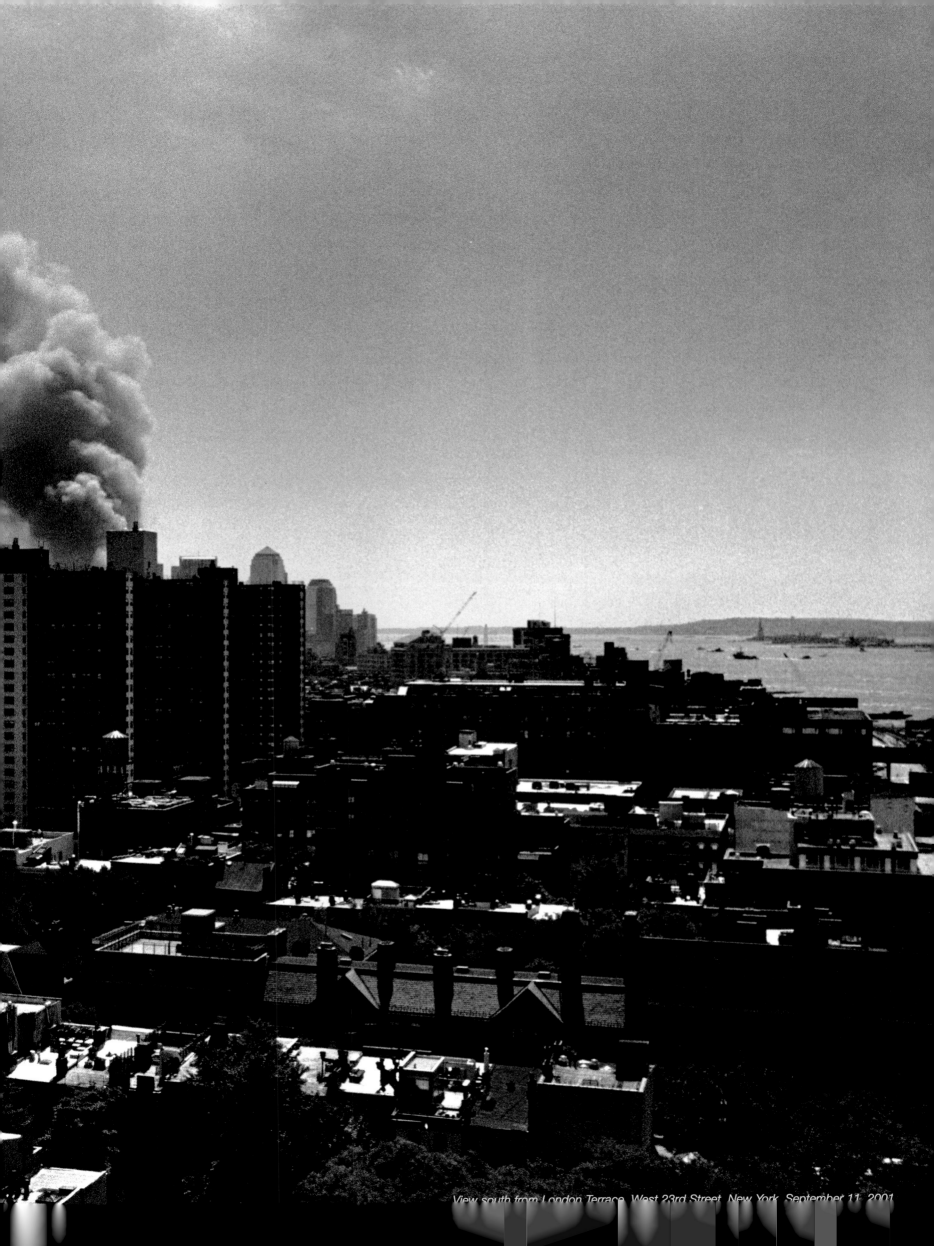

View south from London Terrace, West 23rd Street, New York, September 11, 2001

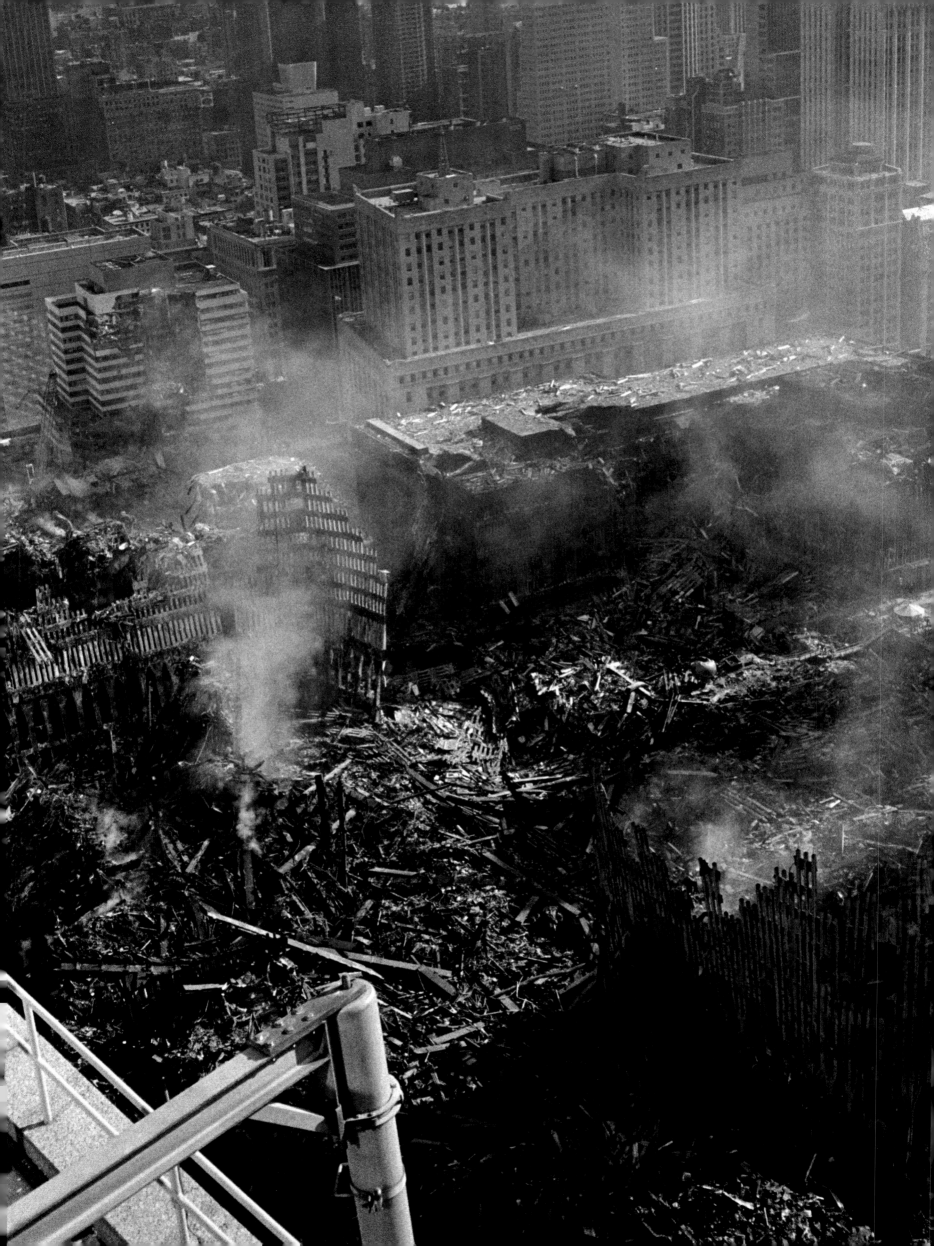

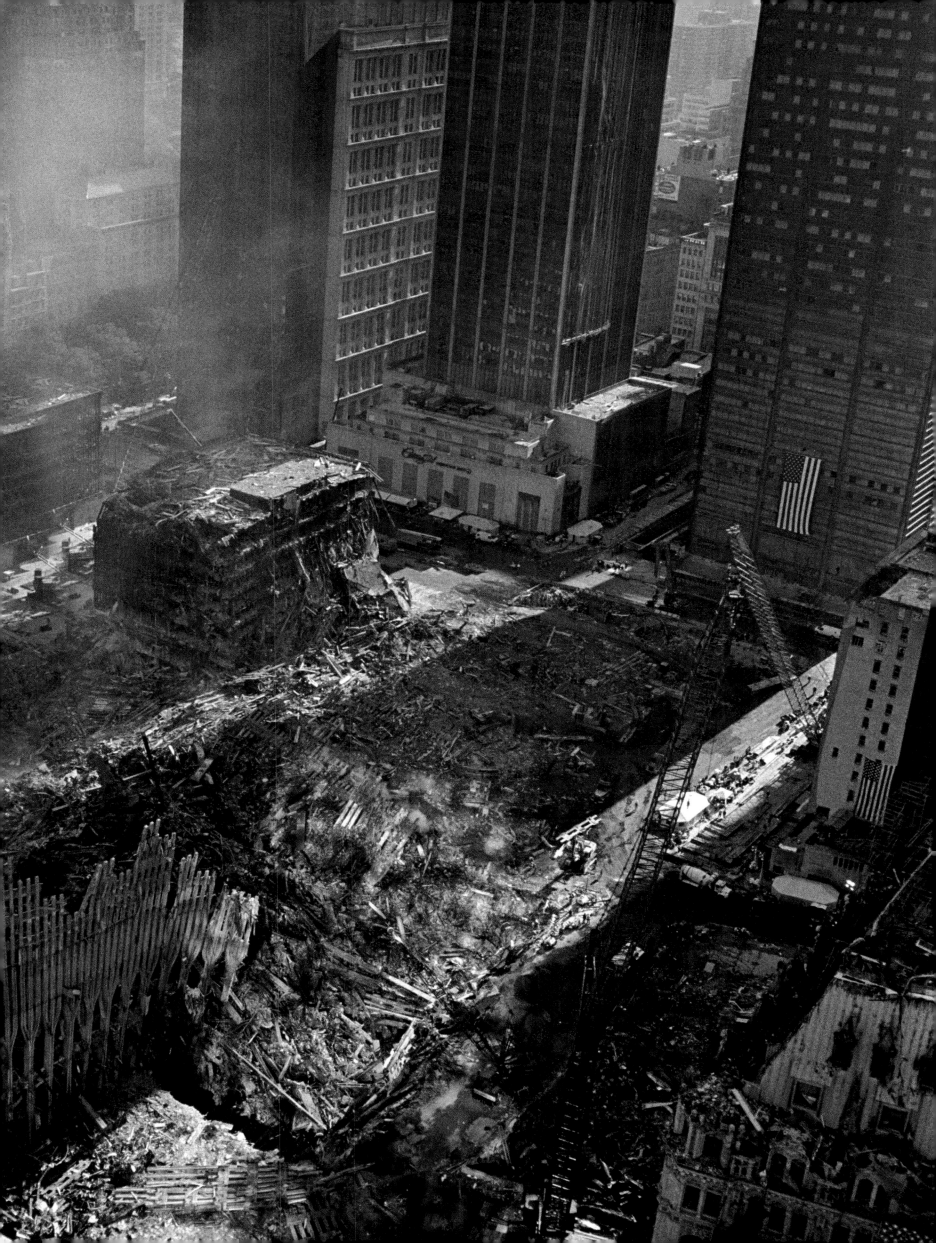

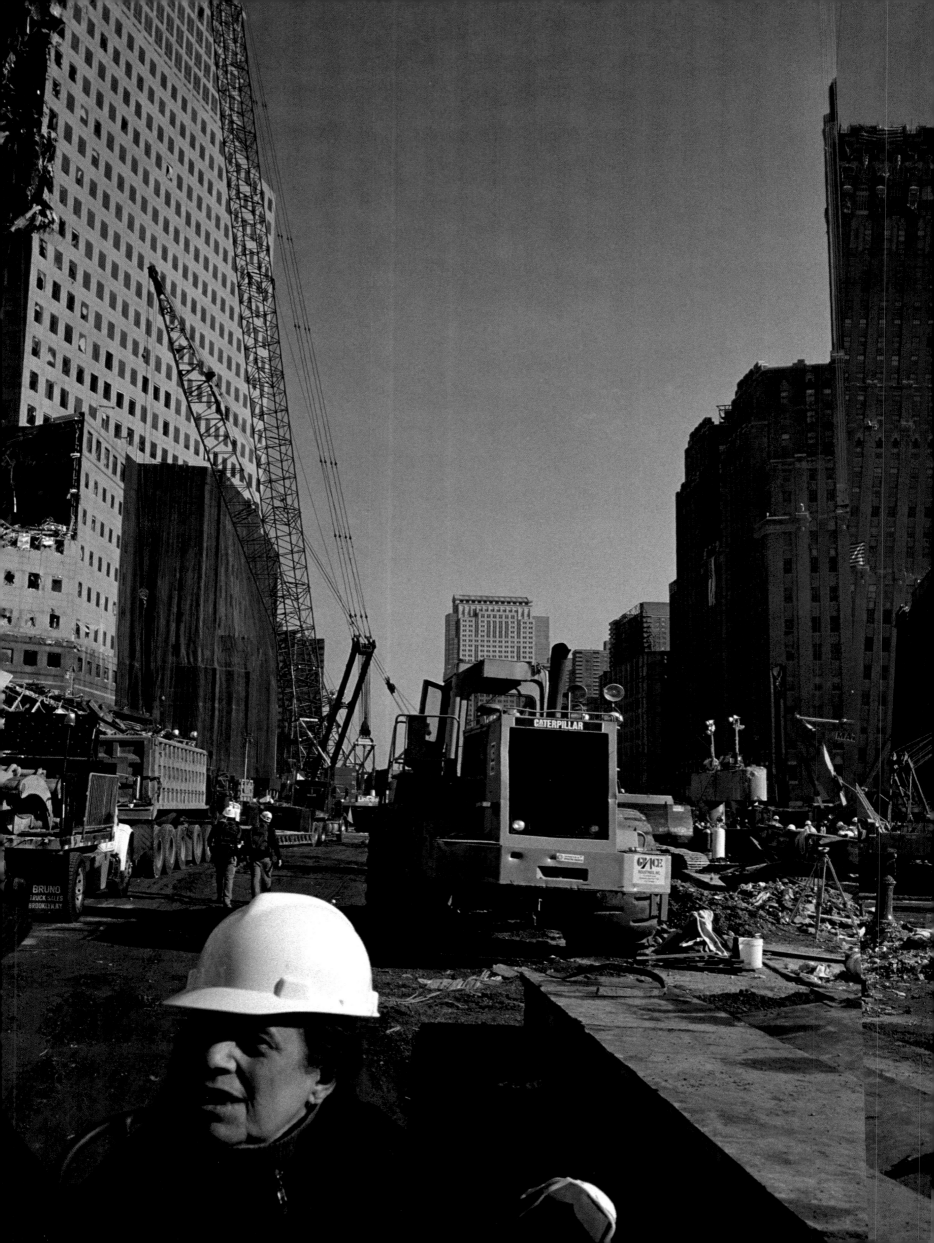

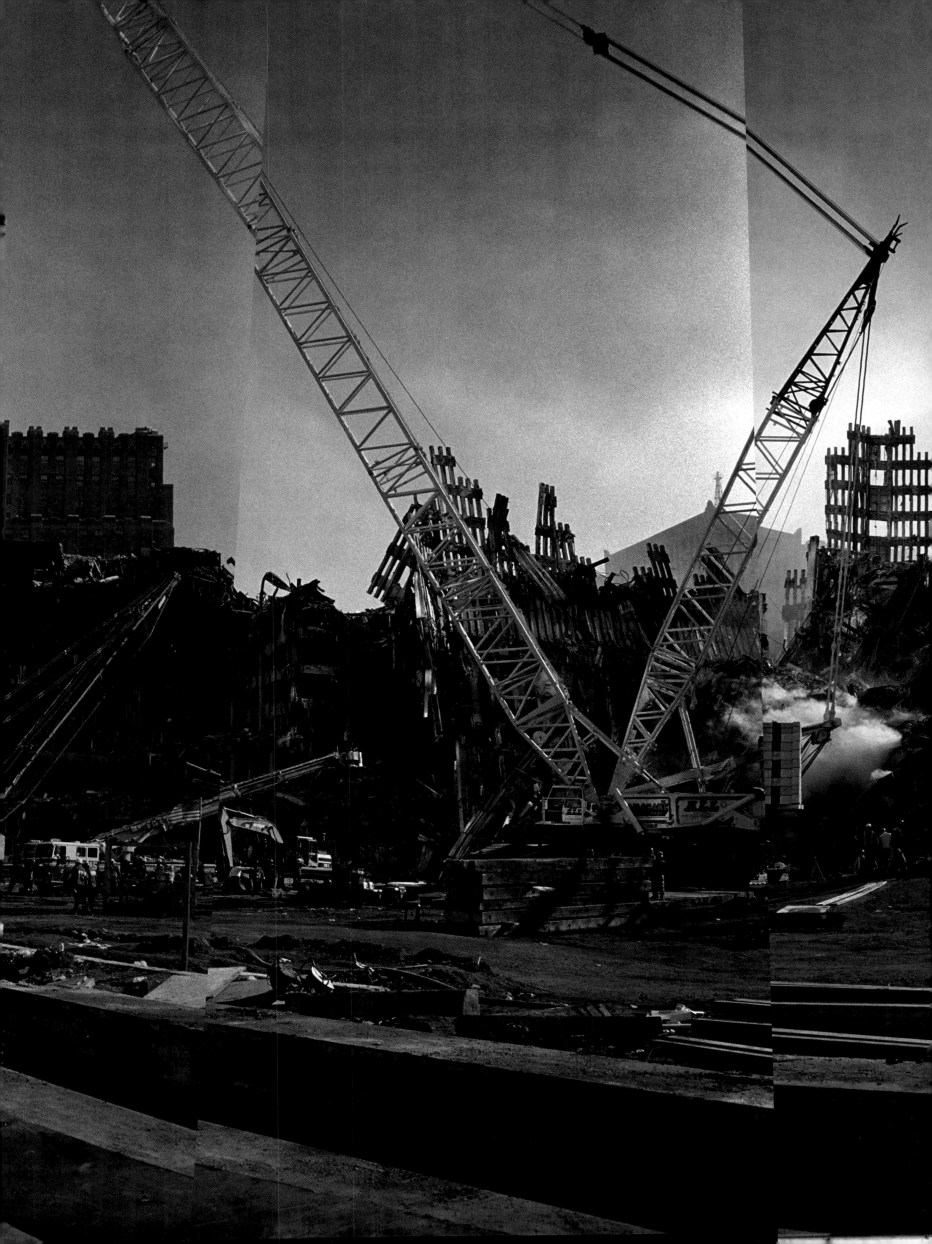

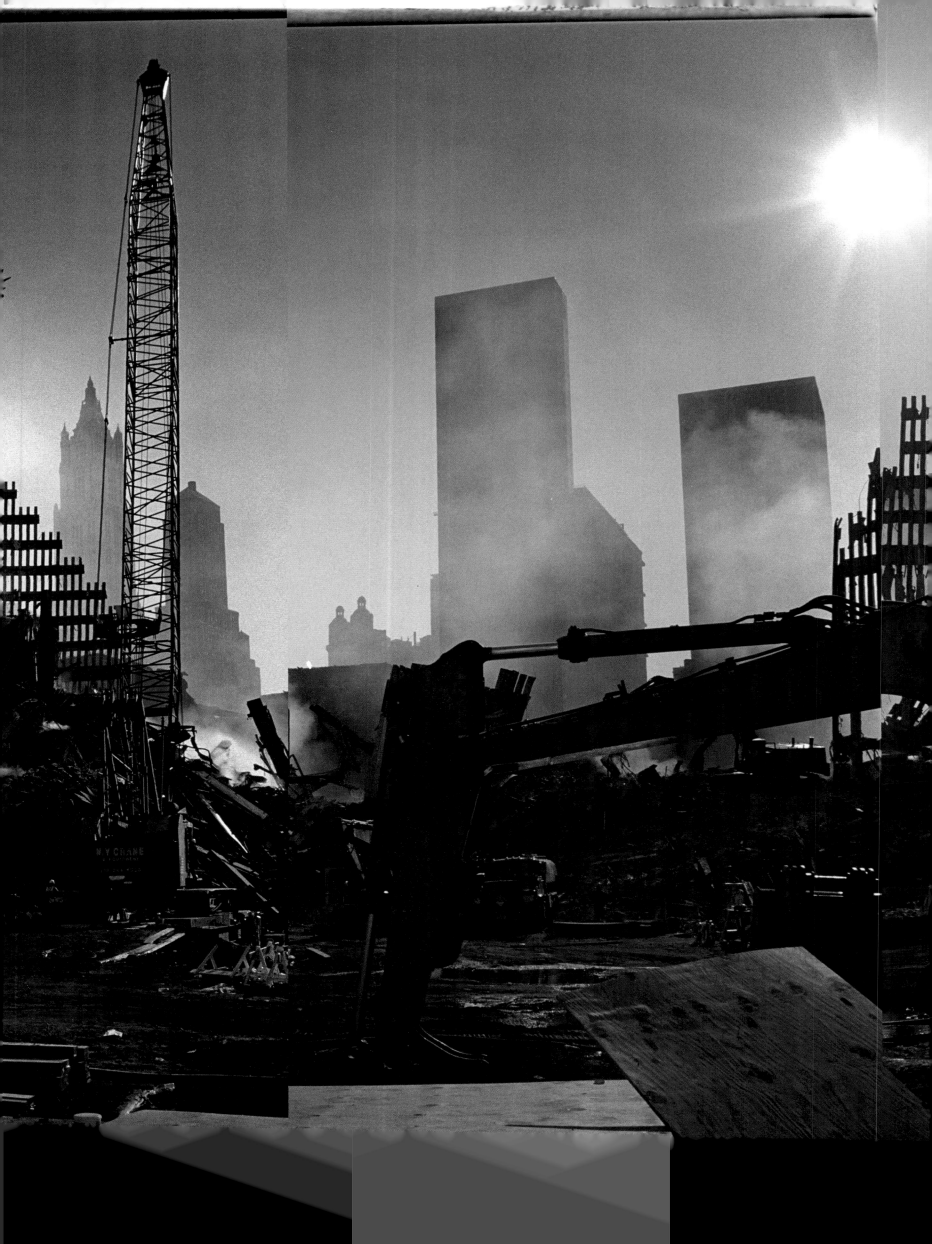

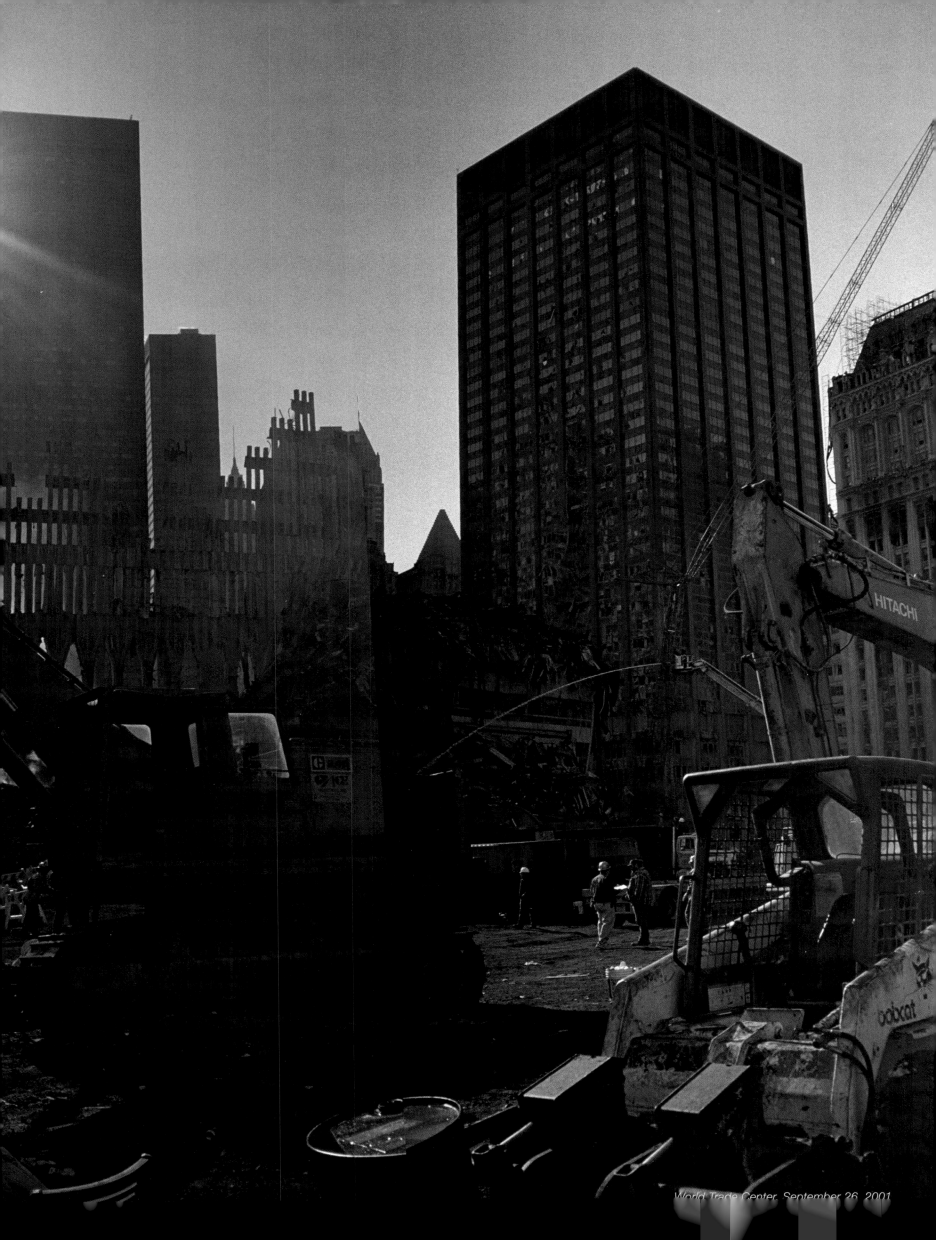

World Trade Center, September 26, 2001

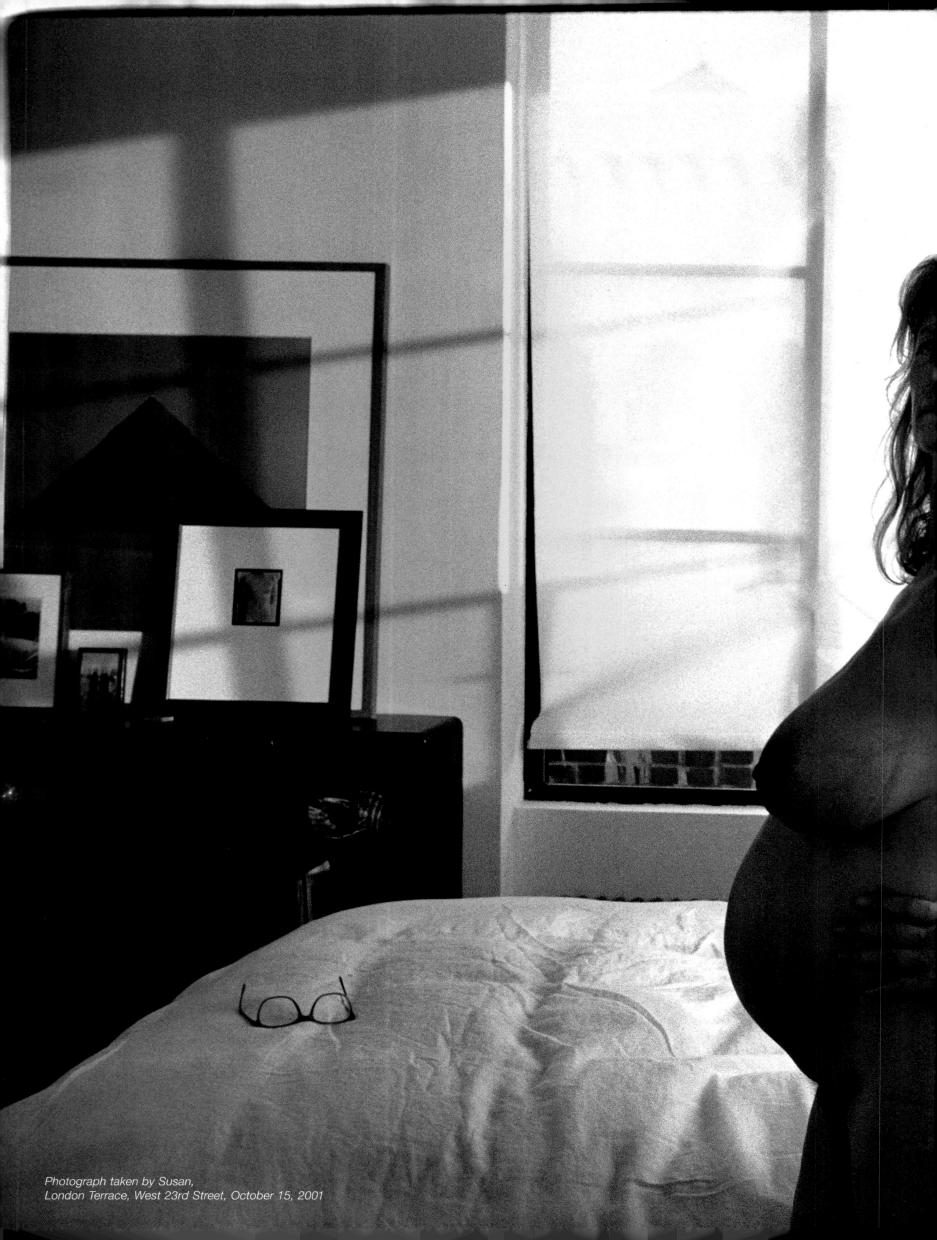

Photograph taken by Susan,
London Terrace, West 23rd Street, October 15, 2001

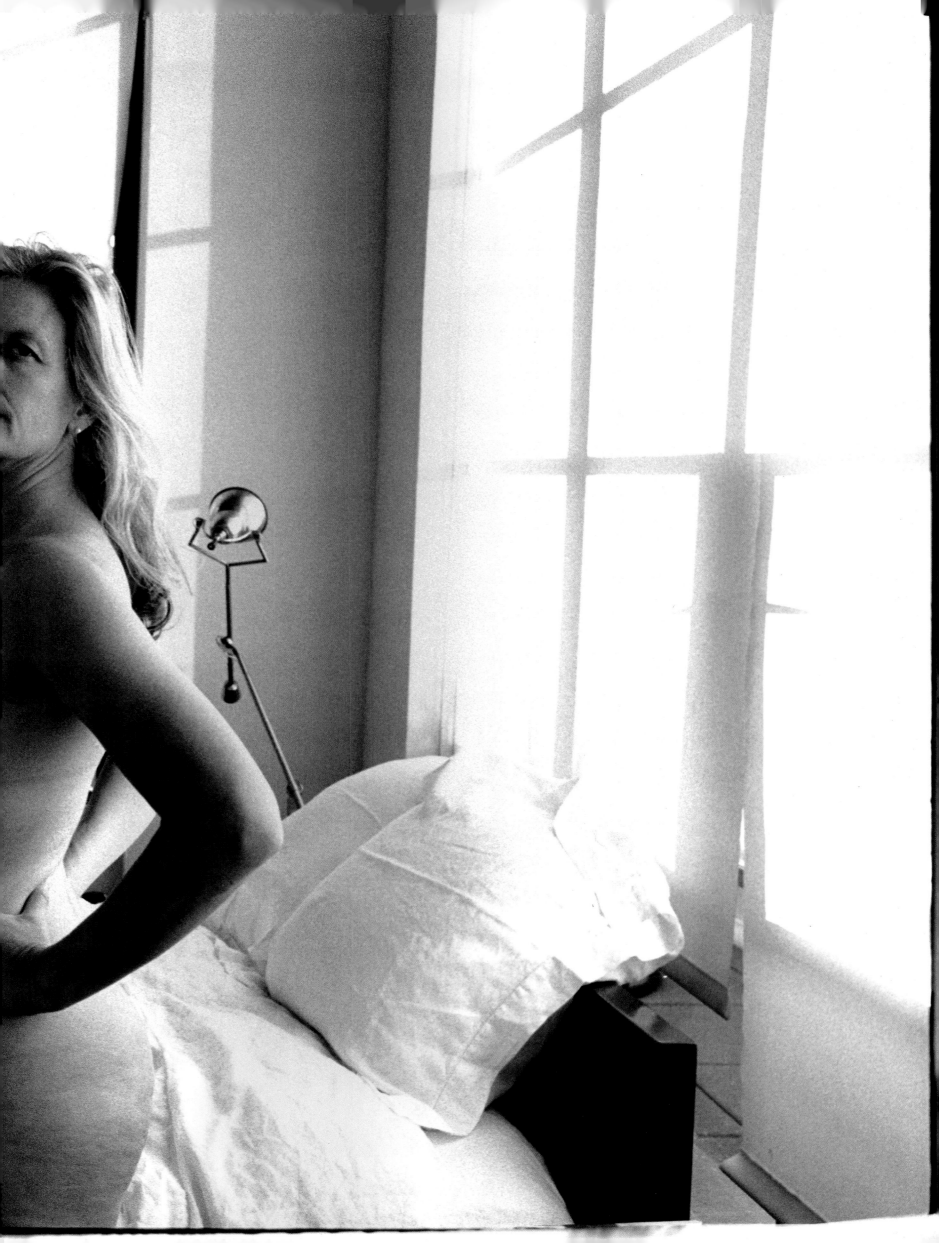

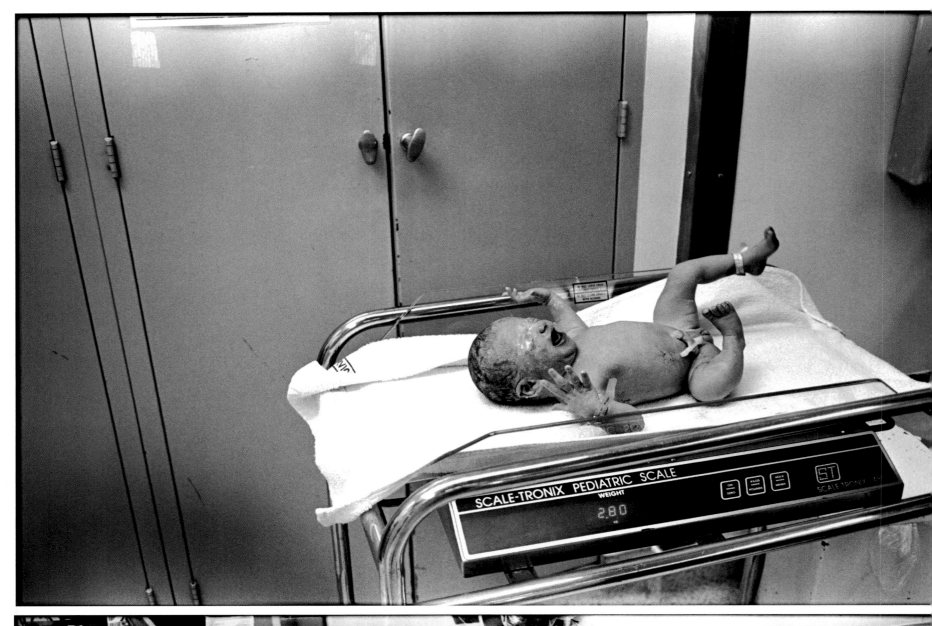

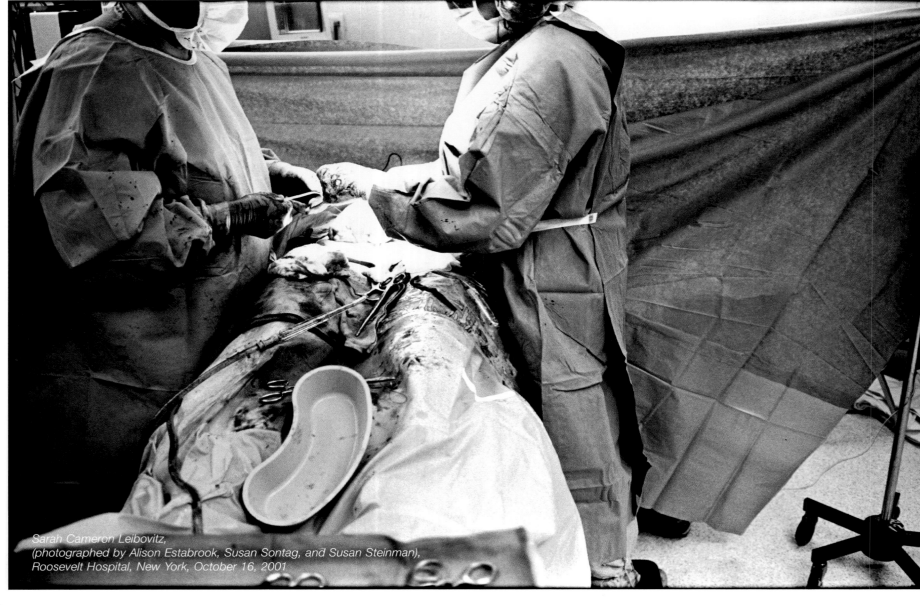

Sarah Cameron Leibovitz,
(photographed by Alison Estabrook, Susan Sontag, and Susan Steinman),
Roosevelt Hospital, New York, October 16, 2001

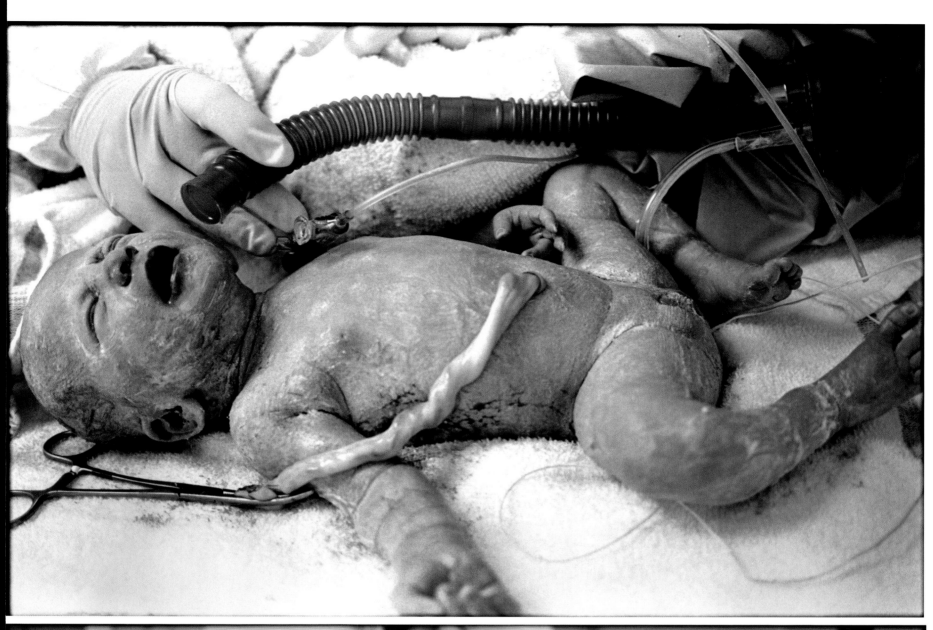

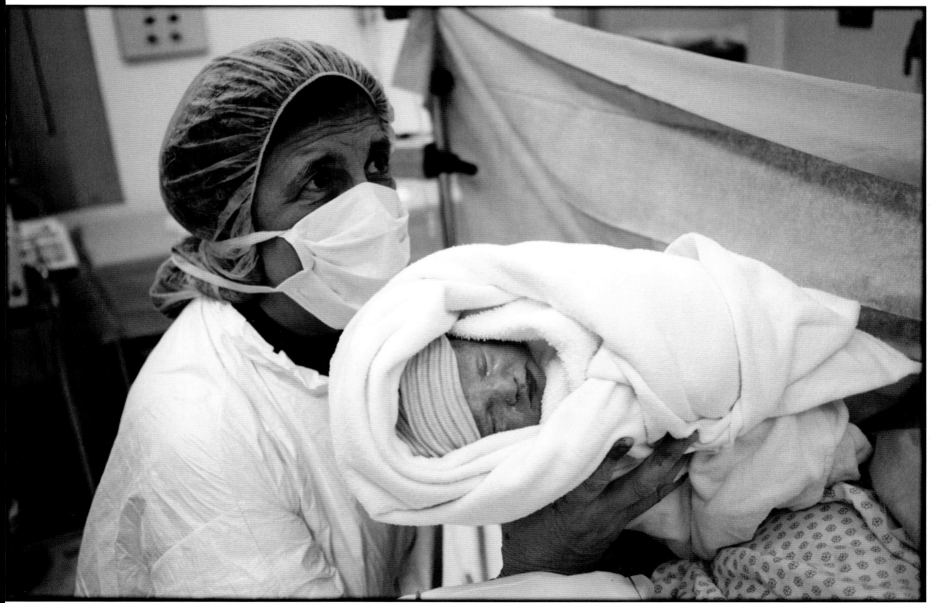

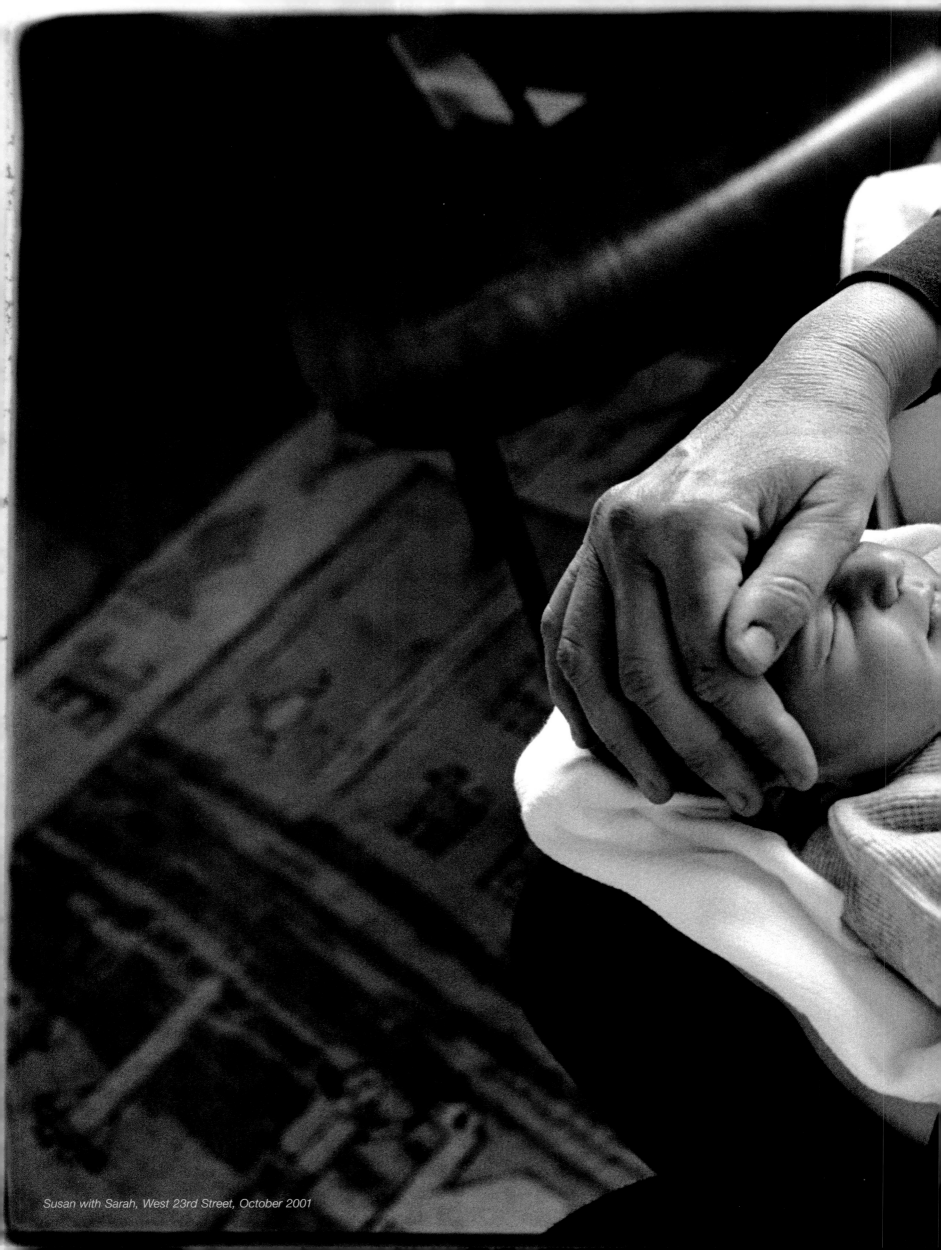

Susan with Sarah, West 23rd Street, October 2001

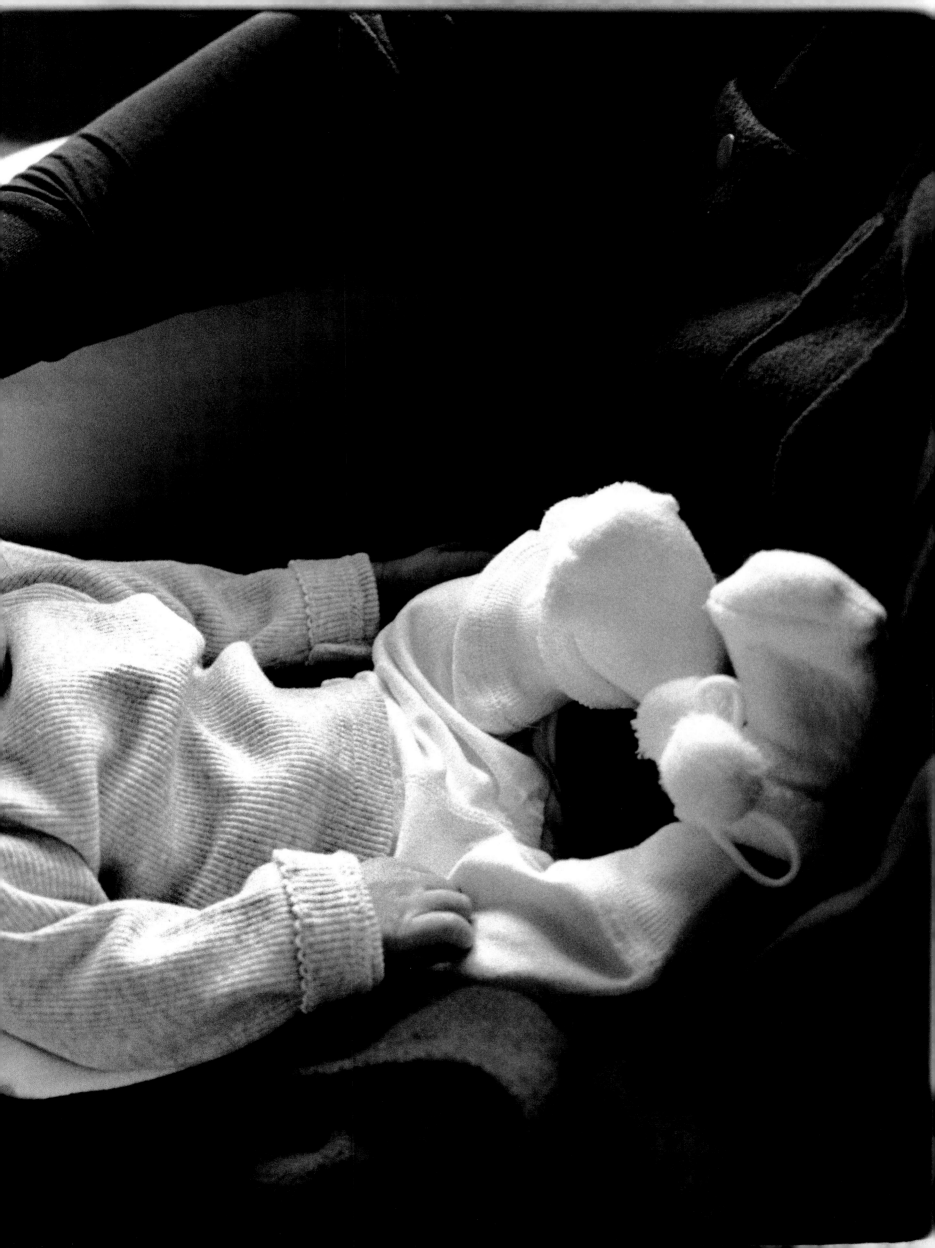

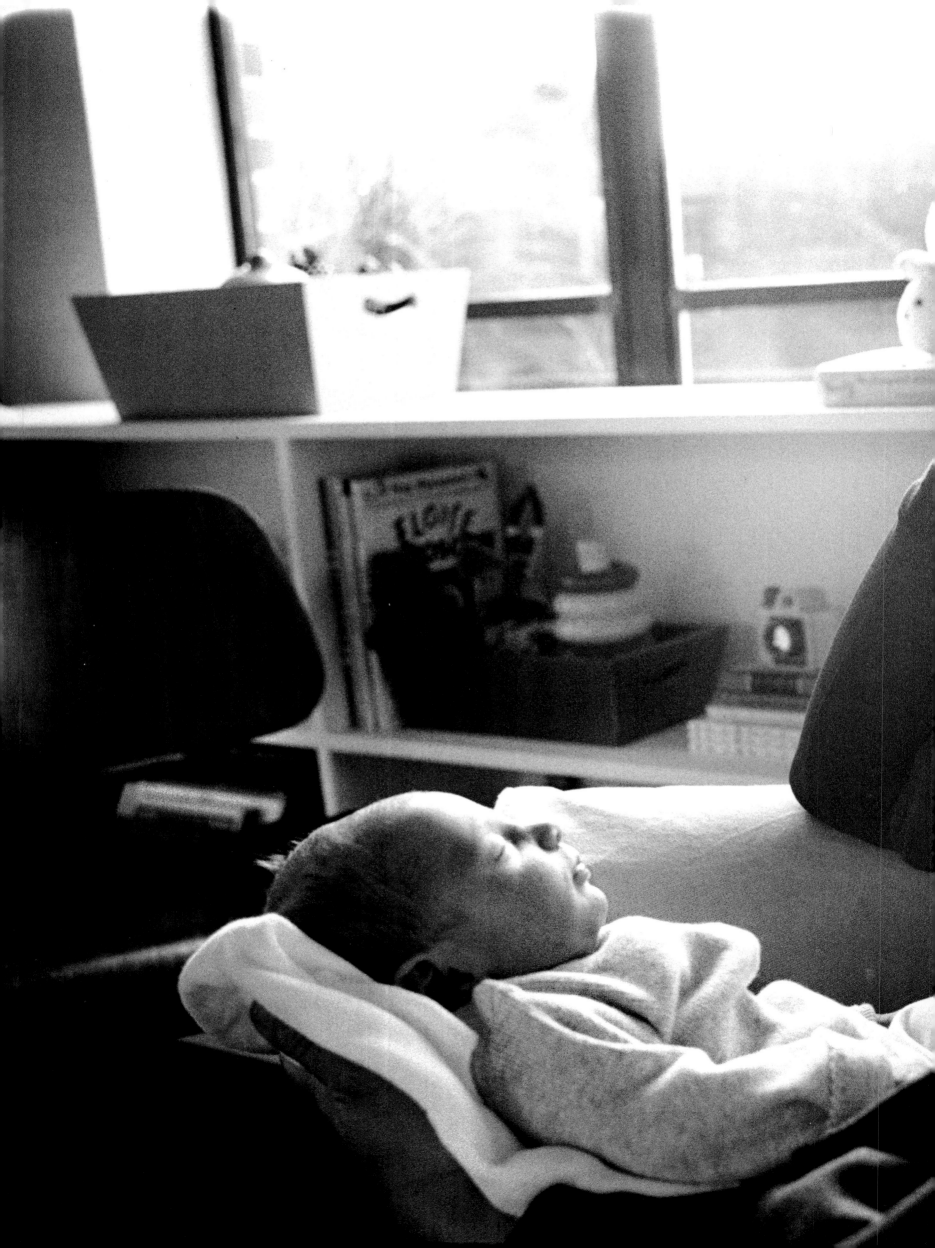

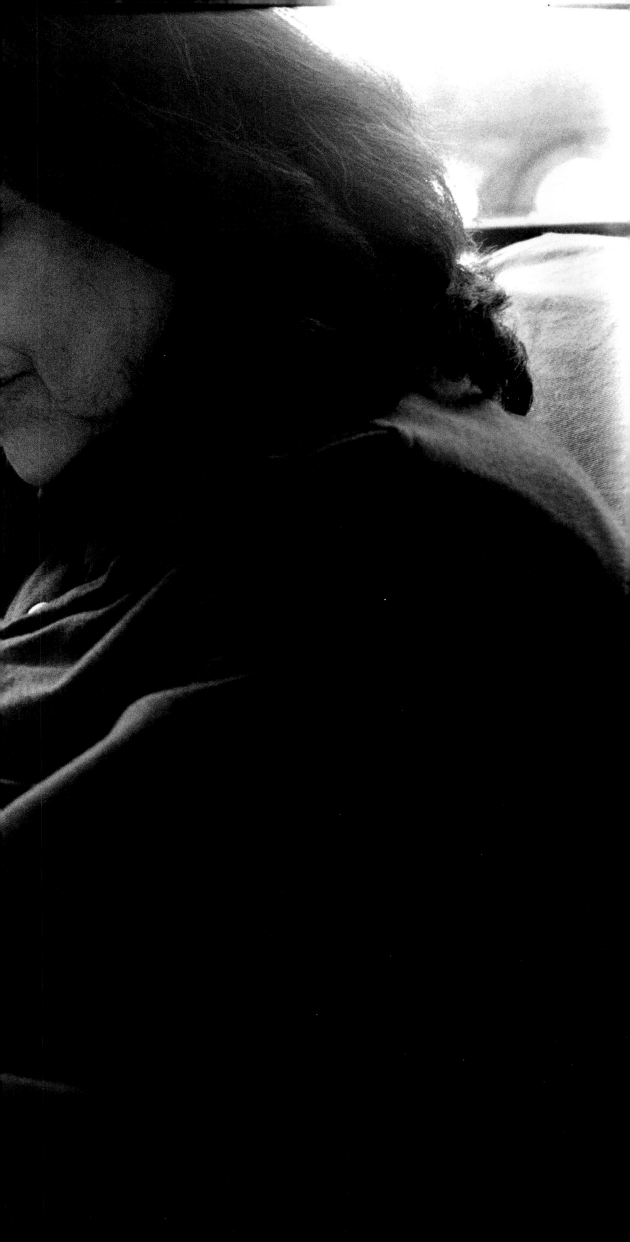

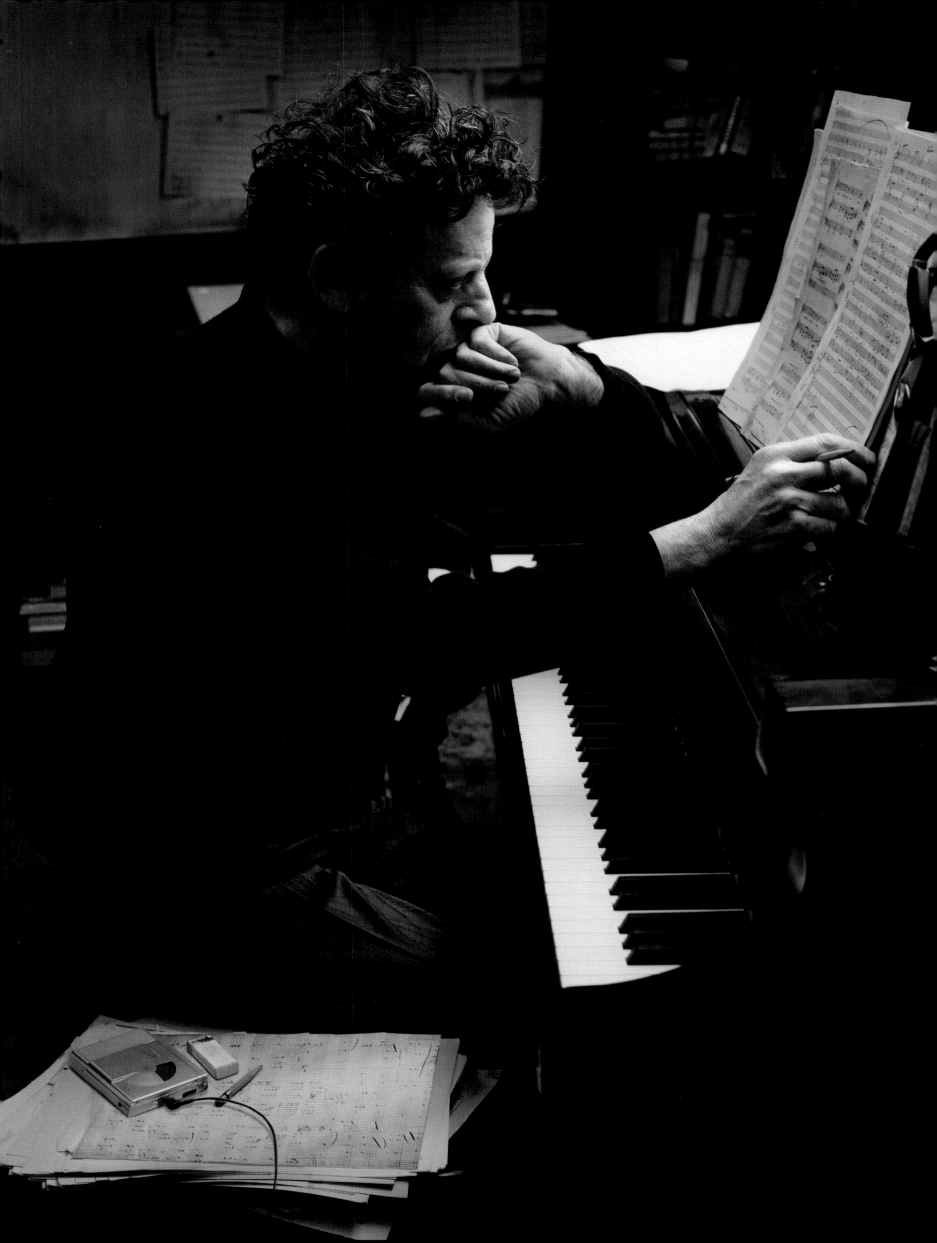

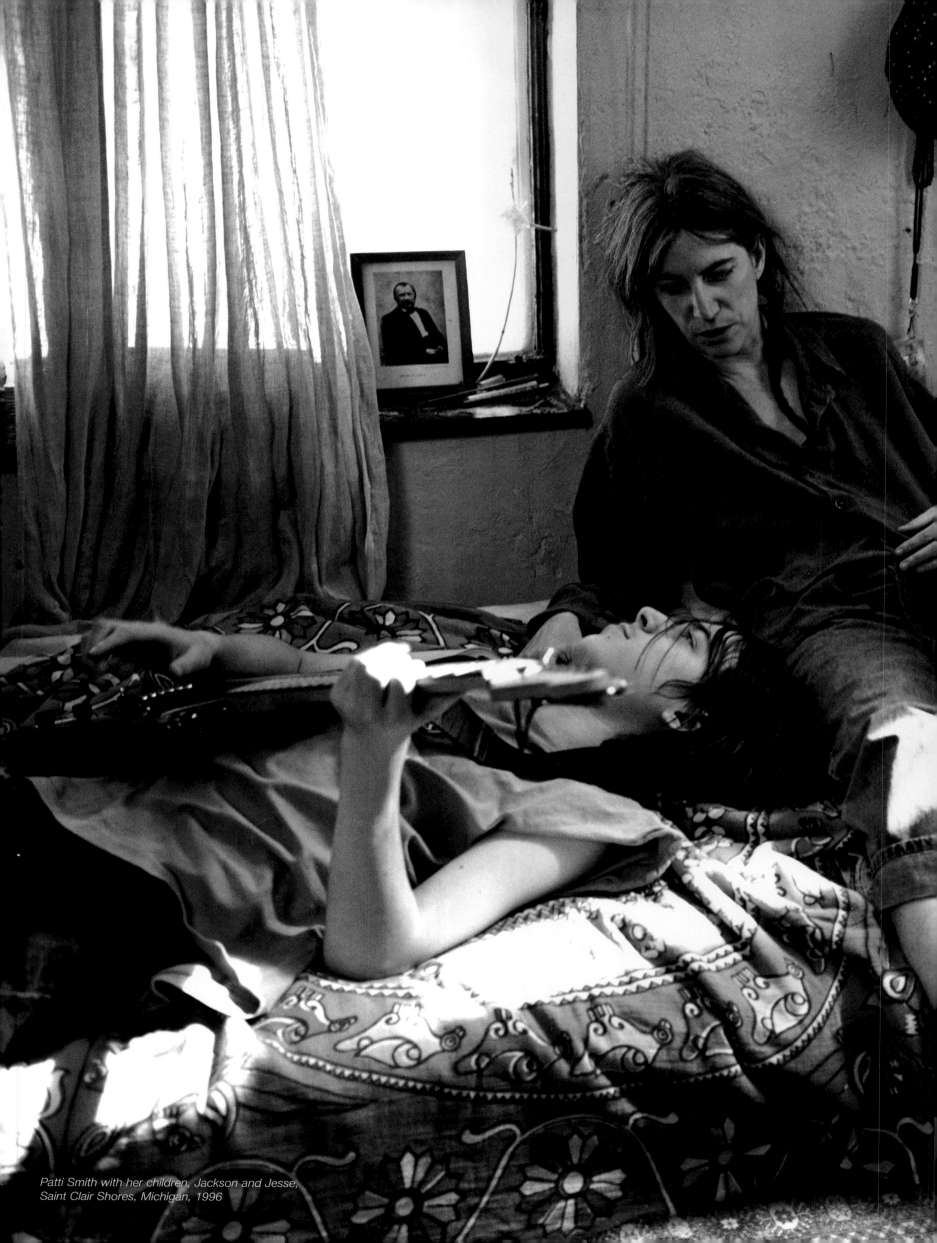

Patti Smith with her children, Jackson and Jesse,
Saint Clair Shores, Michigan, 1996

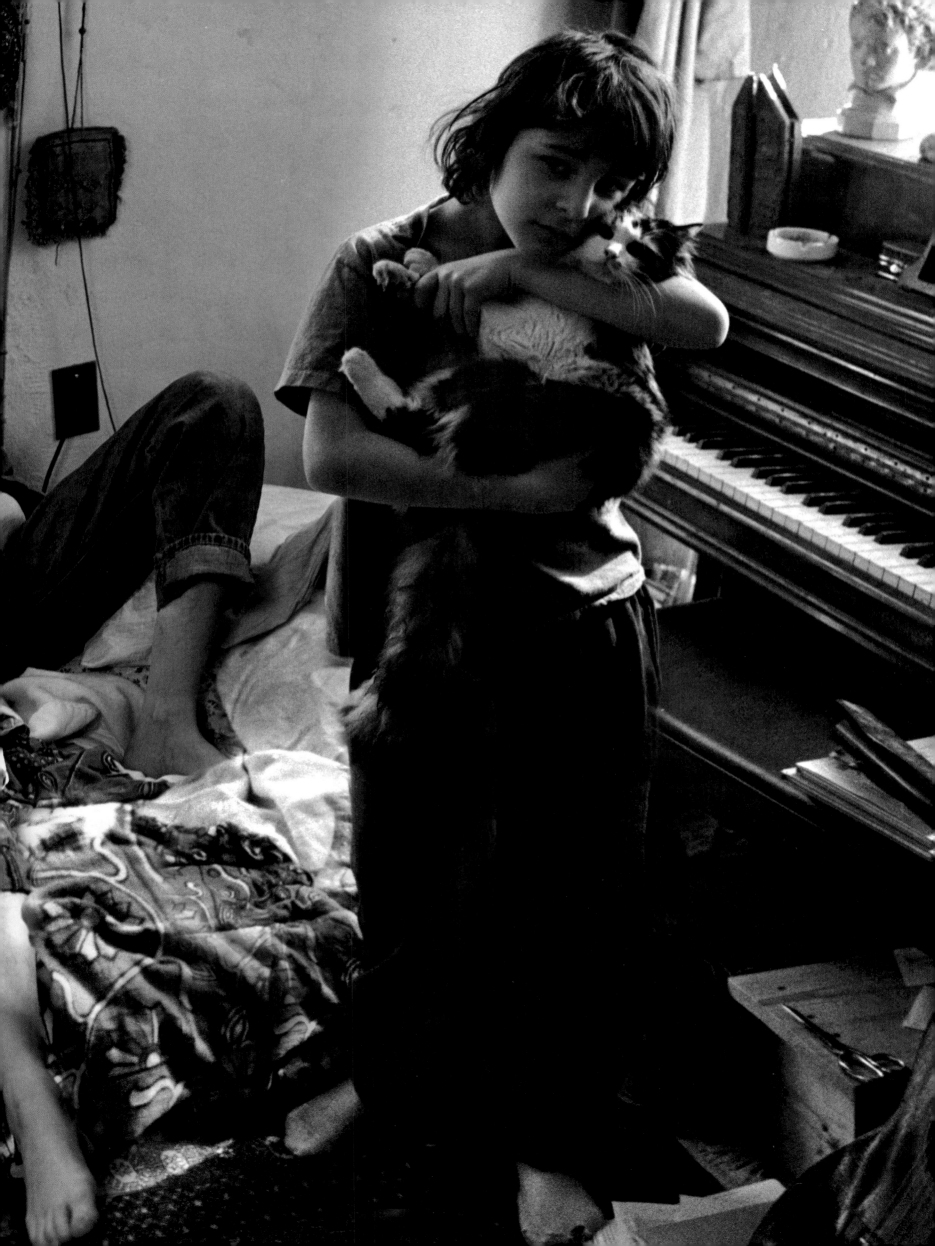

Willie Nelson, Luck Ranch, Spicewood, Texas, 2001

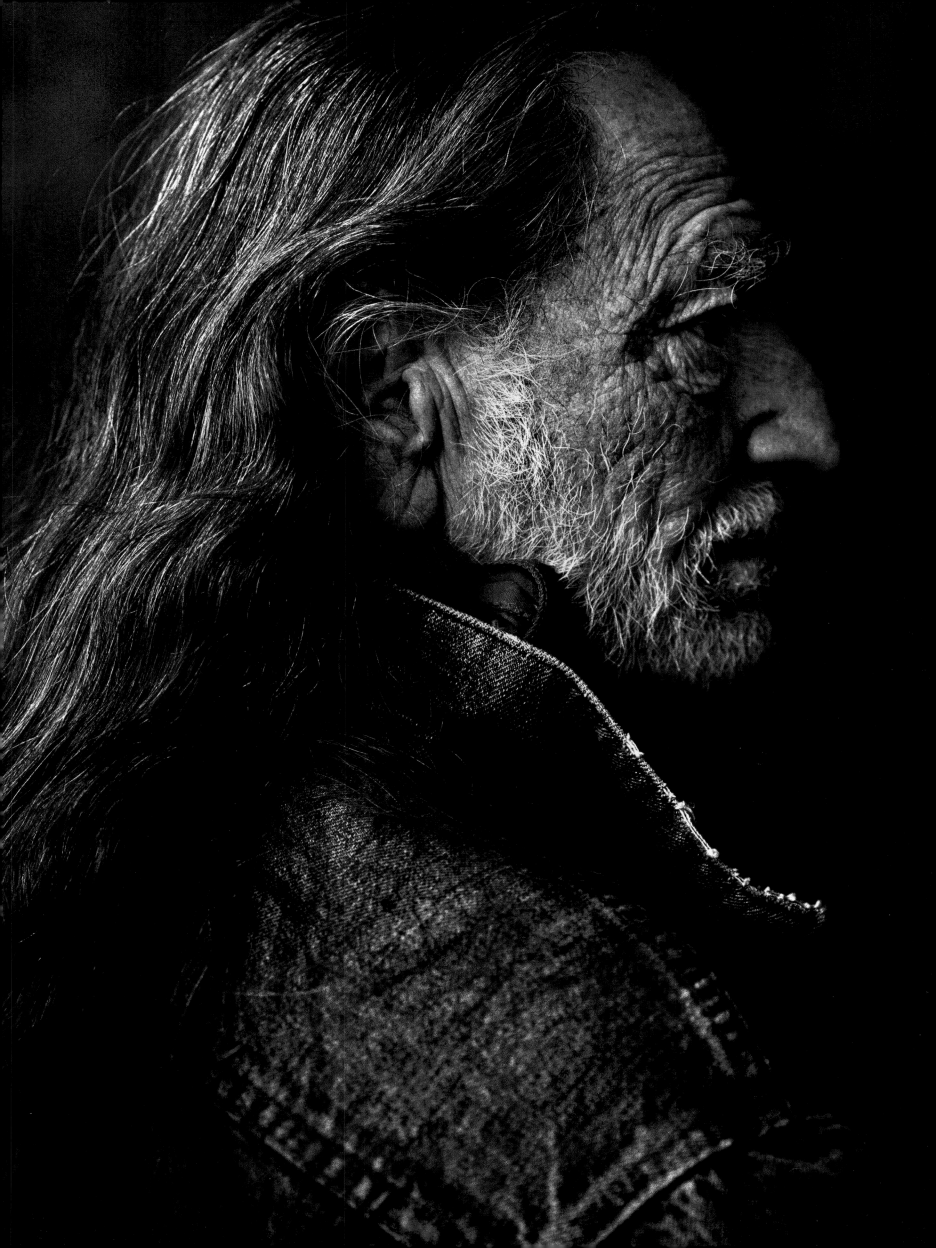

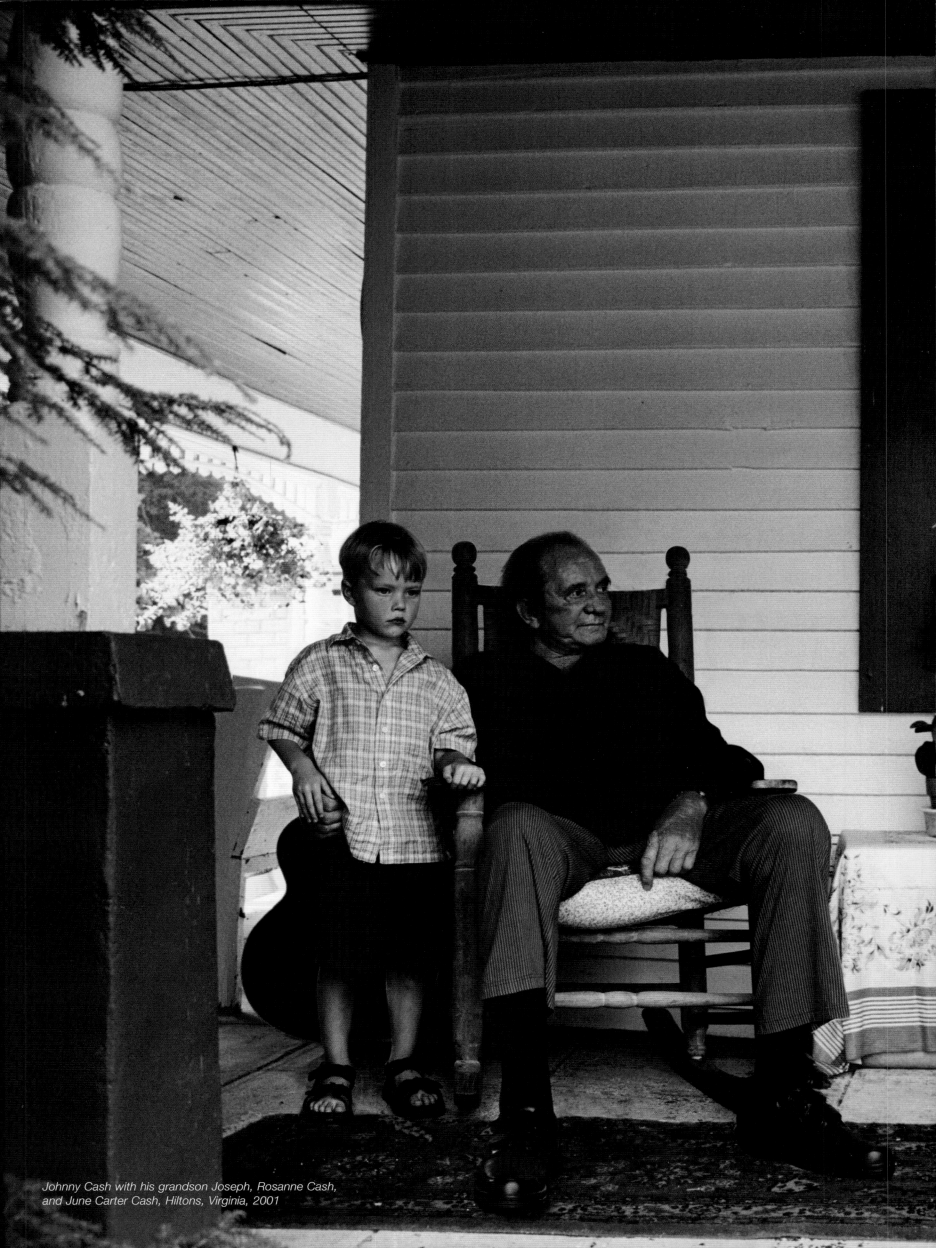

Johnny Cash with his grandson Joseph, Rosanne Cash,
and June Carter Cash, Hiltons, Virginia, 2001

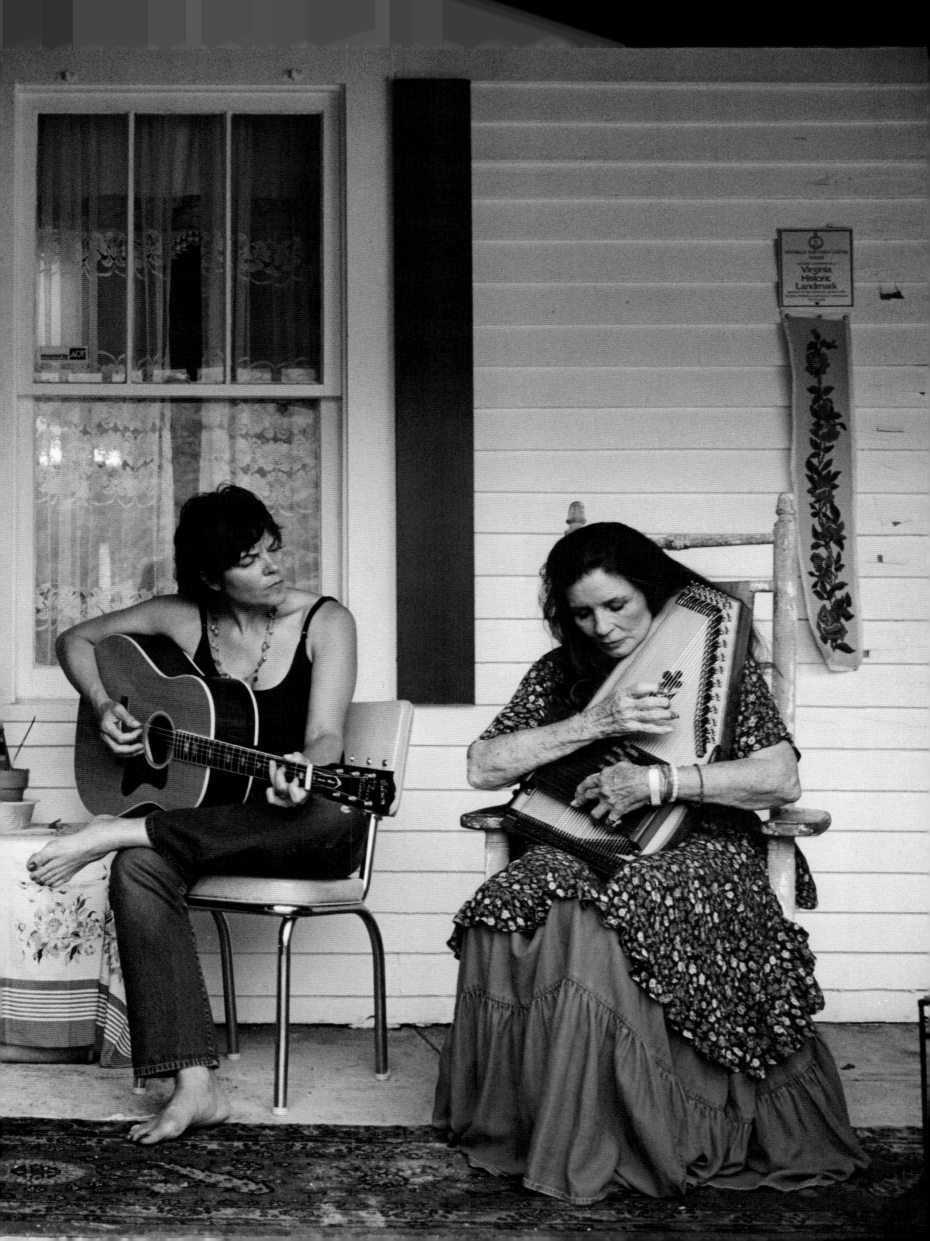

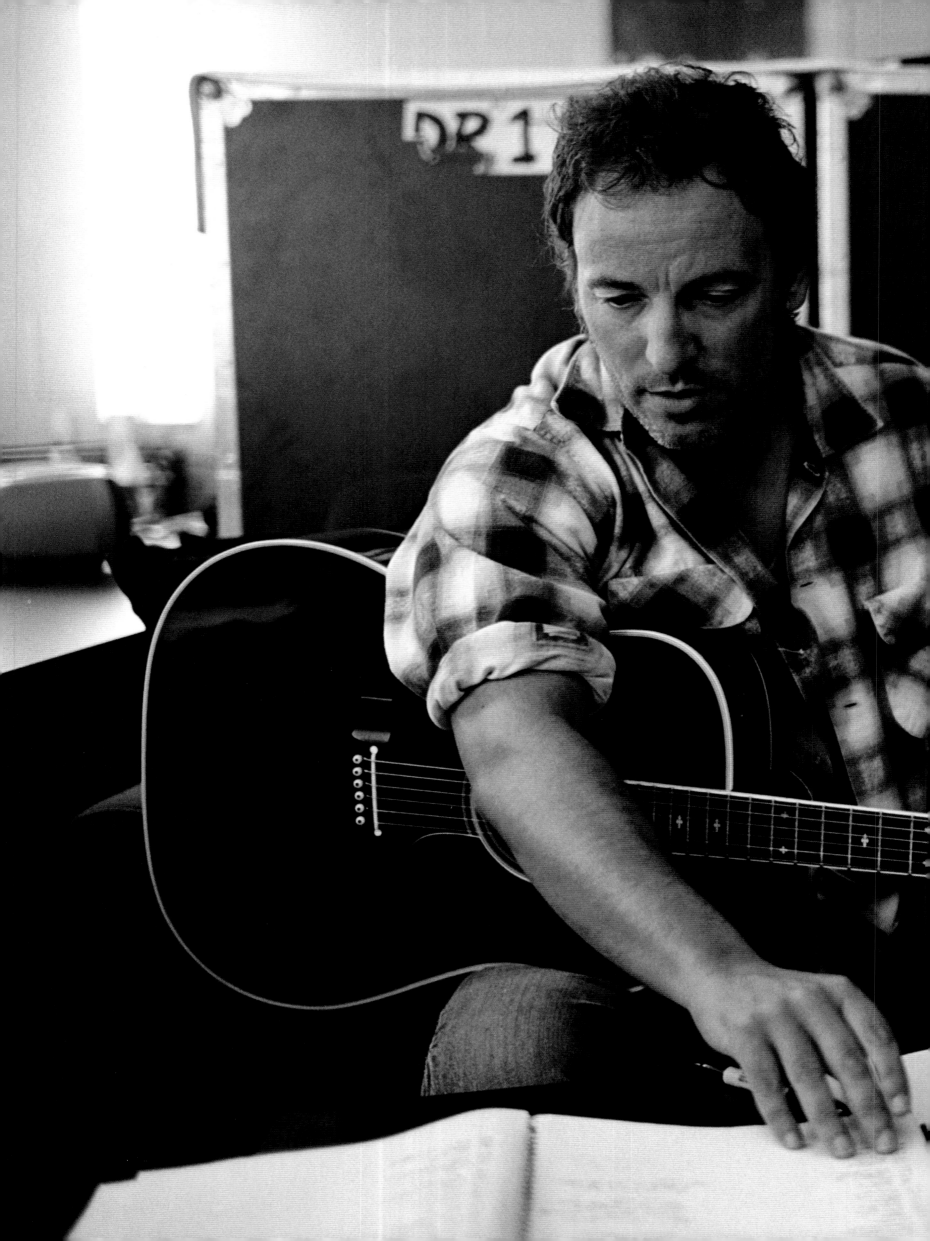

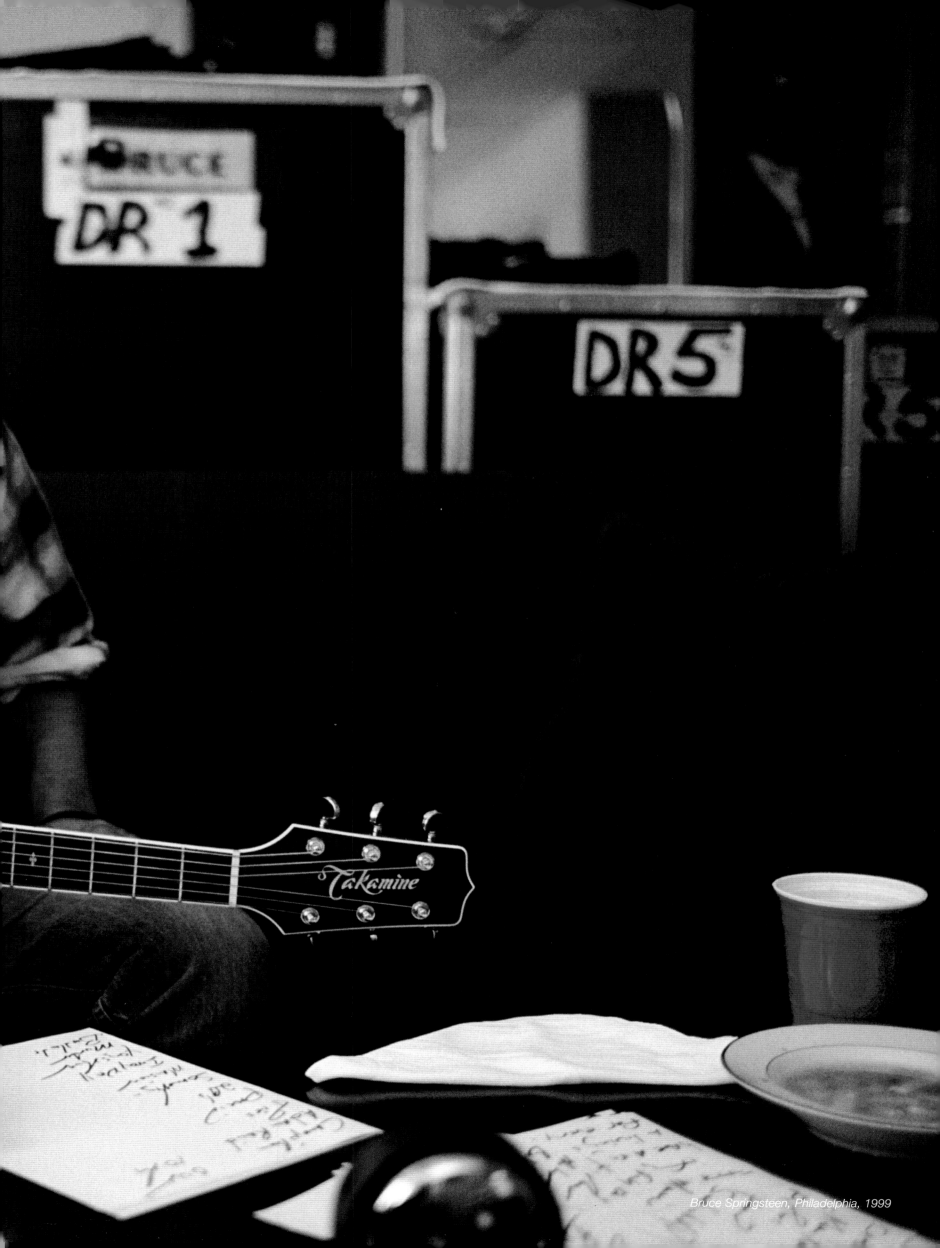

Bruce Springsteen, Philadelphia, 1999

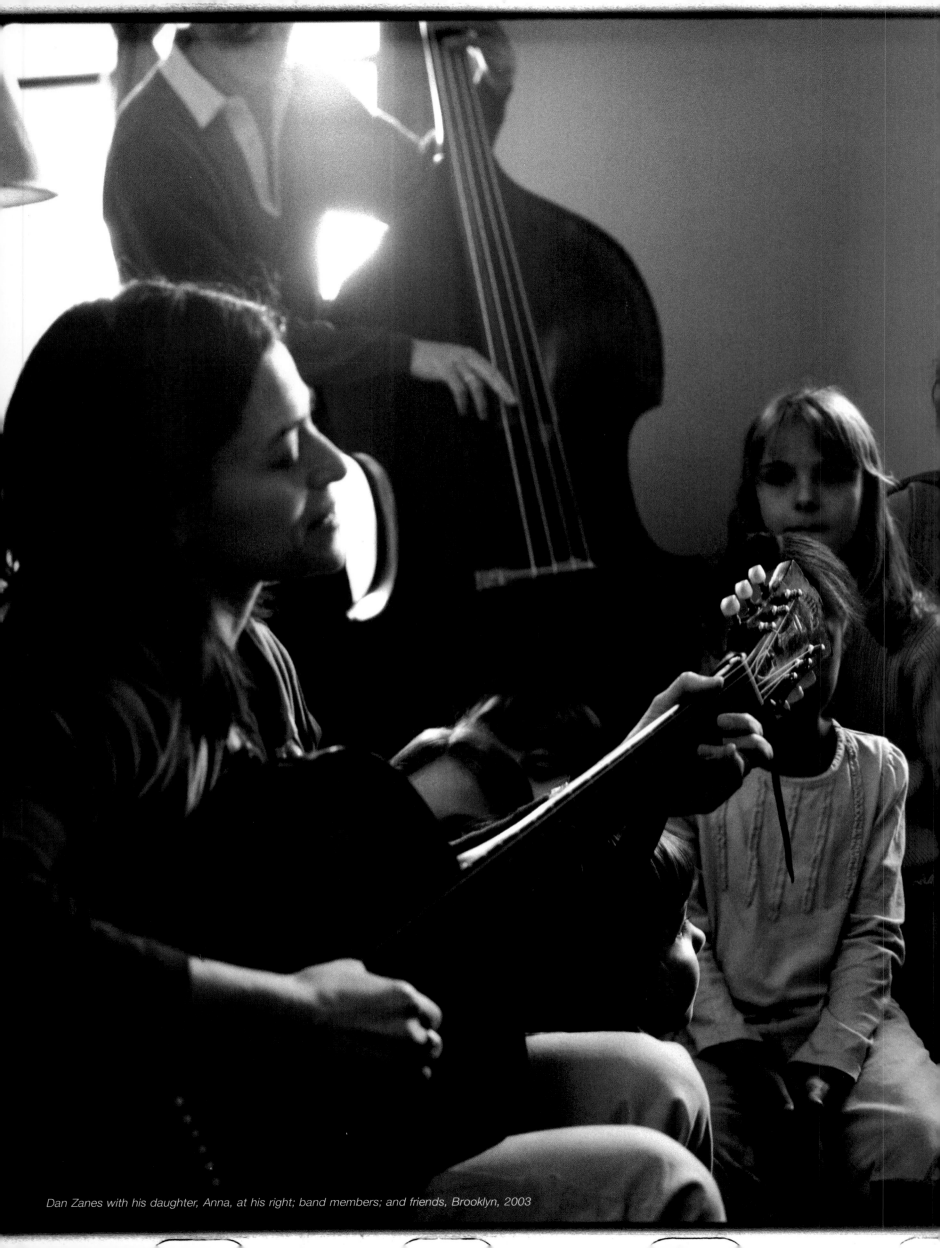

Dan Zanes with his daughter, Anna, at his right; band members; and friends, Brooklyn, 2003

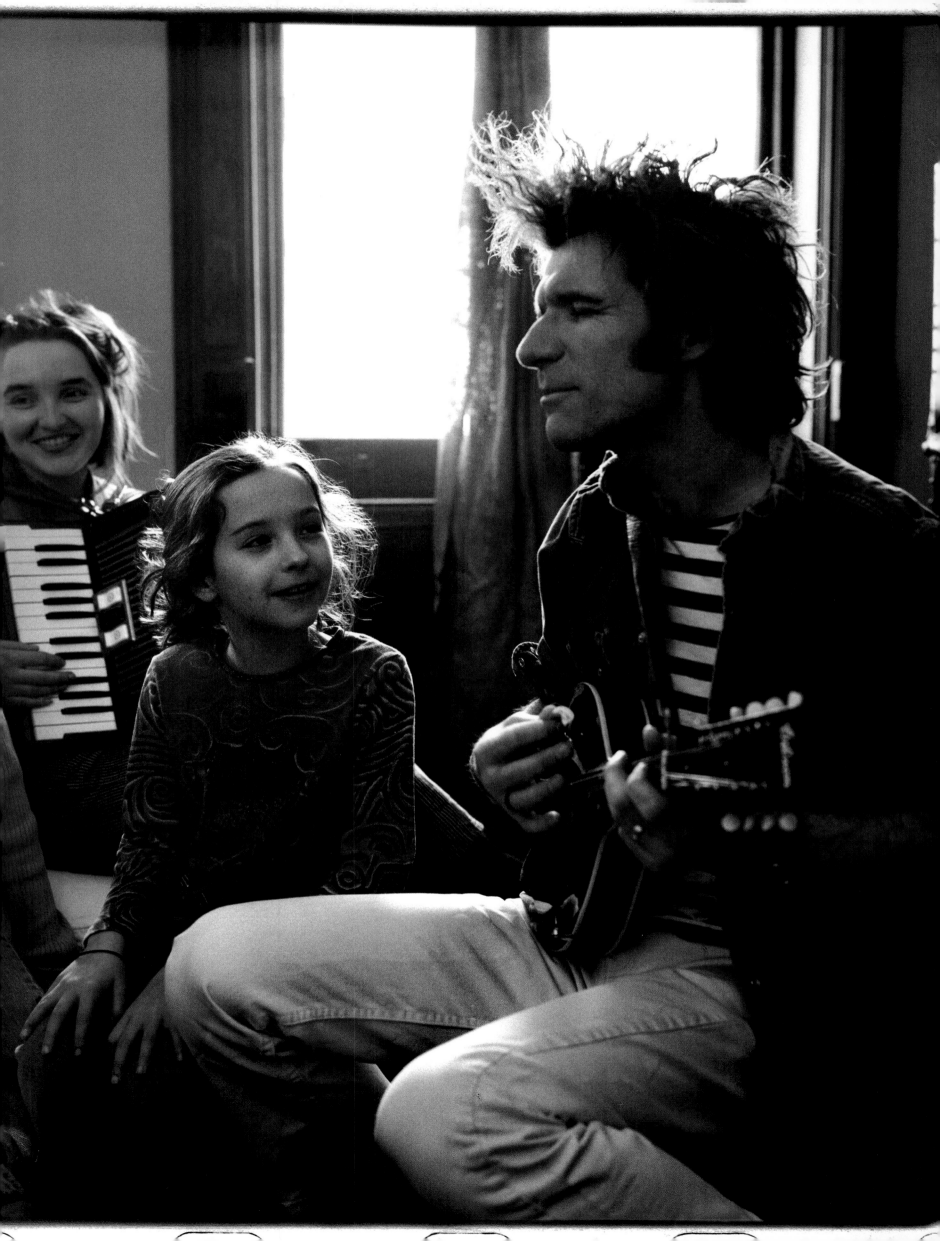

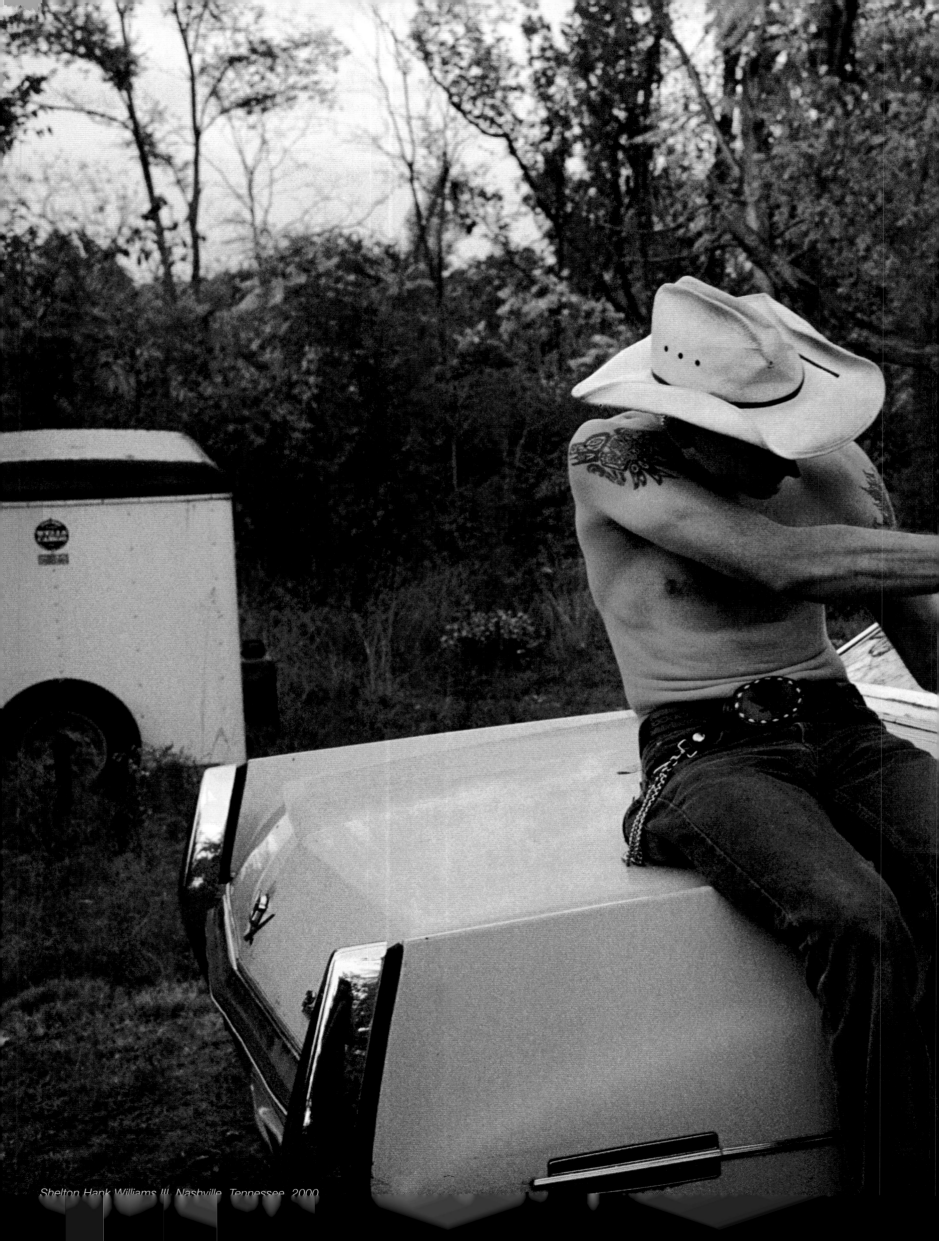

Shelton Hank Williams III, Nashville, Tennessee, 2000

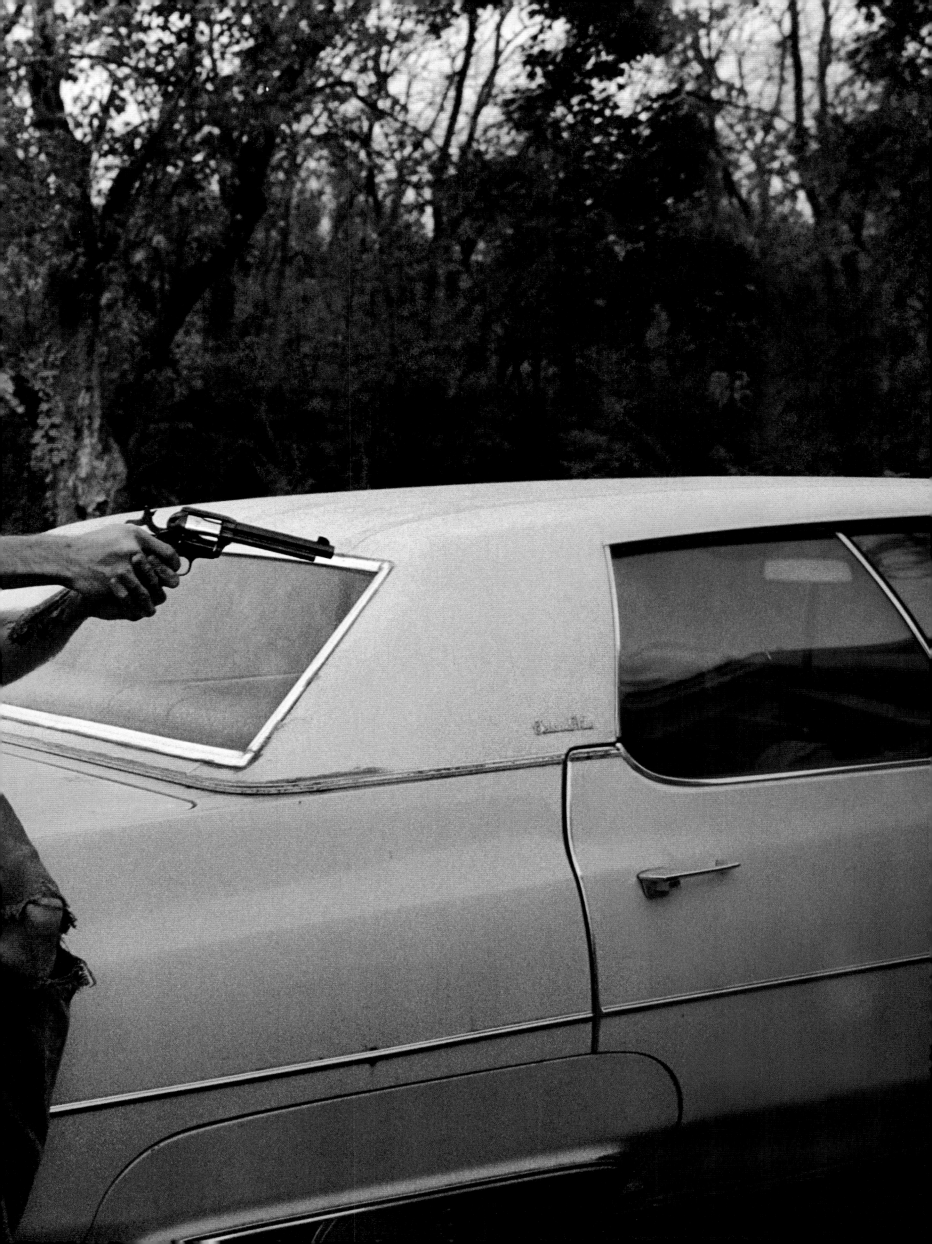

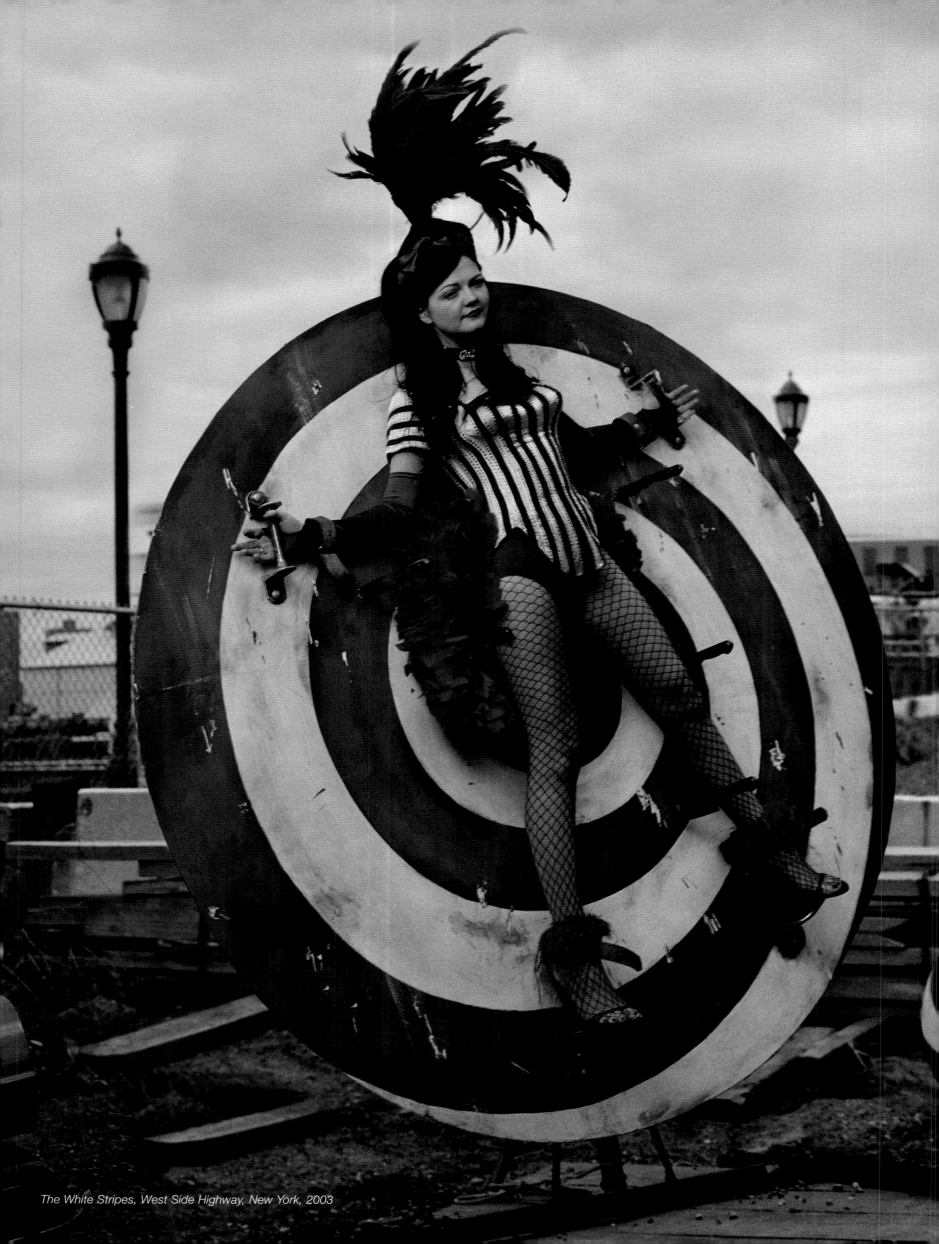

The White Stripes, West Side Highway, New York, 2003

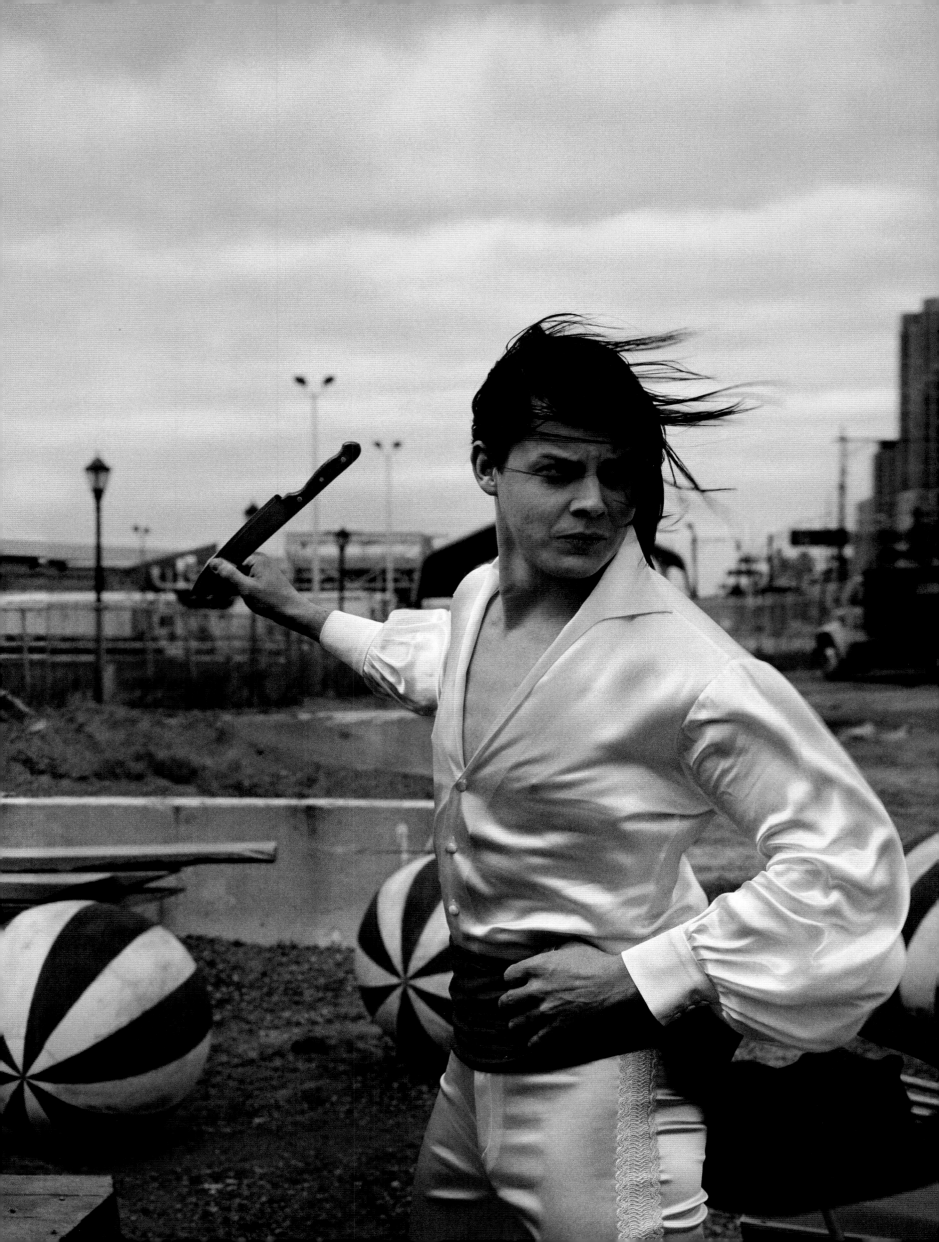

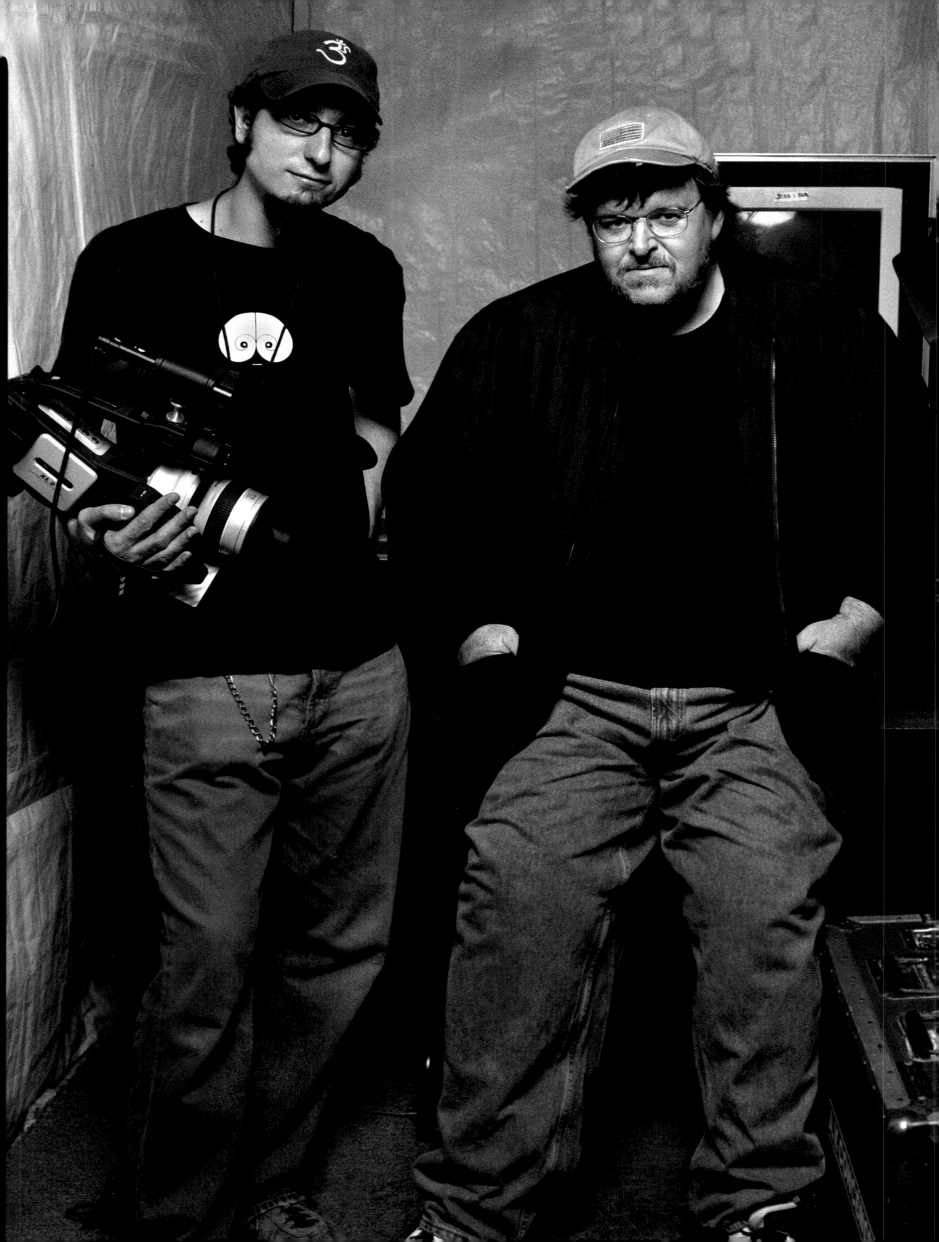

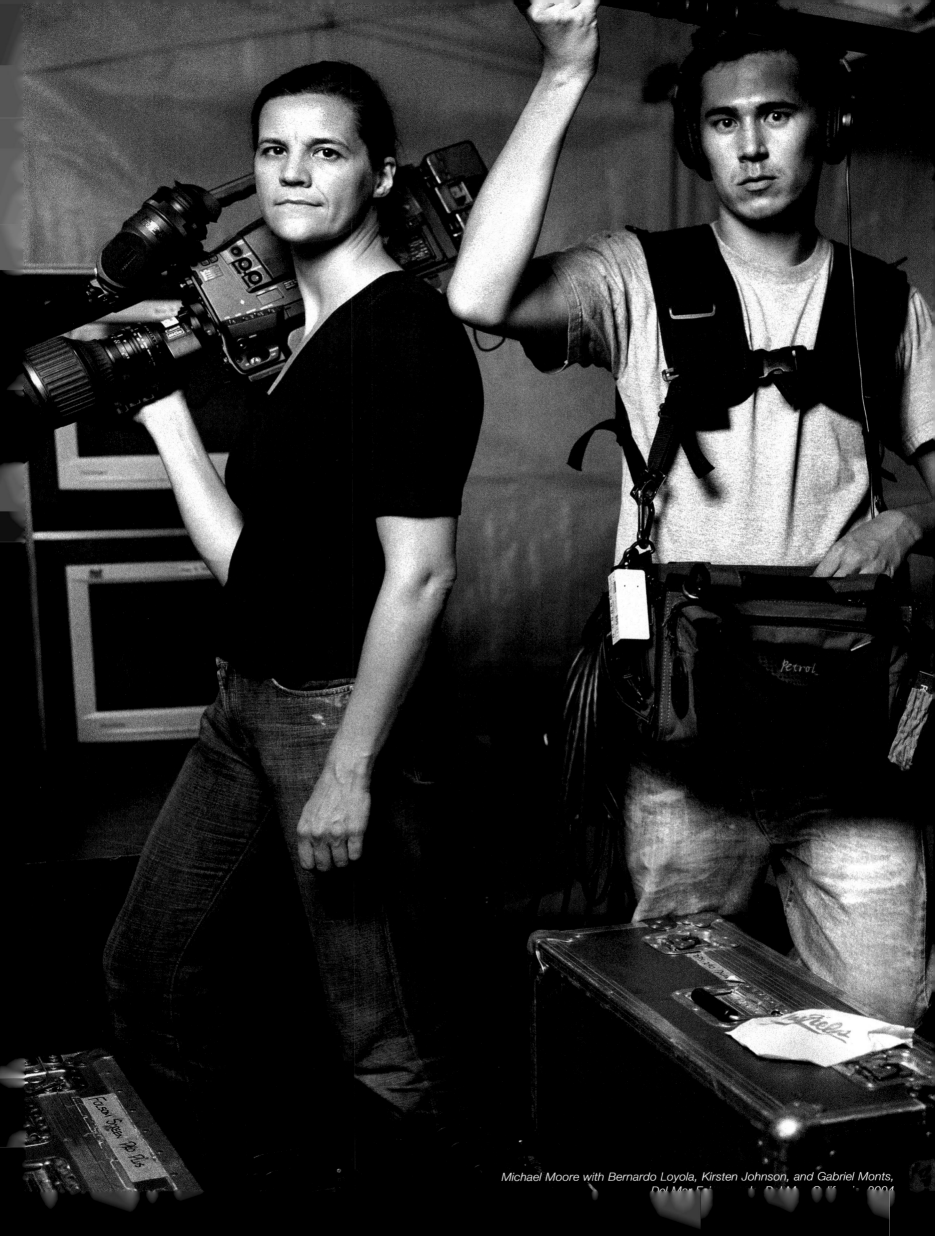

Michael Moore with Bernardo Loyola, Kirsten Johnson, and Gabriel Monts,
Del Mar Fairgrounds, Del Mar, California, 2004.

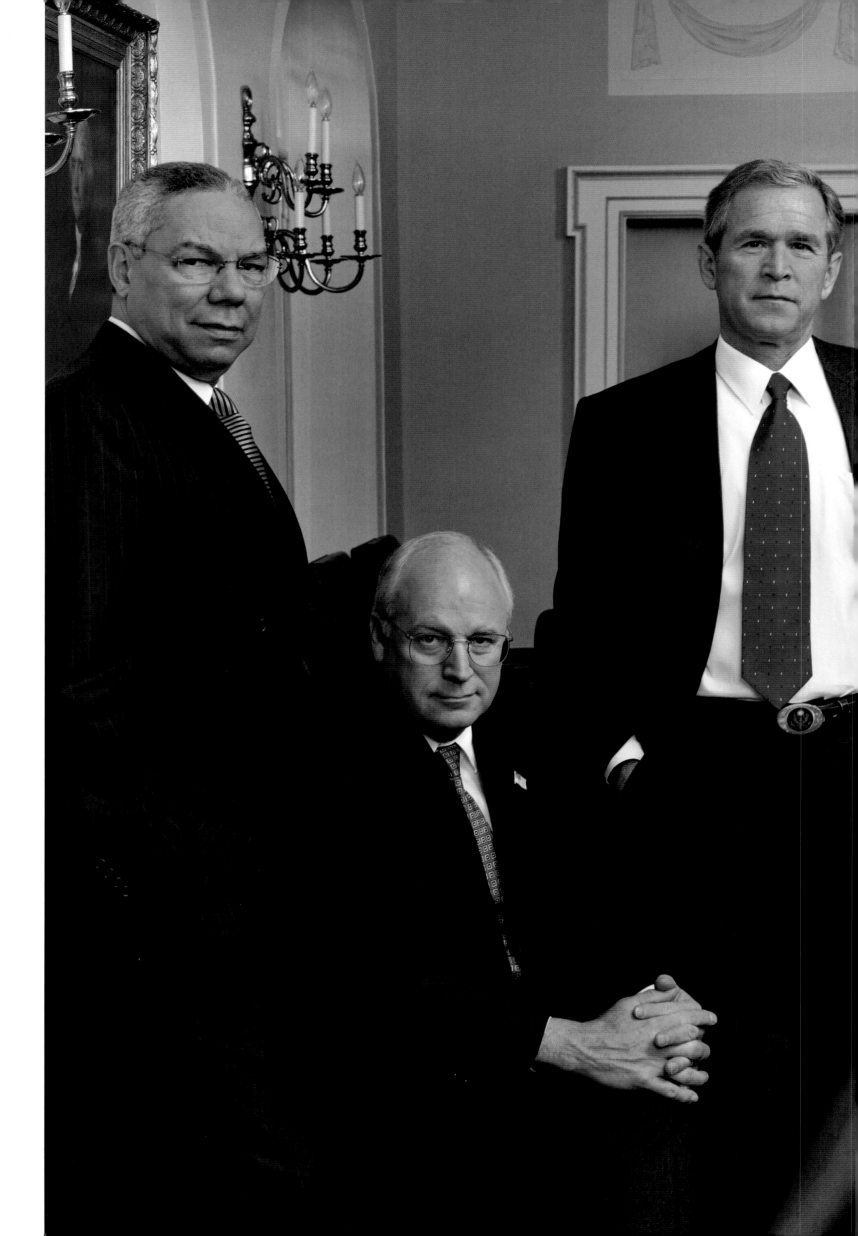

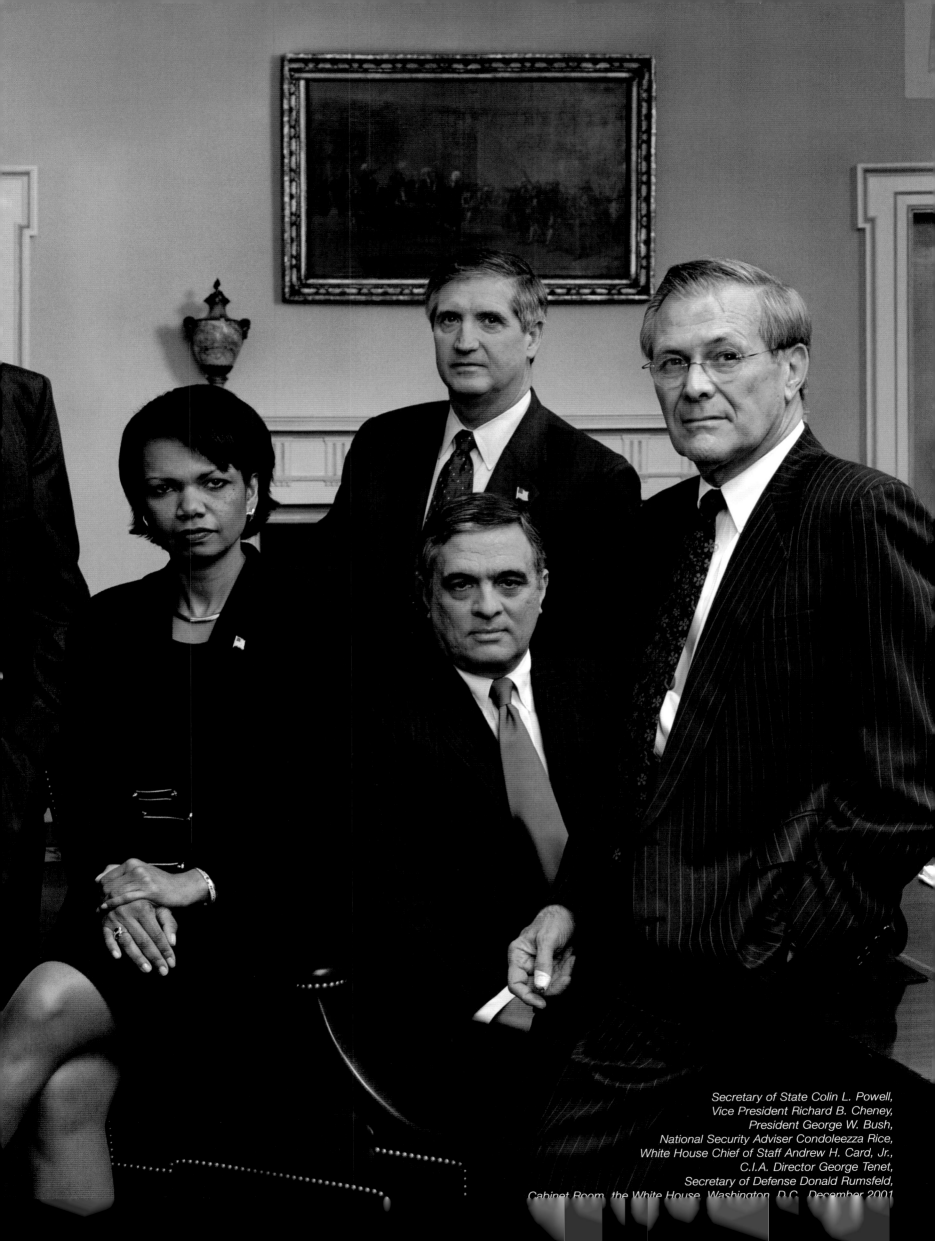

Secretary of State Colin L. Powell,
Vice President Richard B. Cheney,
President George W. Bush,
National Security Adviser Condoleezza Rice,
White House Chief of Staff Andrew H. Card, Jr.,
C.I.A. Director George Tenet,
Secretary of Defense Donald Rumsfeld,
Cabinet Room, the White House, Washington, D.C., December 2001

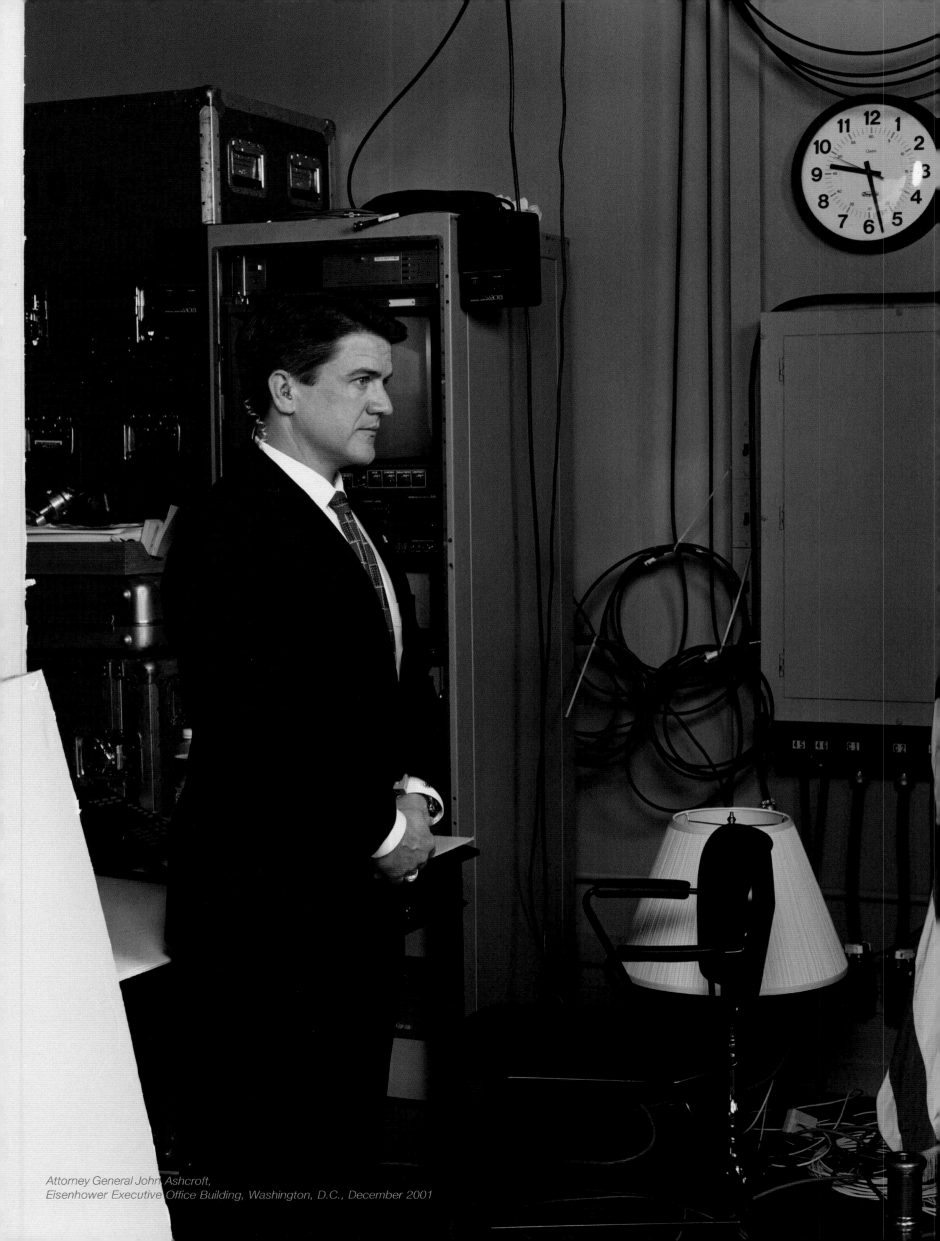

Attorney General John Ashcroft,
Eisenhower Executive Office Building, Washington, D.C., December 2001

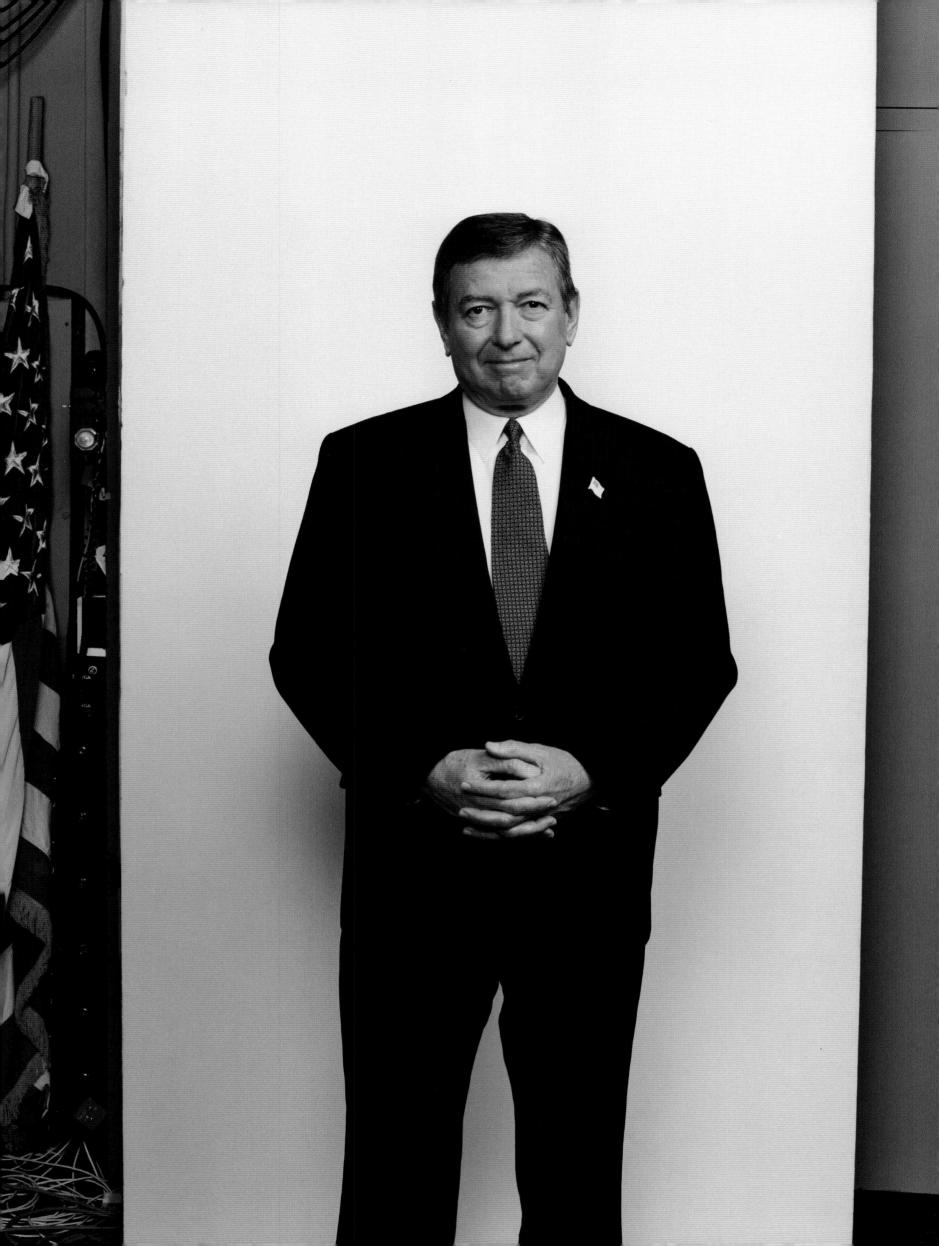

CREATED

8/97 INDUSTRIAL LIGHT & MAGIC
MARIN CO · CALIFORNIA

ILM MODEL/CREATURE SHOP

8/97 LEAVESDEN STUDIOS · STAR WARS
LONDON, ENGLAND EPISODE I

9/97-10/97 ILM · STAR WARS I · GREEN SCREEN · SAN RAPHAEL, CA

11/98 IMAX STUDIOS · STAR WARS
ISTANBUL, TURKEY LEGO COMMERCIAL

3/99 NASHVILLE ARENA · TACO BELL
NASHVILLE, TN CONVENTION

3/30/99 LOS ANGELES (Y JAKS) · NICKELODEON
QUIXOTE STUDIOS MAGAZINE SHOT

4/29-5/2/99 DENVER, CO
WINGS OVER THE ROCKIES
AIR MUSEUM
(SW CONVENTION)

5/12/99 E3 SHOW
LOS ANGELES, CA

5/18/99 NEW YORK, NY
ROSIE O'DONNELL SHOW

6/3/99 DENNIS MUREN'S "STAR ON
HOLLYWOOD WALK OF FAME"
HOLLYWOOD, CA

8/6/99 ILM OPEN HOUSE
SAN RAPHAEL, CA

11/7/99 20th CENTURY FOX / FOX STUDIOS
SYDNEY, AUSTRALIA AUSTRALIA
OPENING

6/00-8/00 FOX STUDIOS AUSTRALIA · SYDNEY
STAR WARS II · PRINCIPAL PHOTOGRAPHY

8/21/00-9/1/00 COMO, ITALY
STAR WARS II

9/4-9/6/00 CASERTA, ITALY
STAR WARS II

9/7-9/9/00 TUNISIA
-NEFTA
-OUTSIDE TOUEZOR
STAR WARS II

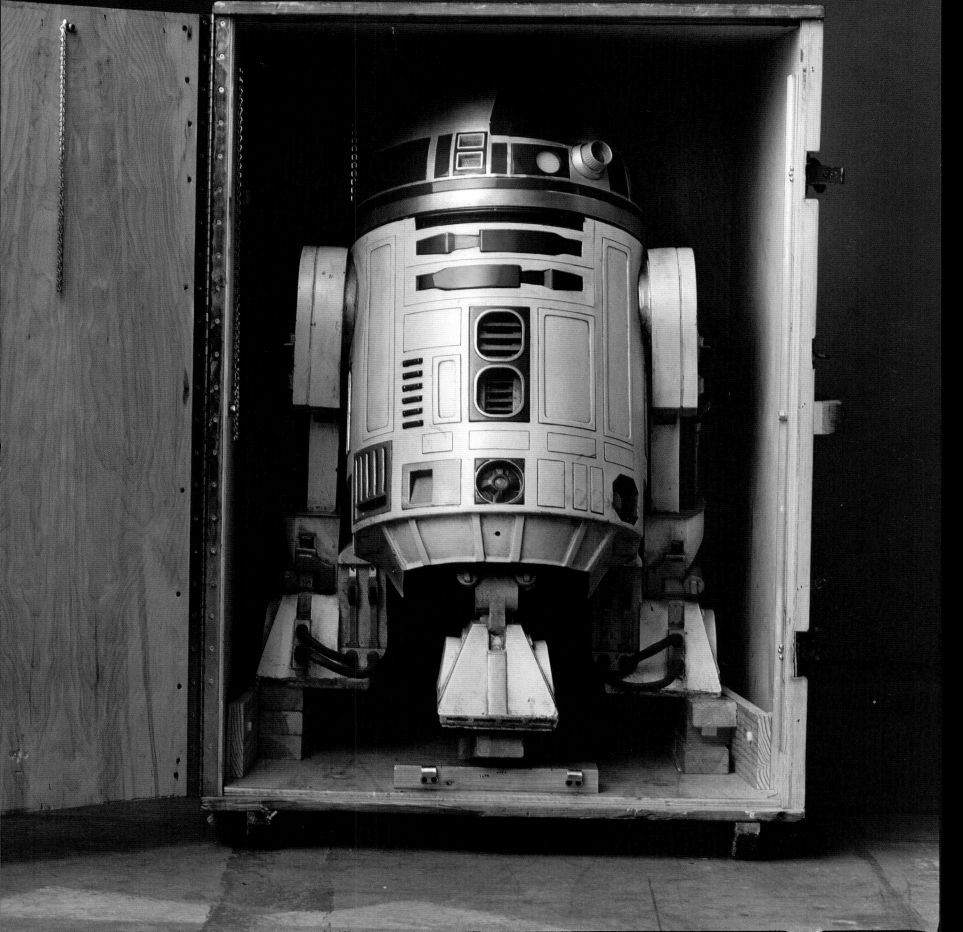

Slimline battle droid on the set of Star Wars: Episode II, Attack of the Clones,
Pinewood Studios, London, 2002

Preceding page:
R2-D2 on the set of Star Wars: Episode II, Attack of the Clones,
Pinewood Studios, London, 2002

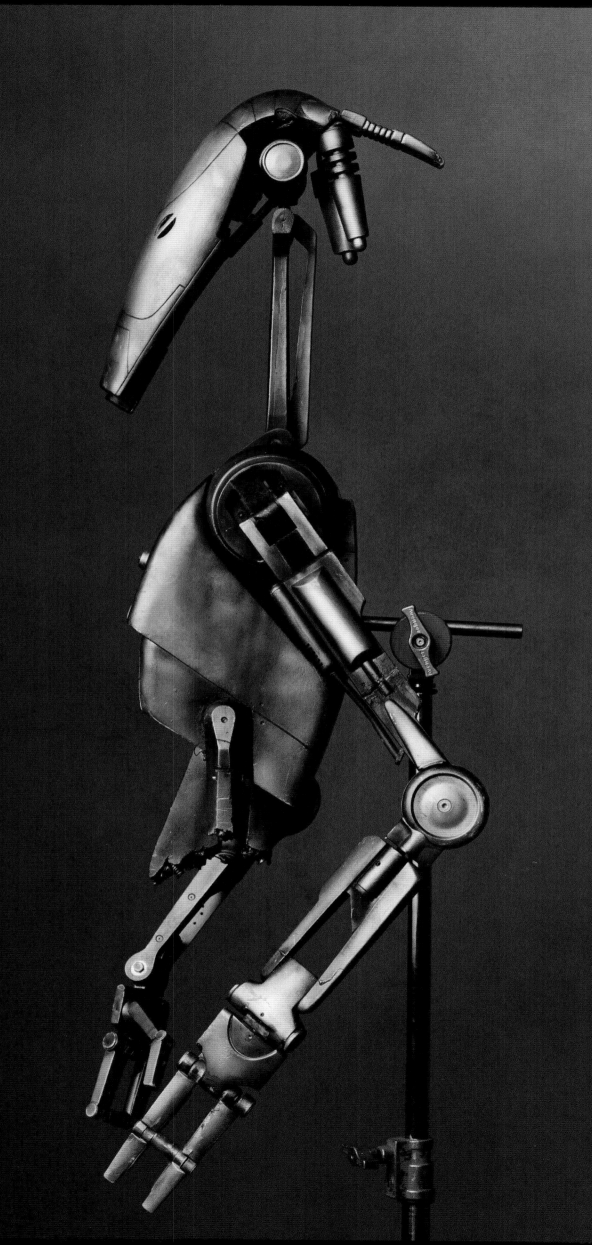

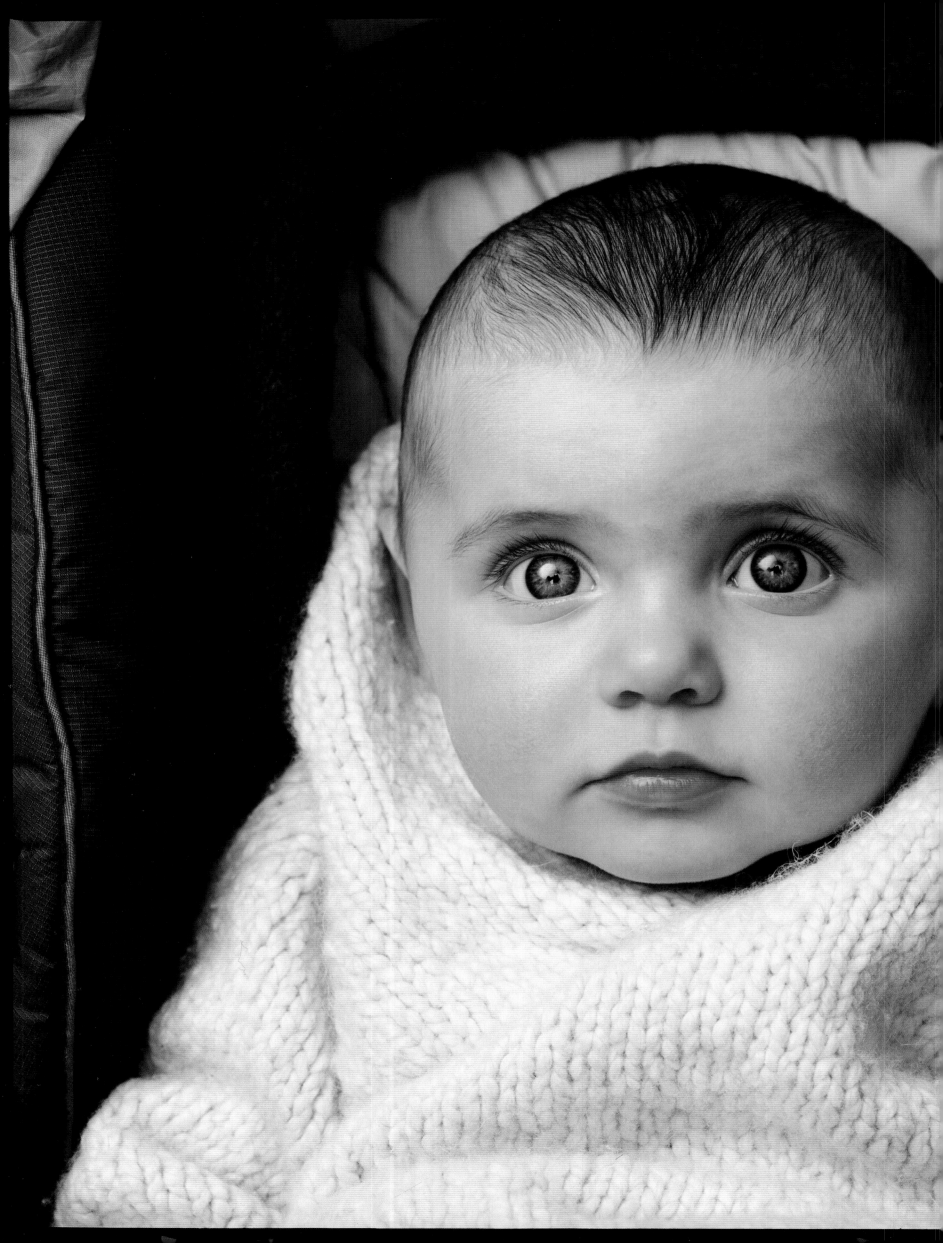

Sarah Cameron Leibovitz, April 2002

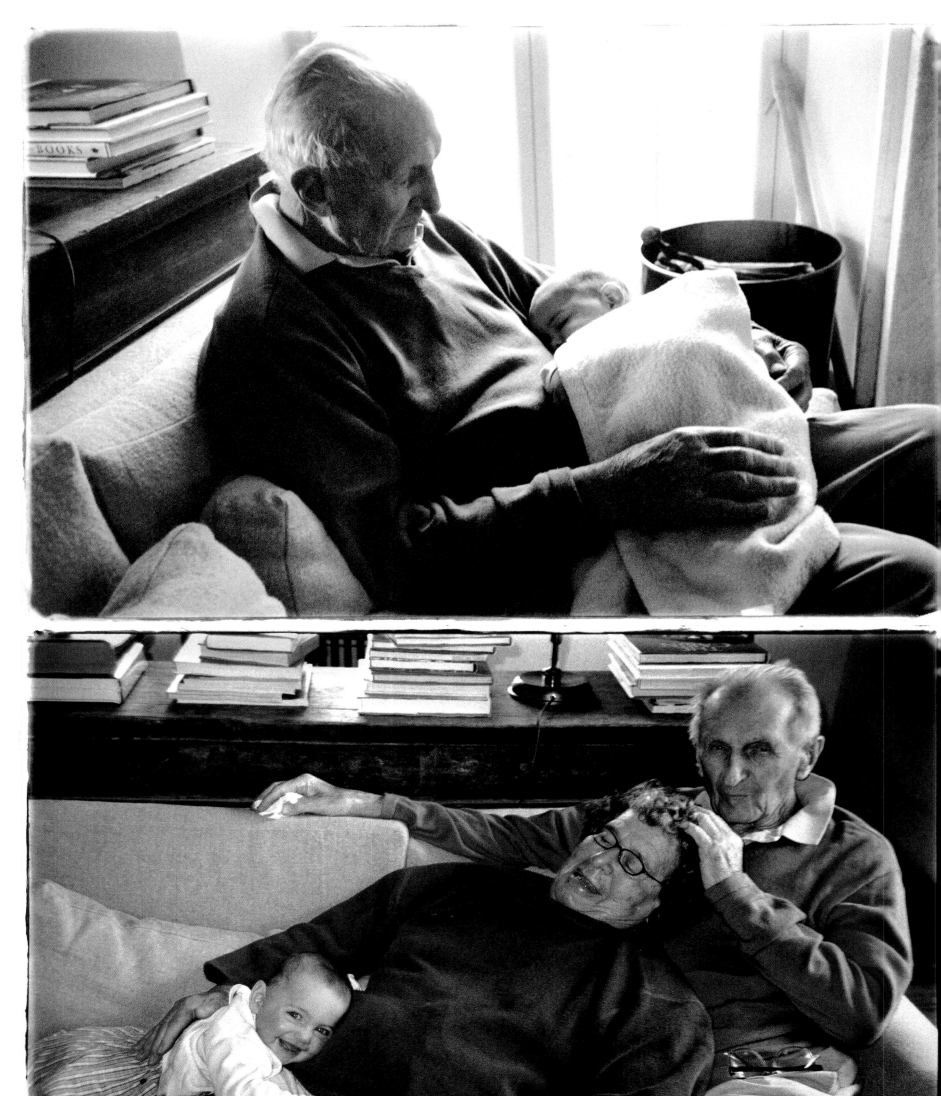

My parents with Sarah, Clifton Point, May 2002

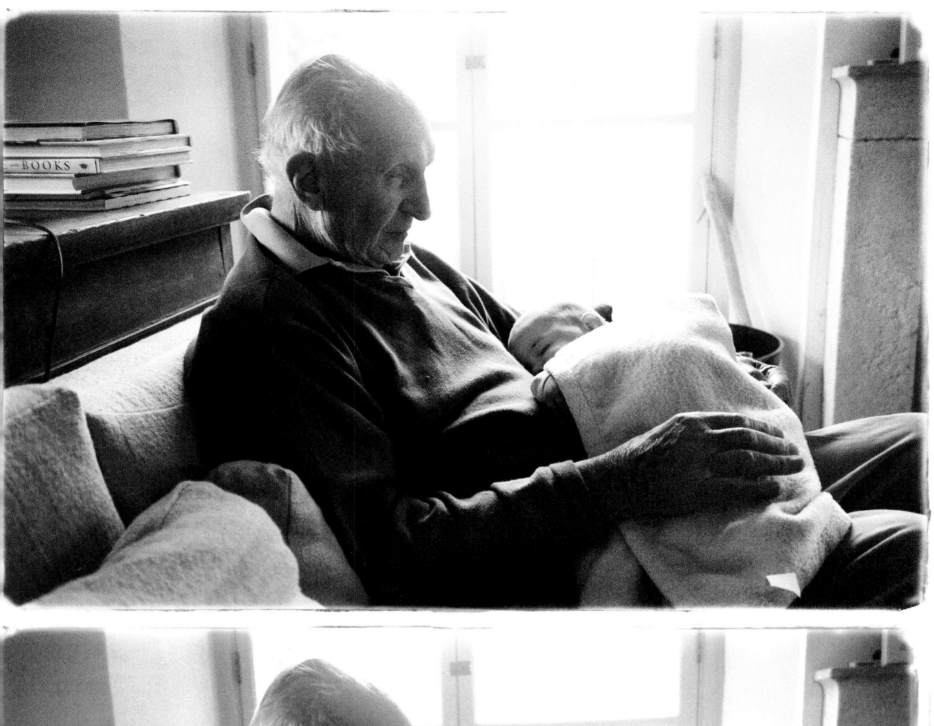
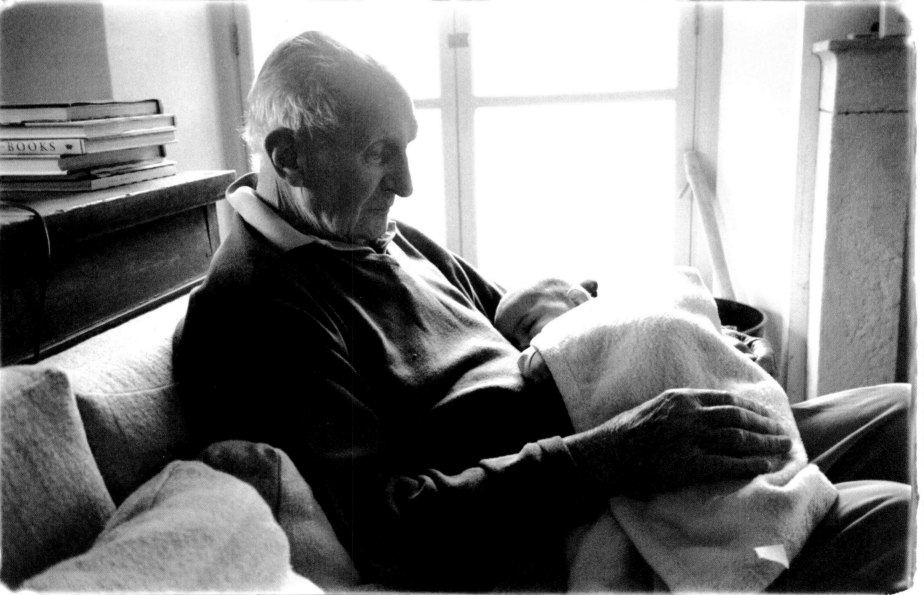

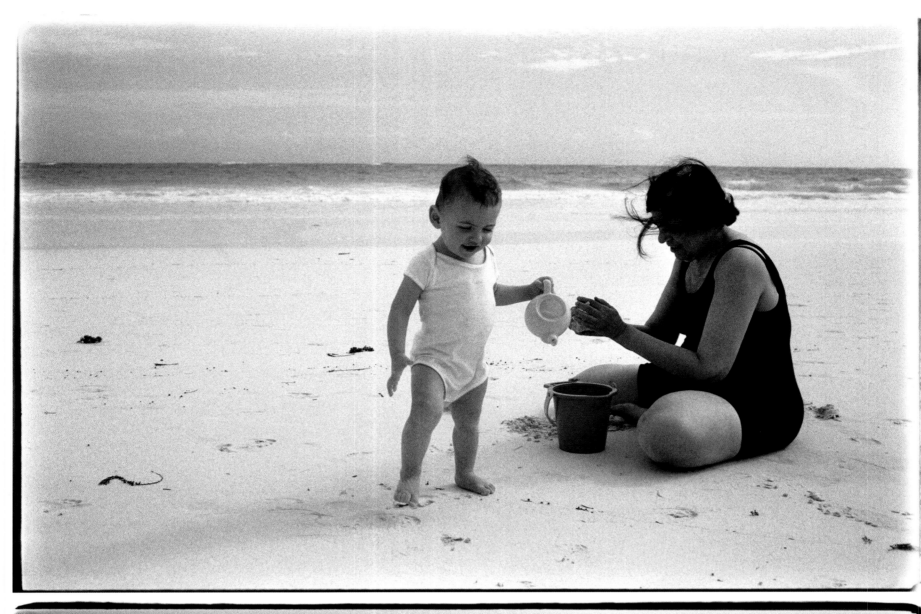

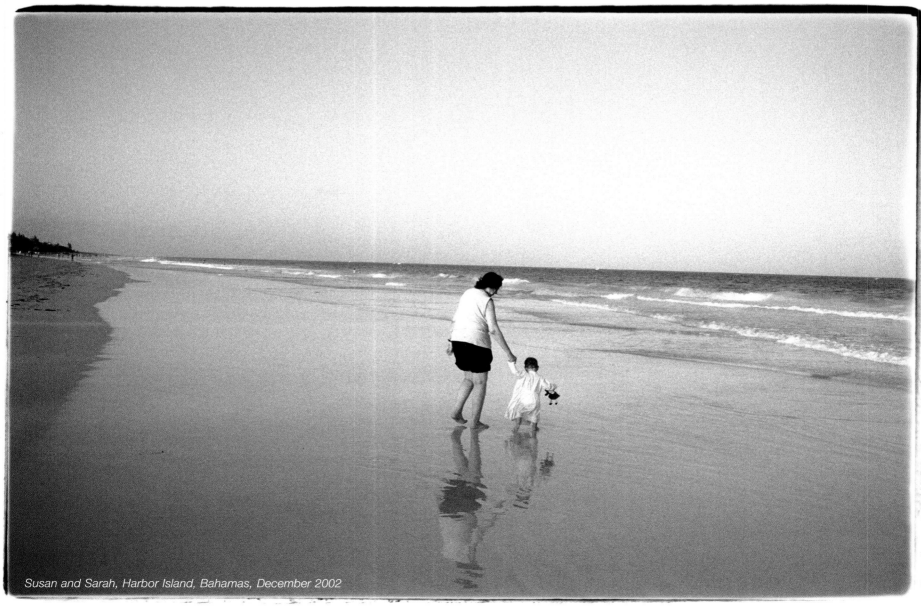

Susan and Sarah, Harbor Island, Bahamas, December 2002

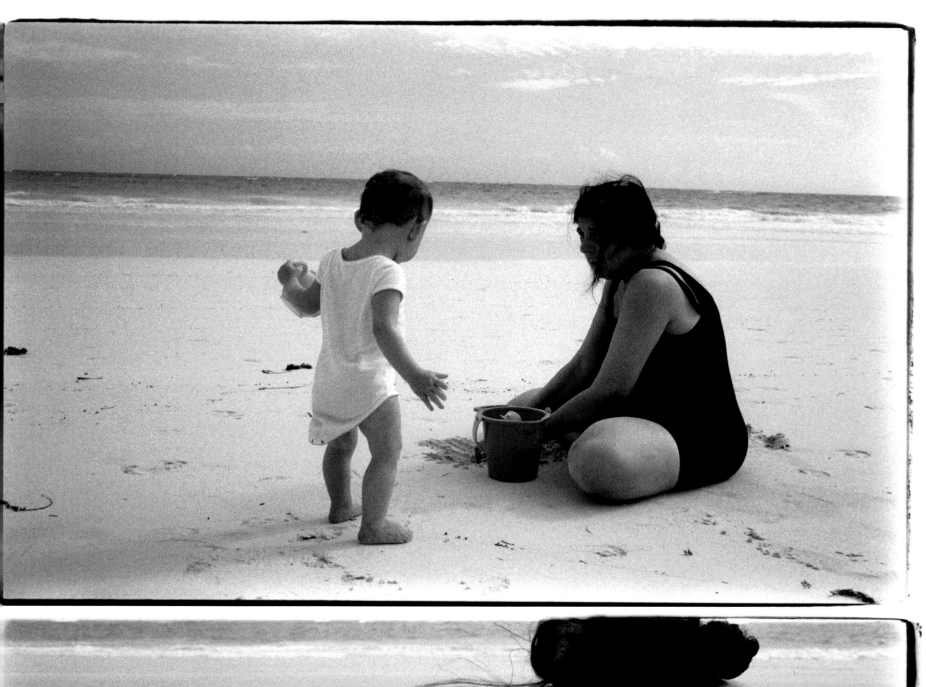

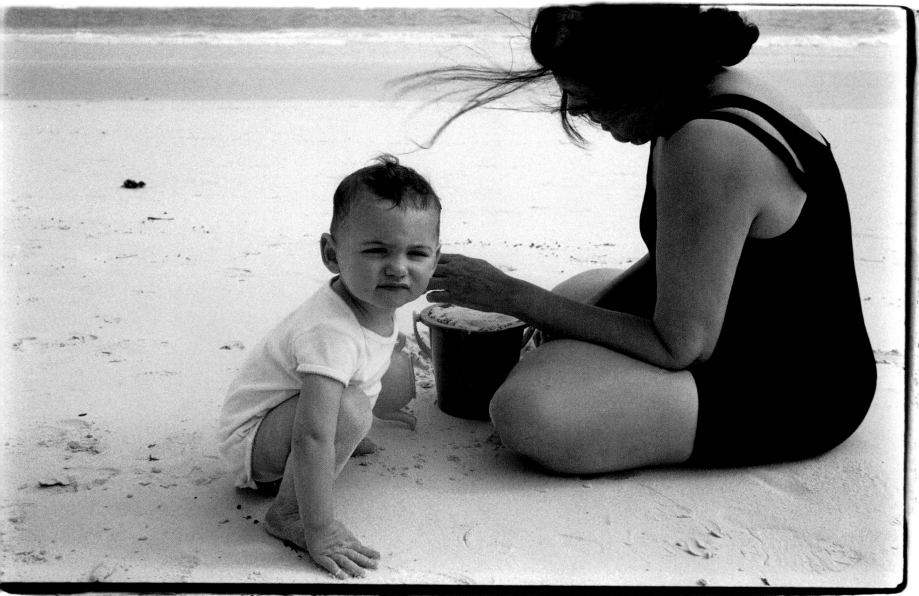

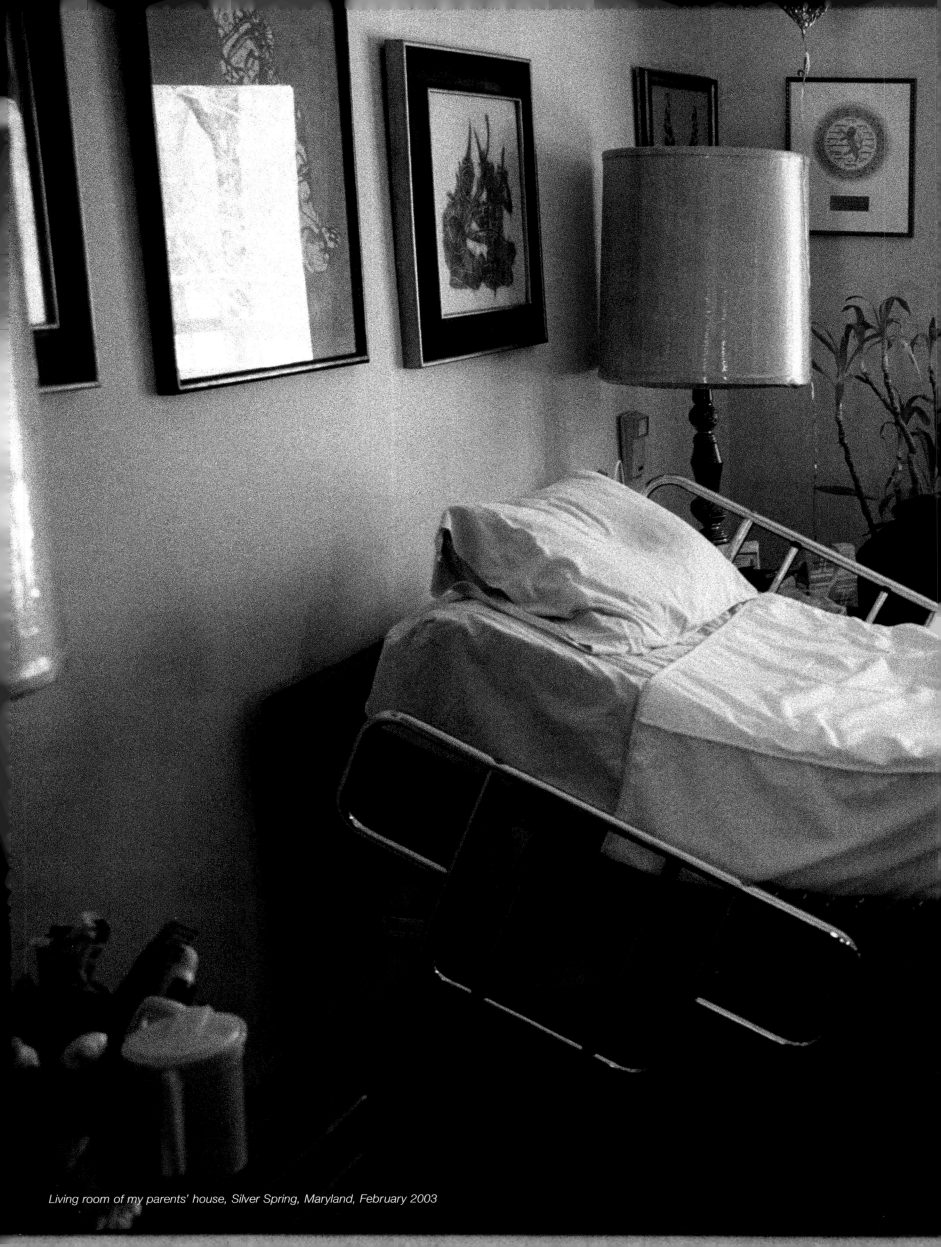

Living room of my parents' house, Silver Spring, Maryland, February 2003

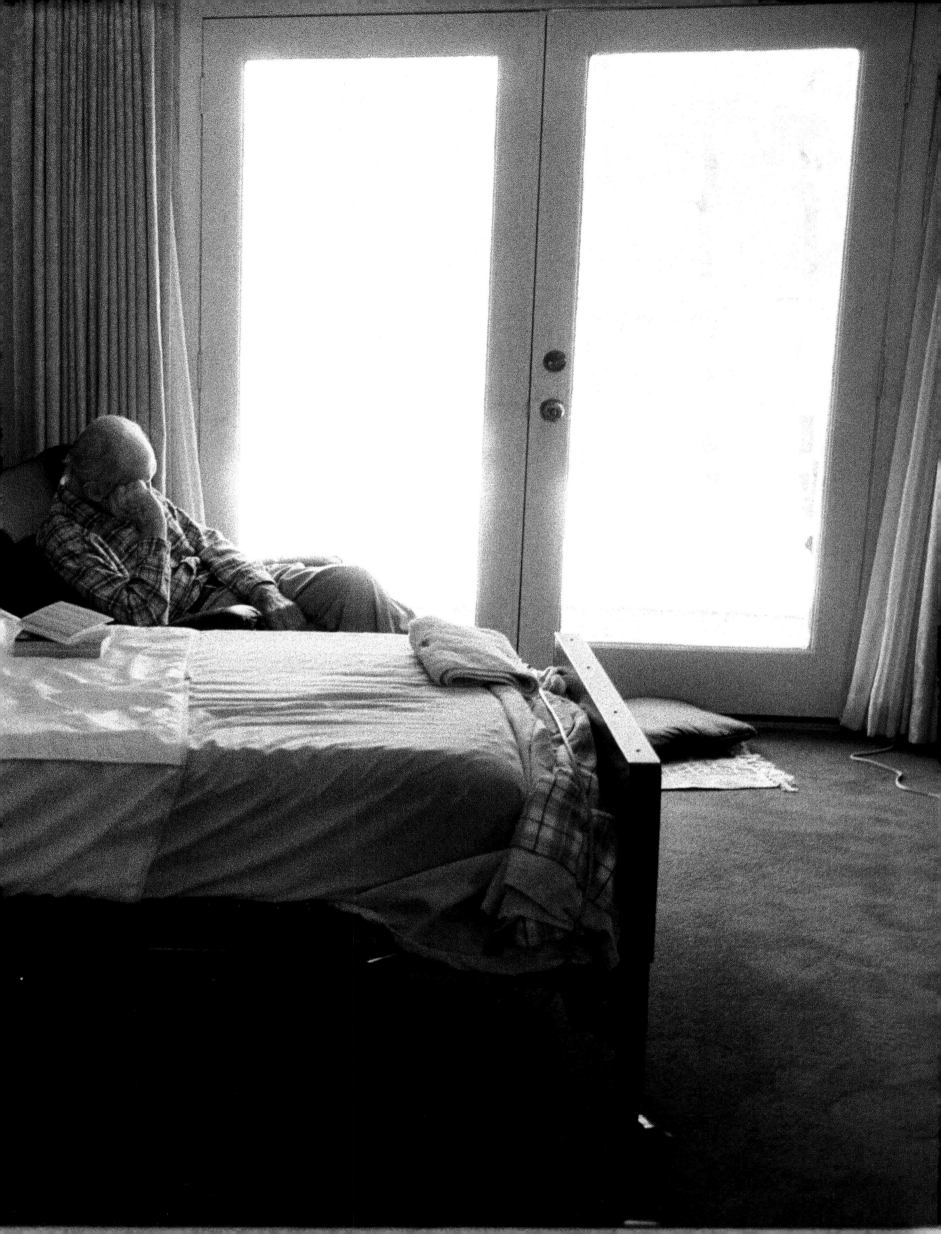

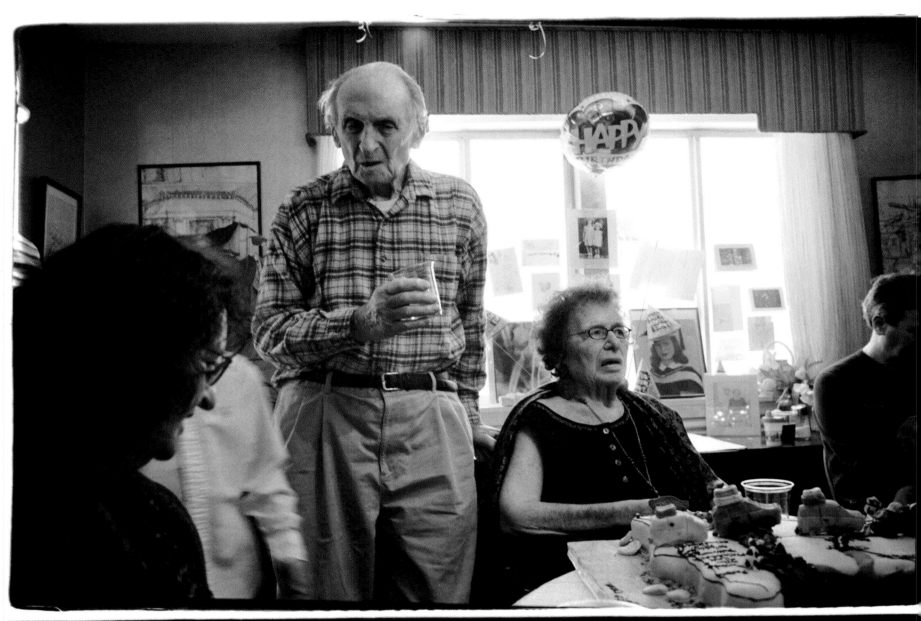
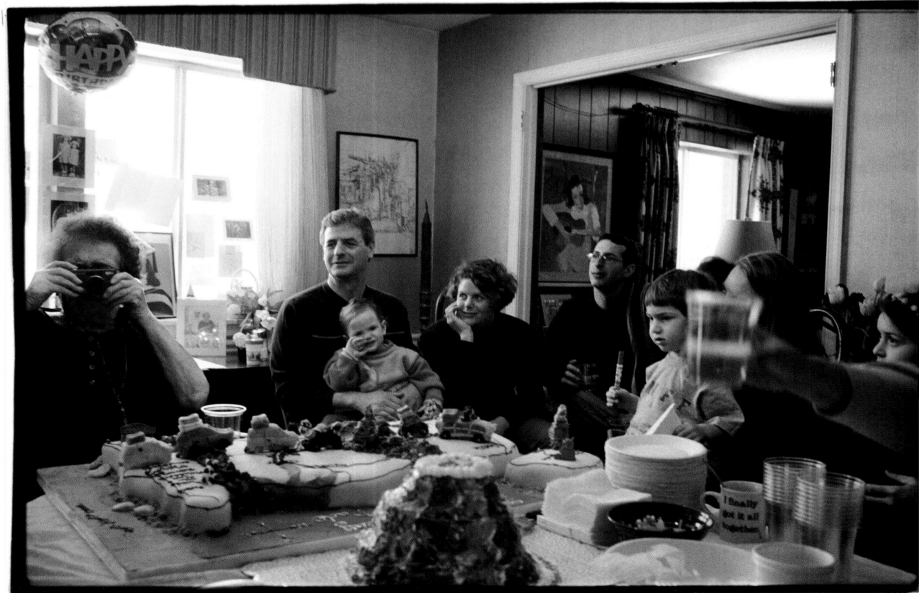

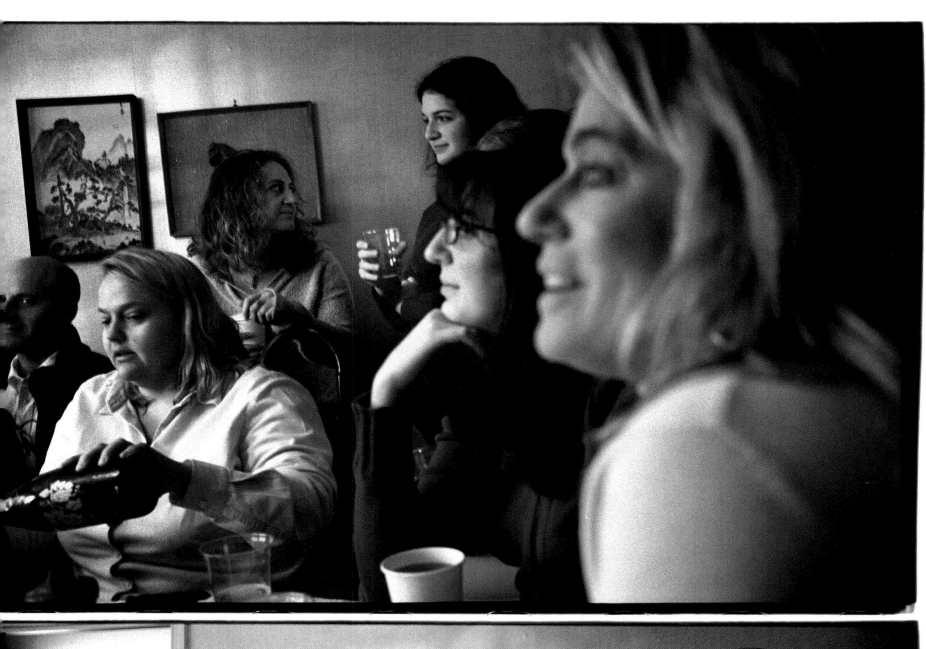

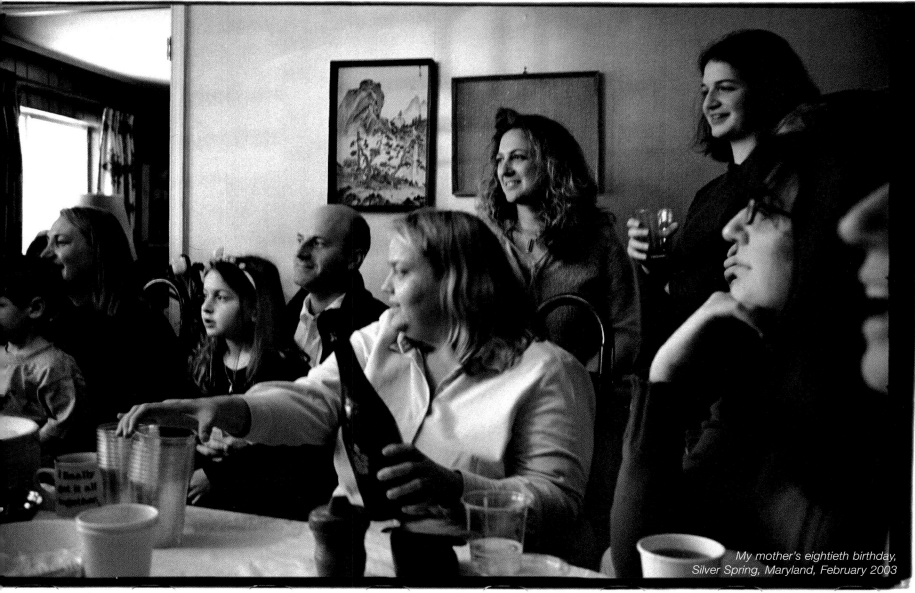

My mother's eightieth birthday,
Silver Spring, Maryland, February 2003

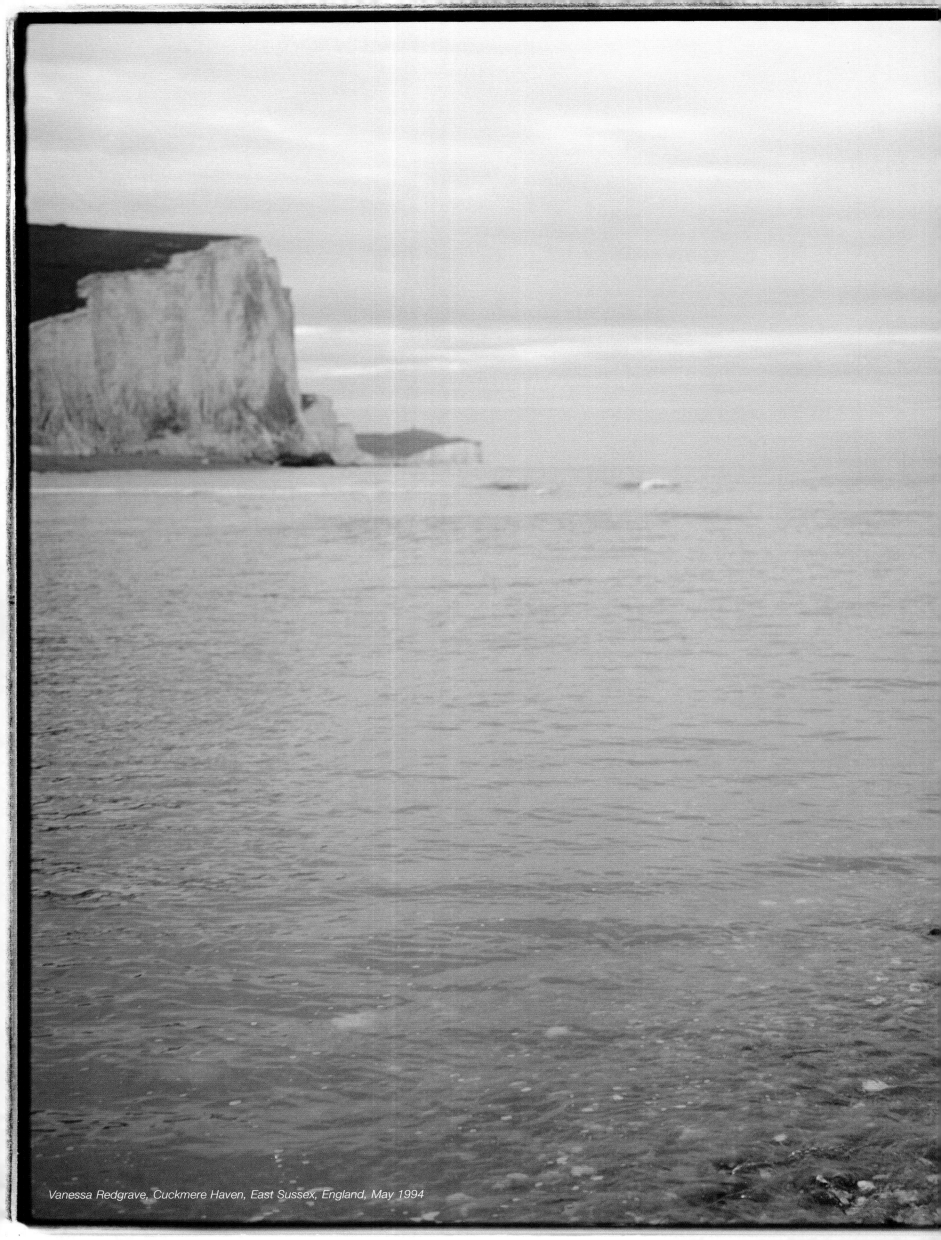

Vanessa Redgrave, Cuckmere Haven, East Sussex, England, May 1994

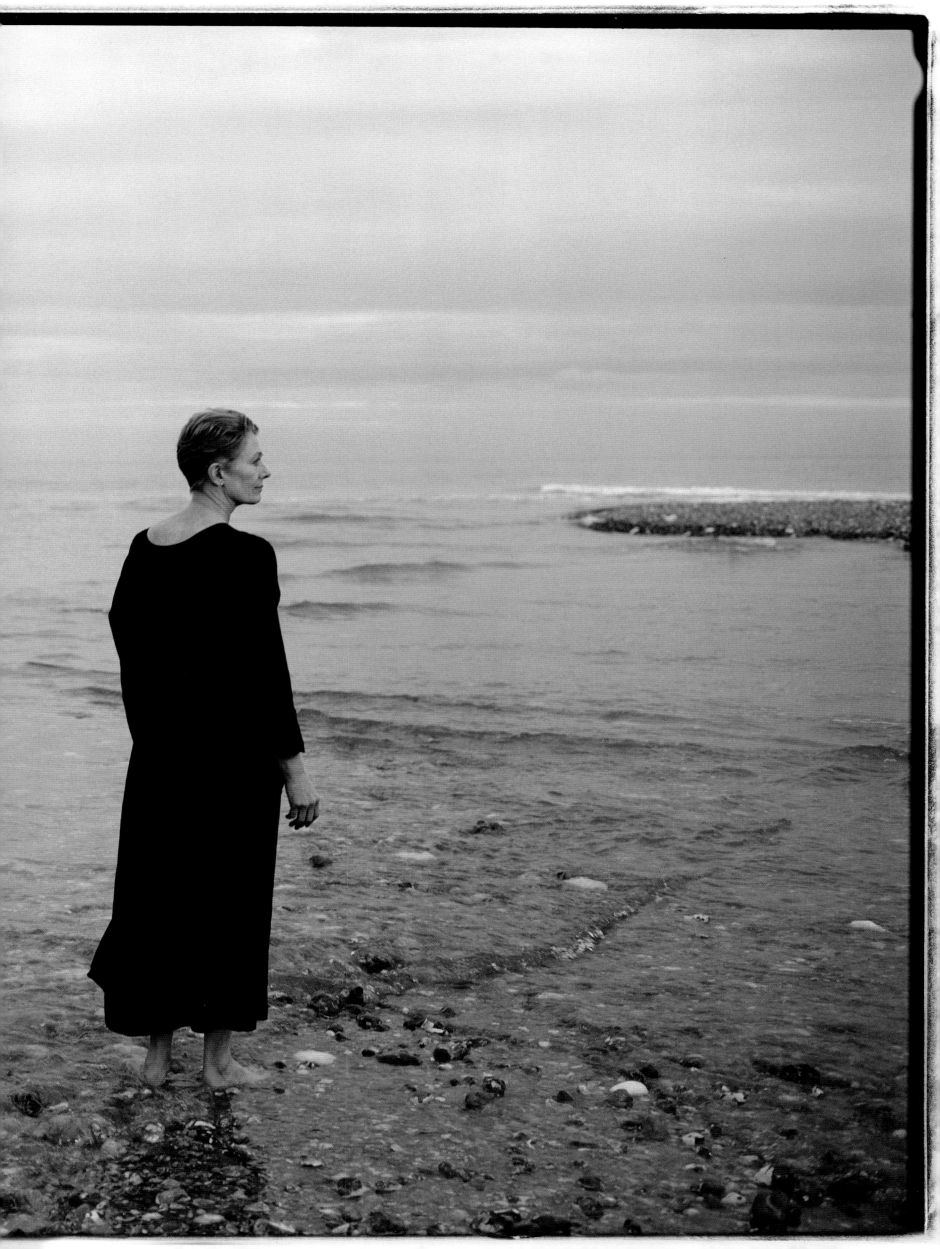

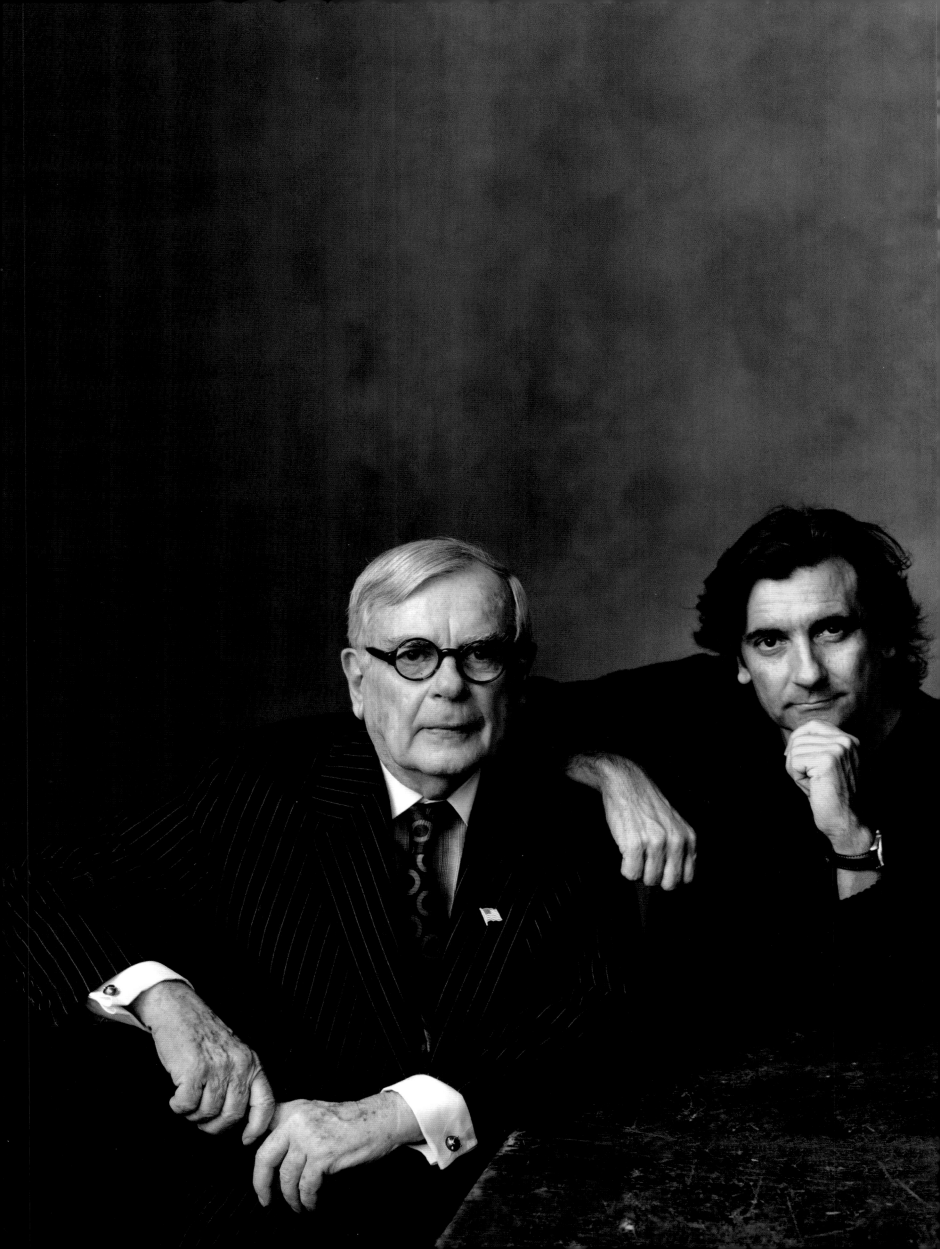

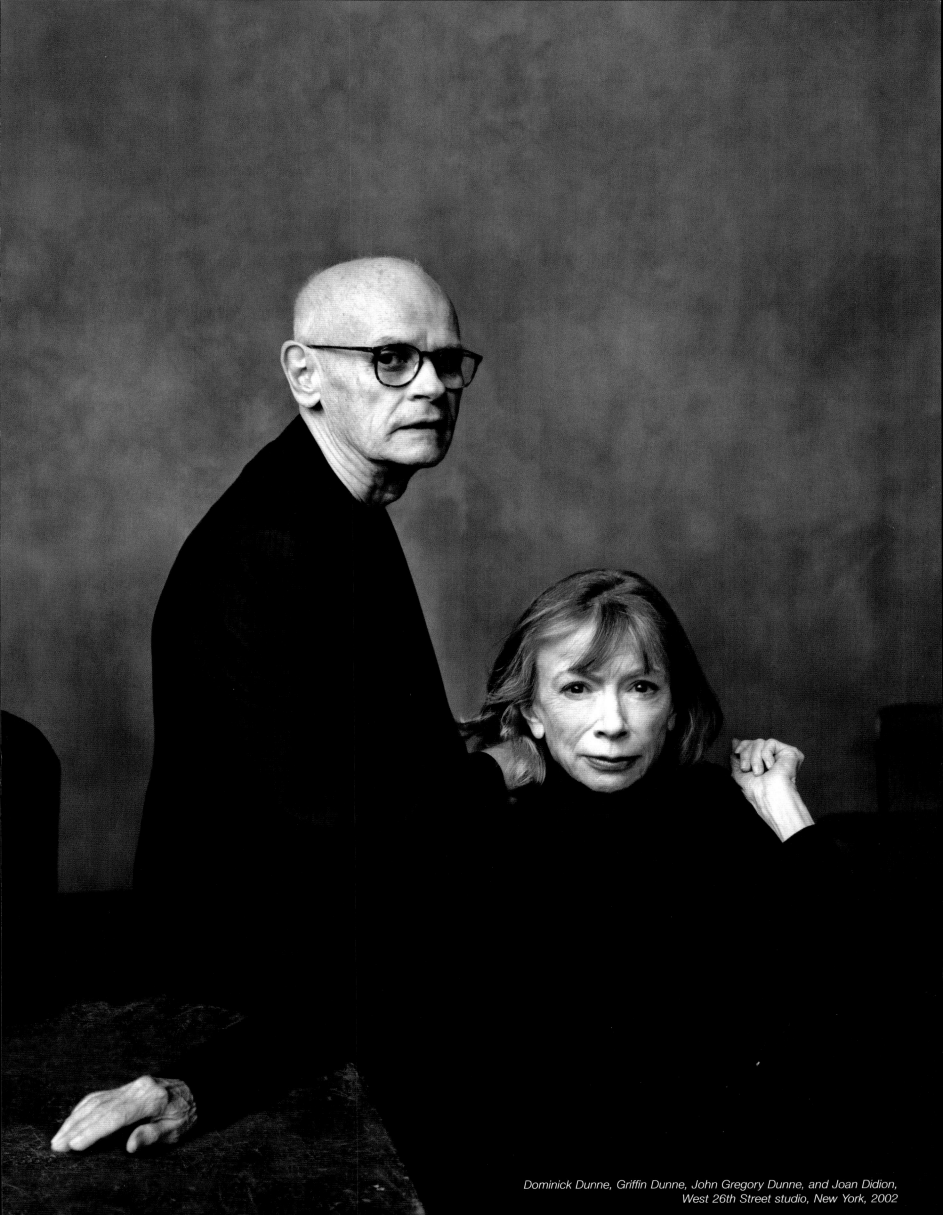

Dominick Dunne, Griffin Dunne, John Gregory Dunne, and Joan Didion,
West 26th Street studio, New York, 2002

Richard Avedon's 8 x 10 Sinar camera,
Avedon Studio, East 75th Street, New York, 2001

Richard Avedon at his studio, East 75th Street, New York, 2001

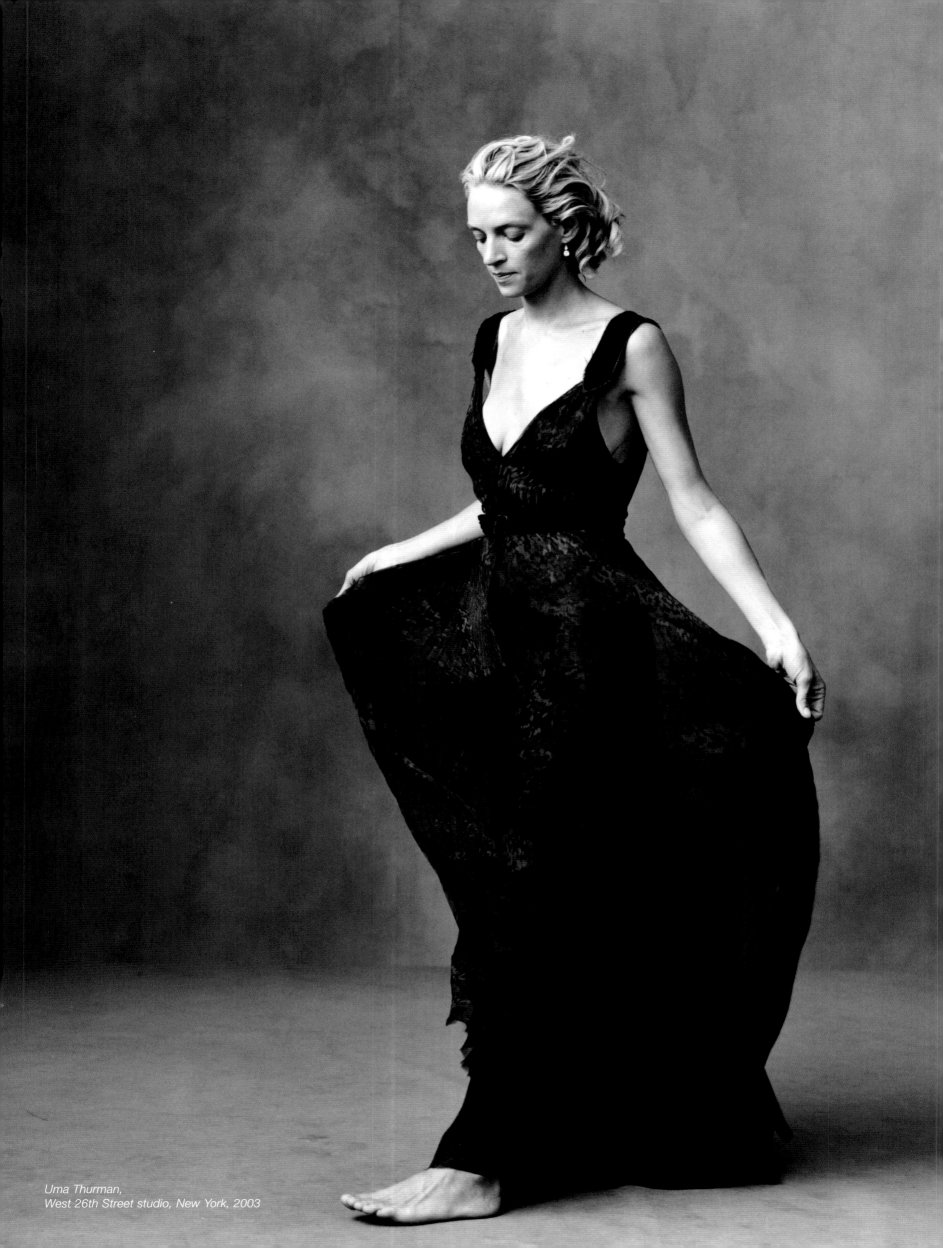

Uma Thurman,
West 26th Street studio, New York, 2003

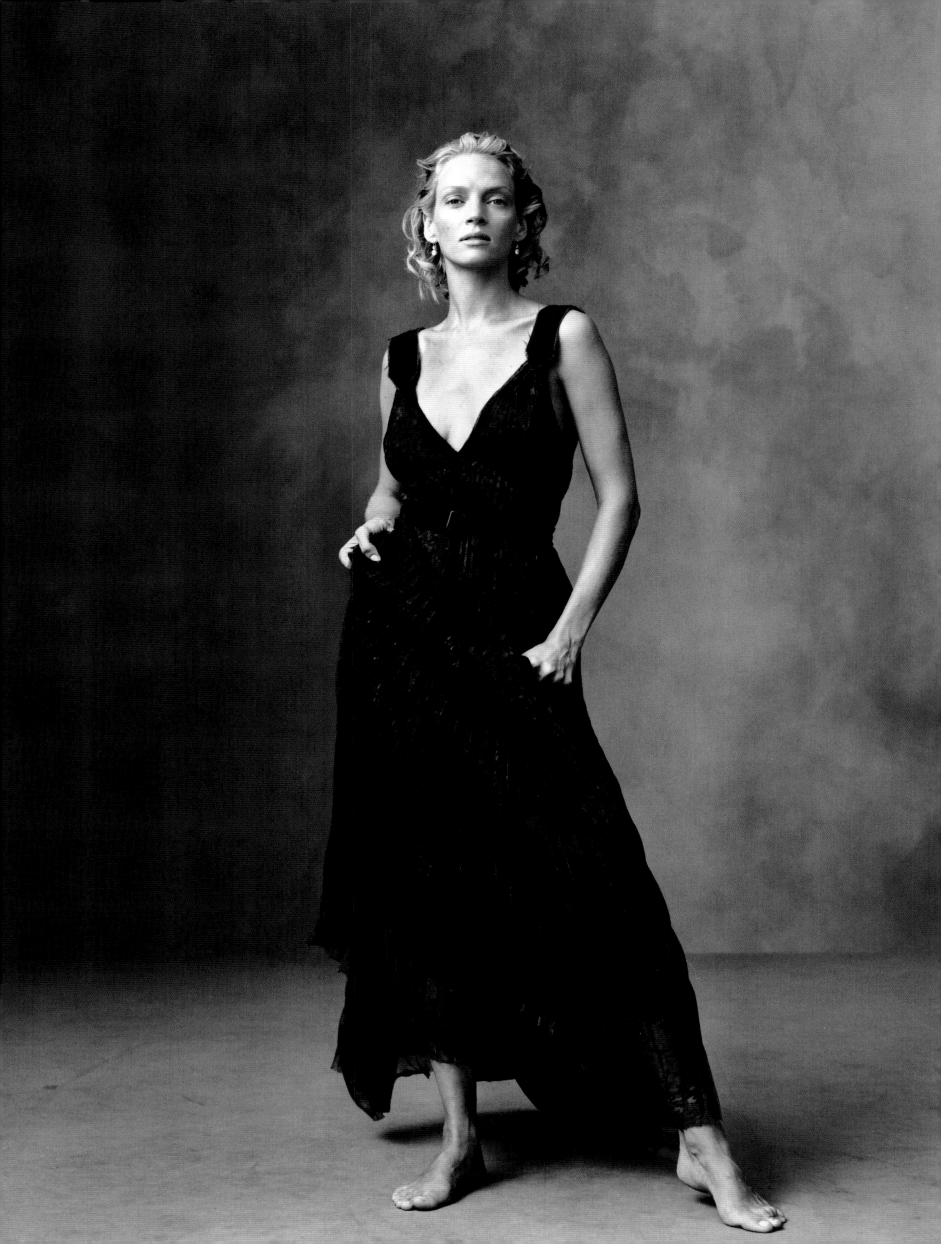

Jamie Foxx, Culver Studios, Culver City, California, 2004

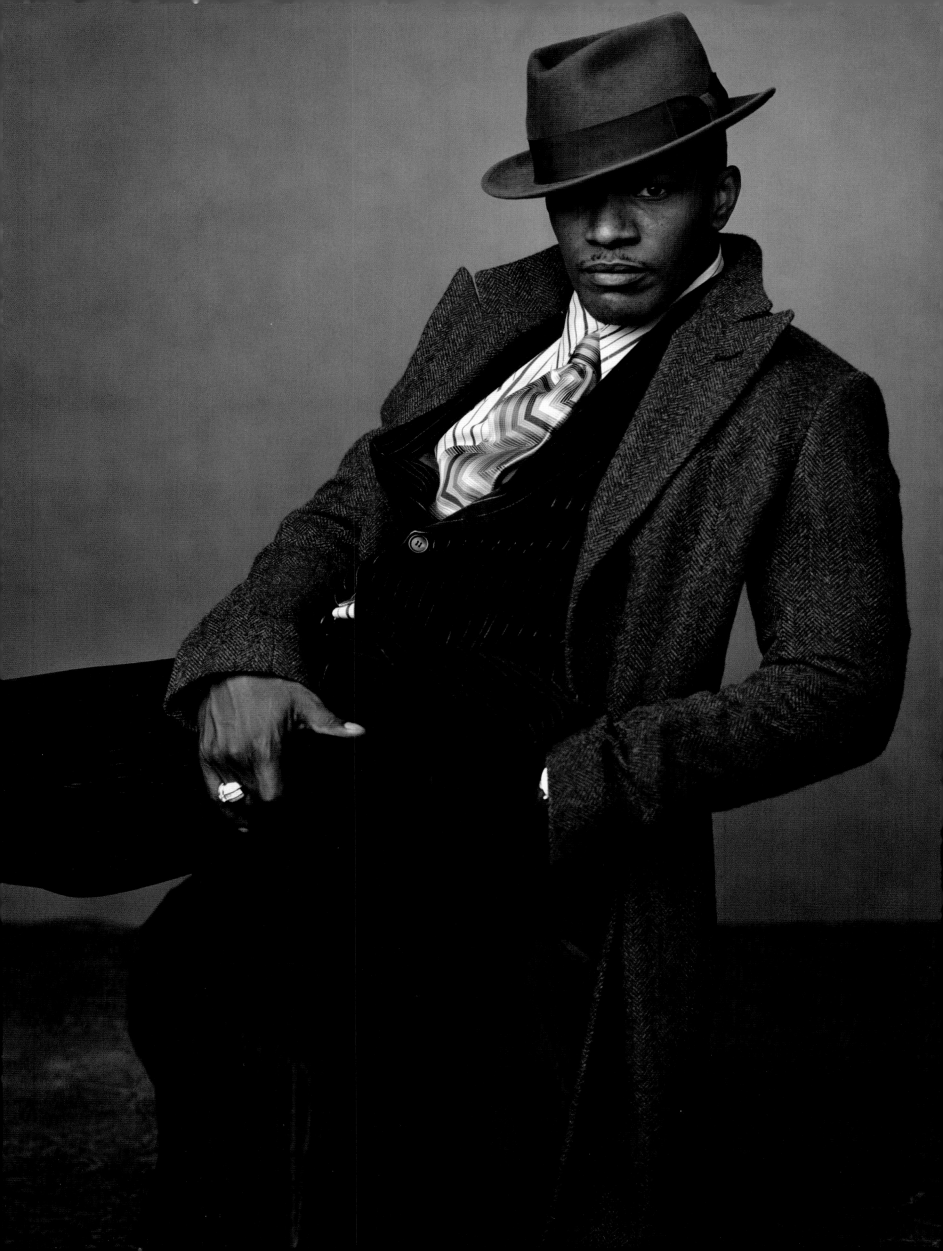

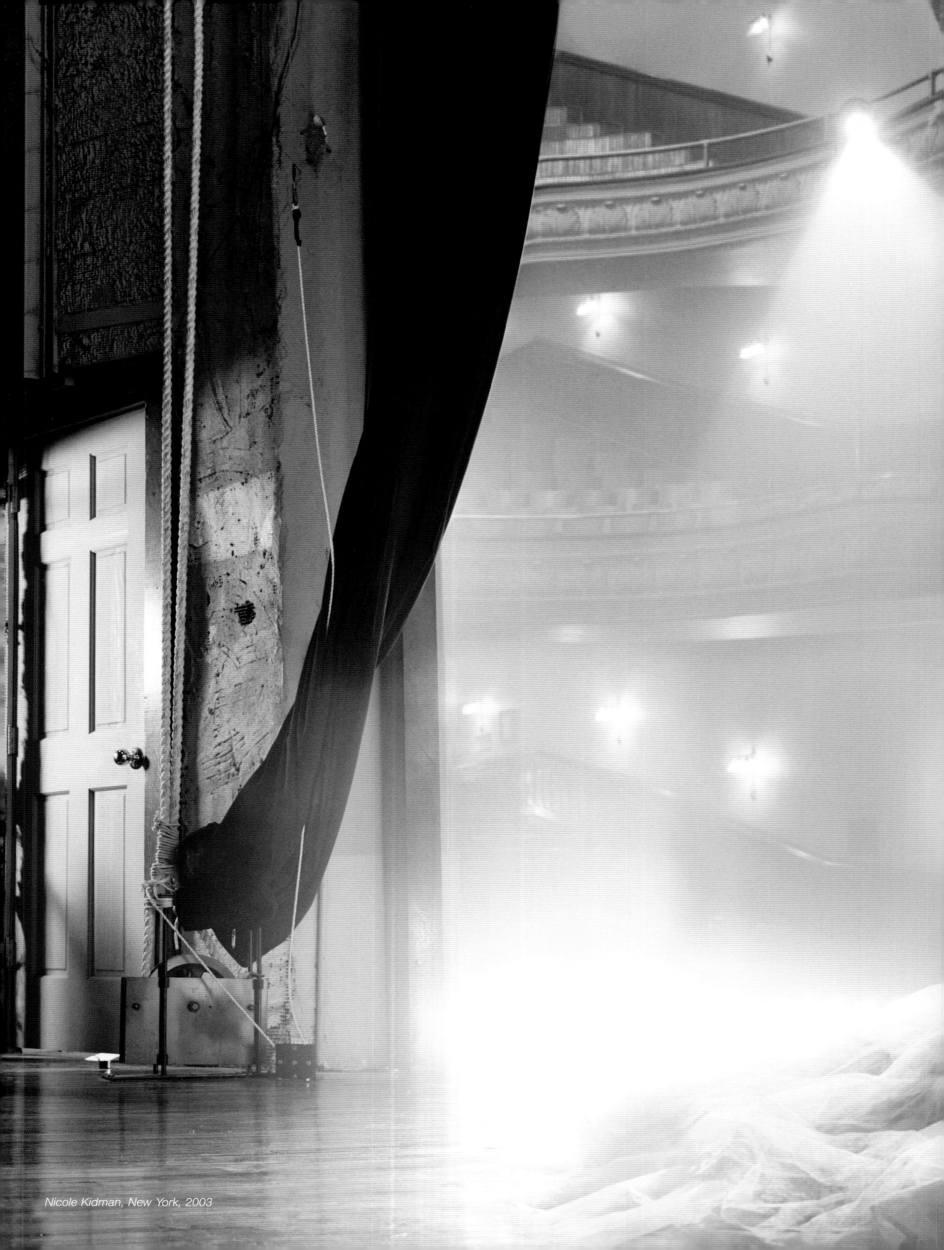

Nicole Kidman, New York, 2003

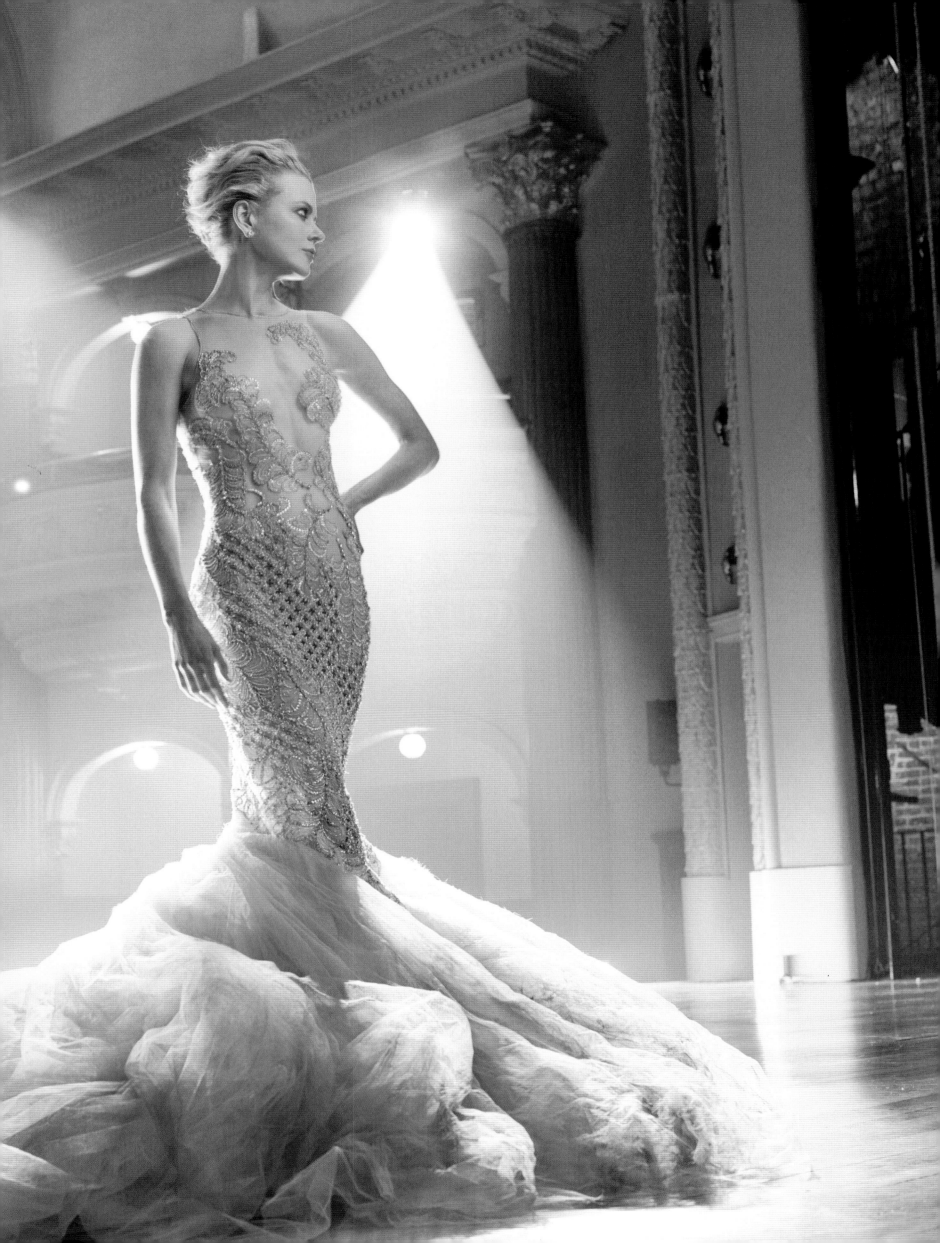

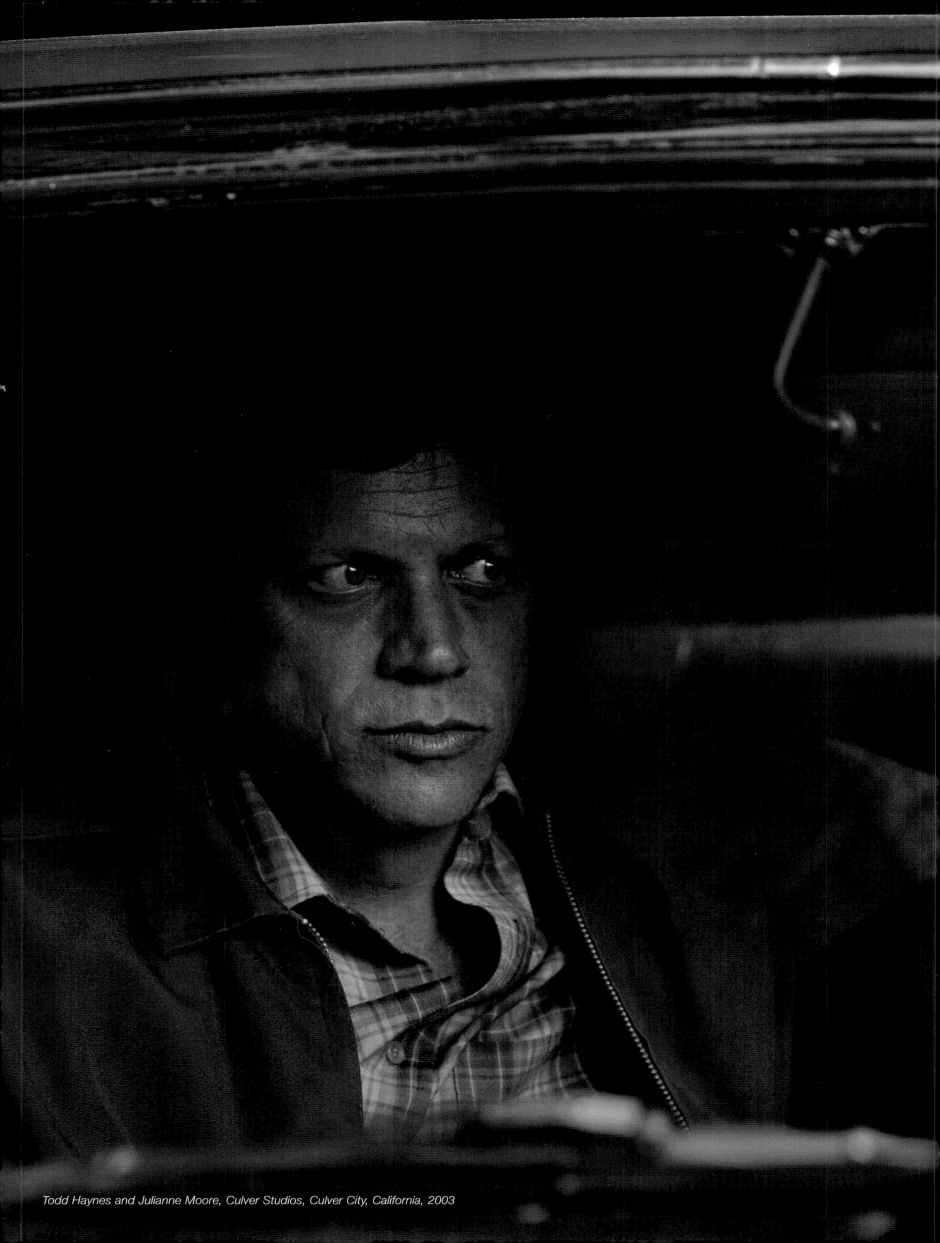

Todd Haynes and Julianne Moore, Culver Studios, Culver City, California, 2003

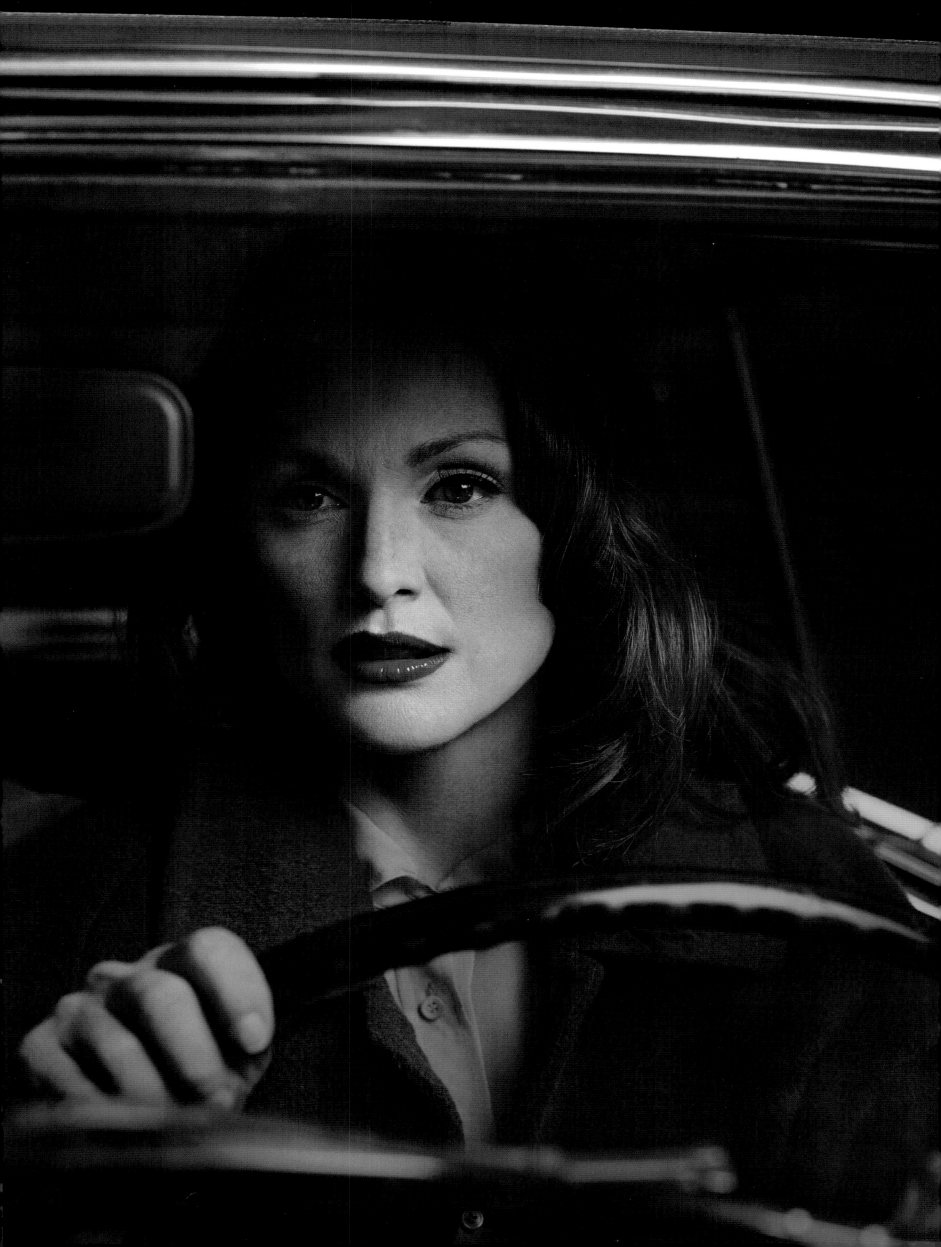

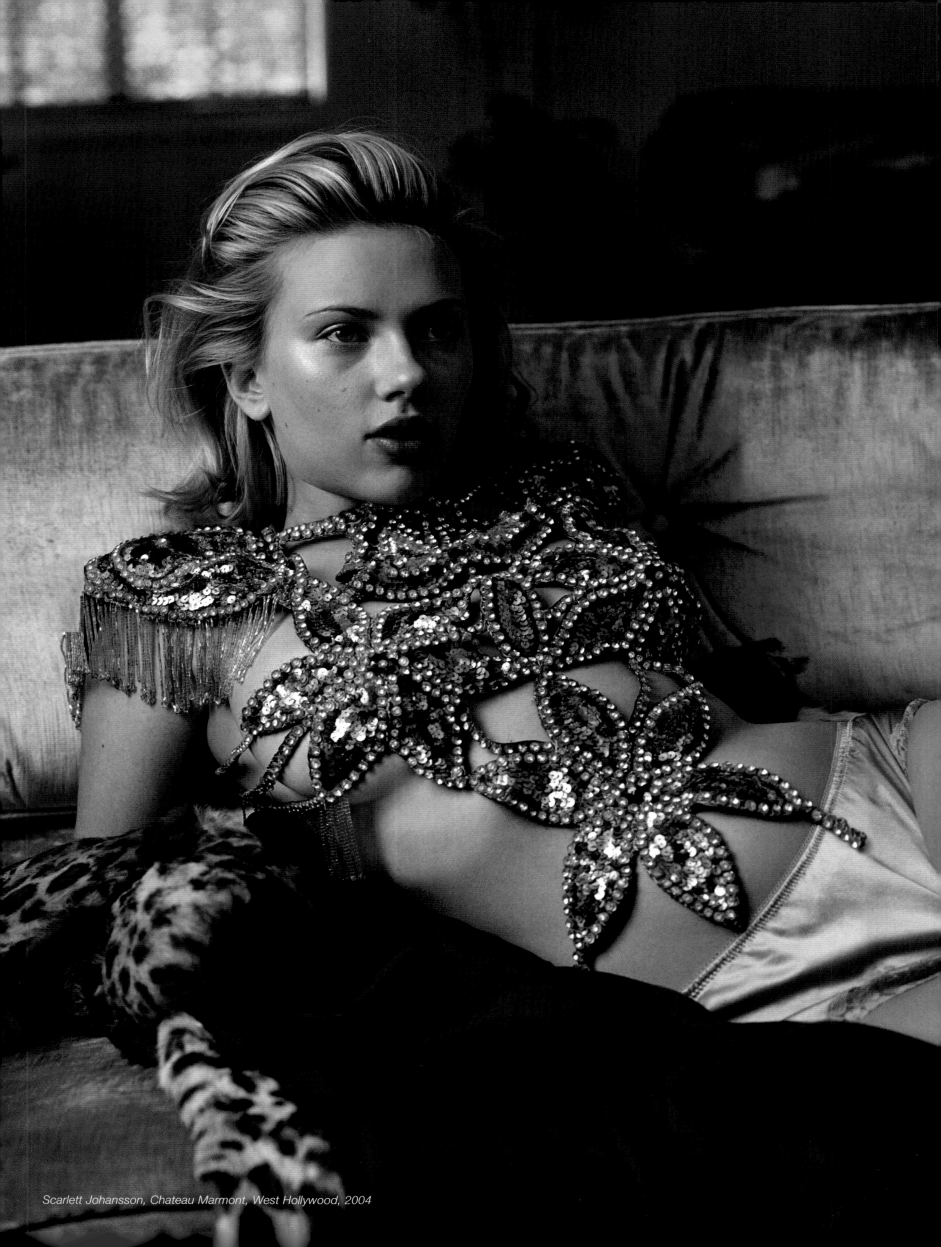

Scarlett Johansson, Chateau Marmont, West Hollywood, 2004

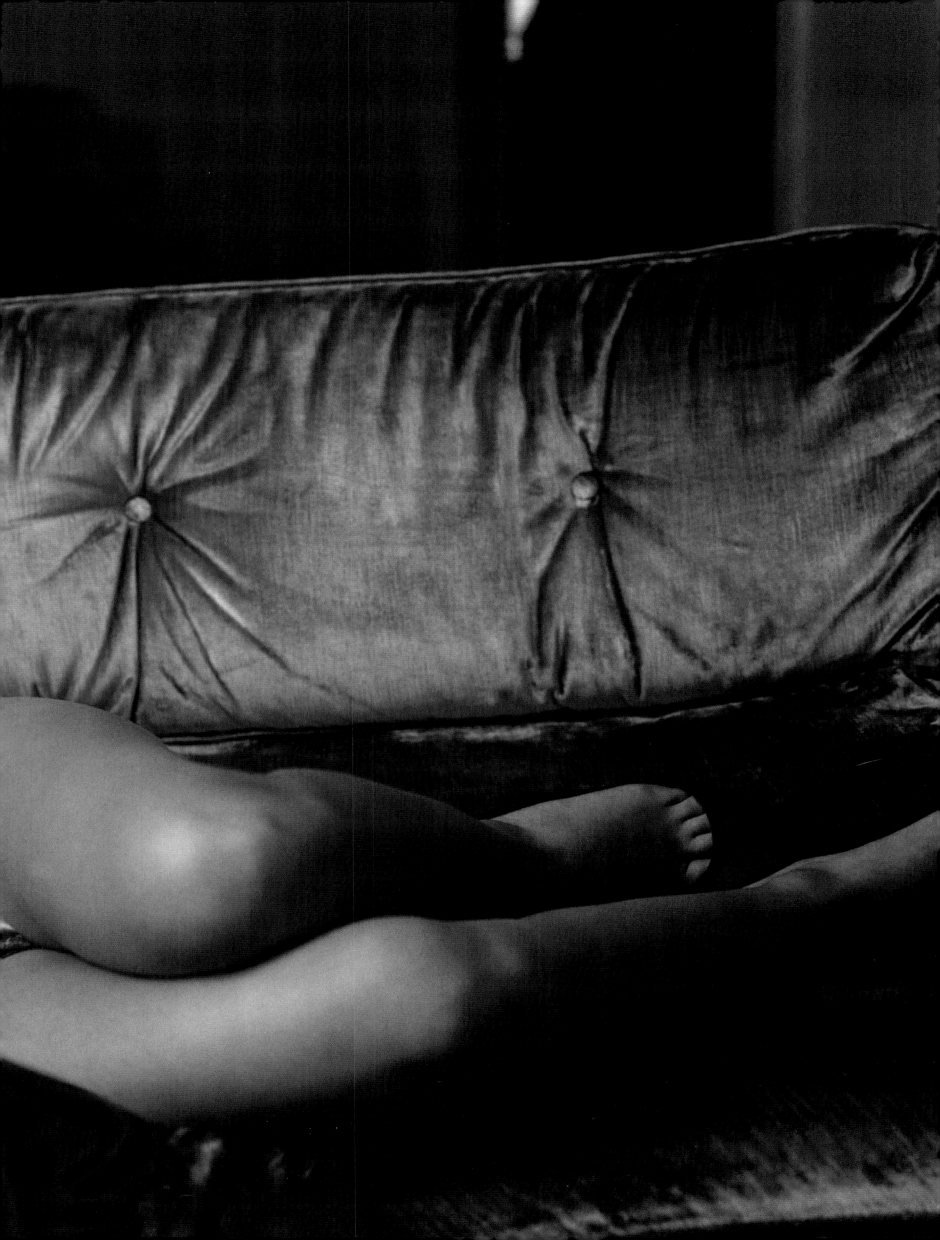

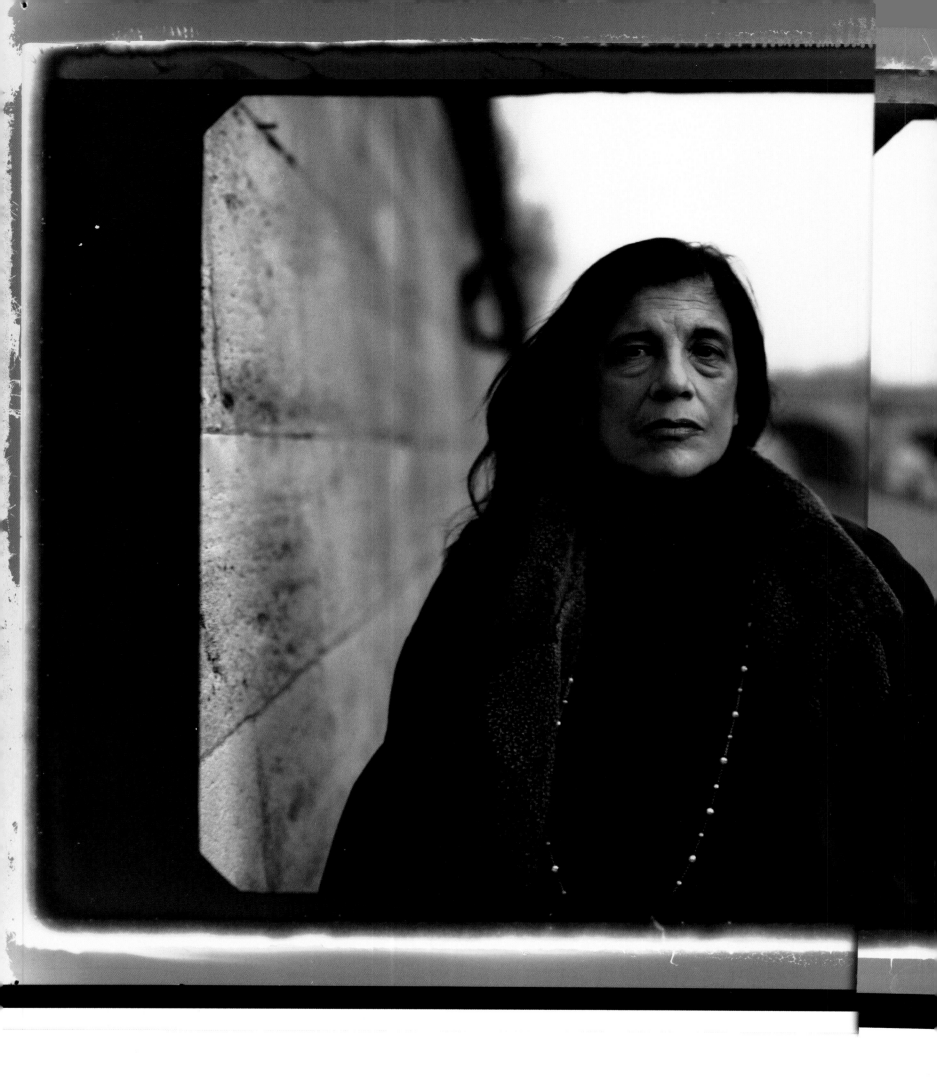

Quai des Grands Augustins, Paris, December 2003

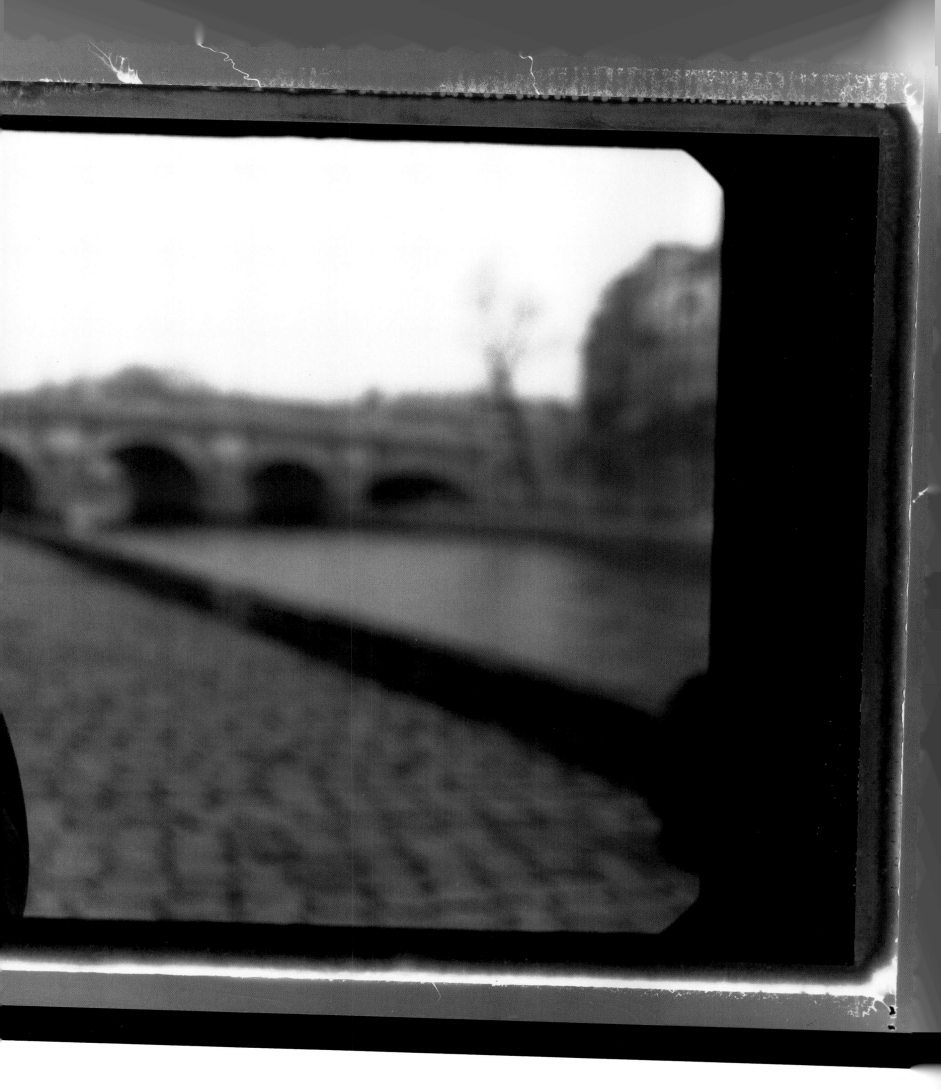

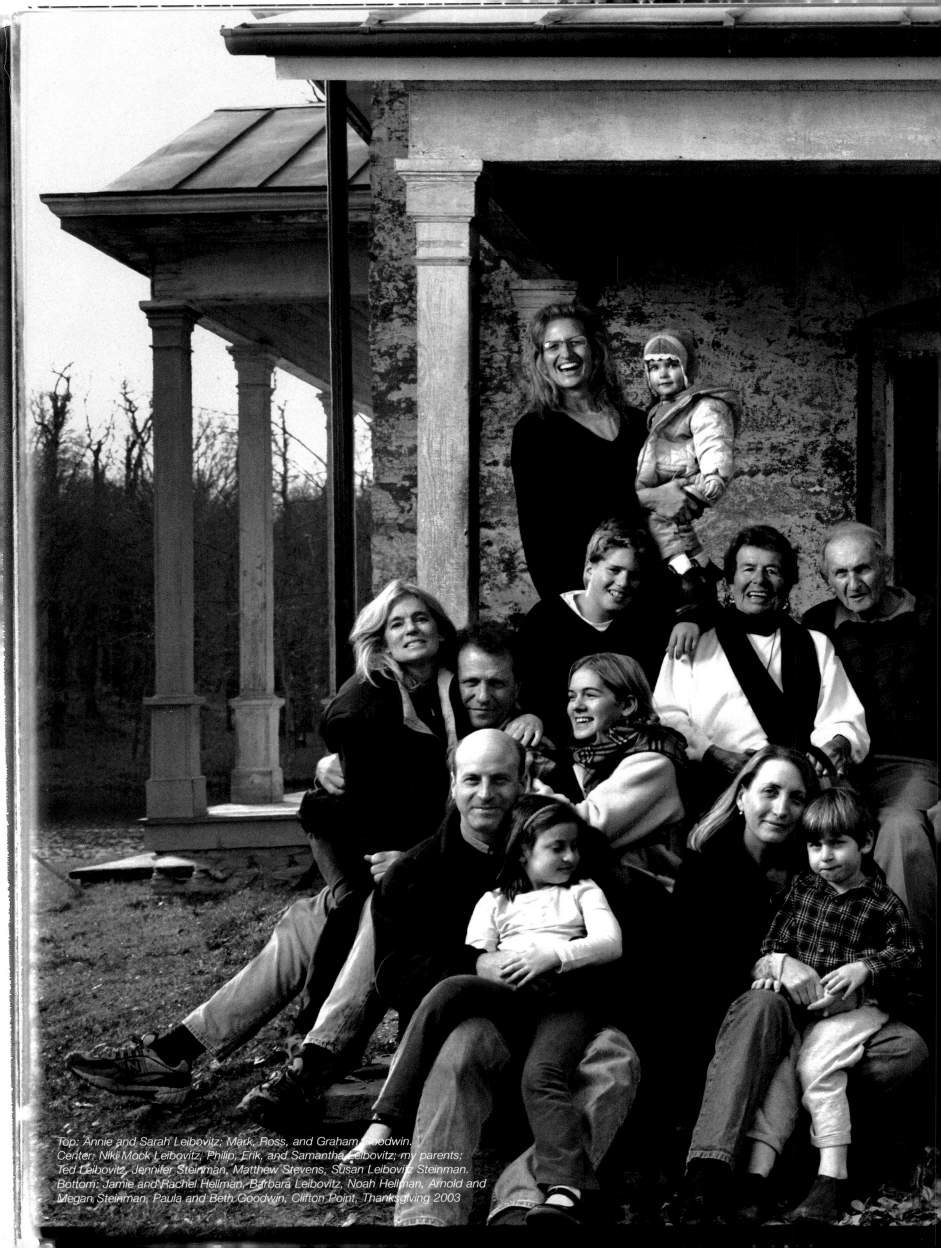

Top: Annie and Sarah Leibovitz; Mark, Ross, and Graham Goodwin.
Center: Niki Mock Leibovitz, Philip, Erik, and Samantha Leibovitz; my parents;
Ted Leibovitz, Jennifer Steinman, Matthew Stevens, Susan Leibovitz Steinman.
Bottom: Jamie and Rachel Hellman, Barbara Leibovitz, Noah Hellman, Arnold and
Megan Steinman, Paula and Beth Goodwin, Clifton Point, Thanksgiving 2003

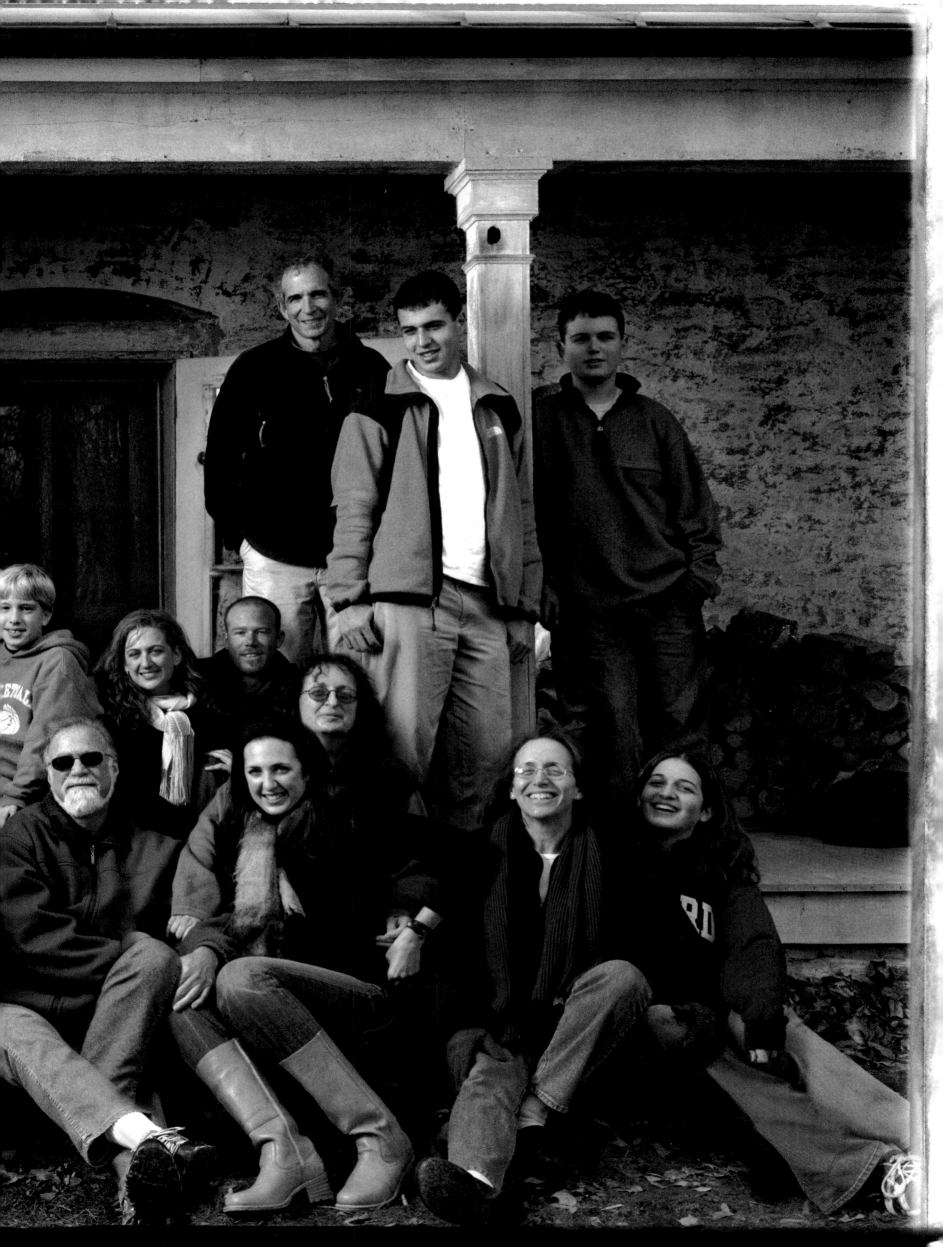

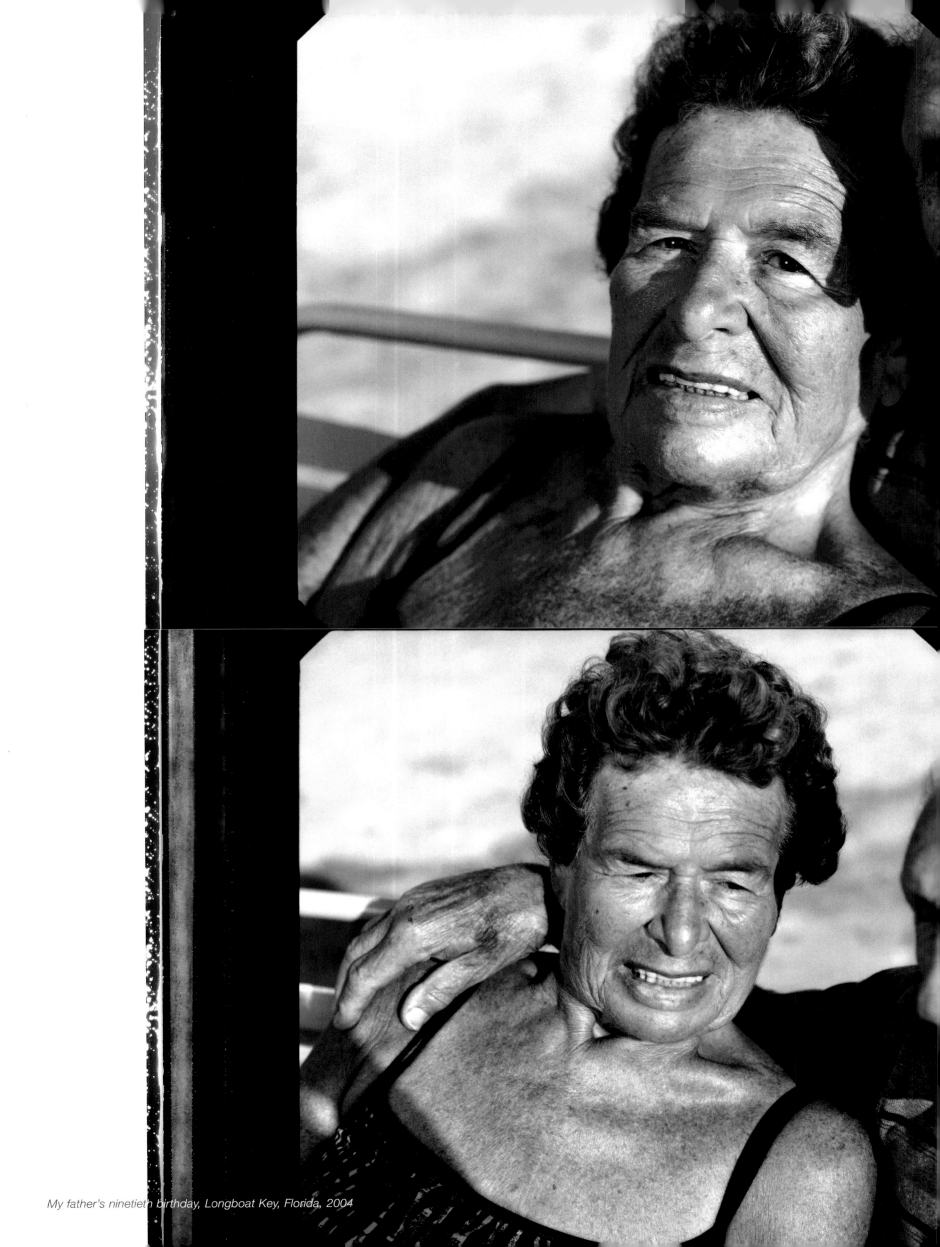

My father's ninetieth birthday, Longboat Key, Florida, 2004

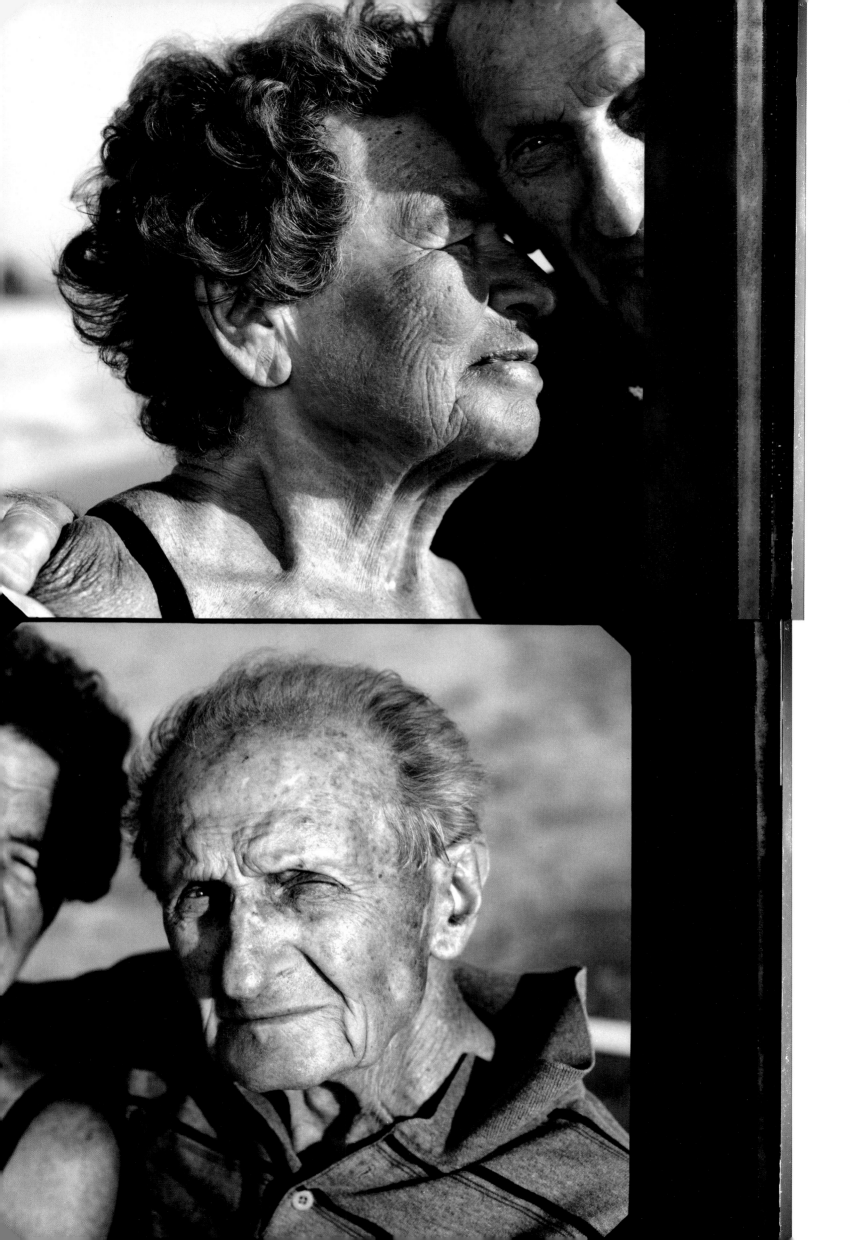

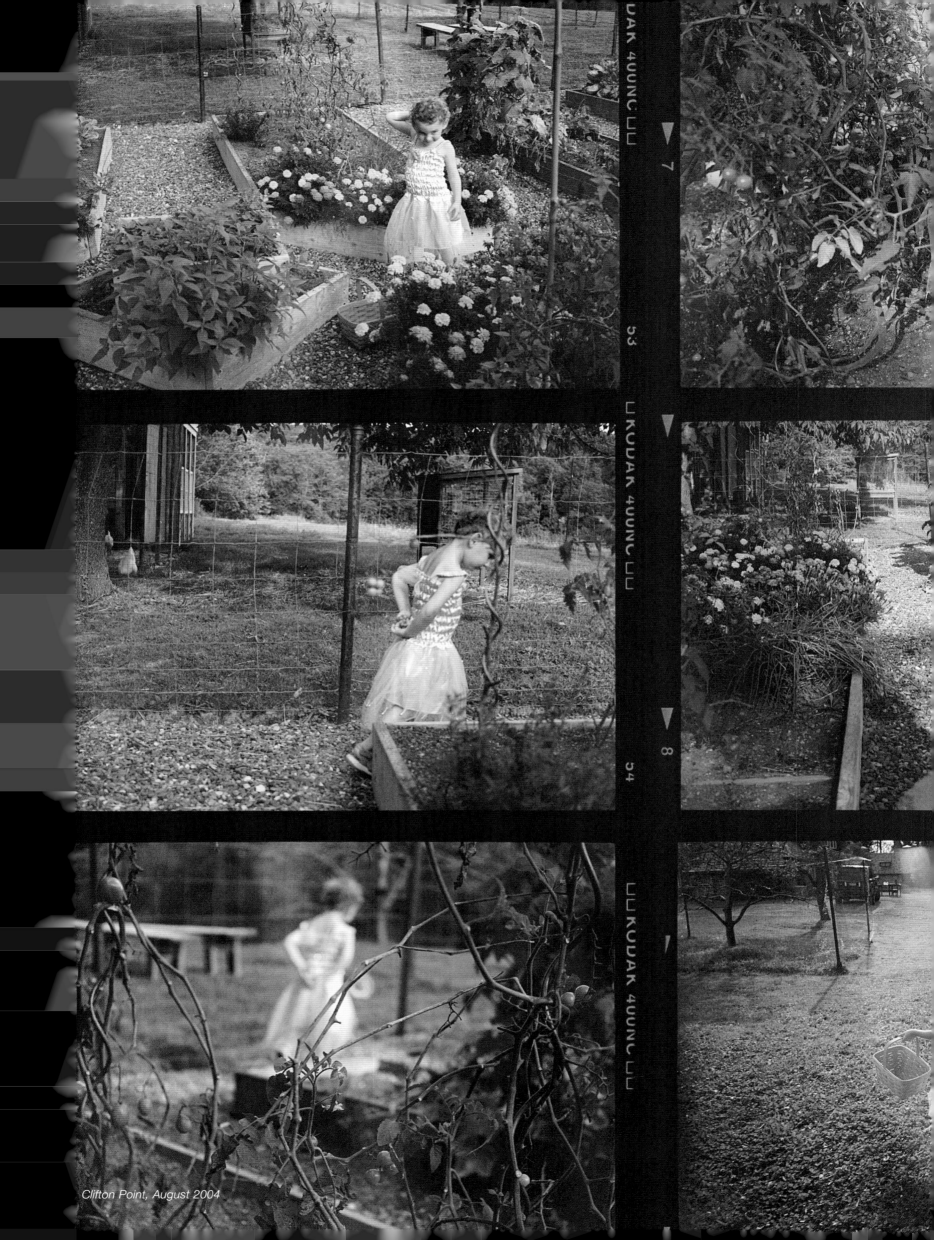

Clifton Point, August 2004

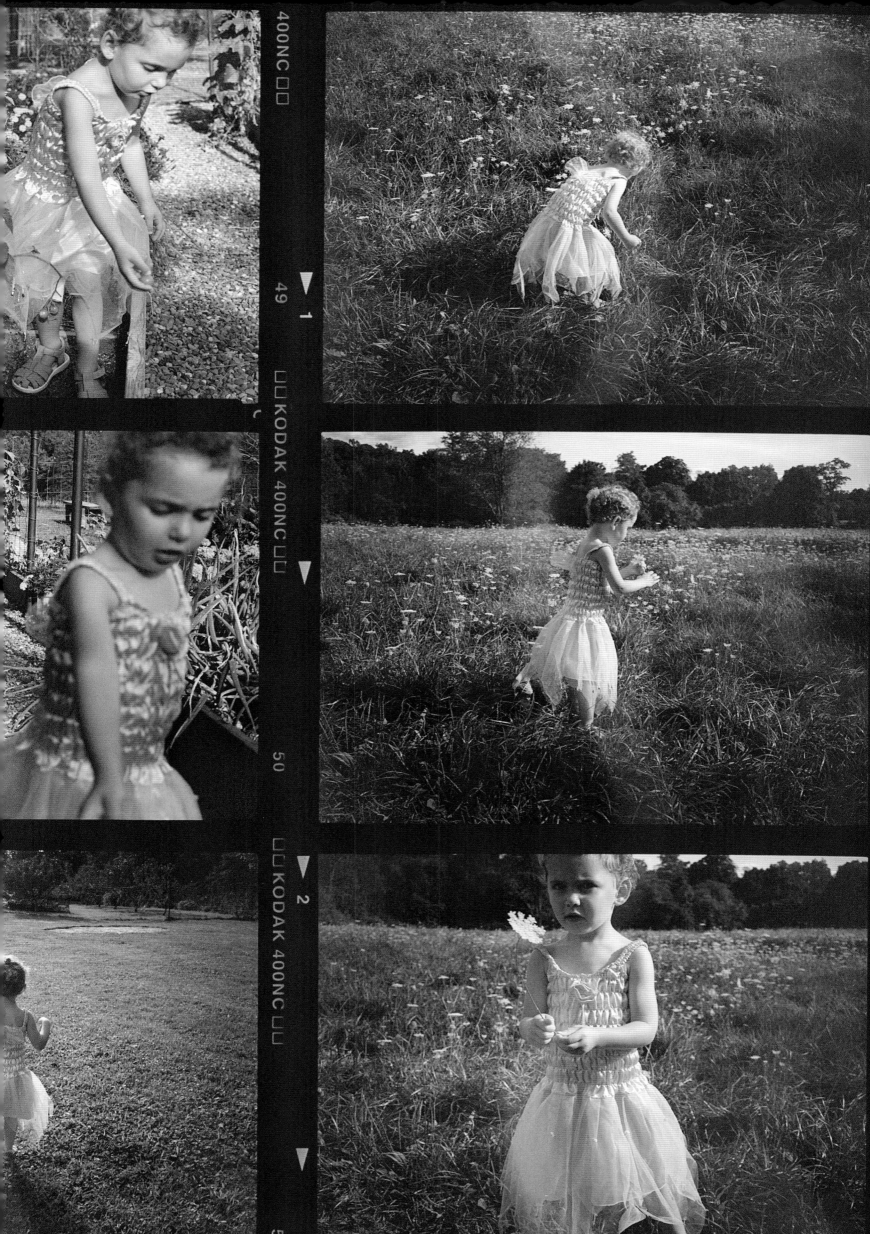

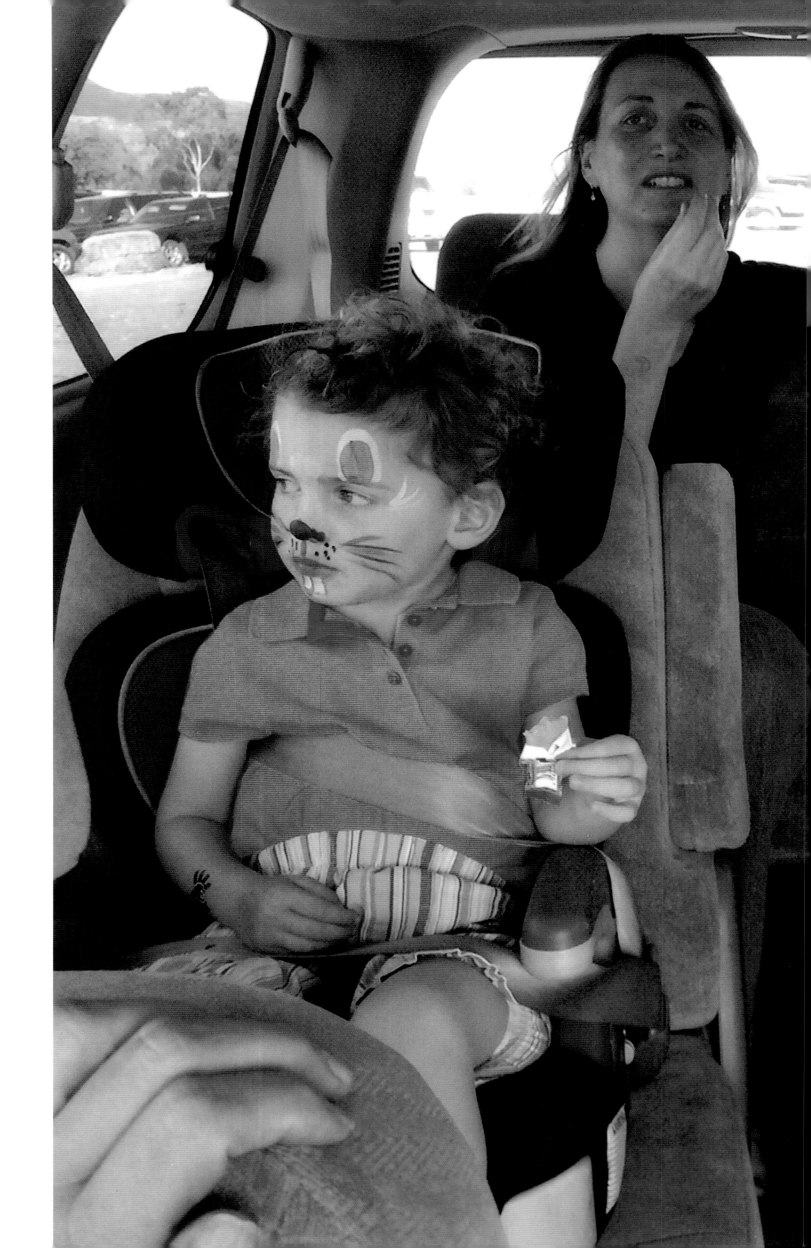

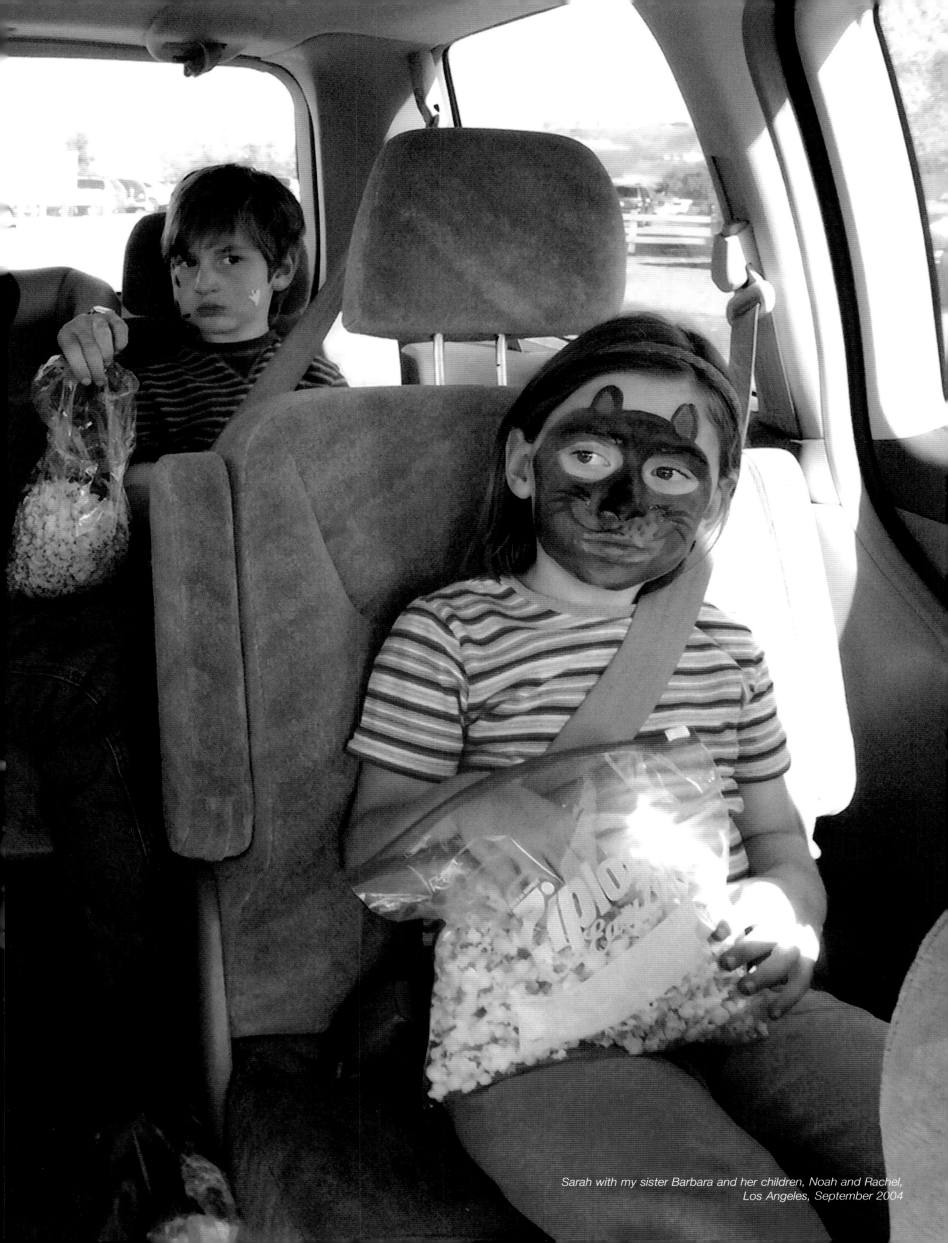

*Sarah with my sister Barbara and her children, Noah and Rachel,
Los Angeles, September 2004*

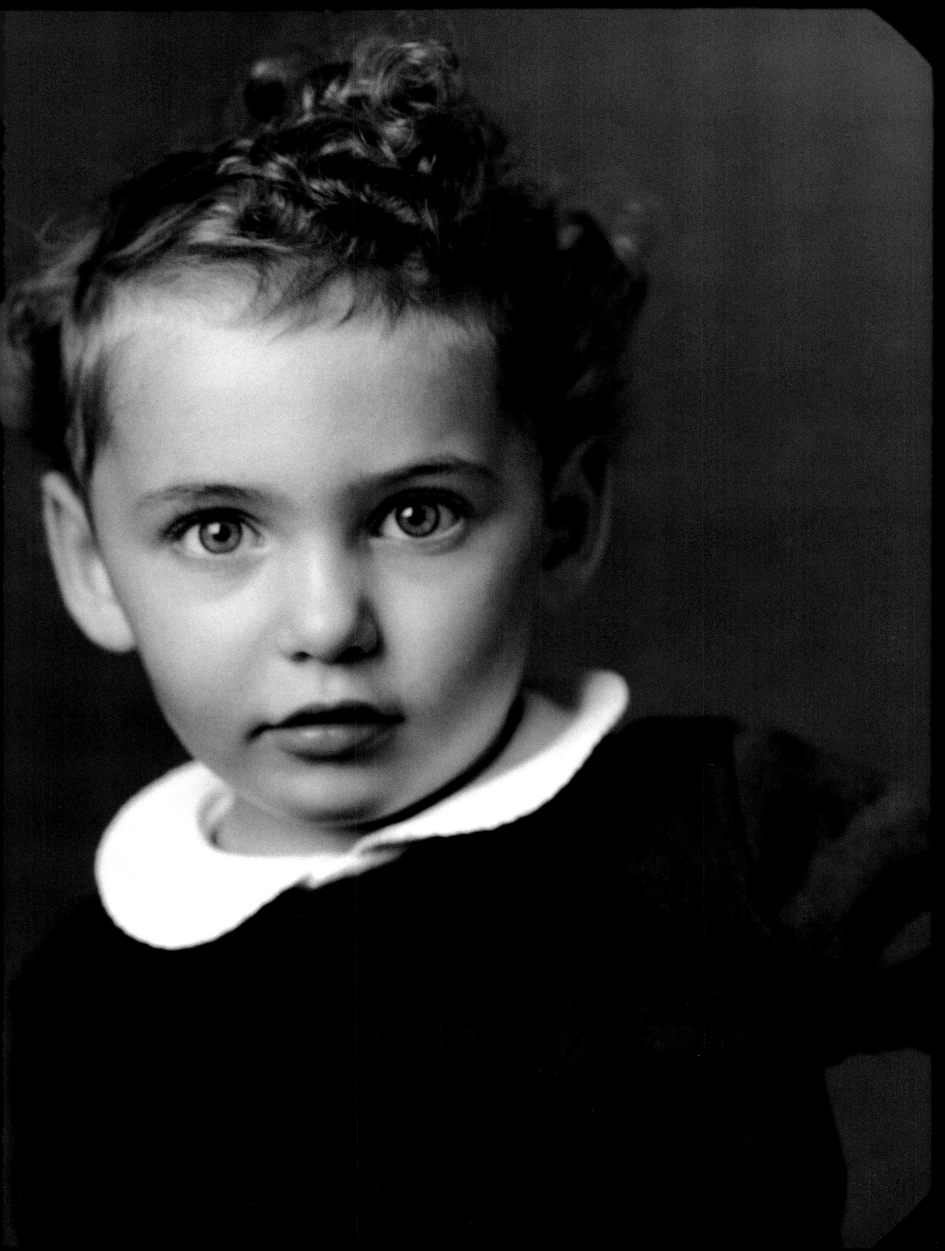

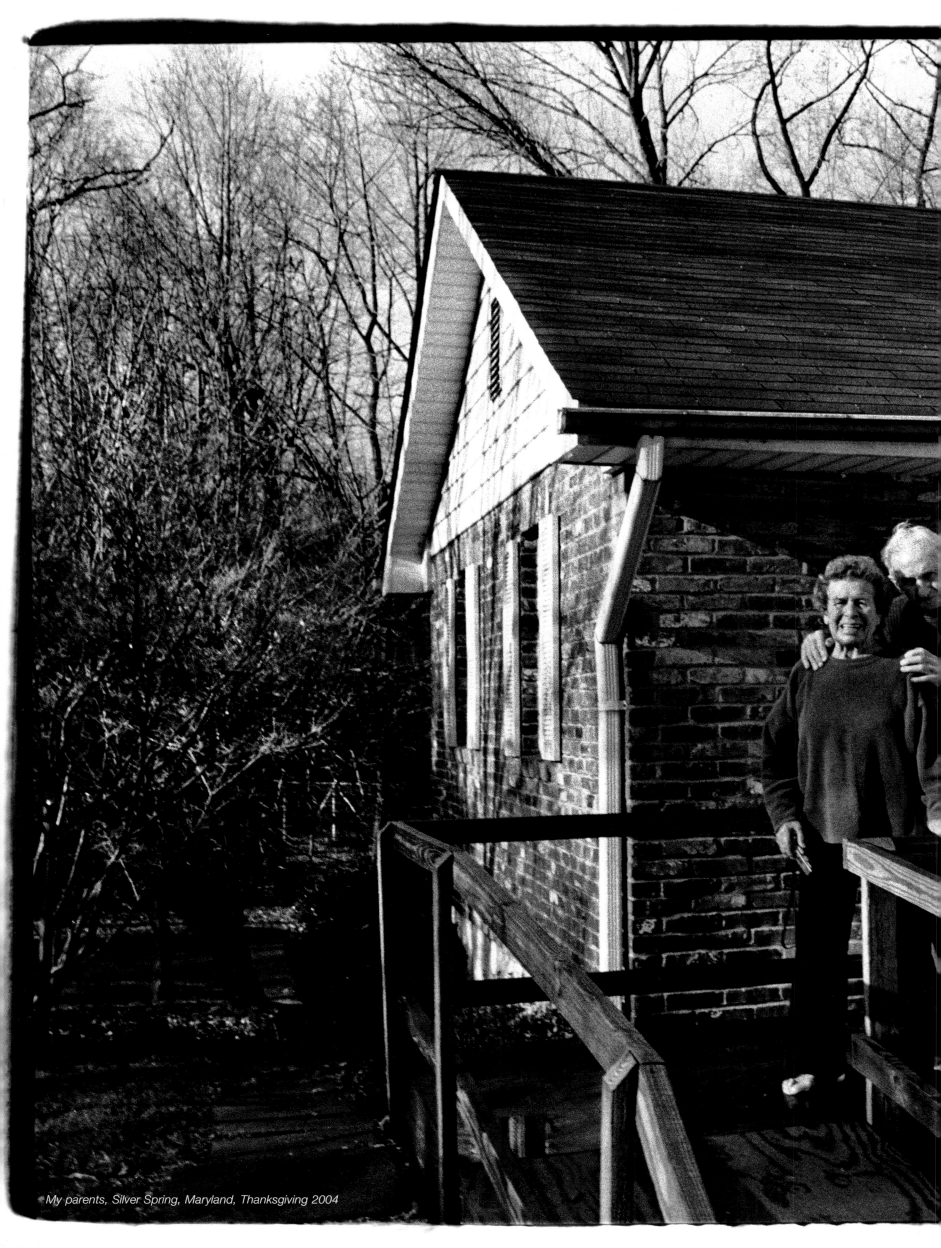

My parents, Silver Spring, Maryland, Thanksgiving 2004

I-5, Seattle, Washington, November 2004

Seattle Center
NEXT RIGHT

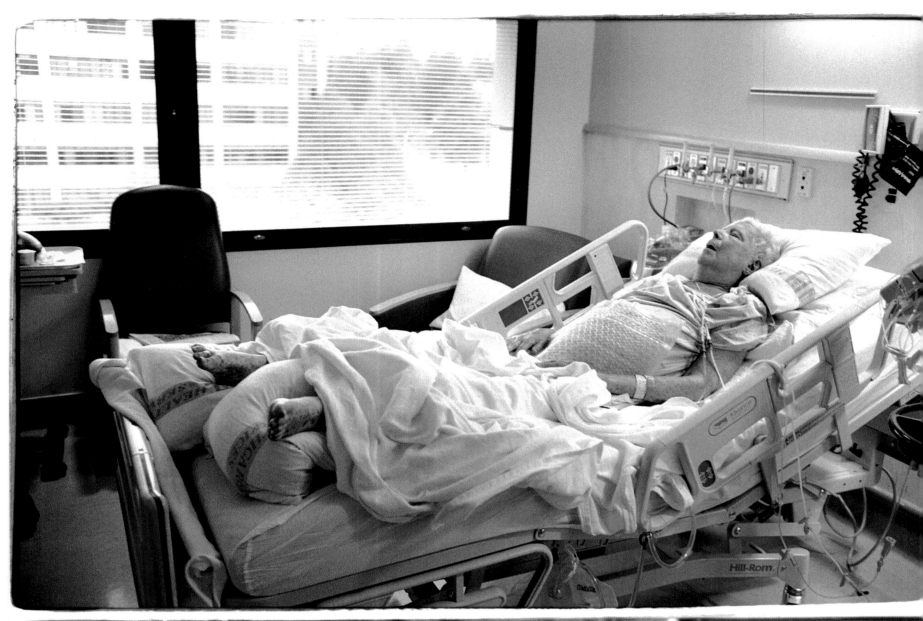

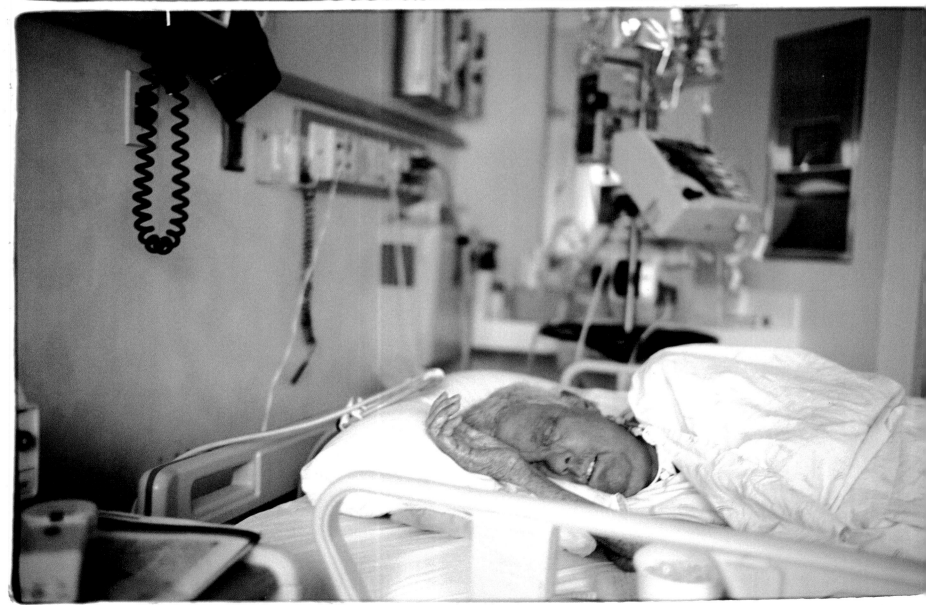

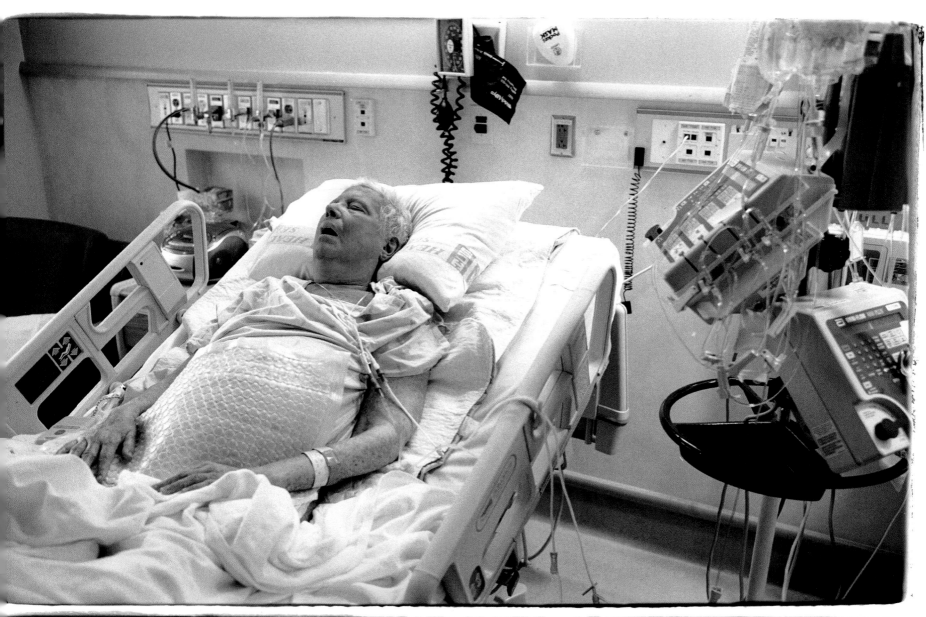

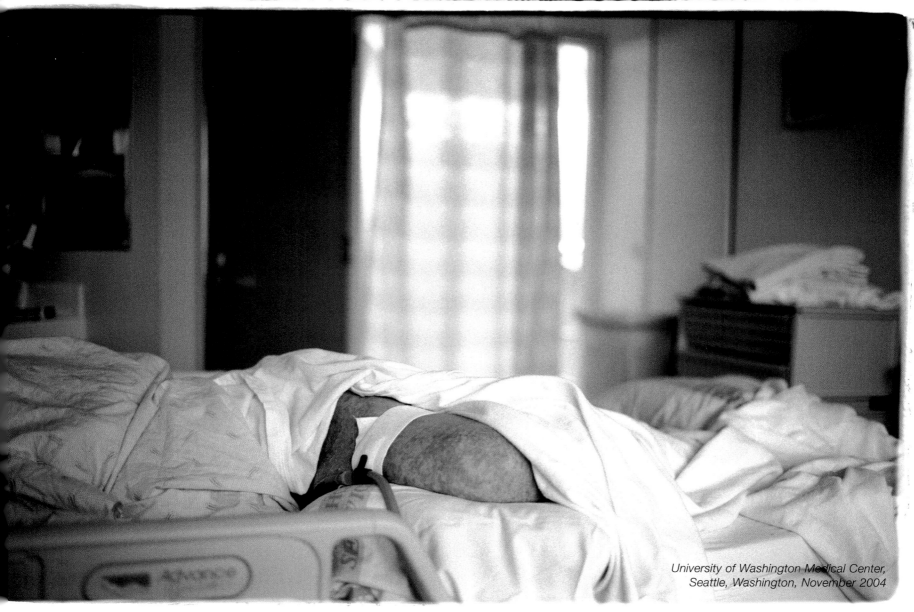

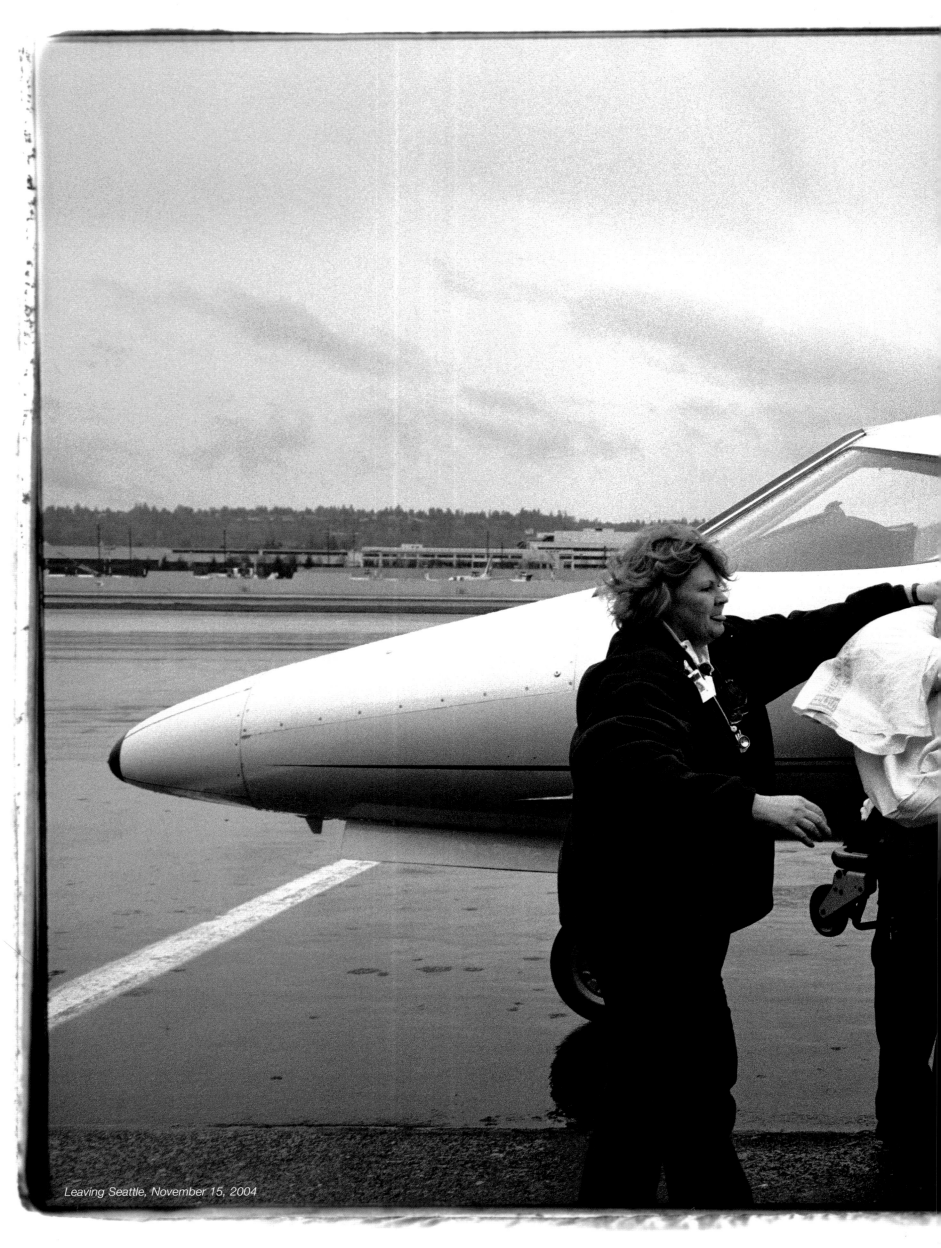

Leaving Seattle, November 15, 2004

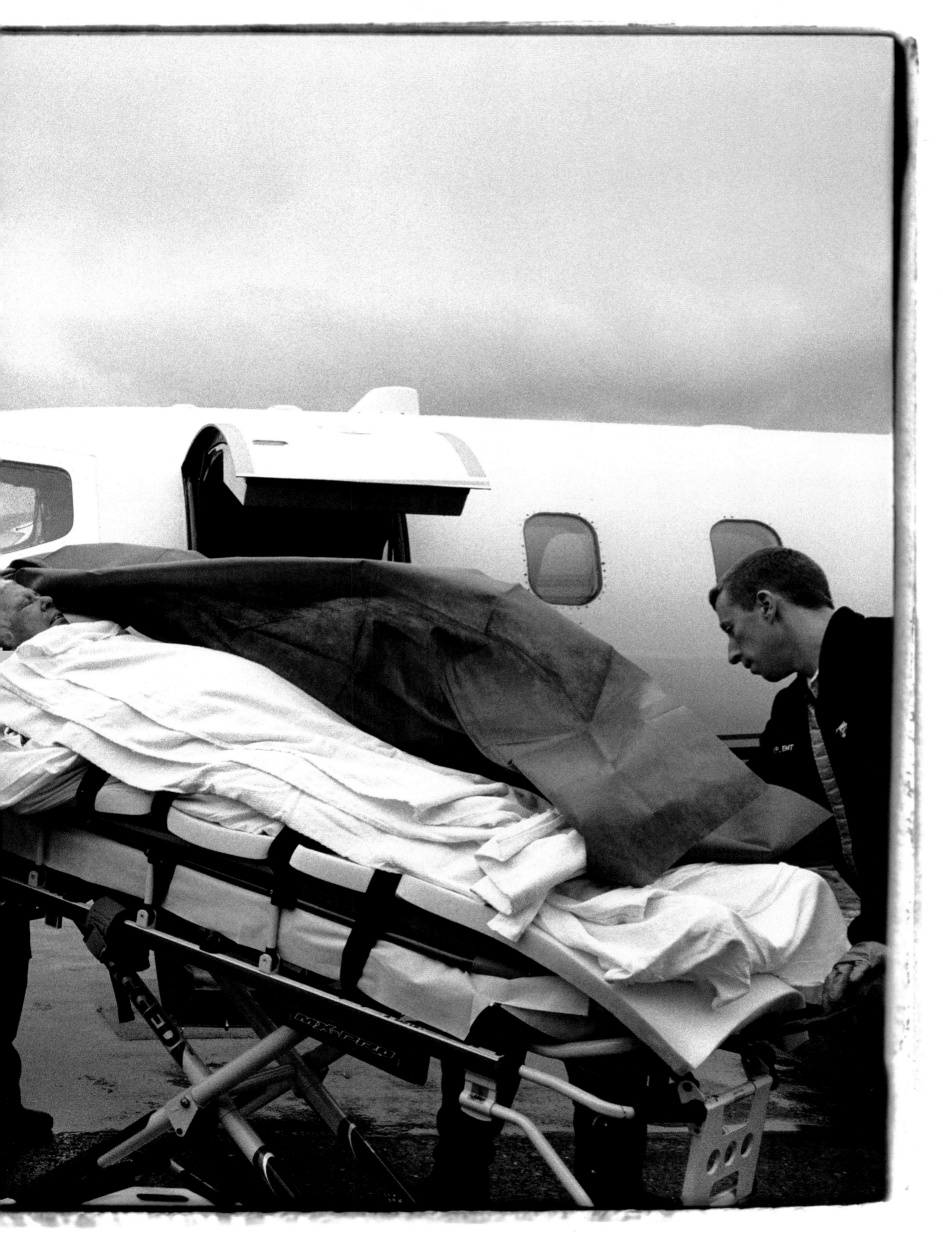

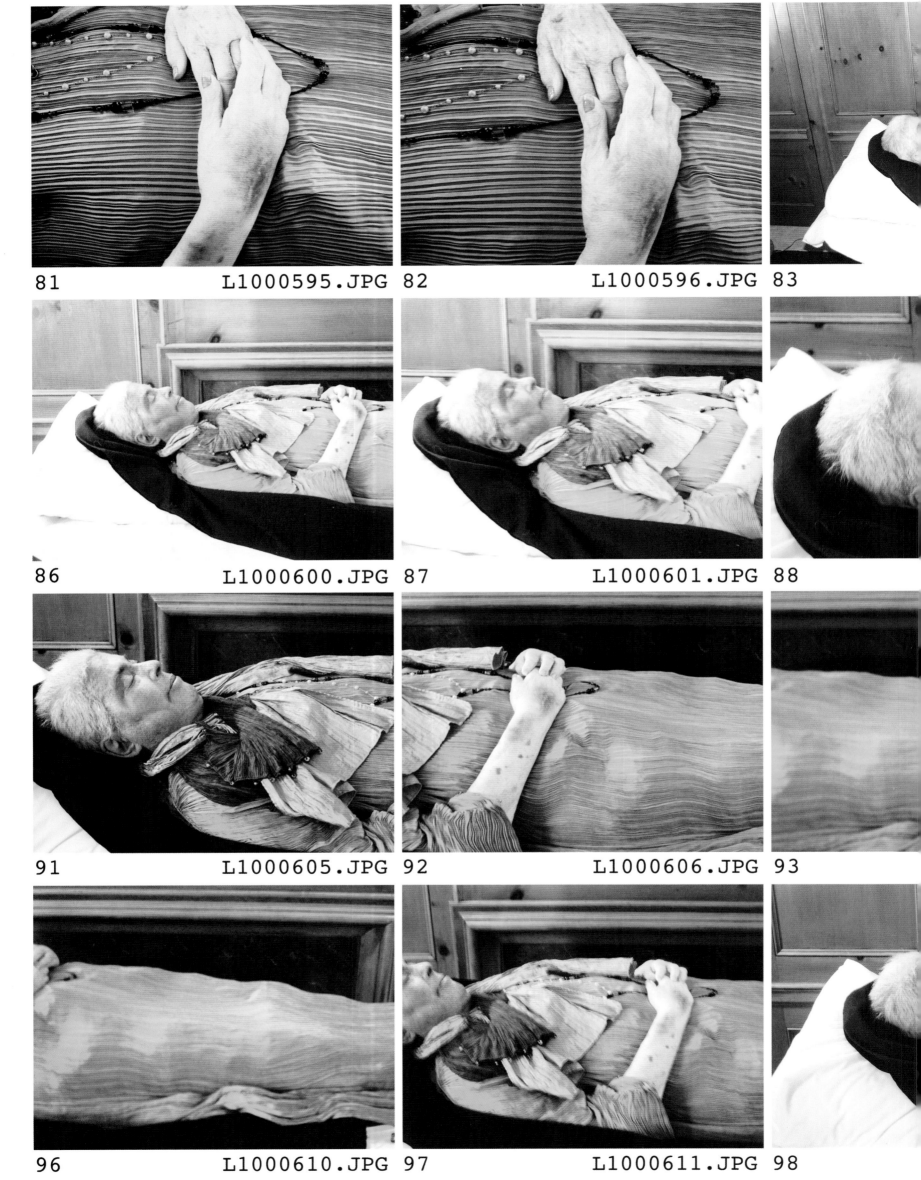

81 L1000595.JPG 82 L1000596.JPG 83

86 L1000600.JPG 87 L1000601.JPG 88

91 L1000605.JPG 92 L1000606.JPG 93

96 L1000610.JPG 97 L1000611.JPG 98

New York, December 29, 2004

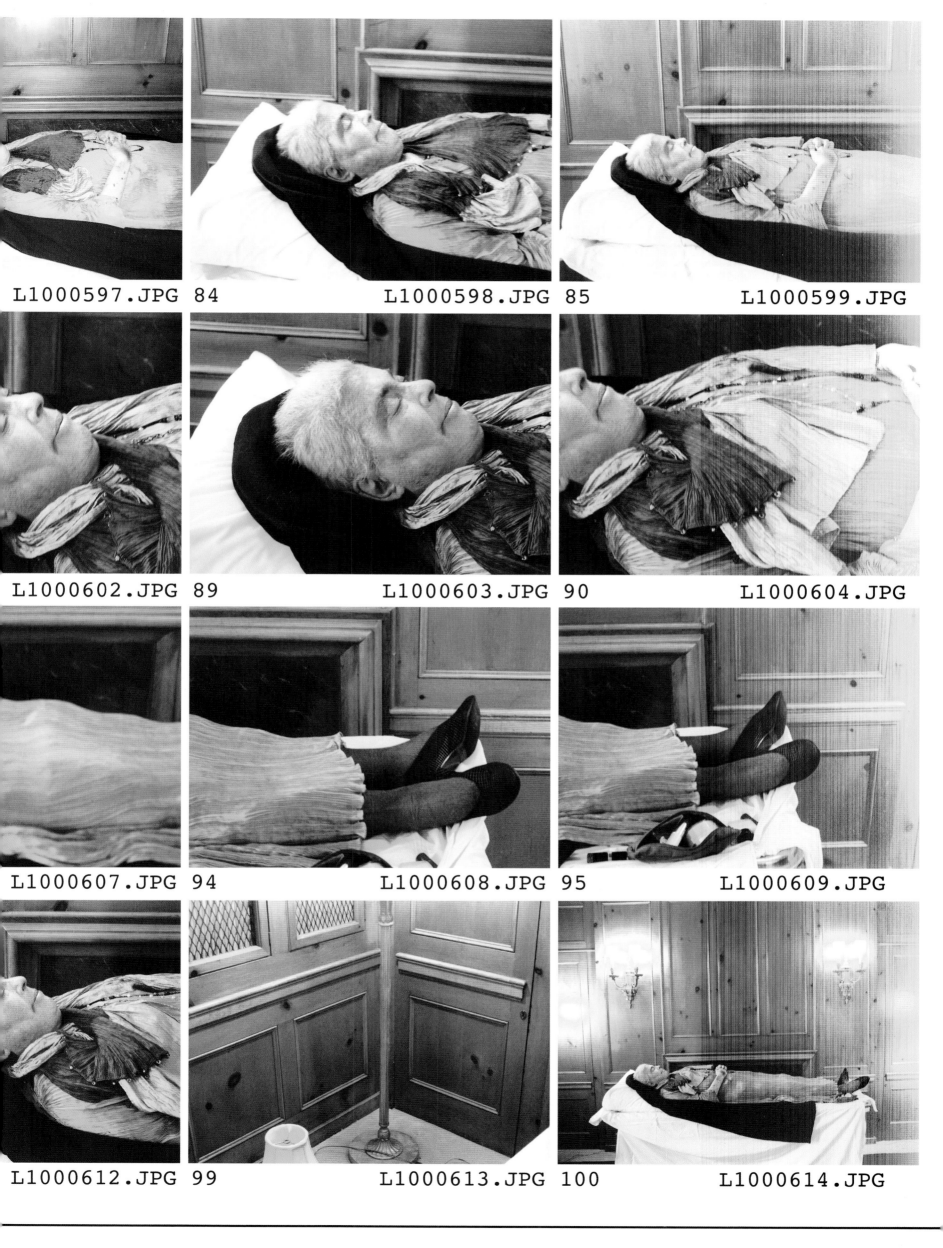

L1000597.JPG 84 L1000598.JPG 85 L1000599.JPG

L1000602.JPG 89 L1000603.JPG 90 L1000604.JPG

L1000607.JPG 94 L1000608.JPG 95 L1000609.JPG

L1000612.JPG 99 L1000613.JPG 100 L1000614.JPG

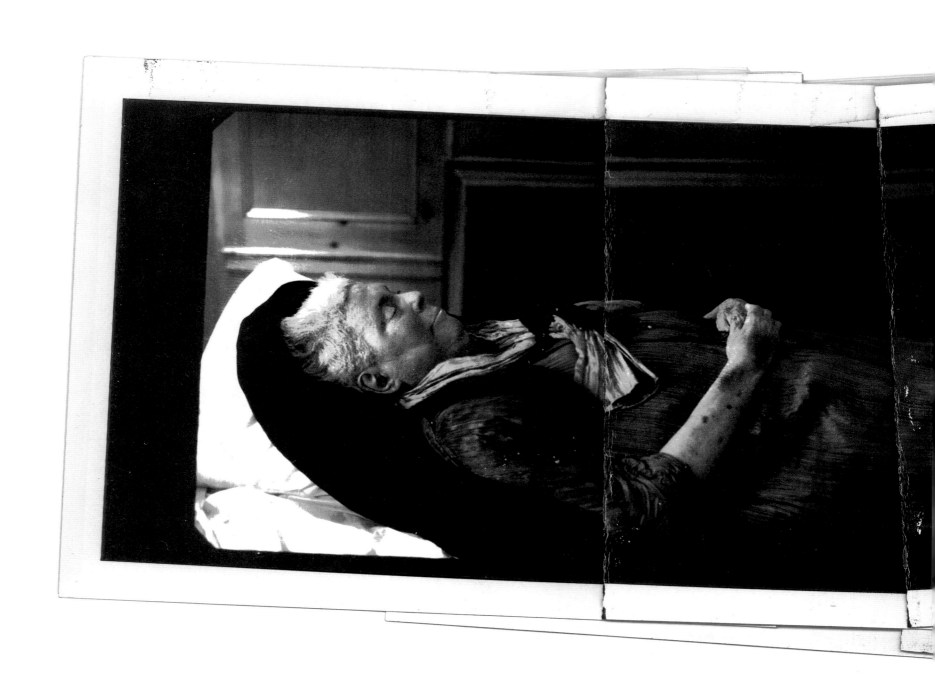

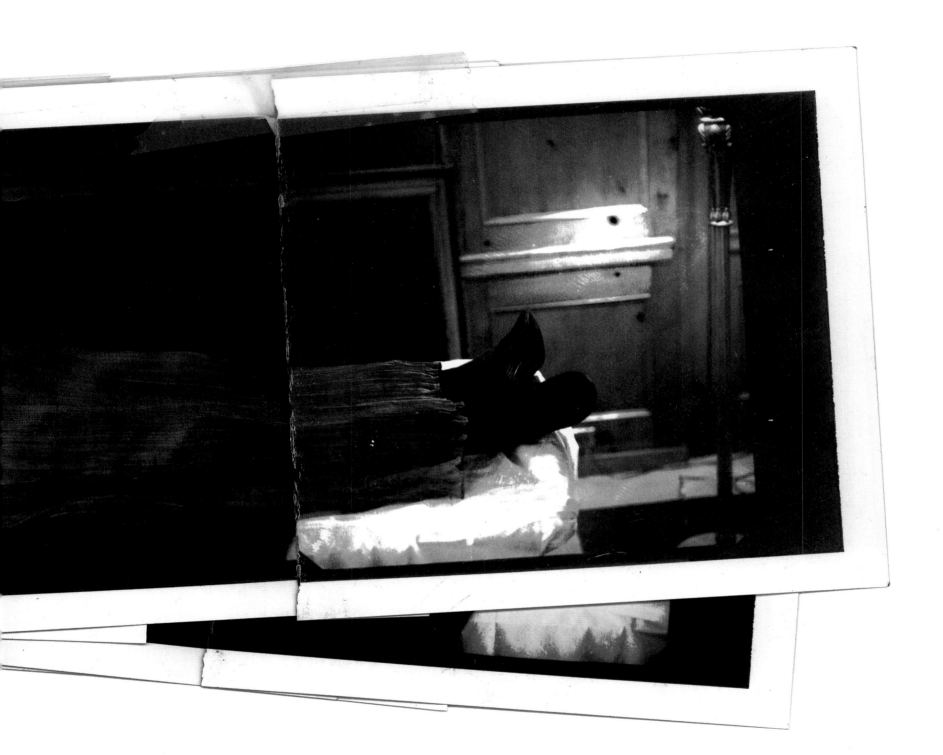

Montparnasse Cemetery, Paris, 2005

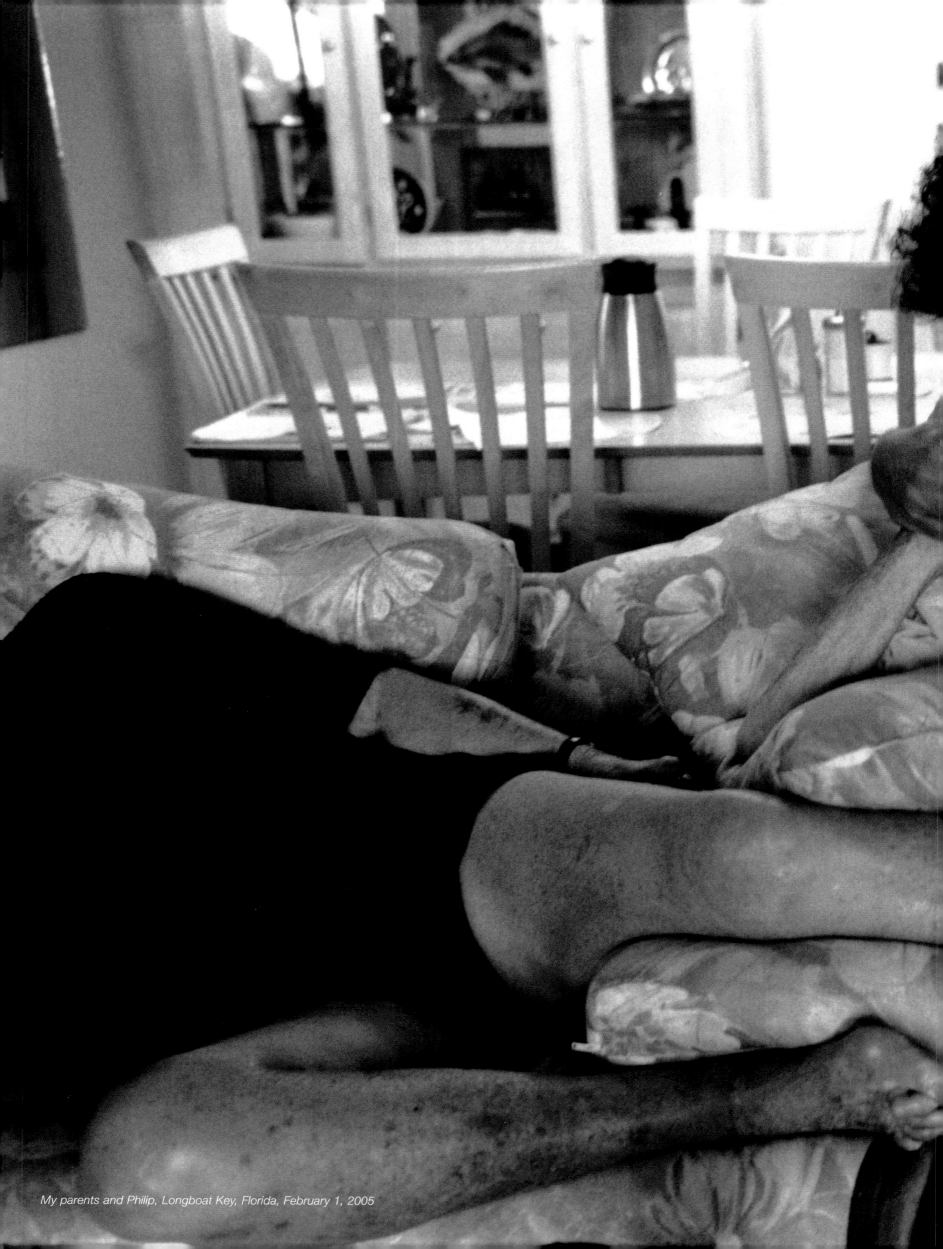

My parents and Philip, Longboat Key, Florida, February 1, 2005

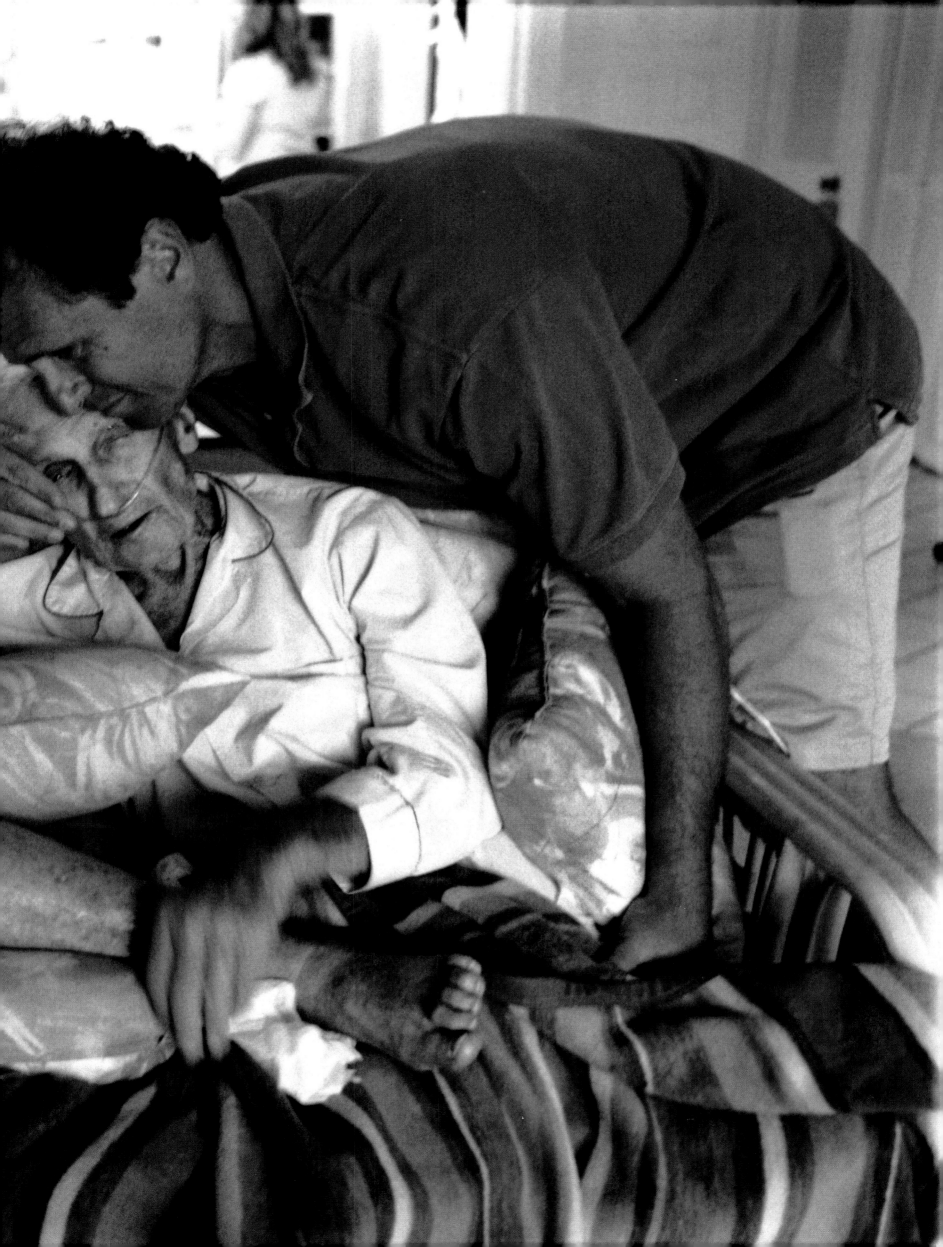

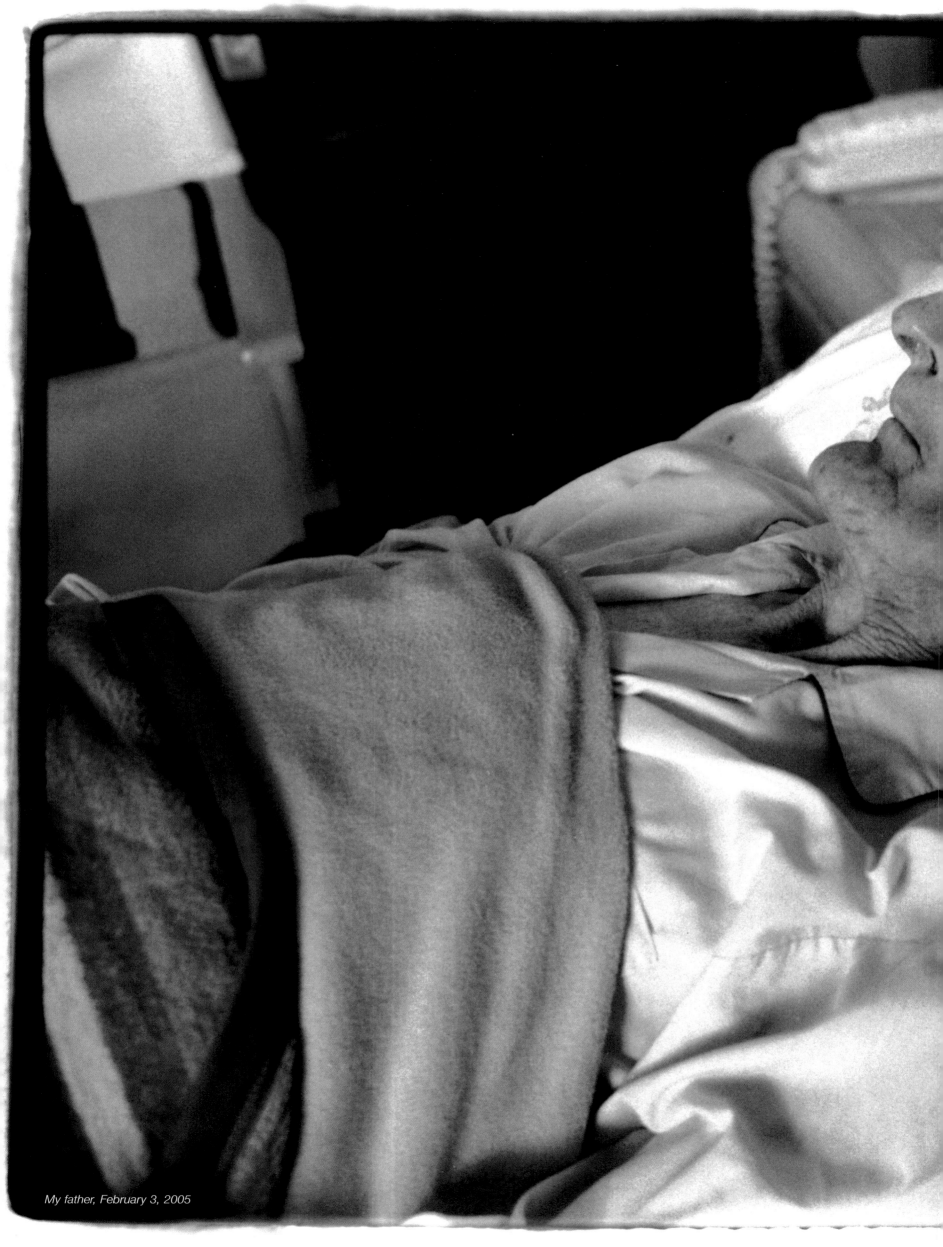

My father, February 3, 2005

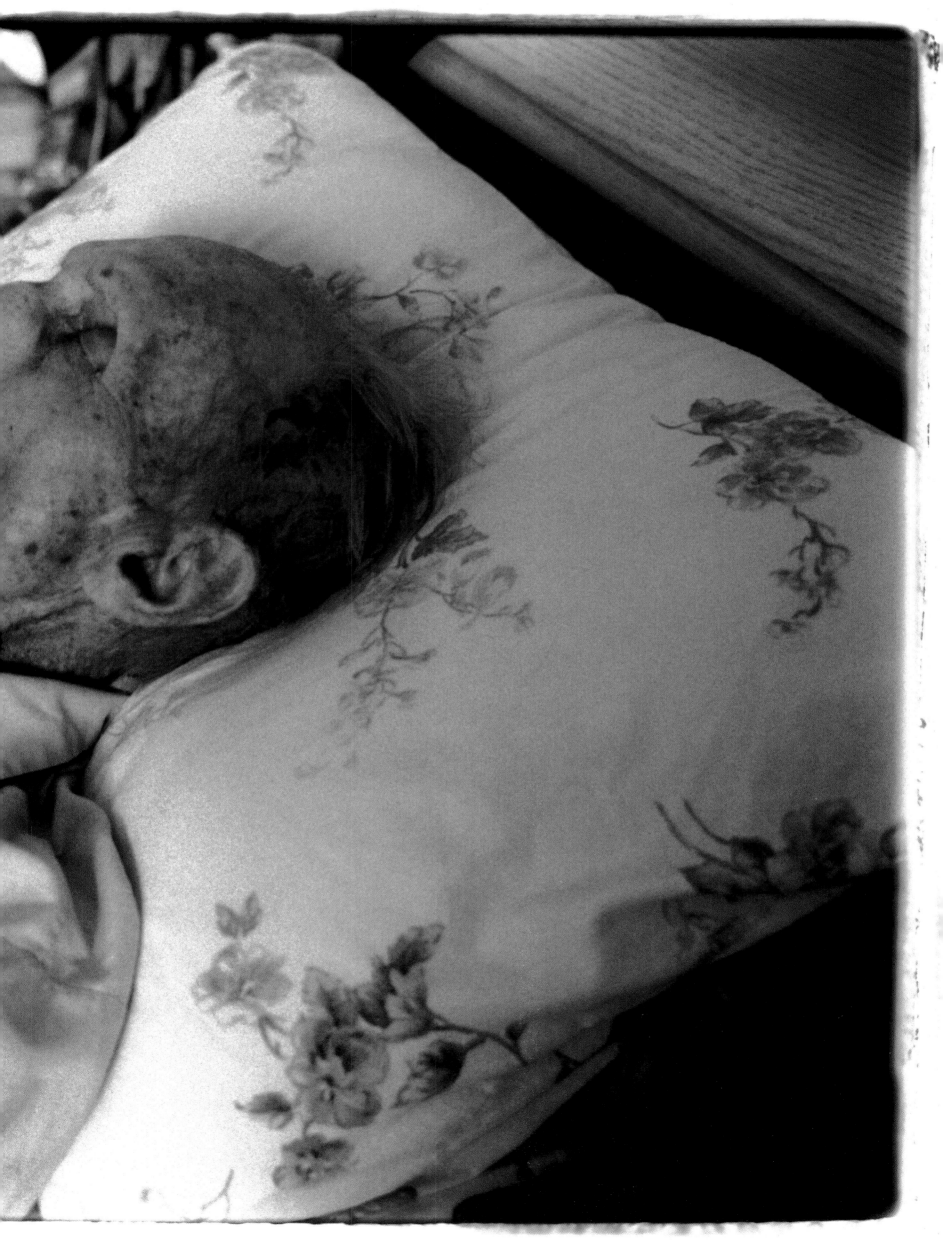

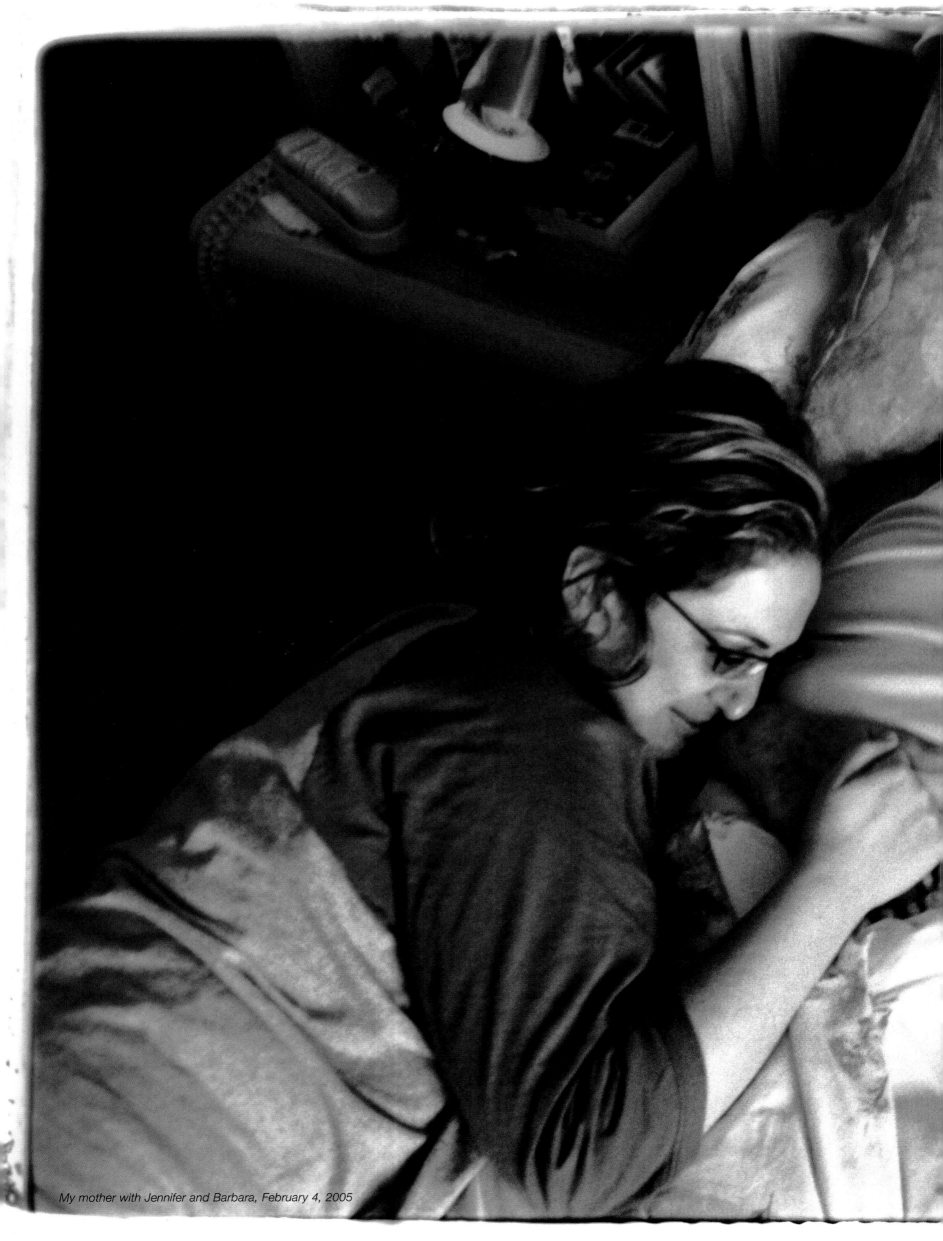

My mother with Jennifer and Barbara, February 4, 2005

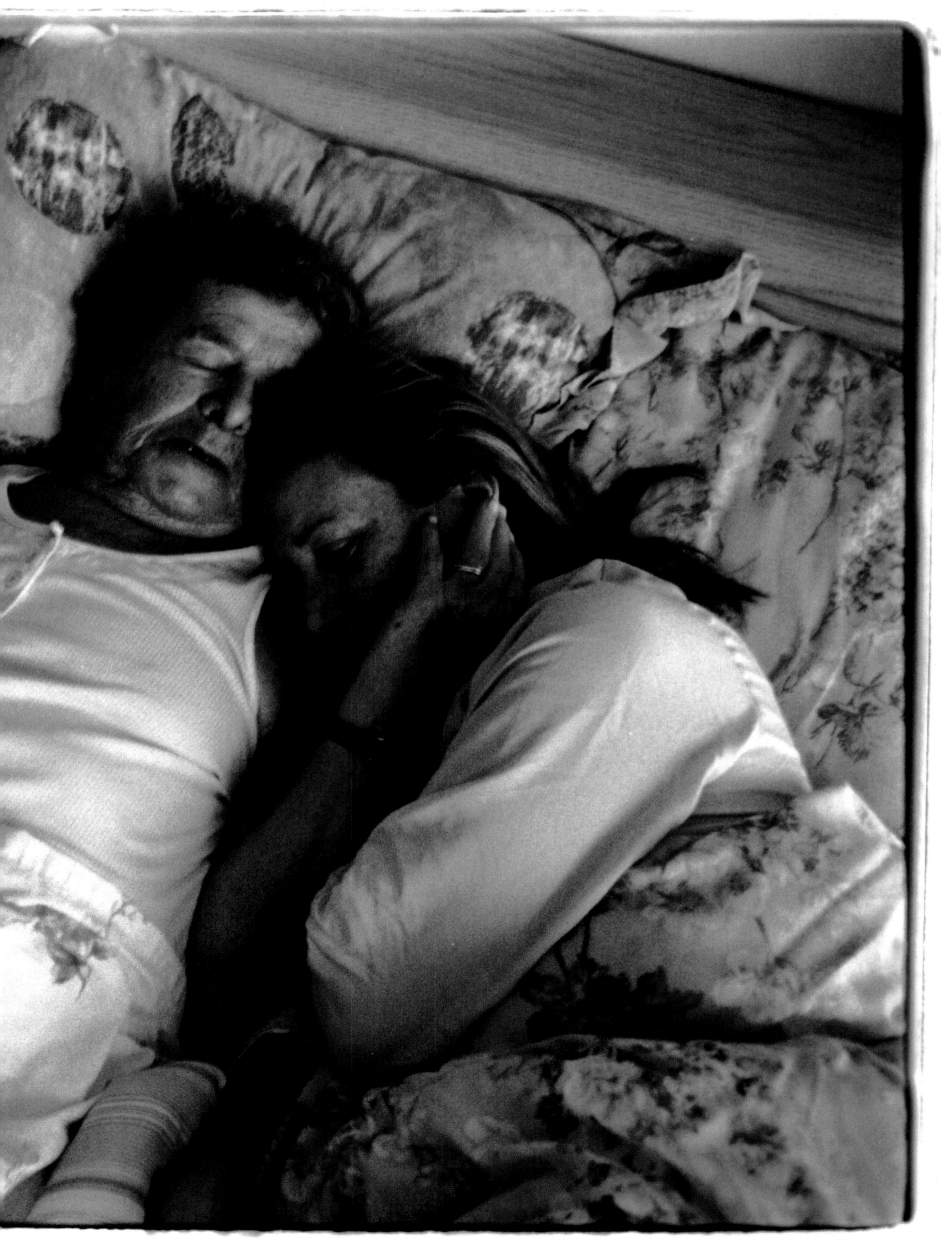

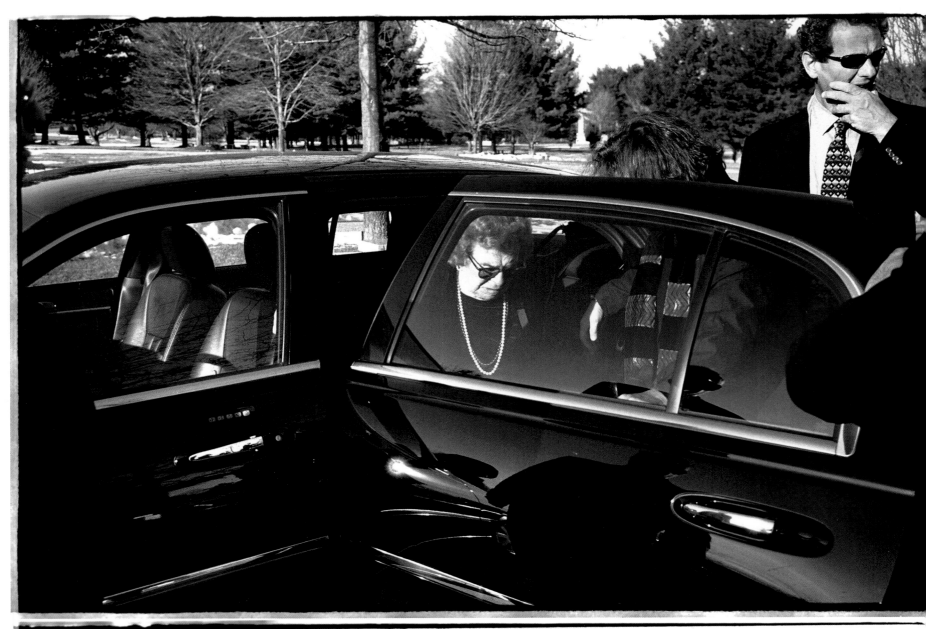

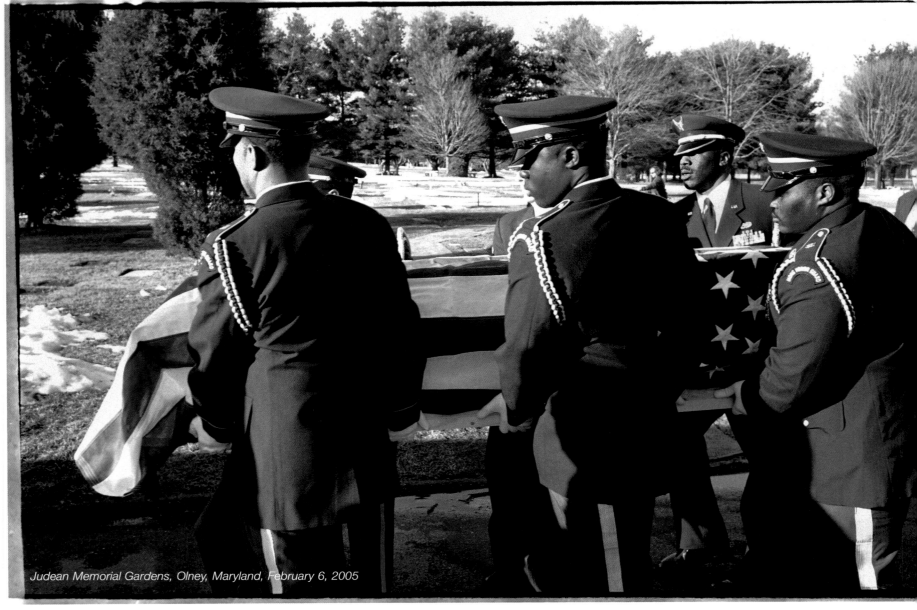

Judean Memorial Gardens, Olney, Maryland, February 6, 2005

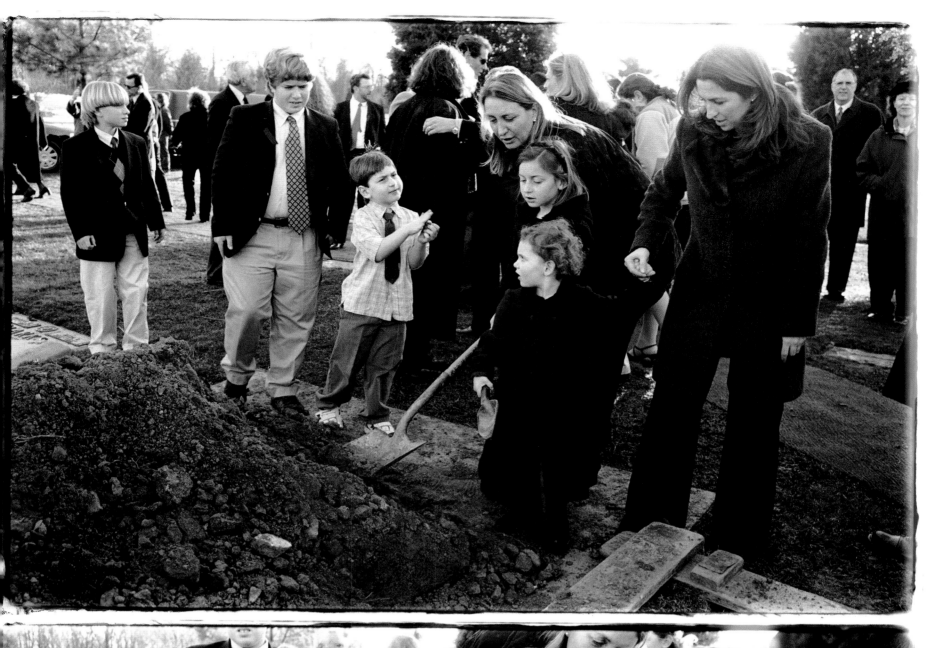
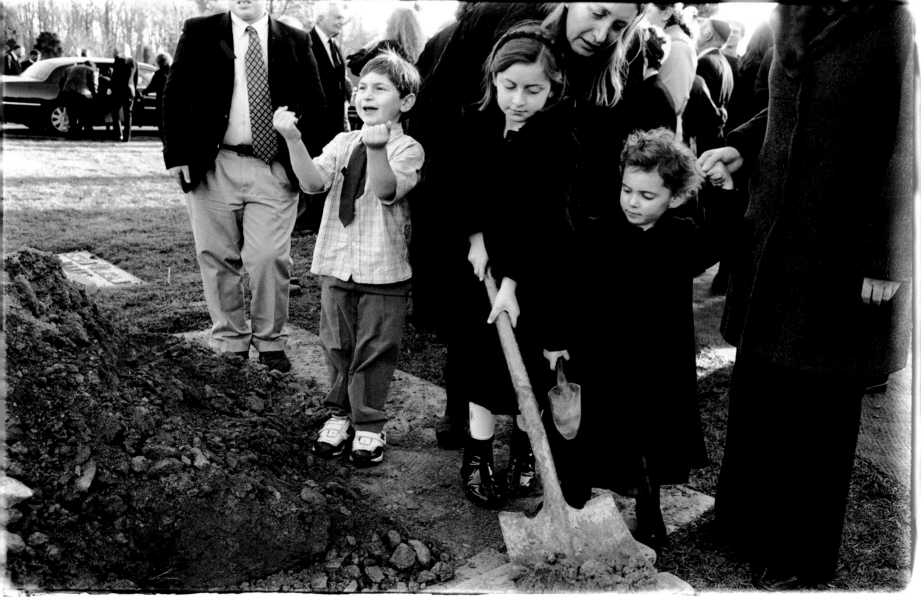

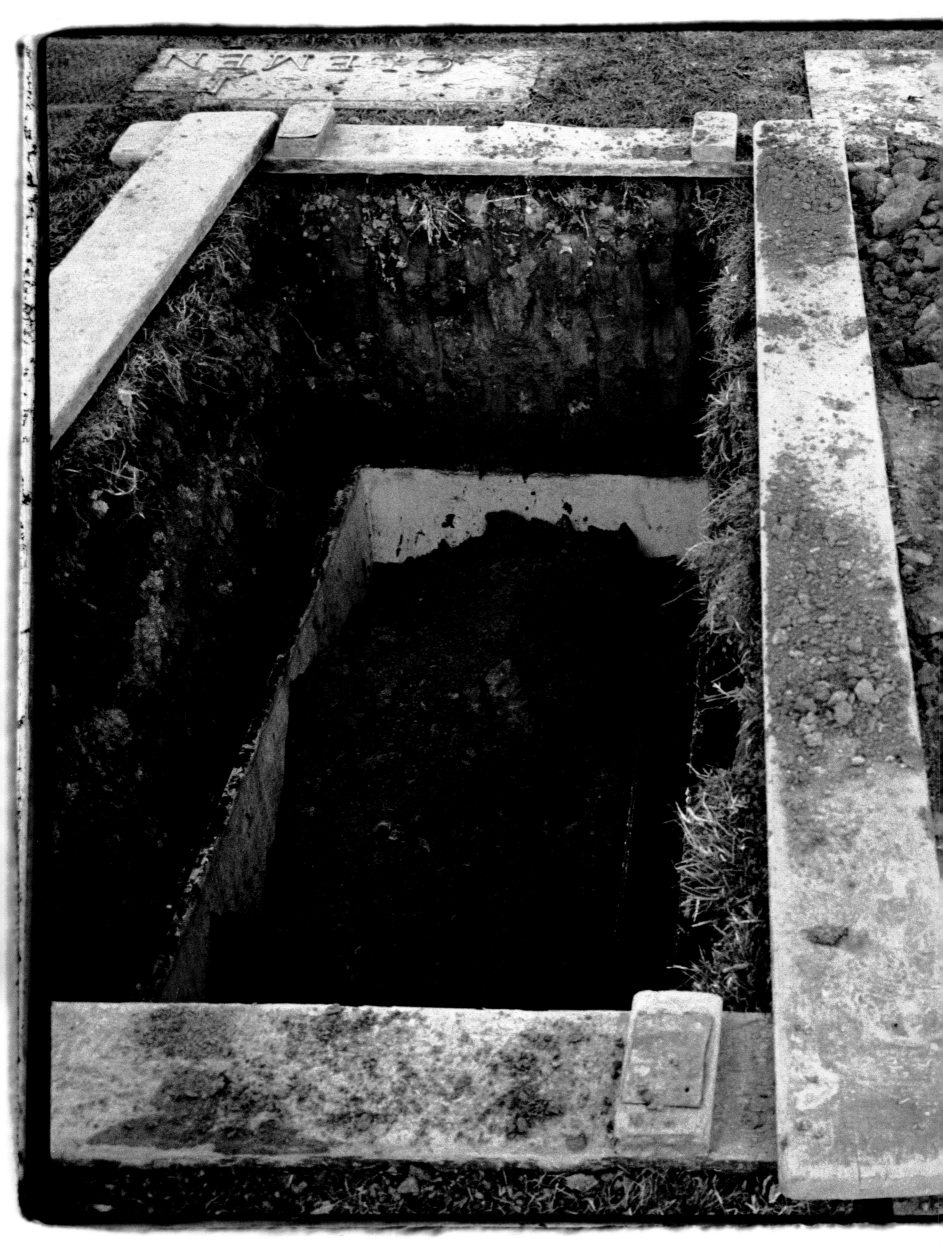

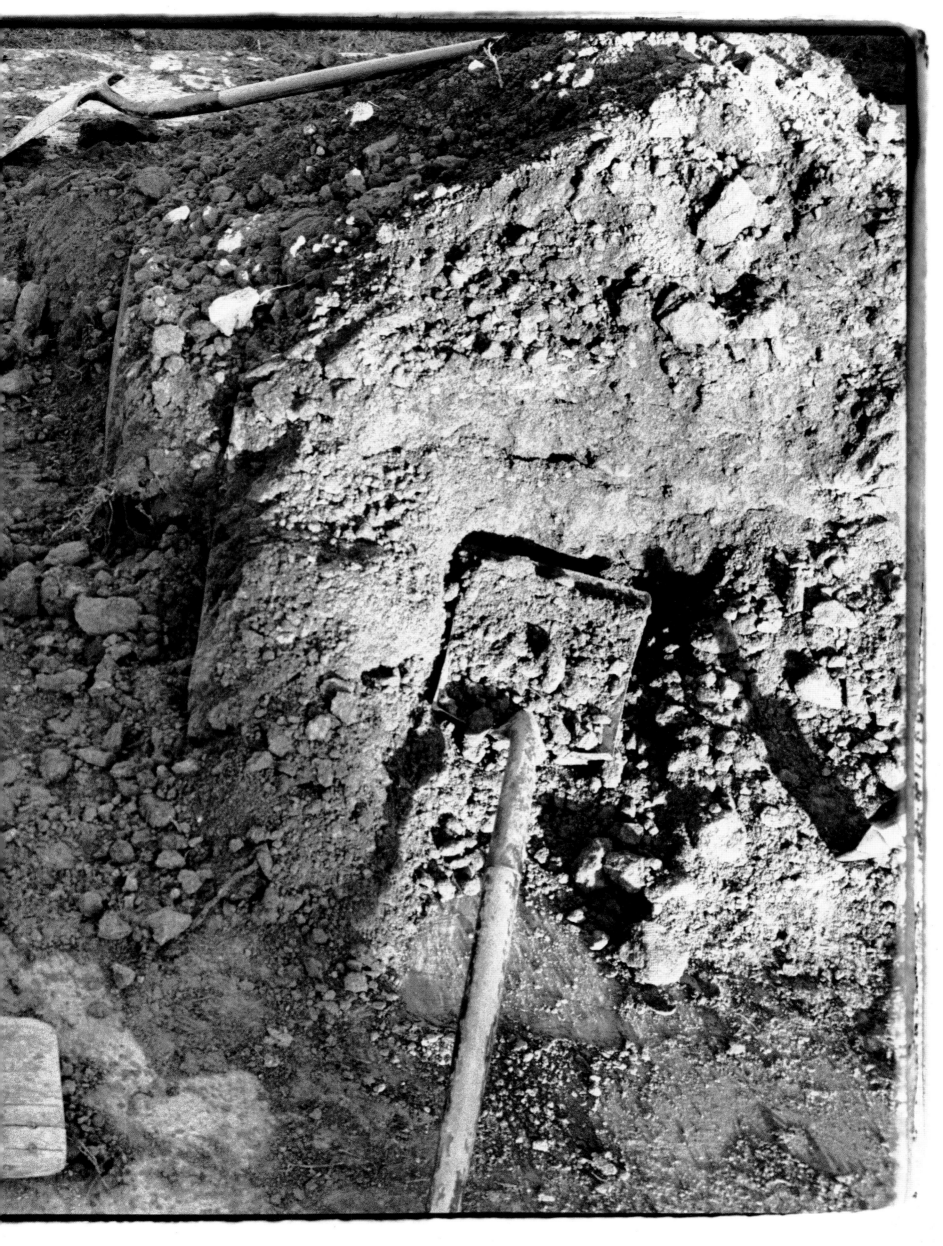

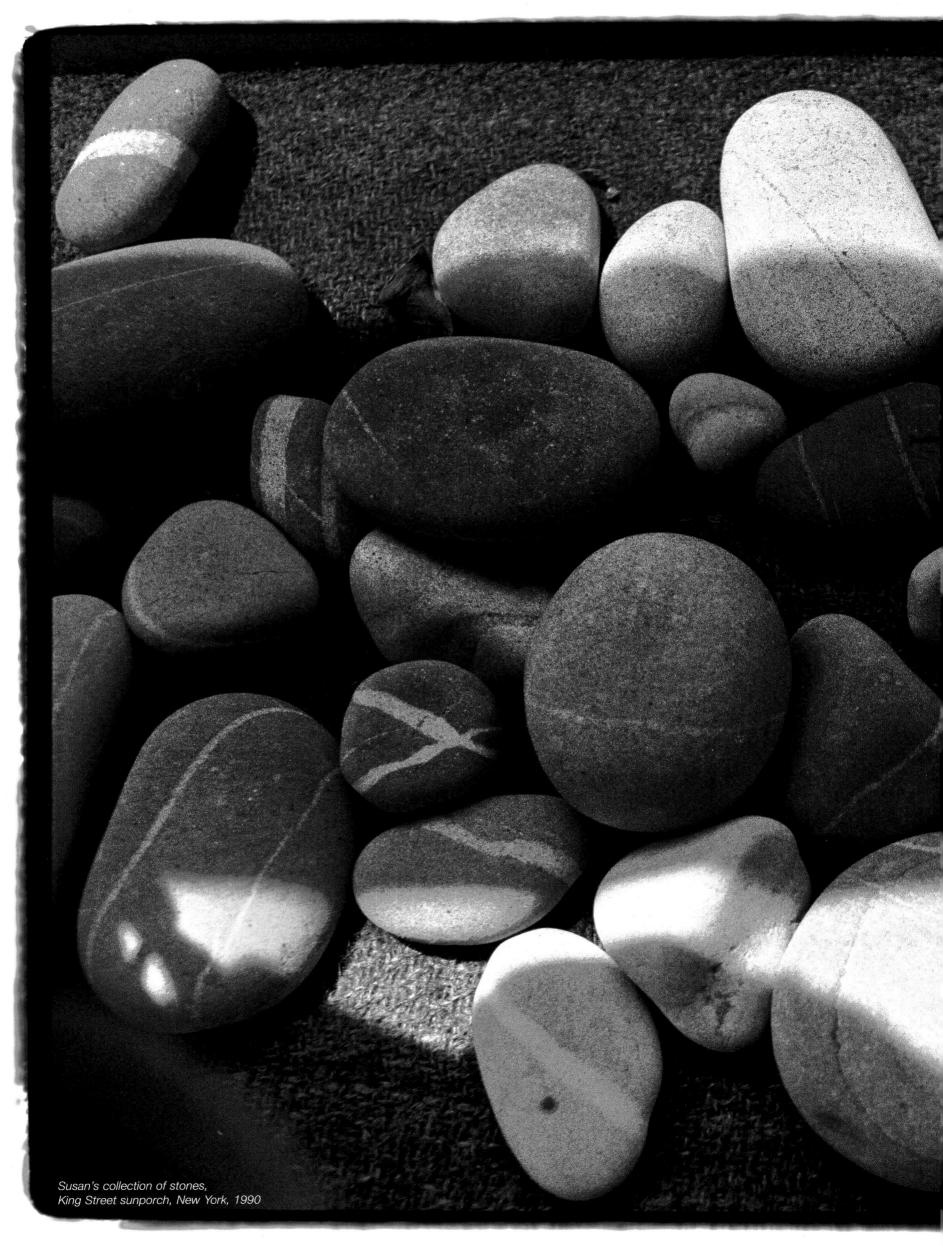

Susan's collection of stones,
King Street sunporch, New York, 1990

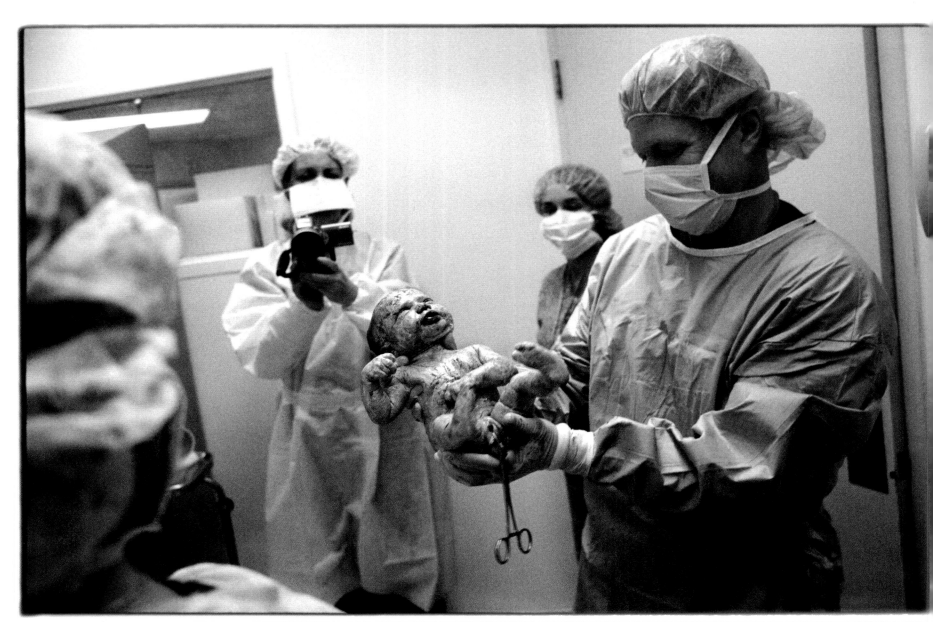

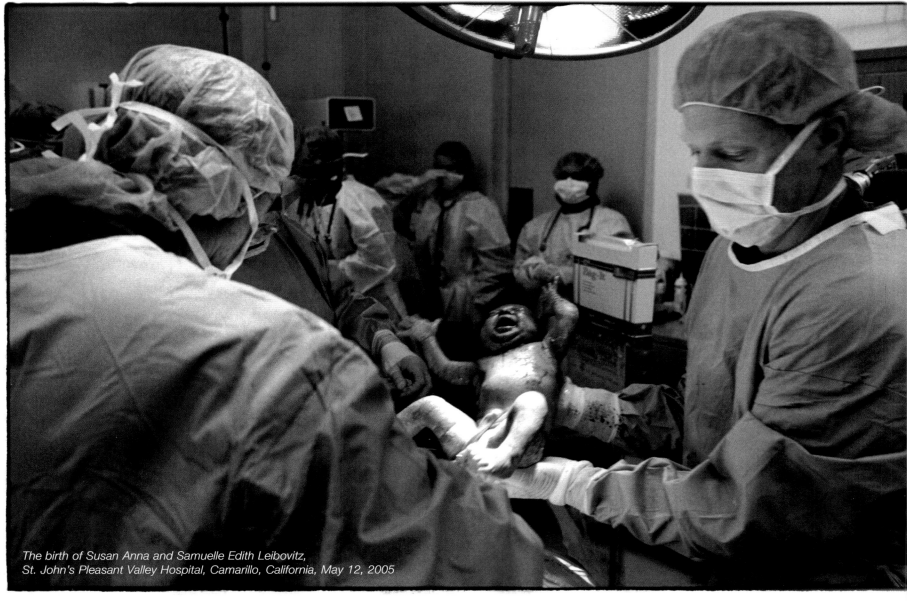

The birth of Susan Anna and Samuelle Edith Leibovitz,
St. John's Pleasant Valley Hospital, Camarillo, California, May 12, 2005

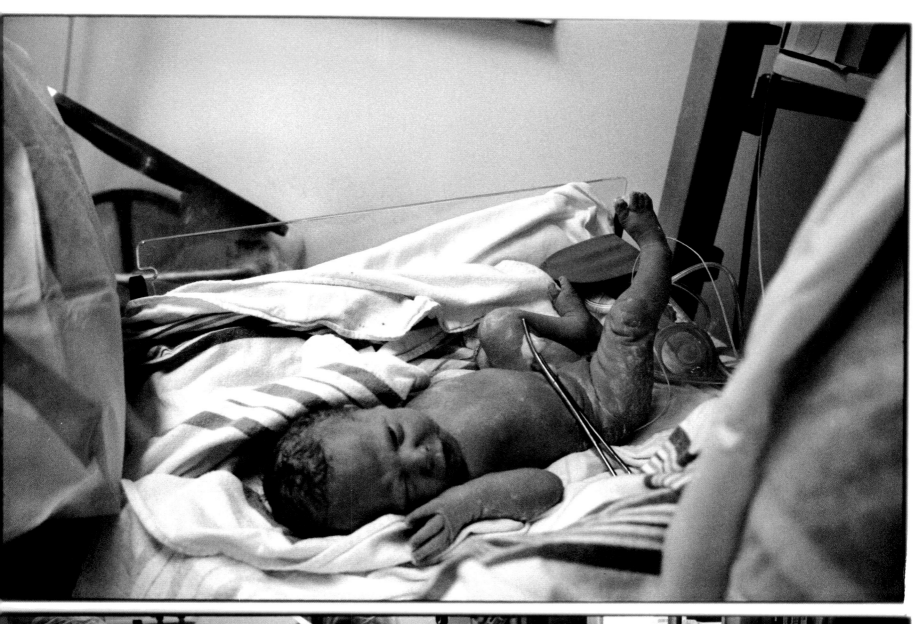
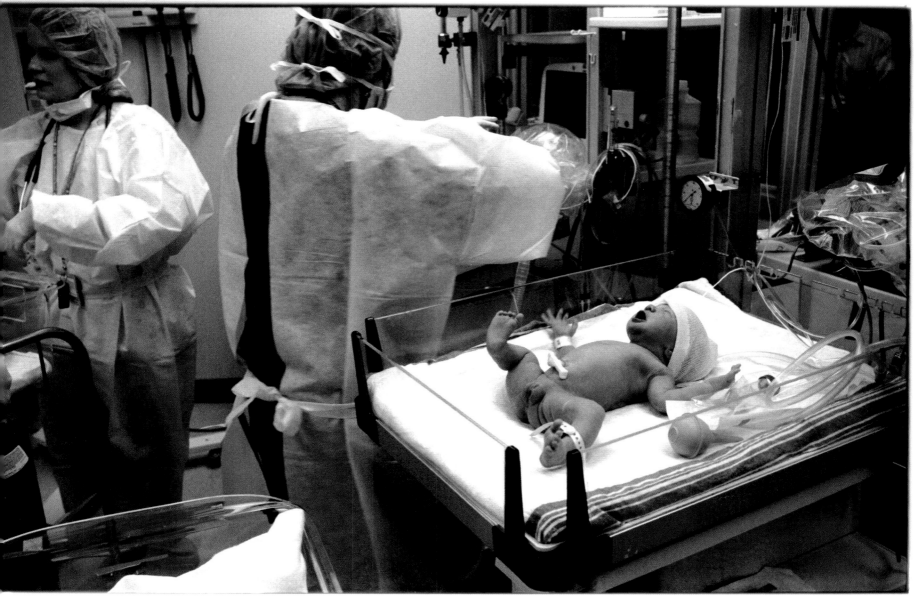

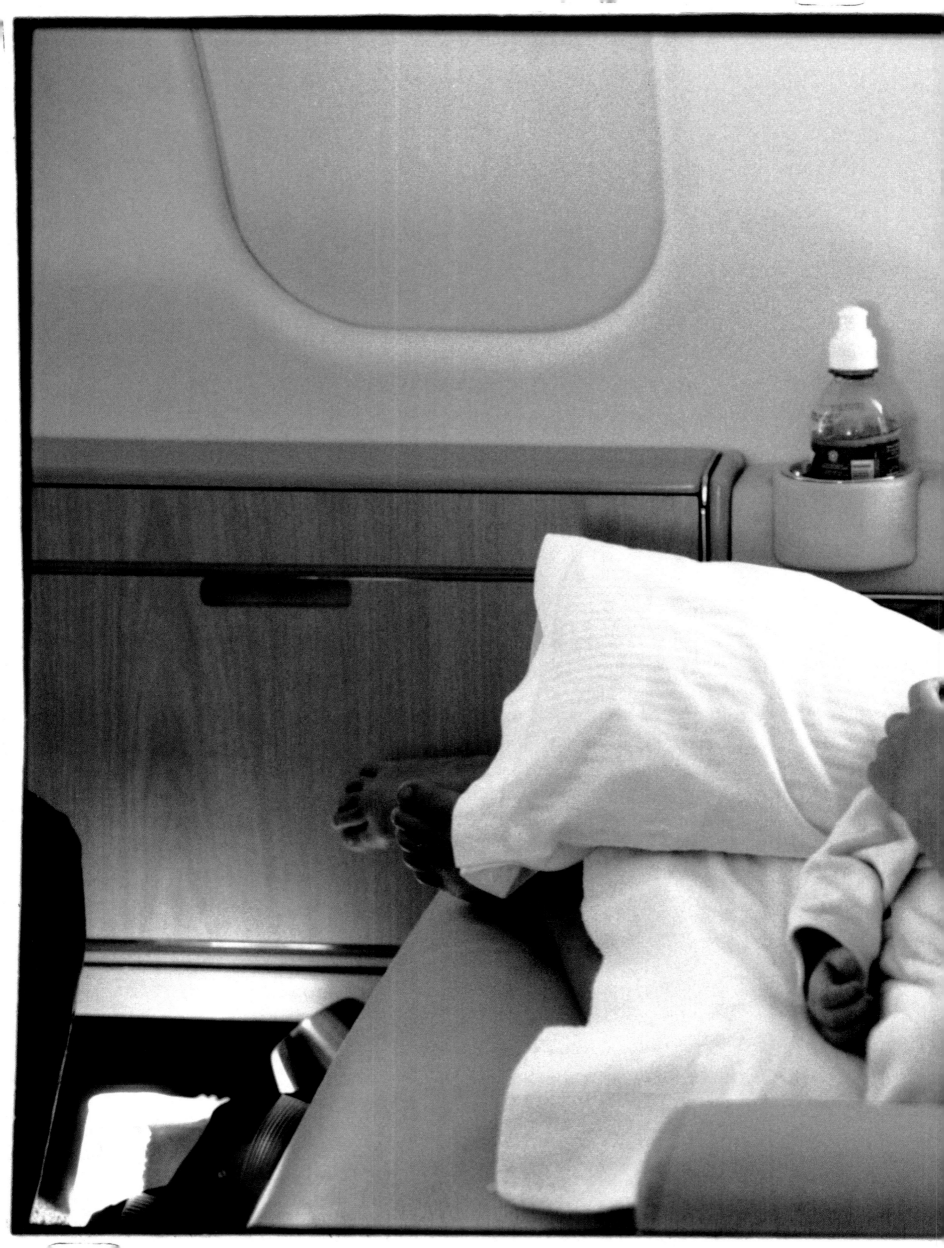

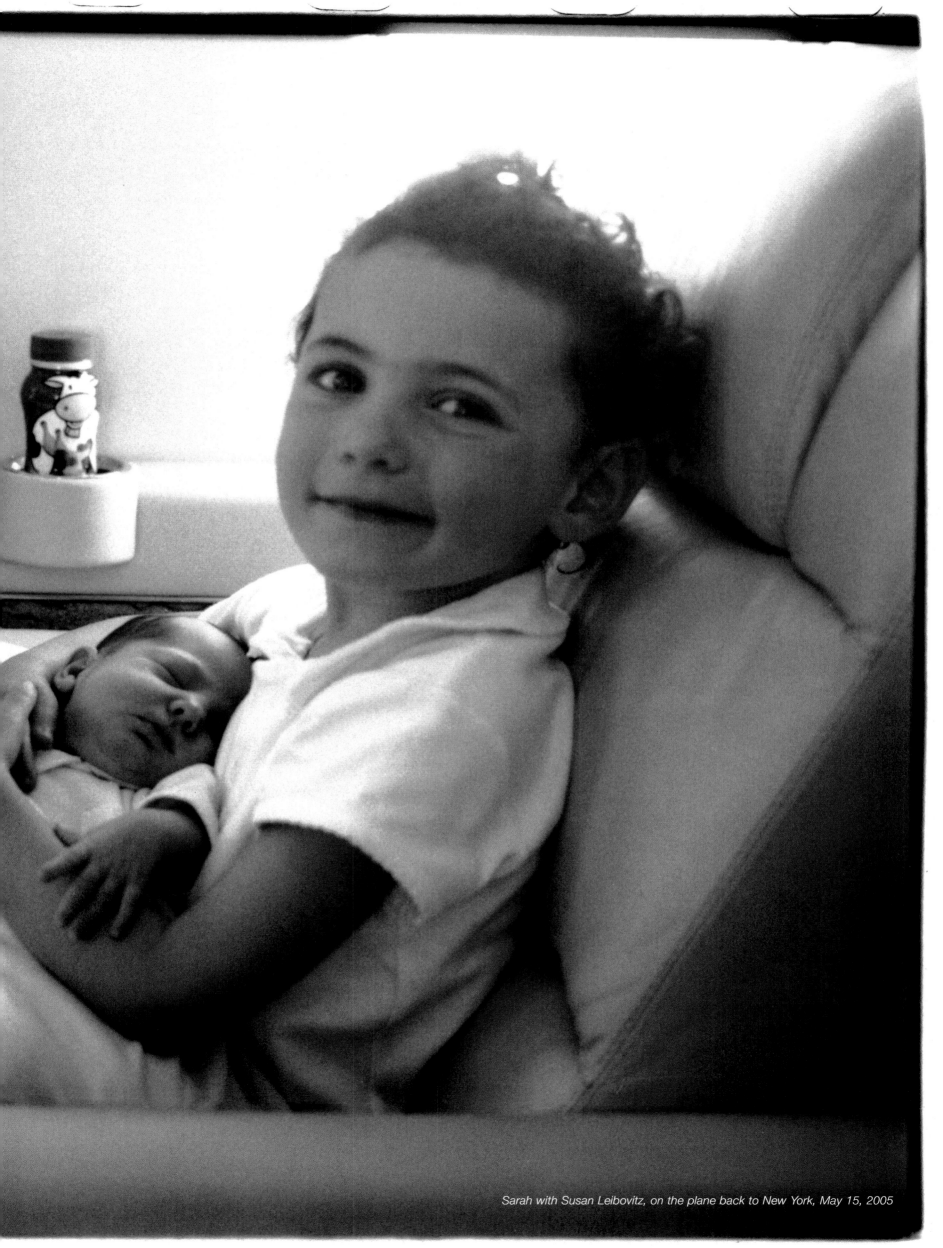

Sarah with Susan Leibovitz, on the plane back to New York, May 15, 2005

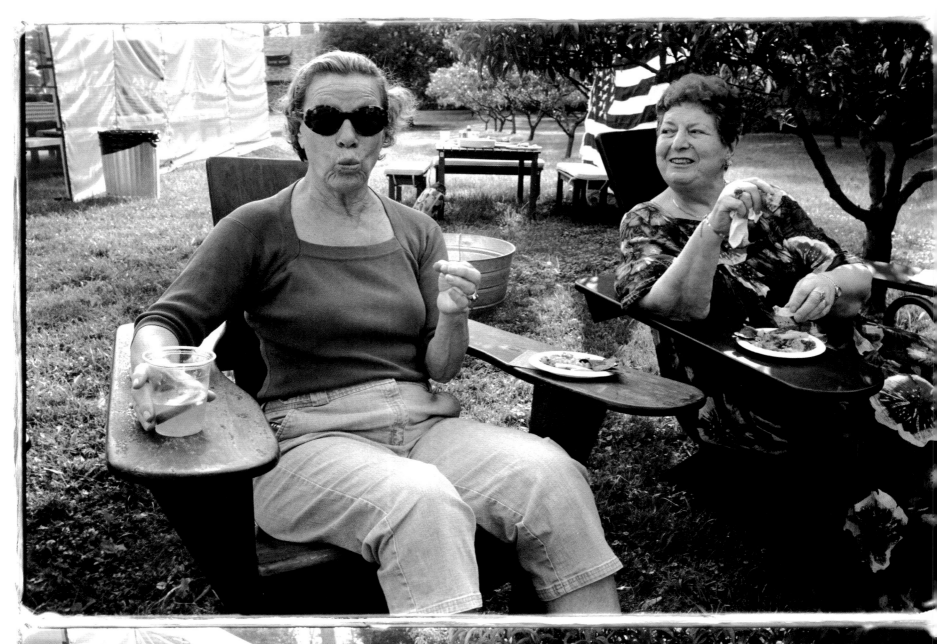

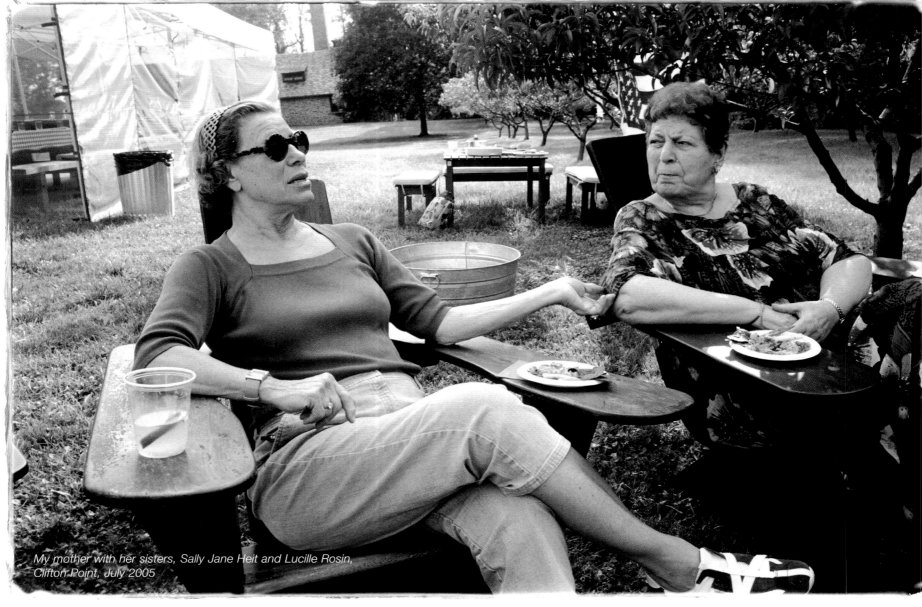

My mother with her sisters, Sally Jane Heit and Lucille Rosin,
Clifton Point, July 2005

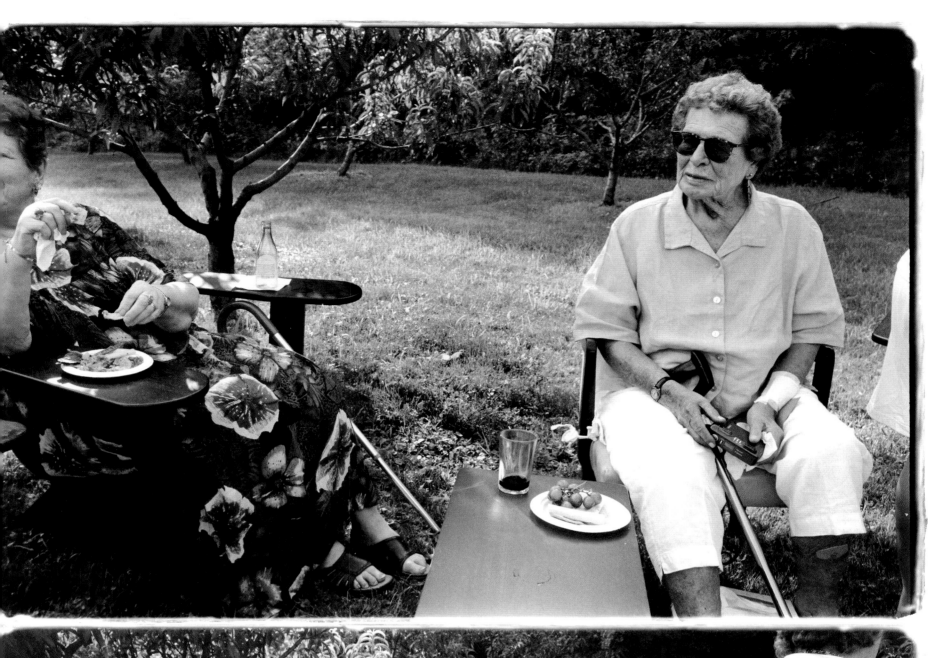
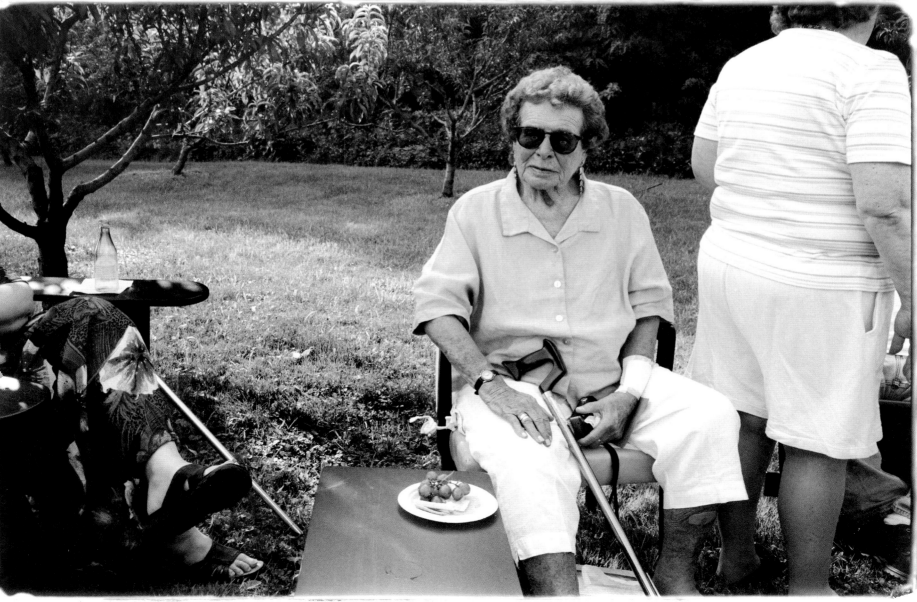

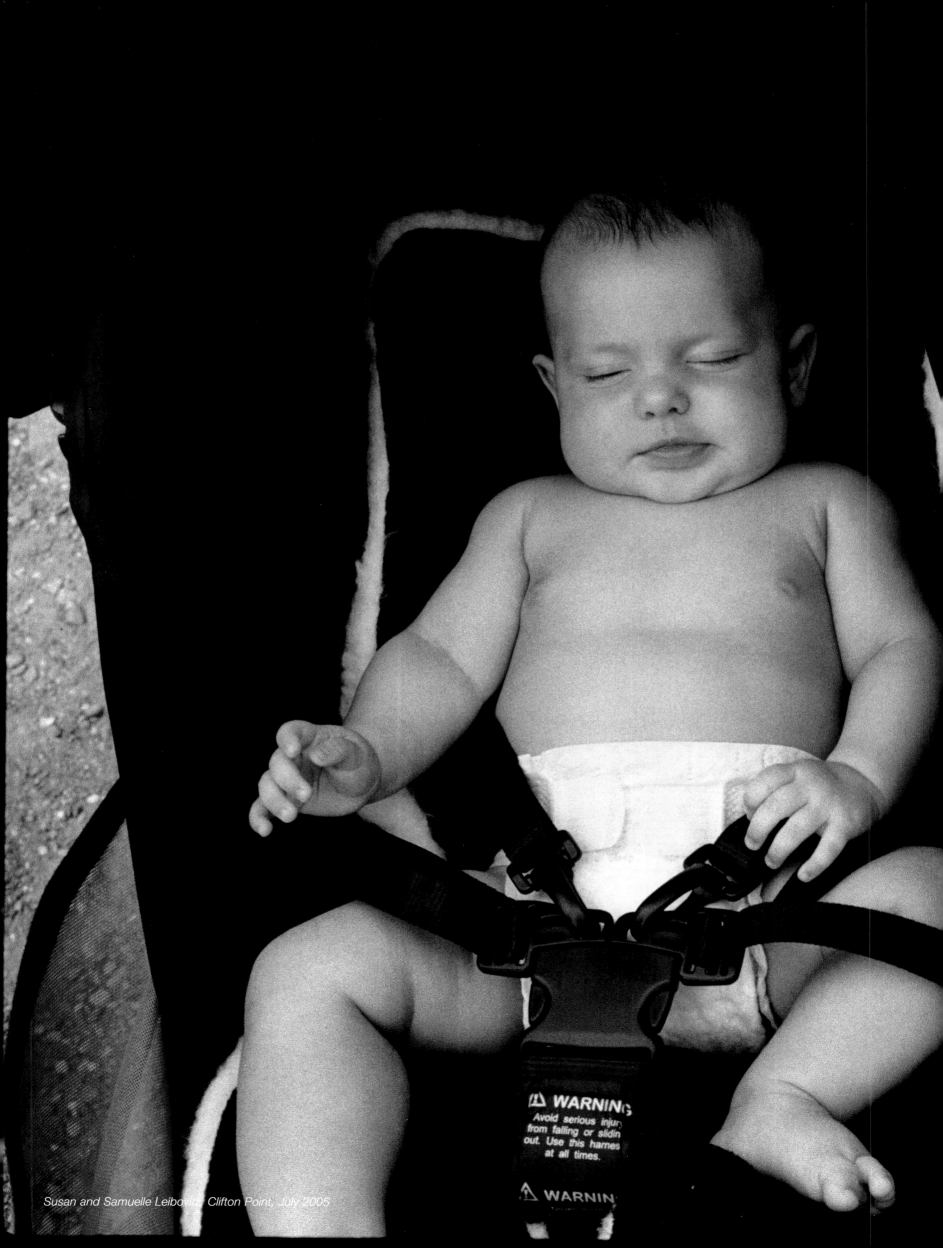

Susan and Samuelle Leibovitz, Clifton Point, July 2005

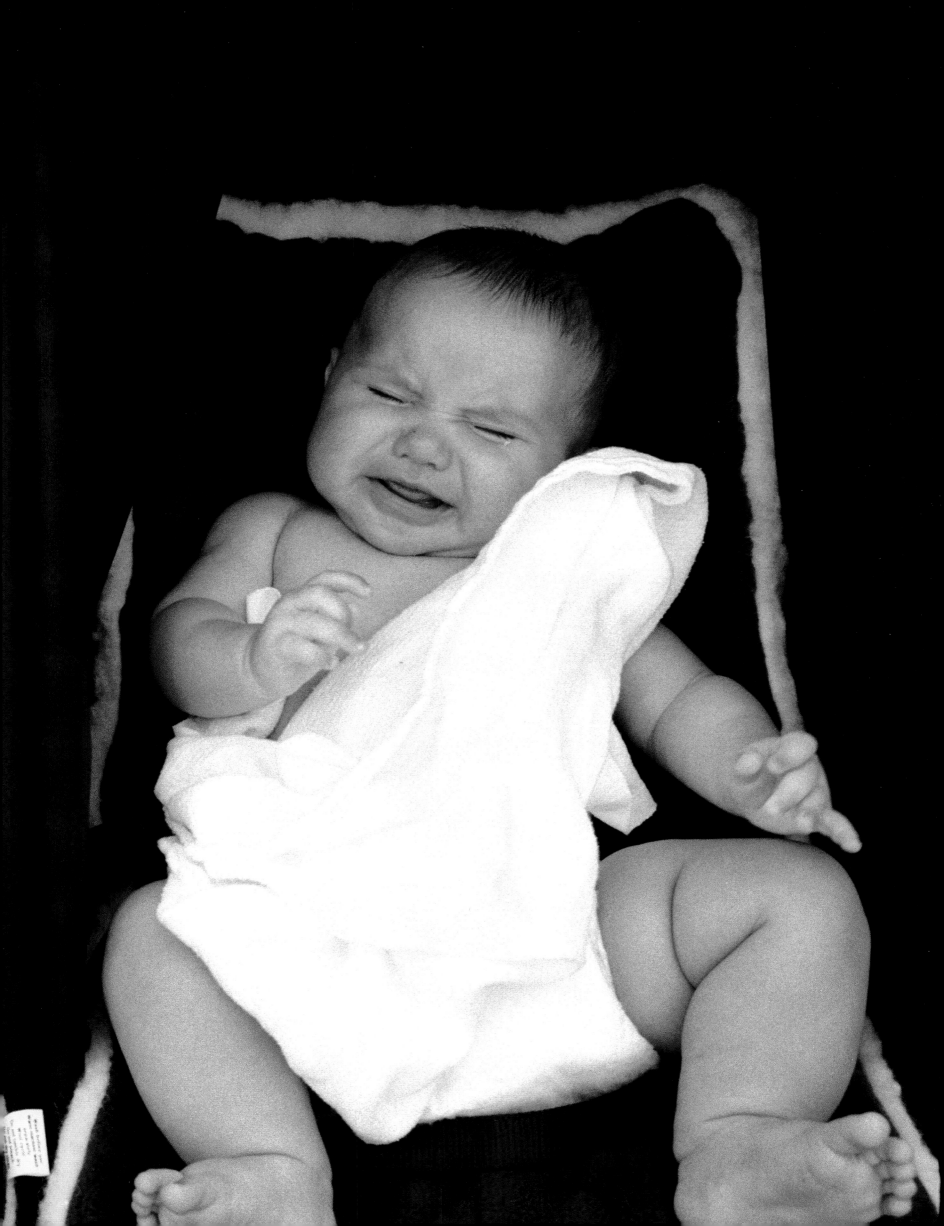

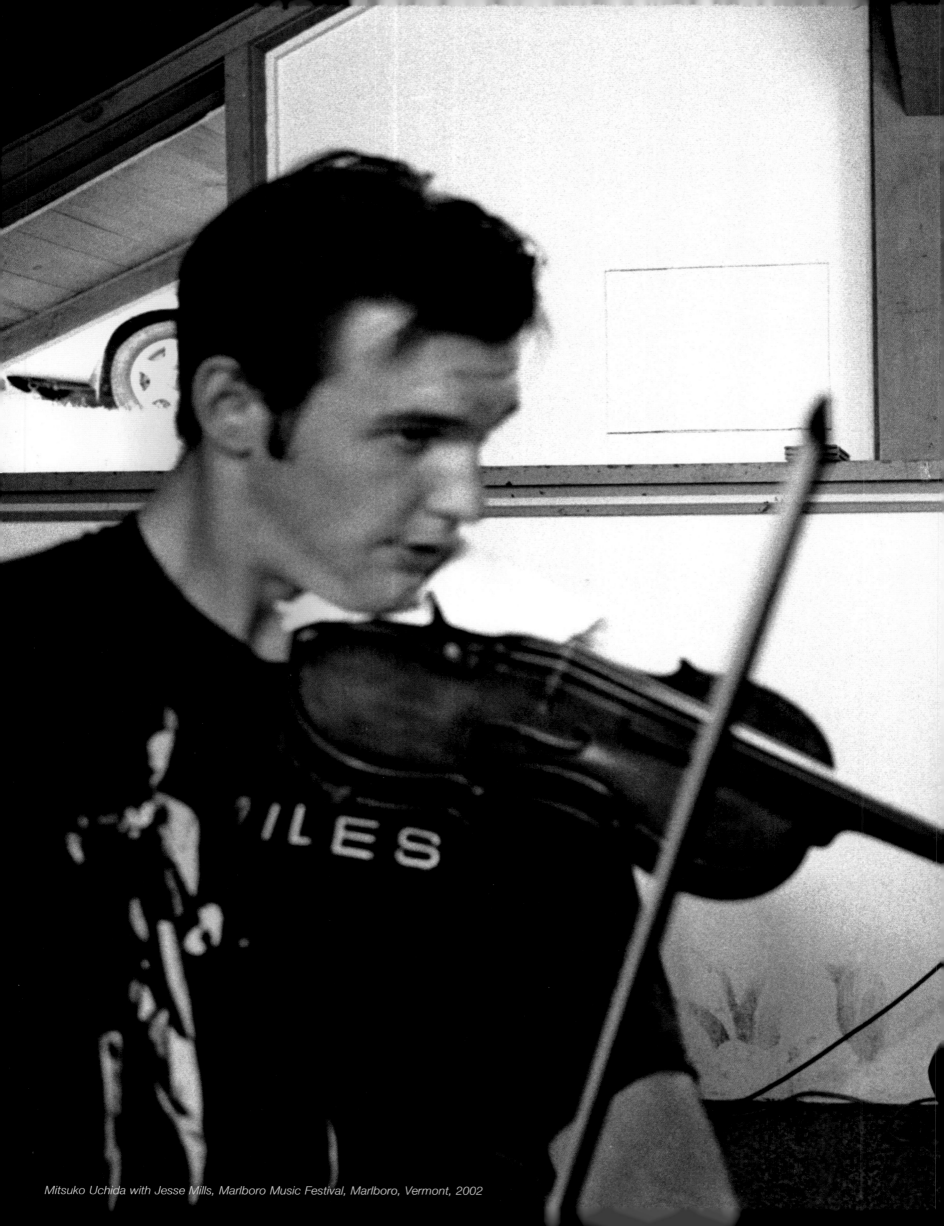

Mitsuko Uchida with Jesse Mills, Marlboro Music Festival, Marlboro, Vermont, 2002

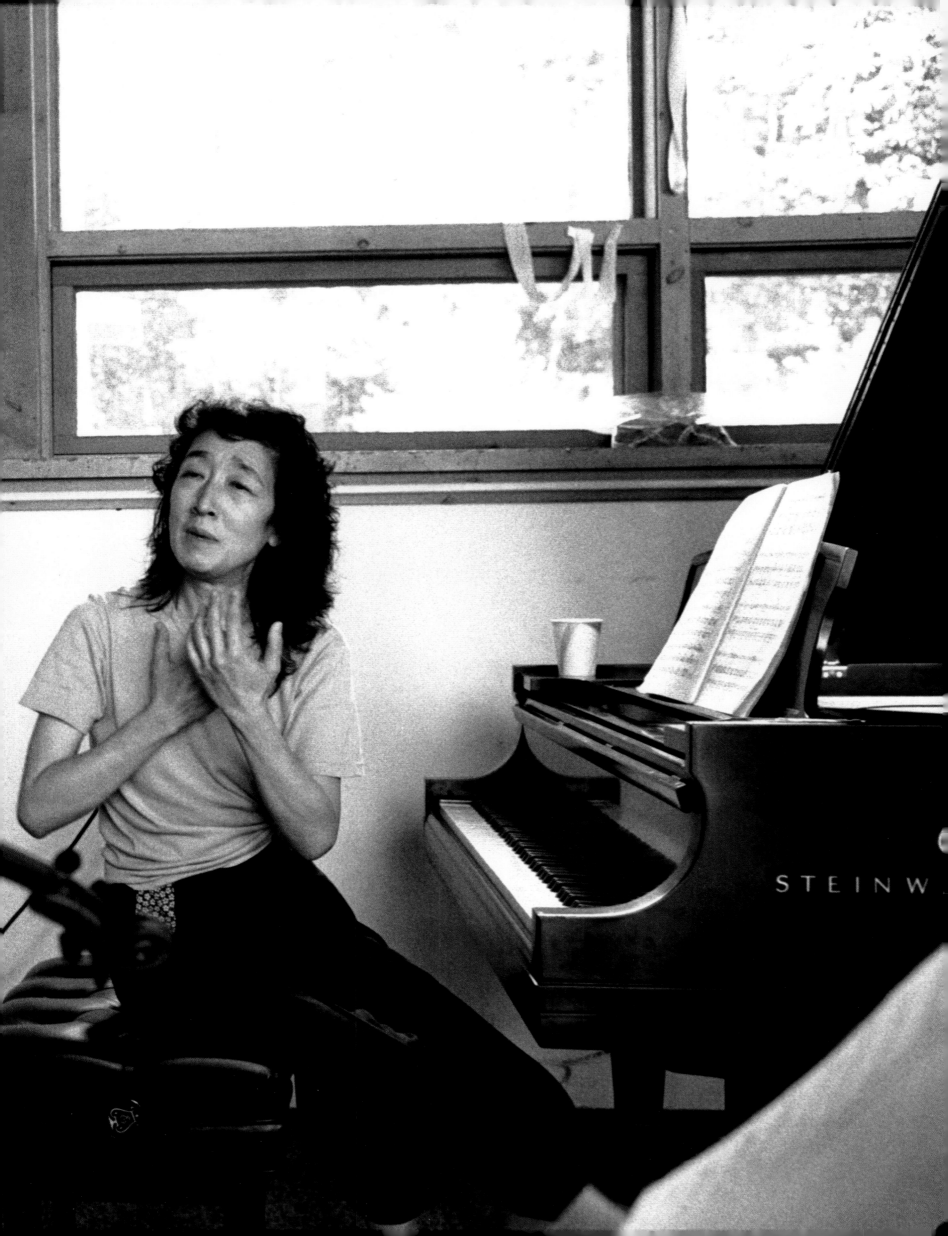

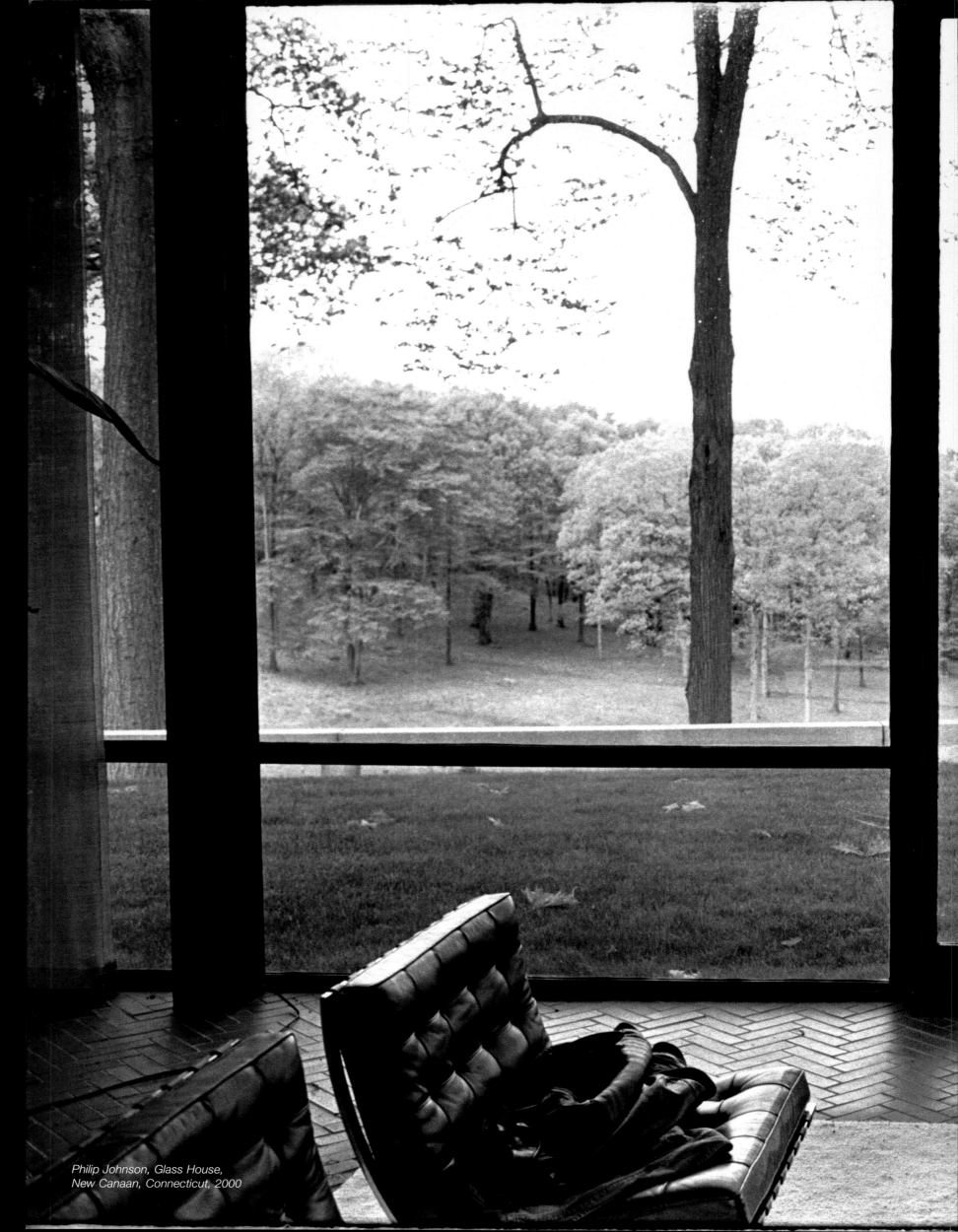

Philip Johnson, Glass House,
New Canaan, Connecticut, 2000

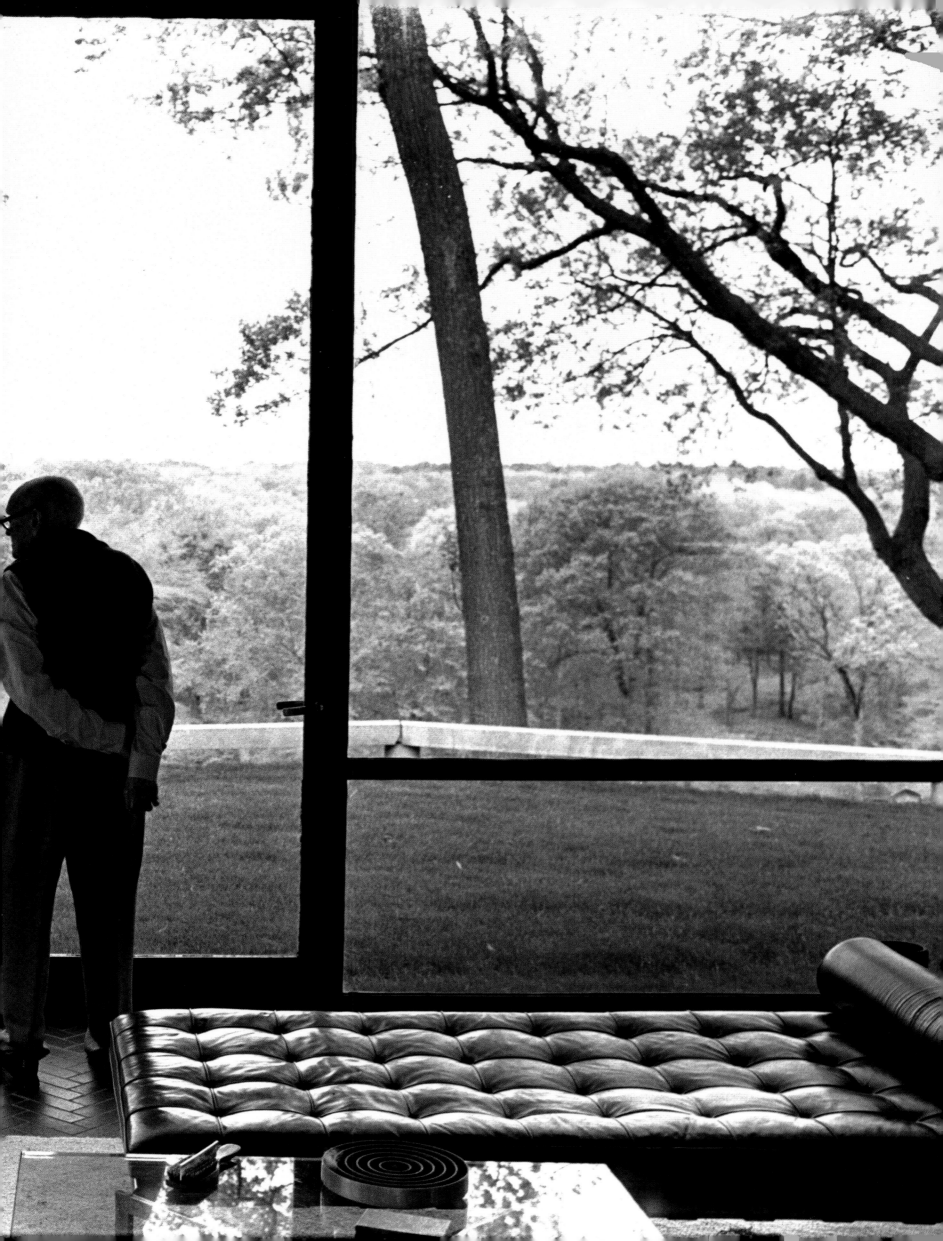

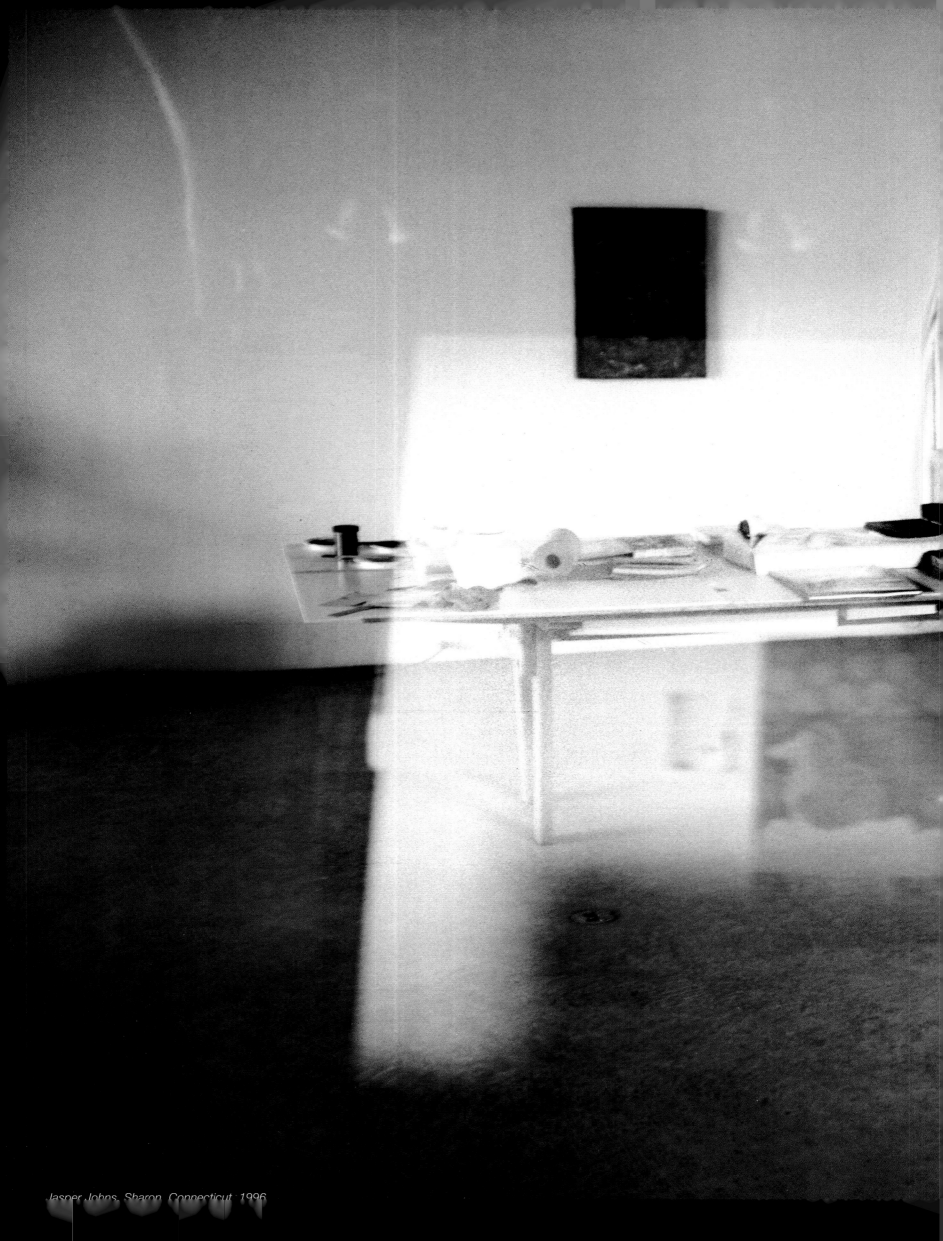

Jasper Johns, Sharon, Connecticut, 1996

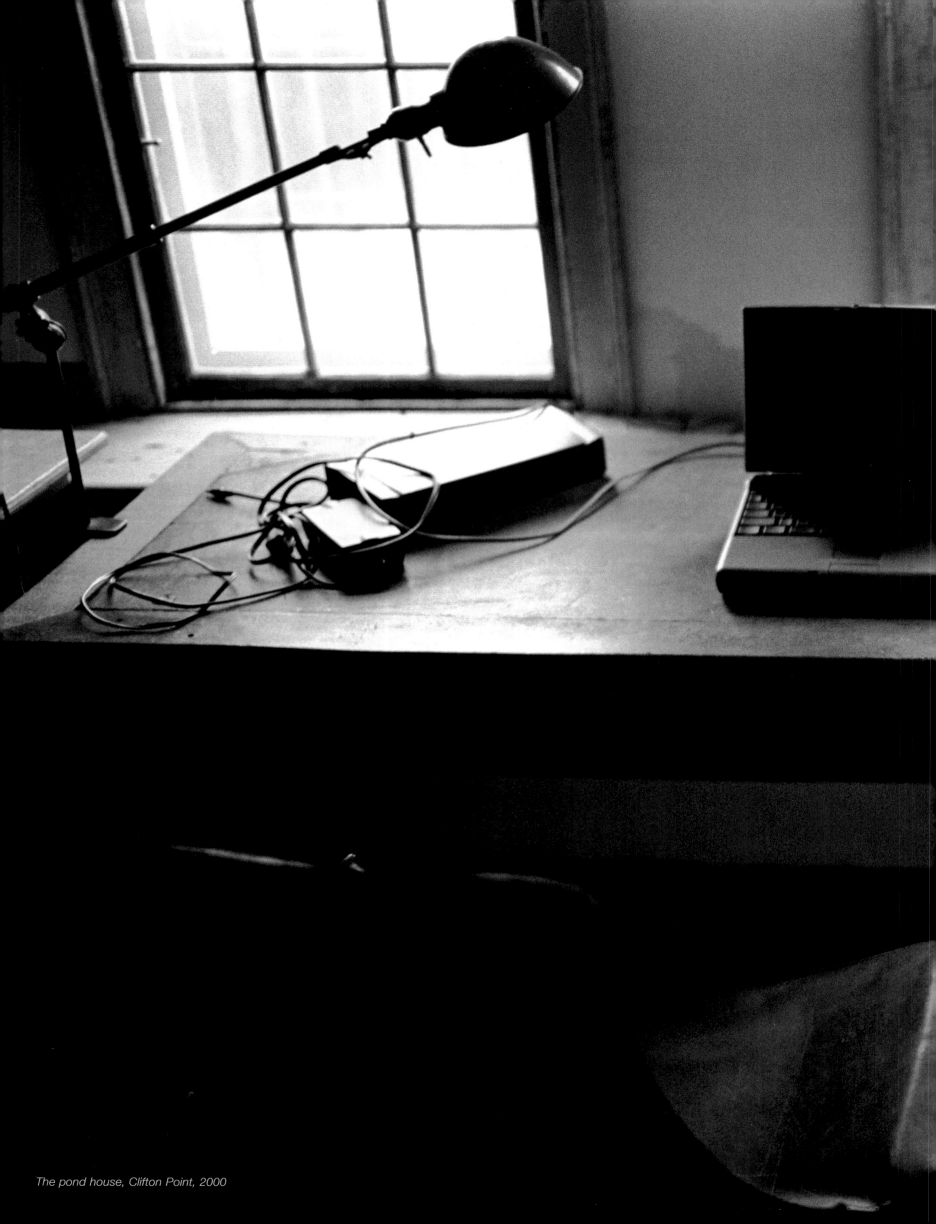

The pond house, Clifton Point, 2000

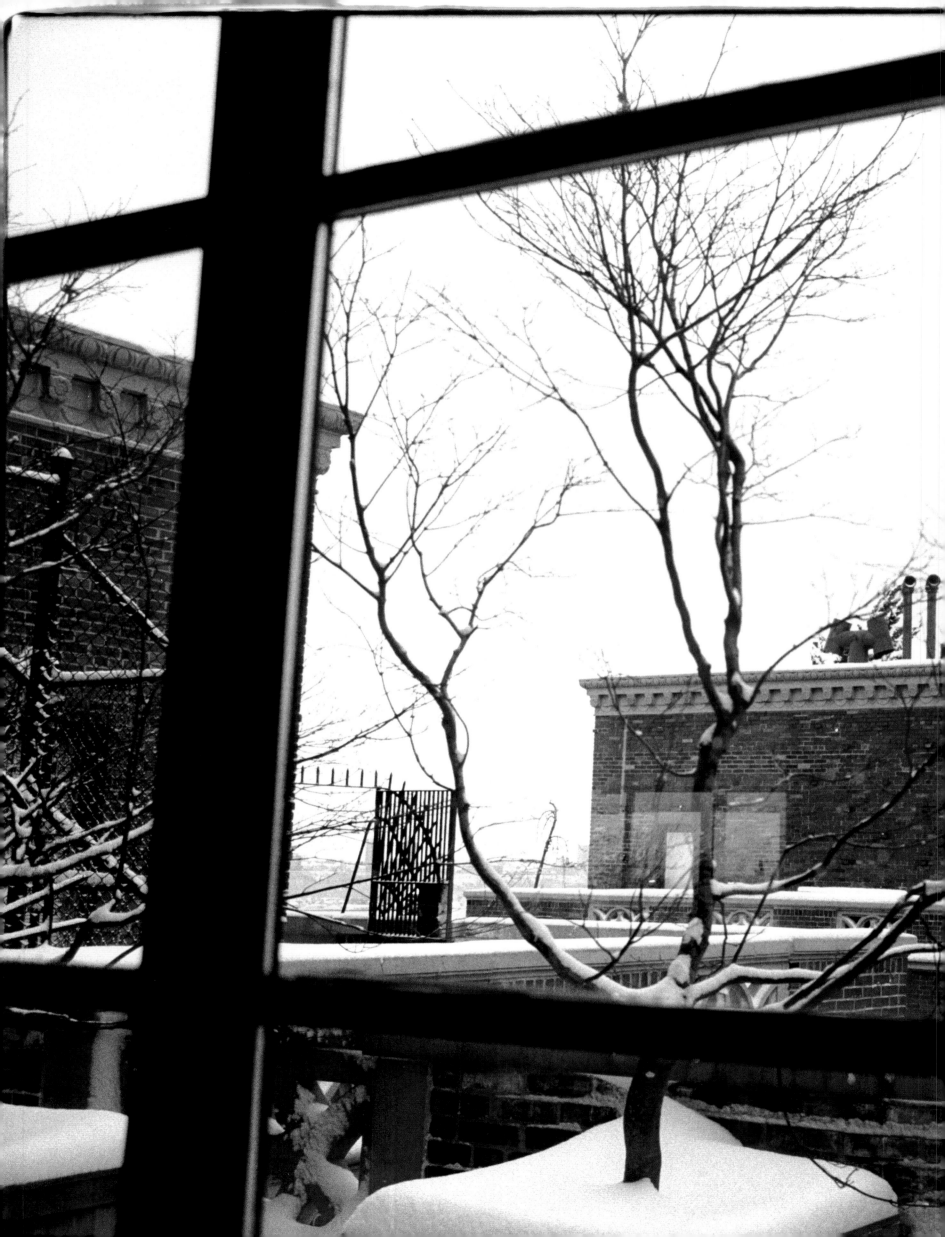

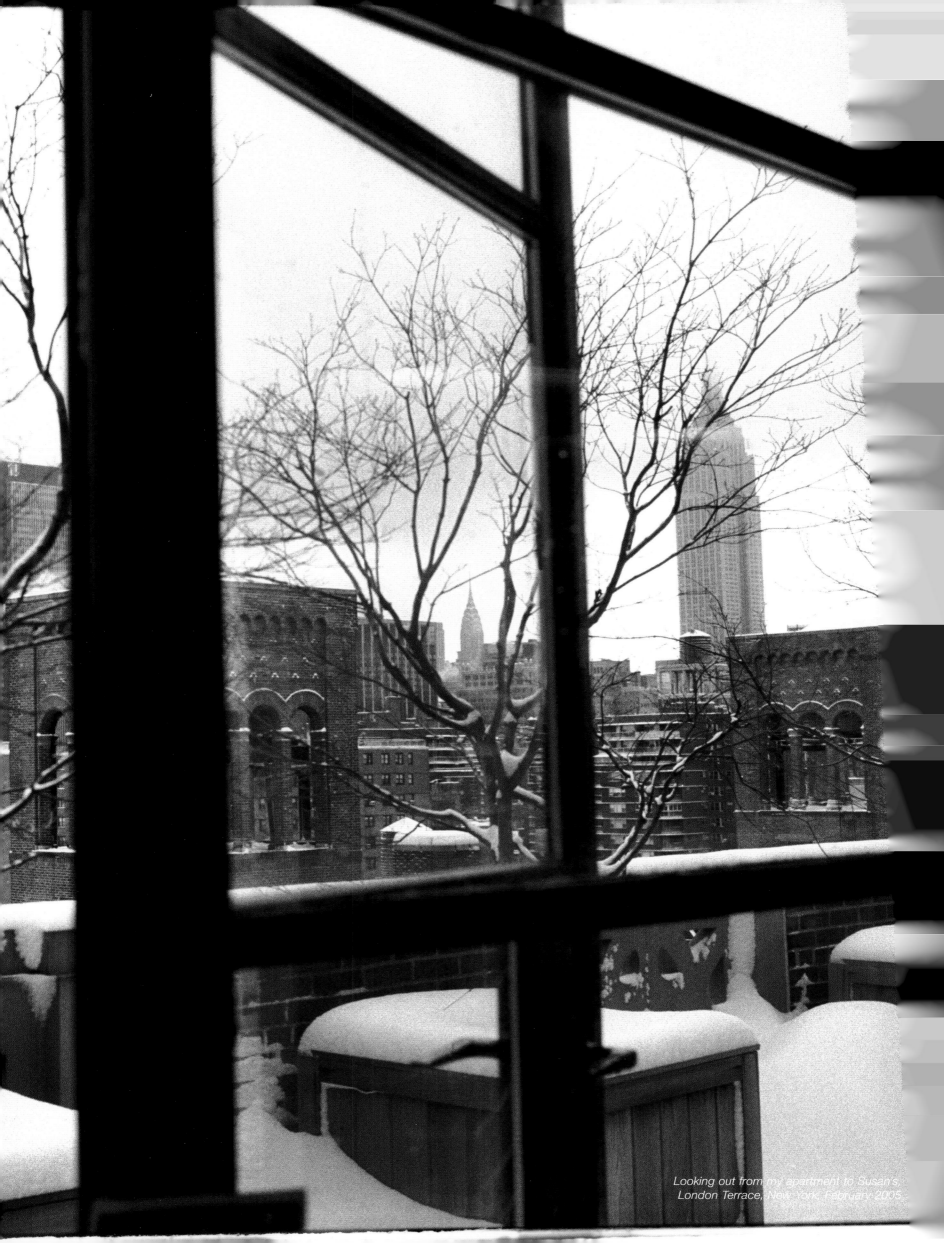

Looking out from my apartment to Susan's,
London Terrace, New York, February 2005

King Ludwig's Schloss Neuschwanstein, Bavaria, Germany, 1990

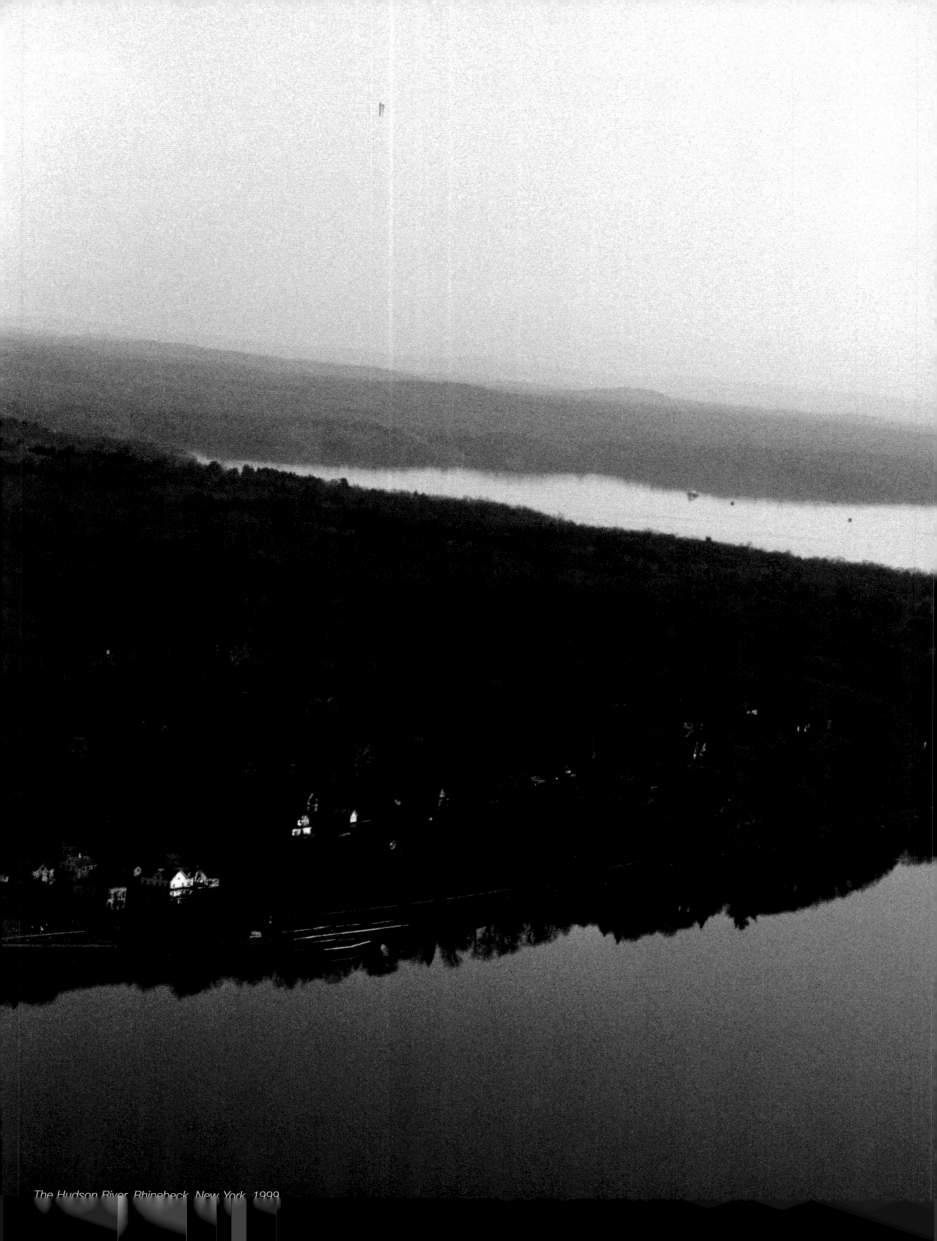

The Hudson River, Rhinebeck, New York, 1999

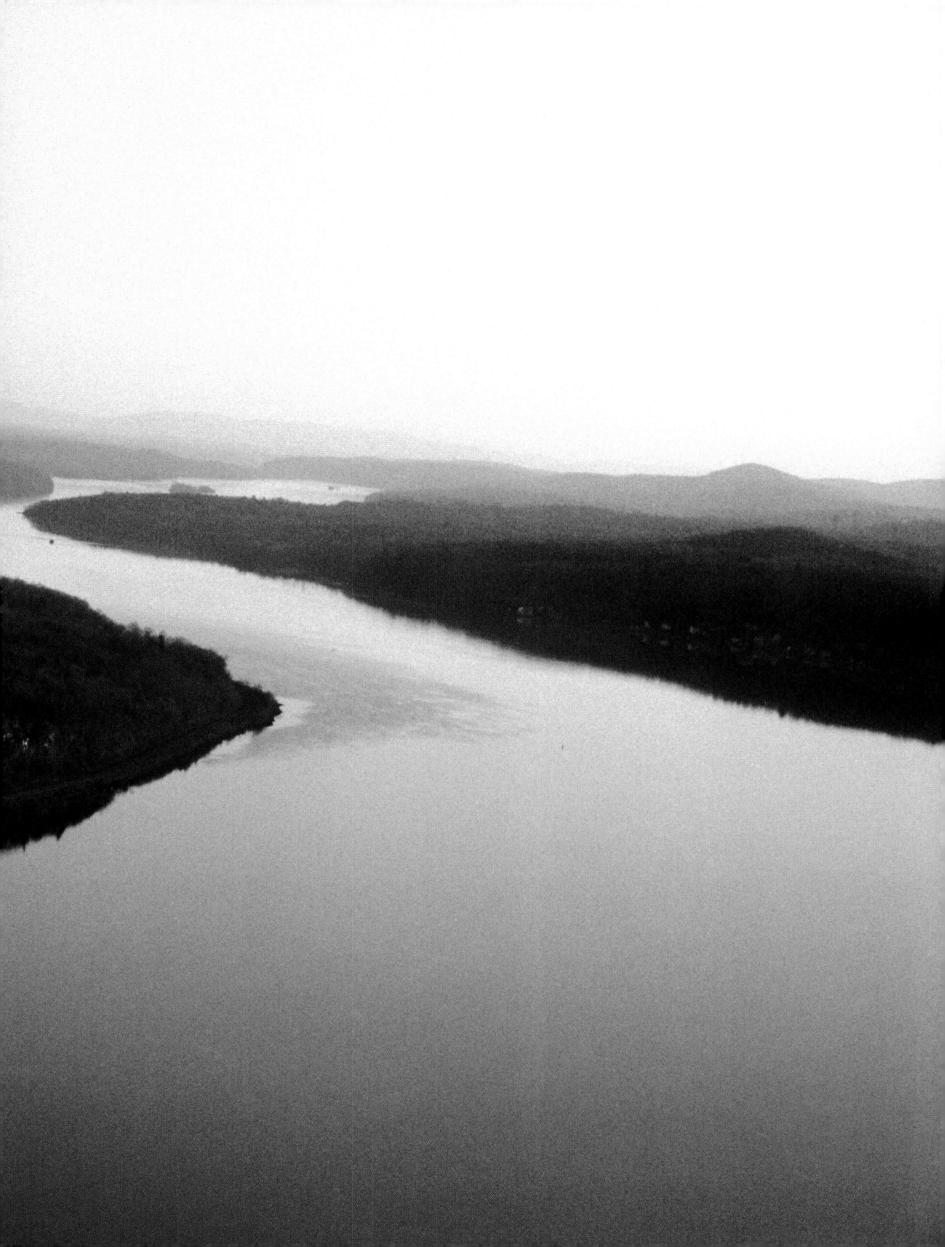

VerKeerderkill Falls, Sam's Point Preserve, Ellenville, New York, 1999

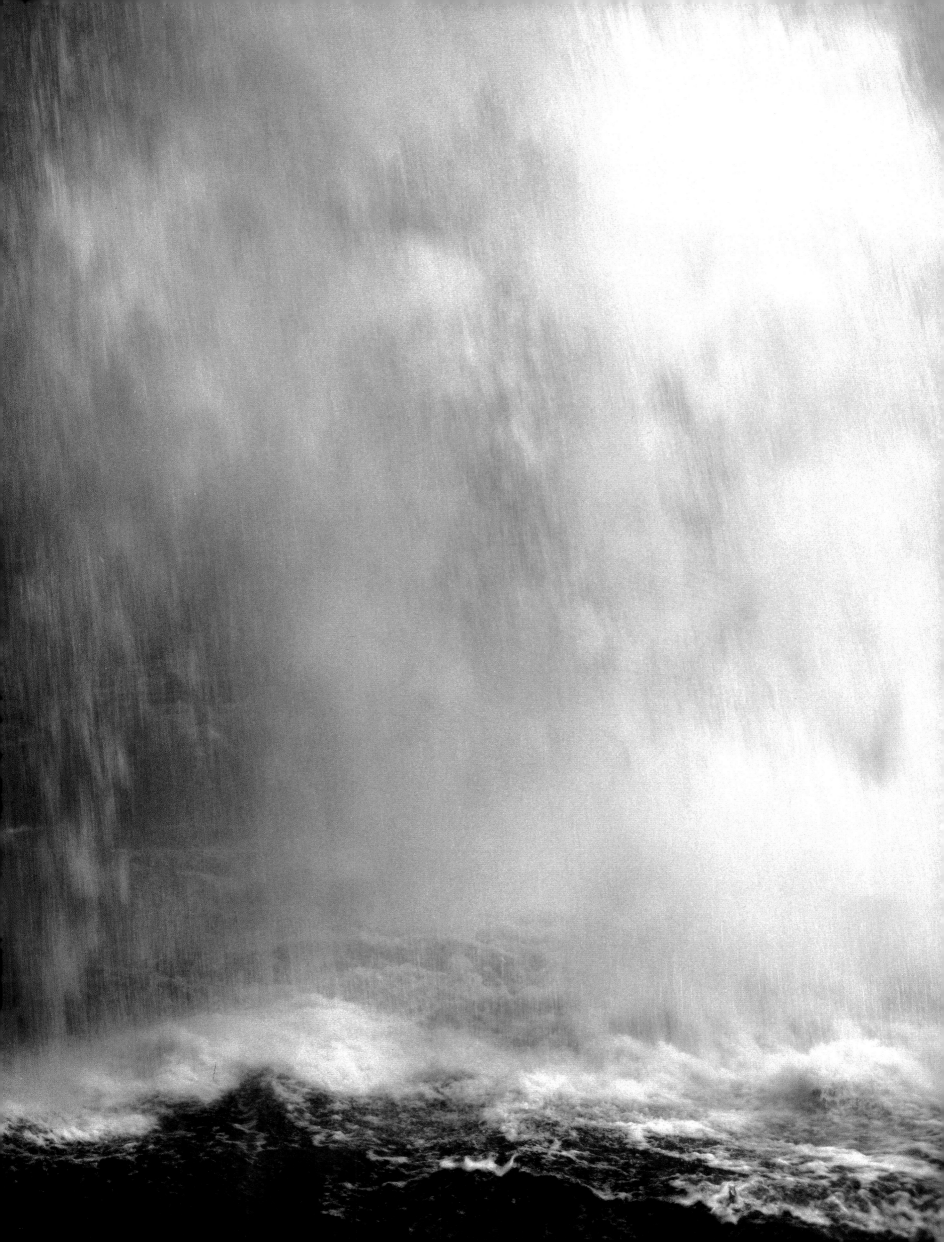

Daisen-in Temple, Kyoto, Japan, 1995

Notes for The Volcano Lover, *Berlin, 1990*

to

d climbed

rs (like

in Dickens'

later...) say
this

I don't

#3

Some Notes on his Character

— exhausted, fascinated by
childishness

— (a great) enabler

climb it

7

Prologuette #3

s. of
stion
d W.
tifully
f Italy
start.
ancholy
least of
ment of
on whose
omething
ore short-
tion which
or got its
invade Italy
astonishing
among the
and economic
one anticipated
ly would take

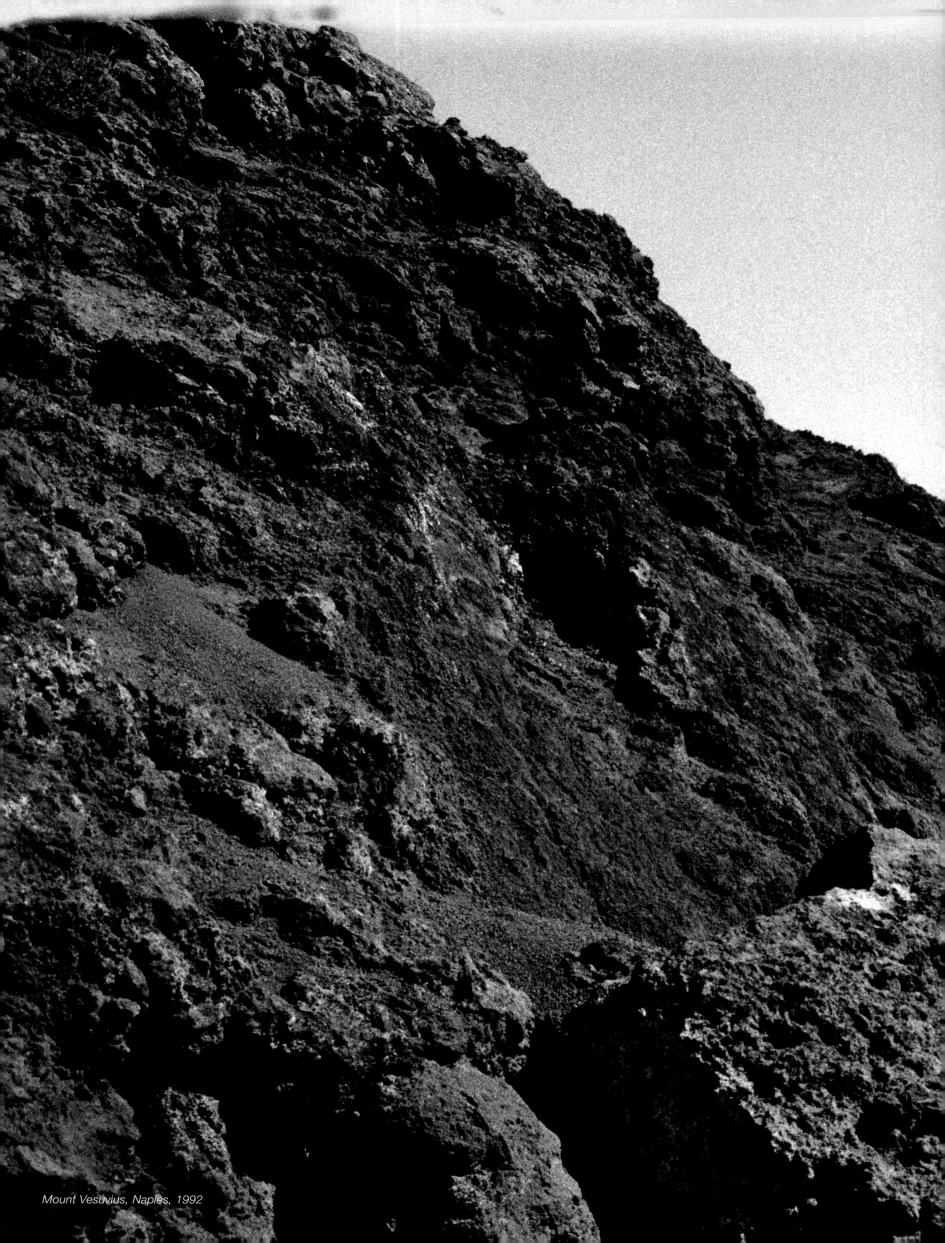

Mount Vesuvius, Naples, 1992

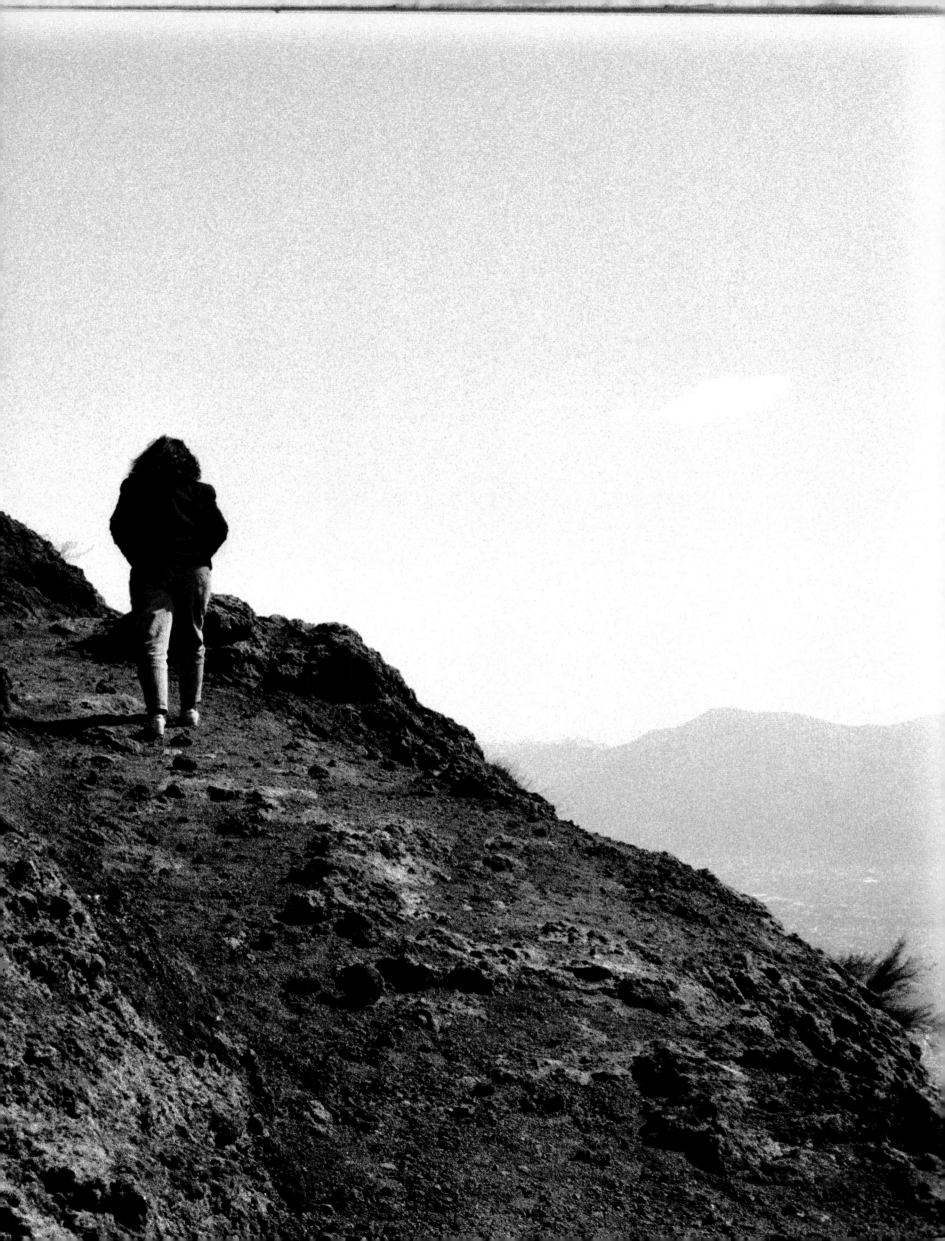

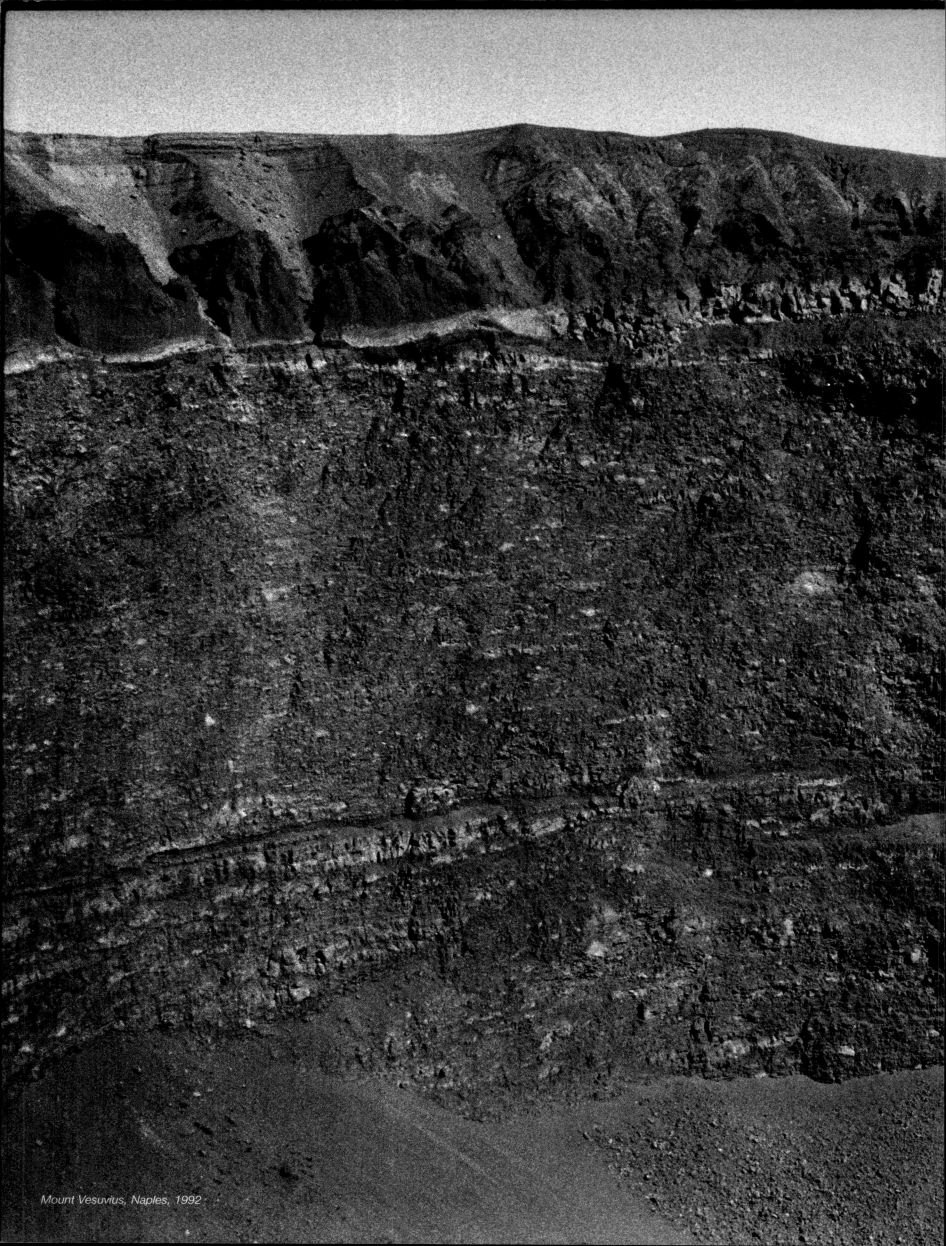

Mount Vesuvius, Naples, 1992

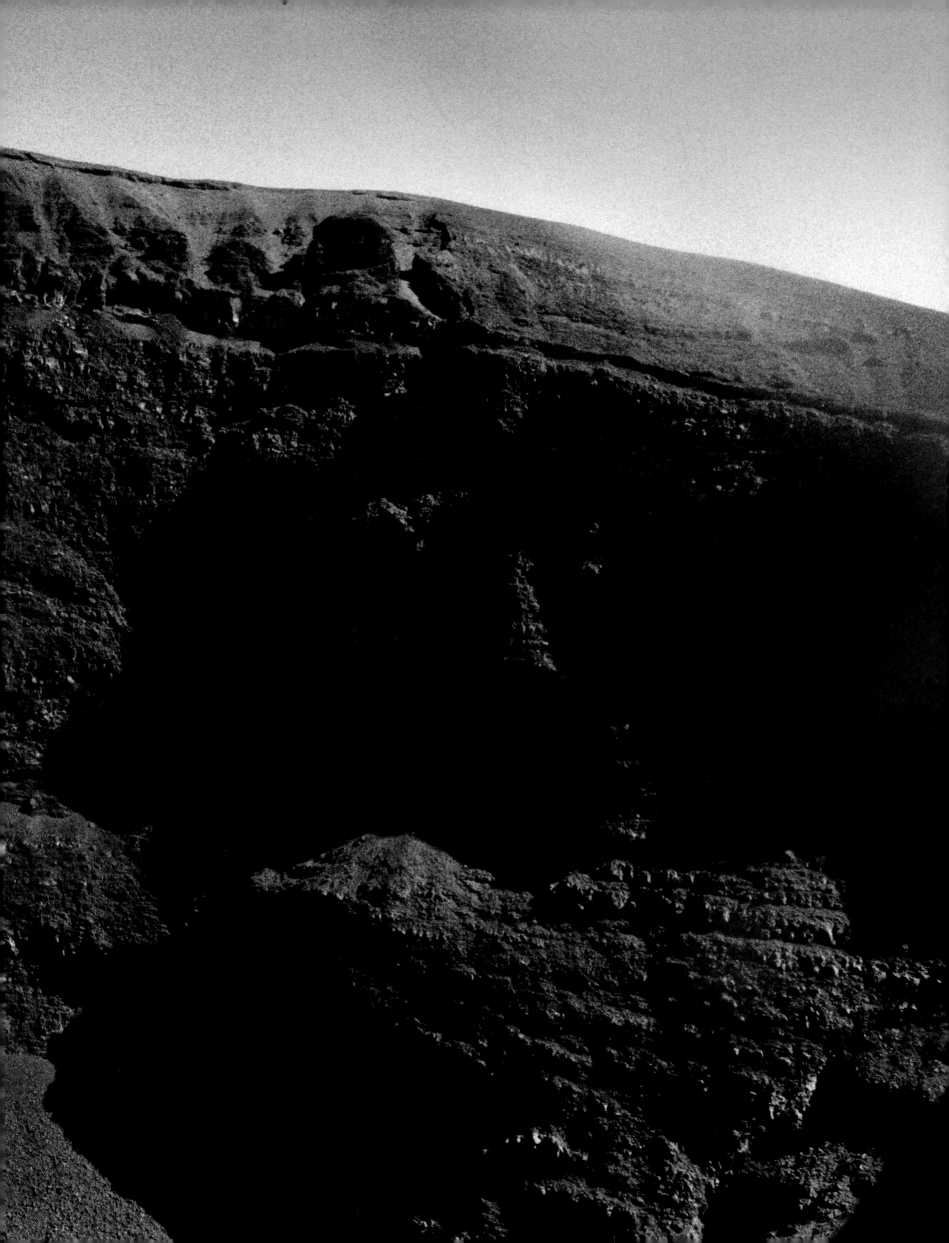

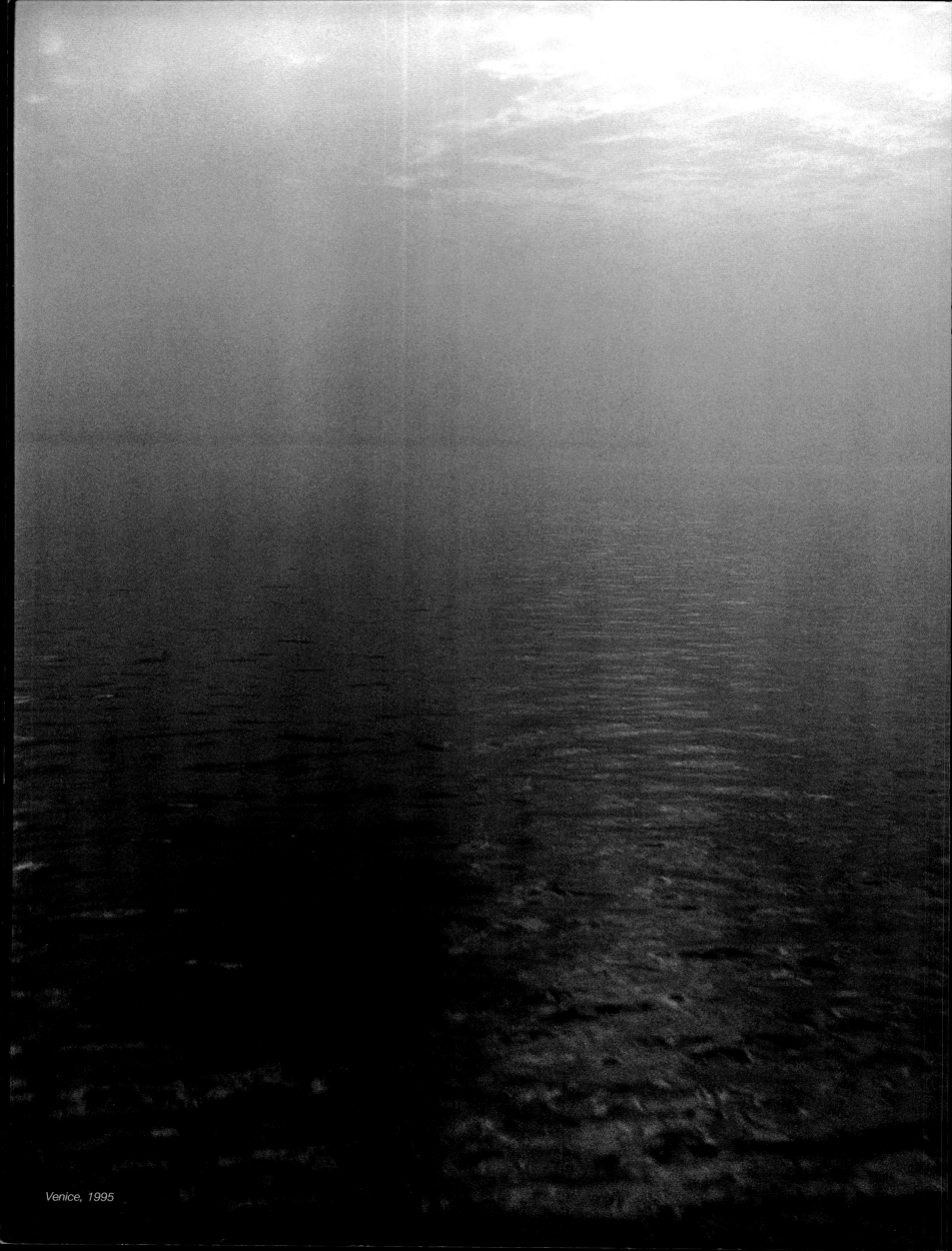

Venice, 1995

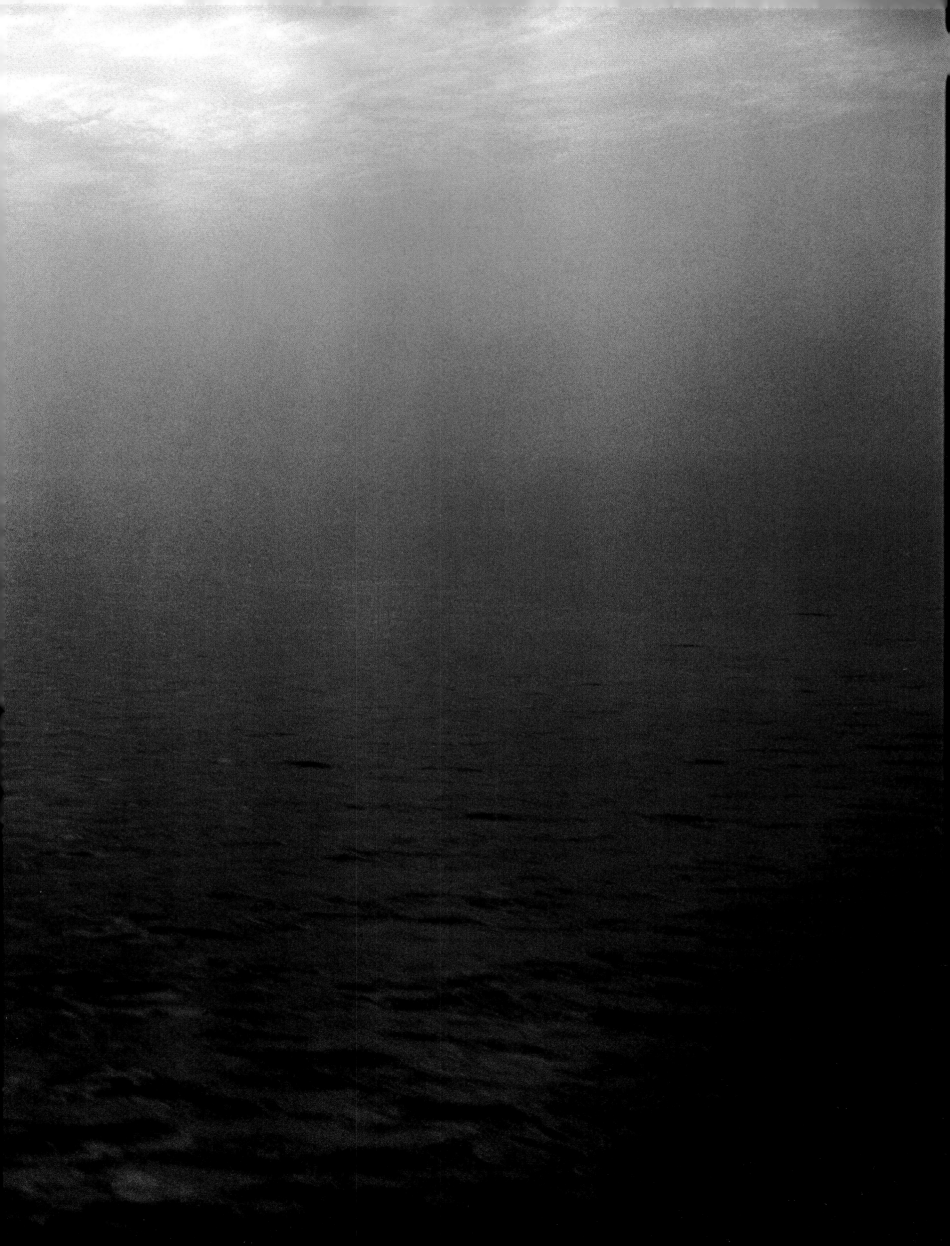

Venice, 1995

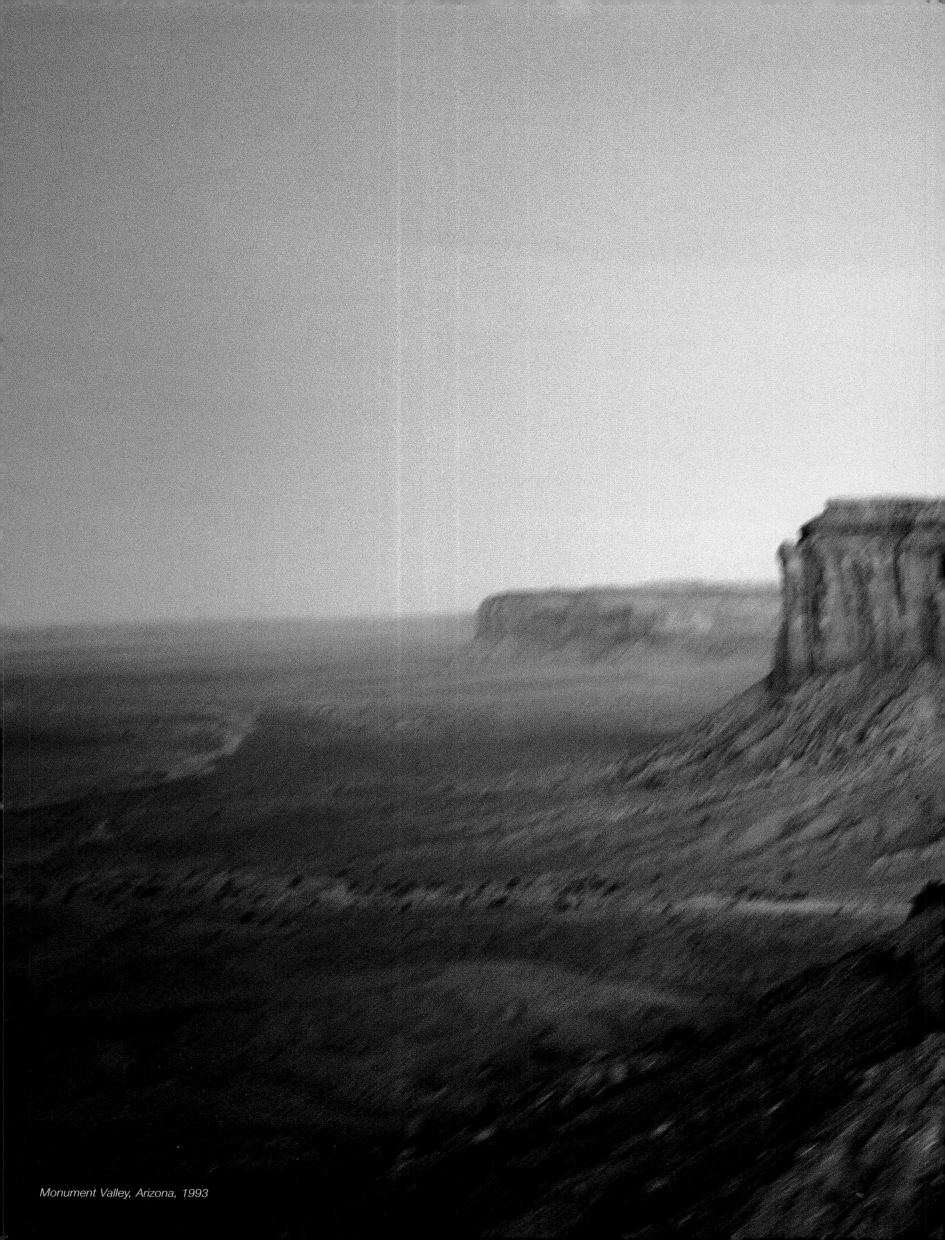

Monument Valley, Arizona, 1993

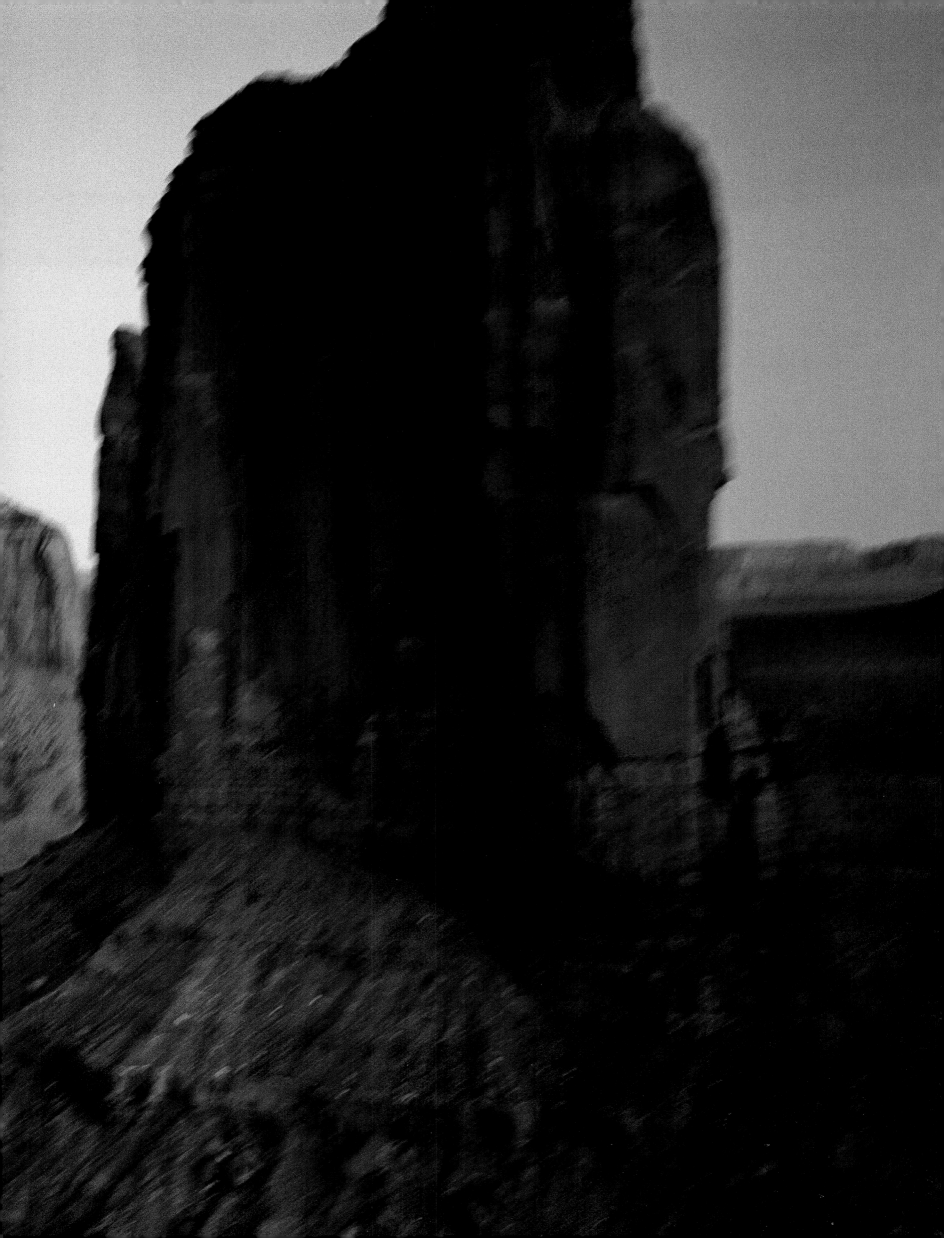

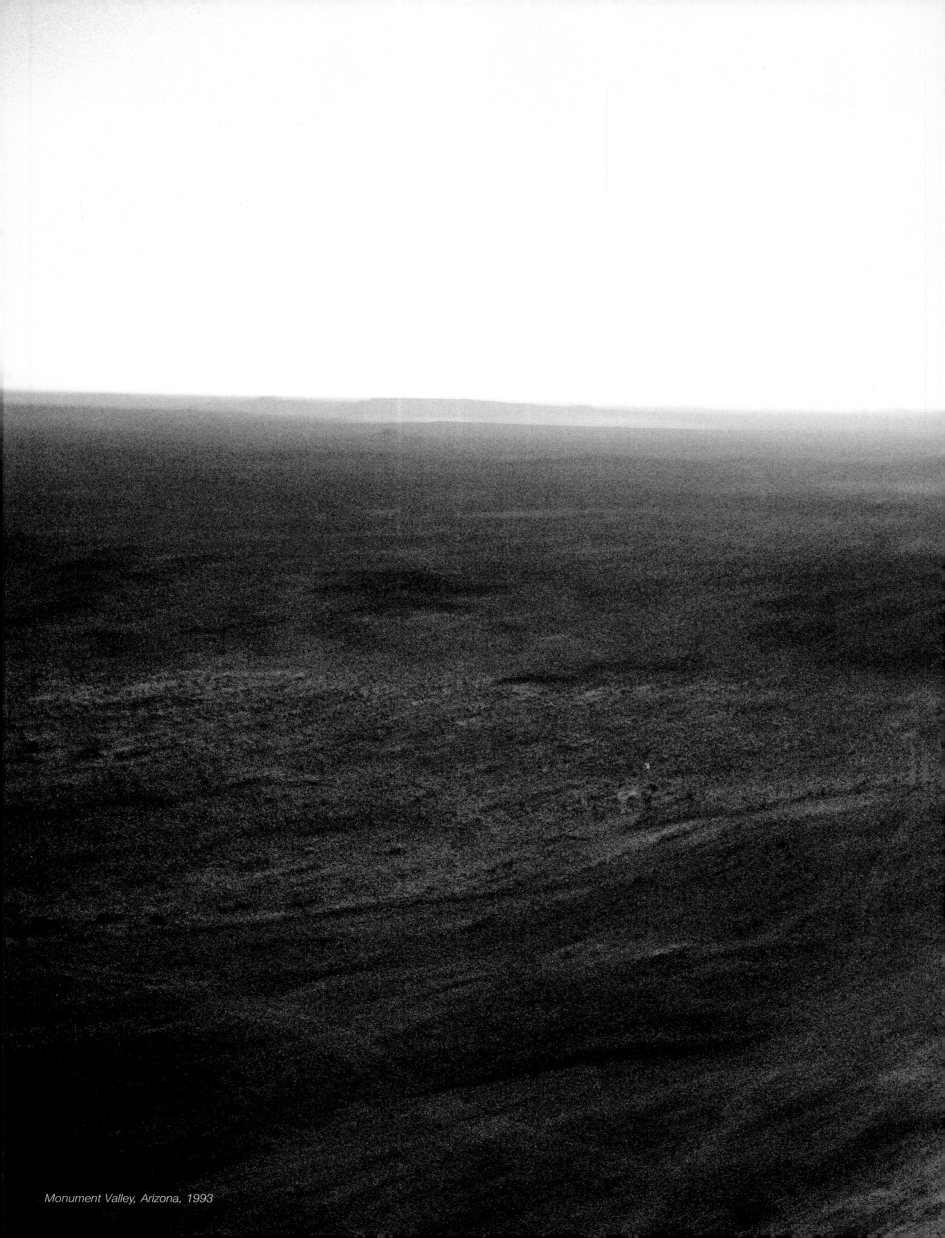

Monument Valley, Arizona, 1993

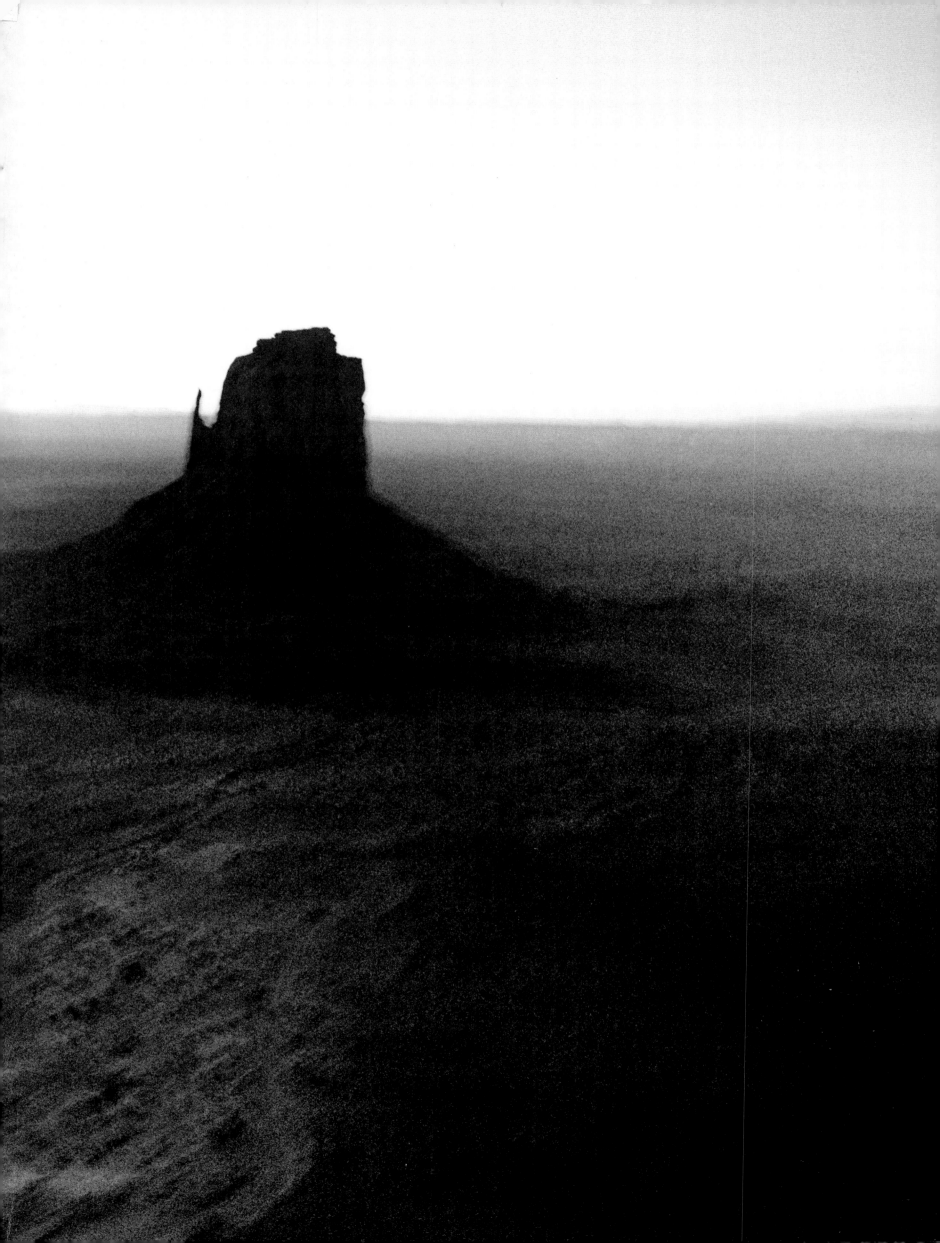

ACKNOWLEDGMENTS

Jim Moffat • Karen Mulligan • Andrew Wylie • Nick Rogers, Paul Gilmore, Henrik Olund, Thanut Singhasuvich, Wayne Wakino, Timothy Young • Ricky Floyd, Kathryn MacLeod • Michael Fisher, Ellen Moses • Elizabeth Elsass, Cat Burkley, Georgina Koren, Jenny Kim, Iratxe Mumford, Matt Rosenberg, Tim Hossler • Ernie Liberati, Anne Donnellon, Jo Matthews, Fred Jagueneau • David Jacobs, John Delaney, Marc McClish, Luke Hanscom, Benjamin Hoy, Esteban Montes, Phil Tsui, Theresa Grewal, Marion Liang, Sarah West • Sandra Colosimo • Sarah Chalfant • Mary Howard, Leslie Simitch, Lori Goldstein, Kim Meehan, Nicoletta Santoro, Wendy Schecter • Sally Hershberger, Julien d'Ys, Stephane Marais, Gucci Westman • Hasan and Baha Gluhić • Lora Zarubin, Alan Neumann, Mona Talbot, Kasia Górska, Peter Perrone, Alex Auder • Sookhee Chinkhan, Janine Johnson, Erik Van Etten, Petra Ruger, Michael Wilson, Anne Steichen, Laurent Bourgois • Barbara Freund, Jacques Moritz • Judith Cohen, Rosanne Cash, Joan Didion, Patti Smith, Mitsuko Uchida, Christian and Dominique Bourgois, Victoire Bourgois, Nicole Stéphane • Robert Pledge, Jeffrey Smith • Edwynn Houk, James Danziger • Jan Lederman, Marion and Henry Froelich • Rick Kantor • Susan White, David Harris • Gina Centrello, Kate Medina, Stacy Rockwood, Janet Wygal • Ruth Ansel • Charles Churchward, Alexandra Kotur, Phyllis Posnick, Tonne Goodman, Camilla Nickerson, Grace Coddington • Jane Sarkin • Tina Brown, Graydon Carter, Anna Wintour • S. I. Newhouse, Jr.

EDITED BY MARK HOLBORN
TEXT BASED ON CONVERSATIONS WITH SHARON DELANO

PRINTED IN ITALY BY CONTI TIPOCOLOR

COLOR AND IMAGE CONSULTING BY PASCAL DANGIN • PRINTS AND SEPARATIONS BY BOX STUDIOS
DESIGNED BY JEFF STREEPER